EW/CL

03549626

GW00467545

28. APR 86
22 SEP 86
05. JUN 87 86
(00) 26 Jun 87
16. OCT 87
09. NOV 87
05. DEC 87
01. MAR 88.

29. AUG 89
TO: HA
FROM: EW/CL
DUE:
30 NOV 1989
McDD
09. NOV
04 JUN

17. JUL 91
SUBJECT TO
RECALL
11. 01. 92
81
&31 7. 92 (00)
27. JUN 92
27. JUN 92
05. DEC
22. DEC
12. JAN 93
19. FEB 93

29. 1-93 (00)

RENEWALS

SURREY COUNTY LIBRARY
(Headquarters, West Street, Dorking)

Charges will be payable at the Adult rate if this item
is not returned by the latest date stamped above.

L.21B

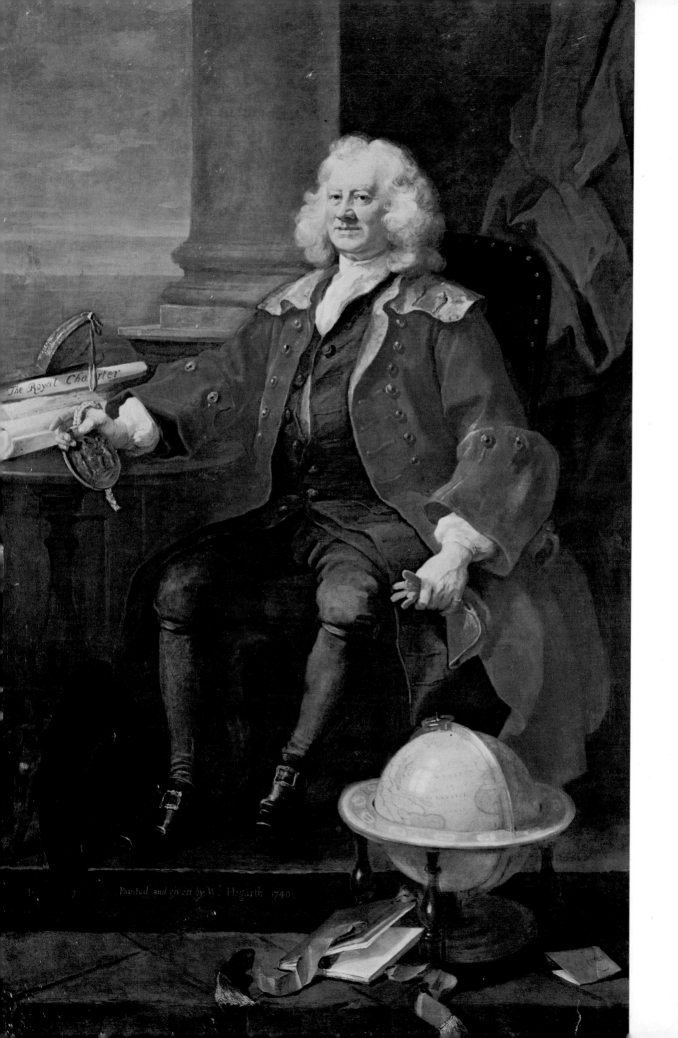

The Royal Charter

Painted and given by W. Hogarth 1746.

The Dictionary of
BRITISH 18th CENTURY PAINTERS
in oils and crayons

COL/751·45
ART

Ellis Waterhouse

Antique Collectors' Club

85-117125

© 1981 Ellis Waterhouse
World copyright reserved

ISBN 0 902028 93 6

All rights reserved. No part of this publication may be reproduced, stored in a retrieval system or transmitted in any form or by any means electronic, mechanical, photocopying, recording or otherwise, without the prior permission of the publisher.

British Library CIP Data
Waterhouse, Ellis
 The dictionary of British 18th century painters
 1. Painting, British 2. Painting, Modern —
 18th century — Great Britain
 759.2 ND466

Published for the Antique Collectors' Club by the
Antique Collectors' Club Ltd.

Frontispiece: WILLIAM HOGARTH. 'Captain Thomas Coram.' 94ins. x 58 ins. 1740. Thomas Coram Foundation, London.
Presented by the artist to the Foundling Hospital, London, of which Coram was the founder. It initiated the greatest period of British portraiture, and demonstrated that character and noble acts were as deserving of respect as noble birth.

The endpapers show engravings by J.H. Ramberg of the main room of the Academy during the 1787 and 1788 exhibitions.

Printed in England by Baron Publishing, Woodbridge, Suffolk.

The Dictionary of

BRITISH 18th CENTURY PAINTERS

in oils and crayons

Ellis Waterhouse

To The Royal Academy of Arts

Contents

	Page
List of Colour Plates	10
Abbreviations	11
Foreword	12
Introduction	14
Dictionary	21
Bibliography	436
Chronological list of datable illustrations	440

List of Colour Plates

Page

William Hogarth, *'Captain Thomas Coram'* . Frontispiece

Jacopo Amigoni *'Mercury about to cut off the head of Argus'* 19

Joseph Cooper, *'Still life of fruit'* . 77

John Singleton Copley, *'Hugh, 12th Earl of Eglinton'* 80

Thomas Gainsborough, *'A peasant girl gathering sticks in a wood'* 137

Edward Haytley, *'The Montagu family at Sandleford Priory'* 156

Thomas Jones, *'Buildings in Naples'* . 213

Sir Henry Raeburn, *'Sir John Sinclair, 1st Bt. of Ulbster'* 216

Sir Joshua Reynolds, *'Members of the Society of Dilettanti (1)'* 305

Sir Joshua Reynolds, *'Members of the Society of Dilettanti (2)'* 324

Sir James Thornhill, *'Part of the ceiling of the Painted Hall at Greenwich'* 374

Pieter van Bleeck, *'Mrs. Cibber as Cordelia'* . 391

ABBREVIATIONS USED IN, AND NOTES ON, THE TEXT
(see also Bibliography)

BAC Yale Yale Center for British Art, Yale University, New Haven, Connecticut
BM British Museum
cat. catalogue
exh. exhibitor, exhibited, etc.
NG National Gallery, London
NMM National Maritime Museum, Greenwich
NPG National Portrait Gallery, London
s. & d. signed and dated
SNG Scottish National Gallery, Edinburgh
SNPG Scottish National Portrait Gallery, Edinburgh

Sales

When sales are mentioned by date only they were by Christie's; sales by Sotheby's are preceded by S. Christie's and Sotheby's sales were in London, unless otherwise stated.

Exhibiting societies

The following are constantly quoted in the text:

SA The Society of Artists of Great Britain, 1760-1791
FS The Free Society of Artists, 1761-1783. The (very rare) catalogues only occasionally call it the 'Free' Society. But they are all listed under this title in Algernon Graves' *The Society of Artists of Great Britain 1760-1791: The Free Society of Artists 1761-1783*
RA Royal Academy from 1769
BI British Institution from 1806

Algernon Graves has published alphabetical dictionaries of all the works exhibited in the eighteenth century, which it is normally convenient to use, but they are not free from mistakes and misunderstandings, and I have constantly checked the exhibits in RA and FS (and when possible the SA ones) from the original catalogues. But the spelling of names and the initials are quite often at fault: the FS catalogues in particular are rich in misprints, and some exhibitions had more than one edition of the catalogue, sometimes with considerable variations.

All pictures are in oil on canvas, unless otherwise stated. Measurements are given height by width.

Foreword

Those who refer to this book — for a Dictionary can hardly have 'readers' — will like to know what they may expect to find in it, and also what they will not find. Artists who, to the best of my knowledge, painted only in miniature are not included; nor are those who painted only in watercolour or some such medium, who are to be found in Mr. Mallalieu's work (see Bibliography). I have included painters whose exhibited works are described as in 'pastel' or 'crayons' since they tend to get left out of dictionaries. Painters whose work is predominantly in watercolours, but who are known (as is the case with J.R. Cozens) to have painted at least one picture in oil, are included, but the student must not expect to find more than the most summary account of their work as watercolourists.

To the art historian the 'eighteenth century' in England really begins with the accession of the Hanoverian dynasty in 1714, and it ends about the time of the death of Reynolds in 1792, when a new period — sometimes called the 'romantic' period — may be said to begin. But it is tidier for those who are not art historians to consider the eighteenth century as running from 1700 to 1800, and this is what I have done. But painters whose surviving works were all done before 1700, such as Francis Barlow (d.1704), are left out; and those whose best periods (such as Ashfield or Kneller) fell in the seventeenth century are only seriously discussed in so far as their work was done after 1700; and those who merely began their career as oil painters shortly before 1800 have their later work treated in a very summary manner. Thus Turner, who had painted only a few oils before 1800, is treated only very briefly. With very few exceptions the illustrations have all been chosen from works datable between 1700 and 1800. I could have wished I had decided to end about 1795, since the number of trivial painters who began to exhibit in the '90s, was excessive. It is often not clear whether exhibited pictures were in oils or some lighter medium, and uncertainty about this has no doubt sometimes led to the inclusion of painters who should have been left out. The painter William Blake, who mercifully never painted in oils, has been omitted deliberately.

Foreign painters who actually visited England have been included, but attention has only been given to their work done in this country and only sketchy accounts may be found of their work outside the country. Foreigners who occasionally exhibited in England from a foreign address have been left out: and even an artist as important for the history of British patronage as Mengs (and one of whose works was actually exhibited at the R.A. as by 'Mr. Minx') has also reluctantly been omitted — as has Pompeo Batoni. A large number of the painters included are only known from the record of their exhibits in the catalogues of the annual exhibitions. There is no doubt that the names of some of these, especially in the catalogues of the 'Free Society', are absurdly misprinted. I have corrected such errors when I can — but a number remain baffling.

I have been accumulating information which might be used in a work of this sort for about forty years, but in a somewhat desultory fashion: in preparing it I have become aware that several months of careful research among rate books,

wills, parish registers, etc., might have filled in a number of gaps. But this has not been practicable and a volume of this sort admits of constant revision and I shall be grateful for any corrections which readers may send. Since nothing serious of the kind has been attempted since Redgrave (1878), there is certainly a need for a book of this sort. Reliable dates seem to me to be the most important things and I have given, wherever possible, precise dates of birth and death, and, when my date differs from that normally given, I have indicated my source. But it should be remembered that artists are not always very reliable about dates. Northcote had to write to his father from Florence to ask if the date for his birth that he had given to the Florentine Academy was the correct one, and Lawrence celebrated his birthday on the wrong day until he was twenty-one, when a legal enquiry caused him to correct it. The dates I have given are at least those which were thought at the time to be correct.

Most books on British painting merely copy what has been written in an earlier book, and, as often as not, there is only a single magazine article or other printed source which is worth quoting. I have usually limited my bibliographical reference to this, or, in some cases, to sources which include a full bibliography (such as Croft-Murray). Where I have been indebted to individuals for a piece of information, I hope I have always indicated it, but, over the years, some sources may have been forgotten.

The institutions to which I have been most indebted in the compilation of this work are the British Art Center at Yale, the Paul Mellon Centre for British Art in London, the National Galleries of Scotland, and the Royal Academy of Arts: and, for the illustrations, Messrs. Christie's and Messrs. Sotheby's. Since very little attempt has been made to acquire for public collections the signed and dated or documented works of the less familiar British painters, it is only when such pictures turn up in the auction rooms that it is possible to pinpoint them and to indicate some term of reference by which they may be mentioned — since they normally return to the same sort of limbo from which they emerged. That it has been possible to illustrate so many of these is due to the generous permission of these auction houses. I am also deeply indebted to the many private owners and dealers who have allowed me to reproduce their works. The few pictures indicated as 'unlocated' are mostly taken from photographs which date from before the last war, whose ownership was even then unknown to me. I have selected signed and dated works as far as possible and have taken the trouble to verify the dates and signatures wherever possible. At the end of many entries the name of some author will be found in an abbreviated form (see Bibliography): this is the book to which I would recommend the reader to refer for the kind of information I have not included — addresses, names of wives and children, lists of works, or engravings after their works, gossip unconnected with their professional activity. All such things have had to be left out to make it possible to compress the dictionary into a manageable size. The only non-factual statements I have allowed myself have been indications of stylistic affinities between painters, in the hope that such suggestions may help the inexperienced student to recognise a possible candidate for the authorship of a portrait. Unfortunately the technical idiosyncrasies of most eighteenth century painters are so inconsiderable that it has not been thought necessary to introduce details of paintings.

Introduction

The eighteenth century is the period in which native British painting may be said to have 'come of age'. It is not that there were no English and Scottish painters of respectable quality working during the seventeenth century, but there was no academic tradition, there were no art schools and nowhere outside his own studio where a painter could show his work. In 1700 the painters in most repute and most patronised by the Crown and the nobility were all foreigners. For portraiture there was Kneller, a German, who was 'Principal Painter to the King', had been knighted in 1692 (and was made a baronet in 1712) and whose chief rival was Michael Dahl, a Swede; for baroque wall painting in palaces and the great houses, which were increasingly being decorated, there were the foreigners Verrio, Laguerre, Cheron and Berchet. Although there was a prevailing tendency to imitate what was being done in France, the idea of founding a 'Royal Academy', with encouragement from the Crown, did not mature until 1768, and the initiative for whatever was done to improve the situation in England always came from the artists themselves. A private Academy, admittedly with Kneller as its first President, was started in 1711, and he gave way to Thornhill in 1716. A group of artists in the 1740s tried to exploit the newly established Foundling Hospital as a place where they could show their pictures, but this scheme came to nothing and it was not until 1760 that the Society of Artists was established, whose main purpose was an annual exhibition; a good deal of bickering went on over these exhibitions until, in 1768, an 'élitist' group seceded and set up the Royal Academy, with the encouragement of George III.

There is evidence that the more intelligent artists resented this preference by the natural patrons of art for foreign painters, and Sir James Thornhill, who had managed to succeed Verrio (d.1707) as the leading baroque decorator, encouraged a 'nationalist' spirit which effectively prevented the Italians Sebastiano and Marco Ricci and Pellegrini from establishing themselves as Verrio's successors. However, Hogarth in 1741 angrily signed *'anglus'* after his name, in a portrait at Dulwich, in resentment that the Prime Minister and most of the nobility were flocking to the Frenchman Van Loo to have their portraits painted; and the precarious state of patronage was very much in the mind of Reynolds all his life, so that, as late as 1788, in his *Discourse* written after Gainsborough's death, he could say: "If ever this nation should produce genius sufficient to acquire us the honourable distinction of an English School, the name of Gainsborough will be transmitted to posterity, in the history of the Art, among the very first of that rising name."

As a rider to this one may quote the story related by Northcote of a British collector who spoke with admiration of Benjamin West's picture of 'Pylades and Orestes' which he had seen at the exhibition of the Society of Artists in 1766. When asked by his son why he had not purchased a picture he spoke of with such praise, he replied: "You surely would not have me hang up a modern English picture in my house, unless it were a portrait?" That this attitude had begun to wear off by the end of the century was perhaps largely due to the French Revolution and the fact that it prevented the British upper

classes from pursuing in youth those 'grand tours' in Europe which had hitherto crystallised their tastes in the arts.

Outside London, in provincial England, there is still a great deal of research needed before anything like a complete picture can be given. Exploration has been made of the arts in Bath, Liverpool and Norwich, and the study of Wright of Derby has provided a useful (but by no means complete) picture of the career of the first major artist, who spent his whole life deliberately outside London. Bristol, Exeter, Plymouth, Preston and York are also promising areas of exploration, and I have included as many names of provincial painters in this dictionary as I have been able to find.

In Edinburgh a 'School of St. Luke' was founded in 1729, but it doesn't seem to have come to much; the Foulis Academy at Glasgow flourished for a time in the 1760s, and after 1772 Alexander Runciman began to change the Trustees Academy at Edinburgh into something which led to the formation of a native Scottish school.

In Dublin, where there had been nothing whatever in the early 1730s, Robert West's private art school seems to have been taken over by the Dublin Society in 1746, and it continued, with varying fortunes, awarding prizes and arranging exhibitions for the rest of the century. But Irish painters of any promise usually migrated to London, although there was a certain patronage for portraits in Dublin, which was exploited by visits from successful Irishmen settled in London, such as Jervas and Slaughter. Occasionally a visitor from London, such as John Astley, made a killing, but normally it was painters from London who wished to escape their creditors, such as Wheatley, 1779-83, and Gilbert Stuart, 1782-87, who benefitted by the local patronage. Painting in Dublin has been more fully explored, first by Strickland, in his astonishing *Dictionary,* and latterly by Anne Crookshank and the Knight of Glin, than it has anywhere else in what used to be called the 'United Kingdom'.

In Wales, as far as I know, there is very little to report, and the attempt by Marchi, Reynolds' main assistant, to start an independent portrait practice there in 1768/9, seems to have been a failure. But a tour in Wales, in search of picturesque landscape, became a standard procedure for many watercolour painters, and some who also employed oils, in the latter half of the century.

The rest of this introduction will be concerned almost wholly with what happened in London. For the first forty years of the century we can best see this through the eyes of the engraver, George Vertue, whose notebooks, which begin about 1713, are a record of the day-to-day gossip of the studios.

When Vertue began his notes Thornhill was the great man in history painting and Kneller was overwhelmingly predominant in portraiture. Kneller's series of forty-two members of the Kit-cat Club, which belong to the National Portrait Gallery, but many of which are displayed at Beningborough Hall, gives the most vivid picture of the age of Queen Anne and provides penetrating likenesses of the chief patrons of the arts of that not very art-loving generation. At Kneller's death in 1723, his predominance was not immediately succeeded either by his Swedish rival Dahl, nor by the English Richardson. It was rather the marble bust which became the fashion in portraiture with the upper classes, and Michael Rysbrack and Peter Scheemakers, followed in the middle 1730s by Roubiliac, dominate the portrait scene until about 1740, when the painted portrait on the scale of life regained its earlier importance. But it was during these years that the conversation piece, introduced by Mercier about 1726 — and the small-scale full length which was a natural complement to it — became fashionable for about a decade. A new kind of sitter, who lived in a house of modest size (in which a marble bust would look silly), also began to want to have his portrait painted, and half a dozen competent portrait painters, Highmore, Vanderbank, Dandridge, the two Seemans, Whood and

others were kept busy. The more conservative members of the upper class also continued to demand life-size full lengths, notably from Richardson or Vanderbank.

Ironically the painter who, to our hindsight, seems the most distinguished of the age, William Hogarth, was one of the least employed. His mind and his manners were too 'radical' to meet with the approval of the upper classes and his series of modern moral fables ('Marriage à la mode', 'The Rake's Progress', &c.), although much more beautifully painted than any other pictures of the time, found no purchasers although they made money by the engravings after them, and these engravings found their way into many homes hitherto innocent of any work of art. Those members of the cultivated and philanthropic middle classes who actually sat to Hogarth were rewarded with a new kind of likeness in which their sympathetic character and good nature were demonstrated — something very unlike the aloof impenetrability which was what the aristocratic sitters required. Highmore and Dandridge followed Hogarth in this revelation of character, and just at the outset of the bourgeois sentimental decade (1740-50), which was ushered in by the anonymous publication (1740) of Samuel Richardson's *Pamela* or *Virtue rewarded*, Hogarth painted and presented to the Foundling Hospital his great life-size portrait of its founder, 'Captain Thomas Coram' (colour frontispiece), which has good claims to being the most original and memorable British portrait of the century. It is with this picture that something one can call a 'British School' came of age.

The 1740s were in many ways the most interesting and disappointing decade of the century. It saw the creation of two groups of paintings which Hogarth hoped — and his active promotion was behind both of them — might give rise to a new class of patron, who would commission, or at least purchase, the kind of picture the artists wanted to paint. These two sets of paintings were those which Hogarth himself and a number of painters, whom he persuaded to do so, presented to the Foundling Hospital for the decoration of its State Rooms (history pictures by himself, Hayman, Highmore, and Wills; portraits by Ramsay and Hudson; a landscape by Lambert; picturesque views of the London hospitals by Haytley, Wale, Wilson and Gainsborough); and the paintings, mostly by Hayman, which he persuaded his friend Jonathan Tyers to commission for the supper boxes and concert room of the pleasure grounds at Vauxhall Gardens. Both these sets of pictures were accessible to all classes who could conceivably commission or buy a picture. They constituted the first public exhibitions of modern art in London. They had almost no effect, and the Foundling Hospital became a 'lounge' for the upper classes. By the 1750s Hogarth had abandoned his hopes of finding a new class of patron. The 1740s, however, did see the return to predominance of the fashionable portrait, and in this case the artists, Hudson and Ramsay, were British and not foreign.

One would naturally suppose that the reign (1727-60) of George II, who 'hated bainting and boetry', would not have seen much progress in the arts, but what happened during these years in fact sets the scene for the great age of British painting, which coincides with the predominance of Sir Joshua Reynolds, which may be said to last from about 1760 to about 1790. In the eighteenth century royal patronage, however lackadaisical, inevitably had considerable influence on the arts, and it was a family failing of the House of Hanover for the King always to be at loggerheads with his eldest son. In this case he was Frederick, Prince of Wales (1707-51), father of George III, and known to the more light-hearted historical writers as 'Poor Fred'. Almost poor Fred's only virtue was a liking for the arts, and as his father favoured (if he favoured anything) the solemn and formal style, he himself encouraged an informal and more popular style — akin to the French rococo and the Hayman

supper box pictures at Vauxhall Gardens.

The two most original and 'creative' painters of the later eighteenth century, Reynolds and Gainsborough, were both trained in London in this decade of the 1740s. Reynolds opted for the solemn and formal and spent his life in trying to invent and encourage the kind of portrait or history picture that the aristocracy (whom he, perhaps accurately, believed were the natural and proper patrons of a country's art) would accept. He rejected entirely the popular subject matter of the Vauxhall Gardens' tradition. Gainsborough always looked for an alternative source of patronage, and found it to some extent in the taste of George III, who found distasteful the solemnities of Reynolds and took after the more informal and domestic tastes of his father. These two traditions, which were to some extent at war with one another, complicate the history of the first twenty years of the Royal Academy's life, and eventually Gainsborough gave up exhibiting there, thus starting the tradition, which has been endemic in Britain, of an opposition between an 'academic' art, and a group of painters, by no means of necessity of the 'avant-garde', who preferred not to exhibit at the Royal Academy.

Gainsborough died in 1788 and Reynolds went blind in the following year, and these two events brought to an end the 'classical age' of British painting. The rival exhibiting societies to the Academy, The Society of Artists and the Free Society, had petered out, but by then some of the more successful society portraitists, such as Romney and Daniel Gardner, had discovered that there was no need to exhibit at the Academy and, although the Academy Schools remained the chief place where an oil painter could get his training, the taste of the public outside the field of portraiture was moving in another direction. This was watercolour, which lent itself much better to the interpretation of the British landscape (seen under the vagaries of the British climate) than oil painting.

When the British painters did eventually produce work of sufficient distinction for a 'British School' to be known abroad it was largely as painters of landscape. In the field of oil painting Turner and Constable are the great names, and in watercolour J.R. Cozens, Turner and Girtin. These latter have no place in a dictionary of eighteenth century oil painters and Turner only just scrapes in, since his earliest oil pictures were just exhibited before the end of the century. It has been supposed by some scholars (usually foreigners) that the astonishing outburst of great landscape painting in Britain about 1800 and onwards, must have been led up to by a regular process of development throughout the century. But this is not really the case. Many names of painters and exhibitors of landscapes appear in this dictionary, but the two great names, Wilson and Gainsborough, are not the founders of our native landscape school. At the beginning of the eighteenth century the landscape taste of the patronage classes was for pictures by Gaspard Poussin and Claude. This taste was catered for by the earliest English landscape painters, Wootton and Lambert, and a remarkable number of minor figures went on painting Gaspardesque views throughout the century. On the Grand Tour British patrons bought Italian views by Vernet — and these were imitated by Wright of Derby — and British collectors did begin to buy Dutch seventeenth century landscapes, chiefly perhaps those by Ruisdael and Wynants. Richard Wilson, who had the same sort of classical education as those who made the Grand Tour, devised in Rome a kind of poetical landscape, in the tradition of Claude, which should have appealed to the patronage classes. But his pictures were British and they failed to please, and the collecting classes (and even George III) preferred the 'lighter style' of Zuccarelli. Gainsborough modelled his first style on the Dutch, and his 'Bath' style on Rubens but, towards the end of his life, he too was harking back to the imitation of Gaspard Poussin. In spite of

Constable's reverence for Gainsborough, his art owes veryn. At the end of the eighteenth century the watercolour painters, feeling that they were somewhat slighted by the Academicians, formed their own societies and started exhibiting on their own (*Mallalieu*).

By the end of the century most European painting could be described as either 'neo-classical' or 'romantic', but these words will be found very sparingly used in this dictionary. A few British painters who lived mostly in Rome — Gavin Hamilton, Jacob More, Robert Fagan — adopted a neo-classical style, but the encouragement of neo-classical trends by the French Revolution made them unpopular in London. Though some of Lawrence's portraits in the 1790s can be considered 'romantic', most British romantic painting dates from after 1800, while Fuseli's Swiss romanticism found few echoes in England. The French Revolution caused a number of French *émigré* painters to migrate to London for a few years and to exhibit there, but they kept rather to themselves and, though a few adapted their style to British taste, they had little impact on the London art scene. A prodigious number of new names do appear, however, among the exhibitors of the 1790s, about very many of whom nothing is known today. But I have included the exhibition records of, I hope, all of them in case some signed or documented work should turn up.

Outside the well-known names British painting has been rather little studied, and a book on British history paintings, which flourished to some extent between about 1780 and 1800, is a desideratum. Engravings exist of a surprising number of history pictures, but many of the originals, perhaps owing to their size, have disappeared. The recent inexpensive reprint of *The Boydell Shakespeare Prints* (Arno Press, New York, 1979) has made it unnecessary for me to use many of these as illustrations, but it is possible that further study of this field might enlarge our ideas of British 'romantic' painting. The movements of public taste can be followed by studying the pictures the leading painters sent to the Royal Academy exhibitions, and I have chosen, when possible, dated or exhibited pictures to illustrate. The unfavourable conditions under which these pictures were shown can be seen in Ramberg's engravings of the main room of the Academy during the 1787 and 1788 exhibitions (see endpapers).

A word should perhaps be said about 'amateur' painters. It might perhaps have been possible to extend their numbers very considerably and it is surprising how many pictures were shown at the Academy 'by a lady' or 'by a young gentleman' (to give only two examples from the first exhibition of 1769). There is no means that I know of of penetrating this anonymity, and it is only occasionally unveiled by a label which may appear on the back of some picture so exhibited. The tribe of upper class amateurs took itself rather seriously and the 2nd Earl Harcourt in 1802 tried to persuade the Bodleian Library in Oxford (which was then more or less the only 'public collection' in the country) to reserve a section for 'gentlemen' artists.

Hogarth's discovery that, although oil paintings other than portraits found no buyers at a fair price, engravings after them sold very well, may have conditioned the type of subject picture which was painted in the latter half of the century. The engraving after West's 'Death of Wolfe' is said to have earned him £15,000; the engravings from Boydell's Shakespeare Gallery and

JACOPO AMIGONI. 'Mercury about to cut off the head of Argus.' c.1732. Moor Park, Herts.
One of a group of four large canvases, with life-sized figures, inset into the walls of the Hall. They all illustrate the story of Jupiter and Io, and were commissioned by Mr. Styles from Amigoni, after quarrelling with Thornhill.

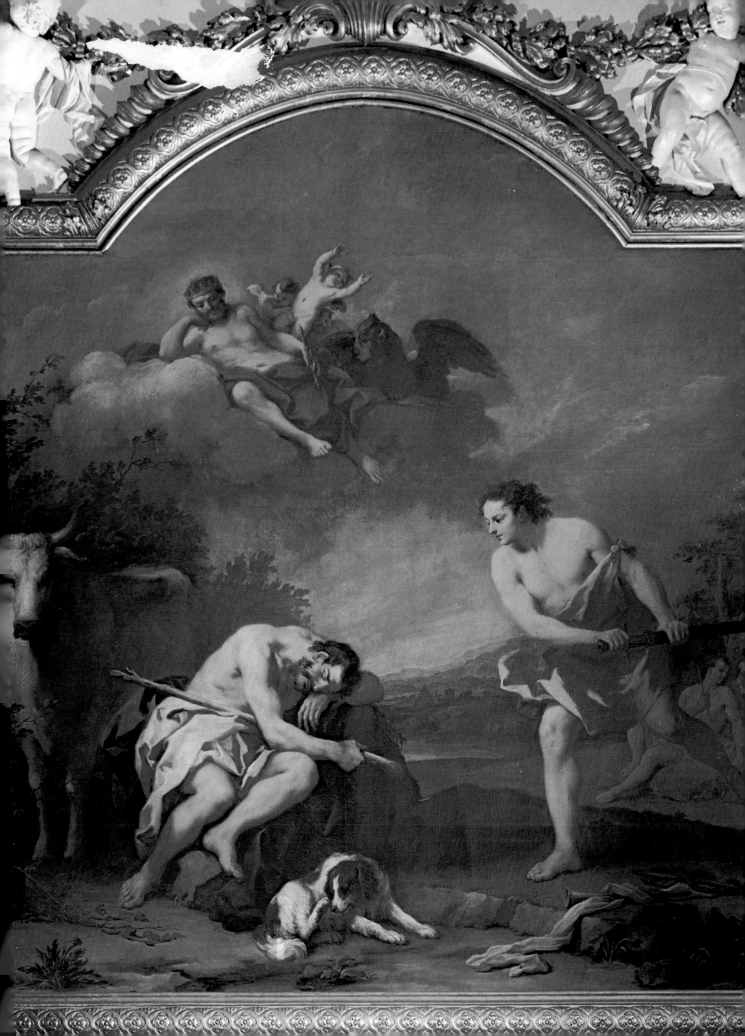

Bowyer's and Macklin's Historical and Poetical Galleries had a ready sale; and the same is true of the paintings of domestic and rural subjects which proliferated towards the end of the century. George Morland, who was well served by his brother-in-law the engraver William Ward, and Wheatley are the principal figures in this movement, and both of them seem to have had relatively little difficulty in selling the originals as well as the engravings after their pictures. Morland is the archetypal figure of the new age. He actually refused to accept commissions from any patron, noble or otherwise, and any picture he painted seems to have been snapped up (and often copied and imitated) by some sort of art-dealing underworld. Morland was perhaps the only painter of any standing in the eighteenth century who managed to paint only the kind of picture he wanted to paint, and to find a market for it. But this was achieved more by dissipation than by good management! It did not mean that Hogarth's hope in the 1740s of training a new middle-class body of patrons had been achieved.

It is true that, except for portraits, the patronage of British art in the early nineteenth century was quite different from that in the eighteenth. A very few of the old class of patron, such as Lord Grosvenor or Sir John Leicester, had deliberately begun to form collections of British paintings, but the great masters of the early nineteenth century, Turner and Constable, sold their pictures with difficulty, and often to the kind of person who would not have been a collector in the eighteenth century. The beginning of this change is indicated by the critic in the *Morning Post* of the Royal Academy of 1784, who, commenting on Opie's 'A School' (p.264) said: "Could people in vulgar life afford to pay for pictures, Opie would be their man." The industrial revolution made it possible for quite a lot of people 'in vulgar life' to afford to pay for pictures, and that is perhaps why there is such a marked cleavage between British eighteenth and British nineteenth century painters in oils, and why the eighteenth century deserves to have a dictionary to itself.

A

ABBOTT, John White **1763-1851**

Amateur landscape painter in oils and watercolour. Born Exeter 13 May 1763; died there 1851. He began as an apothecary and surgeon and ended as a country gentleman. He learned painting from Francis Towne (q.v.) at Exeter. His watercolours and drawings are original and admirable (*Mallalieu*), but it was only oil landscapes that he exh. (as hon. exh.) at RA 1793-1805, 1810 and 1822. These are conscientious but conventional exercises in a generally pastoral or elegiac mood. He also made some etchings. Nothing of his work is known before 1790. Several oil landscapes at Exeter.

(Oppé, Walpole Soc., XIII (1925), 67-84.)

LEMUEL FRANCIS ABBOTT. 'The sculptor Joseph Nollekens' (1737-1823). 29½ins. x 23¾ins. Probably c.1793. National Portrait Gallery (30).
He is shown with his most popular and often repeated work, the bust of Charles James Fox of 1792/3, and wearing a striped Manchester waistcoat, of which he was very proud. Authenticated as Abbott by an engraving of 1816.

ABBOTT, Lemuel Francis *c.***1760-1802**

Portrait painter. Born Leicestershire *c.*1760; died London 5 December 1802. Son of a clergyman; studied briefly with Hayman (q.v.) and then completed his studies at home. He was settled in London by 1784; married by 1787. Exh. portraits at RA 1788-89. He was in good practice, especially with naval officers (his best known sitter being Nelson) and government officials and could achieve a crisp likeness, but his full-length figures stand rather insecurely. His certain portraits are all of men. Ben Marshall (q.v.) was apprenticed to him for three years in 1791. By July 1798 he was certified as insane and never recovered, but portraits by him were exh. RA 1798 and 1800. His unfinished portraits seem to have been completed by a less sensitive hand.

(A.C. Sewter, Connoisseur, CXXXV (Apr. 1955), 178-183.)

LEMUEL FRANCIS ABBOTT, 'Thomas Turner of Caughley' (1749-1809). 30ins. x 24½ins. Earlier 1790s. Christie's sale 1.6.1934 (125).
The alert, momentary pose is very characteristic of Abbott. Turner was manager from 1772 of the Caughley pottery works, Shropshire, and introduced the willow pattern.

ABER(R)Y, J. fl.1738-1753

Portraitist. Lord Egmont (*Diary, 5 April 1738*) saw "Dr Courayer sitting for his portrait to Mr Abery." J. Aberry signed an etching after Hudson's portrait of Sir Watkin Williams Wynne 1753.

ACRAMAN, B. fl.1747

A small portrait of a lady in rather a hard Dutch style is signed and dated 1747, sale 22.6.1945, 128. The name suggests the Bristol region.

ADAMS fl.1780

Exh. 'The Triumph of Neptune', FS 1780.

ADNEL fl.1710

An itinerant portrait painter (or miniaturist) who either died or decamped at Wells in 1710.

(Somerset and Dorset Notes and Queries, XXII (1938), 199.)

ADOLPH(US), Joseph Anton 1729-c.1765

Portrait painter in England. Born Mikulov, (Nikolsburg) 8 October 1729; said wrongly by Th-B. to have died in Vienna 1762. Studied in the Vienna Academy and came, via Paris, to London c.1750/1, where he had some success as a portrait painter: 'George III as Prince of Wales on horseback' (engr. by G. Bockman). A life-size '4th Marquess of Lothian with wife and two children' (Monteviot) is documented in a 1752 inventory. Th-B. says he soon returned to Czechoslovakia where he painted historical and religious works, but the same painter executed two of the full-length civic portraits for St. Andrews Hall, Norwich in 1764 *(Fawcett)*, and signed 'Adolphus pinxit 1765' on the backs of two portraits in Lord Cranworth's possession (painted in Suffolk).

AGAR See D'AGAR, Charles

AGNETTA, Miss fl.1774

Exh. crayons at SA 1774, from a York address.

AIKMAN, William 1682-1731

Scottish portrait painter. Only son of the laird of Cairney, Forfar, where he was born 24 October 1682; died London 7 June 1731. He developed a passion for painting, studied under Medina (q.v.),

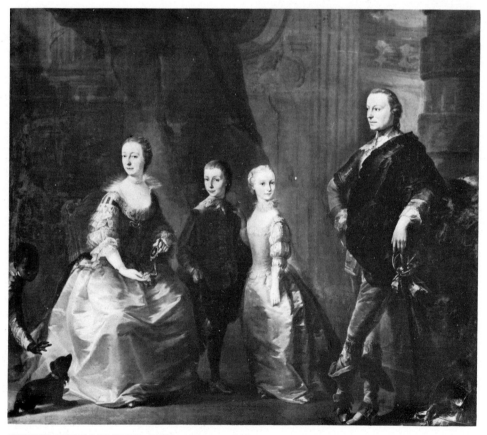

JOSEPH ANTON ADOLPH. 'William Henry, 4th Marquess of Lothian, with his wife and two children.' 88ins. x 102ins. About 1751. Marquess of Lothian, Monteviot.
Documented in an inventory of 1752. This Germanic (Czech) painter was working in Norfolk in the early 1750s. The avoidance of any sense of 'conversation' in the group is curious.

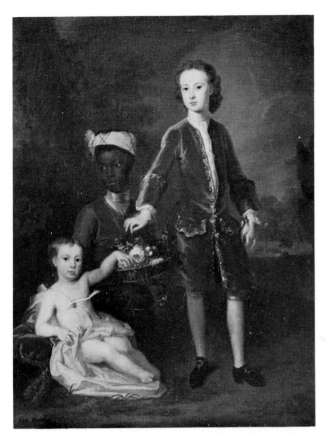

WILLIAM AIKMAN. 'Hon. Thomas and Hon. John Hamilton.'
55ins. x 44ins. s. & d. 1728. Lord Binning, Mellerstain.
Late work, painted in London, when Aikman was a conscious
successor to Kneller.

(Right) EDWARD ALCOCK. 'The poet William Shenstone.'
59½ins. x 39¼ins. Painted at Birmingham 1759/60. National
Portrait Gallery (263).
Alcock was an itinerant portrait painter and miniaturist. He is
here consciously imitating, on a smaller scale, the kind of
portrait smarter sitters were commissioning from Pompeo
Batoni (1708-87) at Rome.

sold the family estate, and went to Rome (1707 or
earlier) for three years. Then to Constantinople
and Smyrna and back to Scotland via Rome and
Florence. He settled in Edinburgh 1712 and was an
excellent taker of sober likenesses, the best
Edinburgh portraitist of the time, and the Scottish
equivalent of Jervas and Richardson (qq.v.) in
London. In Edinburgh he charged 5 guineas for a
head and 10 for a half length, and he painted most
of the nobility, gentry and lawyers of the time. In
1723, about the time of the death of Kneller, he
moved to London and raised his prices for a head
to 8 guineas. In London he was not only patronised
by the Scots, but became well known in literary
circles and the friend of Pope, Gray, Thomson and
others. At the end of his life (1728) he was charging
40 guineas for a whole length.

(Irwin, 1975, 40-45.)

AKEN See VAN AKEN

ALCOCK, Edward fl.1757-1778
Peripatetic portrait painter and miniaturist.
Probably the Alcock recorded at Bath 1757. In
1759/60 he was living at Birmingham and painting
'Shenstone' (NPG). Shenstone says he was never
long in one place and also painted in enamel so he
is presumably the ''Mr Alcock of Bristol, an
excellent miniature painter'' on whom Chatterton
wrote a fulsome poem in 1769. In London 1778,
and no doubt the Alcock (no initial) who exh. small
portraits and genre at RA and FS 1778. Signed and
dated portraits range from 1762 to 1774, including
neat small full lengths in the style of Devis.

(Kerslake, 1977, 72.)

ALCOCK, Samuel fl.1769
Member of Liverpool Art Society 1769.

(Rimbault Dibdin.)

ALDRIDGE, Edward Westfield 1739-c.1778
Portrait painter. Born 1739. Entered RA Schools
1773. Exh. portraits at RA 1775 and 1778.

ALEFOUNDER, John 1757-1794

Portraitist and miniature painter and painter of Indian genre. Born September 1757; committed suicide at Calcutta 20 December 1794. Entered RA Schools 1776 as an architectural student and exh. an architectural drawing RA 1777. From 1779 to 1793 his exhibits were mainly portraits and miniatures and he won medals from the Schools 1782 and 1784. He sought his fortune in India and arrived in Calcutta 1785, where he remained till his death. His Indian portraits on the scale of life are extremely weak and he painted mainly miniatures, but his career was uniformly disastrous. In 1788/9 he did some pictures showing manners and customs of the natives.

(Archer, 1979, 270 ff.)

ALEXANDER, Antonio fl.1776

Exh. a small landscape at RA 1776.

JOHN ALEXANDER. 'James, 5th Duke of Hamilton, and the artist."50ins. x 40ins. s. & d. 1724. Duke of Hamilton and Brandon, Lennoxlove.
Painted for the Marquess of Annandale (from whose descendant it was acquired in the present century), who presumably encouraged the painter to include his own portrait (which he signs 'hic se quoque pinxit'). This was certainly unusual.

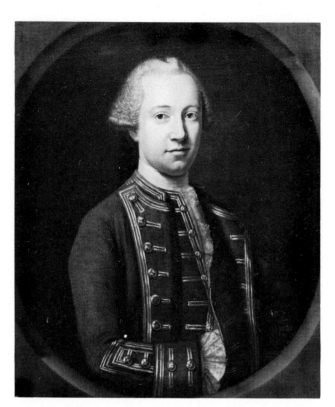

COSMO ALEXANDER. 'John Hope of Amsterdam' (1737-84). 30ins. x 25ins. s. & d. 1763. Sotheby's sale 24.2.1937 (96).
Painted during a short stay in Holland 1763/4, but only slightly closer to the style of the Dutch portraitist Cornelis Troost (1697-1750), than the portraits he painted in Scotland.

ALEXANDER, Cosmo 1724-1772

Scottish portrait painter, and reputedly history painter. Born, probably at Aberdeen, 1724; died Edinburgh 25 August 1772. Son, and presumably pupil, of John Alexander (q.v.). His portraits are like his father's, but better drawn, and their signatures can be confused: Cosmo monograms a small C at the top of the A of Alexander. A Jacobite, he was 'out' in 1745 when he retired to Rome where he is recorded in 1749. Back in Britain in 1754, when he received a substantial legacy from James Gibbs, the Aberdeenshire architect. Probably based on Edinburgh in 1750s, he became restless and is found in the Guild at The Hague 1763/4 (a portrait of 'Adrian Hope', 1763, at Edinburgh is very close to C. Troost). Exh. SA London 1765. Emigrated to the eastern seabord of U.S.A. where he travelled and painted a number of portraits 1768-71 and, at Newport, R.I., became the first teacher of Gilbert Stuart (q.v.), whom he brought back to Edinburgh, but he died soon after his return.

(Groce and Wallace; Gavin Goodfellow, thesis, Oberlin University)

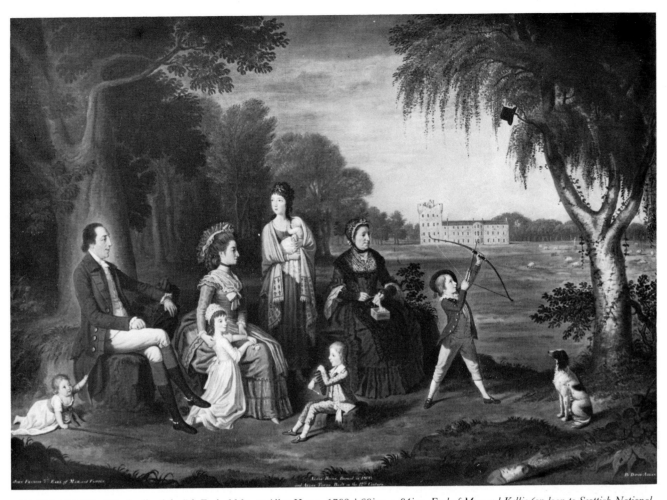

DAVID ALLAN, 'The family of the 7th Earl of Mar at Alloa House, 1783.' 60ins. x 84ins. Earl of Mar and Kellie (on loan to Scottish National Portrait Gallery, Edinburgh).
Allan was at his best in these informal family groups in the open air, with a view of the house and park in the background. This particular Alloa House burned down in 1800.

ALEXANDER, John fl.1710-1757

Scottish portrait and history painter. Born in Scotland (Aberdeen or Edinburgh) *c.*1690; last dated work 1757; dead by 1768, when his daughter married Sir George Chalmers (q.v.); he was great grandson of George Jamesone. First recorded copying Scottish historical portraits in London 1710. In Italy at least 1714-19, mainly at Rome and Florence. Back in Britain 1721, when he painted his one known historical work, a huge 'Rape of Proserpine' for the top of the staircase at Gordon Castle (destroyed; *modello* in Edinburgh Gallery). Married at Aberdeen 1723 where he practised before moving to Edinburgh 1729. He had a good business as a portrait painter at Edinburgh, in a rather pedestrian style; but he was 'out' in 1745 and retired to Italy. Back in Scotland by 1752 when he continued portrait painting until at least 1757.

(E. C-M.; Irwin, 1975.)

ALLAN, David 1744-1796

Portrait, genre and history painter. Son of the shore master at Alloa, where he was born 13 February 1744; he died near Edinburgh 6 August 1796. Through the patronage of the Cathcart family he was enabled to study at the Foulis Academy in the College of Glasgow 1755-62, and to travel to Rome in 1767. Lady Cathcart was sister to Sir William Hamilton, who befriended Allan at Rome and Naples. He studied with Gavin Hamilton (q.v.) in Rome and absorbed the heroic tradition of history painting and sent back some history pictures to the RA 1771 and 1773. He won the gold medal of the Concorso Balestra with a 'Hector and Andromache' (Accademia di S. Luca, Rome). In Naples in 1775 he began painting small scenes of rustic genre, and expanded this side of his talent in etchings and watercolours. His best history picture is 'The Origin of Painting', 1775 (NG of Scotland) and he had little chance of

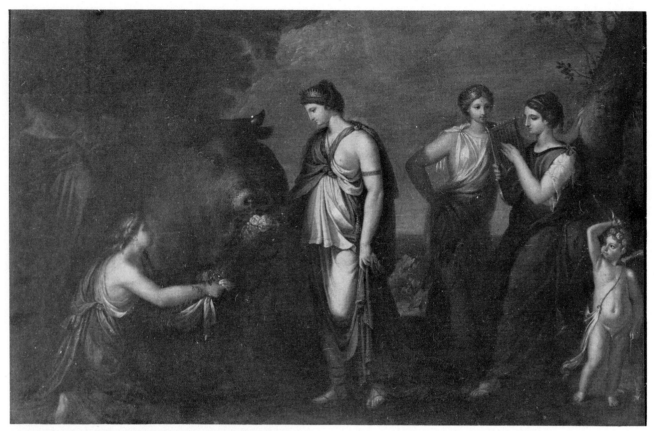

DAVID ALLAN. 'Europa and her maidens, with the bull.' 19½ins. x 28ins. s. & d. 1769. Christie's 9.5.1947 (111).
An early work, painted at Rome in Gavin Hamilton's neo-classic idiom.

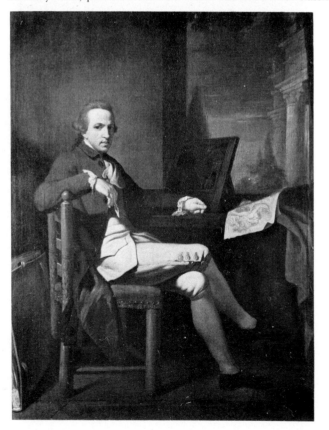

painting such pictures later. He returned from Italy in 1777 and showed some pictures of Neapolitan genre at the RA, and worked in London 1777-80, when he returned to Scotland.

He introduced into Scotland the first family conversation pieces and small portraits of cabinet size, but he soon began to specialise in pictures (and drawings and aquatints) recording the customs and daily life of the common people (first in RA 1781). In 1786 he succeeded Alexander Runciman (q.v.) as Master of the Academy of the Board of Manufactures in Edinburgh, a post he held until his death. He retained aspirations towards history painting and sent three Scottish history scenes to the SA 1791, but these have disappeared. He is best known for his illustrations to Allan Ramsay's *The Gentle Shepherd* (published with engravings 1788).

His executive powers were limited, but the sincerity of his observant eye and his accurate

DAVID ALLAN, 'Self portrait, 1770.' 50ins. x 40ins. Lent by Royal Scottish Academy to the Scottish National Portrait Gallery.
Painted in Rome after seeing Batoni's portraits of travelling British gentry. The drawing on the table is after Annibale Carracci

recording of the contemporary scene make him a precious witness to the past, and he had a great influence on the development of Scottish genre painting which reached its finest moment in Wilkie.

(T. Crouther Gordon, D.A. of Alloa, 1961; Basil Skinner, The Indefatigable Mr. Allan, cat. of Scottish Arts Council exh., 1973.)

ALLEN **fl.1771**
Exh. two portraits, one a small whole length at SA 1771.

ALLEN, Joseph **1769-1839**
Provincial portrait painter. Born Birmingham 12 January 1769; died Erdington 19 November 1839. Entered RA Schools 1787. Exh. RA 1792-1822; BI 1807-8. Failed to settle in London and settled at Wrexham 1798/9, and from there established a good connection in the North West. Worked at various times at Liverpool and Manchester and was a founder member of the Liverpool Academy, 1810; eventually retired to Erdington. Several competent portraits at Liverpool.

(Walker Art Gallery, Merseyside cat.)

ALLEN, Thomas **fl.1767-1772**
Painter of marine subjects, from addresses at Greenwich and Woolwich. Exh. FS 1767-72, his subjects suggesting considerable sea travel.

ALLEYNE, Francis **fl.1774-1790**
Portrait painter, usually on a small scale. Exh. a single portrait at RA and FS in 1774; and at SA 1790. He seems to have specialised in small, oval, three-quarter lengths, usually signed on the back, which look like middle class versions of Wheatley's (q.v.) more elegant small portraits.

(Above) FRANCIS ALLEYNE, 'Mrs. William Wheatley of Lesney House, Kent.' 14ins. x 11½ ins. Signed, inscribed and dated 1786 on the back.

(Right) FRANCIS ALLEYNE. 'William Wheatley of Lesney House, Kent.' Signed, inscribed and dated 1786 on the back. Companion to the facing portrait. Sotheby's sale 14.3.1962 (175).

This is Alleyne's favourite size; there were also companion portraits of the children. Alleyne probably moved round Kent in 1786, going from family to family.

ALLWOOD fl.1776

Exh. 'A sea piece: a brisk gale', SA 1776.

ALMAND, Charles fl.1777

Exh. 'A view of the Island of St. Helena, in the East Indies', SA 1777.

ALMOND fl.1783

Painted in 1783 a number of small portraits, in medallion profile, like coloured silhouettes, of the servants at Knole. They are full of character and he may himself have been one of the downstairs staff.

ALSOP, William fl.1775-1780

Exh. FS 1775-80 nine portraits, almost all small whole lengths from a Wandsworth address.

ALVES, James 1738-1808

Scottish portraitist in crayons and miniature, from an Inverness family. Died Inverness 27 November 1808. He was awarded a gold medal at Edinburgh 1756, and was then in Rome, where he spent eight years. Exh. RA 1775-79, mainly crayons portraits, but two Roman history subjects in 1775, from a London address.

(Foskett; Baker's Diary, 449, 471.)

AMIGONI, Jacopo c.1682-1752

Italian history and decorative painter; also painted portraits. Born c.1682, apparently at Naples, but his parents were Venetian and he calls himself a Venetian in his will; died Madrid 22 August 1752. He was trained as a rococo decorative and history painter in Venice and worked in England 1729-39. He first specialised in large decorative histories and mythological subjects, which he painted on canvas (rather than in fresco) to be mounted as wall

JACOPO AMIGONI. 'Queen Caroline, 1735.' 94ins. x 58ins. Department of the Environment, Wrest Park, Beds.
Amigoni introduced the Venetian rococo into British royal portraiture and has a special liking for cherubs and a background of palace architecture.

JACOPO AMIGONI. 'Sir Thomas Reeve' (d.1737). 48½ins. x 39½ins. Painted 1736. Graves Art Gallery, Sheffield.
He is dressed as Chief Justice of the Common Pleas, as which he was appointed 1735. Engraved as after Amigoni by B. Baron, 1736.

WILLIAM ANDERSON, 'Hussars embarking at Deptford.' 17¾ins. x 24ins. s. & d. 1793. B.A.C. Yale.·
Although a specialist in maritime subjects, Anderson was also very competent at painting shore scenes with numerous figures.

paintings: this was an innovation. The best surviving series *in situ* is the 'Story of Jupiter and Io', *c.*1732 (Moor Park). Not finding full employment in these, he took to portraiture and was patronised by Queen Caroline and other members of the royal family. His full lengths especially have a fine rococo air and are often diversified with Cupids *(for drawings related to his English portraits, see Elaine Claye, Master Drawings, XII 1974, 41-48)*. He married in England (1738) and attempted, with Joseph Wagner, to set up a print shop, but they both returned to Venice 1739. From 1747 Amigoni was court painter in Spain. In England he also did some work as a scene painter.

(E. C-M.; Adrian Baird, Burlington Mag., CXV (Nov. 1973), 735; Urrea.)

ANDERSON, William 1757-1837
Painter of marines, shore scenes and harbours, in oil and watercolour. Born in Scotland 1757; died London 27 May 1837. He started as a shipwright, but took to painting subjects connected with ships and the sea. Exh. RA 1787-1834, BI 1810-26. Most of his oils are slight, with a good feeling for tone; his larger pictures, at their rare best, suggest a knowledge of Teniers and have a combination of water and land.

(Mallalieu; Archibald.)

ANDRÉ, Dietrich Ernst c.1680-c.1734
Polish decorative and history painter. Born Mitau, Courland; died Paris *c.*1734 *(Vertue, iii, 74)*. Worked in Brunswick 1717-19, whence he came, via Holland, to England, where he assisted Thornhill *c.*1722 in monochrome sections of the Great Hall at Greenwich. He was only in England *c.*1722-24 and his only known independent works (signed: 'Andrea Courlandicus' or 'A.C.') are four decorative panels, in yellowish or greyish monochrome, two mythological and two decorative swags with fruit, &c., now at Hovingham.

(J. Harris, Connoisseur, CLVIII (Apr. 1965), 253; E.C-M., i, 263.)

ANDREWS, Mrs. fl.1768-1771
Hon. exh. of a fruit piece and views in Berkshire at SA 1768-71.

ANDREWS, R. fl.1793-1794
Exh. three views of named scenes at RA 1793-94.

ANGELLIS (ANGILLIS), Pieter 1685-1734
Painter of small conversations and histories and scenes of rustic and urban genre. Born Dunkirk November 1685 *(Vertue, iii, 25);* died Rennes 1734. His style is Flemish and derives from Teniers. Master in Antwerp Guild 1715/6. He lived in London 1716-28 in Covent Garden, which is the

PIETER ANGELLIS. 'Figures at a fish stall.' Copper. 17¾ ins. x 15¼ ins. s. & d. 1726. Unlocated.
A very characteristic Angellis scene, painted in a neat style deriving from Teniers. It was formerly at Strawberry Hill and in the collection of Col. M.H. Grant.

ARCEDECKNE, Robin fl.1745

A portrait of 'Robert Trevanion' in a sale 18.11.1960, 129, signed: 'R.A. 1745', was said, presumably on family tradition, to be by 'Robin Arcedeckne'. Painter and sitter were both Cornish and the style is that of Michael Dahl (q.v.).

ARCHER, Jasper fl.1779-1791

Exh. FS 1779-82; SA 1790-91, every sort of frivolous subject, in crayons, oil or watercolour, including 'a scripture subject.'

ARMSTRONG, Augustus fl.1717-1743

Vertue *(i, 48)* mentions a 'Mr Armstrong, painter' as owning a portrait in 1717; and there is a Faber mezzotint of 1743 after a portrait by Augustus Armstrong.

subject of several of his pictures. He liked to enliven his paintings (which are usually small) with displays of fruit, vegetables and fish. In 1728 he went to Rome with the sculptors Delvaux and P. Scheemakers, where he stayed three years. On his way back to England he found good business at Rennes, where he settled and died. His pictures are extremely neat and prevailingly light in tone. *Circa* 1722 he joined in a scheme of painting small scenes from the life of Charles I, jointly with Tillemans, Vanderbank (qq.v.), and others, which were elaborately engraved by Du Bosc, Baron and others.

(Vertue MSS; Grant.)

ANNING, Miss fl.1761-1776

Hon. exh. of flower pieces at FS 1761 and SA 1771; and of nature drawings at SA 1776.

ANNIS, J. fl.1796-1800

Exh. views of named places at RA 1796-1800.

PIETER ANGELLIS. 'The arrest of Charles I.' Signed. Painted about 1722. Christie's sale 13.6.1958 (151, with companions).
One of a set of eight scenes from the life of Charles I painted (apparently for engraving) by a team of painters (Parrocel, Tillemans, Raoux and Vanderbank) about 1722. They were once at Hornby Castle (Duke of Leeds).

GEORGE ARNALD. 'A lane through a wood.' Wood. 15¼ ins. x 19½ ins. s. & d. 1797. Christie's sale 27.6.1980 (72).
Echoes of Gainsborough, Barret and the Dutch 17th century landscape school are all visible in this characteristic work.

ARNALD, George **1763-1841**
Mainly a landscape artist in oils and watercolours
(*Mallalieu*). Born Farndip, Northants, 1763; died
Pentonville 21 November 1841. Pupil of one of the
Pethers (qq.v.). Exh. a steady stream of dull land-
scapes at RA 1788-1841; SA 1790-91; BI 1807-42.
ARA 1810. He painted every sort of scene and, in
later life, marines and sea fights.

(Grant; Archibald.)

ARNOLD, George **1753-1806**
Painter of still-life and animal pictures. Hon. exh.
SA 1770-76 (in 1773 his name is given as Edward.)
Matriculated at St. Edmund Hall, Oxford, 1771.

ARNOLD, John **fl.c.1700-1745**
Vertue (*iii, 32*) mentions him as a painter, nephew
of J. van der Vaart (q.v.), who had assisted his
uncle for thirty years at the time of his death
(1727), probably mainly as a restorer. His own sale
took place 3/4.2.1745/6.

ARNOLD, Richard **fl.1788-1791**
Portrait painter and miniaturist. Exh. SA 1791;
RA 1791 (a miniature). No doubt the Richard
Arnold who signed and dated 1791 a pair of small,
Downman-like portraits, 11½ by 9½ ins., sold S,
2.11.1966, 61.

ARROWSMITH, Thomas **1772-c.1829**
Deaf and dumb portraitist and miniature painter.
Born London 25 December 1772. Entered RA
Schools 1789. Exh. RA 1792-1800 and 1829. Was
working at Liverpool 1823 and later at
Manchester. Several portraits at Liverpool.

(Walker Art Gallery, Merseyside cat.)

ARTAUD, William **1763-1823**
Portrait and history painter. Born London 24
March 1763; died there March 1823. Won
precocious awards from SA 1776/7. Entered RA
Schools 1778, and won gold medal 1786. Exh. an
enamel at RA and pictures 1784-1822. He was
working for Macklin's Bible and Poetic Gallery
1788-93: 'Moses meeting his wife and son', engr.
1792 (Pittsburgh). RA travelling studentship 1795.
1796-99 Rome (mainly), Naples, Florence and
Dresden. Back in England October 1799, he exh.
mainly portraits, but some history and social
genre. Latterly based on London but made annual
tours in the Midlands painting portraits for middle
class homes: several in Leicester Museums.

(A.C. Sewter, Ph.D. thesis, Manchester University, 1952.)

ASHBY, Henry **fl.1794-1855**
Portrait, and occasional genre, painter. Exh. RA
1794-1836; BI 1808-37.

(Redgrave.)

ASHFORD, William ***c.*1746-1824**
Landscape painter long resident in Ireland. Born
Birmingham *c.*1746; died Dublin 17 April 1824.
He settled in Dublin 1764 and had a job in the
Ordnance Office until 1788, from which he first
sent flower pieces as an hon. exh. in 1767. He won
premiums for landscapes in 1772 and 1773 in
Dublin, and rapidly became a professional land-
scape painter and the most successful in Ireland.
He exh. fitfully in London at SA 1777-91 and RA
1775-1811, occasionally giving a London address.
He made a tour in N. Wales 1789/90 but his main
subjects are views of gentlemen's seats and the less
spectacular beauty spots of Ireland. His most
prolific period was before 1800 but in 1813 he was
elected President of the Irish Society of Artists and
he was active in the formation of the Royal
Hibernian Academy of which he became the first
President in 1823, shortly before he died. His
earlier rural scenes owe a good deal to Dutch
example. He normally signs and dates his pictures.

(Crookshank and Knight of Glin, 1978, 134-136.)

ASHLEY, Mrs. **fl.1768-1772**
Exh. FS 1768-72; SA 1769, all sorts of subjects in
crayons and oil, lapsing once into needlework land-
scapes.

ASHTON, Matthew **fl.1718-1728**
Portraitist known only from an engraving, dated
1728, of Archbishop Boulter; there is also a much
later engraving of the poet Ambrose Philips. A por-
trait of 'Sir Samuel Garrard', said to bear the
signature of 'William Ashton' and the date 1718 on
the back, was sold 16.5.1980, 192.

ASTLEY, John **1724-1787**
Portrait painter. Son of a surgeon, baptised Wem,
Salop, 6 April 1724; died Dukinfield Lodge
Cheshire, 14 November 1787.
 Pupil of Hudson (q.v.) in early 1740s; to Rome
1747, Florence 1748; back to Rome 1750 for brief
study under Batoni. In Florence 1751, painting
copies of old masters, where he was patronised by
Horace Mann, whose portrait he painted (W.S.
Lewis Coll., Farmington) and who recommended
him to Horace Walpole. He was friendly with

*WILLIAM ARTAUD. 'Moses meeting his wife and children.' From
the engraving in Macklin's Bible, 1792.*
The original picture (50½ ins. x 40½ ins.) is in the Carnegie
Institute, Pittsburgh, where it was long considered to be by
Angelica Kauffmann. Painted c.1790/1.

WILLIAM ASHFORD. 'Edge of a wood, with figures and a hay-cart.' 30ins. x 41ins. s. & d. 1784. Christie's sale 16.2.1945 (51).
Both figures and composition owe a good deal to the Dutch 17th century school — especially Cuyp; but the tone anticipates the 19th century.

Reynolds in Rome and the styles of their early portraits are not dissimilar. He had reasonable business in London and then went to Dublin in 1756, where he spent three very prosperous years. He is said to have earned £3,000 and his prices were 20 guineas for a half length in 1759. A large group of 'The Molyneux Family', 1758, is in the Ulster Museum, Belfast. He was always a very flashy character and, on his way back to London, he met a rich widow, Lady Dukinfield-Daniell, whom he married, 7 December 1759. She died in 1762 and left him a fortune and the Dukinfield property in Cheshire. He became a playboy rather than an artist and did not bother to exhibit, but he took J.K. Sherwin (q.v.) as an apprentice in 1769, when be bought Schomberg House and decorated the principal apartment with considerable taste. In 1777 he sold his London collection of old masters and retired to Cheshire, where he became a country gentleman. He had considerable promise but never developed his art.

(Mary Webster, Connoisseur, CLXXII (Dec. 1969), 256-261.)

ASTLEY, Mrs. Rhoda **1725-1757**
Amateur portrait painter and copyist. Born London 1 July 1725; died Widcombe, Bath, 21 October 1757. Daughter of Francis Blake-Delaval, she married, 1751, Edward Astley, who succeeded as 4th Bart. after her death. There is a mezzotint after her 'Self portrait' (later at Melton Constable) by McArdell. Bishop Pococke, writing of Seaton Delaval in 1760, says "some of the family pieces are well copied by Mrs Ashley [sic], a lady of the family who had a genius for painting".

(Surtees Soc., CXXIV (1915), 242.)

ATKINS, Samuel **fl.1787-1808**
Painter of marine subjects with some maritime experience. Exh. RA 1787; 1791-96; 1804-08. He appears to have sailed in the East between 1796 and 1804. His competent works are in oil or watercolours.

(Mallalieu.)

ATKINSON, E. **fl.1793-1797**
Exh. still-life pictures at RA 1793-97.

JOHN ASTLEY. 'Sir Horace Mann, 1751.' Wood. 19½ ins. x 14½ ins. Inscribed on the back with the sitter's and painter's names and the date. W.S. Lewis Foundation, Farmington, Connecticut (Yale University).
Painted at Florence, where Sir Horace Mann (c.1701-86), the assiduous correspondent of Horace Walpole, had been resident and envoy from 1738 until his death. This was painted when Astley was friendly with the young Reynolds.

ATKINSON, James

Recorded as a portraitist at Darlington in later 18th century. He published a series of letters on art addressed to James Barry (2nd ed. Edinburgh, 1800).

(Hall, Marshall.)

ATKINSON, John fl.1770-1775

Painter of genre, landscape and flowers. In 1770 he was a pupil of Richard Wilson (q.v.). Exh. FS 1770-75, calling himself 'drawing master' (1773 from Newington Butts; 1774 from Chelsea). Two companion pictures, signed and dated 1771 (FS 1772), from Alnwick 'A girl binding up asparagus' and 'A kitchen' (BAC Yale) are distant echoes of Chardin and W. van Mieris.

ATKINSON, Richard 1750-1776

Landscape and portrait painter. Born 1750. Entered RA Schools 1769. Exh. RA 1772-76, portraits and landscape (in 1776 in watercolour.).

ATWOOD, John fl.*c.*1760

A portrait of a young man, in the manner of Heins, and coming from Norfolk, in Lord Sondes sale 5.2.1971, 63, was signed: 'Jno Atwood.'

ATWOOD, Thomas fl.1761-1764

Exh. flower pieces and landscapes at SA 1761-64.

AUSTIN, William 1721-1820

Austin appears in the list of eminent painters in the *Universal Magazine,* November 1748. He is perhaps the William Austin, known as an engraver, who exh. RA 1776 'A view on the Rhine, near Coblentz', who died at Brighton in 1820 aged 99.

(Redgrave.)

JOHN ATKINSON. 'Girl binding up asparagus'. 30½ ins. x 25ins. s. & d. 1771. Exh. FS 1772. B.A.C. Yale.
A deliberate exercise in the style of Willem van Mieris (1662-1747) whose pictures were popular in England.

B

BAKER, John **1736-1771**
Flower painter. Died London 30 April 1771.
Trained as a coach painter and became so
proficient in painting the wreaths of flowers sur-
rounding the coats of arms, that he graduated to
flower pieces. Exh. SA 1762-68. Became a
foundation RA and exh. RA 1769-71, flower
pieces, one of which was given to the RA by his
fellow ex-coach painter, Charles Catton (q.v.),
1772.

BALDREY, John, Sr. and Jr. **fl. 1770-1821**
Presumably the father was painting crayon por-
traits at Norwich 1775 (*Fawcett*), and an oil portrait
in the manner of Humphry, signed and dated 1780
on back, was sold S, 16.6.1954, 125. The son, born
1758, entered RA Schools as an engraver 1781,
and they jointly formed a firm of print publishers at
Cambridge (J. & J. Baldrey) at least from 1799 to
1809. J.K. Baldrey exh. portraits at RA 1793-94.
The younger Baldrey was an active engraver and
living in retirement at Hatfield in 1821.

(*Redgrave.*).

BALDUCCI, Gregorio **fl. 1777**
Exh. a 'Death of Adonis', SA 1777.

JOHN BAKER. 'Flower piece.' 24½ ins. x 29½ ins. Royal Academy of Arts (Diploma Collection).
Baker was the first foundation RA to die (before he had
painted a Diploma Picture). This was presented to the
Academy by Charles Catton, RA, 1772.

BAM(P)FYLDE, Coplestone Warre **1720-1791**
Amateur landscape painter in oils and water-
colours, and etcher; he was a landed gentleman.
Born Taunton 1720; died Hestercombe, Somerset,
21 August 1791. He made drawings for local topo-
graphical engravings 1755 (*for later watercolours see*

*COPLESTONE WARRE BAMFYLDE. 'A
Mediterranean harbour.' 27½ ins. x 37ins.
Signed 'CWB'. Stourhead (National Trust).*
A conventional 'Mediterranean' (or
perhaps 'Turkish' — owing to the camels)
harbour scene, of a type popularised by
Vernet and Dutch 17th century painters.
The classical rotunda on the shore is an
unusual addition.

JAMES BARBUT. 'Shells.' 31ins. x 41ins. s. & d. 1779. Possibly exh. RA 1779 (7) as 'Shells &c.' Unlocated. Barbut exhibited pictures of 'Shells' at three successive Academies 1777-79.

Mallalieu). Hon. exh. of landscapes SA 1761 and 1763; RA 1771-74 and 1783. His local views are very competent and recall Lambert (q.v.) in style. He also painted fanciful Mediterranean landscapes which reveal a knowledge of Vernet and Marlow (q.v.), two are at Stourhead. He sometimes collaborated with the Somerset figure painter, Richard Phelps (q.v.). His signature is often: 'CWB'. Matriculated at St. John's College, Oxford, 27 February 1737/8, aged 17.

(Extracts from a local sale at Hestercombe 8-11.10.1872, in Somerset Notes and Queries, XXIII (1942), 314 ff; R. Edwards, Apollo, XI (Feb. 1930), 113-116.)

BARBER, Christopher *c.* **1736-1810**
Mainly a miniature painter, but also did portraits and conversations in oils, crayons, and an occasional landscape. Died London 8 March 1810.

(Gentleman's Mag., 1810.)

BARBIER, G.P. **fl. 1792-1795**
Portrait, miniature and genre painter: presumably French *émigré*. Exh. rather abundantly at RA 1792-95, portraits, landscapes and a 'Rinaldo and Armida' (sold S, 14.7.1976, 62), which is an excessively sentimental variation on Prudhon.

BARBUT, James **fl. 1777-1786**
Still-life painter. Exh. RA 1777-86 paintings of shells, flowers and insects. A very competent arrangement of shells in a marine grotto, signed and dated 1779 has a marine backdrop in the manner of Vernet.

THOMAS BARDWELL. 'Elizabeth, Lady Lloyd (1707-88) and her son.' 93ins. x 57ins. s. & d. 1751. Christie's sale 31.10.1952 (59).
One of Bardwell's most ambitious works (busts and half lengths are more usual). His poses ultimately derive from Van Dyck.

THOMAS BARDWELL. 'William Henry, 4th Earl of Rochford, with horse and groom.' 64½ins. x 84ins. s. & d. 1741. Brodick Castle (National Trust for Scotland: on loan from H.M. Treasury).
In the background is Easton Park. It was to Lord Rochford that Bardwell dedicated his treatise on *Painting*, 1756.

BARDWELL, Thomas **1704-1767**
Portrait and decorative painter, and writer on technique. Born in East Anglia 1704; died Norwich 9 September 1767. First recorded doing decorative painting in 1728, shortly before settling at Bungay, running a decorative painting firm which his brother Robert took over in 1738. Between 1729 and 1741 executed a certain number of over-mantels and views of country houses, and his few conversation pieces date 1736-40. Dated portraits on the scale of life begin 1741 with 'Lord Rochford' a Suffolk peer, to whom he dedicated *The Practice of Painting and Perspective made Easy*, 1756, which is almost entirely an original work, of which Edwards admits "the instructions...are the best that have hitherto been published". It has been demonstrated by analysis that he gives an accurate account of his own practice *(Talley and Groen, 1975)*. He certainly visited London in the 1740s and 1750s, but it is not clear if he ever lived there at all rather than at Bungay. In 1752/3 he made a visit through Yorkshire to Scotland, where he painted a number of portraits. From at least 1759 he was settled at Norwich where he had a good practice.

His style and his use of Van Dyck costume is parallel to that of Hudson.

(Talley, Walpole Soc., XLVI (1978), 91-163, with cat. of portraits.)

BARENGER, James **1745-1813**
Painter of butterflies and insects. Exh. water-colours of butterflies (as Mr Baringer) SA 1773, and insects, which need not have been in oils, RA 1793-99. He married a sister of Woollett the engraver and was father of James Barenger Jr. (1780-after 1831) the horse painter.

(Redgrave.)

BARKER (of Bath), Thomas **1769-1847**
Painter of every class of picture, but best known for peasant genre, on scale of life or in small, and landscape. Born near Pontypool May 1769; died Bath 11 December 1847. Son of incompetent horse painter, Benjamin Barker I (d.1793). The family moved to Bath *c.*1782 and Barker is known as Barker of Bath, because he worked there most of his life, and his art was not much thought of in

London. He is said to have been entirely self-taught and was certainly very precocious, and was taken up and educated by a generous coachbuilder and collector, Charles Spackman, who arranged for him to copy Dutch and Flemish 17th century pictures in his own collection. In imitation of Gainsborough's latest 'fancy pieces' (e.g. 'The Woodman', 1787) Barker produced a number of more or less life-size figures of peasants or common urban types which were extremely successful, fetched high prices, and later were copied in cheap engravings, on china and every sort of artifact. A number were exhibited in a special gallery at Bath in 1790 and caused something of a local furore. Spackman sent Barker to Italy 1790-93, with a generous allowance, where he profited a good deal from a study of the tradition of foreign painters in Italy. 'The Bandits', 1793 (Bristol) is characteristic of his rather careful Roman (and Neapolitan)

work. Returning to Bath in 1793, he found his father dead and Spackman bankrupt, but his self-confidence is apparent in the 'Self portrait', 1793 (Holburne of Menstrie Museum, Bath). His occasional exhibitions in London at the RA were only in 1791, 1796-98, 1800, 1804 and 1829; B.I. between 1807 and 1847. He held a one-man show in London in 1797, without much effect, and he turned out an enormous number of small or middle size pictures, mainly of rural life, but also with a religious, historical, or contemporary social content. These are in a sloshy style which is very easy to recognise. Eccentrically he painted a large 'Trial of Queen Caroline', 1821, and a huge (and unexpectedly impressive) fresco of 'The Inroad of the Turks upon Schio, 1825', on the walls of the rather grand Doric House he had built for himself, c.1803, at Bath. Some of his pastoral landscapes, and some of those of his younger brother

THOMAS BARKER OF BATH. 'The Bandits.' 59½ins. x 77ins. s. & d. 'Thos. Barker pinxit Rome 1793.' Bristol City Art Gallery.
One of the neatest and most original of Barker's early pictures. The rather operatic bandits (from Roman studio models) remained a theme for foreign painters visiting Rome for half a century.

(Benjamin Barker II, 1776-1838, who hardly emerges as an artist before 1800), have mistakenly been confused with the early work of Gainsborough (q.v.). He outlived his popularity and his reputation by some years and his numerous remaining works seem to have been sold at the J.H. Smyth-Pigott sale, 10ff.10. 1849, Lugt 19496. He was the father of Thomas Jones Barker (1818-82), also a painter.

(Useful illus. in Apollo, XCVIII (Nov. 1973), 382-386.)

BARNETT, R.C. fl.1798-1799
Exh. RA 1798-99 a 'Portrait of his mother, by candlelight' and 'A View in Blenheim Park'.

BARNEY, Joseph 1751-1829
Light history and fruit and flower painter. Born Wolverhampton 1751; possibly died there. Won a premium for a drawing of flowers at SA 1774. Studied with Angelica Kauffmann and Antonio Zucchi, whose address was also Barney's when he exh. at SA 1777 a flower piece and two light histories in the vein of Angelica. 1778-81 assisted Matthew Boulton at Wolverhampton in finishing by hand his 'mechanical paintings'. His one known major work, the ceiling, in several compartments, of a room at Badger Hall, *c.*1781, is now installed as the staircase ceiling at Buscot Park, and is a very pretty work, clear and light in tone, and wholly in the style of Angelica. Exh. RA 1784-1827; BI 1806-29. From 1793-1820 Drawing Master at the Royal Military Academy, Woolwich. In 1815 he appears as 'Flower Painter to the Prince Regent'. His later exhibits cover a wide variety of subjects; he was also concerned with the decoration of japanned trays, in which his brother had a business at Wolverhampton.

(E. C-M.)

BARRET, George ?1728/1732-1784
Romantic and naturalistic landscape painter in oils and watercolour. Born in Dublin; died Paddington, 29 May 1784. He had some teaching in West's Academy at Dublin (1747) but, as a landscape painter, he was largely self-taught from Dutch or Italian 17th century models. The landscapes of his Irish period are often of the park at Powerscourt and the scenery of the Dargle, but some already show an Italian influence. He brought some of these over to London in 1763 and exh. two at SA 1764, and also won a premium for a landscape at the FS 1764. Exh. SA 1764-68, when he became a foundation member of the RA. Exh. RA 1769-82. He had good success at first and

THOMAS BARKER OF BATH. 'Boys gathering faggots.' 77¼ ins. x 59½ ins. s. & d. 1790. Christie's sale 11.4.1980 (95). These large-scale rustic figures, in deliberate imitation of Gainsborough's 'Fancy Pieces', were the first pictures to win Barker serious acclaim at Bath, and were reported to have been sold for very high prices.

specialised in views in North Wales and closely particularised scenes in noblemen's parks. His particular patrons were the Duke of Portland, for whom he painted a dozen landscapes 1765/7 at prices of 40, 60 and 80 guineas *(Goulding and Adams, 428)*; and the Duke of Buccleuch for whom he painted a series of large views in the park at Dalkeith, RA 1769-71 (now at Bowhill). But he was financially feckless and his pictures were sold up at Langford's, 9.5.1771, Lugt 1731. His later pictures are more picturesque and show that he had studied the work of Richard Wilson (q.v.) *(cf. W.G. Constable, R. Wilson, 144)*. They are often recognisable by rather floppy, mannered, trees, and sometimes by strongly contrasted greens and yellow browns, which led Wilson to call them 'spinach and eggs'. He was, however, one of the best landscape painters in oil of his day; some of his views of country seats were engraved. He does not often sign his pictures but sometimes signs 'GB' in a monogram. His major work in the middle 1770s was painting the walls of a room at Norbury Park (jointly with Sawrey Gilpin, Cipriani (qq.v.), &c.)

GEORGE BARRET. 'A view in Dalkeith Park.'
91ins. x 79ins. Probably exh. RA 1770 or 1771.
Buccleuch collection at Bowhill, Selkirk.
The seven views of Dalkeith in the Buccleuch
collection are his most memorable surviving
works. They were a conscious attempt at
providing a native British type of landscape
composition in opposition to Richard Wilson's
Italianising patterns.

with a panorama of Lakeland scenery.

(*E. C-M.*)

His three sons, all practised painting and his daughter painted miniatures. **Joseph** is only known from having gone to Norbury in 1789 to varnish his father's wall painting. **James** exh. occasionally at the RA from 1785-1819, mainly in watercolour, but at first in oil landscapes in imitation of his father's. **George Jr.** (1767/8-1842) was exclusively a watercolour painter of much distinction (*Mallalieu*).

(*Crookshank and Knight of Glin, 1978, 112-120.*)

BARRETT, Jeremiah **before 1723-1770**
Irish portrait painter. His father died in Dublin 1723 and he died there November 1770. A picture of three children formerly on loan at Pittsburgh, and signed and dated 1738 is rather like an Irish Highmore (q.v.); other dated works are known from 1753.

(*Strickland; Crookshank and Knight of Glin.*)

BARRETT, Ranelagh **fl.*c.*1737-1768**
An extremely skilful copyist. Died London 1768. About 1737 he did a brilliant copy, at Melbury, of Hogarth's 'Lord Hervey and his friends', but he chiefly specialised in old masters. (*Vertue, iii, 112 ff.*). He sometimes signed 'R. Barwick' (*for other spellings see Whitley, I, 105*), but his post-mortem sale (22/3.12.1768, Lugt 1723) calls him 'Ranellah Barrett'.

BARRON, Hugh **1747-1791**
Portrait painter. Born London 1747 (*P. Scholes, The great Dr. Burney', I, 98*); died there 9 September 1791. He began life as a musical prodigy on the fiddle. Apprenticed to Reynolds (q.v.) *c.*1764-66. Exh. SA from 1766 (still with Reynolds) to 1778; RA 1782, 1783 and 1786. His earlier portraits, e.g. 'Lady', 1768 (Corcoran Gallery, Washington), are very close to Reynolds, but his most attractive works are conversation pieces of *c.*1768-70, e.g. 'The Bond family', 1768 (Tate Gallery), which show he had looked at Zoffany (q.v.). On his way to Rome he stopped off at Lisbon, 1770/1, and painted one or two conversation pieces for the British colony. In Rome from October 1772-*c.*78, when he returned to London and settled in Leicester Fields. He continued to paint portraits, but nothing after 1771 has been identified. He remained the best amateur violinist of his time. There are mezzotints by V. Green after two portraits of 1780 and 1782.

(*Edwards.*)

BARRON, William Augustus 1751-after 1806
Topographical landscape painter and draughtsman. Born London 31 October 1751; still alive 1806 (*Edwards*). Younger brother of Hugh Barron (q.v.); pupil of W. Tomkins (q.v.). Entered RA Schools 1771. Exh. landscapes RA 1774-77, of which some may have been in oils. By 1780 he had a job in the Exchequer and had given up painting.

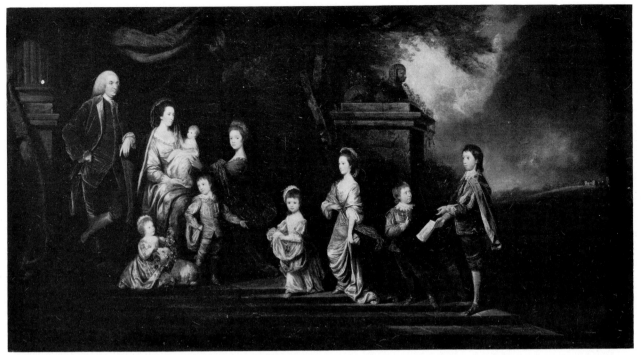

HUGH BARRON. 'John, 2nd Earl of Egmont, his second wife, and their family.' 32ins. x 61ins. Exh. SA 1770 (4). Christie's sale 12.12.1930 (69).
A combination of Reynolds' poses with the 'conversation' arrangement of Zoffany. Barron showed great promise, but seems to have given up painting for music.

BARROW, Thomas ?1749-*c*.1778

Portrait painter, probably northern provincial. Presumbly the Thomas Barrow who entered the RA Schools 1777, aged 28. Exh. FS 1769; SA 1770-75. His address in 1770 was at Romney's in London; from 1771 to 1774 at York. A portrait of a Yorkshire sitter, 'Roger Gee', signed and dated 1773, was sold 22.3.1974, 152, and was in a competent provincial style suggesting Wright of Derby (q.v.). Another Thomas Barrow exh. at RA from 1792, but mainly miniatures and not oil portraits.

BARRY, James 1741-1806

Heroic history painter and, occasionally and very reluctantly, portrait painter — with a very Irish temperament. Born in humble circumstances Cork 11 October 1741; died, in self-imposed squalor,

HUGH BARRON. 'A lady, perhaps Isabella d'Almeida.' 50ins x 40ins. s. & d. 1768. W.A. Clarke collection, Corcoran Gallery of Art, Washington, D.C.
Long plausibly attributed to Reynolds until Barron's signature was discovered. It is closer in style to Reynolds' work than that of any other of his known pupils.

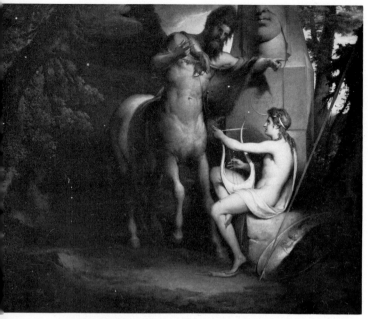

*JAMES BARRY. 'The Education of Achilles.' 40½ ins. x 50¾ ins.
Exh. RA 1772 (14). B.A.C. Yale.*
The centaur Chiron is teaching the young Achilles to play the
lyre. Barry's intensive study of the Antique in Rome enabled
him to produce a handful of pictures in a much purer neo-
classical style than any of his contemporaries.

London 22 February 1806; buried in St. Paul's
Cathedral. He taught himself to paint by copying
prints and anything he could lay hands on and
went to Dublin, 1763, with some historical compo-
sitions he had invented. These seem to have been
impressive and he was brought to the attention of
Edmund Burke, who became his sponsor and
mentor. After a little study under Robert West
(q.v.) in Dublin, Burke persuaded him to come to
London in 1764, and introduced him to Reynolds
and James 'Athenian' Stuart (qq.v.), who
encouraged him and perhaps innocently fanned his
lofty aspirations. He was certainly both talented
and precocious. Burke financed a journey to
Rome, via Paris, in 1766, where Barry remained
until 1770, doing little painting but studying the
great masters and the Antique intensively. He
returned via Florence, Bologna (where he
presented his 'Philoctetes' to the Accademia
Clementina) and Venice. Exh. RA 1771-76, first
his 'Adam and Eve', 1771 (Dublin). ARA 1772,
RA 1773. He exhibited a number of impressive
history pictures, such as 'The Death of Cordelia',
RA 1774 (Tate Gallery). In 1776 he exh. a picture
of some portraits (Burke and himself) in the
character of 'Ulysses and his companions escaping
from Polyphemus' (Cork Art Gallery), and a
'Death of Wolfe' (New Brunswick), which was
unfavourably criticised, so that he never exhibited
again. He seems to have acquired the reputation of
being the most distinguished history painter of the
time, but schemes for decorating St. Paul's and the
Society of Arts jointly with others collapsed, and he
offered to paint pictures himself, without
remuneration, for the walls of the great room of the
(Royal) Society of Arts. These six huge canvases
illustrating 'The Progress of Civilisation' occupied
him from 1777 to 1783. They are not only his
major achievement, but the finest example of
historical painting in Britain produced in this
century. Barry wrote an explanatory booklet on
them, and there is no doubt that, in spite of certain
incongruities, the intellectual effort involved was as
considerable as the technical. They were generally
admired but did not lead to commissions.

Barry was made Professor of Painting at the RA
in 1782, but he was dilatory about preparing his
lectures and, when he did give them, devoted much

*JAMES BARRY. 'Portraits in the characters of Ulysses and his
companions escaping from the cave of Polypheme.' 50ins. x 40ins.
Signed. Exh. RA 1776 (18). Crawford Municipal Art Gallery, Cork.*
Ulysses is a portrait of Edmund Burke, and his chief
companion is Barry himself. Burke in fact was perhaps the only
person who had some good influence over Barry, for whom the
outside world was normally a sort of 'cave of Polyphemus'.

JOHN BAUDENBACH. 'Leopards with their kill.' 41½ ins. x 47½ ins. s. & d. 1770. Sotheby's sale 14.11.1962 (163).
This unknown painter was a specialist in wild animals.

time to vituperating his colleagues. His bad temper and language and generally difficult nature caused the Academy to expel him in 1799 from the Chair and their number. His later years were largely devoted to a vast, unfinished 'Pandora' (Manchester). He loathed portraits, but when he painted them, they are always remarkable — notably a 'Self portrait' (Dublin) completed in 1803 from an earlier picture. His paintings were few and many were in his post-mortem sale 10/11.4.1807, Lugt 7215.

(Ed. Fryer, The Works of J.B., 1809; Strickland; William Presley, Ph.D. thesis, Yale, forthcoming c.1981.)

BARTOLI, Francis **1765-1783**
Born 4 November 1765. Entered RA Schools 1781. Exh. RA 1783 a 'Portrait of a Hybernian'. In 1793 a F. Bartoli Jr. exh. portraits and a 'Cupid and Psyche'.

BARWICK, R. See BARRETT, Ranelagh

BATEMAN, L. **fl.1775**
Exh. portraits, one in crayons, at SA 1775.

BATTY, John **fl.1772-1779**
Yorkshire painter of topographical landscapes, mainly as tinted drawings. Exh. SA 1772, one at least in oil; RA 1779, from York.

BAUDENBACH, John **fl.1770-1777**
Animal painter in oils and watercolours. Exh. RA 1772-73; SA 1777. A picture signed and dated 1770 of 'Leopards with their kill' sold S, 14.11.1962, 163.

BEACH, Thomas **1738-1806**
Portrait painter, centred on South West England. Born Milton Abbas, Dorset, 1738; died Dorchester, Dorset, 17 December 1806. Studied in St. Martin's Lane Academy in London and with Reynolds (q.v.) from 1760 to early 1762. His earliest portraits (1762) show a strong Reynolds' influence, but this is no longer in evidence when he started to exhibit (from Bath) at the SA in 1772. Exh. SA 1772-83 (when he was Vice-President); RA 1785-90 and 1797, with a London address, but he was essentially based on Bath. His year's pattern of activity is known from a diary for 1798, which alone has survived. He set out from Bath in

THOMAS BEACH. 'Dr. Richard Pulteney, M.D.' 30ins. x 25ins. s. & d. on the back 1788. Leicestershire Museums and Art Galleries.
Richard Pulteney (1730-1801) was a Leicestershire botanist of great distinction. In 1765 he moved to Blandford, Dorset (a town visited by Beach on his summer itineraries) and practised as a physician.

THOMAS BEACH. 'The Stapleton Family.' 59ins. x 54ins. s. & d. 1789. Holburne of Menstrie Museum, University of Bath.
Brothers and sisters: the boy William (1770-1826) is in the uniform of the Oxfordshire Yeomanry. Beach liked informal groups of this sort.

June and travelled round Dorset and Somerset until December, painting portraits in the houses of the county nobility and gentry. This had certainly been going on for years. He usually painted single portraits, often in a feigned oval, and often signed and dated; but there are interesting groups: 'The Stapleton family', 1789 (Holburne of Menstrie Museum, Bath) and 'The Tyndall family', 1797 (loan to University of Bristol), which have a pleasing and provincial awkwardness. The likenesses are usually excellent, without concessions to flattery, and easy to recognise. Soon after 1800 he gave up painting and retired to Dorchester.

(Elise S. Beach, T.B., 1934, with cat. of more than 300 portraits.)

BEARE, George fl.1744-1749

Provincial portrait painter of distinguished quality, latterly centred on Salisbury. More than twenty signed portraits are known, all dated between 1744 and 1749. Presumably trained in London. The earliest in style, and the only full length, 'Sir Frederick Evelyn as a boy', 1744 (Salisbury Museum), suggests a knowledge of Mercier (q.v.), but training at St. Martin's Lane Academy is likely. He was living at Salisbury in 1746 (Whitefoord sale, Wokingham, 14/15.1.1934, 225), and several sitters in 1747 (*Kerslake*) have Salisbury connections. He has been mistaken for Hogarth (q.v.).

(Collins Baker, Country Life, 1958, 572/3, 998.)

BEATSON, Miss Helena 1763-1839

Scottish amateur painter in crayons of considerable precocity. Niece and pupil of Katherine Read (q.v.), whose style she followed. Hon. exh. RA 1774, aged eleven; SA 1775. Accompanied her aunt to India in 1777, where she married, 1777, and abandoned her art. Her husband became Sir Charles Oakeley, Bart. in 1790.

(Foster, 64.)

BEAUCLERCK, Lady Diana 1734-1808

Talented amateur artist and illustrator (but not as talented as Horace Walpole thought). Daughter of Charles Spencer, Duke of Marlborough; married first, 1757, 2nd Viscount Bolingbroke; second, 1768, Topham Beauclerck. Her drawings of romantic subjects are interesting and she did the

GEORGE BEARE. 'A grandmother with her granddaughter(?).' 50ins. x 40ins. s. & d. 1747. B.A.C. Yale.
The sitters are said to be members of the Grove family of Taunton. From this portrait one can understand why some of Beare's portraits have been attributed to Hogarth.

*GEORGE BEARE. 'Sir Frederick Evelyn (1733-1812) as a boy.'
49½ins. x 34½ins. s. & d. 1744. With Charles Young, 1979.*
The only full length (and landscape) so far known by George
Beare, whose dated works only range from 1744 to 1749. The
sitter suggests that it was painted in London. Acquired by the
Salisbury Museum, 1979.

illustrations for two books 1796/7. (*Hammelmann*).
Some accomplished crayon portraits were in the
sale from Woolbeding House, S, 19.11.1970. She
also designed bas reliefs for Wedgwood.

(Mrs. Steuart Erskine, Lady D.B., 1903; Mallalieu.)

BEAUMONT, Sir George Howland 1753-1827

The most professional amateur landscape painter,
and one of the great art patrons of his age. Born
Dunmow, Essex, 9 November 1753; died
Coleorton Hall, 7 February 1827. He succeeded as
7th Baronet 1762. Most of his work consists of
watercolours and drawings (*for his training in this
field see Mallalieu*). His rather limited exhibited work
(RA, hon., 1779, 1794-1825) was mostly in oil, in a
style based on his admiration for Claude and
Richard Wilson (q.v.) from whom he may have
had a few lessons (*but see W.G. Constable, Richard
Wilson, 1953, 141*). His personality as an artist was
not important, but as the friend and patron of
artists and a patron of immense good will, though

sometimes limited understanding, he was
unequalled. Farington's *Diary* is a great source for
his life and character.

(Margaret Greaves, Sir G.B., 1966.)

BECK, George *c.*1748/50-1812

Landscape painter in England and America. Born
Elford, Staffs., 1748 or 1750; died Lexington,
Kentucky, 14 December 1812. Exh. landscapes
RA 1790-3; SA 1791. His wife Mary Beck (married
1786; died 1833) also exh. landscapes RA 1793.
They migrated to the U.S. 1795 and he painted
and she ran schools for girls at Baltimore,
Philadelphia, Cincinnati and Lexington. He was a
competent professional landscape painter.

(Groce and Wallace.)

BECKWITH, Thomas 1731-1786

Yorkshire antiquarian draughtsman, who
occasionally painted indifferent portraits. Born
Rothwell, nr. Leeds, 1731; died York 17 February
1786. His two known portraits are 'The Masonic
Lodge Board' (Duncombe Place, York) and
'Francis Drake' (Yorkshire Museum).

(Ingamells, Connoisseur, LXXX (July 1964), 37, n.7.)

BEECHEY, Sir William 1753-1839

Painter of portraits and occasional fancy pictures.
Born Burford, Oxon., 12 December 1753; died
Hampstead 28 January 1839. ARA 1793; RA

*GEORGE BECK. 'Raynham Hall and Park.' 49½ins. x 65ins.
s. & d. 1791. Exh. RA or SA 1791. Christie's sale 21.11.1980
(63).*
Painted in a tradition ultimately deriving from Lambert. Soon
after exhibiting this Beck migrated to the United States.

SIR WILLIAM BEECHEY. 'A gentleman.' 11ins. x 9ins. Inscribed on the back 'Beechey 1783'. Christie's sale 23.3.1967 (142/2).
One of Beechey's early portraits, painted at Norwich, in a style still reminiscent of Zoffany, and very unlike his later work.

1798; knighted 1798. Entered RA Schools 1774 and first exh. RA 1776 and then fairly steadily, and latterly abundantly, up to 1839 — one of the longest careers as an Academy exhibitor. He received some teaching from Zoffany (q.v.), and most of his portraits from 1776 to 1786 are small-scale pictures, sometimes full lengths or conversations, which owe a debt to Zoffany. The few so far identified are excellent likenesses and Beechey's portraits of this period tend to go under the names of other painters. After some years in London he moved to Norwich, where he was in good practice from 1782 to 1787, and started to paint portraits on the scale of life. Exh. SA 1783 and RA 1785/6 from Norwich. He returned to London 1787 and soon had a very good practice; his account book survives for 1789 to part of 1791 (in 1789 small portraits for 5 guineas and portraits 30 by 25 ins. for 10 guineas — which was raised in 1790 to 15 guineas). The most ambitious of these early pictures is the 'Oddie children', 1789 (Raleigh, N.C., 80 guineas), which rivals Hoppner's (q.v.) contemporary child groups. Beechey and Hoppner (d.1810) remained fairly even rivals and both became ARA 1793, and both detested one another. They were soon eclipsed in smartness by the young Lawrence (q.v.). Hoppner was the flashier and appealed to the

Prince of Wales; while Beechey was made portrait painter to Queen Charlotte in 1793. When Beechey raised his prices to 30 guineas a head (*Farington Diary, 7 Jan. 1795*) Opie justly said that his ''pictures were of that mediocre quality as to taste and fashion, that they seemed only fit for sea captains and merchants'' while Lawrence and Hoppner ''had each of them as it were a portion of gentility in their manners of painting''. For the rest of his life Beechey turned out a steady stream of fashionable portraits, which are sound likenesses and show considerable variety, but never reveal strength or nobility of character or intellectual distinction. The series of the 'Royal princesses', RA 1797, and the enormous 'The King reviewing the Dragoons', RA 1798 (all in the royal collection) mark the moment of his greatest success. Account books survive from 1807 to 1826, and in 1825 he raised his price for a head from 40 to 60 guineas. In character he was rather impetuous and cantankerous. He exh. at the BI 1806-36 a number of fancy pictures and landscapes, but these are of no consequence. He married, as his second wife, the miniature painter, Anne Phyllis Jessup, in 1793. Two of his sons also exh. pictures at the RA.

(W. Roberts, Sir W.B., 1907.)

SIR WILLIAM BEECHEY. 'Thomas Starkey.' 29ins. x 24ins. s. & d. 1796. Christie's sale 28.11.1936 (144/2).
One of Beechey's sound, realistic London portraits, before he degenerated into a society portraitist.

BEESLEY
A family of fruit and flower painters. **Robert,** fl. 1767-1798. Exh. FS 1767-83, sometimes with addresses at Buckingham, Streatham and Mitcham. A pair of fruit and flower pictures, signed and dated 1798, were sold S, 14.9.1977, 4. **Ann** (Mrs. Robert) exh. FS. 1774-83. **John,** exh. fruit pieces and a landscape FS 1776-79.

BEETHAM (BETHAM), 1774-after 1816
Jane (Mrs. Read)
Painter of miniatures, portraits and fancy pictures. Pupil of Opie (q.v.), and part cause of his divorce; but she was not allowed to marry him and soon afterwards, in 1796, married a rich solicitor, John Read. Exh. RA 1794-1816.

(Long.)

BEIDERMAN See BIEDERMAN, (J.)C.

BELL, Mrs. Maria (Lady Bell) fl.1783-1825
Painter of portraits and fancy subjects and copyist. Sister of William Hamilton RA (q.v.) she married Thomas Bell (knighted 1816, when Sheriff of London); died 9 March 1825. Exh. RA (as Mrs. Bell) 1783-1806. There is a mezzotint by G. Clint of her 'Self portrait' (probably RA 1806). She was also an hon. exh. at RA 1816 and 1819 (latterly with two busts), and made many copies of Reynolds' portraits.

(Gentleman's Mag., 1825, i, 570.)

BELL, William 1735-?1806
Portrait and history painter. Native of Newcastle; probably the Joseph Bell who died there 26 April 1806 (a friend of Thomas Bewick). The first student to enter the RA Schools 1769, aged 34. Won a gold medal 1771 for a 'Venus entreating Vulcan to forge arms for Aeneas'. Exh. SA 1776 'Susannah and Elders.' From c.1770 until at least 1775 he was 'limner' in the family of Sir John Hussey Delaval (created Lord Delaval 1783) and "for years was permanently employed in [Delaval's] country houses and in London, teaching the children, painting portraits &c." *(R.E.G. Cole, History of Doddington, Lincoln, 1897, 170).* Four full lengths are at Seaton Delaval, and others by or copied by Bell are at Doddington and in Ireland. Bell later retired to Newcastle and practised as a portrait painter; a portrait of 1782 shows some influence from Romney (q.v.), others of 1788 are merely provincial.

ANTONIO BELLUCCI. 'The Ascension of Christ.' Let into the ceiling of the nave of the Church at Great Witley, Worcestershire. Painted c.1720.
An example of Italian rococo religious style. Painted for the Chapel of the Duke of Chandos' house at Canons, Edgware, it was transferred to Great Witley in 1747.

BELLERS, William fl.1761-1773
Topographical landscape painter in crayons and chalks as well as oil. He was a London printseller and exh. more than sixty landscapes at the FS 1761-73, with a strong bias in subject matter towards the Lakes and Cumberland, though he also painted Birmingham and Sussex. Boydell published a set of engravings after him, 1774.

(Grant.)

BELLOTTI
In 1765 'A piece of ruins' was exh. at SA with a London address (at Mr. Grant's) by a certain Bellotti. Bernardo Bellotto (1720-80), the nephew of Canaletto, is not known to have visited London, but could have done so briefly in 1765, between Dresden and settling in Warsaw in 1767.

BELLUCCI, Antonio **1654-1726**
Venetian-trained late baroque religious and history
painter. Born and died at Pieve di Soligo, nr.
Treviso. One of the first of the travelling Venetian
painters of the 18th century, having been court
painter at Vienna and Düsseldorf before coming to
England in 1716 where he remained until 1722.
There is an enormous 'Family of Darius before
Alexander' at Oxford. His chief patron was the
Duke of Chandos, for whom he did much work at
Canons, the ceiling paintings of whose chapel
(c.1719/20) were transferred in 1747 to the church
at Great Witley (*Watson, Arte Veneta, VIII (1954),
295-302*).

(*E.C-M.; Donzelli and Pilo, 1967, 85-89.*)

BELLUCCI, Giovanni Battista **fl.c.1700-1739**
Portrait painter of Venetian origin. Accompanied
his father (or uncle) Antonio (q.v.) to England in
1716, as assistant, but stayed behind after Antonio
left in 1722. Walpole says he did good business in
Ireland, but this was a mistake for Scotland where,
among others, he was painting portraits for the
Earl of Haddington 1722-24, and for the Earl of
Leven 1739. He has a soft and fluffy manner, easily
recognisable.

BEMFLEET, G. **fl.1772**
Possibly a flower painter. Exh. 'Narcissus', SA
1772.

BENAZECH, Charles **1767-1794**
Painter and draughtsman of historical subjects,
fancy pictures and portraits. Son of a landscape
draughtsman and engraver (who exh. SA 1761-62);
died London 1794, age 27 (*Redgrave*). In Rome
1782 and returned via Paris at the beginning of the
Revolution. Member of Florentine Academy. Exh.
RA 1790-91.

BENBRIDGE, Henry **1743-1812**
American portraitist and miniature painter. He
sent to the FS 1769, from Italy (where he studied
under Mengs and Batoni) a portrait of 'General
Paoli', which he had painted for Boswell (now San
Francisco). Exh. RA 1770 two portraits from
London (one of 'Benjamin Franklin') but returned
to Philadelphia the same year.

(*Groce and Wallace.*)

BENCRAFT **fl.1783**
He was perhaps an actor by profession. Exh. 'a
scene in the Fair Penitent', FS 1783.

*GIOVANNI BATTISTA BELLUCCI. 'Patrick Hume of
Kimmerghan.' 36ins. x 28ins. s. & d. 1722. Lord Binning,
Mellerstain.*
There is still a somewhat Venetian air about Bellucci's
portraits.

BENNETT **fl.1783**
Exh. 'a Tyger' at FS 1783. An M. Bennett was
exhibiting miscellaneous pictures from Maidstone
and Greenwich RA 1797-1801; and a T. Bennett
from Woodstock exh. sporting pieces.

BENWELL, J. Hodges **1762-1785**
Mainly a draughtsman and illustrator in crayons
and watercolours. Born Woodstock 1762; died
London 1785. Entered RA Schools 1779 and was
awarded a silver medal 1782. Taught drawing at
Bath and specialised in fancy subjects in a mixture
of crayons and watercolour, some of which were
engraved. Exh. RA 1784 an illustration to
Gessner's *Idylls*, perhaps an oil.

(*Redgrave.*)

BENWELL, Miss Mary fl.1762-after1800
(Mrs. Code)
Portrait painter in crayons, oils and miniature. She exh. SA 1762-74 and 1791 (as Mrs. Code) crayons and miniatures in about equal proportion; RA 1775-82 (as Miss Benwell), 1783-91 (as Mrs. Code). Had lived in widowed retirement for some years in 1800 (*Edwards*). Her reputation was sufficient for her portrait to appear in two Florentine series of artists' self portraits.

BERCHET, Pierre 1659-1719/20
French decorative historical painter. Trained under La Fosse; died London January 1719/20 (*Vertue, i, 87*). He is said in his last years to have painted only small mythologies. His one surviving major work is the very handsome ceiling painting of the chapel of Trinity College, Oxford, *c.*1694.

(*E.C-M., i, 243.*)

WILLIAM BERCZY. 'General Robert Prescott' (1726-1815). Wood. 10ins. x 7¾ ins. Sotheby's sale 23.11.1966 (24).
The sitter was Governor of Canada 1796-1807. There is a mezzotint after this portrait by J. Young.

BERCKHARDT fl.1795
Exh. 'Filial piety' and 'Pastoral innocence', RA 1795.

BERCZY, William fl.1790-1791
Painter of large miniature portraits (10 by 7¾ ins.) in a neat Downman-like style. Exh. RA 1790 (when his wife exh. two 'Insides of a Tuscan kitchen'). He had been a member of the Florentine Academy. A portrait of George III was engraved 1791. His 'General Robert Prescott', engr. J. Young, sold S, 23.11.1966, 24.

BERRIDGE, John 1740-1804
Portrait painter. Native of Lincolnshire. Born 1740; still alive 1804 (*Farington, 6 Oct. 1804*). Pupil of Reynolds (q.v.) 1766-68. Entered RA Schools 1769. Exh. SA 1766-75 (when he became a director); RA 1785 and 1796-97. His engraved 'Miss Rose in the character of Tom Thumb', SA 1770, is entirely in the style of Reynolds, but other portraits dated in the 1770s and later are much closer to the style of N. Dance (q.v.). He became lazy in later life.

PIERRE BERCHET. 'Sacrifice of Isaac.' 12ins. x 10ins. Signed. Christie's 25.4.1958 (118).
One of the small histories he was painting at the end of his life. It is in a wholly foreign idiom.

JOHN BERRIDGE. '*Miss Rose in the character of Tom Thumb, Act ii, Scene ii.*' *45 ½ ins. x 35 ½ ins. Exh. SA 1770 (10). Private collection.*
Engraved in mezzotint by E. Fisher, 1770. It has easily been mistaken for a portrait by Reynolds.

JOHN BERRIDGE. 'Charlotte and Willoughby John Wood.' 38½ins. x 47ins. Dated on the picture 1770. Signed. Sotheby's sale 10.12.1952 (73).
Two of the children of Willoughby Wood of Thoresby. The picture is said to have been exhibited at the FS perhaps 1775 (40) and the date of 1770 on the picture may not be accurate.

BERTRAND, Guillaume　　　**fl.1764-1800**
French portraitist, especially in crayons. Pupil of Carle van Loo, at same time as R. West of Dublin (q.v.), and later of N. Hallé. Exh. FS London 1764; then moved to Dublin where he opened a drawing school 1765. Exh. Dublin 1765-70, where his crayon portraits were admired. Returned to Paris 1770. Exh. at Paris Salon 1791 and 1800.

(Strickland.)

BERTRAND, Mary　　　**fl.1772-1776**
Painter of portraits and fancy pieces. Pupil 1772/3 of Mason Chamberlin (q.v.). Exh. RA 1772-76. It is likely that a Miss Bertrand who exh. miniatures at RA 1800 was another person.

BEST, J.　　　**fl.1750-1792**
Sporting and animal painter: horses, prize oxen, and gamecocks. Exh. SA 1772-80; RA 1782 and 1787.

BESTLAND, C.　　　**1763-c.1837**
Miniaturist (portraits and subject pieces), engraver and print seller, and occasional portraitist in oil. Cantlo Bestland born April 1763; entered RA Schools as a painter 1779. C. Bestland exh. mainly miniatures RA 1783-1837; BI 1806-36. The

miniaturist dictionaries call him 'Charles'. C. Bestland signed a portrait, in the style of O. Humphry (q.v.), sold 5.3.1937, 3; and a 50 by 40ins. of 'Dr. Eyre', 1792 (Hall of the Vicars Choral, Wells).

BETHAM See BEETHAM, Jane

BIEDERMANN, (J).C.　　　**fl.1799-1831**
Painter of rustic genre and occasional portraits. Probably of Swiss origin. Exh. RA 1794-1815 (at first miss-spelled Beidermann, from Tetbury, Glos.); BI 1807-1816 and 1831.

BIGG, William Redmore　　　**1755-1828**
Painter of rustic genre and occasional portraits. Born January 1755; died London 6 February 1828. Pupil of E. Penny (q.v.). Entered RA Schools 1778. Exh. RA 1780-1827 (very abundantly); FS 1782; BI 1806-28. ARA 1787; RA 1814. He specialised in pictures of cottage sentiment, in which the obviously virtuous poor are very prominent. Many of these were engraved. His

WILLIAM REDMORE BIGG. 'A girl at a cottage door shelling peas.' 30ins. x 25ins. s. & d. 1782. Plymouth, Museum and Art Gallery.
One of a pair of companion pictures (the other is 'A girl gathering filberts') which were both exh. RA 1782. They are very typical of Bigg's treatment of the deserving poor.

small-scale, full-length portraits and conversations are usually charming and more obviously 'sincere' than those of Wheatley. His 'ethos' is very much that of his first master, Edward Penny.

(Grant.)

BINDON, Francis *c.*1690-1765
Deplorable amateur Irish portrait painter; also architect. Younger son of an M.P. from County Clare; died *en voyage* in Ireland, 2 June 1765. Said to have studied at Kneller's Academy in London and in Italy. He was presented with the freedom of the Guild of St. Luke in Dublin 1733. Dean Swift writes (16 June 1735) correctly: "I have been fool enough to sit for my picture at full-length by Mr Bindon" (this, and others, survives). In 1758 he gave up painting.

(Strickland; Crookshank and Knight of Glin, 1979.)

BING See BYNG

BINGS fl.1782
Exh. 'Shipping' FS 1782.

BINNIE, Frederick fl.1771
Scottish (?amateur) painter. A quite competent head at Prestonfield of 'Sir William Dick' is signed on the back: 'Fred^k. Binnie Pxt. 1771 after a drawing of Mr Ramsay's.' The drawing must have been made in the late 1730s.

BITTIO, A. de fl.1772
Italian factotum painter for the Bishop of Derry (Frederick Hervey, later Earl of Bristol). Native of Belluno. Brought back from Italy, at first to Ireland, in 1772, to make topographical drawings. A signed portrait of 'Lady Hervey and daughter', *c.*1772/3 (NPG, formerly Rushbrooke) looks like a copy after Nathaniel Dance (q.v.).

BLACK, Alexander fl.1779
Hon. exh. of 'A view of Bordeaux', RA 1779. Probably unconnected with 'Mr Black Jr', an hon. exh. of 'A camp near Southampton', RA 1797.

BLACK, Mary 1737-1814
Portrait painter in oils and crayons and reasonably competent copyist of old masters and of contemporary portraits. Died London 24 November 1814, aged 77. Daughter of Thomas Black (q.v.);

MARY AND THOMAS BLACK. 'Dr. Messenger Monsey' (1693-1788). 50ins. x 40ins. Said to be documented as painted in 1764. Royal College of Physicians, London.
This surprisingly competent portrait is credited to a lady whose other recorded pictures are undistinguished. The sitter was an eccentric doctor. It may have been largely the work of her father.

assistant to Alan Ramsay in early 1760s. Her documented 'Dr Messenger Monsey', 1764 (Royal College of Physicians) is a very competent portrait in the manner of Dance (q.v.). She was a fashionable teacher of crayons to upper-class ladies. Exh. SA 1768 and was made an hon. member of SA *(Whitley, i, 238)*. Signed and dated portraits of the later 1790s are in the manner of Westall (q.v.) and do not look the work of the same artist.

THOMAS BLACK. 'Rehearsal of Gustavus Vasa *by Henry Brooke.' 24ins. x 29ins. s. & d. (on the back) 1738. Christie's 29.3.1963 (74).* The title is 'traditional' (i.e. an old note on the back) and it is said to represent Farinelli hissed off the stage. But Farinelli was already in Madrid by 1738.

BLACK, Thomas fl.1738-1777

Portrait and genre and drapery painter. Said to have been a member of the St. Martin's Lane Academy and to have died in 1777; father of Mary Black (q.v.). He apparently signed and dated, 1738, on the back, a 'Rehearsal of the play *Gustavus Vasa* by Henry Brooke' which was in the style of Angillis, sale 29.3.1963, 74. Exh. a whole length of a lady FS 1764.

BLACKBERD, C. fl.1784-1810

Portrait painter and engraver. Exh. RA 1784-86 and 1810 (a 'Self portrait'). He engraved portraits of a number of non-conformist divines.

BLACKBURN, Joseph fl.1752-1778

Portrait painter in a style akin to Highmore (q.v.); presumably of British training. First recorded in Bermuda 1752/3; active in New England (mainly Boston and Portsmouth, New Hampshire) up to 1763. In London 1764. Perhaps became an itinerant portraitist in England. Signed and dated portraits of British sitters range from 1764 to 1778. A 'Mr Blackburn' exh. three history pictures FS 1769.

(Collins Baker, Huntington Library Quarterly, IX (1945/6), 33 ff.)

BLAKEY, N. fl.1739-1748
'Blakey' is listed as 'an eminent painter' in the *Universal Magazine*, November 1748. He is presumably the N. Blakey who signed and dated 1739 a portrait of 'Field Marshal Keith' (coll. Earl of Kintore), who was then in the Russian service, which could be a copy and is in a French rococo style.

BLEECK See VAN BLEECK

BLOXHAM fl.1782
Exh. 'A landscape and cottage', FS 1782.

BOCKMAN, Gerhard 1686-1773
Portrait painter and mezzotint engraver. Died London 2 April 1773 ''the last surviving disciple of Sir Godfrey Kneller, and followed his business to the last year of his life'' (*London Magazine*). Nine of his Kneller copies survive in the royal collection. Some of his mezzotints are after his own work (*Chaloner-Smith*).

BODILO fl.1783
Exh. 'Landscape and cattle', FS 1783.

BOERENS, Mrs. M.M. fl.1790
Exh. 'Flowers, fruit, &c.', RA 1790 and claimed to be a member of the Royal Danish Academy.

BOGDANY, Jakob 1660-1724
Specialist painter of exotic birds and flowers. Born Eperjesen, Hungary, 1660; died London 11 February 1724. Of gentle birth and apparently self trained. He was in England by 1691, employed by William III by 1694; naturalised 11 April 1700. His fine series of exotic birds (Kew Palace) were painted *c*.1708/10 for Admiral George Churchill's aviary in the Little Park at Windsor; bought *c*.1710 by Queen Anne (*Millar, 1963*). A son, probably **William** FRS, 1729/30, is also said to have painted in the same style.

BOLTEBY See BOULTBEE, John

BOND, John Daniel 1725-1803
Painter of classical landscapes. Died Birmingham 18 December 1803, aged 78. He was the leading exponent of landscape at Birmingham. He exh. a drawing after Vernet at SA 1761; but oil landscapes FS 1762-80. His style goes back to Gaspard Poussin, perhaps via George Lambert.

(*Grant.*)

BOND, William fl.1772-1776
'William Bond Jr', a pupil of one of the Burgess family in 1772, exh. crayons of fancy subjects and views of Sussex, which could have been in oil, FS 1772-76.

JAKOB BOGDANY. 'A vase of exotic flowers.' 30¾ins. x 56ins. Signed. Christie's sale 12.12.1980 (71).
Bogdany's more usual subject matter is of exotic birds, but he was equally distinguished as a flower painter. This was probably painted for William, 6th Lord North.

BONNEMAISON, Ferèol 1770-1827

French *émigré* painter of portraits and fancy subjects. Native of Montpellier; died Paris 1827. He fled to London from the Revolution and exh. RA 1794-95. Returning to Paris he showed at the Salons from 1796 to 1816. Later chiefly active as a restorer and 'expert'.

BORCKHARDT, C. fl.1784-1810

Chiefly a miniaturist, but also painted portraits in oil and crayons. Exh. RA 1784-1810.

(Long.)

BORGNIS, Giuseppe Maria 1701-1761

Italian decorative and historical painter. Born Craveggia, nr. Domodossola, 1701; buried West Wycombe 12 October 1761. He worked in his native valley up to *c.*1751, when he was brought to England by Sir Francis Dashwood to work at West Wycombe Park. His ceilings there are pastiches from motives of the Carracci and Raphael's Farnesina frescoes. Two at least of his sons came to England, presumably with him. **Giovanni,** born 1728, who succeeded his father at West Wycombe and did ceilings in the church and house (payments 1761-63) modelled on Wood's Palmyra engravings. **Peter Maria,** born 1739-after1810, who entered RA Schools 1778 and probably was the Borgnis who exh. two portraits at FS 1783. He later ran a general decorator's shop in London and did some ornamental work for Zucchi and Soane.

(E.C-M.)

BORREKENS fl.1797

A 'Borrekens' exh. two mythologies at RA 1797. He was presumably J. P-F. Borrekens (Antwerp 1747-1827) who was latterly a landscape painter.

BOSWORTH, Richard 1771-1793

Entered RA Schools 1790, aged 19. Exh. portraits RA 1791 and 1793.

SIR (PETER) FRANCIS BOURGEOIS. 'Peasant with a cart and cattle.' Wood. 12½ins. x 16ins. One of a pair, one of which is signed and dated 1784. Christie's sale 26.3.1976 (50/2).

A copy of this has been mistakenly published as a very early Gainsborough. Its style owes something to both Gainsborough and de Loutherbourg.

BOULTBEE, John **1753-1812**
Sporting painter. Baptised Osgathorpe, Leicestershire, 4 June 1753; died Liverpool 30 November 1812. Entered RA Schools 1775 and exh. landscapes at FS 1775; SA 1776; RA 1776. He must have studied the work of Sawrey Gilpin, and also perhaps Stubbs (qq.v.), and he exh. horse pictures RA 1783 from Derby, and 1787-88 from Loughborough. Signed and dated horse pictures range from 1784 to 1805. He lived later at Chester and finally at Liverpool, where he exh. eight sporting pictures in 1812 shortly before his death. Some pictures of 1797 of cattle and sheep at Petworth, signed 'J. Bolteby' are probably his. He has a certain feeling for atmosphere and hazy landscapes.

(W. Shaw Sparrow, Connoisseur, XCI (March 1933), 148-159.)

BOULTBEE, Thomas **1753-1808**
Landscape and portrait painter. Baptised Osgathorpe, Leicestershire, 4 June 1753; died Great Chatwell, Shropshire, 1808. Twin with John Boultbee (q.v.) with whom he entered RA Schools 1775. Exh. portraits and landscapes FS 1775; SA 1776; RA 1776-77 (the entry under 1783 was probably a mistake for his brother). He is said to have given up the professional exercise of painting and his works are not known.

BOURGEOIS, Sir (Peter) Francis **1756-1811**
Landscape and history painter. Born London 1756; died there 8 January 1811. His father was a rich, Swiss *émigré* watchmaker. He became a pupil of de Loutherbourg (q.v.) *c.*1774-76, and imitated the various kinds of subject matter exploited by de Loutherbourg, but his pictures are all inferior examples of his teacher's. He travelled in Europe in 1776 and had some success on his return to London, being much puffed by the dealer, Noel Desenfans, who made him his heir. Exh. RA 1779-1810. ARA 1787; RA 1793 for reasons which are obscure *(but see Whitley, ii, 142)*. He was appointed, through Desenfans, painter to the King of Poland, who knighted him, and George III allowed him (16 April 1791) to use the title in England. He established the Dulwich College Gallery with the pictures bequeathed to him by Desenfans, in which his own pictures are more than generously represented.

BOURGUIGNON, H.F. See GRAVELOT, H.

BOUVIER **fl.1774**
Exh. a portrait of a lady, SA 1774.

OLDFIELD BOWLES. 'Self portrait.' 28ins. x 20ins. Probably from the 1770s. National Trust, Clevedon Court.
One of the ablest of the amateur painters. This portrait descended in the family of his second wife, the Eltons of Clevedon Court. On the easel is one of his imitations of Richard Wilson.

BOWLES, Oldfield **1740-1810**
Skilful amateur landscape painter and occasional portraitist. Matriculated Queen's College, Oxford 1758, aged 18; died in Hampshire 18 October 1810. He was the squire of North Aston, Oxon. He had a special devotion to the style of Richard Wilson (q.v.) and took lessons from Wilson's pupil, Thomas Jones (q.v.) from 1772-74 *(Walpole Soc., XXXII (1951), 27-33)*. Exh. (always as hon. exh.) SA 1772-77; FS 1783; RA 1781 and 1795. He signs his imitations of Wilson with a monogram 'OB'. Small-scale, full-length portraits of himself and his second wife, in the manner of Zoffany (q.v.), in which he is shown as a painter, with a Wilson-like landscape on his easel, are at Clevedon Court, National Trust.

(Constable, Richard Wilson, 145.)

CARL FREDRIK VON BREDA. 'Lady Jane James.' Wood. 50ins. x 40ins. s. & d. 1794. Sotheby's sale 12.12.1945 (55).
In his portraits painted in England von Breda adopts a decidedly English style, similar to the contemporary portraits of Beechey.

BOY, Godfrey **1701-after1748**
German court painter. Born at Frankfurt a/M. A youthful 'Self portrait', engraved in mezzotint by himself (*Chaloner-Smith, i, 81*) is said to have been done in London. He is reputed to have been painter to the English Court at Hanover. Signed portraits of 'George II', 1747, and 'Adolph von Steinburg' (Hanoverian Minister in London), 1748, sold S, 21.6.1967, 35/6, were in a very Germanic style.

BOYDELL, Josiah **1752-1817**
Portrait and history painter, and publisher. Born nr. Hawarden, Flint, 18 January 1752; died Halliford 27 March 1817. Nephew, and eventually partner and successor to Alderman John Boydell (1719-1804), who revived the engraving industry in Britain and promoted the Shakespeare Gallery (1786 ff.). Entered RA Schools 1769. Exh. SA 1776 (a portrait and a fancy picture); SA 1772-79 portraits (several of them small scale whole lengths) and history pictures, and historical drawings in chalk. He also painted seven subjects for the Shakespeare Gallery, but latterly devoted his time to publishing and activity in the City, where he too became an Alderman.

(DNB.)

BRADBURY, William **fl.1721**
An account exists for painting a picture of 'Time and Death' for Barton Church (?Barton Blount), Derbyshire, in 1721 (*Chandos-Pole MSS, 06,8*).

BRADSHAW, Capt. George **fl.1791**
Hon. exh. of 'Landscape, Evening', RA 1791.

BREDA, Carl Fredrik von **1759-1818**
Swedish portrait painter. Born Stockholm 16 August 1759; died there 1 December 1818. Trained as portrait and history painter at Stockholm under Lorenz Pasch, where he won prizes in 1780. He had painted members of the Swedish royal family before coming to London in 1787. Exh. RA 1788-96, when he returned to Stockholm and became court painter, professor at the Academy and the leading portraitist in Sweden. In England he was much influenced by Reynolds (q.v.). His most interesting English portraits were those of the Lunar Society, done in Birmingham 1792/3, e.g. 'James Watt' (NPG), and 'William Withering' (Stockholm).

(Emil Hultmark, C.F. von B., Stockholm, 1915.)

BREREWOOD, Francis *c.*1694-1781
Amateur painter and architect; kinsman of the family of Calvert, Lords Baltimore, for whom he acted as an artistic factotum in England. He signed, probably in the mid-1720s, a small-scale seated full length in an architecturally fanciful interior, in the manner of Troost, of 'Hon. Benedict Calvert' (Baltimore Museum).

(Mrs. Russel Hastings, Antiques, Jan. 1934, 15-17.)

BREWER, Robert **1775-1857**
Landscape painter in watercolours and occasionally in oils. Born Madeley, Shropshire, 1775; died Birmingham 1857. Exh. a 'View on Finchley Common', RA 1796.

(Mallalieu.)

BREWERS, R. **fl.1797**
Exh. 'Effect of an approaching storm', RA 1797.

BRIDGES, Charles **fl.1724-1740**
Portrait painter in London; said by Thomas Hearne (*Collections, XI (1921), 214*) to be brother to John Bridges, FSA (d.1724). He took a likeness by stealth of Rev. Thomas Baker, 1733, which was engraved by Simon (one example in Bodleian). He went to Virginia 1735 with an introduction from his brother to Governor Gooch, later Bishop Thomas Gooch; and painted a number of portraits. Returned to England 1740.

BRIDGMAN **fl.1774**
Exh. SA 1774 a naval picture with an incident when George III was on board the yacht *Augusta*.

BRODIE, James **fl.1731-1736**
Scottish amateur but professionally trained portrait painter, only known for signed and dated portraits of his own family: 'Alexander Brodie', 1731 (Dunvegan Castle), 'Lord Lyon', and 'James Brodie', 1736 (Brodie Castle). His style suggests training in France under one of the Van Loos.

BROME, Charles **1774-1801**
Mainly an engraver, but also exh. some portraits in oil. Entered RA Schools 1790. Drowned in the Serpentine 23 April 1801. Exh. at RA 1798-1801 a few portraits and a landscape.

RICHARD BROMPTON. 'George IV as Prince of Wales.' 78ins. x 57ins. Painted 1771. Exh. RA 1772 (26). Christie's sale 20.6.1947 (9).
One of a pair of companion portraits of royal children painted for their governess, Lady Charlotte Finch. They were later bought by H.M. The Queen Mother and given to the royal collection.

BROMPTON, Richard c.1734-1783

Portrait painter. Said to have been born c.1734; died at St. Petersburg 1783 (*Archives de l'Art français, XVII (1932), 153*). Pupil of Benjamin Wilson (q.v.); went to Rome 1757 and was studying with Mengs 1758. He remained in Italy until 1765, when he returned to London with Dance (q.v.) (*Walpole Soc., XXXVI (1960), 74/5n.*), having painted at Padua 1764 a conversation piece of 'The Duke of York and his friends,' of which he made several repetitions, which have sometimes passed as by Zoffany (q.v.). (*Millar, 1969, 13*). Exh. SA 1767-77, and 1780 (when he was elected President); FS 1767-68; RA 1772 the two portraits of the 'Prince of Wales' and the 'Duke of York' (Buckingham Palace). At first he had a good practice in London, painting 'Lord Chatham', 1772 (Chevening, several repetitions); and an enormous group of 'Henry Dawkins and family', 1773 (Over Norton Hall). In 1773/4 he restored (rather badly) the great Van Dyck group at Wilton.

RICHARD BROMPTON. 'William Pitt, Earl of Chatham.' 33ins. x 59½ins. Sotheby's sale 12.7.1967 (103).
An enlarged variant of Brompton's often repeated portrait of Chatham of 1772, of which the prime example is at Chevening.

But he was tiresome and quarrelsome *(Whitley, ii, 255 ff.)* and was imprisoned for debt 1780. Rescued from this by the Empress Catherine of Russia, he went to St. Petersburg as a court portrait painter and was doing quite well there when he died. He was a reasonably competent portrait painter, when an unflattering likeness was required; and his rather smooth execution enabled him to make small replicas of his larger portraits on copper.

BROOK, Joseph fl.1690-*c.*1725
Portrait painter and copyist at Bury St. Edmunds *(S.H.A. H(ervey), The Diary of John Henry, first Earl of Bristol, Wells, 1894, 159ff).* He did portraits of the children, copied a Dahl (q.v.) &c. As Fayram (q.v.) succeeded him in 1728 at this sort of work, he probably died 1725/8.

BROOKE, Henry 1738-1806
Irish painter of religious and historical subjects. Born and died in Dublin. Said to have come to London 1761 and to have had some success with an exhibition of his work; back in Dublin by 1767. He practised as a drawing master from 1770 and exhibited religious and historical subjects at Dublin Society of Arts 1770-80. Presumably the 'Henry Brooke Junior' (his uncle Henry had a reputation as an author) who exh. 'Panthea mourning over Abrodotes' *(sic)*, SA, 1776.

(Strickland.)

BROOKE, Robert fl.1748
Irish portrait painter; father of Henry Brooke (q.v.). Lived at Rantavan, co. Cavan. A portrait of the 'Duke of Cumberland on horseback', 1748, is recorded.

(Strickland.)

BROOKE, W. See BROOKS, William

BROOKES See BROOKS, William

BROOKING, Charles 1723-1759
Painter of marine subjects. Buried London 25 March 1759 'before his 36'th birthday'. Probably brought up at Deptford and intimately familiar with the sea and shipping. Partly trained by copying Dutch sea pieces, and the most accomplished and promising British marine painter of his age. His largest and most ambitious work was painted for the Foundling Hospital in 1754. He gave some instruction to Dominic Serres (q.v.) at the end of his life.

(Brooking exh. cat., Aldeburgh Festival/Bristol, 1966; Archibald.)

CHARLES BROOKING. 'Shipping in a breeze.' 19¼ ins. x 29¼ ins. Signed. Sotheby's sale 6.3.1946 (143).
Brooking's promising career was cut short just as he was beginning to be known. His work is equally competent whether he is dealing with rough seas or calm.

BROOKS, Thomas 1749-after 1791
Landscape painter. Born 1749; entered RA Schools 1777. He seems to have been the 'W. Brooke' who exh. 'a small landscape', RA 1779, and 'a view of Hampstead Heath' as T. Brooks (from the same address), RA 1791. Perhaps related to William Brooks (q.v.).

BROOKS, William fl.1780-1801
Landscape painter. Exh. RA 1780-89 and 1797-1801 (in 1783 wrongly entered as W. Brooke; FS 1782-83 as Brookes). Latterly he lived and painted at Hampstead. He also painted views of country houses. Quite a competent painter.

(Constable, R. Wilson, 145; Grant — too rosy an account.)

BROOME fl.*c.*1740
Irish portrait painter. Known only from four signed portraits at Adare of *c.*1740.

(Crookshank and Knight of Glin, 41.)

BROWN fl.1741-1744
Amateur portrait painter of some quality. Agent to the 1st Earl of Ilchester at Redlynch Park. Small full lengths of 'Lady Ilchester', 1741 and 'Lord Ilchester with his son out shooting', 1744 (now at Melbury) suggest knowledge of the portraits of E. Seeman (q.v.).

MATHER BROWN. 'Alexander, Lord Loughborough.' 50ins. x 40ins. Painted soon after his appointment as Lord Chancellor in 1793. Scottish National Portrait Gallery, Edinburgh.
Engraved in mezzotint by Henry Hudson 1793. The sitter (1733-1805) was created Earl of Rosslyn in 1801.

BROWN, Mrs. Ann fl.1698-1720
Portrait painter and professional copyist. Signed and dated 1698 a female portrait sold at Hampton Court, Hereford, 1925, 540. She figures as a copyist in the 1st Earl of Bristol's accounts 1710-20, *(S.H.A. H(ervey), The Diary of John Hervey, first Earl of Bristol, Wells, 1894, 161/2)*. Perhaps the same as Mrs. Ann Howard who was paid for the same sort of work 1720.

BROWN, David fl.1792-1797
Painter of landscape and rustic genre. Infatuated imitator, copyist, patron and exploiter of George Morland (q.v.). Exh. RA 1792-97.

(Grant.)

BROWN, Miss E. fl.1797-1803
A specialist in the painting of specific flowers. Exh. RA 1797-1803.

BROWN, George fl.1769-1780
Landscape painter. Entered RA Schools 1769. Exh. RA 1773-80, watercolours for the last two years.

BROWN, Mather 1761-1831
Portrait and history painter of American origin and very uneven quality. Born Boston 7 October 1761; died Twickenham 25 May 1831. He had some instruction from Gilbert Stuart before 1775 and practised in Massachusetts before settling in England in 1781, where he became a pupil of Benjamin West (q.v.) and entered RA Schools 1782. He at first had a fair practice with sitters with American connections. In his best period,

MATHER BROWN. 'King George III.' 98ins. x 72ins. s. & d. 1790. Sotheby's sale 22.11.1961 (89).
It is unlikely that the King ever actually sat to Mather Brown. This picture hung in the Roxy Theater in New York from 1929 to 1955.

*c.*1785-95, he achieved a powerful likeness with strong shadows, for example his 'Earl of Rosslyn', engr. 1793 (SNPG). Such portraits were based on careful drawings (*Burlington Mag., CXIV (Aug. 1972), 534-541*). At this time he acquired the honorific titles of Portrait Painter to the Duke of York (1789) and to the Duke of Clarence (1791), and he also painted 'George III' (long in Roxy Theater, New York). Of his numerous large histories the least deplorable is 'The sons of Tipoo delivered as hostages to Lord Cornwallis', 1793 (Oriental Club, London). After 1800 his success and his quality alike declined. For a time in the early 1820s he worked at Manchester, but he lived mainly in London, turning out masses of inferior paintings.

(*Dorinda Evans, Ph.D thesis for Courtauld Institute, Washington, forthcoming.*)

BROWN of Monmouth
Reputed painter of an extremely provincial head inscribed 'The Man of Ross', sold 26.2.1960, 148.

BROWN, N. fl.1736
A portrait of 'John Buckler' of Warminster (private coll.) is signed: 'N. Brown/1736' in what is clearly a local provincial style.

BROWN, Nathaniel fl.1765-1771
Exh. FS 1765-71, mainly portraits, but also still-life and occasional oddities. He may be the 'N. Brown' who signed and dated a portrait of 'Admiral Thomas Shirley', 1760, sold 2.12.1949, 149, in a style which suggests a knowledge of Reynolds (q.v.).

BROWN, Peter fl.?1760-1791
Possibly the P. Brown who signed and dated 1760 a portrait of 'Mary Arundell' with a parakeet, sold S, 8.2.1950, 99. He exh. flower pieces, some in watercolours, SA 1766-68; animal pictures at FS 1767; mixed subjects at RA 1770-91, but after 1783 flower pieces. From 1785 he was Botanical Painter to the Prince of Wales.

BROWN, Robert ?1672-1753
History painter. Possibly baptised Ottery St. Mary 1672; died London 26 December 1753. Studied under Laguerre (q.v.) and was assistant to Thornhill (q.v.) at St. Paul's. He did some decorative work for London churches and was the teacher of Hayman (q.v.)

(*Walpole; E.C-M., i, 263-264.*)

BROWN, Robert fl.1792-1834
Landscape painter of very modest powers. Exh. RA 1792-1821; BI 1808-34.

(*Grant.*)

BROWNE, Joseph fl.1767-1783
East Anglian painter of decorative landscapes. An undated engraving after his portrait by T. Kerrich, calls him 'Josephus Browne, Norwicensis, Ruralium Prospectuum Pictor' and he has been confused in the British Museum catalogue with the engraver John Browne (who was educated at Norwich); in the Norwich 1783 Directory he is also (wrongly) called John (*Fawcett*). An overmantel at Shrubland Park, signed 'J. Browne 1767' is in a style owing something to Claude, Gaspard Poussin, and the Dutch. It suggests a professional painter of conventional overmantels. Possibly the 'Browne' listed as 'an eminent painter' in *Universal Magazine*, November 1748.

BRUNIAS, Agostino fl.1752-1779
Italian decorative history painter; also painted West Indian genre; his name is often misspelled. Studied painting and called 'Romano' when he won a prize at the Academy of S. Luke, Rome, 1752. Robert Adam and Clérisseau converted him into an architectural draughtsman and took him to Spalato, 1756. Came to London with Robert Adam 1758 and remained in his employment for some years. Exh. landscapes with ruins and figures FS 1763-64. In the West Indies (Dominica) by 1770, whence he sent drawings to SA 1770. He took to painting local West Indian genre and showed pictures of this character on his return to England, RA 1777-79 (*H. Huth, Connoisseur, CLI (Dec. 1962) 263-269*). Several of these are at BAC Yale.

(*E.C-M.*)

BRUNTON, James *c.*1751-1772
Painter from Norwich, where he died of consumption, 1772. Son of a clockmaker but spurred to become a painter by reading Reynolds' first *Discourse*. Entered RA Schools and was a pupil of Cipriani 1770.

(*Fawcett, 1978.*)

BRUYN, Theodore de **1730-1804**

Decorative historical painter; later painted landscape views. Born Amsterdam 1730; died London early 1804. Studied at Antwerp under Nicolaes van den Bergh, where he became a master 1759 and remained until 1765 *(Rombouts and Van Lerius, ii, 799)*. Brought to England to do decorative work for the Duke of Norfolk at Worksop *c.*1768. Entered RA Schools 1773, aged 43. Exh. FS 1769-71; SA 1772, mainly chiaroscuro compositions. His chief surviving works of this kind are in the chapel at Greenwich, *c.*1779, and at Farnley Hall, 1789 *(E.C-M.)*. He later exh. landscapes at RA 1773-1803, mainly neat views of specific sites in clear, fresh green tones, and pictures of country houses in their parks. Two sons were entered as painters in RA Schools: **John** 1782, aged 18, and **Henry** 1792, aged 20

BRYAN, John fl.1790-1791

Hon. exh. of two pictures of shipping, SA 1790/1.

BUCK, Samuel **1696-1779**

Extremely prolific engraver and topographical draughtsman. Died London 17 August, 1779, aged 83. Exh. FS 1761 and 1774/5 (including flower pieces); SA 1768, and RA 1775 (drawings and watercolours). A single oil painting, a 'View of Ripon', 1740 (formerly Agnew), with figures like Hayman *(Grant)* has considerable charm.

BUDD, George fl.1745-1752

A painter of humble origins, and perhaps 'democratic' tendencies, who painted every sort of picture and taught drawing. Now only known from engravings after his 'Execution of Lords Kilmarnock and Balmerino', 1746, and McArdell's mezzotint of his portrait of 'Timothy Bennett', 1752.

(Edwards.)

THEODORE DE BRUYN. 'Painshill, the seat of B. Bond Hopkins.' 19ins. x 25½ins. s. & d. 1789. Exh. RA 1790 (108) and (115). Christie's sale 23.6.1950 (72/1).
One of a pair of views of Painshill, no doubt commissioned by the owner. Very precise and elegant records of a house and park.

SAMUEL BUCK. 'View of Ripon 1740.' 21½ins. x 48¾ins. Reported to be signed and dated. Formerly with Agnew's.
Buck is normally familiar as a not very distinguished topographical engraver. It may be that the very lively figures in this picture, which are reminiscent of Hayman, are by another hand.

BUNCK, James fl.1766-1775
Genre and ornamental painter. An artisan painter of small genre and landscape pieces, who specialised in candlelight effects after Schalcken and Honthorst. He was much employed in painting figures on clock faces. Exh. FS 1766-75; RA 1773-74.

(Edwards.)

BUNN, James fl.1773-1783
Scene painter and painter of all work at Norwich.

(Fawcett.)

BURBECK, Elizabeth fl.1742
She signed 'Eliza Burbeck pinxt/A.C.1742' a picture, in the manner of Richardson (q.v.), of a man in a feigned oval, looking like a copy of a mezzotint, absurdly called 'The Family Doctor', in Earl of Feversham sale, 26.5.1967, 82.

BURDEN, John 1773-1814
Landscape painter, especially of scenes in Wales and the west country. Entered RA Schools 1793, aged 20. Exh. RA between 1796 and 1814. His address in 1807 was Litchfield.

BURGESS, F.L. fl.1778
Exh. 'Landscape with cattle, with a return from shooting', RA 1778.

THOMAS BURGESS. 'Lewyns Boldero Barnard of South Cave' (1708-83). 49ins. x 39ins. s. & d. 1779. Christie's sale 25.11.1938 (82).
Conceivably a copy of an earlier portrait as the costume is nearer to that of 1760.

BURGESS, Thomas *c.?1730-1791*

Portrait and history painter. He studied at the St. Martin's Lane Academy. Exh. FS 1770-73, mainly portraits in oil and chalks and some conversations; SA, 1774-75; RA 1778-91, mainly historical compositions. His engraved 'Isaac Polak', FS 1770, has decided character. He was father of William Burgess (q.v.) and probably of another **Thomas Burgess**, who exh. landscapes at RA 1802-6 (*Mallalieu*), and died 23 November 1807, aged 23.

BURGESS, William **1749-1812**

Portraitist in crayons and occasional landscape painter, but most of his work is chalk drawings or tinted watercolours (*Mallalieu*). He died London 11 May 1812. He kept a drawing Academy in Maiden Lane. He gained a premium at the SA 1761 and exh. SA 1761-91; FS 1770-72; RA 1774-1811. He was the ancestor of a large tribe of Victorian painters.

BURKE

Exh. from a Bath address, a 'Portrait of a young artist', SA 1772.

BURKE, P. *fl.c.1735*

The earliest known Irish landscape painter (*Crookshank and Knight of Glin, 1978*).

BURLINGTON, Dorothy, **1699-1758**
Countess of

Amateur portrait painter with a pretty talent for caricature. She was Lady Dorothy Savile, daughter of the Marquess of Halifax and married Richard, 3rd Earl of Burlington March 1720/1. A head of 'Princess Amelia' of *c.*1730, in the style of C. Philips (q.v.), is signed 'D. Burlington/pinxt' (Hardwick Hall), and there are pastels of her two daughters at Chatsworth. Vertue (*iii, 115*) records seeing with approval very many of her crayons, many of them copied from older portraits.

BURNELL, Benjamin **1769-1828**

Painter of architectural views. Entered RA Schools 1791 as an architectural student, but this was changed to painting. Exh. RA 1790-1828; BI 1806-13.

BURNET, H. fl.1794

A very competent small scale (18 by 16 ins.) '?Self portrait' of a middle aged artist sitting before an easel, painting (or restoring) a landscape in the manner of Cuyp, sold 27.5.1936, 116, was signed 'H. Burnet' and dated 1794.

BURNET, James M. fl.1783

Exh. 'Lions', FS 1783.

BURNEY, Edward Francesco **1760-1848**

Occasional portrait and history painter, and a very accomplished caricaturist and illustrator. Born Worcester 7 September 1760; died London 16 December 1848. Nephew of Charles Burney, the musicologist, and cousin of Fanny Burney, and stained drawings illustrating her *Evelina* were his first RA exhibits. Entered RA Schools 1777 and exh. RA 1780-1803, mainly light historical scenes or family portraits, but the 1802/3 contributions were on serious religious themes. He was too shy to paint portraits other than of family and friends — his best is the 'Fanny Burney', 1782 (NPG), but he executed very accomplished copies after portraits by Reynolds and Lawrence (qq.v.). His large watercolour scenes from contemporary life are of very high quality. After 1803 he worked mainly as an illustrator.

(*Mallalieu; Hammelmann for illustrations up to 1800.*)

BURNEY, James See MACBURNEY

BURTON, John fl.1769-1789

Landscape painter, especially of moonlights. He exh. SA 1769-77; RA 1778-84. He was an actor by profession and the *Morning Post* reported that, soon after Gainsborough's death (1788) he was commissioned to make many copies of his landscapes (*Whitley, Gainsborough, 316*). His daughter exh. fruit pieces and landscape drawings SA 1773-78; and a 'Master Burton' was an hon. exh. of a landscape in chalks, SA 1780.

BUTLER, James fl.1763

Exh. three architectural views at FS 1763, one certainly a drawing.

BUTLER, Thomas fl.c.1750-1759

Sporting painter with a rather wooden style which seems to derive from E. Seymour (q.v.). Before 1750 he is said to have been a bookseller and stationer in Pall Mall.

EDWARD FRANCESCO BURNEY. 'Fanny Burney (Madame D'Arblay).' 29½ ins. x 24½ ins. Painted 1782. National Portrait Gallery (2634).
Painter and sitter were first cousins. Fanny Burney's novel *Evelina* was a great deal more famous in its own day than it is today.

BUTTS, John *c.*1728-1765
Irish painter of landscapes and almost anything else. Born Cork *c.*1728; died Dublin May 1765. His art first inspired J. Barry (q.v.) to an interest in painting. Butts settled in Dublin 1757 as a scene painter and worked as a copyist and forger for a dealer. His own style seems to have been for vaguely classical landscapes.

(Crookshank and Knight of Glin, 1979.)

BYFIELD, J. fl.1793-1800
Occasionally exh. landscape views at RA between 1793 and 1800.

BYNG, Edward *c.*1676-1753
Portrait and drapery painter. Born, possibly at Potterne, Wilts., *c.*1676 *(J.D. Stewart, Kneller);* died there 12 February 1753. He was assistant and drapery painter to Kneller (q.v.) from *c.*1693, and was chief assistant at the time of Kneller's death (1723) and charged in Kneller's will to complete unfinished portraits. He seems to have inherited the drawings which were left in Kneller's studio, most of which are now in the British Museum.

(Croft-Murray and Hulton, 204-268.)

BYNG, Robert fl.1697-1720
Painter of portraits and occasional sporting conversations. Died August 1720. Probably an elder brother to Edward Byng (q.v.) and a pupil, and certainly a close follower, of Kneller (q.v.). Portraits signed by him range from 1697 to 1719. His hand is perhaps to be found among the drawings catalogued under Edward in the British Museum.

(Croft-Murray and Hulton.)

BYRES, James 1734-1817
Antiquarian and art dealer in Rome, for most of his life. Born and died Tonley, Aberdeenshire. He was 'out', with his father, in 1745 and educated in France. Studied painting under Mengs at Rome from 1757 to 1761, and assisted him on the nave ceiling of S. Eusebio, but soon afterwards became a student of architecture and one of the main *ciceroni* of ancient Rome. He left Rome finally in 1790.

(Ford, Byres.)

BYRON, Frederick George 1764-1792
Nephew of the 5th Lord Byron. Died Bristol February 1792. He was an amateur painter, in thick gouache or crayons, of flashy society genre, with officers and horses. Hon. exh. SA 1791. A signed gouache of 1786 was sold 19.6.1953, 22.

BYRON, William, 4th Lord 1669-1736
Amateur portrait painter and skilled etcher. Born 4 January 1669; died Newstead 8 August 1736. He was a pupil of Tillemans (q.v.) and his portrait of the '1st Earl of De La Warr', of before 1723, was engraved in line.

C

CADDICK family

A family of Liverpool portrait painters, whose works have not been wholly disentangled. It was composed of: **William Sr.,** probably born Liverpool 9 April 1719; died there 29 December 1794. He visited London 1746 and developed a style in the manner of Hudson. Worked at Chester 1747 but later became the leading portrait painter in Liverpool. **Richard,** eldest son of William Sr. Born Liverpool 7 June 1748; died there May 1831. Member of Liverpool Society of Arts 1769; he probably carried on his father's practice but his conversation piece of his own family (Liverpool) shows considerable updating of style. He appears to have retired from the profession *c.*1805. **William Jr.,** younger son of William Sr., and brother of Richard. Born Liverpool 16 June 1756; died there 12 March 1784. Exh. at RA 1780 a 'portrait in the character of Circe'.

(Walker Art Gallery, Merseyside cat.)

CALLANDER, Adam　　　　　　**fl.1780-1811**

Scottish landscape artist, apparently in oils as well as watercolour. Exh. RA 1780-1811; BI 1806-11. His exhibits vary from general scenes of 'Morning' or 'Sunset', to views of specific sites in Scotland, Wales or distant places, such as Tenerife.

CALLARD, Thomas　　　　　　**fl.1768-1774**

Landscape painter. Died in 1774. Pupil of his brother-in-law, William Tomkins (q.v.) in 1768. Exh. SA 1768-69; RA 1770-71; FS 1770 and 1774 (as 'the late'). He may have visited Germany in 1771.

(Edwards, 169.)

CALZA, CALZE See CUNNINGHAM, E.F.

CAMBRUZZI, de　　　　　　**fl.1775-1777**

Exh. portraits in crayons at RA 1775-77.

CAMERON　　　　　　**fl.*c.*1770**

A rustic Scottish painter of portraits. A portrait of a peasant with a mug of ale, lettered 'Will: Howison. By Cameron', more or less life-size and with a certain rude power, is at Gosford and is listed in the 1771 catalogue.

CAMPBELL, Peter　　　　　　**fl.1776**

Exh. 'a small landscape', SA 1776.

CANALETTO　　　　　　**1697-1768**

Giovanni Antonio Canale, known as 'Canaletto', the greatest Venetian view painter of his age. Born Venice 28 October 1697; died there 20 April 1768. He early acquired a reputation for painting Venetian views, especially for visiting British travellers, and was already in 1730 somehow associated with Joseph Smith (later British Consul at Venice) whose huge collection of Canalettos is now at Windsor Castle (*cf. K.T. Parker, Drawings of A.C. . . . at Windsor Castle, 1948*). With the drying up of British visitors to Venice, owing to the war of the Austrian succession, Canaletto came to England in May 1746, and remained there (with returns to Venice for some months in 1750/1 and 1753/4) until 1755, where he exercised his view-painting gifts partly on the Thames and partly on the houses of such patrons as the Dukes of Beaufort and Northumberland and the Earl of Warwick. His first two English views, painted for the Duke of Richmond 1746 (Goodwood) are as brilliant as anything he had painted at Venice, but the English climate to some extent muted his gifts. On returning to Venice he resumed his production of Venetian views. His work was much imitated in England and he had considerable influence on Samuel Scott (q.v.).

(Full account of Canaletto in England by Hilda Finberg, Walpole Soc., IX (1920), 21-76; W.G. Constable, C., 2 vols., 1962.)

CANTER, James　　　　　　**fl.1771-1783**

Painter of chimney pieces, buildings and ruins in the vein of Pannini. Exh. SA 1771; RA 1773-74; FS 1774-83. He visited Spain and painted views of Madrid and the Escorial; also painted views of the seats of Roman Catholic peers: Duke of Norfolk, Lord Arundel of Wardour.

(E.C-M.)

CAPPE, Joseph　　　　　　**1760-1779**

Entered RA Schools 1779 as a painter, aged 19.

ANTONIO CANALETTO. 'Old Walton Bridge over the Thames.' 19¼ ins. x 30¼ ins. Formerly inscribed by the artist and dated 1754 on the back. By permission of the Governors of the Dulwich College Picture Gallery.
This was a special commission and not one of Canaletto's standard views. The two figures in the centre foreground are Thomas Hollis (who commissioned the picture), and his friend Thomas Brand, to whom he bequeathed it.

CARDINALL, Robert fl.*c.*1730
Suffolk painter. Painted *c.*1730 figures of Moses and Aaron for the reredos of St. Peter's, Sudbury (*C.F.D. Sperling, History of the Borough of Sudbury, 1896, 131*). He was a pupil of Kneller (q.v.) and a portrait of 'Robert Gainsborough' of Sudbury in the Duleep Singh Gallery at Thetford is inscribed on the back as being by him.

CAREE (CARREE) fl.1783
Exh. 'cattle', FS 1783.

CAREW fl.1783
Exh. 'a scene in Vauxhall', FS 1783.

CAREY, Peter 1776-1795
Landscape painter. Entered RA Schools 1792, aged 16, having been a pupil of Farington in 1791. Exh. RA 1795 views of 'Rochester Bridge' and 'Maidstone Bridge and Church' which were probably in oils.

JAMES CANTER. 'A piece of ruins.' 51ins. x 39ins. Signed. Sotheby's sale 6.5.1964 (55).
Very probably exh. RA 1774 (28), but Canter exhibited also at FS 1776 two other variations on the 'piece of ruins' theme.

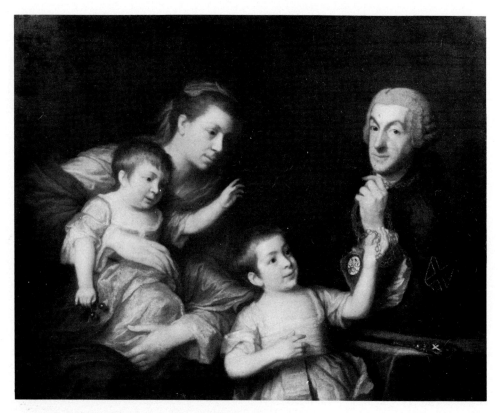

ADRIAEN CARPENTIERS.
'The Quarme family.' 39½ ins. x
50ins. s. & d. 1767. Christie's sale
12.7.1940 (805).
Robert Quarme (d.1787) was
Usher of the Green Rod to the
Order of the Thistle, and is
displaying the insignia of that
office.

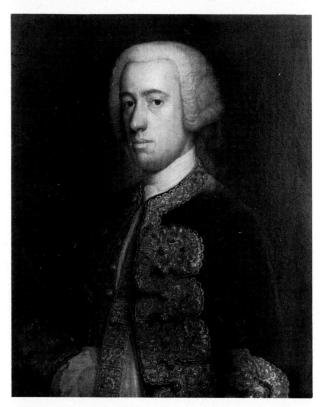

ADRIAEN CARPENTIERS. 'A member of the Twisden family of
Bradbourne.' 30ins. x 25ins. Apparently signed and dated 1739 on the
back. Formerly at Bradbourne.
Carpentiers was a competent itinerant portrait painter, whose
earlier style suggests a connection with Highmore.

CARMICHAEL, Elizabeth fl.1768-1789
Portrait painter in oils and crayons. Exh. FS 1768;
SA 1769-71; RA 1777-89.

CARMICHAEL, James fl.1767-1774
Exh. miniatures at SA 1767 and portraits, which
are not described as miniatures, SA 1774.

CARPENTIERS, Adriaen fl.1739-1778
Portrait painter, said to be of Flemish origin (and
not son of the sculptor, Andries Carpentière).
Working in England from at least 1739; died
London 1778. He perhaps began as a peripatetic
portrait painter in a style related to that of
Highmore (q.v.). In Kent 1739 (two portraits at
Bradbourne), Bath 1743, Oxford 1745 (two por-
traits in Town Hall), East Anglia from 1751 and at
Norwich in 1757. He probably settled in London
c.1760. Exh. SA 1760-67 (in 1767 as
'Charpentier'); FS 1762-66; RA 1770-74. He was
friendly with foreign artists working in London and
did portraits of Zuccarelli (q.v.) and Roubiliac, SA
1761 (versions at BAC Yale and 1762 NPG.). His
style has individuality, but is not very pronounced.

GEORGE CARTER. 'The Apotheosis of Garrick, with portraits of the principal actors.' 59½ ins. x 77½ ins. Exh. RA 1784 (336). By permission of the Governors of the Royal Shakespeare Theatre, Stratford on Avon.

This picture, which Horace Walpole considered 'ridiculous', was engraved, with a key to the portraits, by Smith and Caldwell, 1783. Seventeen fellow actors, in Shakespearian roles, make their farewells to Garrick, who is borne to Parnassus, where Shakespeare and the Muses of Tragedy and Comedy wait to welcome him. (*The Georgian Playhouse* exh. 1975, 46.)

CARR (KERR), Johnson 1743-1765

Apprentice to, and competent imitator of, Richard Wilson (q.v.). Died 16 January 1765, aged 22. He won several prizes for drawings 1759-63, and was an apprentice in Wilson's studio *c.*1758-63 and assisted in painting some of his pictures.

(Edwards; Constable, Richard Wilson, 137.)

CARR, W. fl.1792

Signed and dated 1792 a small (and bad) family group sold S, 7.4.1954, 78. He was not the Rev. William Holwell Carr (1758-1830), an amateur landscape painter, who did not take the name of Carr till 1798.

CARTER, George 1737-1794

Painter of literary genre and histories. Baptised Colchester 10 April 1737; buried Hendon 19 September 1794 *(DNB).* Began life as an unsuccessful shop assistant. First taught himself painting and entered RA Schools 1770. Exh. SA 1772-74 scenes of rustic genre and illustrations to *The Sentimental Journey* (one engr. by Valentine Green 1774). Set out with Copley (q.v.) in August 1774 for Rome via Paris. His 'Wounded Hussar', RA 1775, sent from Rome, also engr. by Valentine Green. Exh. RA 1775-79 (in 1778 an altarpiece for St. James's, Colchester) and then not until 1784, when he showed 'The Apotheosis of Garrick' (Stratford on Avon). His visits to Gibraltar and St. Petersburg presumably took place between 1779 and 1783. In 1785 he held a pretentious private exhibition of thirty-five 'history' pictures in London *(Edwards, 235-238),* which included the 'Siege of Gibraltar', 1784 (NPG), 'The Death of Captain Cook', 1781 and a Morlandish 'Children's Games (from Shenstone)', 1785 (both ex Lord Crawford). These are curiously clumsy but show some attempted rivalry with Copley; and Carter had some success with engravings after these and genre pictures by J. Jones, J.R. Smith (qq.v.), &c. He was in Calcutta 1786 to 1788 and continued to paint scenes from Indian history after his return to London *(Archer, 273 ff.)* and retirement to Hendon. His post-mortem sale took place 29/30.4.1795, Lugt. 5325. He was always a feeble executant.

GEORGE CARTER. *'Death of Captain Cook.' 58ins. x 82ins. s. & d. 1781. Christie's sale 11.10.1946 (44).*
One of a group of large pictures from recent history which Carter painted as a speculation and exhibited in London in 1785 with a rather pompous catalogue.

CARTEAUX, Jean François 1751-1813
Exh. RA 1776 two portraits, one highly allegorical, claiming (perhaps falsely) to be a 'medallist, from the Royal Academy of Paris'. He was a pupil of Doyen.

(Brune, 47.)

CARTWRIGHT, John fl.1767-1808
A. J. Cartwright exh. fitfully at RA 1778-1808, portraits, landscapes, and histories. Perhaps also the 'Mr Cartwright' who exh. portraits at FS 1767. Redgrave says Fuseli lodged with him in 1779.

CARVER, Richard fl.1697-1754
Irish painter of landscapes in a superporte style and of historical subjects. A native of Waterford, he had some reputation in Dublin, where he died. He was father of Robert Carver (q.v.).

(Crookshank and Knight of Glin, 1979.)

CARVER, Robert c.1730-1791
Irish scene painter who also practised as a painter of ideal landscapes. Born in Dublin, son of Richard

ROBERT CARVER. 'An ideal landscape.' 16½ ins. x 21ins. Signed 'RC'. Christie's sale 2.4.1954 (72).
Half way between the styles of Gaspard Poussin and George Lambert.

ANDREA CASALI. 'Edward the Martyr, Prince Ethelred and Queen Elfreda.' 24¾ ins. x 20¼ ins. Christie's sale 15.2.1974 (80).
A sketch for a very large picture, now at Burton Constable, which was exh. FS 1761 and was one of a group of pictures painted for the elder Beckford at Fonthill House.

Carver (q.v.); died in London 1791. He was already painting scenery in Ireland in the 1750s. Sent landscapes to the Dublin Society of Arts 1765-68. Garrick liked his scene painting and persuaded him to come to London 1769, where he did scenery for Drury Lane, transferring to Covent Garden 1775. Exh. SA 1770-80, being elected president for 1777; RA 1789-90. He signs his pictures 'R.C.'; these are mostly variations on the style of Gaspard Poussin in the same spirit as Gaspardesque pictures by Lambert (q.v.).

(Crookshank and Knight of Glin, 1979; E.C-M.)

CARWARDINE fl.1771-1772
Exh. portraits at SA 1771 and 1772.

CASALI, Cavaliere Andrea c.1700-1784
Italian history and portrait painter. Born Civitavecchia c.1700; died Rome 7 September 1784. Pupil at Rome of Trevisani; his first public work there was 1735, but he had then already been made a Cavaliere by Frederick William of Prussia. Spent some months in Paris on his way to London where he remained from 1741 to 1766, except for a visit to Holland and Germany 1748/9. His sale before his return to Rome was 18.4.1766. He painted, c.1755, a set of full-length fancy ancestors' portraits for Holkham, and gave an 'Adoration of the Kings', 1748/50 to the chapel of the Foundling

Hospital. He won premiums for history pictures at the Society of Arts 1760-62 and 1766. Exh. SA 1760 and, from Rome, 1775-78; FS 1761-68 and from Rome 1769-83. He painted a number of decorative chiaroscuros and had a considerable vogue painting mythologies or historical subjects, notably for Alderman Beckford at Fonthill House, whence come some ceilings now at Dyrham, and 'Edward and Elfrida' and 'Gunhilda', c.1760/61 at Burton Constable. Six very large historical pictures were in the sale at Wanstead House, 6.1822. Casali also made etchings after some of his own designs.

(E.C-M.; Urrea.)

CASANOVA, François Joseph 1727-1803

One of the best known battle painters of his age. Born London 1727; died Brühl 1803. He was educated in Venice and was brother to the notorious memorialist, Jacques Casanova. Received in the French Académie 1763. Visited London 1767 and exh. two battlepieces FS 1767.

CASTEELS, Pieter 1684-1749

Flemish born painter of flowers and dead or live fowl. Born Antwerp 3 October 1684; died Richmond, Surrey, 16 May 1749. Son and pupil of his father, another Pieter Casteels. Came to London with his brother-in-law, Pieter Tillemans (q.v.). Director in the Kneller Academy 1711 and returned briefly to Antwerp to become a Master 1713. His main practice was in London up to 1735 where he specialised in very accomplished arrangements of exotic birds in the manner of Hondecoeter, but occasionally painted small-figure histories in architectural settings. In 1726 he published twelve etchings of his own compositions.

PIETER CASTEELS. 'A peacock and exotic fowls.' 50ins. x 61ins. s. & d. 1732. Christie's sale 26.11.1965 (143).
Casteels painted very many arrangements of exotic birds in a style modelled on Hondecoeter.

Retired in 1735, at first to Tooting and then to Richmond, where he made designs for calico printing.

(Vertue MSS.)

CASTRUZZI fl.1774

Exh. crayons portraits at SA 1774.

CHARLES CATTON, Sr. 'Happisburgh Beach, Norfolk.' 10½ins. x 30¾ins. The title, name of the artist and the date 1766 are inscribed on the back. Felbrigg Hall (National Trust).
This unexpected work obviously owes a good deal to Gainsborough's Suffolk landscapes of the 1750s.

CATTON, Charles, Sr. **1728-1798**

Painter of landscapes, animals, and occasionally of portraits and history. Born Norwich September 1728; died London 28 August 1798. Foundation RA 1768. Trained as a coach painter and revolutionised that expiring industry, becoming coach painter to George III. He also studied at the St. Martin's Lane Academy, and exh. SA 1760-68; RA 1769-98. Master of Painter-Stainers Company 1783. His most attractive works are modest East Anglian landscapes, e.g. 'Happisburgh Beach', 1766 (Felbrigg, National Trust).

CATTON, Charles, Jr. **1756-1819**

Painter of landscapes and animals and illustrator. Born London 30 December 1756; died in upper New York State 24 April 1819. Son and pupil of Charles Catton Sr. (q.v.). Entered RA Schools 1775. Exh. RA 1776-1800, but emigrated to US *c.*1802, where he did not paint professionally. He painted landscapes rather in the style of Morland (q.v.), and many topographical watercolours *(Mallalieu)*, as well as portraits of dogs. In 1789 he published a set of aquatints of animals.

CAVE, William **1737-1813**

General decorative and historical and religious painter. Born Winchester 1737; died there 27 November 1813. He and his three sons monopolised all the decorative and religious painting in Winchester from 1773 onwards, turning out religious subjects for the Catholic Chapel, mythological figures for the theatre, and any decorative painting that was needed.

(E. C-M.)

CERVAN (CERVENG), John **fl.1771-1776**

John Cervan exh. RA 1776 two topographical landscapes from an address in Exeter. He is probably the John Cerveng who exh. landscapes and portraits at RA 1771-73; at SA 1773 (Cervang) and 1775 (Cherveng), with London addresses.

CHALMERS, A. **fl.1798**

Exh. RA 1798 'The coronation chairs', 'Mr. Kemble as The Stranger' and 'The tomb of Henry VII'. See also Chalmers, William A.

CHALMERS, Sir George, Bart. *c.***1720-1791**

Scottish portrait painter. Born Edinburgh; buried London 15 November 1791. About 1764 he claimed to have inherited the baronetcy of Chalmers of Cults (and thereafter signed his pictures as '..Equ^s Baron^s') but his right to do so

SIR GEORGE CHALMERS. 'A shepherdess spied upon.' 50ins. x 40ins. s. & d. 1760. Unlocated.
This was painted as a furniture piece and let into the wall over a mirror, probably for the Baird family at Lennoxlove. The 'classic shepherdess' pose was used by Reynolds in 1764 for a portrait.

may be doubted. He was the son and presumably pupil of Roderick Chalmers, Ross Herald, and started as a heraldic painter and engraver. Traces of this persisted in his work which is usually hard and wiry in outline. In 1739 he engraved two portraits of his own painting. He is said to have studied in Rome, but this left no impression on his style. In Minorca 1755, where he painted 'General Blakeney', engr. McArdell. By 1760 he had seen at least engravings after Reynolds. Practised in Edinburgh, where he married (1768) the sister of Cosmo Alexander (q.v.). Exh. RA 1775-90 (from London 1775/6, from Hull 1778-81, and then again from London), but his portraits become increasingly feeble.

*SIR GEORGE CHALMERS. 'The Ace of Hearts.' 25ins. x 20ins.
Signed 'Geo. Chalmers Equs Barot' and dated 1781. Sotheby's sale
12.7.1967 (67).*
Traces of the herald painter still survive in this late work.

CHALMERS, Sir Robert, Bart. 1749-1807

Hon. exh. of sea pieces RA 1790-99 (at first as
'Capt. R. Chalmers' but had assumed the
baronetcy in 1799). Nephew of Sir George
Chalmers (q.v.). Died at Portsmouth 1807, aged
58.

CHALMERS, William A. 1768-?1794

Painted in watercolours and, apparently, in oils,
architectural and theatrical subjects, e.g. 'Burial of
Sir J. Reynolds', RA 1792. Entered RA Schools
1791, aged 23. Exh. RA 1790-94. Redgrave
identifies him with A. Chalmers (q.v.).

CHALON, Henry Bern(h)ard 1771-1849

Very prolific animal painter. Born (perhaps in
Amsterdam) 6 May 1771; died London 1849.
Entered the RA Schools 1788 and won a silver
medal 1790. Exh. (very abundantly) RA
1792-1849; BI 1807-49. In 1796 he was 'Animal
painter to the Duchess of York' and later filled the
same role for the Duke of York and the Prince of
Wales. He began with cattle and wild animals but
latterly specialised in horses and dogs.

CHAMBERLAIN, William 1771-1807

Painter of portraits and figural genre. Born
London 1771; died Hull 12 July 1807. Entered RA
Schools 1790. Pupil of Opie (q.v.) 1794. Exh. RA
1794-95 and perhaps 'A Newfoundland dog', 1802
(from a Chichester address) and 'Cat and dog
playing', 1803. A signed portrait of a boy with a
dog, sold 11.6.1937, 98, was dated 1796 and was in
a heavily impasted style. He was in practice at Hull
when he died.

(Monthly Mag., Aug. 1807.)

*MASON CHAMBERLIN. 'Bertie Greatheed.' 65ins. x 40ins. Exh.
SA 1768 (21). Christie's sale 3.5.1946 (19).*
Identifiable from Walpole's notes of the SA 1768. The
attribution had survived on the old label.

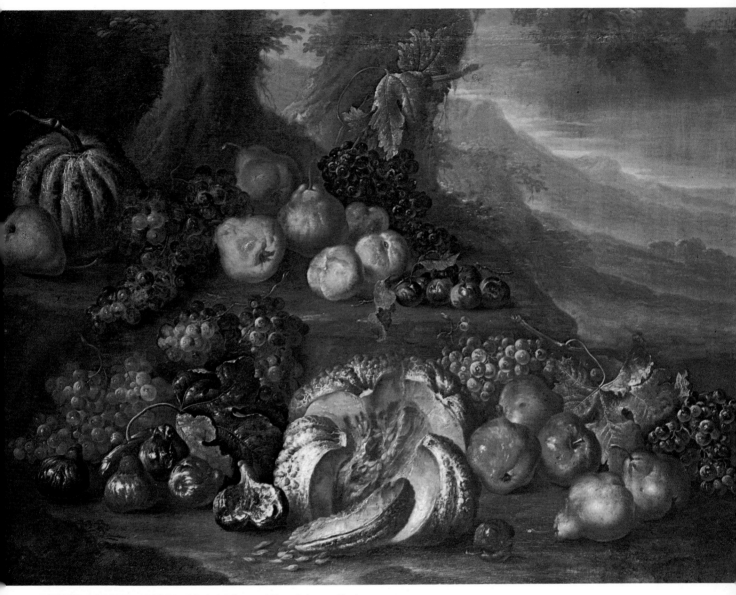

JOSEPH COOPER. 'Still life of fruit.' 34ins. x 49ins. Private collection.
The signature on this painting reveals his christian name. He was obviously a professional and familiar with still life pictures painted in Italy (Rome or Naples).

CHAMBERLIN, Mason **1727-1787**

City of London portrait painter, and very occasional history painter. Died London 26 January 1787, aged 60 (Farington, i, 132). Foundation RA 1768. Began life in a counting house in the City, but turned to art and became a pupil of Hayman, in whose manner he painted a few conversation pieces c.1761. Exh. SA 1760-68; FS 1764 (premium-winning history picture); RA 1769-86. Until 1785 he lived in the City (Spitalfields) and perhaps had a preponderance of middle-class sitters and dissenting ministers; but he painted two royal princes in 1771 and a number of noblemen. Most of his portraits are on the scale of life, excellent likenesses and full of character, but oddly varied in style. He likes to sign rather faintly in a top or bottom corner 'Chamberlin pinxt.' and is never flattering; his patterns do not reflect the work of his better known contemporaries. A good example of his later 'conversations' is 'Captain Bentinck and his son 1775', RA 1776 (Greenwich).

CHAMBERLIN, Mason, Jr. **fl.1786-1826**

Landscape painter in oils and watercolours. Exh. RA 1786-1826; BI 1807-9, mainly generalised landscapes or views of the Midlands and southern counties.

CHANDLER, John Westbrooke **1764-1804/5**

Portrait painter and miniaturist. Natural son of 2nd Earl of Warwick. Born 1 May 1764; died insane at Edinburgh c.1804/5. Entered RA Schools 1784, and exh. RA 1787-91. His portraits reveal a blend of the styles of Hoppner and Romney — three are at Eton College. In 1800 he published *Sir Hubert, an Heroic Ballad* and left the same year for Aberdeen, thence to Edinburgh. His talent was not considerable.

CHAPMAN, Charles **fl.c.1747-?1776**

Painter of architectural decorations, employed at Vauxhall (Edwards) and Kew (E.C-M.). Son of an actor (d.1747). He may be the Charles Chapman who exh. 'Four small portraits, in chalk', RA 1776.

CHARPENTIERS See CARPENTIERS, A.

CHARPIN **fl.1765**

Exh. 'A landscape, with Gypsies merry-making', FS 1765.

CHEARNLEY, Anthony **fl.1740-c.1785/87**

Amateur Irish landscape painter (Crookshank and Knight of Glin, 1978).

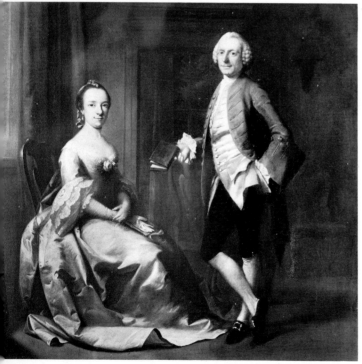

MASON CHAMBERLIN. 'A Lady and Gentleman.' 25½ins. x 27ins. s. & d. 1761. B.A.C. Yale.
A continuation of Hayman's conversation piece style. The picture was first discovered in Aberdeen.

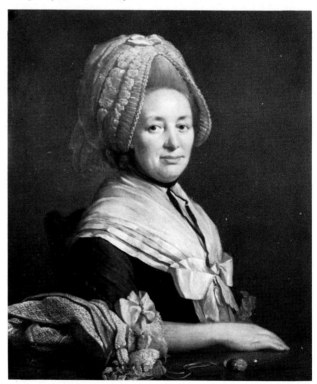

MASON CHAMBERLIN. 'Elizabeth Ourry 1780.' 29ins. x 24ins. Sitter's name and date probably on the back. Christie's sale 21.3.1969 (60).
This is in Chamberlin's most characteristic style of middle class portraiture.

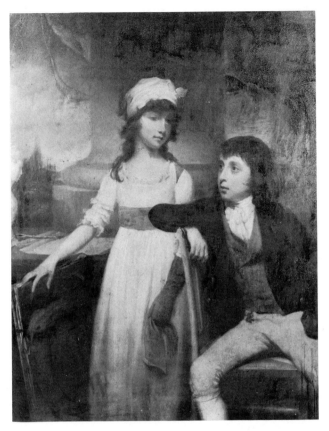

JOHN WESTBROOKE CHANDLER. 'Children of John Conyers of Copt Hall, Essex.' 50ins. x 40ins. s. & d. 1795. Sotheby's sale 29.11.1950 (135).
This shows competent adaptation of the manners of both Romney and Hoppner.

CHERON, Louis 1660-1725

History painter and book illustrator. Born Paris 2 September 1660; died London 26 May 1725. Won the *prix de Rome* at the Académie in 1676 and in Rome studied especially the work of Raphael and his scholars. He did religious painting in Paris but, being a protestant, was encouraged by the Duke of Montagu to come to England and paint the ceilings at Boughton House (building completed 1694), which remain his major surviving works. He became a denizen 1703, and was naturalised 1710. He had a certain practice in easel pictures of historical subjects, but was chiefly concerned with teaching drawing at Kneller's Academy (from 1711), and was one of the chief promoters of the St. Martin's Lane Academy, 1720. From 1715 he did much book illustration (*Hammelmann*). Many of his drawings are in the British Museum and he had great influence on the teaching of drawing in London in the 1720s.

(Vertue MSS; E.C-M., i, 243-245.)

CHESTER, John 1761-1783

Portrait painter. Born 29 September 1761. Entered RA Schools 1783. Exh. a portrait RA 1783.

CHILD, R. fl.1785-1788

Exh. RA 1785-88 'Dead birds', 'Cat and dead game', 'Pigeons'.

CHINNERY, George 1774-1852

Portrait and miniature and landscape painter in every possible medium and usually on a small scale. Born London 5 (or 7) January 1774; died Macao 30 May 1852. Entered RA Schools 1792 and exh. RA 1791-1802, at first miniatures. In Dublin 1797, where he married, and became active in Irish painting affairs 1800-2. He sailed for Madras 1802 and worked in Calcutta 1807-25, when he moved to Macao, where he lived till his death, painting all the time industriously and mainly on a small scale, portraits and scenes of Eastern life, in a very personal technique of considerable brilliance and charm. He again exh. RA, from Macao between 1831 and 1846. His work before 1800 consists mainly of neat small portraits in a style anticipating Linnell's.

(Strickland; Long; Mallalieu; H. and J. Berry-Hill, G.C., 1963.)

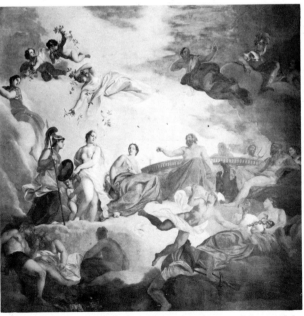

LOUIS CHERON. 'Venus protesting to Jupiter at a banquet of the Gods.' c.1694. Ceiling of the main staircase. Buccleuch collection, Boughton House, Northants.
Cheron was the great teacher of drawing (especially after Raphael) in the London Academies of the early 18th century. The finest examples of his wall and ceiling paintings are at Boughton House.

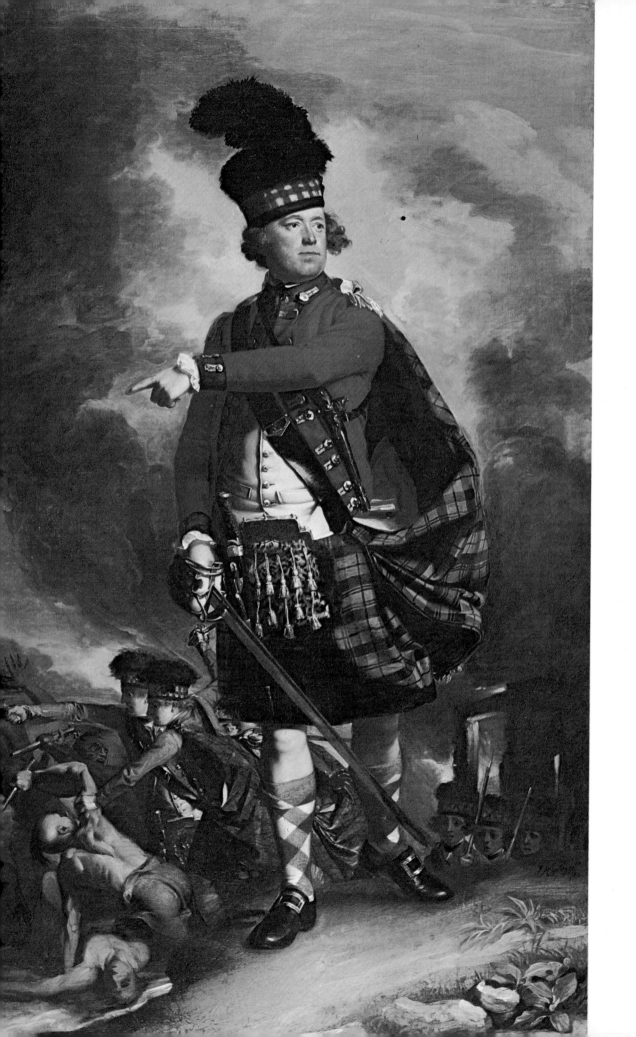

CHIPPENDALE, Thomas *c.*1750-*c.*1822
Son and successor of the famous furniture designer. Born London *c.*1749/50; will proved there January 1823. Exh. RA drawings in 1785; in 1786 'a watchman' and 'an orange girl'; in 1801 'inside of a prison with effect of lamplight.'

CHRISTMAN, John Christopher fl.1776-1780
Exh. dead and living birds, SA 1776-78; FS 1780.

CHUBBARD, Thomas *c.*1738-1809
Liverpool portraitist in oils and crayons, and landscape painter. Died Liverpool 'of old age' 30 May 1809. Member of Liverpool Art Society 1769 and exhibited there abundantly 1774. He was one of the leading Liverpool painters of his time. Exh. London FS 1771; SA 1772-73, mainly Lancashire landscapes.

(Rimbault Dibdin, 67.)

CIPRIANI, Giovanni Battista 1727-1785
Historical and decorative painter and draughtsman, and one of the great backroom figures of the neo-classic style in England. Born in Florence; died Hammersmith 14 December 1785. Foundation RA 1768. Exhibited fitfully at RA 1769-79. Trained in Florence by Hugford (q.v.) in a late baroque style, he met Chambers and Wilton in Rome in the early 1750s and was brought back by them to England in 1756, where he later did a good deal of historical decorative painting for Chambers (and some for Adam), and joined Wilton as instructor at the Duke of Richmond's short-lived Academy (1758), which taught neo-classic principles. His earliest surviving ceiling decoration, 'Apollo and Minerva presiding over Religion, Eloquence, Mathematics &c.,' *c.*1757 (Buckland House, Oxon.) is still late baroque, but his later work is much more neo-classical *(list in E.C-M.)*. His most important surviving figure paintings, mostly in monochrome, have been dispersed, from 19 Arlington Street (Lord Zetland sale, 27.4.1934, 114) and Lansdowne House. Most of the latter are at Philadelphia. Cipriani's importance lies rather in his teaching at the RA Schools and the mass of his decorative designs, many of which were engraved by his close friend Bartolozzi, and had a profound influence. He was the teacher of J.H. Mortimer (q.v.) and collaborated with Barret, Mortimer and others in several large decorative schemes. Sales of

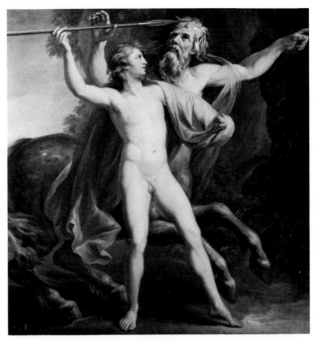

GIOVANNI BATTISTA CIPRIANI. 'Chiron instructing Achilles with the dart.' 41½ins. x 41½ins. c.1776. Philadelphia Museum of Art (Purchased John McFadden Jr. Fund).
Companion to the following plate.

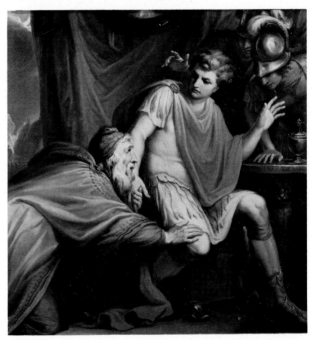

GIOVANNI BATTISTA CIPRIANI. 'Achilles beseeched by Priam for the body of his son Hector.' 41½ins. x 41½ins. c.1776. Philadelphia Museum of Art (Purchased John McFadden Jr. Fund).
This and the previous plate form part of a series (of which others are also at Philadelphia) originally painted for Lansdowne House, London. Before they were acquired by Philadelphia in 1972 they had been supposed to be by Barry.

JOHN SINGLETON COPLEY. 'Hugh, 12th Earl of Eglinton, leading his troops against the Cherokees.' RA 1780.
A history picture depicting an incident twenty years old. The burning wigwams of the Cherokees are visible in the background.

his paintings and drawings in 1786 and 1787 are Lugt 4007/4168. His younger son, **Henry**, exh. RA 1781 a childish 'Portrait of a young nobleman', but soon abandoned art and was ultimately knighted 13 September 1831 as senior exon of the Yeoman of the Guard.

(Hammelmann for illustrative work for English publishers; Edwards; E.C-M.)

CLAPHAM fl.1768-1771
'Master Clapham' a youthful pupil of Daniel Dodd (q.v.), exh. heads and flowers in crayons FS 1768-71.

CLARK, Thomas fl.1765-?1775
Irish painter of portraits. Died ?London 1775. Entered Dublin Drawing School 1765, and exh. there before coming to London. Entered RA Schools 1769; incompetent assistant to Reynolds 1771 *(Whitley, ii, 284)*. Exh. RA 1769-70 and 1775.

(Strickland.)

CLARKE, James c.1745/50-1799
Scottish portrait painter and copyist. Lived for thirty years at Naples until his death 1799. Son of a

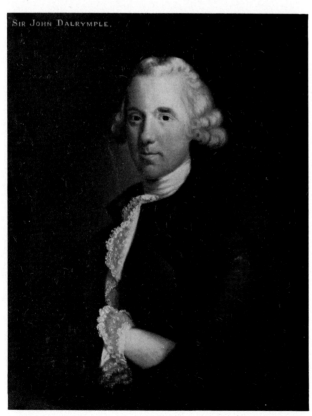

JAMES CLARKE. 'Sir John Dalrymple Hamilton Makgill, Bart.' 29¼ins. x 24ins. s. & d. 1767 on the back. Private collection.
Painted shortly before the artist settled for life at Naples.

poor man at Inverness, he acquired some training as a portrait painter and painted, 1767, a number of portraits not unlike those of William Millar (q.v.) (at Oxenfoord, Dalmeny and Broomhall). On the strength of these he was sent to Naples by Sir Ludovic Grant and Sir John Dalrymple (later 5th Earl of Stair), c.1768. He received some patronage there from Sir William Hamilton, and remained at Naples, acting as an 'antiquary' and copying pictures in the Gallery for travellers, until his death, when he left £200 to Lord Stair.

CLARKE, Theophilus 1776-c.1832
Portraitist and painter of domestic and occasionally literary themes. Entered RA Schools 1793, aged 17. ARA 1803 (after exhibiting subjects from Thomson and Milton) and continued on the list of ARAs up to 1832. Said also to have been a pupil of Opie. Exh. RA 1795-1810; BI 1809. Most of his exhibits after 1797 were portraits and a few were engraved — examples are at NPG and Eton College.

CLARKSON, Nathaniel 1724-1795
Portrait and history painter. Died Islington 20 September 1795, aged 71. Began as a coach and sign painter and painted an altarpiece (now destroyed) for the new church (1754) at Islington. Exh. portraits SA 1762-67.

(Smith's 'Nollekens', i, 24.)

CLAYTON, John 1728-1800
Specialist in painting fruit in oil and crayons; also painted landscapes in watercolour. Died Enfield 23 May 1800 in his 73rd year. Brought up as a surgeon. Exh. FS 1762-63; SA 1764-68, and 1778. He seems to have retired from the art after the destruction of many of his works by fire in 1769.

(Redgrave.)

CLERK, Alexander fl.1729-1737
Unsuccessful Scottish amateur painter. Younger brother of Sir John Clerk, 2nd Bart. of Penicuik. Studied under John Alexander at Edinburgh 1729-31; under Pond and Hysing in London 1733; and under Imperiali at Rome 1737.

(Fleming, Adam, 328n.)

CLERK, Sir James 1710-1782
Amateur Scottish painter. 3rd Bart. of Penicuik. Sent to London 1727 to learn painting under Aikman (q.v.). He became a considerable patron of the arts in Scotland.

(Fleming, Adam, 28.)

CLERMONT, Andien de fl.1717-1783

French flower and decorative painter. Died Paris 4 February 1783. Pupil of the younger Baptiste Monnoyer, with whom he probably came over from Paris 1717. At first a flower painter, but his main activity in England was the painting of rococo decorations in which monkeys are prominent (*singeries*). The best surviving *in situ* are of *c.*1745 at Kirtlington Park. He returned to Paris *c.*1756.

(E.C-M.)

CLEVELEY, John, Sr. fl.1726-1777

Shipwright and marine painter at Deptford. Apprenticed to a Thomas Miller 1726; died Deptford 21 May 1777. Painter of docks and ship-building scenes. Exh. records are confusing but a number of shipping pieces exh. FS from 1764 onwards are no doubt his. His twin sons were born Deptford 25 December 1747: **John, Jr.,** died London 25 June 1786, and **Robert,** died Dover 29 September 1809. Both were skilful marine artists in oil and watercolours, and John was taught water-colour by Paul Sandby (q.v.). They went as artists attached to various expeditions and most of their work is not in oils. John exh. RA 1770-86; Robert (at first as hon. exh.) 1780-1803. Robert was 'marine painter to the Duke of Clarence' 1801, and 'to the Prince of Wales' 1802. He specialised in scenes of naval actions.

(Wilson; Mallalieu; Archibald.)

CLIVE, Charles fl.1764-*c.*1775

Portrait painter. A signed full length of the '1st Lord Clive', 1764 (Shrewsbury Museum), and a three quarter length of the '2nd Lord Clive' (Powis Castle), reveal a competent and professional portrait painter, with a style influenced by Ramsay (q.v.). He might be the Charles Clive who died at Mortlake 1794.

COCHRAN, William 1738-1785

Glasgow portrait painter. Born Strathaven 12 December 1738; died Glasgow 23 October 1785. Studied at Foulis Academy Glasgow 1754; in Rome *c.*1761-66, where he painted some history pictures. Settled as an unambitious portrait painter at Glasgow, where there are examples in the Gallery.

(Redgrave.)

CHARLES CLIVE. *'Edward, 1st Earl of Powis.' 50ins. x 40ins. The attribution is traditional. Powis Castle (National Trust).* Probably painted soon after the sitter succeeded his father as 2nd Lord Clive in 1774. The painter is otherwise only known from a signed portrait of the sitter's father at Shrewsbury — but he would seem to have been a professional.

CODE, Mrs. See BENWELL, Mary

COLE, Joseph fl.1770-1782

Exh. 'a piece of flowers' on eight occasions at RA between 1770 and 1782, and once (1781) a 'portrait of a child'. In the Society of Antiquaries a portrait of 'Archdeacon Wilkins' (d.1745) is signed 'I. Cole fec.', and is a sound provincial work.

COLLET, John *c.*1725-1780

Painter of low life subjects. Born London; died there 6 August 1780. Studied at St. Martin's Lane Academy and was a pupil of Lambert (q.v.). He exh. every sort of picture at the FS 1761-80 (and posthumously 1783!). Some of his pictures are rustic landscapes, but his speciality was rather vulgar scenes of urban low life (e.g. 'Female bruisers' and 'The recruiting sergeant') many of which were popularised by engravings by Goldar. They owe something to Hogarth but are wholly lacking in social criticism.

SAMUEL COLLINGS. 'Frost on the Thames.' 32ins. x 48ins. Exh. RA 1789 (409). B.A.C. Yale.
Said in the RA catalogue to have been 'sketched on the spot' and perhaps a very early example of open air painting. The influence of Rowlandson is visible.

SAMUEL COLLINGS. 'Self portrait.' 29ins. x 24ins. Probably c.1790. B.A.C. Yale.
The only oil portrait by this distinguished caricaturist known.

COLLINGS, Samuel fl.1784-1795
Occasional genre painter; also a caricaturist. Exh. RA 1784-89 and contributed designs for *The Bon-Ton Magazine*, 1792-95. His two known paintings (both at BAC Yale), a 'Self portrait' and 'Frost on the Thames' (RA 1789) are fresh and lively and the latter rivals Rowlandson.

(Mallalieu.)

COLLINGS, W. fl.1790
Exh. 'portrait of an artist' at RA 1790. He might have been the 'William Collins, aged 31' who entered the RA Schools 1785. Also exh. SA 1791 a portrait and a scene of fire.

COLLINS, Charles *c.*1680-1744
Painter of dogs, exotic birds, dead game, etc., of considerable competence. Died London 1744. He also did watercolour studies of birds 1736-43.

(Vertue.)

COLLINS, John fl.1740-1753

Landscape painter; an accomplished exponent of the Gaspardesque, with anticipations of Richard Wilson's style.

(Grant; for a picture signed and dated 1753, see J. Hayes, Connoisseur CLXXIII (Jan. 1970), 20.)

COLLINS, Richard fl.1726-1732

Portrait painter. Son of another Richard Collins, a painter of Peterborough. Died 1732. He was a pupil of Dahl (q.v.) and had a fair business as a portrait painter in Lincolnshire and Leicestershire: a sort of provincial Highmore (q.v.). He was also a topographical draughtsman.

(A.C. Sewter, Apollo XXXVI (Sep. and Oct. 1942), 71 ff., 103 ff.)

COLLINS, W. fl.1791

Exh. portraits in crayons SA 1791 as hon. exh.

CHARLES COLLINS. 'Dead game.' 35½ ins. x 28 ins. s. & d. 1734. Sotheby's sale 18.6.1952 (128).
An example of a fairly standard pattern of still life painting, derived from the works of the Dutch 17th century painter, Weenix.

COLLOPY, Timothy fl.1777-c.1810

Irish portrait and religious painter. Born Limerick; died London c.1810/11. A baker's apprentice, who was sent by Limerick Catholics to study art in Rome for some years. On his return he painted altarpieces in Limerick and practised as a portraitist. In Dublin 1777 and 1780; settled in London c.1783. Exh. RA 1786 and 1788. Ended up as a picture cleaner.

(Strickland.)

COLOMBO (Colomba), 1717-1793
Giovanni Battista Innocenzo

Italian-Swiss decorative and theatre painter and theatre architect. Born Arogno (prov. Lugano) 1717; died there 1793. One of a family of decorative painters, he began his wandering career at Mainz and travelled widely in western Germany, including work on the theatre at Hannover for George I. He was certainly in England in 1774, when he exh. four theatrical landscapes at RA and he designed scenery for the King's Theatre in 1774 and 1780. Long in service of Duke of Württemburg and at Turin and Como. A signed example sold 14.12.1979, 83.

(Brun; Th.-B.; E.C-M.)

COMER, John fl.1763

Exh. a portrait at FS 1763.

CHARLES COLLINS. 'A lobster.' 27¼ ins. x 35 ins. s. & d. 1738. Sotheby's sale 12.11.1980 (47).
The niche arrangement is unusual; there seems a deliberate attempt to get away from the Baroque Dutch arrangements of lobsters.

DANIEL DE CONING. 'A gentleman aged 59.' 29ins. x 24ins. s. & d. 1710. Christie's sale 10.2.1967 (166).
A competent itinerant Dutchman, whose style in England is closer to that of Thomas Murray than to Kneller.

CONIERS fl.1717-1721
Painter of birds and animals; pupil of Cradock (q.v.). Working in 1721 *(Vertue, i, 80).*

CONING, Daniel de 1668-after 1727
Portrait painter of Dutch origin. Born Amsterdam, 1668; apprenticed to Jacob Koninck I in Copenhagen; living at Oxford 1690 *(Oud Holland I (1883), 306).* A portrait of 'Lord King', 1720 (NPG) is signed 'Daniel de Coning', and some ten portraits of the Tracy family at Stanway are signed 'De Coning pinxit 1726' (or 1727). In style like the work of Hermann Van der Mijn (q.v.).

CONSTANTIN, René Auguste fl.1712-1726
Portrait painter of Dutch training. Member of Painters' Guild at The Hague 1712; later worked in Germany and England, possibly in the household of George II when Prince of Wales; apparently in England 1716/17.

(Kauffmann, 1973, 72.)

CONTENCIN, Peter fl.1777-1819
In 1777-78 'Peter Contencin Junr' was hon. exh. of portraits (one a drawing) at SA. A 'P. Contencin' exh. five times at RA between 1797 and 1819 a miniature, portraits, and a 'sketch on the coast of Cornwall'.

COOK, R. fl.1785-1787
Exh. portraits at RA 1785-87.

COOPER, J. fl.1714
A pair of extremely provincial portraits, one of them signed 'J. Cooper' and dated 1714, in a style remotely derived from Kneller, were in a sale 2.6.1950, 157.

COOPER, Joseph fl.1735-1743
Still life painter. Died 1743 Lambeth. Mentioned by Vertue *(iii, 122)* as 'very skilful in painting fruit and flowers'. Probably the 'J. Teal Cooper', whose 'Cocks and Hens' and 'Eagle and Lamb' are listed in a MS catalogue of 1735 of pictures at Hursley Park. A signed example suggests the influence of Italian still life pictures.

COOPER, Richard fl.1790s
The exhibition records of three Richard Coopers at the end of the 18th century are hopelessly confused — a miniaturist, a watercolour painter *(Mallalieu)*, and, apparently one who occasionally painted bad landscapes in oil.

(Grant.)

COPLEY, John Singleton 1738-1815
Portrait and history painter. Born 3 July 1738, probably at Boston, where his parents were recent Irish immigrants; died London 9 September 1815. ARA 1776; RA 1779. In Boston, more or less self-taught, he became the most remarkable portrait painter New England had produced, with a penetrating sympathy for the local character *(his American portraits cat. in Barbara Neville Parker and Anne Bolling Wheeler, J.S.C., American Portraits..., Boston, 1938).* He contributed, from America, to the SA London 1766-72 and was made a Fellow. He left Boston for Europe in June 1774 and travelled via London and Paris to Rome, where, partly under Gavin Hamilton's guidance, he studied intensively Raphael and the Antique. In October 1775 he rejoined his family in London, where he settled for the rest of his life.

Copley's English style is curiously different from his New England style in portraiture. His portrait arrangements are much more sophisticated and

owe a good deal to the latest English portraits he had seen — even though many of his early London sitters had American connections. He exhibited at the RA 1776-1812. His first major work in his new style is the 'Copley Family', RA 1777 (Washington). But he was always ambitious to be a history painter and he created a sensation with 'Watson and the Shark', RA 1778 (Washington), an entirely novel realistic representation of a dramatic contemporary incident. His 'Earl of Eglinton', RA 1780 (Los Angeles) is almost a miniature contemporary history picture, and from 1779 to 1781 he was engaged on the huge 'Death of Chatham' (Tate Gallery), which was shown privately with a shilling entrance fee and established a new precedent in heroic reportage. The best of these history pictures is 'The death of Major Pierson' 1783, (Tate Gallery) which anticipates some of the achievement of Delacroix. Copley's other great histories are 'The Siege of Gibraltar', 1783-91 (Guildhall) and his last major work, 'The Victory of Lord Duncan', 1798/9 (Camperdown House, Dundee). His history pictures of scenes from an earlier age are unfortunate.

He also had a considerable practice in portrait painting (he was charging 100 guineas for a full length in 1783) and is at his best showing people in their public character. His two most remarkable portrait groups — 'Three Princesses', RA 1785 (Buckingham Palace) and 'The Sitwell Family', RA 1786 (Renishaw Hall) — were severely criticised but are highly original. He also painted a number of religious compositions.

Copley had a difficult and cantankerous nature and spent the years after 1788 feuding with Benjamin West and making life difficult for himself and his fellow Academicians. 'The Red Cross Knight, RA 1793 (Washington), a sort of family allegory, shows that he was still capable of brilliant invention. He was the most distinguished painter of the contemporary historical scene in English 18th century painting.

(Jules D. Prown, J.S.C., 2 vols, 1966, with cat.)

CORBOULD, Richard 1757-1831
Painter of pretty landscapes, and of almost every other sort of picture, from miniatures to religious history; also a most prolific book illustrator. Born London 18 April 1757; died Highgate 27 July 1831. Pupil of R. Marris (q.v.) 1773 and entered RA Schools 1774. Exh. FS 1776; RA 1777-1811;

JOHN SINGLETON COPLEY. 'Samuel and Eli.' 77½ ins. x 59¾ ins. s. & d. 1780. Sold at Robinson and Fisher's, London 24.10.1935 (136).
Engraved in mezzotint by Valentine Green, 1780. It apparently hung in the Lecture Room of the Royal Academy at Somerset House, 1781 (*The Ear Wig,* 1781, p.22). It has since been acquired by the Wadsworth Atheneum at Hartford, Conn.

BI 1806-17. He also worked in watercolours and etched, and was a very competent, if uninspired, all-round artist.

(For book illustrations, see Hammelmann.)

CORDINER, Rev. Charles 1746-1794
Hon. exh. of picturesque views of Scotland FS 1790-91, from Banff. Died Banff 1794, aged 48.

CORNISH, John fl.1751-1762
Portrait painter. Painted the American 'Charles Paxton' in England 1751 (*Groce and Wallace*). A portrait dated 1762 is recorded and another which indicates the painter worked at Oxford.

(Duleep Singh, i, 265.)

CORREGGIO, Joseph ?fl. later 18th century
Still-lives of fruit, signed Joseph Correggio, and late 18th century were sold S, 5.2.1958, 147.

HENDRIK DE CORT. 'Castle Howard and the Mausoleum.' Wood. 41ins. x 61ins. Christie's sale 6.4.1951 (136).
De Cort did not normally sign his works, but his distinguished style is easily recognisable. He had good patronage among the nobility.

CORT, Hendrik Frans de **1742-1810**
Flemish topographical painter and draughtsman. Born Antwerp 1742; died London 28 June 1810. Pupil of Antonissen at Antwerp and a Master there 1770. He settled in England and exh. RA 1790-1803; BI 1806. He travelled the country extensively and worked much for the nobility, producing neat views of country houses and parks, much in the style of Paul Sandby (q.v.). He also painted picturesque views of towns and castles, usually in a rather clear tonality.

COSWAY, Maria (Mrs. Richard) **1759-1838**
Born Maria Louisa Catherine Cecilia Hadfield at Florence; died at Lodi 5 January 1838. Married in London, 1781, Richard Cosway (q.v.). She was a miniaturist and a painter of light historical subjects in the vein of Angelica Kauffmann. Something of a youthful prodigy, she studied at Florence and Rome and was elected a member of the Florence Academy 1778. Came to London 1779 and was introduced to the best circles. After her marriage to

Cosway she exh. RA 1781-1801, mainly historical subjects. She was a talented musician and the Cosways gave spectacular musical parties in the 1780s. She lived abroad a good deal, 1791-94, and 1811-c.1815, founding a girls' college at Lodi in 1812, to which she retired after Cosway's death, converting it into a convent. She was made an Austrian Baroness in 1834.

COSWAY, Richard **1742-1821**
Miniaturist of spectacular gifts, but also painted oil portraits and occasional religious and mythological subjects. Baptised at Okeford, nr. Tiverton, Devon, 5 November 1742; died London 4 July 1821. ARA 1770; RA 1771. He was a youthful prodigy, came to London 1754, spent a few months

RICHARD COSWAY. 'William, 3rd Viscount Courtenay.' 92ins. x 69ins. s. & d. 1791. Earl of Devon, Powderham Castle.
Cosway signs his name in Latin as 'Painter to the Prince of Wales'. The remarkable fancy dress is traditionally what Lord Courtenay (1768-1835) wore at his coming of age ceremonies at Powderham in 1790.

with Hudson (q.v.) and then studied at Shipley's Drawing School from which he won a series of prizes for drawing from the Society of Arts, 1755-60. Exh. SA 1760 and 1767-69; FS 1761-66. Entered RA Schools 1769. Exh. RA 1770-1806. Many of his exhibited portraits were in oils. He started exhibiting miniatures in 1762 and soon became the smartest and one of the most elegant miniature painters England has produced. From 1785 he was 'Principal Painter to H.R.H. the Prince of Wales' and he was much in vogue in the flashy circles of the Prince of Wales. In 1784 he presented an altarpiece, 'The Liberation of St. Peter', to the church at Tiverton and he produced a number of small subject pictures in a Corregiesque vein. His most remarkable portraits on the scale of life are four at Powderham Castle, dating 1791-93, and there are others at Blenheim, c.1800, and several at Longford ranging from 1795 to 1812 (full lengths were £75, half lengths £50). They are smart and somewhat mannered but solid and not evanescent, as are the miniatures. He was a great collector of old masters and bric-à-brac and post-mortem sales were in 1821 and 1822, Lugt. 10041, 10182, 10198.

(G.C. Williamson, R.C., his wife and pupils, 1897.)

COTES, Francis 1726-1770

Portrait painter in oils and crayons. Born London 20 May 1726; died there 19 July 1770. Elder brother of the miniaturist Samuel Cotes (1734-1818). His father was a pharmacist, whose expertise Cotes may have found useful in preparing his own crayon colours. Apprenticed to George Knapton (q.v.) in early 1740s, from whom he may also have learned oil painting, but his practice at first was only in crayons. His first pastels date from 1747 and have a novel brilliance of colour and sharpness of outline. A single oil of 1753 is known but his practice in oils only began seriously in 1757. His earlier rococo style was modified by the example of Liotard (q.v.) (who was in London 1753-56), in the direction of realistic portraiture, and he played some part in establishing the portrait style of the new age; but he was concerned only with fashion and handsome likeness and not with character. He learned something from the patterns of Ramsay and Reynolds, but prettified and vulgarised their inventions. His sitters usually have milk-and-roses complexions and their clothes are always bright and new and fashionable. In his oil portraits after 1764 the draperies are often by Peter Toms, who also worked for Reynolds. His crayons must be wholly autograph, and he rates as the most

FRANCIS COTES. 'Luke Gardiner, 1st Viscount Mountjoy.' 35½ins. x 28ins. s. & d. 176(?5). Sotheby's sale 4.4.1973 (67). Luke Gardiner (1745-98), who was created Viscount Mountjoy in 1795, is shown as a fellow-commoner of St. John's College, Cambridge, with the chapel in the background.

accomplished British pastellist of the century, he wrote a short note on his technique which was published in the *European Magazine,* 1797. He was the teacher of John Russell (q.v.).

From 1765, when he took a large house at 32 Cavendish Square (later Romney's), he was the most fashionable portrait painter after Reynolds and Gainsborough and only his death prevented his becoming a serious rival to Reynolds. In 1768 his price for a head in crayons was 25 guineas; and his charges for oil portraits are said to have been 20 guineas a head, 40 a half length, and 80 for a full length. He was a member of the Society of Artists and prominent in its exhibitions and activities from 1760 to 1768, when he was one of the four artists who first promoted the Royal Academy; he became a foundation RA. His first portrait of the royal family dates from 1767. He very often signs his portraits and his style is easily recognisable, and is notable for its concern with outline and silhouette.

(Edward Mead Johnson, F.C., with cat. of more than 300 portraits.)

FRANCIS COTES. 'Unknown gentleman.' Pastel. 23½ins. x 17ins. s. & d. 1747. Leicestershire Museums and Art Galleries.
The date is perfectly clear and makes it Cotes' first known work — but it is more mature in style than several later dated pastels. The costume was probably that of a local club.

FRANCIS COTES. 'Elizabeth Gunning, Duchess of Hamilton and Argyll.' 96ins. x 57ins. s. & d. 1767. Duke of Argyll, Inveraray Castle.
The sunflower, normally aimed at the sun, has transferred its attention to the Duchess, who was considered the great beauty of her time.

FRANCIS COTES. Called 'Lady Alston'. 34ins. x 38½ins. s. & d. 1764. Sotheby's sale 17.11.1971 (87).
The sitter was in fact Margaret Lee, housekeeper and mistress of Sir Thomas Alston, Bart., whose wife was alive and undivorced.

COUNTZE, Frederick 1773-*c.*1799
Painter of history subjects and landscapes. Entered RA Schools 1793, aged 20. He was probably of German origin and his father the Keeper of the Stables at Kensington Palace (d.1789). Exh. RA 1795-99, latterly mainly landscapes.

COURT, W. fl.1780
Exh. FS 1780. 'Lady reading, a St. Catherine.'

COX, Joseph 1757-*c.*1793
Entered RA Schools 1787. Only exh. RA 1793, two portraits, a flower piece and a decorative picture. A profile of George III is engraved after J. Cox in *An inventory of Cox's Museum,* 1794.

COY, James *c.*1750-*c.*1780
Irish landscape painter. Died at Westport *c.*1780, aged about 30. Pupil of Robert Carver before 1769 and of George Mullins 1769. Exh. Dublin 1769-74.

(Strickland.)

COZENS, Alexander *c.*1717-1786
The most famous drawing master of his day and one of the founders of the romantic landscape tradition. Born in Russia; died London 23 April 1786. He had some experience in Vernet's studio in Rome before settling in England for good in 1746. Although he made a few studies in oils on the lines of his blot technique for watercolours, only one oil landscape (1756) has been recorded.

(A.P. Oppé, Burlington Mag., XCVI (Jan. 1954), 21; for bibl. as draughtsman see Mallalieu.)

COZENS, John Robert 1752-1797
The most poetical of English watercolour painters and an inspiration to Girtin and Turner (q.v.). Born London 1752; died there *c.*14 December 1797. Son of Alexander Cozens (q.v.). He travelled to Italy with Payne Knight (1776) and Beckford (1782); and became incurably insane in 1794. A single oil painting is recorded with certainty, a

ALEXANDER COZENS. 'A wooded landscape.' 27ins. x 34ins. s. & d. 1756. Christie's sale 21.5.1954 (75).
The only known oil on canvas by Cozens (one or two tiny oil studies on paper are also known).

large 'Hannibal crossing the Alps' exh. RA 1776, which has disappeared.

(C.F. Bell, Walpole Soc., XXIII (1934/35); some addenda printed 1947; Mallalieu.)

CRADOCK, Marmaduke *c.* 1660-1716/17

Painter of birds and animals in the manner of Casteels (q.v.) His christian name is sometimes wrongly given as 'Luke'. Born in Somerset; buried London 24 March 1716/17. Apprenticed to a house-painter. Vertue *(i, 79/80)*, who admired his work, says he was self-taught and worked largely for dealers. An example, called Cradock in 1736, was in the sale from Knowsley, 22.4.1955, 30. A rare, signed, work is in BAC, Yale.

(Croft-Murray and Hulton, 291.)

MARMADUKE CRADOCK. 'Exotic fowl.' 16½ ins. x 19¾ ins. Signed. B.A.C. Yale.
Cradock painted a great many pictures of this kind, but rather few are signed.

CRANCH, John 1751-1821

Amateur painter of portrait, landscape, and history. Born Kingsbridge, Devon, 12 October 1751; died Bath February 1821. He only once succeeded in exh. SA 1791 a 'Burning of the Albion mill'. Lived long at Bath before he died *(Redgrave)*. Also exh. RA. 1800 (hon.) a 'moonlight'; BI 1807-8.

(Grant.)

CRANKE, James 1707-1780

Lancashire portrait painter. Died Urswick, Lancs., October 1780 aged 73. Started as a plasterer and had trained himself to a very high level. Vertue *(iii, 134)* in 1746 says he had seen a man's head "painted strongly . . . and at least as well as any-one living", which is justified by his 'Thomas Osborne', bookseller, 1747 (BAC Yale). By then he was presumably working in London and there is a bill at Sandon (Feb. 1745) for seven portraits of members of the Ryder family (at 10 guineas for half lengths and 20 guineas for whole lengths) which are quite as good as Hudson and very similar to his. Cranke also painted large copies after the old masters — Raphael, Rubens, Correggio — but not from the originals.

CRANKE, James 1748-*c*.1798

Portrait painter. Entered RA Schools 1775, aged 27. Possibly a son of the last. Exh. portraits RA 1775, 1777, up to 1798. An hon. exh. of landscapes 1799-1800 must have been another person.

CRAWFORD, G. fl.1770-1799

An hon. exh. RA 1770 of a landscape drawing and another in oil. Possibly the same as an hon. exh. of a 'moonlight' in three successive years, 1797-99.

CRAWFORD, Thomas fl.1743

Known only for painting pictures of the retainers in country houses in the Midlands. Two of 1743 are at Corby Castle (*Country Life, 14 Jan., 1954*) and two more, probably by him, at Broughton Castle (*ib., 13 Feb., 1954, 440*).

CRAWLEY, Edmund fl.1772

Hon. exh. of picturesque landscapes in crayons, FS 1772.

CREED, Mrs. Elizabeth 1642-1728

Amateur painter of portraits and epitaphs. Daughter of Sir Gilbert Pickering, 1st Bart. Died May 1728. Her painted family epitaphs are in the Oundle area (*K.A. Esdaile, Burlington Mag., LXXVI (July 1940), 24f.*). A portrait in the manner of Richardson, of 'Pollexfen Bastard', *c*.1725, in Lord Poulett's sale, S, 19.2.1969, 51, was inscribed 'Creed pinxt' in a later hand.

CRONE, Robert *c*.1718-1779

Irish painter of classical landscapes. Born in Dublin *c*.1718; died London. Studied under Hunter in Dublin and won prizes 1748 and 1750. Sent to Italy 1755 and briefly a pupil of Richard Wilson; left Rome 1767. He developed a style which was based on the imitation of Claude and Wilson. Exh. SA 1768; RA 1770-78 (many of his exhibits being drawings).

(Walpole Soc., XXXVI (1960), 48 n. 5; Crookshank and Knight of Glin, 1979, 120 ff.)

RICHARD CROSSE. 'John Crosse, the artist's father.' 46ins. x 38½ins. Sotheby's sale 22.11.1961 (190).
Documented by family tradition. It shows how a miniature painter could work on the scale of life if he wanted to.

CROOK, James 1759-*c*.1781

Portrait and history painter. Entered RA Schools 1776, aged 17. Silver medals 1778 and 1779. Exh. portraits and history subjects RA 1778-81.

CROSSE, Richard 1742-1810

Deaf and dumb miniaturist who also painted a few very competent oil portraits of his own family. Born Knowle, Devon, 24 April 1742; died there 1810. Settled in London *c*.1760 and retired to Wells *c*.1798. Exh. SA 1760-69 and 1790-91; FS 1761-66; RA 1770-96 (always miniatures). His oil portraits are not unlike the earlier work of Reynolds; those of his father and mother were sold S, 22.11.1961.

(Basil Long, Walpole Soc., XVII (1929), 61-94, where the artist's ledger is transcribed, list of known oil portraits 65/6.)

JAMES CRANKE. 'Thomas Osborne'. 78ins. x 56ins. s. & d. 1747. B.A.C. Yale.
Thomas Osborne was one of the best known of London booksellers. This is one of Cranke's few signed works and is at least as accomplished as the work of Hudson. The drapery (better than Hudson's) may well be his own work.

CROUCH, W. fl.1774-1776
Exh. FS 1774-76 a portrait, a religious and a
mythological picture, and a miniature.

CUBITT, Thomas 1757-c.1778
Portrait painter. Entered RA Schools 1773, aged
16. Exh. two portraits SA 1776 and 1778.

CUFAUDE, Francis fl.1745-1749
Very provincial East Anglian portrait and land-
scape painter. Portraits are recorded dated 1746
and 1749 (Ipswich Museum). He is mentioned as a
painter of all work (portrait, miniature, chimney
pieces) working at Denton, Norfolk *(Memoirs of a
Royal Chaplain, ed. Albert Hartshorne, 1905, 56, 59).*

CUITT, George 1743-1818
Yorkshire landscape painter and occasional por-
trait painter. Born Moulton, Yorks., 1743; died
Richmond, Yorks., 3 February 1818. As a bright
local lad he was sent to Italy 1769 by Sir Lawrence
Dundas and dutifully exh. an 'Infant Jupiter', RA
1776, and an occasional portrait up to 1778. A por-
trait of 'Francis Blackburne', 1777 (St. Catherine's
College, Cambridge), has a solid Yorkshire
provincial air with no suggestion of Italy. About
1777 he retired to Richmond for health reasons and
he exh. local topographical landscapes RA
1788-98. These are accurate in delineation but of a
rather monotonous green. He was the father of
George Cuitt Jr. (1779-1854) who was a
distinguished antiquarian topographical etcher and
occasional landscape painter, who sent Welsh
views to the RA from Chester, 1809 and 1818.

CUMING, J.B. fl.1793-1812
Exh. from an address in Walworth at RA portraits
from 1793 to 1798 and landscapes from 1804 to
1812. But there may be some confusion with a son
or brother, **Richard Cuming,** who entered the RA
Schools 1794, aged 18, and, from the same address
at Walworth, exh. landscapes RA 1797-1803.

CUMING, William 1769-1852
Irish portrait painter. Painted the Lord Mayor of
Dublin 1792 but his Dublin exhibits begin 1800.
He was PRHA 1829-32, when he more or less
retired.

(Strickland.)

CUNNINGHAM, Edward Francis *c.*1741-?1795
Portrait painter in oils and crayons — and in
England under the pseudonym of E.F. Calze
(Calza). Said to have been born of a good Jacobite
family at Kelso, which was 'out' in 1745. Taken to
Italy by his father (perhaps to Bologna, if he is the
person sometimes known as 'il Bolognese'); trained
at Parma, Rome (?Mengs and Batoni), and
Naples, and active in Venice and Paris. Brought to
England by Lord Lyttelton and had some success
as a portrait painter. Exh. RA 1770-73 (as 'E.F.
Calze') when several of his portraits were engraved
in mezzotint by V. Green. He left the country in a
hurry and travelled to Prussia and St. Petersburg.
It is not clear if he was also 'F. Calza, il Bolognese'
who exh. crayons, portraits and histories RA
1777-81. By 1784 he was court painter at Berlin
and he is said *(Th-B.)* to have died there 28 April
1793, though Redgrave says he died in poverty in
London, 1795. Court portraits exist in Berlin. His
pictures are peculiar in colour and coarse in
execution.

CURRY, James fl.1730-1738
Portrait painter active in Dublin; known from a
Faber engraving of 'Viscount Mountjoy as Grand
Master of Irish Freemasons'.

(Strickland.)

CURTIS, John fl.1790-1808
Landscape painter. Pupil and, with his wife, lodger
with William Marlow (q.v.) at least 1790-95; his
known landscapes are pretty feeble. Exh. RA
1790-99 landscapes (except for a naval encounter,
1797). It is unlikely that the J. Curtis who exh. RA
1820 and 1822 was the same person.

CURTIS, Sarah fl.before 1692-1742/43
Professional portrait painter. Pupil of Mrs. Beale
(d.1699) and set up in business 'seven years before
Mrs Beale died' *(Vertue, v, 14)*; died 11 January
1742/3. She was the first wife of Benjamin Hoadly,
who had become Bishop of Winchester before she
died. After marriage she only painted family and
friends. A portrait of the Bishop by her is in NPG.

CUST fl.1784/85
A 'Mr Cust' was hon. exh. of landscapes at RA
1784-85. The least unlikely member of the family
would be Francis Cockayne Cust (1721/2-1791),
the recorder of Grantham.

D

D'AGAR (De Garr), Charles **1669-1723**

Portrait painter. Born in Paris 1669; died London May 1723. Son of the painter Jacques d'Agar (1642-1715), with whose whole family he migrated to England 1681 *(Huguenot Soc., XVIII (1911), 127),* and whom he accompanied to Copenhagen *c.*1685 (after apprenticeship to one Robert Robinson, painter-stainer). His father, with whom he is often confused, remained as court painter in Denmark, where he died 1715, but Charles returned to England and settled in London 1691, where he had a good practice, painting portraits very much in the style of Dahl (q.v.). His charges in 1707 were £7 for a 30 by 25 ins. and £12 for a 50 by 40 ins. Vertue says he left a son, who was also a painter, whose name may have been David.

(Vertue, iii, 15.)

DAGLEY, Richard **fl.1785-1841**

All purpose painter, miniaturist, medallist and illustrator. He painted portraits, landscapes, domestic subjects in oil and watercolours and miniatures. Exh. RA 1785, 1790-1833; BI 1822-25. For ten years before 1815 he was drawing master at Doncaster. He was never really either talented or successful.

(Redgrave.)

DAHL, Michael **?1659-1743**

Portrait painter. Born Stockholm 29 September probably 1659; died London 20 October 1743. He studied in Sweden under Ehrenstrahl and started on his travels in 1682, coming first to London, where he may have had some experience in Kneller's studio; via Paris to Rome 1684; left Rome 1687 and came via Frankfurt to London, where he settled for good in March 1689. He soon became the best patronised portrait painter in England after Kneller. He was employed by Prince George of Denmark and did a good many portraits of the Court under Queen Anne, of which the set of Admirals at Greenwich *c.*1702-8, in competition with Kneller, are good examples. A great patron in the 1690s was the Duke of Somerset, for whom he painted the Petworth 'Beauties', also probably in rivalry with Kneller. After 1714 he lost Court patronage but painted an immense number of the nobility, the Law, and the Church. His style is extremely close to that of Kneller but his interpretation of character is less brash and more human. He held a respected position in the London art world until his retirement, from old age, about 1740. In 1712 he charged £50 for a full length royal portrait; in 1724 30 guineas for a half length. He had a son, another Michael (who died 26 November 1741), by whom no paintings have been identified. He was the teacher of Hans Hysing (q.v.) and others.

(Nisser.)

CHARLES D'AGAR. 'Lord George Douglas.' 59½ins. x 42ins. Payment of £16 2s. 6d. for this is recorded in 1709. Buccleuch collection, Drumlanrig Castle, Dumfriesshire.

D'Agar does not normally sign and absolutely certain examples are very few.

MICHAEL DAHL. 'Lady Barbara Browne.' 28ins. x 25ins. The artist's receipt of £31 10s. for this, dated 1732, survives. Sotheby's sale 24.5.1933 (7).
From Ditchley. It is not easy to distinguish a Dahl from a Kneller of this kind.

DAHT, Louis fl.1775
Portrait painter with a very provincial style, who worked in the Shetland Isles.

DALL, Humphry fl.1717
Mentioned as a painter in the will of the still-life painter, Marmaduke Cradock.

(Croft-Murray and Hulton, 291.)

DALL, Nicholas Thomas fl.1748-1776
Scene painter and painter of ruins and topographical landscapes. Of Scandinavian origin, but trained in Italy; died London 10 December 1776. He seems to have studied the Bolognese *quadratura* tradition in Italy, where he was commissioned by Thomas Anson *c.*1748 to paint the scenographic ruin pieces still at Shugborough Hall *(Yorke, 137).* He was settled in London by 1756 and was scene painter at Covent Garden from 1757 until his death. Exh. SA 1761-70; RA 1771-76. ARA 1771. He also painted views of gentlemen's seats, notably in Yorkshire, and a series of topographical views in Yorkshire of *c.*1773 is at Harewood.

(E.C-M.)

NICHOLAS THOMAS DALL. 'Oakage Hall, Colwich.' 35ins. x 53ins. s. & d. 1773. Christie's sale 4.7.1952 (106/2).
One of a pair. His style owes something to scene painting.

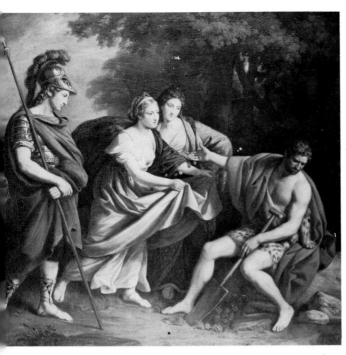

NATHANIEL DANCE. 'Timon of Athens, act iv, scene iii.'
48½ins. x 54ins. Exh. SA 1767 (43). Hampton Court (reproduced by gracious permission of Her Majesty The Queen).
Painted soon after leaving Rome, in a neo-classic style reminiscent of that of Gavin Hamilton.

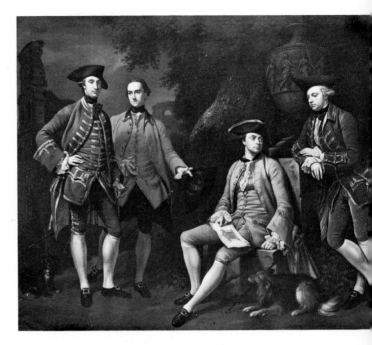

NATHANIEL DANCE. 'Sir James Grant and his friends.' 38ins. x 50ins. Signed. Painted 1760/1. B.A.C. Yale.
Painted in Rome. Dance had to paint four versions, one for each of the sitters. Although there are traces of the style of Dance's first teacher, Hayman, these are overlaid by the influence of Batoni's Roman portraits.

DALTON, Richard c.1715-1791

Failed painter, antiquarian draughtsman, artistic busybody and engraver. Born Dean, Cumbria; died London 7 February 1791. First apprenticed to a London coach painter, but he was in Rome 1741/2, studying from the Antique, and returned to London 1743, already involved in the art trade. Again in Rome 1749, where he met Lord Charlemont, whom he accompanied on his travels in Sicily, Greece, Turkey and Egypt as antiquarian draughtsman. Active in the London art world and involved in the abortive scheme for an Academy in 1755. Again in Rome 1758/9, buying pictures for Lord Bute, through whom he was appointed Librarian to George III in 1760. Again in Italy buying pictures for George III in 1763. He was briefly Treasurer of the Society of Artists 1765, but took the side of the Royal Academy, by whom he was apparently appointed 'Antiquary'. In 1778 he succeeded Knapton as Surveyor of the King's pictures, an appointment he held up to his death. No oil painting by him is known, but there are drawings, etchings and engravings.

(Walpole Soc., XXXVI (1960) 68n.)

DAMINI, Vincenzo fl.1713-1744

Italian history painter, said to have been a pupil of Pellegrini and to have come to England c.1713, probably connected with John Devoto (q.v.), the scene painter, whose portrait he painted. Only known for a wall painting of some imaginary Bishops in Lincoln Cathedral, 1728. Returned to Italy early 1730 with Giles Hussey (q.v.) as a pupil. Later recorded at Aquila.

(E.C-M.; Eric Young, Arte Veneta XXXIII (1979) 70-78.)

DANCE, Nathaniel 1735-1811

Neo-classic history painter and portraitist; changed his name to Dance-Holland and became a baronet, 1790. Born London 18th May 1735; died Winchester 15th October 1811. Son of the architect, the elder George Dance; pupil of Hayman from c.1749; went to Rome 1754 and remained there until 1765. From 1762 in some sort of business relationship with Batoni. Exh. SA 1761-67; FS 1764. His first exhibit *The Death of Virginia*, 1761 (now only known from engraving) was the first British neo-classic history painting, and Dance's early aspirations were all in that direction, but in Rome he also painted a number of conversation pieces and became a competent portrait painter. A passion for Angelica Kauffmann,

99

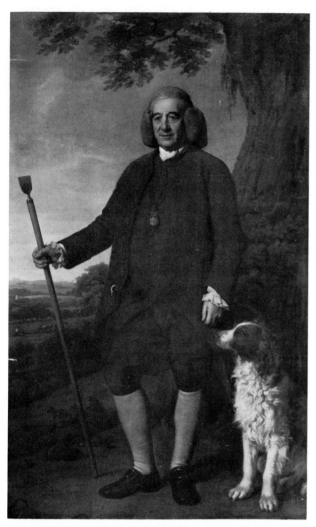

NATHANIEL DANCE. 'Thomas Brown, Garter King of Arms.' 91ins. x 55ins. c.1775. B.A.C. Yale.
Engraved by W. Dickinson, 1780, at the time of Brown's death. He was appointed Garter King of Arms 1774.

an hon. exh. Dance showed some landscapes at the RA 1792, 1794 and 1800, which are reported to have been in pale green tones (?anticipating Constable), but none has certainly been identified. His male portraits especially are solid and full of character, prosier than those of Reynolds, and can easily be identified: many are certified by contemporary engravings.

(David Goodreau, cat. of the Nathaniel Dance exh., Kenwood, 1977; also Ph.D. thesis, with cat., for UCLA, c.1975.)

DANDRIDGE, Bartholomew 1691-*c.*1755
Painter of portraits and conversation pieces. Baptised London 17 December 1691; last recorded there 1754. He had a good business in London and took over Kneller's old studio in 1731. He was a pioneer of the rococo conversation piece and Vertue considered him the ablest and most original exponent of such pictures of his time. 'The Price Family', *c.*1728 (New York) is a good example.

(C.H.C. Baker, Burlington Mag., LXXII (March 1938), 132ff.)

DANIEL fl.1764-1767
Exh. still life pictures at FS 1764-67.

DANIELL, Samuel 1775-1811
Topographical artist (especially drawings and aquatints) and painter of the animals of South Africa and Ceylon. Born 1775; died in Ceylon December 1811. Nephew of Thomas Daniell (q.v.) and younger brother of William Daniell (q.v.) but trained independently of them. Pupil of T. Medland, the topographical engraver, 1791-93. Exh. SA 1791; RA 1792-93 and 1804-6. He joined General Dundas' expedition in South Africa 1801 and travelled extensively in the unknown interior of Africa, bringing back many drawings of landscape, people and animals, from which he published aquatints in *African Scenery and Animals*, 1804/5. In 1806 he left for Ceylon, where he undertook the same sort of work and remained till he died. A painting of Ceylon was exh. posthumously at RA 1812.

(Thomas Sutton, The Daniells, 1954; Maurice Shellim, India and the Daniells, 1980.)

DANIELL, Thomas 1749-1840
Topographical painter and draughtsman and aquatinter of Indian scenes. Born Chertsey 1749; died London 18 March 1840. He started as a coach painter 1763-70 with Maxwell and then with Catton (q.v.), but entered the RA Schools 1773

conceived in Rome, came to nothing when both had come to London in 1766. Dance's 'Timon of Athens', SA 1767 (Royal Collection) may reflect this. Foundation RA 1768. He had very good patronage for portraits in London and showed portraits of the King and Queen (Uppark) at the first RA 1769. Exh. RA 1769-76, mainly portraits until 1776, when he showed 'The death of Mark Antony' (Knole) and ceased to exhibit. He seems to have inherited a fortune in the 1770s and gave up portrait painting altogether in 1782, but remained a prominent figure in the art world until 1790, when he became an MP, resigned from the RA and married an immensely rich widow. In later life he and his brother George Dance the younger (1741-1825, architect and portrait draughtsman) did a great many political caricature drawings, but their authorship cannot now be disentangled. As

and from 1774 to 1784 exh. RA flower pieces, topographical views (especially of Yorkshire) and, in 1780, scenes from Spencer. He sailed with his nephew, William (q.v.), in 1785, via Canton, to Calcutta. Both travelled extensively, at first in northern India, converting their drawings into 150 oil paintings in 1791, for which they organised a lottery. In 1792 they travelled in southern India and were back in England by 1794, where they published a series of 144 aquatints of 'Oriental Scenery' in six parts, 1795-1808. These splendid works imposed a new vision of the Indian scene on the British mind. He became ARA 1796; RA 1799 and exh. RA 1795-1820; BI 1806-30. His subjects were almost wholly Indian or such Anglo-Indian scenes as the gardens of Sezincote, RA 1818/9. He more or less retired in 1820 and painted rather little thereafter.

(Thomas Sutton, The Daniells, 1954; Mallalieu; Farington, 22 Aug. 1803; Maurice Shellim, India and the Daniells, 1980.)

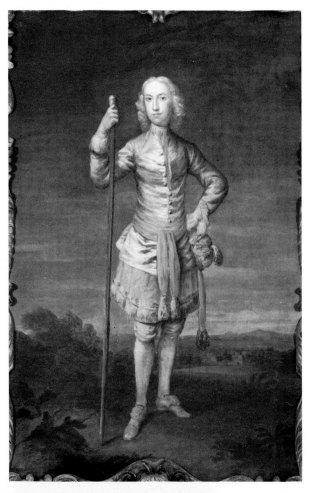

BARTHOLOMEW DANDRIDGE. *'Valentine Knightley in Eton Montem dress.'* 70ins. x 45ins. s. & d. 1736. Sotheby's sale 21.3.1979 (80).
The Eton 'ad Montem' procession was a curious ceremony (abolished in the 1840s) which took place on Whit Tuesday. Two 'salt bearers', who wore a variety of fancy dress, levied contributions from visitors.

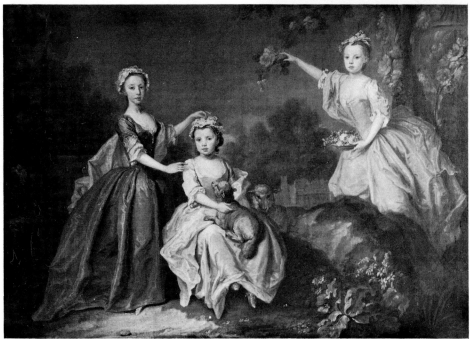

BARTHOLOMEW DANDRIDGE. *'The Ladies Elizabeth, Jane and Juliana Noel.'* 45ins. x 68½ins. Signed. c.1736/7. Manchester, City Art Gallery.
The three eldest daughters of the 4th Earl of Gainsborough; born 1731, 1733 and 1734.

HENRI-PIERRE DANLOUX. 'The family of Henry, 3rd Duke of Buccleuch.' 49ins. x 39½ ins. s. & d. 1798. Buccleuch collection, Bowhill, Selkirk.
The most elaborate and accomplished of this French refugee painter's works done in Britain.

DANIELL, William **1769-1837**

Topographical artist and aquatinter. Born 1769; died London 16 August 1837. Nephew and pupil of Thomas Daniell (q.v.), whom he accompanied and worked with in India 1785-94. Entered RA Schools 1799, when already a very experienced painter of Indian topographical landscapes. Exh. RA 1795-1837; BI 1807-36. ARA 1807; RA 1822. He was the best aquatinter in the family and most of his work is in watercolour or aquatint. After 1802 he turned his attention to British scenery and from 1814 to 1825 produced unaided an enormous series of engravings 'The Voyage round Great Britain'. He also painted Indian panoramas and was awarded a prize by the BI in 1826 for a 'Battle of Trafalgar'.

(Thomas Sutton, The Daniells, 1954; Maurice Shellim, India and the Daniells, 1980.)

DANKS, Benjamin **1758-1790**

Painter of domestic subjects. Entered RA Schools 1782 aged 24 and was a pupil of H. Walton (q.v.) 1783. Exh. RA 1783 and 1790 'Patience' and 'The rat trap'.

DANLOUX, Henri-Pierre **1753-1809**

French *émigré* portrait painter. Born Paris 24 February 1753; died there 3 January 1809. He was a friend of Vien and accompanied him to Rome, where he remained till 1780 and acquired a portrait style somewhat reminiscent of Madame Vigée-Lebrun. Later settled at Lyon and fled from the Revolution to London January 1791, returning to Paris late in 1800. He took some trouble to meet British painters and admired Romney above the others, and he had a number of British sitters. He exh. RA 1792-96 and 1800 (always portraits except for a figure of 'Calypso'), but he did also paint genre and history. In 1796 he visited Scotland where he had some success and painted an accomplished group (signed and dated 1798) of 'The family of the 3rd Duke of Buccleuch' and an ambitious portrait of 'Admiral Viscount Duncan' (small replica in NPG). His English *Diary* is a valuable source of information about the French *émigré* world *(Roger Portalis, H-P.D. et son journal durant l'émigration, Paris, 1910)*. Danloux did not meet with much success after his return to Paris.

DARE, J. **fl.1783**

Exh. a 'View from nature', SA 1783.

DASHWOOD, J **fl.1790**

Exh. 'Cutters: a sea piece', SA 1790 from an address at Newport, Isle of White.

DASHWOOD, R. **fl.1789-1797**

Hon. exh. at RA of a 'Landscape with sheep and goats', 1789; and antiquarian views of Paestum and Rome in 1797.

DAVIES, R. **fl.1771-1806**

Hon. exhs. named R. Davies (an 'artillery captain in 1771, and an 'esquire' in 1806) fitfully exhibited flower pictures and views between 1771 and 1806.

DAVIS, Charles **1741-1805**

Pastellist, resident at Bath, where he was painted by Thomas Beach (q.v.), 1798 (Victoria Art Gallery, Bath), who was his tenant.

DAVISON **fl.1783**

Exh. FS 1783 'Boy and ass'.

DAVISON, Jeremiah *c.*1695-1745

Portrait painter from a Scottish family, but born in England. Died London December 1745. His style is not unlike that of Highmore and he frequented presumably the Kneller Academy. He first emerges *c.*1730, when he painted the Prince of Wales and did some copying (after Van Dyck and Lely) in the royal collection. He painted the Duke of Atholl in a masonic context, and was brought to Scotland by the Duke, where he did very good business *c.*1737-40 (portraits at Blair Castle and Abercairny). He was one of those, with Hudson (q.v.) and others, who employed Van Aken (q.v.) for drapery, but his faces are nearer to Hogarth and less smooth than Hudson's.

(Vertue; Irwin, 1975.)

DAVY, Robert **fl.1755-1793**

Portrait painter in oils, crayons and miniatures, and professional copyist. Born Cullompton, Devon; died London 28 September 1793. He studied in Rome 1755 to *c.*1760 and again in 1765. Exh. SA 1762-70; RA 1771-82. In 1777 and 1778 he showed 'a conversation'. He was best known as a drawing master (Woolwich Academy).

(Edwards; Long.)

JEREMIAH DAVISON. 'James, 2nd Duke of Atholl.' 92ins. x 57ins. s. & d. 1736. From the collection of the Duke of Atholl, Blair Castle.
The most ambitious portrait of Davison's great Scottish patron. It is very close in style to the contemporary work of Highmore.

DAWES, Philip *c.*1750-1774
Painter of stage scenes and light historical subjects. Pupil or assistant to Hogarth in earlier 1750s; there may have been a post-mortem sale in 1780. Exh. SA 1760-62; FS 1764-74 a series of subjects from Shakespeare in a manner deriving from Hogarth. He has been confused with a mezzotint engraver, P. Dawe, who seems to have been connected with Henry Morland.

(Edwards.)

DAY, Thomas *c.*1733-*c.*1808
Probably landscape painter and restorer, known as 'MacGilp Day'. Died *c.*1808, aged 75 (*Farington, 28 June 1808*). Usually confused with the miniaturist but he was probably the T. Day from Brentwood, Essex, who exh. a landscape RA 1774 and the T. Day from near Romford, Essex, who exh. land-scapes SA 1783, and ended up as a restorer in poor circumstances. But 'MacGilp Day' has also been supposed to be another miniaturist, Alexander Day (*cf. TLS, 16 May 1952, 324*).

DAY, Thomas fl.1768-1788
Portraitist in crayons and miniature. In 1768 he is listed as 'Master Day, pupil of Mr Dodd' and also as a pupil of Ozias Humphry (q.v.). Exh. FS 1768-71; SA 1768-78; RA 1773-88 (nearly always miniatures). Entered RA Schools 1770 (*cf. Long — with confusions*).

DEAN, Hugh Primrose fl.1758-*c.*1784
Irish-born landscape painter of classical pretensions. He was married in Cork 1761; died in London *c.*1784. He met Lord Palmerston at Chepstow, 1765, who became his patron and paid for his journey to Italy. In Rome 1768-79, with some time spent in Florence, where he became a member of the Academy, 1776. Exh. FS 1765; SA 1766-80; RA 1777, 1779, and 1780, always land-scapes. Early views on the Elbe and Danube, 1768, do not necessarily require a visit. He was one of those glib Irishmen, who got himself nicknamed 'the Irish Claude', and was a devoted imitator of Gaspard Poussin. In 1780 he also opened a 'transparent representation of the eruption of Vesuvius' as a side show, but when this venture failed to get him patronage he turned Methodist preacher.

(Edwards; Strickland.)

DEAN, John 1754-1798
Mezzotint engraver and occasional painter of fancy subjects. Born 16 May 1754; died 1798. Entered RA Schools 1771, and pupil of Valentine Green 1773. Exh. a portrait and fancy subjects, some of which he engraved himself, RA 1789-91.

DEAN, P. fl.1789-1790
Exh. flower pieces at RA 1789; SA 1790.

DE BITTIO See BITTIO, A. de

DE BREDA See BREDA, C.F. von

DE BRUYN See BRUYN, T. de

DE CAMBRUZZI See CAMBRUZZI

DE CONING See CONING, D. de

DE CORT See CORT, H.F. de

PHILIP DAWES. 'Scene from The Taming of the Shrew.' *24½ ins. x 29½ ins. s. & d. 1762. Exh. SA 1762 (27). Sotheby's sale 12.2.1964 (191).*
The influence of Hogarth is very pronounced.

DE FLEURY, J. fl.1799
Exh. RA 1799 'The flower girl' and a literary subject.

DE GARR See D'AGAR, C.

DE GIRARDY See GIRARDY, J. de

DE GROOT, J. fl.*c.*1735-1748
Portrait painter. Faber Jr. engraved in mezzotint a portrait of 'Thomas Coster, M.P.', *c.*1735, after 'J. de Groot Junr.'. He is probably also the 'De Groit' listed as 'an eminent painter' in the *Universal Magazine,* Nov. 1748.

DELACOUR, William fl.1740-1767
Portrait painter in oils and crayons; also decorative painter and scene painter. Died Edinburgh 1767 'of old age'. First recorded in London doing scene paintings for London theatres; already in 1752 calls himself 'portrait painter in oils and pastel'. Scene painting in Dublin 1753 and in Edinburgh by 1757. He became definitely established as an artist in Edinburgh and was made first Director of the School of Design 1760. His large gouache wall paintings at Yester are dated 1761 and show knowledge of Gaspard Poussin and Pannini. Portraits, very provincial in style, survive in Scottish collections dating from 1758 to 1765.

(E.C-M.)

DE LA NAUZE, Alexander 1704-1767
Portrait painter in Dublin, where he died 31 January 1767, aged 63.

(Strickland.)

DELANE (DELANY), Solomon fl.1752-1812
Irish landscape painter in a classical tradition. Trained in Dublin under Robert West and died there 1812. He etched a portrait in Dublin 1752, but was in Rome by 1755 and only left in 1782, having conceivably travelled as far as Athens. He is said to have become very expert in imitating (and perhaps faking) the work of Claude, and he certainly also studied Gaspard Poussin. Exh. (from Rome) SA 1763, 1773 and 1776; RA 1771, 1777-84, when he returned to Dublin. Five

WILLIAM DELACOUR. 'Self portrait.' Wood. 13½ ins. x 10½ ins. s. & d. 1765. Christie's sale 6.7.1956 (14).
This has rather more character than his commissioned portraits.

R. DELLOW. 'E. Newman as a boy.' 49ins. x 39ins. s. & d. 1725. Sotheby's sale 18.2.1959 (91).
An extremely close follower of Kneller.

Gaspardesque 'Views near Dublin' of *c*.1785-87 are at Belvoir Castle. In 1787 he was appointed Cork Herald and he sent pictures to exhibitions in Dublin 1802 and 1812.

(Strickland; Crookshank and Knight of Glin, 1979.)

DELLOW, R. **fl.1711-1749**
Portrait painter in the Kneller tradition. Latest dated portrait said to be 1749. Subscriber to Kneller's Academy 1711 and one of those who completed Kneller's unfinished pictures (*Vertue*). His name is often read as 'Dellon' but he appears in Oxford college accounts as 'Delleau'.

(Poole, iii, 164.)

DE LONGASTRE *c*.**1747-1799**
French *émigré* portrait painter in crayons of high professional competence. Said to be about 50 in 1797 and to have been a gendarmerie colonel (*Farington, 10 May, 1797*) His initial is uncertain; only known from exh. at RA between 1790 and 1799. His '4th Duke of Buccleuch', 1795, is at Bowhill.

DE LOUTHERBOURG See LOUTHERBOURG, P.J. de

DENES, William **fl.1778**
Exh. FS 1778 'Jupiter and Europa' and a landscape.

DENUNE, William (or ?Peter) **fl.1729-1750**
Scottish portrait painter. Signs simply 'De Nune'. Perhaps the William who signed the indenture of the Edinburgh Academy of St. Luke 1729 and died Dumfries June 1750. Dated works are known, 1742-50, which suggest a knowledge of Hudson (q.v.); two are at Edinburgh.

DENYS, Peter **fl.1779**
Exh. 'a dog', in crayons, RA 1779.

DE LONGASTRE. *'Mrs Fryer.' Pastel. 21ins. x 17½ins. s. & d. 1798. Christie's sale 2.7.1948 (123).*
Although not recorded as exhibiting in France, De Longastre obviously had good professional training.

WILLIAM DENUNE. *'Unknown gentleman.' 29½ins. x 24½ins. s. & d. 1745. National Gallery of Scotland, Edinburgh (2037).*
His works are not known out of Scotland, but he may have been familiar with London portraiture of the 1740s.

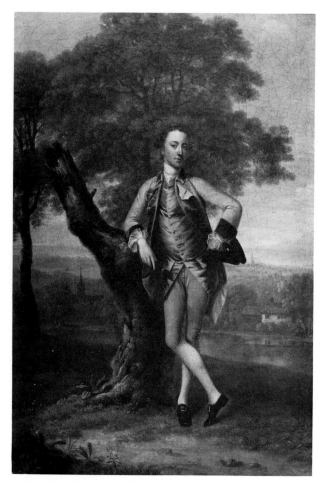

ARTHUR DEVIS. 'Thomas Lane.' 25ins. x 16½ins. s. & d. 1755. Mrs Donald Hyde. Four Oaks Farm, N.J.
This is a standard size for Devis portraits, suitable for small rooms. The somewhat genteel pose and the suit were both often repeated.

DESPORTES, François **1661-1743**
French painter of animals and flowers. Received at the Académie 1699 as 'painter of animals' and thereafter much employed by the French crown. Briefly in England 1712 (official leave to visit England 21 September 1712), where he was employed by Lord Burlington (*Vertue, iv, 64*).

DEVIS, Anthony *c.*1729-1816
Topographical landscape painter in oils and watercolours. Born Preston 18 March 1728/9; died Albury, Surrey, 26 April 1816. Half brother of Arthur Devis (q.v.). In London from 1742; premium for landscape at SA 1763. Exh. FS 1761 and 1763; RA 1772 and 1781. He painted a few oil landscapes and travelled very extensively, mainly producing topographical watercolours.

(S.H. Pavière, The Devis family of Painters, 1950; Mallalieu.)

DEVIS, Arthur *c.*1711-1787
The leading exponent of the small scale, middle class, conversation piece and the corresponding small scale whole length single figure (24 by 16 ins.). Born Preston 19 February 1710/11; died Brighton 25 July 1787. Pupil of Tillemans (q.v.). In good practice (probably both in Lancashire and London) by 1745. He had a few upper class sitters, but his neat and genteel style appealed chiefly to the newly enriched classes. Exh. FS 1761-75 and 1780. He became President of the FS at the time of the secession of those who formed the Royal Academy. In later years he took to painting on glass. His repertory of poses is of great value for the social historian, but seems to have amused the nobility.

(S.H. Pavière, The Devis family of Painters, 1950; Ellen D'Oench, Ph.D. thesis, Yale, 1979; A.D. and his contemporaries exh. Yale, 1980.)

DEVIS, Arthur William **1762-1822**
Portrait and history painter and painter of Indian peasant scenes. Born London 10 August 1762; died there 11 February 1822. Son and pupil of Arthur Devis (q.v.). Entered RA Schools 1774. Exh. FS (mainly drawings) 1775-80; RA 1781-82. He went out in the *Antelope* in 1782 as draughtsman to an expedition to the East Indies, was stranded for a year at Canton in 1784, and practised painting with success in India *(Forster)* 1785-95. Apart from portraits he painted (1792 ff.) a remarkable series of pictures illustrating the 'arts, manufactures and agriculture of Bengal', sold S, 21.5.1979, 27-49, repd. On his return to England he painted mainly portraits and a few history pictures. Exh. RA 1791-1821; BI 1806-19. He was financially feckless in his later years and was mainly supported by John Biddulph of Ledbury. His portraits have individual character and are rather varied.

(S.H. Pavière, The Devis family of Painters, 1950.)

DEVIS, Thomas Anthony **1757-1810**
Painter of portraits and fancy pictures. Born London 15 September 1757; died 28 September 1810. Son of Arthur Devis (q.v.) and presumably his pupil, but the feeblest artist member of the family. Entered RA Schools 1773. Exh. FS 1775-79; SA 1777; RA 1782 and 1788. Little of his work is known to survive and that little is undistinguished.

(S.H. Pavière, The Devis family of Painters, 1950.)

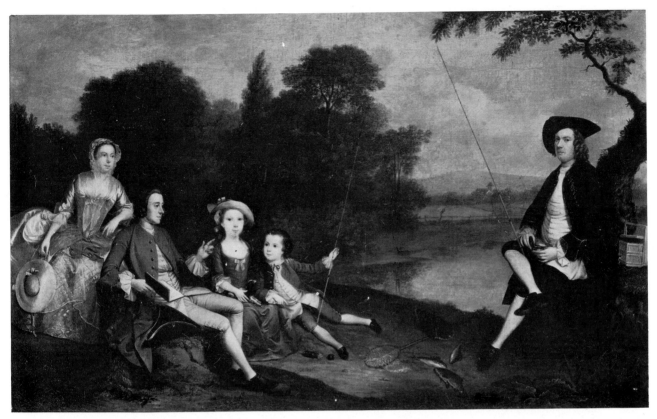

ARTHUR DEVIS. 'The Swaine family.' 24½ ins. x 39¾ ins. s. & d. 1749. B.A.C. Yale.
The only Devis of a fishing party known, and an unusually natural and domestic group.

ARTHUR WILLIAM DEVIS. 'Ploughing, Bengal.' 18ins. x 24ins. c.1793. Sotheby's sale 21.3.1979 (33).
One of a set of twenty-six paintings, executed 1793-95 (and intended for engravings) illustrating the Arts, Manufactures and Agriculture of Bengal. Two more are now in the Ashmolean Museum, Oxford.

ARTHUR WILLIAM DEVIS. 'Colin Shakespear.' Circle. 34ins. Signed. Perhaps c.1785. Christie's sale 8.5.1936 (63).
Painted in India in a style which suggests that Devis was trying to emulate the portraits Zoffany was painting in India at the same time.

109

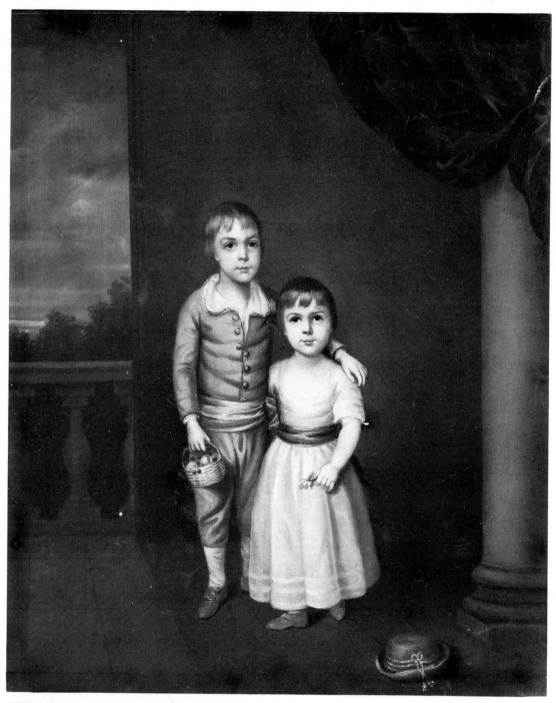

THOMAS ANTHONY DEVIS. 'Thomas Henry Bund and William Bund.' 29ins. x 24½ins. s. & d. 1778. Christie's sale 29.3.1935 (67).
One of the very few known works by the son of Arthur Devis, who did not have his father's elegance.

DEVOTO, John fl.1708-?1752

Decorative history and scene painter. Of Italian origin, but born in France; documented as in England 1708-52 (a dated frontispiece). In 1708 he was assistant to Lanscroon (q.v.) at Burley-on-the-Hill. In 1718 took an apprentice in London as a 'master history painter'. A portrait of him by Damini (q.v.) was engraved by Faber, 1738, as 'Historicus, scenicusque pictor' and his work as a scene painter is well documented (*E.C-M., The Society for Theatre Research Pamphlet Series, 2, 1952*). Only drawings, in a style related to Thornhill's, survive for his work as a history painter. It was presumably another John Devoto, a son, who exh. a flower piece in Indian ink at SA 1776.

(E.C-M.)

DE WILDE, Samuel 1751-1832

Portrait painter in oils and watercolours, especially of actors in character parts. Baptised London 28 July 1751; died there 19 January 1832. His family was of Dutch origin. Apprenticed to a joiner, but switched to art and entered RA Schools 1769; one would guess he had some early contact with Zoffany or Walton (qq.v.). Exh. SA 1776-78 (small portraits); RA 1778-1821; BI 1812. His theatrical portraits began in 1790 for John Bell's *British Theatre* and first appeared at the RA 1795. From then on he did little else, and the bulk of his work is in pencil or watercolour. The largest collection is at the Garrick Club.

(Ian Mayes, The De Wildes, exh. cat. Northampton, Sep./Oct., 1971.)

DIAKOFF, Filetre fl.1773

Exh. 'two portraits, in oil', RA 1773.

DICKINSON, Miss A. fl.1796-1804

Exh. pictures of flowers or fruit, RA 1796-1804.

DICKSON, Miss Frances fl.1772

Exh. three portraits, SA 1772.

DIEMAR, Benjamin fl.1772-1783

Painter of historical subjects (possibly in miniature), miniatures and watercolour landscapes. Exh. SA 1772, from Cambridge, watercolour landscapes; RA 1776, 1778 and 1783 (in last year only, from Cambridge).

DIXON, Miss fl.1771

Exh. 'Portrait of a boy', SA 1771.

DODD, Daniel fl.1761-1780

Portraitist in crayons and miniature and occasionally in oil; also flower painter. Exh. rather abundantly at FS 1761-80; SA 1772 and 1780. Said to have taught the miniaturist Smart.

(Long.)

DODD, D.P. fl.1768-1778

Painted heads, figures and landscapes. Probably son of the last. Exh. FS 1768-78.

DODD, R. fl.1787-1789

Exh. portraits RA 1787-89.

DODD, Ralph fl.1779-1817

Maritime painter. Exh. FS 1779-80; SA 1780-91 (also one portrait); RA 1782-1809.

(Archibald.)

DODD, Robert 1748-1815

Maritime painter: probably brother of last. Exh. SA 1780.

(Archibald.)

SAMUEL DE WILDE. 'Henry Beckwith.' 9¾ ins. x 7¾ ins. Inscribed with artist's name and date 1788 on the back. Private collection.
This shows De Wilde's style shortly before he began on his well known series of theatrical portraits of actors in specific roles.

WILLIAM DOUGHTY. 'William Mason.' Oval. 29ins. x 24ins. Exh. RA 1778 (87). York City Art Gallery.
William Mason (1724-97) was a great friend and the biographer of Reynolds who had painted his portrait (which Doughty later engraved in mezzotint) in 1774. This was a present from the sitter to the 2nd Earl Harcourt.

DOMINICUS, Mrs. fl.1789
Hon. exh. of a 'Hebe', RA 1789.

DOOR fl.1782
Exh. a 'Landscape with a water mill', FS 1782.

DOUGHTY, William 1757-1782
Portrait painter and mezzotint engraver. Born York 1 August 1757; died at Lisbon 1782. He was a *protégé* of William Mason, who sent him to London, where he entered the RA Schools 1775 and studied under Reynolds up to 1778. Exh. RA 1776-79. He visited Ireland (1778) without much success and scraped some accomplished mezzotints after Reynolds 1779. He set out for India in 1780 but died *en route.* He was potentially the ablest of Reynolds' students and the closest to Reynolds in style.

(J. Ingamells, Apollo, LXXX (July 1964), 35ff.)

DOWDNEY fl.c.1760
A portrait of 'Henry Bankes' (d.1776) at Kingston Lacy is traditionally called 'Dowdney'.

DOWNER, Nathan fl.1769-1774
Painter of portraits and character heads. Entered RA Schools 1769. Exh. RA 1771-74.

DOWNES, Bernard fl.1761-1775
Portrait painter and occasional landscape painter. Exh. SA 1761-68; RA 1770-75.

DOWNMAN, John 1750-1824
Mainly distinguished as the prettiest and most elegant of portrait painters of his age in chalk and watercolours, but he was also an accomplished executant in oils. Born, probably near Ruabon, 1750; died Wrexham 24 December 1824. Pupil of Benjamin West (q.v.) 1768 and entered the RA Schools 1769. Exh. FS 1768; RA 1770-1819; BI 1806-10. ARA 1795. Although from 1773 he exh. a few, mainly small, subject pictures, they were mostly disastrous. He travelled to Italy and was in Rome with Wright of Derby 1773-74. In 1777-78 he was at Cambridge where, in addition to the beginnings of his series of portrait drawings, he painted a number of small portrait heads in oils, in a neat manner, similar to that of Wheatley. He began about 1776 his annotated 'albums' of portrait drawings (several of which are in the Fitzwilliam Museum, Cambridge) from which he could later execute a number of repetitions *(for the best account of what survives, see E. Croft-Murray, British Museum Quarterly, XIV (1940), 60-66.)* From 1779 to 1804 he was settled in London, but later travelled considerably. In 1806 he made an injudicious marriage at Exeter, but left after his wife died in 1808. He was again mainly in London until he settled in Chester, 1817.

(G.C. Williamson, J.D., 1907.)

DRAKE, Nathan c.1728-1778
Painter of portraits, country houses and landscape at Lincoln and York. Born Lincoln; died York 19 February, 1778. Apprenticed to his brother, a cabinet maker, at York, where he was settled for the rest of his life. Some of his topographical views (and some illustrations to Thomson's *Seasons*, 1775) were engraved. Exh. SA 1771-76. A rather Canalettesque 'View near Lincoln', signed 'ND', is at Lincoln. Another Nathan Drake, a London colourman, was also a painter and it was probably he who exh. a landscape FS 1783.

(Cat. of Paintings, York Art Gallery, II, 1963.)

DRAPER, Mrs. William See EVELYN, Susanna

JOHN DOWNMAN. 'Unknown gentleman.' Copper. 8¾ ins. x 7¼ ins. s. & d. 1778. Christie's sale 21.12.1950 (70/1).
Probably one of the portraits of undergraduates or dons painted while Downman was at Cambridge 1777/8.

DRUMMOND, Samuel ?1770-1844

Painter of portraits and, later, of naval and biblical scenes. Entered RA Schools 1791, aged 21 (Redgrave says he was born London 25 December 1763); died August 1844. He began with crayons portraits, but is best known for later portraits in oils (several in NPG) of even mediocrity. Exh. SA 1790; RA 1791-1844; BI 1807-44. ARA 1808, for reasons which are not clear.

(For practice see Farington, 4 June 1804; Archibald.)

JOHN DOWNMAN. 'The Return of Orestes.' Panel. 19½ ins. x 25ins. Exh. RA 1782 (119). Formerly with Messrs. A. Tooth (1948).
A record of a performance in private theatricals in which all the characters are portraits — with the Prince of Wales as Orestes.

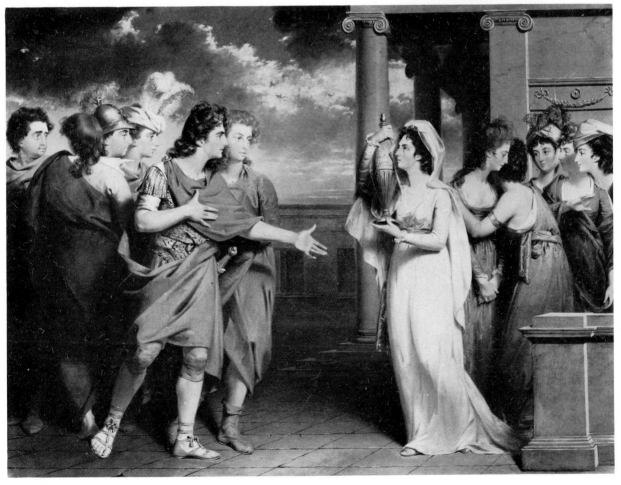

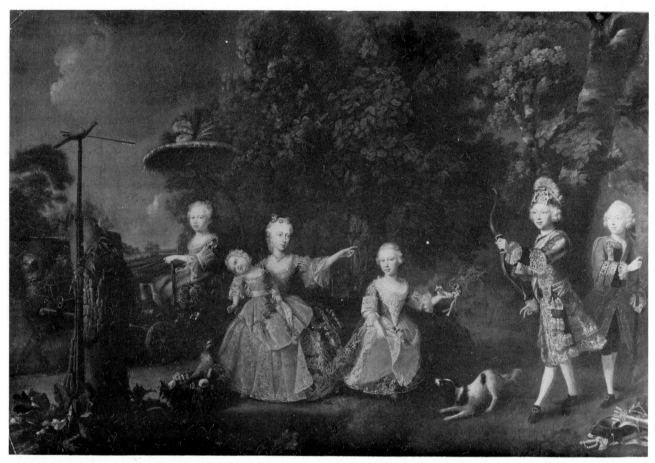

BARTHELEMY DU PAN. 'The children of Frederick, Prince of Wales, with their mother.' 94¼ ins. x 144ins. s. & d. 1746. Reproduced by gracious permission of Her Majesty The Queen.
One of the earliest royal portraits in an informal conversation piece. Prince George (later King George III) is shown in the uniform of the Royal Company of Archers, with the St. Andrew's cross.

DU BOURG, M. fl. 1786-1808
Probably a French *émigré* painter. Exh. portraits at RA 1786 and 1797, and a 'Scene near Vauxhall', 1808.

DUCREUX, Joseph 1737-1802
French painter of portraits in oil, crayons and miniature. Born Nancy 26 June 1737; died Paris 24 July 1802. The only pupil of Quentin de La Tour. 'Premier Peintre' to Queen Marie Antoinette, but not a member of the Académie. He paid a brief visit to London and exh. three portraits and two character heads at RA 1791, but he also exh. at the Paris Salon 1791 and 1793.

DUFFIN, Paul fl. 1755-1775
Itinerant painter of portraits and low class genre; and, later, picture dealer and cleaner. His father kept a madhouse at Chelsea and Redgrave says he painted a number of portraits in the Canterbury area. A 'Rent Day' is dated 1755. Exh. SA 1772-73 'Ale-house politicians' and 'The Levee'; RA 1775 a 'Procession to a country wedding'.

DUFOUR, Charles fl. 1778
Exh. a landscape, FS 1778.

DUFOUR, William fl. 1765
Exh. portraits at FS 1765.

DUFRETAY, L. 1771-1802
Presumably a French *émigré* portrait painter. Allowed to study at RA Schools 1795, aged 24. Hon. exh. of portraits 1797, 1801, and (not hon.) 1802.

DUHAMEL, Guillaume (William) fl.1767-1783
Painter from Bruges of landscapes, histories and fancy subjects. Exh. FS 1767-68; SA 1780 and 1783; RA 1780-81 and 1783.

DUNKARTON, Robert ?1744-c.1810
A first rate mezzotint engraver, who began as a portraitist in crayons. His crayons exhibits were SA 1768 (when a pupil at Pether's); RA 1774-79. His latest dated prints published by himself are 1810 (*Chaloner-Smith*). He won seven premiums for drawings at the SA 1761-67.

DUNTHORNE, James 1730-1815
Portrait painter and miniaturist at Colchester, where he was also a surveyor. Apprenticed to Joshua Kirby 1745 (*information: J. Bensusan-Butt*). He exh. miniatures at RA 1784 and 1786, and some of his fancy pictures were engraved. His son, another James, who predeceased him, was a caricaturist of some ability.

DU PAN, Barthélémy 1712-1763
Swiss portrait painter in oil and crayons. Born Geneva 18 August 1712; died there 4 January 1763. He studied at Paris and Rome and was already in England 1743. His major work in England is the large group of the 'Children of Frederick, Prince of Wales', 1746 (Windsor Castle) which is something of a landmark in its informality for a royal portrait group. He was briefly in Ireland in 1750 and back in Geneva by 1751.

(Burlington Mag., LXXXVIII (June 1946), 152.)

DU PARC, Mrs. fl.1766
Exh. crayons portraits, SA 1766. She is perhaps the same as the 'Mrs Du Part' who exh. portraits, FS 1763.

DUPONT, Gainsborough 1754-1797
Devoted assistant and imitator of his uncle, Thomas Gainsborough, in portrait, landscape and fancy pieces. Born 24 December 1754; died London 20 January 1797. He was apprenticed to Gainsborough 1772 for seven years and entered RA Schools 1775. He remained with Gainsborough as his only assistant until Gainsborough's death, producing studio replicas and scraping mezzotints of the late fancy pictures, for which he made small oil copies. His first unaided work of this sort was 1784. After his uncle's death, he inherited his studio properties and lived for a time in Mrs. Gainsborough's house, but he was of too timid and retiring a disposition to inherit his practice, though he was patronised by Pitt and the royal family. Exh. RA 1790-95. Some of his portraits, e.g. two at Southill of 1788, are hardly to be distinguished from late Gainsborough, but he tends to elongate the figures and exaggerate the scratchiness of Gainsborough's technique. From 1793 he did several portraits of actors for Thomas Harris — several of which are at the Garrick Club (*J. Hayes, Connoisseur, CLXIX (Dec. 1968), 221ff.*). His major work is 'The Elder Brethren of Trinity House', 1796 (Trinity House). A number of landscapes (often attributed to Gainsborough) can be identified with certainty (e.g. Detroit and Brooklyn Museums): these are flimsier than Gainsborough's.

(J. Hayes, The Drawings of Thomas Gainsborough, 1970, 64); J. Hayes, The Landscapes of Thomas Gainsborough, forthcoming.)

DURADE, J.B. fl.1767
Hon. exh. of 'A view of the spring of Vaucluse', SA 1767.

GAINSBOROUGH DUPONT. 'Gypsy encampment.' 35½ ins. x 27½ ins. Courtesy Brooklyn Museum.
This is probably identifiable with the picture in Gainsborough Dupont's sale 11.4.1797 (89).

DURAND, John fl.1777-1778
Exh. landscapes, RA 1777-78.

DURANT, John 1770-1797
Entered RA Schools 1791, aged 21; silver medal
1793. Exh. a portrait RA 1796 and 'Mad Peg, from
a song by Dibdin', 1797.

DURNO, James c.1745-1795
Historical painter. Born Kensington c.1745; died
Rome 13 September 1795. Pupil of Casali and
West, for whom he made copies. Won premiums
for drawings at SA 1762 and 1765; and for history
pictures 1766, 1770 and 1773. Exh. FS 1767 (a por-
trait); SA 1767-73 (histories). Entered RA Schools
1769. Went to Rome 1774, where he remained till
his death. One of the two pictures he painted at
Rome for Boydell's Shakespeare Gallery is in the
Soane Museum and is remarkably feeble (*Nancy
Presley, The Fuseli Circle in Rome, exh. cat., BAC Yale,
1979, 79-81*). He came second in a competition for
the ceiling of the great hall of the Ducal Palace at
Genoa, 1783, for which there are drawings at
Berlin.

(Peter Dreyer in Jahrbuch der Berliner Museen, 1973, 38ff.)

DUSIGN, Dederick fl.1769-1770
Portrait painter. Native of Bath; died Rome 1770.
Entered RA Schools 1769 and died soon after
reaching Rome. Redgrave says he was a pupil of
Reynolds. His mother was sister to the Earl of
Hyndford.

*GAINSBOROUGH DUPONT. 'A lady and her children.' 57½ ins.
x 46½ ins. Exh. RA 1793 (526). Christie's sale 26.7.1946 (42).*
The attenuation of the figures and the way of treating the hair
are characteristic of Dupont.

*GAINSBOROUGH DUPONT. 'William Mainwaring'
(1737-1812). 97ins. x 53ins. c.1793. Probably exh. RA 1793.
Middlesex Guildhall, London.*
Engraved in mezzotint by J. Jones 1794. This figure also is
somewhat attenuated.

E

EARL(E), James　　　　　**1761-1796**
American portrait and miniature painter. Born
Paxton, Massachusettes, 1 May 1761; died
Charleston, S. Carolina, 18 August 1796. Younger
brother of Ralph Earl (q.v.). Came to England and
entered RA Schools 1789. Exh. RA 1787-96; SA
1791. Returned to America 1796 and was painting
portraits at Charleston, when he died.

(Groce and Wallace.)

EARL, Ralph　　　　　**1751-1801**
American portrait and landscape painter. Born
Shrewsbury, Massachusettes, 11 May 1751; died
Bolton, Connecticut, 16 August 1801. Elder
brother of James Earl (q.v.). Was established as a
portraitist at New Haven before he fled to England
1778. In England 1778-85 and said to have studied
with B. West (q.v.). Painted portraits in London
and in Norfolk, some of which retain a certain
innocent New England quality. Exh. RA 1783-85,
when he returned to US and practised successfully
in Connecticut.

(Long; Groce and Wallace.)

ECCARD, John Giles　　　　　**fl.*c.*1740-1779**
Portrait painter, native of Germany. Died London
October 1779. Assistant, and perhaps pupil, of
J.B. Van Loo (q.v.) with whom he may have come
to London 1737. He was Van Loo's assistant until
he left England in 1742 and then set up on his own
with some success. He specialised in portraits on a
fairly small scale (*c.*15 by 12 ins.) and painted a
series of twenty-six for Horace Walpole between
*c.*1746 and 1754 (those of 'Gray' 1748 and
'Walpole', 1754, are in NPG). Stylistically he
derives entirely from Van Loo. Exh. SA 1761 and
1768. He sold his studio and retired to Chelsea
1770.

ECCLES, Rev. Mr.　　　　　**fl.1777**
Hon. exh. of a 'Fruit piece', RA 1777 (in crayons).
Perhaps the Rev. Mr. Eccles who died at Bath,
1777.

ECKART, Miss E.　　　　　**fl.1798**
Exh. 'an Italian view', RA 1798.

ECKHARDT, Johannes Aegidius
See ECCARD, John Giles

ECKSTEIN, John　　　　　**fl.1787-1838**
Painter of portrait and domestic genre. Died 1838.
There is much confusion over exhibiting Ecksteins
(disentangled by *Gunnis*). The painter was
probably the son of the sculptor Johann Eckstein
(died Havana 1817, aged 81). He exh. RA 1787 a
portrait (apparently in oils), and 1796-1802 por-
traits and scenes of domestic genre. His father
migrated to Philadelphia 1794. Several of his por-
traits are engraved.

(O'Donoghue.)

EDWARDS, C.A.　　　　　**fl.1792-1797**
Exh. flower pieces at RA 1792-97.

EDWARDS, Edward　　　　　**1738-1806**
Painter of all manner of subjects. Born London 7
March 1738; died there 10 December 1806. Son of
a cabinet maker and first apprenticed to one; but
studied painting at the Duke of Richmond's
Academy, 1759, St. Martin's Lane Academy,
1761, and RA Schools 1769. Exh. FS 1766; SA
1767-72; RA (very abundantly) 1771-1806. ARA
1773 and Teacher of Perspective at RA from 1788.
He visited France and Italy 1775/6. Although he
had aspirations towards history painting, his only
such commission was for a single picture for
Boydell's Shakespeare Gallery. His portraits were
adequate but pedestrian; he also attempted
decorative and scene painting. He is best
remembered for his *Anecdotes of Painters,* which
appeared posthumously 1808 and contains a short
biography.

EDWARDS, John　　　　　**fl.1763-?1797**
Flower, and occasional animal, painter in oils and
crayons. Exh. FS 1763; SA 1764-91 (latterly from
Mitcham and Morden); RA 1786 and 1788.
Probably also the J. Edwards who exh. 'Dead
game' as an hon. exh. 1797.

EDWARDS, Samuel　　　　　**fl.1769-1771**
Hon. exh. of portraits in oils, SA 1769-71.

EDWARD EDWARDS. 'Interior view of Westminster Abbey, taken at the commemoration of Handel from the manager's box.' 58¼ ins. x 40ins. Exh. RA 1793 (198). B.A.C. Yale.

''Many of the figures are portraits'' (RA cat.). This is perhaps the most interesting known work by Edwards, who was 'Teacher of Perspective' at the RA.

STEPHEN ELMER. 'Heron and Trout.'
37½ins. x 45ins. s. & d. 1777. Private
collection.
Elmer was the most popular painter of
such subjects of his day.

EDWARDS, ?Thomas fl.*c.*1710
A 'Tommaso Odoardi, pittore in ritratto inglese' is
named in a document in the Odescalchi Archives of
*c.*1710 as the principal purveyor of art to British
tourists in Rome.

(Information: A.M. Clark.)

EDY, John William 1760-1802
Landscape painter. Born 7 May 1760. Entered RA
Schools 1779. Exh. RA 1785 and 1801-2, latterly
views in Norway and Denmark.

EGERTON, Hon. Miss fl.1779
Hon. exh. of a picture of 'two ladies', RA 1779. It
is not clear who she was.

EICHEL fl.1770-1771
Exh. small landscapes at FS 1770-71.

ELFORD, Sir William *c.*1749-1837
Amateur landscape painter in oils and watercolour.
Born ?Plympton *c.*1749; died Totnes 30 November
1837. FRS 1790; baronet 1800. He was often an
hon. exh. of Devonshire landscapes at RA
1774-1837 and was quite an accomplished artist.

(Mallalieu.)

ELLIOTT, Lieut. William fl.1781-1791
Amateur painter of marine historical subjects.
Gazetted Lieutenant 1781. Hon. exh. RA 1784-89;
SA 1790-91. His subjects are usually naval actions
in Canada, Jamaica, etc.

(Archibald.)

ELLYS, John *c.*1701-1757
Portrait painter. Born March 1700/1; died London
14 September 1757. Pupil of Thornhill *c.*1716 and
later studied in the Vanderbank Academy. He had
some success but his identified portraits are very
dreary survivors of the Kneller tradition, of which
he was one of the last exponents. In 1736 he
succeeded Mercier as 'Principal Painter to the
Prince of Wales'. He bought pictures for and
advised Sir Robert Walpole, who rewarded him
with the Keepership of the Lions in the Tower —
after which he did little painting.

(Vertue MSS; E.C-M.)

ELMER, Stephen *c.*1714-1796
Specialist in the painting of "those objects which
are familiar to the sportsman, the cook and the *bon
vivant*," *(Edwards)*. His profession was that of

maltster, but he practised painting abundantly as a side line. He lived at Farnham, Surrey, where he died 1796, aged 82, and where a number of his pictures are in the local gallery. Exh. FS 1764-83; RA 1772-95. ARA 1772. He was considered the best still-life painter in England of his time, but his abilities were only moderate.

ELMER, William **1762-1799**
Still-life and occasional portrait painter; son and follower of Stephen Elmer (q.v.). Born 6 January 1762. A mezzotint of him as a schoolboy by B. Clowes is dated 1772. Entered RA Schools 1782. Exh. SA 1778-80; RA 1783-84 and 1797-99. From 1788 to c.1796 he worked in Ireland with some success, but had returned to Farnham by 1797. He is not heard of after 1799.

(Strickland.)

ELMES, W. **fl.1797**
Exh. 'Hooke Tower, with a view of the harbour of Waterford', RA 1797.

ELOUIS, Jean-Pierre-Henri **1755-1840**
French painter of portraits in oil and miniature. Born Caen 20 January 1755; died there (where he was curator of the Museum from 1814) 23 December 1840. Pupil of Restout. Came to London and entered RA Schools 1784. Exh. RA 1785-87 (mainly miniatures but two oil portraits in 1787). Went to US c.1787 and worked mainly in Baltimore and Philadelphia. Returned to France 1807.

(Long.)

ELVERY, J. **fl.1762**
Exh. three portraits, FS 1762.

EMES, John **1762-c.1809**
Landscape painter in oils and watercolours, and engraver. Born 30 December 1762; died before 1810 (*Mallalieu*). Entered RA Schools as an engraver 1780. Exh. views of the Lakes RA 1790-91 of which two of those in 1791 seem to have been in oils.

ENNIS, Jacob **1728-1770**
Irish history and portrait painter. Baptised Dublin 29 February 1728; died in Ireland 1770. Studied in Dublin under Robert West, whom he succeeded as master in the Dublin Society's Drawing School 1763. Won premiums 1747-50; in Italy c.1754-56, where he picked up a style similar to Angelica Kauffmann's. Exh. both history pictures and portraits in Dublin 1765-70.

(Strickland.)

ERSKINE, Colin *c.*1704-after 1743
Scottish born painter, resident in Rome. In Rome 1733, aged 29, as 'Nicolas Araschini'; still there 1743, when his son, later Cardinal Charles Erskine, was born.

(Information: A.M. Clark.)

ETTY, John **fl.1697-1702**
Painter at York. Became a Freeman of York as a 'limminer' 1697 (*Surtees Soc., vol. CII*) and is mentioned by Thoresby as a painter (*Diary, 5 June 1702*). Another John Etty is recorded there as a painter-stainer 1710.

EVANS **fl.1774**
Exh. 'a landscape with dead game', FS 1774.

EVANS, George **fl.1764-before 1770**
A house painter who also painted a number of indifferent portraits (*Edwards*). He was a member of the St. Martin's Lane Academy and exh. SA 1764 a picture of a little boy wheeling a kitten in a barrow.

EVANS, James **1759-1781**
Born October 1759. Entered RA Schools as a painter 1781. Nothing is known of his work.

EVANS, William **fl.1797-1807**
Exh. portraits (some apparently in oils) RA 1797-1807. Probably not the same as the William Evans, who entered the RA Schools as an engraver 1790, aged 18, and who lapsed into neurasthenia soon after 1809.

(Redgrave.)

EVELYN, Susanna **1669-1754**

Amateur painter. Third daughter of the diarist, John Evelyn; married 1693 William Draper of Adscomb. In Ralph Thoresby's *Diary (1830, i, 340-341)* under 1701 he writes ''John Evelyn carried me...to his son Draper's at the Temple, and showed me many curious pieces of his ingenious daughter's performance, both very small in miniature, and as large as the life in oil colours, equal, it is thought, to the greatest masters of the age.'' There was a 'Flight into Egypt' by her at Wotton.

CHARLES EXSHAW. 'Harriet Eyre.' 28ins. x 23½ins. s. & d. 1760. Christie's sale 21.3.1958 (150).
An Irish painter who also dealt in old masters and subjected his art to a good many different influences.

EXSHAW, Charles **fl.1747-1771**

Irish painter of history, landscape, and portrait; also etcher and picture dealer. Native of Dublin; died London 1771. Studied and travelled in France, Flanders and Italy, 1747-55, when he returned to Dublin and put up for sale a large collection of old masters. He returned at once to the Continent, was a pupil of Carle Van Loo in Paris 1757, and made etchings after Rembrandt in Amsterdam 1760. He tried to start a drawing Academy in London (*Edwards*), and exh. SA 1764 a landscape and 'an old man's head'. A male portrait of 1766 (Dublin) is a reasonably accomplished work half way between Hudson and Reynolds.

(H. Potterton, Connoisseur, CLXXXVII (Dec. 1974), 269-273.)

F

FAGAN, Robert **1761-1816**

Portrait and history painter, resident in Italy. Born ?Cork 5 March 1761; committed suicide in Rome 26 August 1816. He is the only British portrait painter who deliberately adopted a neo-classic style, which he certainly picked up in Italy. Entered RA Schools 1781, but left England, via Paris (1783) for Rome, where he was mainly settled, with a visit to Naples 1792/3, until turned out by the French 1797; but he was back in 1800. Both his wives were Italian. He carried on a considerable activity excavating and dealing in old masters; aspired to history painting (some decorative *grisailles* with classical reliefs, *c.*1793, are at Attingham), but little other than portraits are now known. Exh. RA 1793 and 1812-16. In 1809 he was appointed Consul General for Sicily and Malta, and went to live in Palermo. His widow married a Sicilian and still had a number of his pictures at Palermo, 1829.

(Crookshank and Knight of Glin, 64-65; R. Trevelyan, Apollo, XCVI (Oct. 1972), 298 ff.)

FAIRAM See FAYRAM

FAIRBONE, John **1770-1798**

Painter of portraits, genre, landscape and literary history. Entered RA Schools 1790, aged 20. Exh. RA 1794-98.

FAIRFIELD, Charles *c.***1760-1804**

Landscape painter and copyist. Died Brompton, aged about 45 (*Redgrave*). He painted gaily coloured landscapes in a Morlandish vein and specialised in copying (?forging) Dutch and Flemish landscapes.

(Grant.)

FALCONET, Pierre **1741-1791**

French portrait painter. Born Paris 8 October 1741; died there 25 June 1791. Son of sculptor, Etienne Maurice Flaconet. Trained in Paris and came to London 1765, allegedly to study under Reynolds, and at once became a member of the Society of Artists. Exh. portraits and an occasional history picture SA 1767-72; RA 1773. He left London 1773 to join his father in St. Petersburg and was back in Paris by 1778. He entered RA Schools 1769, but had already achieved a curiously

ROBERT FAGAN. 'Sophia, Lady Mainwaring.' 29ins. x 24ins. s. & d. 1792. Unlocated.
Fagan, whose known works were all painted in Italy, had leanings towards the neo-classical.

'English' type of portrait by 1766. Many of his London portraits were near-profiles, in the style of the drawings he made, 1768/9, of twelve of the leading English artists, which were engraved in the dotted manner by Pariset.

FARINGTON, George **1752-1788**

Mainly a history painter. Born Warrington October 1752; died at Murshedabad 1788. Younger brother and, at first, pupil of Joseph Farington (q.v.) but, aspiring to history painting, he transferred to West (q.v.). Entered RA Schools 1770, silver medal 1771; gold medal for a history picture 1780. Exh. SA 1771 and 1780 (landscapes); RA 1773 and 1782 (portraits). In 1782 he went to India, where he worked mainly at Calcutta. He died while engaged on a large painting of the Durbar at Murshedabad.

(Edwards; Foster.)

FARINGTON, Joseph 1747-1821

Landscape painter and topographical draughts-man. Born Leigh, Manchester, 21 November 1747; died Didsbury, Manchester, 30 December 1821. Sent to London 1763 as pupil to Richard Wilson (q.v.), whom he assisted until 1767/8, and whose work he always profoundly admired. Entered RA Schools 1769. Exh. SA 1765-73; RA 1778-1813. ARA 1783; RA 1785. He exh. a good many landscapes in oil, but few have been identified and those few are boring. It looks as though he may have been to some extent colour-blind. His great strength is in pen and ink and wash drawings, in which he studied Canaletto and the British topographical tradition as well as Wilson, and he has topographical, picturesque, and antiquarian virtues *(W. Ruddick, exh. of J.F. watercolours and drawings, 1977; Mallalieu).* After extensive sketching tours, mainly in the north, he settled in London in 1781 and soon became the *éminence grise* of the Royal Academy. His fame largely rests on his *Diary, 1793-1821*, which is the prime source for information about the arts in London *(complete text, ed. K. Garlick and A. Macintyre, 1978ff.).*

ffARINGTON, R. fl.late 18th century

A very curious landscape with monks and others fishing, with a dash of Cuyp and of a good many other things, was in anon sale, 16.6.1961, 123.

(Grant, revised ed. vol. IV, pl. 284.)

FARN, J. fl.1790

Exh. SA 1790 'Zelim and Selena: an Eastern tale, from the New Novelist' from an address at Newington Butts.

FARRER, Nicholas 1750-1805

Portrait painter. Born Sunderland 1750; died 1805. Pupil of R.E. Pine. His portraits indicate a knowledge of Reynolds.

(Redgrave: Steegman, ii, 126.)

FAYRAM, John fl.1713-1743

Portrait painter and copyist; also painted and etched landscapes of views near London. Subscribed to Kneller's Academy 1713 *(Vertue, vi, 169).* Dated portraits range from 1727 to 1743 and are much in the manner of Enoch Seeman. He did much work for the 1st Earl of Bristol *(S.H.A.H(ervey), The Diary of John Hervey, first Earl of Bristol, Wells, 1894).*

(For London views see Grant.)

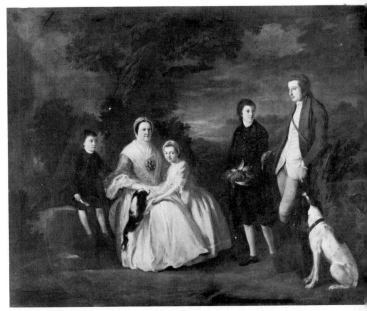

PIERRE FALCONET. *'The Tudor family, of Pennally, Co. Pembroke.'* 37½ ins. x 49½ ins. s. & d. 1766. Sotheby's sale 13.5.1953 (57).
Painted within a year of arriving in England, Falconet absorbed a feeling for British style very rapidly.

JOHN FAYRAM. *'Capt. the Honble William Hervey, R.N.'* 48ins. x 39ins. Signed, dated 1739. Christie's sale 25.2.1949 (47).
Fayram was especially patronised by the Earl of Bristol and his family.

JOHN FEARY. 'Conversation piece with a view of Greenwich.' Wood. 27½ ins. x 48ins. Dated April 5 1775. Exh. RA 1779 (90). B.A.C. Yale.
A painting very much in the style of Wheatley.

JAMES FELLOWES. 'An unknown lady.' 25ins. x 23½ ins. s. & d. 1740. Christie's sale 5.7.1937 (63).
Only signatures can differentiate Fellowes from several contemporary portraitists.

FEARNSIDE, W. **fl.1791-1801**
Landscape painter, mainly in watercolours. Hon. exh. at RA 1791-95 and 1801 (a view of Christiania), landscapes some of which were probably in oils.

FEARSON, N.J. See FREARSON, J.

FEARY, John **fl.1766-1788**
Landscape painter, especially of views round London and of gentlemen's seats. Won a premium for drawing at SA 1766; died 1788. He was apparently deformed (*J. T. Smith, i, 291*). Said to have been a pupil of R. Wilson. Entered RA Schools 1769. Exh. FS 1770-71; RA 1772-88. His 'View of One Tree Hill, Greenwich', RA 1779 (BAC Yale) is like the early work of Wheatley. About 1784 he made a tour of Devonshire. His remaining drawings were sold by Greenwood, 22/23.4.1790, Lugt. 4573.

FELLOWES, James **fl.1719-1751**
Portrait painter, especially active in the north west. 1719 is the date of Vertue's engraving of the portrait of 'Dr Humphrey Gower' (d.1711); 1751 are the latest known dated portraits. He usually signs and dates on the back, and his style is like that of E.

Seeman (q.v.). He was especially active in Cheshire (e.g. fifteen portraits in Puleston sale 18.12.1933).

FERG, Franz de Paula **1689-1737**
Painter of neat small-scale landscapes with genre figures. Born Vienna 2 May 1689; died London 1737 (*Vertue, iii, 81*). Trained and practised in Germany and came to England *c*.1718. His manner is Flemish and has little British about it, but was much admired in England. His pictures are often on copper and some are engraved. His name is still recklessly used in sale catalogues.

FERRERS, Benjamin **fl.1695-1732**
Mainly a portrait painter but his earliest known signed picture is a 'Plant in a china pot', 169(?5) (Newbattle Abbey). Died 1732 *(Th-B.)*. He was deaf and dumb and a subscriber to Kneller's Academy 1711. Some rather clumsy portraits and conversation pieces (dates ranging from 1708 — engraved 'Bp. Beveridge' — to 1728) are known in a style faintly suggestive of Dahl.

ffARINGTON See after FARINGTON

FIDLER, J. **fl.1796-1803**
Topographical landscape painter. Exh. west country views (apparently in oils) RA 1796-98 (latterly from a Monmouth address); and, as hon. exh., 1802-3.

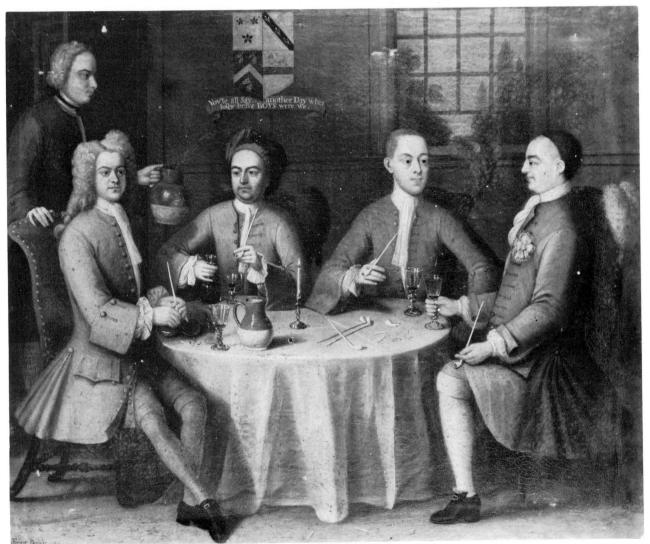

BENJAMIN FERRERS. 'Sir Thomas Sebright, Sir John Bland, and two friends.' 24ins. x 29½ins. s. & d. 1720. Christie's sale 26.1.1951 (105).
A deaf and dumb painter, with affinities to Michael Dahl.

NATHAN FIELDING. 'View of Burley-on-the-Hill.' 17½ins. x 21½ins. s. & d. 1794. Christie's sale 20.6.1947 (23).
A country house view still very much in the style of the 1760s. Nathan was the father of Copley Fielding.

FIELDING, Nathan T. **1747-c.1814**
Portrait and landscape painter. Born Sowerby, near Halifax, 1747 (a 'Self portrait' sold S, 17.4.1957, 85, is inscribed on the back 'Self. 1797. Aet.50). Last heard of 1814. He at first painted porcelainy portraits which earned him the title of 'the English Denner', but later took to landscape and was the teacher of four watercolour painter sons — notably Copley Fielding (1787-1855) and Thales Fielding (1793-1837). He settled in London 1788 and exh. portraits and a landscape SA 1791. By 1804 he was living at Keswick and was in Liverpool 1807-9. Exh. BI 1812-14.

(Grant.)

FILLIETTE, François **fl.1769-1772**
Entered RA Schools 1769. Exh. SA 1770 'A Flemish country diversion', and 1772 a small whole length.

FINCH, Mr. **fl.1764**
Exh. a portrait FS 1764. Some copies of the FS 1766 catalogue also have a portrait exh. by Christopher Finch.

FINCH, Lady Henrietta **fl.1777-1814**
Constantia
Amateur painter. She signed with a monogram 'HCF' a picture of a girl with a dove, dated 1777, in the style of R.E. Pine (q.v.) in Earl of Aylesford sale 23.7.1937, 54. She was the youngest daughter of the 3rd Earl of Aylesford. Died 1814.

FISHER, G. **fl.1780-1781**
Hon. exh. of two views in the Isle of White, RA 1780-81.

NATHAN FIELDING. 'Self portrait 1797.' Wood. 19¼ ins. x 15½ ins. Sotheby's sale 17.4.1957 (85).
Inscribed on the back 'Self. 1797. Aet 50', which is the only evidence we have for Fielding's date of birth.

FISHER, Jonathan fl.1763-1809
Irish painter and engraver of Irish landscapes. Won a premium for landscape at Dublin 1763; died there 1809. Exh. in Dublin 1765-1801. He was a very prolific painter of picturesque Irish landscapes and himself published sixty aquatints of the 'Scenery of Ireland' 1785/6.

(Strickland.)

FLECKNEY fl.1783
Exh. 'An old Cart-Horse', FS 1783.

FLIN, John d.1747
Irish 'humorous and facetious painter', who also painted religious pictures in Galway. Mercifully only his epitaph is known.

(Strickland.)

FLOYD fl.1783
Exh. three nondescript pictures, FS 1783.

JONATHAN FISHER. 'Rostrevor Mountain and Bay.' 31½ ins. x 49ins. Christie's sale 29.3.1935 (64).
Identifiable from one of the artist's own engravings from the painting.

FOLDSONE, John fl. 1769-1784
Portrait and history painter but only portraits are known. Died in London 1784. Exh. SA 1769-70; RA 1771-83. He painted a number of conversation pieces and specialised in small portraits which he completed in a day at the sitter's home. His figures in these are rather flimsy, but a few scale of life portraits done at the end of his life (two of 1783 sold S, 14.10.1953, 98) show a respectable talent. He was father of the miniature painter, Mrs. Anne Mee.

(Edwards.)

FONTANELLI, Carlo 1755-1780
Entered RA Schools 1776, aged 21. Exh. small whole-length portrait FS 1779; RA 1780 a portrait, while lodging with Zucchi (q.v.).

FORBES, Anne 1745-1834
Portrait painter and copyist in oils and crayons. Born and died in Scotland; granddaughter of William Aikman (q.v.). In Rome 1767-70, where she studied under Gavin Hamilton (q.v.) and made copies of old masters. She settled briefly in London and exh. portraits at RA 1772, but did not meet with much patronage and returned to Scotland, where she had a modest success. Her portraits have little positive character.

FORD, Miss fl. 1771-1783
Amateur landscape painter. Hon. exh. of ten landscapes at RA 1771-83.

FORREST, Charles fl. 1765-1780
Irish portraitist in crayons and miniature. Pupil in Dublin Society's School 1765. Exh. Dublin 1771-74 and 1780. SA London 1776. Some of his small crayons full lengths are neat and in the manner of H.D. Hamilton (q.v.).

JOHN FOLDSONE. 'A lady' (?of the Hornby family). 35½ ins. x 27½ ins. s. & d. 1783. Sotheby's sale 14.10.1953 (98/1).
At the end of his life Foldsone promised to become a portraitist of some distinction.

ANNE FORBES. 'Lady Anne Stewart, 1774.' 31ins. x 25ins. National Gallery of Scotland, Edinburgh.
An early label on the back gives the name of the painter and the date 1774. Her works are more frequent in crayons than in oils.

JAMES FORRESTER. 'Landscape with hermits by a lake.' 51 ¼ ins. x 75 ½ ins. s. & d. 1766 on a label on the back. Private collection.
Bought in Rome 1767 by the 4th Earl Fitzwilliam. One of a pair.

FORREST, Thomas Theodosius **1728-1784**
Amateur landscape painter; also attorney and writer for the stage. Born London 1728; committed suicide there 8 November 1784. Pupil of Lambert. Hon. exh. SA 1762-68; RA 1769-74 and 1781, mostly landscape and many in watercolours, but he exhibited a 'History', 1773.

(Mallalieu.)

FORRESTER, James **1730-1776**
Irish landscape painter in a classical vein. Born Dublin July 1730; died Rome 31 January 1776 *(Forcella, I, 396, No. 1512)*. Studied under Robert West in Dublin (1747) and won a prize there 1752. In Rome 1755 until his death. He exh. one landscape RA 1771, sent from Rome. Two huge landscapes of 1766 (signed on the backs) are at Milton Park, in a style deriving from Gaspard Poussin and Claude. He also etched *(Walpole Soc., XXXVI (1960), 58/9).*

FORTINELLI **fl.1783**
Exh. landscapes with ruins, FS 1783.

FOSTER, William **fl.1772-1812**
Portraitist in oils, watercolour and miniatures. It is not certain whether the William Foster, who exh. portraits at SA 1772-78, is the same as the one who died in 1812 and latterly specialised in portraits of actresses in pencil and watercolour.

FOUNTAIN(E), George **fl.1698-1745**
Court portrait painter of Huguenot origin, in a Knellerish style. He seems already to have been court painter at Hannover in 1723, but was paid his expenses for transferring from London in 1730.

(Millar, 1963, 169.)

FRANCESSINI, Signora **fl.1762**
Hon. exh. of 'A head: in crayons', SA 1762.

FRANÇOIS, Jacob **fl.1759-1796**
Flemish history painter. His son, Celeston, was born in 1759, and he was teaching at Antwerp academy 1796. He was briefly in London and exh. 'The judgment of Paris' at RA 1788.

ROBERT FREEBAIRN. 'Powis Castle.' 45ins. x 62ins. Exh. RA 1793 (291). Christie's sale 6.11.1959 (87).
The interpretation of a Welsh landscape into a Wilsonish Italian pattern.

FREARSON, John **1762-1831**
History, landscape and, at first, miniature painter.
Entered RA Schools 1786, aged 24. Exh. RA
1786-89 (as 'Fearson') and 1797-1831; BI 1806-22.
He is listed (as 'Fearson') among history painters
at Rome in 1796 (*Farington, ii, 499*).

FREEBAIRN, Robert **1764-1808**
Landscape painter. Born London 16 March 1764;
died there 25 January 1808. Said to have been
briefly Richard Wilson's pupil *c*.1781. Entered RA
Schools 1782 and was apprenticed to Philip
Reinagle 1782-85. Exh. RA 1782-1807; BI 1806-8
and, posthumously, 1809-13. After 1786 he went to
Italy where he looked at the work of Jacob More
(q.v.), and he returned from Rome 1791. Most of
his exhibited landscapes are of Italian scenes and
he had a number of these engraved; his 'Powis
Castle', RA 1793, interprets Welsh landscape in an
Italian spirit. His best work is distinguished.

(Grant.)

FREEMAN, Joseph **fl.1778-1799**
Surveyor and land-agent at Cambridge, where he
lived and taught himself painting. Died Cambridge
1799. Hon. exh. SA 1775, 'A Rabbit, from
nature'; FS 1775-76, drawings. (A 'Mr. Flower
Freeman, junior' also hon. exh.; at FS 1775-76 a
conversation and a portrait, in crayons.) He was
much employed by Cambridge colleges in copying
and repairing portraits, and he copied most of the
portraits for the Palace at Ely. Well documented in
Emmanuel College accounts 1779-88.

(G.R. Owst, 1949.)

FREEMAN, Thomas **1757-1780**
Exh. 'A nobleman's family', from a Windsor
address, RA 1780. Probably born 15 October
1757; entered RA Schools as a painter 1776.
Another Thomas Freeman exh. RA 1774-86 archi-
tectural drawings and historical designs for
ceilings.

FREESE, N. fl.1794-1814
Mainly a portrait painter, but also exh. a miniature and views at RA 1794-1814.

(Long.)

FRENCH, Henry See TRENCH, Henry

FRENCH, Thomas fl.1736-1803
Decorative and scene painter. Died at Bath 5 September 1803. Painted romantic landscape decorations in Vauxhall Gardens and exh. paintings of the same character at FS 1774. Scene painter at Drury Lane 1771-94. Latterly at Bath.

(E.C-M.)

FRIER, Walter fl.1715-1731
North country or Scottish provincial portrait painter. Painting at Carlisle 1715 (*Nicolson*). A group of rather clumsy portraits of 1721, suggesting a knowledge of Aikman, is at Prestonfield. Latest dated portrait known is 1731. He signs with the 'WF' in monogram.

FRITH, Rev. Mr. fl.1788-1793
Hon. exh. at RA 1788 and 1793 (latterly as from Grove, Kentish Town) of 'The Lyric Muse' and 'Hebe'.

FRITH, E. fl.1791
Hon. exh. RA 1791 of 'Portrait of a spaniel' and 'a country girl'.

FROST, John fl.1758-1785
Provincial topographical painter.

(Harris, 164.)

FRY, J. fl.1720-1732
Portrait painter, probably working at Cambridge and in East Anglia. Known only from an engraving (1720) of a portrait of 'Mathias Earbery'; and a portrait at Emmanuel College, Cambridge, of 'John Balderston' signed 'I. Fry pinx. 1732' after a Loggan miniature of 1684.

FRY, Thomas fl.1704-1710
Provincial painter in Somerset. Did some painting in churches at Wells (1704) and Dunster (1708) and painted the drapery of an unfinished portrait, 1710.

(Somerset and Dorset Notes and Queries, XXII (1938), 263.)

FRYE, Thomas *c.*1710-1762
Irish portrait painter in crayons and oil; also a mezzotint engraver. Born in Ireland; died London 3 April 1762. His earliest known works are crayons portraits of 1734 which almost suggest a knowledge of Rosalba Carriera. He was in England by 1735 and was painting miniatures and oil portraits in the later 1730s. His mezzotint after his own full length of 'Frederick, Prince of Wales', 1741, indicates considerable experience, and some contact with Van Loo (q.v.) is possible. In 1744 he helped to found the Bow porcelain factory and acted as manager until 1759, when he returned to portrait painting. Exh. SA 1760-61 portraits in oil, crayons and miniature. In 1760-62 he produced two remarkable sets of mezzotints of fancy heads in the manner of Piazzetta drawings; his last portraits suggest a knowledge of Hogarth. He was one of the most original and least standardised portrait painters of his generation.

(Michael Wynne, Burlington Mag., CXIV (Feb. 1972), 79-84.)

FRYER See FRIER, Walter

FULTON, Robert 1765-1815
American portraitist in oils and miniature; and engineer. Born near Lancaster, Pennsylvania, 14 November 1765; died New York City 24 February 1815. Practised as portrait and miniature painter in Philadelphia before coming to England 1786. Studied with West (q.v.) and perhaps in RA Schools 1788. Exh. portraits and history SA 1791; RA 1791 and 1793. After 1793 his main interest shifted to engineering (canals, submarines and steamboats). In France *c.*1796 to 1803, when he was briefly in London (*Farington, 29 May 1803*). Returned to US 1806.

(Groce and Wallace.)

FURLY, Miss fl.1783
Exh. portrait of a lady, FS 1783.

FUSELI (FÜSSLI), Johann Heinrich 1741-1825
History painter of heroic, and often gruesome and ghoulish, literary themes; also a prolific draughtsman. Born Zurich 6 October 1741 or 21 February 1743 (*Farington, 26 Nov. 1804*); died London 16 April 1825. Son of a cultured Swiss family and trained for the Church; he was friendly with Lavater, who had a great influence on him. He had a very broad classical education, with a wide knowledge of 'World Literature'. He translated *Macbeth* into German as a young man, and *Macbeth* always

THOMAS FRYE. 'Sir Charles Townley.' 35ins. x 27ins. s. & d. 1740. Christie's sale 19.5.1939 (33).
The sitter is wearing a herald's tabard as Norroy and Clarencieux Herald at Arms.

played a central role in his imagination. He was the apostle of the German *Sturm und Drang* movement in England, where he came in 1764 and translated into English (1765) Winckelmann's *Reflections on the Painting and Sculpture of the Greeks*. His amateur drawings impressed Reynolds who urged him to take up painting, but he never had a proper academical and technical training, so that the condition of most of his pictures has sadly deteriorated. He studied in Rome 1770-78 (with visits to Venice and Naples) and concentrated on Antiquity and those aspects of Michelangelo which set the canon for expressive Mannerism, but the themes which obsessed him were mostly from Shakespeare, Milton, Homer, Ossian, Wieland, &c., and he contrived a highly romantic neo-classic idiom for illustrating such themes. He was much the most mature mind and leading spirit among the British artists in Rome during these years and had a profound influence on some of them, notably Alexander Runciman (q.v.). In these years he was also friendly with the Swedish sculptor Sergel and they mutually influenced one another (*Nancy Presley, The Fuseli Circle in Rome, exh. cat., BAC Yale, 1979*). He changed the spelling of his name to 'Fuseli' at this time and, from 1779, when he finally settled in England, he may be considered an English artist, however eccentric.

Exh. SA 1775, 1778 and 1783; RA 1774, 1777, 1780-1825; BI 1806. ARA 1785; RA 1790. He became Professor of Painting at the RA in 1799 and Keeper in 1804, and his lectures had a considerable influence on those who were students after 1800. He made the largest contribution (from 1786 onwards) to Boydell's Shakespeare Gallery, and he also produced his own Milton Gallery (of forty-nine subjects) in 1799. His works also became known from numerous engravings. He was one of the few serious artists who was friendly with Blake, and he was also on good terms with most of his Academy colleagues, although his scholarship was far above theirs. He had an undoubted predilection for bizarre themes, and his neo-classicism was much more a European than an English style. His work is most fully represented in the Zurich Gallery. His lectures and other writings were published by John Knowles, 1831.

(*P. Tomory, 1972; full catalogue raisonnée, G. Schiff, Zurich/München, 2 vols., 1973; Oeuvrekataloge Schweizer Künstler, vol. 12.*)

JOHANN HEINRICH FUSELI. 'The Three Witches.' 20ins. x 25ins. Christie's sale 2.6.1967 (172).
From *Macbeth*, a version of a picture exh. RA 1783. Fuseli's powerful and macabre fancy shows more fully in his drawings rather than in his dun-coloured oil paintings.

G

GAGNIER, Mrs. John fl.*c.*1720-after 1725

Professional portrait painter at Oxford; the wife of the Professor of Arabic, John Gagnier (*c.*1670-1740). Her work was "equal to most of the Painters in London of the Second Class" (*Wanley, 24, v, 1725*).

GAIN(E)S fl.1770-1787

Landscape painter in watercolour and, apparently, in oil. Exh. FS (watercolours) 1770-72 (in 1770 as 'pupil of Mr. Hodgson'); RA 1777, 1782, 1786-87.

GAINSBOROUGH, Thomas 1727-1788

Landscape and portrait painter, and the creator of a new kind of poetical 'fancy picture'. Baptised Sudbury, Suffolk, 14 May 1727; died London 2 August 1788. He studied in London 1740-48, mainly apparently in the St. Martin's Lane Academy under Gravelot and Hayman (qq.v.), as far as figure painting was concerned, and he taught himself landscape painting largely by copying and imitating Dutch 17th century works (notably Wynants and Ruisdael). He was an acknowledged

THOMAS GAINSBOROUGH. 'Bumper.' 13 ¾ ins. x 11 ¾ ins. s. & d. on the back 1745 and inscribed 'Bumper. A most remarkable sagacious Cur'. Private collection.

The earliest dated known picture by Gainsborough. The dog is treated with the seriousness of a family portrait and set against the East Anglian landscape.

THOMAS GAINSBOROUGH. 'Mr. and Mrs. Browne of Tunstall.' 33ins. x 55½ins. c.1754/5. Sybil, Marchioness of Cholmondeley, Houghton Hall.
The little girl, Anna Maria, was born 1753. This is perhaps the least artificial of the early Gainsborough portrait groups seated in an East Anglian landscape.

landscape painter by 1748, when he presented 'The Charterhouse' (one of a series of views of London Hospitals by accepted landscape painters) to the Foundling Hospital. He returned to Sudbury 1748 and soon afterwards settled in Ipswich, where he remained until moving to Bath in 1759. He made his living by portrait painting at Ipswich and also painted, for his own pleasure, many, mainly small, landscapes of the Suffolk scene in the spirit of Ruisdael. A few small scale portraits which combine figures with this landscape tradition, e.g. 'Mr and Mrs Andrews' and 'Mr Plampin' (both in NG) are among the eccentric masterpieces of British 18th century portraiture; but this style was considered provincial and had no future. He also enlarged his little landscape pictures and painted a few overmantels and overdoors (two of 1755 at Woburn) in an artificial rococo style, which lingers as a substratum in his later landscapes. At Bath

THOMAS GAINSBOROUGH. 'Unknown gentleman' (detail). Ashmolean Museum, Oxford.
Painted at Ipswich in the 1750s. This detail shows beautifully what Gainsborough called the 'pencilling', which he was anxious to preserve in the modelling of the head. (Waterhouse, *Gainsborough*, no. 764.)

135

THOMAS GAINSBOROUGH. 'Mary, Countess Howe.' 96ins. x 60ins. Greater London Council as Trustees of the Iveagh Bequest, Kenwood.
From the middle 1760s. One of the first (and most beautiful) of Gainsborough's life-size portraits with the figure in a formal and perfectly natural pose.

THOMAS GAINSBOROUGH. 'George, 1st Lord Rodney.' 90½ins. x 58½ins. Painted 1783/6. Earl of Rosebery, Dalmeny House, South Queensferry.
An example of a dramatic 'historical' portrait in Gainsborough's latest style. The cascade of fleur-de-lis drapery suggests Rodney's recent defeat of the French fleet.

1759-74, practising mainly as a fashionable portrait painter, and he probably visited London for some weeks annually from 1762. Exh. SA 1761-68, when he was invited to become a foundation member of the Royal Academy. Exh. RA rather fitfully 1769-83; and, after rows with the RA, at FS 1774 and 1783. Latterly, deciding that the RA's way of hanging pictures was unsuited to his style — as indeed it was — he showed his pictures in his own studio in London, where he had moved in 1774. His own preference was for landscapes of a poetical and Arcadian kind, but he sold surprisingly few of these, and his reputation, in his own lifetime was as a portraitist. He was generally considered as second only to Reynolds, except by the royal

THOMAS GAINSBOROUGH. 'A peasant girl gathering sticks in a wood'. 67ins. x 49ins. Being painted 1782. City of Manchester Art Galleries.
An example of Gainsborough's 'fancy pictures' in which he idealised humble models, whom he chose with particular care.

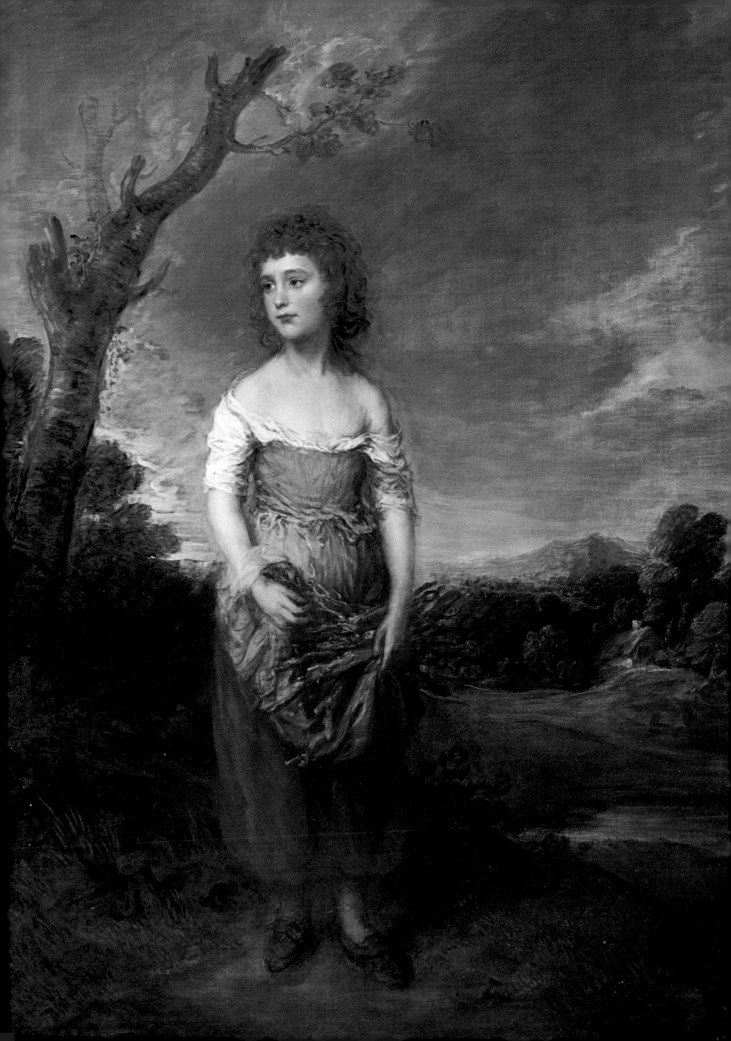

THOMAS GAINSBOROUGH. 'Landscape: river scene.' 46ins. x 65½ins. Philadelphia Museum of Art (The John Howard McFadden collection).
Probably from the 1770s, during the period in which Gainsborough remodelled his landscape style after Rubens.

family, who employed him for preference after 1776. A comparison between the two as portrait painters hardly makes sense as each excelled in the qualities the other lacked. Gainsborough executed almost every inch of his portraits with his own hand, and prided himself on the delicacy and bravura of his 'pencilling' (which is of unexampled beauty), while Reynolds left a great deal (especially drapery) to assistants. Gainsborough had only one pupil and assistant, his nephew, Gainsborough Dupont (q.v.) from 1772 onwards, who chiefly did copies and replicas. From 1781 onwards Gainsborough painted a small number of 'fancy pictures', with figures on the scale of life, for which he mainly used as models figures of exceptionally beautiful beggar children. These owe quite a lot to Murillo, and he valued them more highly than his other works.

The refinement of his portrait style was achieved at Bath and owes a great deal to a knowledge of Van Dyck, whose work he certainly saw at Wilton. In the same way he modified his landscapes as the result of a knowledge of Rubens: 'Peasants returning from market' (Toledo, Ohio) and 'The Harvest Wagon' (Barber Institute, Birmingham University), of the later 1760s, are the masterpieces of this mature style. Later (from 1783) he cultivated the manner of Gaspard Poussin, which he reinforced by a visit to the Lakes, and some of his last portraits and such pictures as 'The Mall', 1783 (Frick Collection, New York) reveal a deliberate study of Watteau. Although he painted a few rural English landscapes, e.g. 'The Market Cart' (NG), which seem to anticipate Constable (as Constable himself felt), his landscape style is basically artificial and nearer to the French rococo than to Nature — although his few, late, coast scenes, e.g. 'The mouth of the Thames' (Melbourne) belie this. He was a very prolific landscape draughtsman (*cat. John Hayes, The Drawings of T.G., 2 vols, 1970; Hayes' work on the landscape paintings is forthcoming*), but most of the later drawings were made at home in the evenings from imitation model 'landscapes'.

(Full cat. of oil paintings in Ellis Waterhouse, G., 1958.)

THOMAS GAINSBOROUGH. 'A view at the mouth
of the Thames.' 62ins. x 75ins. Exh. RA 1783 (240).
By permission of the National Gallery of Victoria,
Melbourne (Felton bequest 1947).
An extraordinary anticipation of impressionist
style, far in advance of contemporary taste.

THOMAS GAINSBOROUGH. 'Greyhounds coursing
a fox.' 70ins. x 93ins. Greater London Council as
Trustees of the Iveagh Bequest, Kenwood.
Painted about 1787. One of a pair of large
decorative pictures in the vein of Snyders, with
which Gainsborough was experimenting at the
end of his life.

CALEB JOHN GARBRAND. 'An unknown lady.' 29½ ins. x 24½ ins. s. & d. 1777. Sotheby's sale 16.2.1949 (114).
A characteristic example of Garbrand's rather middle class portraits.

GANDY fl.1778

Exh. FS 1778 'A Piece of Fish' and 'A ship-piece' from a Liverpool address.

GANDY, William c.1655-1729

Itinerant portrait painter in Devonshire. Buried at Exeter July 1729. Son of a painter, James Gandy, who died in Ireland 1689. He mainly lived and worked at Exeter, where a number of portraits survive, but moved to Plymouth for some years in 1714.

(Collins Baker, Lely &c, ii, 56ff., 170.)

GARBRAND, Caleb John 1748-1794

Portrait painter. Born in London 1748 (from a family of Jamaican origin); died Chittagong 10 March 1794. Entered RA Schools 1771. Exh. SA 1776 and 1780; FS 1778-79; RA 1775-80. He was in India by 1783, where he soon gave up painting (''at which he was but a sorry hand'') for trade.

(Foster, 1931, 32-3.)

GARDINER, Miss Mary fl.1762-1770

Hon. exh. SA 1762-70, mainly of 'views' or rustic genre. A pair of pictures of Border Castles were sold 11.4.1980, 84.

MARY GARDINER. 'Caerphilly Castle.' 15¼ ins. x 23ins. One of a pair, one of which was signed. Probably exh. SA 1769 (324). Christie's sale 11.4.1980 (84/2).
The picture exh. 1769 was catalogued as 'A view of Caerphyli Castle in Glamorganshire, with the remarkable leaning tower, taken on the spot.'

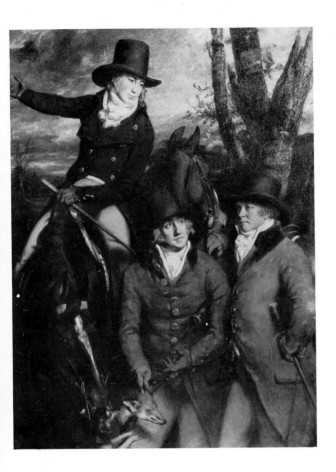

DANIEL GARDNER. 'Charles Pennington.' 25ins. x 30ins. Sotheby's sale 15.11.1944 (86).
One of a group of unexpectedly sensitive and affectionate portraits of a family, who were clearly friends of the artist.

GARDINER, William Nelson 1766-1814

A raffish Irishman, jack of most artistic trades and, after 1801, a bookseller. Born Dublin 11 June 1766; committed suicide London 8 May 1814. He was least incompetent as an engraver and assistant to Bartolozzi, but his eyesight failed. Exh. RA 1787-93 drawings and a few paintings of genre subjects or religious themes.

(Strickland.)

GARDNER, Daniel c.1750-1805

Portrait painter, mainly in crayons and gouache. Probably born Kendal c.1750; died London 8 July 1805. He had some lessons from the young Romney at Kendal before 1762 and was probably also helped by Romney when he came to London 1767/8. Entered RA Schools 1770. Briefly assisted in Reynolds studio c.1773. He exh. a drawing RA 1771 but found no need to exhibit again, establishing a fashionable practice in fairly small scale portraits in crayons or gouache (sometimes in a highly loaded medium of uncertain composition) in which he orchestrated Reynolds' patterns in a rococo manner. He did not employ oils until 1779, and then not often — mainly in groups of portraits of the Pennington family (who were family friends

DANIEL GARDNER. 'The Casamajor family, 1779.' Oil and gouache on paper. 31½ins. x 38ins. Dated 1779. B.A.C. Yale.
A somewhat extreme arrangement of a rococo family group, in a heavily loaded technique whose composition is not altogether certain.

141

GEORGE GARRARD. 'Douglas, 8th Duke of Hamilton.' 60ins. x 74ins. Exh. RA 1786 (1). Duke of Hamilton, Lennoxlove.
Engraved in mezzotint by Ward 1797. An unusually romantic work, much above Garrard's normal powers.

and whose children's portraits show remarkable tenderness of feeling) and of the Heathcote family (sold 27.5.1938, the largest now at Montacute House). His oils have an odd rough texture, as if painted on towels. He was friendly with the young Constable.

(Helen Kapp, cat. of Gardner exh., Kenwood, 1972.)

GARDNOR, Rev. John **1729-1808**
Landscape painter and drawing master; also did aquatints. Buried Battersea 6 January 1808, aged 79. Exh. FS 1763-69; RA 1782-96 (very abundantly). He kept a drawing academy in Kensington until he took Orders in 1769, becoming curate and then (1778) Vicar of

Battersea. His oil landscapes include many views in Wales and, after 1787, on the Rhine. A number were engraved by himself in aquatint. He is a respectable painter of the old topographical school.

(E.C-M.)

GARDNOR, Richard **fl.1765-1793**
Landscape painter. Nephew and collaborator of John Gardnor (q.v.). Exh. FS 1765-67; RA 1786-93.

GARNERY, Priori **fl.1785-1795**
Portrait painter. Exh. three portraits RA 1785. There is a mezzotint by Pergolesi after his portrait of Miss Simonet, the first British female balloonist in 1795.

GARR, De See D'AGAR, Charles

GARRARD, George **1760-1826**
Mainly an animal painter and sculptor, but he had considerable gifts for portrait, landscape, and urban scenes. Born 31 May 1760; died Brompton 8 October 1826. Pupil of Sawrey Gilpin (q.v.), whose daughter he married. Entered RA Schools 1778. Exh. RA 1783-1826; BI 1806-25. ARA 1800. He was an abundant exhibitor, at first of pictures of horses and dogs, but expanding his field to scenes in which animals and agricultural life were prominent. From about 1795 he more or less deserted painting for sculpture, modelling expecially animals and reliefs *(Gunnis)*. His occasional pictures of a brewhouse or an equestrian portrait on a small scale are of very high quality. The brewing family of Whitbread were good patrons, as was the Duke of Bedford.

GARRISON, J. **fl.1706-1713**
Portrait painter, perhaps largely in the Wigan/Preston area; a rather pedestrian artist in the Kneller/Dahl tradition. Jacob and John Garrison were witnesses to the will (1706) of the painter W.W. Claret. A group of portraits of the Bradshaigh family, dated 1713, was formerly at Haigh Hall, Wigan.

GARTH, B. **fl.1796-1800**
Exh. views at RA 1796-1800.

GARVEY, Edmund **fl.1767-1813**
Landscape painter. Born at Kilkenny *(Farington, 14 Feb. 1804)*; died London 1813. Pupil in Ireland of Robert Carver (q.v.). Studied in Rome and was first in London before 1764. Exh. FS 1767-68 and 1779; RA 1769-1808. He won premiums from the SA 1769 and 1771. ARA 1770; RA (for no fathomable reason) 1783. He practised at Bath, where he was friendly with Gainsborough, 1768-78, when he settled in London. He exhibited conventional views of many European scenes, but need not have visited them, though he was again in Rome in 1798. He also sometimes returned to Ireland and painted Irish views. His landscapes are profoundly ordinary and monotonous in colour and his appointment as RA, against Wright of Derby (q.v.) puzzled many contemporaries. But Garvey seems to have been a good-natured man and Wright was cantankerous.

EDMUND GARVEY. 'View of Bath.' 16ins. x 21ins. s. & d. 1769. Private collection.
Garvey was a friend of Gainsborough's when he lived at Bath. The justification for his becoming an RA is rather obscure.

THOMAS GAUGAIN. 'Maria from Sterne.' 40ins. x 32ins. s. & d. 1779. Exh. RA 1780 (4). Christie's sale 15.6.1962 (73). Maria, the mad girl, who appears in both *Tristram Shandy* and the *Sentimental Journey* was a subject curiously popular with painters.

GAUGAIN, Thomas 1756-?1810
Professional portrait copyist and engraver. Born Abbeville 24 March 1756. Entered RA Schools 1771. Exh. RA 1778-82 portraits and literary genre (e.g. 'Sterne's *Maria*'', RA 1780 — in the manner of Wheatley).

GAVIN, George fl.1750-1775
Irish portrait painter.

(M. Wynne, Irish Georgian Society, XIX (1976), 10-13.)

GAYFERE, Thomas, Jr. 1755-1827
Mason and architect. In 1802, jointly with his father, he was appointed master mason of Westminster Abbey *(Colvin.)* Exh. SA 1774 (as 'Grayfrere junior'); hon. exh. RA 1778-80 views which may have been in oils.

GEMELL fl.1723
A portrait at Hopetoun of 'Robert Johnston of Hilton' is inscribed on the back 'by Gemell 1723'. It is in the manner of Medina and is probably by the painter otherwise called 'Jemely' (q.v.).

GEORGE, John fl.1763-1771
Exh. FS 1763-71 portraits, all but one stated to be in crayons.

GESSNER, Johann Konrad 1764-1826
Swiss landscape, animal (especially horses) and military painter; also a competent etcher. Born Zurich 2 October 1764; died there 8 May 1826. Son of subject painter and book-illustrator, Solomon Gessner (d.1788). Studied in Dresden and Rome and returned to Zurich on his father's death. Visited England and exh. RA 1797-1803, mainly military and equestrian scenes. Also a watercolour painter.

(Brun.)

GIANELLI fl.1777
Exh. SA 1777 a portrait of George III on horseback

THOMAS GIBSON. 'George Vertue.' 29ins. x 24ins. s. & d. 1723. Society of Antiquaries of London. George Vertue (1684-1756) was the most assiduous collector of antiquarian information about the arts of his day.

SAWREY GILPIN. 'Horses in a thunderstorm.' 33ins. x 47ins. s. & d. 1798. Exh. RA 1799 (131). Royal Academy of Arts (Diploma collection).
Gilpin liked to introduce a dramatic element into his pictures of sporting subjects.

GIBSON, Thomas *c.*1680-1751
Portrait painter. Died London 28 April 1751. A
leading portrait painter in London from at least
1711 to 1729, when he fell ill. He was an active
director of the Academy founded by Kneller in
1711 and painted much in Kneller's style, but with
rather tamer execution. After a stay in Oxford
*c.*1732 he recovered health and returned to
London, but his last recorded works were portraits
of the Princess of Wales and her children, 1742.
Most of his engraved portraits are of clergymen or
men of some learning. His prices remained modest
at 12 guineas for a half length (1728).

(Vertue MSS; Poole.)

GILCHRIST, Mrs. fl.1774-1775
Exh. portraits SA 1774-75.

GILL d.*c.*1749
Portrait and perhaps landscape painter.

(Harris, 266.)

GILL, Charles fl.1769-*c.*1828
Portrait and genre painter. Born Bath (son of the
leading pastrycook); died there *c.*1828. Entered RA
Schools 1769; pupil of Reynolds 1771-74; then
settled at Bath. Exh. RA 1772-75, and 1781 (from
London), probably also 1795, 1810, 1818-19. His
'An old rustic and boy', RA 1781 (W.S. Lewis
Foundation, Farmington, Conn.), is like the work
of Hugh Barron. He became partly crippled and
returned to Bath 1787, and was the occasional
recipient of charity from the RA 1796-1828.

(Whitley, ii, 285.)

GILPIN, Sawrey 1733-1807
Animal painter of a superior kind. Born Scaleby,
near Carlisle, 31 October 1733; died Brompton 8
March 1807. Brother of Rev. William Gilpin
(1724-1804) the writer on the picturesque and
amateur artist. Sent to London 1747 and
apprenticed to Samuel Scott (q.v.) 1749-56, who
lived in Covent Garden, which led to Gilpin's
passion for drawing the horses bringing the

SAWREY GILPIN. 'Gulliver addressing the Houyhnhnms.' 41ins. x 55ins. s. & d. 1769. B.A.C. Yale.
One of a series of Gulliver scenes painted by Gilpin. They are one of the few subjects in which horses can play a role in a 'history' picture.

supplies to market. He stayed on as assistant to Scott until 1758, when he dedicated himself to horse painting and was encouraged by the Duke of Cumberland. After Stubbs, he was the finest horse painter of the age and also had a mastery of landscape. Exh. abundantly at SA (of which he was President in 1774) 1762-83; RA 1786-1807. ARA 1795; RA 1797. To show that horse painting could include history, he showed 'The election of Darius', 1769 (York) and a series of pictures of 'Gulliver and the Houyhnhnms', SA 1768-72 (two at BAC Yale). He was the teacher of George Garrard (q.v.) and his son, **William Sawrey** Gilpin (1762-1843) first exh. watercolours at RA 1797.

GIRARDY, J. (or S.) de fl.1784
Exh. flower pictures at RA 1784.

GLADWIN, John 1751-1777
Born 24 October 1751. Entered RA Schools as a painter 1777; otherwise unknown.

GLANVILLE fl.1780
Exh. SA 1780 'His own portrait in crayons: a first attempt'.

GLOVER, John 1767-1849
One of the most prolific and pedestrian painters of landscape in both oils and watercolours. Born Houghton-on-the-Hill, Leicestershire, 18 February 1767; died Launceston, Tasmania, 9 December 1849. He began as a drawing master and his first oil landscape was perhaps RA 1799. Most of his oil landscapes, many very large, were produced in the 19th century. Exh. RA 1795-1812. He was one of the founders of the Old Watercolour Society, and in 1831 he mercifully emigrated to Tasmania, where he continued painting abundantly. "Technically Glover is one of the least distinguished painters that our School has produced" (Grant).

(Mallalieu.)

GODDARD, James 1756-1783
Painted portraits in crayons, and miniatures. Born 23 January 1756. Entered RA Schools 1771. Exh. FS 1782-83. A drawing exh. SA 1771 was probably by his father (cf. Long).

GOGAIN, Thomas See GAUGAIN, Thomas

GOHLI
fl.1773

Exh. half length portraits of the Prince and Princess of Brunswick SA 1773. Conceivably the Johann Gottfried Göhle, who painted religious works at Bunzlau 1774/5.

(Th.-B.)

GOLD
fl.1782

Exh. 'Horses' and 'A dog', FS 1782.

GOOCH, Thomas
1750-1802

Sporting painter; pupil of Sawrey Gilpin (q.v.) 1777-80. Exh. SA 1778 and 1780; RA (rather abundantly) 1781-1802. He had some fashionable clients in the early 1780s (picture of 1782 at Yale), but a paralytic stroke affected his right hand in 1796 *(Farington, 9 July 1796)*. He retired into the country in 1800.

(Pavière.)

GOODEN, Master B.
fl.1774

Exh. 'A head: in chalks', FS 1774.

GOODWINE, S.
fl.1748-1749

Painted a *trompe l'oeil* with a picture of a white woodcock signed and dated 1749, sold S, 21.3.1979, 66. He is listed as 'an eminent painter' in the *Universal Magazine,* Nov. 1748.

GOUGE, Edward
fl.1690-1735

Portrait painter and copyist of history pictures. Pupil of Riley (d.1691); buried London 28 August 1735. Matriculated Padua University 1705; was painting copies and portraits in Rome 1707. In 1711 was a Director of the Academy founded by Kneller. His portraits are like those of Richardson but inferior.

(Egmont, Diary 1 Sep., 1735; B. Ford, National Trust Year Book, 1975/6, 24.)

GOUPY, Joseph
c.1680-c.1770

Painter in pastel and gouache, and a notable copyist in those mediums; also miniaturist, watercolour painter, caricaturist and etcher. Nephew and pupil of Louis Goupy (q.v.); died in London (his posthumous sale 3.4.1770, Lugt 1826). Travelled extensively in Italy and Malta. By 1711 established in London, where he was a subscriber to Kneller's Academy. Did some scene painting in the 1720s. In 1736 made 'Cabinet Painter to the Prince of Wales'. He got very high prices for his crayon copies of old masters. Exh. SA 1765.

(Walpole Soc., IX (1921), 77 ff.; E.C-M.)

THOMAS GOOCH. *'Sir William Clayton with groom and hunter.'* *19ins. x 23½ins. s. & d. 1791. Christie's sale 23.6.1950 (35).* Gooch was one of the most competent of the sporting painters before the emergence of Ben Marshall.

EDWARD GOUGE. *'The wife of Sir Roger Hudson.'* *50ins. x 40ins. Christie's sale 13.2.1948 (20/2).* The attribution rests on an old tradition. The sitter's husband (d.1743) was a Turkey merchant, who was knighted in 1721.

GOUPY, Louis *c*.**1670-1747**
Born in France; died in London 2 December 1747.
He came young to London and painted portraits in
oil. In 1711 a subscriber to Kneller's Academy but
transferred later to the 1720 Academy.
Accompanied Lord Burlington to Italy 1719. On
his return transferred his interest to portraits in
crayons and paintings in gouache. Ended as a
fashionable teacher of crayons and watercolour
painting.

(E.C-M.)

GOWERS, David **fl.1799-1808**
Portrait painter. Exh. RA 1799-1801 and 1808.
His portrait of 'Robert Orchard', a Soho grocer,
was engraved in mezzotint 1803.

GRACE, Mrs. Mary **fl.1749-1786**
Painter of rustic genre and occasionally of portrait
and history. Died Homerton *c*.1786. She was *née*
Hodgkiss and said to have been self-taught. Her
portrait of a dissenting clergyman 'Rev. Thomas
Bradbury' was engraved by Faber Jr., 1749. In
London she lived off Throgmorton St. and had a
'city' clientele. She was elected an honorary
member of the SA. Exh. SA 1762-69 (portraits in
crayons). In 1769 she retired to Homerton and
built a gallery in which to show her pictures. A por-
trait of her was engraved 1785. Her talents were
extremely limited.

(Whitley, I, 213/4.)

GRAFTON **fl.1774**
Exh. 'A piece of flowers, in crayons', RA 1774.

GRAHAM, George **fl.1783**
Hon. exh. SA 1783 of a 'Scene in Shakespeare's
Tempest'.

GRAHAM, John *c*.**1706-***c*.**1775**
Dutch history and decorative painter, said to have
been born and died in London. Pupil of Terwesten
and Arnold Houbraken. Travelled extensively to
Antwerp and Italy and settled at The Hague,
where his pictures were sold in 1775, Lugt 2432,
before he retired to London. His work is unknown.

GRAHAM, John **1755-1817**
History and portrait painter. Born Edinburgh 17
March 1755; died there November 1817. Trained
as a coach painter. Came to London and exh. por-
traits and animal pictures. Entered RA Schools
1783. Exh. RA 1780-97 history pictures (at first
with lions in them) and portraits; FS 1782-83; SA

1783. He also painted a Shakespeare scene for
Boydell and made designs for illustrations in
poetical works *(list in Hammelmann.)* In 1798
appointed Master of the Trustees Academy,
Edinburgh, where he had Wilkie, Watson-Gordon
and Sir William Allan among his pupils.

(Irwin, 1975, 94.)

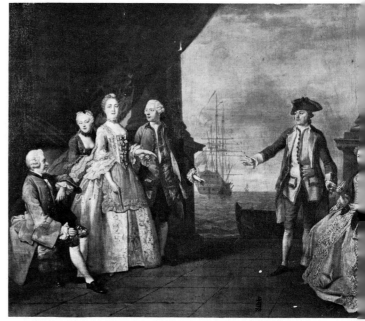

HUBERT GRAVELOT. 'Augustus Hervey saying farewell to his
wife, 1750.' 39½ins. x 49ins. National Trust, Ickworth.
Documented as being, at least in part, by Gravelot; but
Hayman may have assisted in some of the figures.

GRAVELOT, Hubert **1699-1773**
French designer and illustrator; very occasional
figure painter. His real name was Hubert François
Bourguignon. Born Paris 26 March 1699; died
there 19 April 1773. He was a pupil of Restout and
Boucher and worked in England from late 1732
until 1746, where he introduced rococo ideas and
techniques, and especially the notion of the elegant
engraved book. He played a very active role in
running the St. Martin's Lane Academy, in
association with Hogarth and Hayman; his part in
planning the decoration of the supper boxes in
Vauxhall Gardens was considerable, if unclear. He
had a great influence and was to some extent the
teacher of the young Gainsborough. He painted
very little in oils and his one documented con-
versation piece, at Ickworth *(Gazette des Beaux Arts,
Feb., 1932)* is undistinguished, but he had a
profound influence on the development of the arts
in London in the 1740s. A small genre piece, docu-
mented by engraving, is at Marble Hill House.

(Hammelmann.)

GRAY fl.1783

Exh. horse and animal pictures, FS 1783.

GRAY, George 1758-1819

Painter of fruit and of portraits in oil and crayons.
Born and died at Newcastle, where he was
apprenticed to one Jones, an itinerant fruit painter.
Exh. RA 1811.

(Bewick, Memoirs.)

GRAYFRERE See GAYFERE, Thomas

GREEN, Amos 1735-1807

Flower and still-life painter. Born at Halesowen
1735; died York 10 June 1807. Brother of the
engraver Benjamin Green. Exh. SA 1760-65,
latterly from Birmingham. He lived later at Bath.
In 1796 he married a pupil, Harriet Lister of York,
and they lived at Burlington and made sketching
tours in the north, painting watercolours.

*(Mallalieu; DNB; widow's memoir, Memoir of A.G., Esq.,
York, 1823.)*

GREEN, James 1771-1834

Mainly a watercolour *(Mallalieu)* and miniature
painter but also painted portraits in oil. Born
Leytonstone, Essex, 13 March 1771; died Bath 27
March 1834. Entered RA Schools 1791. Exh. RA
1793-1834. His portraits on the scale of life (several
in NPG) are all after 1800.

(DNB; Long.)

*J. GREEN OF OXFORD. 'The fencing lesson.' 35ins. x 45ins.
s. & d. 1746. Sotheby's sale 8.3.1950 (125).*
One of the characters may be Thomas Hollis. It is painted in a
style which recalls the decorations of the Vauxhall Gardens
supper boxes.

GREEN(E) of Oxford fl.1733-1768

At least two generations of painters of this family
were active at Oxford. Their christian names are
uncertain as most references are to 'Green the
painter' or 'Green junior'. Several (as well as the
engraver Benjamin Green) were concerned with
the Oxford Almanacks *(Helen Mary Petter, The*

GREEN OF OXFORD. 'An Oxford Book Auction, 1747.' 12½ ins. x 35½ ins. Formerly John Bryson collection, Oxford.
The signature is not quite clear, but it is dated. It is an unique document. Presented by the executors to the Bodleian Library,
Oxford, 1980.

Oxford Almanacks, 1974, index).

'Green junior' copied a portrait of 'Thomas White' for the Bodleian, 1750, and signed 'An Oxford Book Auction', 1747 (Bodleian Library) in the manner of Gawen Hamilton. He may have been the J. Green who signed 'The Fencing Lesson', 1746 (sale, S, 8.3.1950, 125) or the W. Green who signed and dated 1765 two grisaille paintings after Rysbrack's statues of 'Rubens' and 'Van Dyck' (sold S, 27.8.1955, 66).

A 'John Greene, Oxford' was painting copies of portraits in 1768 *(Waterford MSS.)* and mentions a brother, perhaps recently deceased.

(For a catena of references to the family see J. Sparrow, Burlington Mag., CII (Oct. 1960), 452 n.)

GREEN, William **1761-1823**

Landscape painter, mainly in watercolours. Born Manchester 1761; died Ambleside, Westmoreland, 1823. He lived in the Lake District and specialised in views from those parts. Exh. RA 1797-98 and 1801 some such views which may have been in oils.

(Mallalieu.)

GREENLEY, Miss **fl.1795-1797**

Hon. exh. of west country views (and possibly of a portrait) RA 1795-97 (but her name gets spelt also as Greenby, Greenland and Greenhead!).

GREENWOOD, John **1727-1792**

Portrait and landscape painter of American origin; also engraver and auctioneer. Born Boston, Massachusetts, 7 December 1727; died Margate 16 September 1792. Apprenticed to an engraver but he practised as a portraitist before leaving Boston for Surinam, where he painted many portraits 1752-57. In Holland 1758 (as an engraver); settled in London 1762, and exh. SA 1764-76 landscapes, portraits (some in crayons) and genre pictures. From *c.*1773 he acted mainly as an auctioneer.

(Groce and Wallace.)

GREGG, J. **fl.1796-1817**

Exh. botanical paintings at RA 1796-1817.

GREIRSON **fl.1782**

Exh. FS 1782 'Ship on fire'.

GRIFFIER, Jan, Sr. **1645(or 1652)-1718**

Ideal and topographical landscape painter. Born Amsterdam; died London 1718. Came to London soon after 1666 and became a pupil of Jan Looten. He painted ruins and river scenes and picturesque castles in a Netherlandish style. Back in Holland

*c.*1695-1705, when he returned to England. Certain bird's-eye views of cities — London *(cf. Burlington Mag., CXVI (June 1974), 314, at Sibiu)*, Oxford, Gloucester — seem to date from these years.

(Ogdens.)

GRIFFIER, Jan, Jr. **fl.1738-1773**

Topographical and ideal landscape painter in England. He is said to have excelled in copies after Claude. Dated works are known from 1738. Posthumous sale, 4/5.6.1773, Lugt 2174. He was probably the grandson of Jan Griffier, Sr. and son of Robert (q.v.) though he and Robert are usually called brothers.

GRIFFIER, Robert **1688-***c.***1750**

Topographical painter and marine painter; also copyist of and dealer in old masters. Born London 7 October 1688, son of Jan Griffier, Sr.; probably died in London. He became a citizen of Amsterdam in 1716, but was back in London by 1727. His 'Regatta on the Thames', 1748 (Duke of Buccleuch) suggests he had looked at Canaletto.

GRIFFIN, William **1751-1772**

Entered RA Schools 1772, aged 21; silver medal 1772. Exh. crayon portraits at SA 1772.

JAN GRIFFIER Sr. 'A turkey and other fowl.' 44ins. x 54ins. s. & d. 1710. Christie's sale 5.11.1965 (16).
Presumably by the elder Jan Griffier who is better known as a topographical painter.

JAN GRIFFIER Sr. 'View of Windsor Castle.' Signed. Private collection.
Griffier tended to make repetitions of popular subjects such as Windsor Castle.

GRIFFITH, Moses **1747-1819**
Antiquarian and topographical draughtsman and
engraver *(Mallalieu)*. He is said to have painted
some family portraits in oils *(Steegman, i, pl.Ic)* but I
don't believe this.

GRIFFITHS, John **fl.1764-1774**
Exh. SA 1764-74 a very odd variety of pictures,
several of which were of the kind called 'a
deception'.

GRIGNION, Charles **1752-1804**
Portrait and occasional history painter. Born in
London; died Leghorn 4 November 1804. Pupil of
Cipriani. Entered RA Schools 1769, aged 17; gold
medal 1776. Exh. RA 1770-84 (mainly portraits
but in 1784 'The Death of Captain Cook', sent
from Rome). A certified portrait is 'Capt. Sir
Richard Pearson' (Greenwich), engraved 1780;
certain attributed portraits, in the manner of
Downman, may be doubted. RA travelling
scholarship in 1782 to Rome, where he lived until
the Napoleonic invasion, and was influenced by

*CHARLES GRIGNION. 'Honble. Charlotte Clive.' 50ins. x 40ins.
s. & d. Rome 1787. Powis Castle (National Trust).*
One of Grignion's few absolutely certain works. It shows a
strong influence from Angelica Kauffmann.

Angelica Kauffmann and Wilhelm Tischbein. He retired to Leghorn and is said *(Redgrave)* to have painted some good landscapes. He is not to be confused with the engraver, Charles Grignion (1716-1810), who was his father.

GRIMBALDESTON, Walter fl.1711-1738
Landscape painter. Involved in founding the Kneller Academy 1711 *(Vertue).* His posthumous sale was in 1738.

(Harris, 163.)

GRIMM, Samuel Hieronymus **1733-1794**
Swiss painter of topographical watercolours *(Mallalieu).* He had practised in oils before settling in England in 1768.

(Rotha Mary Clay, S.H.G., 1941.)

GRISONI, Giuseppe **1699-1769**
Italian-trained history and portrait painter. Born Mons 24 October 1699; died Florence 1769. Trained young in Florence by Tommaso Redi; met John Talman in Rome, who induced him to come to England *c.*1720. His main work in England was a ceiling (destroyed) at Canons, but he painted a

number of portraits; the most ambitious is that of the '1st Earl of Macclesfield' (R. Dutton Collection) *(Burlington Mag., CII (Feb. 1960), 71).* He returned to Italy, with his pupil, William Hoare (q.v.) 1728. Several altarpieces survive in Florence.

(E.C-M.)

GROGAN, Nathaniel *c.***1740-1807**
Irish painter in oils and watercolours of landscapes and slightly caricatural scenes of Irish rural life. Born Cork; died there 1807, aged 67. He sent four landscapes to the FS 1782, but probably from Ireland. His very competent pictures reveal a training which cannot have been acquired in Cork and show knowledge of London painting. His genre pictures are superior to the work of Egbert van Heemskerk and suggest a knowledge of both Hogarth and Ostade. Two of his sons feebly imitated their father's style.

(Crookshank and Knight of Glin, 1978.)

GROOMBRIDGE, William **1748-1811**
Kentish landscape painter and miniaturist. Born Tunbridge 1748; died Baltimore, Maryland, 24

GIUSEPPE GRISONI. 'Thomas, 1st Earl of Macclesfield as Lord High Chancellor.' 96ins. x 76ins. From the 1720s. Ralph Dutton, Hinton Ampner Manor.
The attribution to Grisoni is reliably documented. The theme is an allegorical justification of Lord Macclesfield's tenure of office.

WILLIAM GROOMBRIDGE. 'View of Maidstone.' 24½ ins. x 39½ ins. Christie's sale 23.6.1950 (12).
A typical Kentish landscape in the Lambert tradition.

May 1811. Exh. miniatures and landscapes from various addresses in Kent (latterly Canterbury) FS 1773-75; SA 1776; RA 1777-90. Possibly a pupil of James Lambert Sr. of Lewes (q.v.). Some influence of R. Wilson has been detected in his works (*W.G. Constable, Wilson, 145/6*). He seems to have been the same person as the painter who arrived in Philadelphia *c.*1794 and moved to Baltimore 1804, where he also painted miniatures and landscapes.

(Groce and Wallace.)

GULICH fl.1760
Signed and dated 1760 a picture of 'two farmhouse dogs' in a Netherlandish-looking landscape at Ingatestone.

GULSTON, Elizabeth fl.1780-1826
Occasional hon. exh. RA 1795, 1797 and 1801 of genre and literary subjects. Daughter of Joseph Gulston of Ealing Grove (d.1786; his wife d.1780), some of the portraits in whose collection she etched. She was buried at West Clandon, Surrey, 1826.

(Redgrave.)

GUMBRAGE fl.1778
Exh. two landscapes, one in the style of Van Goyen, FS 1778.

GUTTENBRUNN, Ludwig fl.1770-1813
Portrait painter in oils and crayons, and occasional history painter. Born Krems, nr. Vienna; last heard of in Rome 1813. 'Self portrait' given to Uffizi 1782 as 'Painter to the Archduke of Austria'. Exh. RA 1790-93. Court portraitist in St. Petersburg 1795-*c.*1805.

(Edwards; Th.-B.)

GUYNIER, Claudius fl.1716-1729
French portrait painter, possibly born at Grenoble; father-in-law of G.M. Moser. In England 1716 and employed by Lord Harley, for whom he painted his daughter (Welbeck) and the Master of Christ's College (for £3 4s. 6d.).

(Goulding and Adams.)

GYLES, Rev. Mr. fl.1765-1772
Hon. exh. FS 1765; SA 1771/2; from Worcester. Probably James Gyles, metriculated Merton, Oxford, 1747, aged 18.

H

HACKERT, Johann Gottlieb **1744-1773**
German painter of Italian landscapes. Born Prenzlau, Uckermarck, 1744; died Bath 1773. One of four painter brothers. Worked with his brother **(Johann) Philip** at Paris 1766 and in Rome and Naples from 1768. Their neat linolear style is very similar. Exh. at SA 1771, from Rome. Came to London 1773 and exh. Italian views (oils, watercolours and drawings) RA 1773. His brother **J.P. Hackert** also exh., presumably from Italy, at SA 1774, 1776, 1790-91.

HADFIELD, W. **fl.1782/83**
Brother of the architect, George Hadfield, and of Mrs. Cosway (q.v.). He exh. a drawing at the RA 1782 and what may well have been an oil Italian view in 1783.

HAECKEN See VAN AKEN

HAGART(H)Y, James **fl.1762-1783**
A very modest painter, of Irish extraction, of all kinds of picture, which he exh. FS 1767-83. He was secretary of the Free Society at the time of its decease in 1783. He was capable of an occasional neat view of a house. A son, **J. Hagarty, Jr.** also exh. FS 1772-83, miscellaneous items, mainly in chalks.

(Strickland.)

HAGEN See VANDERHAGEN

HAILES, D. **fl.1771**
Hon. exh. of a portrait in crayons SA 1771.

HAKEWILL, John **1742-1791**
Decorative house painter and occasional portraitist. Born London 27 February 1742; died there 21 September 1791. Studied under Wale (q.v.), and at Duke of Richmond's Academy and RA Schools (1769). Won many prizes for drawings and a silver palette for landscape from Society of Arts 1772. Exh. SA 1765-73 (mainly portraits), but preferred to specialise in decorative painting, notably arabesques. Two sons were architects and grandsons also were artists.

(E.C-M.)

JAMES HAGARTY. 'Mr. Tutte's house at Hammersmith.' 24ins. x 29½ins. Exh. SA 1778 (70). Christie's sale 19.11.1965 (114). A curious middle-class commission.

HALFORD, Robert **fl.1776**
A 'master Robert Halford, at Mr Day's School, Fulham' exh. FS 1776 'The meeting of Isaac and Rebecca.'

HALL, Charles **fl.c.1740**
This name is given to the portrait at Packington of 'Elizabeth, Countess of Aylesford' of c.1740, in a style not unlike that of Highmore.

HALL, T. **fl.1796-1801**
Exh. three landscapes at RA 1796, 1798 and 1801.

HALLS, John James **1776-c.1828**
Portrait and history painter. Born ?Colchester, 1776; last exhibited 1828. Studied at RA Schools 1798, having precociously exh. a watercolour landscape at RA 1791. Settled in London 1799 and exh. histories and portraits at RA 1798-1827, and histories at BI 1806-28. He also had a good portrait practice and a number of his portraits are engraved.

(Redgrave.)

GAVIN HAMILTON. 'Elizabeth Gunning, Duchess of Hamilton.'
93ins. x 57ins. c.1752. Duke of Hamilton, Lennoxlove.
Painted soon after her marriage in 1752; engraved in
mezzotint by Faber Jr. 1753. She was one of the great beauties
of the day. For a later portrait, see Francis Cotes' portrait of
her s. & d. 1767, page 91.

HAMBLETON
See HAMILTON, Hugh Douglas

HAMILTON, Gavin 1723-1798

Neo-classical history painter and portrait painter.
Born Murdieston House, Lanark, 1723; died in
Rome 4 January 1798. He is best known as one of
the leading excavators and dealers in classical
sculpture in Rome and he also dealt in important
old masters and persuaded his clients to com-
mission his own history pictures as part of the
transaction. Educated at Glasgow University
1738-42, he went to Rome and became a pupil, of
Agostino Masucci (up to 1748). From 1752 to 1756
he acquired some reputation as a portrait painter in
London, but returned to Rome in 1756 determined
to paint heroic histories with life-size figures. His
first major work was 'Dawkins and Wood dis-
covering Palmyra', 1757-59 (on loan to Glasgow
University), and about 1760 he began a series of six
poetic scenes from *The Iliad,* completed in 1775,
which he considered his major achievement
(Burlington Mag., Jan., 1978). The earliest of these

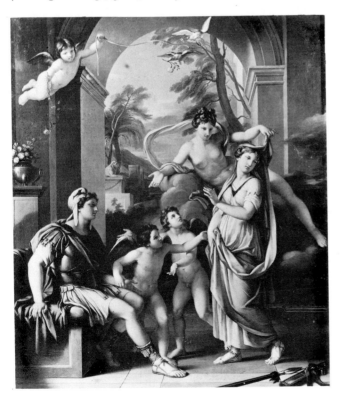

was 'Achilles mourning Patroclus', 1760-63
(Edinburgh). He exh. SA 1762-71 and fitfully at
the RA 1770-88, from Rome where he lived con-
tinuously (except for a short visit to Scotland in
1783) until his death. He was one of the founders of
neo-classical history painting and had most of his
pictures engraved, so that he acquired a con-
siderable European reputation and was perhaps
better known abroad than in Britain. His chief sur-
viving work in Rome was a neo-classic room,
1782-84, in the Villa Borghese, of which the ceiling

GAVIN HAMILTON. 'Venus offering Helen to Paris, 1784.'
3.25 x 2.80. Rome, Museo di Roma.
One of three large pictures of 'The story of Paris' painted for
the Villa Borghese, Rome, in 1782-84. The companion ceiling
paintings are still *in situ.* They illustrate Hamilton's final neo-
classical style.

EDWARD HAYTLEY. 'The Montagu family at Sandleford Priory, 1744.' 35½ ins. x 60ins. Messrs. Leger's.
Edward Montagu (d.1775) and his wife Elizabeth, the famous 'blue-stocking', at their country house near Newbury. The picture can be dated from the family papers now in the H.E. Huntington Library, San Marino, California. It was this picture which first identified Haytley as one of the leading painters of 'conversations'.

paintings survive *in situ,* while the large wall canvases of 'The story of Paris' are in the Museo di Roma. He played a considerable role in establishing a taste for the neo-classic and had an influence on, among others, Canova and Benjamin West (q.v.). Many of his (never numerous) large pictures are now known only from engravings.

(D. Irwin, Art Bulletin, XLIV, 1962.)

HAMILTON, Gawen *c.*1697-1737

Painter of conversation pieces and small whole length portraits. Born in West of Scotland, near Hamilton; died London 28 October 1737. Studied under an obscure bird painter named Wilson. Practised in London from *c.*1730 and was one of Hogarth's chief rivals at that time in conversation pieces, and thought by some contemporaries superior to Hogarth. His best known certain work is 'The Club of Virtuosi', 1735 (NPG).

(Vertue.)

HAMILTON, Harriott *c.*1769-after 1828
(Mrs. John Way)

Irish portrait painter and copyist of old masters. Daughter of Hugh Douglas Hamilton (q.v.); born in London; married John Way 1817. Exh. portraits in Dublin as Mrs. Way 1826/7; last heard of 1828. She finished off at least one of her father's works.

(Strickland.)

GAWEN HAMILTON. 'A conversation of Virtuosi, 1735.' 34½ ins. x 43¼ ins. National Portrait Gallery (1384).
This picture is fully described by Vertue (iii, 71-72) and the sitters' names are inscribed on the picture below them. For a full account see *Kerslake* pp.340-342. They include the chief painters, engravers and sculptors of the day — except Hogarth.

HAMILTON, Hugh Douglas 1736-1808

Very prolific Irish portraitist in crayons and oil, and very occasional history painter. Born Dublin 1736 *(Farington, 1 March 1804)*; died there 10 February 1808. Studied under West in Dublin 1750-56, when he set up on his own in Dublin painting small oval crayon portraits. He moved to London *c.*1764, where he charged 9 guineas for these small ovals and was extremely successful, painting also full lengths and occasional 'conversations'. Exh. FS 1764-72 (in 1764 as 'Mr Hambleton'); SA 1766-75. He won prizes for history pictures in oils from the Society of Artists in 1764 and 1765. In 1778 he removed to Rome, where he remained (except for visits to Florence *c.*1787-89) until 1791. Exh. RA 1787 and 1791 (from Rome). He painted an immense number of British visitors to Rome and was persuaded by Flaxman to enlarge his practice by doing also life-scale portraits in oils. Friendship with Flaxman and Canova directed him to more or less neo-classical settings for some of his later portraits. He continued this style after his return to Dublin in 1791, where he had a busy portrait practice until retirement in 1804. In 1800 he exh. some historical pictures in Dublin and he charged 120 guineas for a whole length at the end of his life.

(Strickland; Crookshank and Knight of Glin, 1978.)

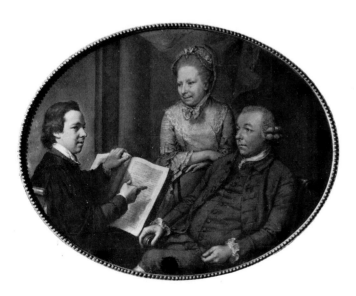

HUGH DOUGLAS HAMILTON. 'Revd. William Rose and his parents.' Coloured chalks. 15ins. x 19ins. s. & d. 1775. Christie's sale 12.10.1945 (38).
An example of Hamilton's crayons done in London, before he settled for some time in Rome.

WILLIAM HAMILTON. 'Mrs. Siddons as Zara.' 50ins. x 40ins. c.1784. Sotheby's sale 5.2.1947 (78).
Hamilton also painted a full length of Mrs. Siddons in Hill's *Zara*. This picture descended in Mrs. Siddons' family and does not seem to have been cut down. It was formerly in the Los Angeles County Museum.

HAMILTON, John fl.1767-after 1787
Landscape painter and etcher. Born Dublin; died London. It is doubtful if he painted in oils. Exh. landscape views of Wales and the north west at SA (of which he became Vice-President *c.*1775) 1767-77.

(Strickland.)

HAMILTON, William 1750/51-1801
Decorative, history and portrait painter. Born Chelsea; died London 2 December 1801. Son of a Scottish assistant to Robert Adam, who sent him very young to Rome. At first a pupil of Zucchi (q.v.) (possibly in Rome 1766 and certainly in London from 1768) and trained as an architectural draughtsman. RA Schools 1769 and turned to figure painting. Exh. RA 1774-1801. ARA 1784, RA 1789. He produced a steady stream of narrative scenes, often small, in a 'gothic' and romantic style, and painted many pictures for Boydell's Shakespeare Gallery and for Macklin.

He also designed cabinets and stained glass for William Beckford and others. His best portraits are of actors, many of them of Mrs. Siddons. His charming and mannered narrative scenes sometimes show the influence of Fuseli (q.v.), with whom he collaborated in illustrating Thomson's 'Seasons' and Gray.

(Edwards; E.C-M; Hammelmann.)

HAND, Thomas fl.1790-1804
Faithful follower, factotum and copyist of George Morland (q.v.) who assisted in turning out many of 'Morland's' later pictures. Died within a few weeks of Morland. Exh. SA 1790; RA 1792-1804. A signed landscape is in the Tate Gallery.

(Grant.)

HANDY, John fl.1787-1791
Exh. landscapes and one portrait RA 1787-91; SA 1791. Pretty and topographical.

(Grant.)

HANNAN, William fl.1751-1772
Topographical landscape and decorative historical painter. Said to have been born in Scotland and to have died at West Wycombe *c.*1775. Exh. SA 1769-72, mainly views in oil and watercolour of the Lake District, from an address in High Wycombe. His main employment was with Sir Francis Dashwood (Lord Le Despencer) at West Wycombe Park, where he painted views of the house and grounds 1751 (engraved 1754/7), several neo-classical ceiling decorations, and a fresco 'Chariot of Night', 1770, in the west portico. He seems to have had some sort of partnership with Giuseppe Borgnis (q.v.) (d.1761), who worked at West Wycombe from 1753. His views are in the manner of Lambert, but clumsier.

(E.C-M; West Wycombe Park, National Trust Guidebook.)

HARCOURT, George Simon 1736-1809
2nd Earl Harcourt. He fancied himself as an amateur landscape painter and presented one of his landscapes to the Bodleian Library, Oxford, 1802, to replace an inferior one painted some years before.

HARCOURT, Hon. Mrs. 1750-1833
Wife of the Hon. William Harcourt, later (1809) 3rd Earl Harcourt. Hon. exh. of landscapes RA 1785/6.

WILLIAM HAMILTON. 'Scene from Love's Labours Lost, *act iv, scene i.*' 84ins. x 105ins. s. & d. 1788. Christie's sale 9.5.1947 (62).
Painted for Boydell's Shakespeare Gallery, and a typical example of Hamilton's rococo literary subject pieces.

WILLIAM HANNAN. 'A view in West Wycombe Park.' 33ins. x 47ins. Christie's sale 16.6.1961 (58).
One of several examples of a set of oil paintings of views in West Wycombe Park, of which engravings were made 1754-57.

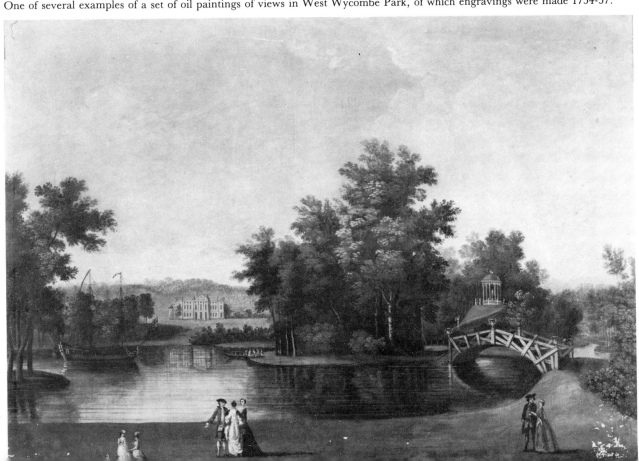

HARDING, Francis fl.*c*.1730-*c*.1766
Landscape and coach painter; an extremely skilful copyist of Canaletto (q.v.) and Pannini *(Vertue)*. Three of his Pannini overmantels, painted *c*.1730 for Blackheath Park, were sold S, 18.11.1970, 12-14. He was also a respectable landscape painter.

(Mrs. Finberg, Country Life, 1 May, 1920.)

HARDING, J. or T. fl.1796-1798
Exh. three Kentish landscapes RA 1796-98.

HARDING, O. fl.1796
Exh. a portrait at RA 1796.

HARDWICK fl.1773
'Mr Hardwick, at the Tower' exh. FS 1773 a male portrait in crayons.

HARDY, Thomas 1757-*c*.1805
Portrait painter and mezzotint engraver. Born June 1757; latest print recorded 1804. Entered RA Schools 1778. Exh. RA 1778-98; SA 1790 (in error as 'F. Hardy'). He exh. a single fancy picture, and was involved in radical politics.

HARE, Miss fl.1770
Exh. 'Birds: flowers: Strawberries', FS 1770.

HARGRAVE fl.1780
Exh. 'a nymph: in crayons' from an address at Exeter FS 1780.

HARGRAVE, J. fl.1693-*c*.1719
Painter in the Kneller tradition by whom several signed or engraved portraits exist. He is probably the Mr. Hargrave who gave Vertue some information in 1719.

HARGREAVES, Thomas 1774-1847
Portraitist and miniature painter. Born Liverpool 16 March 1774; died there 5 January 1847. Entered RA Schools 1790 and was apprenticed to Lawrence 1793-95 and continued to assist him up to *c*.1798. Exh. RA 1798, 1808/9 and 1819. He was settled in Liverpool by 1807 and became a founder-member of the Liverpool Academy 1810. In Liverpool his work was mainly in miniature.

(Walker Art Gallery, Merseyside cat.)

HARPUR, Philip fl.1764-*c*.1770
Trained in Dublin as a draughtsman 1764-68; later did crayon portraits in Dublin in the style of Hugh Douglas Hamilton (q.v.).

(Strickland.)

HARRINGTON, Miss fl.1796-1797
Hon. exh. of 'Flowers', RA 1796-97.

HARRIS fl.1771
Exh. 'A farm yard', FS 1771.

HARRIS, Master Charles fl.1780
Hon. exh. of 'Profile of a gentleman; in chalk', SA 1780.

HARRIS, John fl.*c*.1722-1759
Topographical painter and engraver. Conceivably the 'Harris Junr' mentioned as an engraver by Vertue in 1713; and probably the Harris who gave Vertue *(i,106)* information in 1722 about Knyff. Known as the painter of Knyff-like views of Dunham Massey 1751, engraved by Boydell *(Harris, 157)*. He was painting more conventional views of country houses up to at least 1759.

THOMAS HARDY. 'Sir Henry Gould' (1709-94). 46ins. x 37ins. Engraved in mezzotint by the artist 1794. Christie's sale 28.3.1947 (90).
It bears the misleading date of 1760 on the back. The engraving was published four days before the sitter's death and 1794 is a likely date for the portrait.

JAMES HARVEY. 'Cleopatra on her barge.' 24ins. x 29½ins. s. & d. 1789. Christie's sale 8.11.1963 (107).
This painting is all that is known about the artist who was clearly an imitator of Angelica Kauffmann.

R. HARVIE. 'Elizabeth (Dalrymple) wife of William Duff.' 28ins. x 24ins. s. & d. 1763. Christie's sale 11.10.1946 (74).
A typical portrait by this Scottish artist, of whom no details are known.

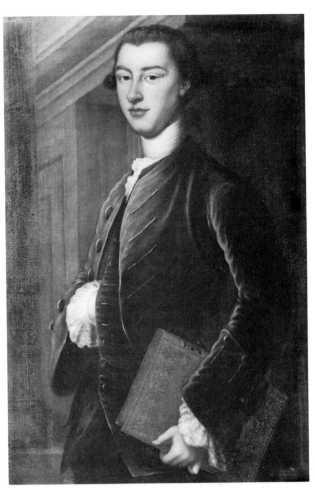

J.S. HARVEY. 'Benjamin Way of Denham Place.' 36½ins. x 24½ins. Signed. Sotheby's sale 11.6.1958 (92).
Benjamin Way (1740-1808). Nothing is known of the painter, who may have been a pupil of Hudson.

HARTLEY, Mrs. fl.1775
Hon. exh. of views in Gloucestershire, SA 1775.

HARVEY, (?James) fl.1789
Signed and dated 1789 a 'Cleopatra on her barge' like an enfeebled Angelica Kauffmann (sale, 8.11.1963, 107).

HARVEY, John See HERVÉ, Jean

HARVEY, J.S. fl.c.1760
Signed a competent portrait of 'Benjamin Way of Denham Place' (sold S, 11.6.1958, 92) in the Hudson tradition.

HARVIE, R. fl.1751-1763
His signature and dates ranging from 1751 to 1763 appear on portraits of Scottish border families. They have a certain individuality and suggest provincial variations on Alan Ramsay (q.v.).

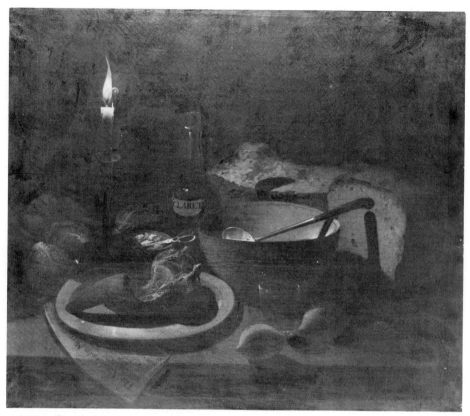

MOSES HAUGHTON. 'Still life.' 28½ ins. x 33 ins. s. & d. 1773. Christie's sale 25.2.1955 (141/1).
An example of Haughton's more usual type of picture.

HASSEL, ?William fl.*c.*1720

Mentioned by Vertue *(iii,6)* as the first teacher of George Lambert (q.v.); presumably a landscape painter. He has very doubtfully been supposed to be the portrait painter and miniaturist Werner Hassel (fl.1674-1710).

(Long.)

HAUCK, John Maurice fl.1759-1767

Portrait painter active in York 1760/1 (two signed and dated examples in York Gallery, 984, 1161). Presumably the 'Mr Hawck' who exh. portraits at SA 1761-67.

(York Art Gallery cat., vol.II, 1963, and Appendix, 1974.)

HAUCK, Philip Elias fl.1761-1765

Exh. 'Four human skeletons, painted in one picture' at FS 1761; listed a member of the Society of Artists 1765.

HAUGH, George 1756-1827

Baptised Carlisle 12 March 1756; died Doncaster 27 May 1827. Entered RA Schools 1772. Exh. RA 1777, 'a head (from Cumberland), and 1779 portraits (from a London address). Painted occasional sporting pictures.

(Egerton.)

HAUGHTON, Moses, Sr. 1734-1804

Trained as a Birmingham enameller, but took to painting still-life and occasionally other subjects. Born Wednesbury 1734; died near Birmingham 1804. Exh. 'Dead Game' (from Birmingham) RA 1788, and a sorceress and a witch (from a London address) 1792. A signed and dated (1784) 'Sigismunda' is like Angelica Kauffmann; and a landscape of 1789 recalls de Loutherbourg. A nephew, **Moses Jr.** (1774-1848) was a miniaturist and engraver and exh. RA 1800-48.

HAWES fl.1786

Documented as painting at Doncaster and as having painted the 'Rev. Edmund Cartwright and his five children' there in 1786 *(The Ancestor, X, 11 n.)*

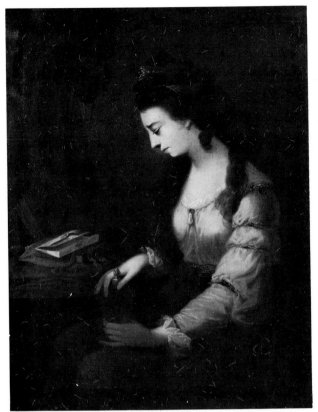

MOSES HAUGHTON. 'Sigismunda.' 49¼ ins. x 39¾ ins. s. & d. 1784. Christie's sale 2.12.1935 (150).
Sigismunda weeping over the heart of her lover, Guiscardo, a theme from Boccaccio, popularised by Dryden. It had already been painted by Hogarth.

HAY, Andrew fl.1710-1754
Scottish portrait painter and picture dealer. Native of Fife; died 1754. Trained as a portraitist in the style of Medina (q.v.). Signed portrait of 1710 at Mellerstain. By the 1720s, had given up painting for picture dealing travels to Italy.

(Dennistoun, i, 33.)

HAY, John fl.1768-1776
Mainly a miniature painter and a pupil of R. Cosway (q.v.) 1768/9. Entered RA Schools 1769 and exh. life-size portraits RA 1770-71. Exh. SA 1768/9 and 1776; FS 1776. A 'Mr Hay' who exh. 'An Inside of an ale house at an Election Time', FS 1783, may have been another.

(Long.)

HAY, W. fl.1776-1797
Mainly a miniature painter, but he exh. two portraits at RA 1792 and a landscape (from a Plymouth address) 1787. Exh. RA 1776-97 rather fitfully. In 1790 he had a Bath address.

(Long.)

HAYMAN, Francis *c.*1708-1776
Painter of history, portrait, genre; and a central figure in the art world of the middle of the century. Born in Devon 1708 (possibly earlier); died London 2 February 1776. Apprenticed to Robert Brown (q.v.) 1718. When young he did scene painting for Drury Lane. He was the 'best historical painter in the Kingdom' between the death in 1734 of Thornhill (q.v.) and the arrival in 1756 of Cipriani (q.v.) — but little of his decorative historical painting has survived *(E.C-M.)*. His work came principally before the public in his decorations of the supper boxes and other pavilions at Vauxhall Gardens, which he did for Jonathan Tyers from *c.*1741 to *c.*1761 *(Gowing, Burlington Mag., XCV. Jan. 1953)*, which were perhaps seen by more people in London than any other paintings. They include several new kinds of picture, scenes from literature (especially Shakespeare), scenes from the Theatre, and scenes of rural folklore (two in the V & A). The most interesting of these, from the 1740s, reflect the influence of Gravelot (q.v.) — with whom Hayman was active in teaching at the St. Martin's Lane Academy 1745 — and the French rococo. For

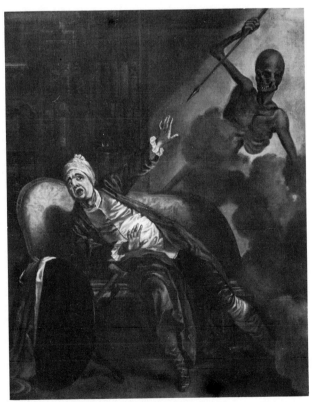

FRANCIS HAYMAN, 'Death of the unbeliever.' 29½ ins. x 24½ ins. Sotheby's sale 27.6.1962 (78).
Engraved by Bowles. One of a pair of paintings done for a pavilion in Jonathan Tyers's garden near Dorking before 1764 (cf. *Gentleman's Mag.*, March 1781, 124).

163

FRANCIS HAYMAN. 'Subject from King Lear.' 15ins. x 24ins. Unlocated.
Hayman painted the subject in large in the Prince's Pavilion in Vauxhall Gardens c.1745.

FRANCIS HAYMAN. 'The Duke's chaplain reproving Don Quixote and Sancho Panza.' 17½ins. x 13ins. Engraved in 1755 edition of Don Quixote by Grignion. Christie's sale 16.6.1961 (140).
Hayman also painted oil versions of many of the designs he made for book illustrations.

FRANCIS HAYMAN. 'The play scene in Hamlet.' 25ins. x 30ins. Robinson & Fisher sale 29.3.1924 (66).
Also a subject painted in the Prince's Pavilion in Vauxhall Gardens.

164

FRANCIS HAYMAN. 'Jonathan Tyers, with his daughter and son-in-law (Elizabeth and John Wood).' 38ins. x 33ins. B.A.C. Yale. Jonathan Tyers, the proprietor of Vauxhall Gardens, was Hayman's most considerable patron.

FRANCIS HAYMAN. 'A gentleman in Hungarian Hussar uniform.' 16¼ins. x 12¾ins. Sotheby's sale 6.7.1977 (8). It appears that Hungarian Hussar uniform was a popular form of fancy dress (like 'Van Dyck costume') and the sitters had not in fact enrolled in one of Maria Teresa's regiments.

Tyers in the 1740s Hayman also painted a number of out of doors family conversation pieces (two in BAC Yale) with a larger figure scale than Hogarth's; these had much influence on the young Gainsborough. Hayman had a large practice in conversation pieces and small scale full lengths during the '40s and '50s, and a rather smaller practice on the scale of life. He also painted some of the earliest theatre pictures 'Garrick and Mrs Pritchard in The Suspicious Husband', 1747 (BAC Yale). In 1743/4 he collaborated with Gravelot in designing engravings for Hanmer's Shakespeare, and he was very active as an illustrator for the next thirty years *(list in Hammelmann)*. He was one of those most concerned in the formation of the Society of Artists in 1760, and was President 1766-68; after which he became a Foundation Member of the Royal Academy, of which he became Librarian in 1771. Exh. SA 1760-68; RA 1769-72, mainly history pieces, of which few survive: 'The Good Samaritan', 1752 (BAC Yale).

(Deborah Lambert MA thesis on the history paintings, for Courtauld Institute, 1973; Hayman exh. cat., Kenwood, 1960; thesis by Brian Allen in progress.)

HAYOIT fl.1771-1783
Exh. flower paintings at FS 1771-83.

HAYS fl.*c.*1729
He worked as a copyist at Gloucester and was moving to London *c.*1730 *(Mrs. Delany, 1861, I, 201/2.)*

HAYTER, Charles 1761-1835
Mainly a miniaturist but also did portraits in crayons. Born Twickenham 24 February 1761; died London 1 December 1835. Entered RA Schools 1786. Exh. RA 1786-1832, chiefly miniatures. He was father of Sir George Hayter.

(Long.)

GUY HEAD. 'Echo flying from Narcissus.' 78ins. x 56½ins. Exh. RA 1800 (228). Sotheby's sale 10.12.1958 (159).
Engraved by I. Folo, in Rome, where it was no doubt painted. Head was one of the few British neo-classic painters.

HAYTLEY, Edward **fl.1740-1761**
Portrait and landscape painter; perhaps a native of the Preston area (like Arthur Devis (q.v.), with whose work his own has an affinity). First recorded as providing flower drawings in 1740 for Elizabeth Robinson (later Mrs. Montagu, with whose family he became very friendly). His 'Mrs. Montagu and family at Sandleford Priory', 1744, includes a remarkable naturalistic landscape as well as elegant figures in a conversation piece, and is one of the best examples of the genre. In 1746 he gave two circular views to the Foundling Hospital. He also painted portraits on the scale of life and exh. portraits at SA 1760-61.

(Leger Galleries exh., June-July, 1978.)

HAYWARD **fl.1771**
Hon. exh. of a fruit piece, RA 1771.

HAZLITT, John **1767-1837**
Miniaturist and occasional portrait painter. Baptised Marshfield, Gloucestershire, 6 July 1767; died Stockport 16 May 1837. Brother of William Hazlitt the essayist. Practised as a miniaturist in the United States up to 1787, when the family returned to England *(Groce and Wallace)*. Exh. RA 1788-1819, mainly miniatures. Several oil portraits of his family in Maidstone Arts Gallery. Moved to Stockport 1832.

(Long.)

HEAD, Guy **1762-1800**
Painter of neo-classic histories and copyist; also occasional portrait painter. Born Carlisle 4 June 1762; died London 16 December 1800. Entered RA Schools 1778. Exh. FS 1779; SA 1780; RA 1779-81 and 1800. He went abroad after 1781 and was a member of the Florence Academy 1787; of that of Cassel 1788. Was settled in Rome by 1790 and member of the Accademia di S. Luca 1792, giving as his diploma picture a neo-classic picture of 'Iris'. At the time of the French invasion he took refuge on Nelson's ship at Naples and travelled round Sicily with Charles Lock in 1799. He died soon after returning to London and his collections (many Greek vases as well as paintings) were first put up for sale by private contract 27ff.4.1801. His widow (Jane, *née* Lewthwaite, who painted classical landscapes in watercolour) brought fifty more from Rome in 1803, and there were auctions of all his remaining works at Wigton and in London 1805 (large classical subjects and many copies, especially after Wilson).

(Edwards.)

HEARLIN **fl.1765**
Exh. 'Wild Drakes', SA 1765.

HEATHER, John **fl.1763-1765**
Flower painter. Exh. FS 1763-65.

HEATLEY See HAYTLEY, Edward

HEATLEY, Mrs. fl.1797-1805
Hon. exh. of landscapes RA 1797-1805.

HEEMSKERK, Egbert van, II fl.c.1700-1744
Painter of coarse drolleries, hardly distinguishable
from his father's. (His father, Egbert I, also an
etcher, died in London 1704.) He is said to have
died 1744.

HEIGHWAY, Richard fl.1787-1793
Painter of genre subjects in the manner of Henry
Walton (q.v.) whose pupil he was in 1787; also
painted miniatures on glass. Exh. RA 1787-89 and
1793 (from Lichfield 1789, Shrewsbury 1793).

HEINS, D. (John Theodore, Sr.) 1697-1756
Portrait painter and mezzotint engraver of German
origin. Born 1697 (from 'Self portrait' sold S,
26.6.1974, 93); died Norwich 1756. He settled in
Norwich about 1720, where his first official com-
mission for a civic portrait (for St. Andrew's Hall)
was 1732. His portraits are competent but
pedestrian; also painted candlelight scenes.

(Fawcett, 1978.)

JOHN THEODORE (DIRCK) HEINS. 'Thomas Wright.'
49ins. x 39ins. s. & d. 1739. Christie's sale 7.10.1949 (152).
There is a certain Germanic air behind Heins' Hudsonish
patterns for English portraits.

JOHN THEODORE (DIRCK) HEINS. 'A composition symbolic of Trade.' 28ins. x 53ins. s. & d. 1743. B.A.C. Yale.
A rare example, with Flemish antecedents, of a symbolical scene.

HEINS, John Theodore, Jr. *c.*1732/33-1771
Occasional portrait painter and miniaturist at Norwich, but better as a topographical etcher. Born Norwich *c.*1732; died London 1771, where he had moved in the 1760s. He was an inferior portrait painter to his father (q.v.). Exh. FS 1767; SA 1768-70.

(Fawcett, 1978.)

HENAULT fl.1797
Exh. RA 1797 two genre subjects (which sound in the manner of Greuze) and a miniature.

HENDERSON, Mrs. See KEATE, Miss G.J.

HENSHAW, William 1753-after 1775
Born 22 September 1753. Entered RA Schools 1773. Exh. RA 1775 a portrait in a mixture of chalk and crayons (as a pupil of Bartolozzi).

HERBERT fl.1783
Hon. exh. of 'A view in Italy', RA 1783.

HERVÉ, Jean 1681-1735
Decorative and scene painter. Native of Poitou; in London by 1723; buried London 23 June 1735. Trained in the tradition of Laguerre.

(E.C-M.)

HESELTINE, William fl.1799-1805
Painted genre, history and portraits. Exh. RA 1799-1805. Apparently worked at RA Schools 1800.

HEUDE, Nicolas fl.1672-1703
French decorative history painter. Said to have been born at Le Mans; died Edinburgh 1703. *Agréé* at French Academy 1673, but left France as a protestant 1683 and became an assistant to Verrio (q.v.). Went to Scotland *c.*1695, where two competent ceilings survive at Caroline Park. *(E.C-M., i, 248).* A son (?), who signs **'L. Heude'**, painted a feeble portrait of 'John Tran' (Glasgow University).

HEWART, Thomas 1767-1787
Signed and dated '1787. Aet 20', a copy (now at Ham House) of Danckerts' 'Pineapple picture'.

HEWSON, Miss fl.1789
Hon. exh. of a portrait RA 1789.

HEWSON, Stephen fl.1775-1805
Least unknown as a portrait painter, but also tried genre and other subjects. Exh. FS 1775-80; SA 1776-91; RA 1777-1805.

(Long.)

HICKEL, Karl Anton 1745-1798
Austrian portrait painter, briefly in London. Born Česka Lipa 1745; died Hamburg 1798. Trained in Vienna. Left France for London during French Revolution. Exh. SA 1791; RA 1792-96. In 1793 he called himself 'Painter to the Emperor of Germany'. He had some vogue in political circles as a painter of small, neat portraits, often in a feigned oval: many were used for his chief work in England — 'The House of Commons, 1793' (NPG).

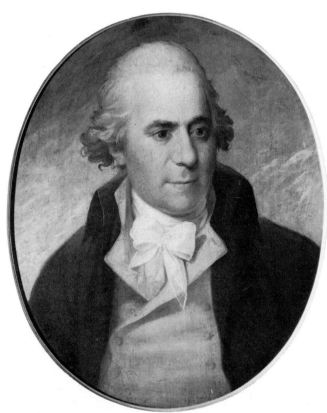

KARL ANTON HICKEL. 'Joseph Pease of Darlington.' 22ins. x 18ins. s. & d. 1793. Christie's sale 12.4.1946 (111).
Hickel specialised in small study heads of this sort, many of them (but not this) for his picture of 'The House of Commons, 1793'.

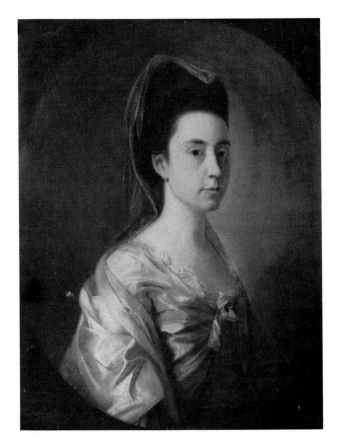

THOMAS HICKEY. 'Elizabeth, Duchess of Buccleuch.' 29ins. x 24ins. s. & d. 1771. Christie's sale 21.7.1939 (85).
Although painted when he had just left Ireland for London, this has a curiously Scottish air.

HICKEY, Thomas 1741-1824

Irish portrait painter; worked long in India. Born Dublin May 1741; buried Madras 20 May 1824. Studied in Dublin 1753-56. In Italy *c.*1760-66; back in Dublin 1767, where he exh. 1768-70. To London, where he entered RA Schools 1771. Exh. RA 1771-78 (the last year from Bath) and 1792. He painted portraits at Lisbon 1782/4, when he proceeded to India on a first visit until 1791. Accompanied Lord Macartney to China 1792/4. Back in India 1798, where he had considerable success, until his death. His portraits are readily recognisable, but are flabby and have little positive character.

(Archer, 205ff; George Breeze, MA thesis with cat., Birmingham University, 1973.)

HIGGIN, W. fl.1786

Exh. 'portrait of a lady', RA 1786. He is presumably the William Higgins born 15 September 1759; entered RA Schools 1784.

HIGGS fl.1774

Exh. 'Marriage of Cupid and Psyche', SA 1774.

HIGHMORE, Anthony 1718-1799

Occasional painter of portraits and topographical landscapes. Born London; died Canterbury 1799. Son and pupil of Joseph Highmore (q.v.) with whom he was still working as late as 1755. When his father retired to Canterbury in 1761, he too retired and gave up painting. Some views of Hampton Court are engraved and he painted a copy of Kneller's 'William III' for The Mansion House, York, in 1755.

HIGHMORE, Joseph 1692-1780

One of the best portrait painters in the reign of George II and an occasional painter of histories and themes from literature. Born London 13 June 1692; died Canterbury 3 March 1780. He was a man of some learning and originally studied the Law. He set up as a portrait painter in 1715 and studied for ten years in Kneller's Academy. He first became noticed in drawing (and later painting)

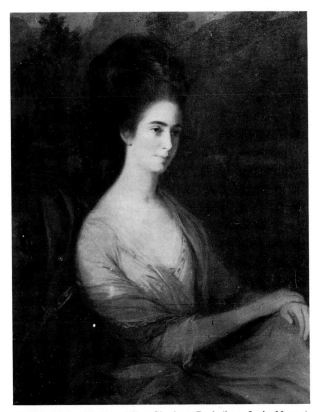

THOMAS HICKEY. 'Miss Charlotte Dee' (later Lady Nugent). 35¼ins. x 29½ins. s. & d. 1781. Christie's sale 16.7.1937 (44).
Painted in India and typical of Hickey's later style.

JOSEPH HIGHMORE. 'The children of William Eyre Archer.'
22ins. x 30ins. s. & d. 1747. Unlocated.
Although Highmore's obituary says he was famous for his
conversation pieces, this is one of the few known.

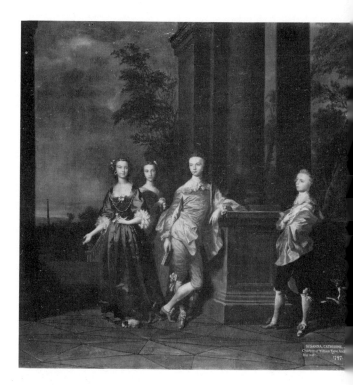

the Knights of the revived Order of the Bath for
engraving in 1725. Very many signed and dated
portraits are known from 1728 until his retirement
to Canterbury in 1761, when he gave up painting
and took to literary pursuits. His portrait practice
was varied — full lengths (some of royalty) and
other sizes on the scale of life, small-scale full
lengths and conversations (for which he had a
particular reputation). His development runs

JOSEPH HIGHMORE. 'Mrs. Sharpe and child.' 50ins. x 40ins.
s. & d. 1731. B.A.C. Yale.
Highmore, like Hogarth, specialised in lively naturalistic
middle-class portraiture.

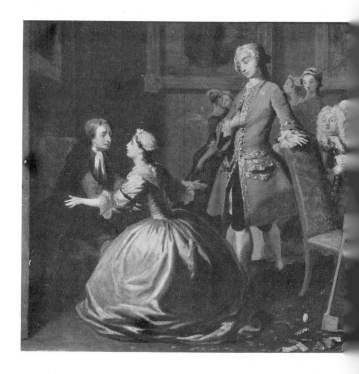

JOSEPH HIGHMORE. 'Pamela unexpectedly meets her father.'
24ins. x 29ins. c.1744. National Gallery of Victoria, Melbourne
(Felton bequest 1921).
One of a dozen illustrations to Samuel Richardson's novel
Pamela (1741), which were engraved in 1745. The whole series
is divided between the Tate Gallery, the Fitzwilliam Museum,
Cambridge, and Melbourne.

parallel with that of Hogarth, and both delighted in freshness of handling paint. Highmore painted a 'Hagar and Ishmael' as a gift to the Foundling Hospital, 1746, and a series of enchanting illustrations for his friend Samuel Richardson's *Pamela*, which were engraved in 1745 (four each in the Tate Gallery, Fitzwilliam Museum, Cambridge, and at Melbourne). He was one of the first to emphasise the private character and good nature of his sitters, e.g. 'Mr Oldfield and his friends' (Tate Gallery). Just before retiring he exh. at SA 1760 and FS 1761.

(Obituary, Gentleman's Mag., 1780, 176-179; Alison Shepherd Lewis, doctoral thesis, Harvard, 1976.)

HIGHMORE, Thomas 1660-1720
Serjeant painter and uncle of Joseph Highmore (q.v.). Born London 22 June 1660; died there 8 March 1719/20. Indented to Leonard Cotes 1674. Appointed Serjeant Painter 25 April 1703. In 1689 Thornhill (q.v.), his kinsman, who succeeded him as Serjeant Painter, became his apprentice.

(Somerset and Dorset Notes and Queries, XV (1917), 215.)

HILL, J. fl.1780-1783
Exh. landscapes and 'A Madonna's head', FS 1780 and 1783. Perhaps in 1780 a pupil of Hewson (q.v.).

HILL, Robert fl.1750
Signed (on the back) and dated 1750 a portrait of a lady (sold S, 3.6.1964, 107) which was like an even more provincial version of a Bardwell (q.v.).

HILL, Samuel fl.1756-c.1770
Itinerant Irish painter of crayon portraits.

(Strickland.)

HILL, Thomas 1661-1734
A portrait painter of some distinction. Said to have been born 1661; died Mitcham 1734. He worked in London but had some connection with the south west, where he worked at Wells and at Melbury (c.1698 and 1720). He was taught drawing by Faithorne and painting by Dirk Freres (c.1678/9). His portraits have distinction and refinement and

ROBERT HILL. 'A lady, perhaps of the Morgan family.' 29½ ins. x 24½ ins. s. & d. 1750 on the back. Sotheby's sale 3.6.1964 (107). Hill is only known from this portrait, and may have been an amateur.

THOMAS HILL. 'Humphrey Wanley.' 48ins. x 40ins. s. & d. 1711. Society of Antiquaries of London.
Wanley was one of the greatest Antiquaries of his time, and was friendly with Hill, who was a painter of considerable intellectual distinction.

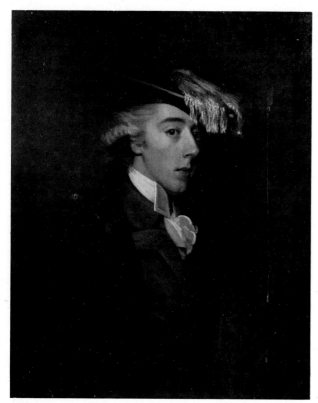

PRINCE HOARE. '*George Fulke, 2nd Lord Lyttelton*' *(1763-1828). 30ins. x 25ins. s. & d. 1784. National Trust, Stourhead.*
Lord Lyttelton matriculated from Balliol College in 1781, but suffered from periodical bouts of insanity. One of Prince Hoare's very few known portraits.

are nearer to Dahl than to Kneller, and quite a number were engraved. He gave up painting and sold the contents of his studio in 1725. A number of portraits of Humphrey Wanley are known, ranging from 1711 to 1722.

(Goulding and Adams, 449/450.)

HILTON, William fl.1777-1822
Provincial portrait painter. Born Newark. Father of the historical painter, William Hilton (1786-1839). Exh. SA 1777 and 1783; RA 1778. He was at Nottingham 1783; at Lincoln 1786; and worked at Norwich after 1800.

HINCKS, William 1752-1797
Self-taught Irish painter of portraits in crayons, oil and miniature. Born Waterford. Exh. Dublin 1773-80, when he moved to London. Exh. RA 1781-97; FS 1782. He entered RA Schools 1780, aged 28.

(Long.)

HIRSCHMANN, Johann Leonhard 1672-1750
German portrait painter. Born Nürnberg 1 November 1672; died there 13 November 1750. Reported to have been a pupil of Kneller in London *c.*1704, and his style suggests this. He was back in Germany in 1706.

(Th.-B.)

HITCHCOCK, J. fl.1790-1793
Exh. portraits and one landscape at RA 1790-93.

HOADLY, Mrs. Benjamin See CURTIS, Sarah

HOARE, Mary c.1753-1820
Second daughter of William Hoare (q.v.); married Henry Hoare of Stourhead 1765. Imitated her father in crayons and painted histories in the same medium. Exh. SA 1761 and 1766; FS 1761-64. There are crayons by her at Stourhead.

HOARE, Prince 1755-1834
Portrait and history painter; later, writer on art and playwright. Baptised Bath 9 October 1755; died Brighton 22 December 1834. Son and pupil of William Hoare (q.v.). He won a premium for a flower picture from SA 1772. Entered RA Schools

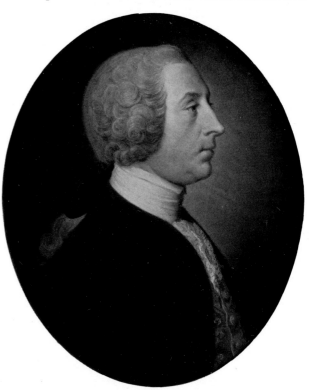

WILLIAM HOARE. '*Henry Hoare*' *(1705-85). Pastel. 22½ins. x 19½ins. National Trust, Stourhead.*
One of a considerable number of pastels at Stourhead by William Hoare and his daughter, Mary, who married a younger son of the family at Stourhead.

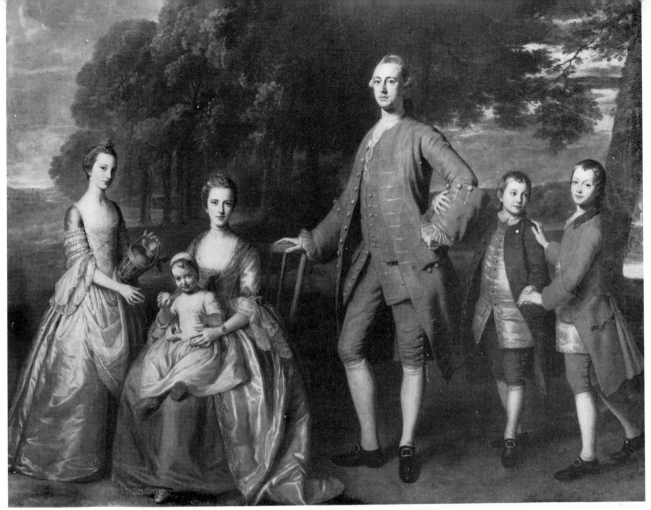

WILLIAM HOARE. 'The Drake family of Fernhill, Berkshire.' 84ins. x 107ins. Christie's sale 18.6.1971 (42).
Sold as 'English 18th century school', but all the figures can be paralleled in known pictures by Hoare, whose most important known work it is.

1773. He went via Florence to Rome in 1776, where he studied under Mengs and became friendly with Fuseli (q.v.). He returned to England with Northcote via Florence, Venice, Germany and Belgium 1779/80. He exh. portraits and history at RA 1781-85, when he gave up painting and travelled for his health until 1788. On returning to London he wrote a number of books on the fine arts and many musical farces. In 1799 he succeeded Boswell as foreign corresponding secretary to the RA. His portraits (two are at Stourhead) are accomplished but lack positive flavour. He exh. a Roman landscape at FS 1783. In 1815 he was an hon. exh. at RA of a portrait of Northcote.

(Nancy Presley, The Fuseli circle in Rome, exh. cat. BAC Yale 1979, 96-98.)

HOARE, William 1707-1792
Portrait painter in oil and crayons. Born Eye, Suffolk, 1707; died Bath 9 December 1792. His name originally may have been Hoard. RA December 1769, soon after the foundation of the Academy. Studied under Grisoni (q.v.), whom he

accompanied on his return to Italy 1728. After nine years abroad, mainly in Rome (where he studied under Imperiali) he returned and was settled in Bath by 1739, where he lived for fifty years (with a short break in London c.1751/2, where he met with little encouragement). He was the first fashionable portraitist to settle in Bath and was the most successful and employed painter there until Gainsborough arrived in 1759, and he always remained the favourite portraitist of the Duke of Newcastle and his family and political associates (see Kerslake s.v. 'Newcastle', 'Pelham', &c.). His most abundantly repeated portrait was that of 'Chatham', of which the first version may have been 1754. Exh. SA 1761-62; RA 1770-79, when he probably gave up painting. Other than portraits, an altarpiece survives at St. Michael's, Bath. His portrait style is serious, but a little blank, a continuation of that of Richardson, and shows no evidence of Italian study. It is easily recognised. There are crayons by him at Stourhead.

(Apollo XXXI (Feb. 1940) 39-43; XCVIII (Nov. 1973) 375 ff.)

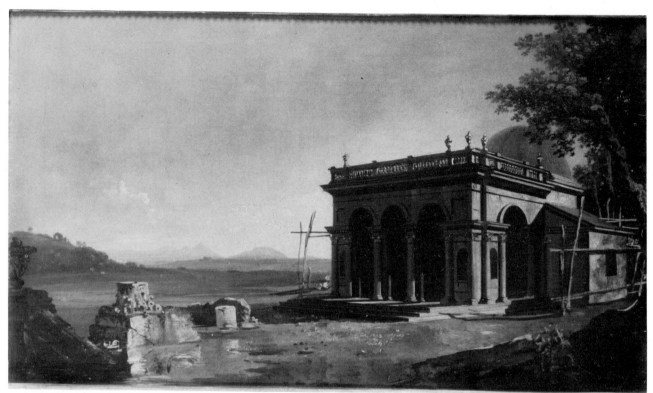

WILLIAM HODGES. 'View of a Greek House at Weston.' 18ins. x 32½ins. Exh. SA 1772 (132). Christie's sale 31.3.1939 (81). Once supposed to be by Richard Wilson, but the building is Diana's Temple by Paine at Weston Park (1770) — see *Country Life*, 26.4.1946, 760.

WILLIAM HODGES. 'A view of Tahiti.' 35ins. x 53ins. s. & d. 1776. Christie's sale 19.11.1948 (162/1). Presumably one of the pictures (or a replica) exh. RA 1776. Many others, from drawings made on Captain Cook's second voyage, are at the Admiralty.

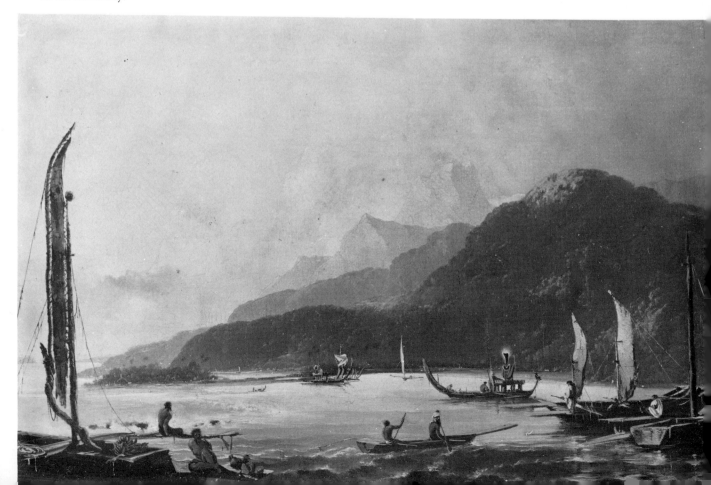

HODGE, R.P. fl.1769-1780
Still-life painter. Exh. FS 1769-80.

HODGES, Charles Howard 1764-1837
Portrait painter and mezzotint engraver. Born Portsmouth 23 July 1764; died Amsterdam 24 July 1837. Probably a pupil of John Raphael Smith (q.v.). Entered RA Schools as engraver 1782 and won silver medal 1784. Exh. a portrait SA 1783, but all his known oil portraits were executed in Holland. He produced good mezzotints of English sitters (many after Reynolds) up to 1794. But he settled in Holland about 1788, where he lived at Amsterdam and The Hague until his death. In Holland he had a good practice in oil portraiture, of which many examples are in the Rijksmuseum, Amsterdam.

HODGES, William 1744-1797
Landscape painter and aquatint artist. Born London 28 October 1744; died Brixham 6 March 1797. After some training at Shipley's Academy he became pupil and assistant to Richard Wilson (q.v.) c.1758-65, and became skilful at copying his works. Exh. SA 1766-80; FS 1768 and 1774; RA 1776-94. ARA 1786; RA 1787. After travelling the country and painting picturesque scenes and country house views, he joined Captain Cook's second expedition to the South Pacific as draughtsman, 1772-75. Exotic scenery aroused his talents and he produced a number of fine landscapes for the Admiralty on his return (Greenwich, &c.). He went to India late in 1779 and was much patronised by Warren Hastings 1780-84 (*Stuebe, Burlington Mag., CXV (Oct. 1973) 659-666*), and published handsome books with aquatints from them on his return. He visited the Continent in 1790 and tried his hand also at scene painting, doing pictures for Boydell's Shakespeare Gallery and even allegorical historical subjects (Soane Museum), but with little success. He gave up painting for banking in 1795, but his bank collapsed. His South Seas and Indian scenes are distinguished, original, and sometimes romantic.

(DNB; Isabel Combs Stuebe, doctoral thesis for NYU (IFA) 1978.)

HODGINS, Henry fl.1762-1796
Irish scenery and landscape painter. Left Dublin for London 1762; died Maidstone 11 September 1796. He worked mainly as a scene painter for Covent Garden. Exh. landscapes SA 1778-83.

(Strickland.)

HODGSON, Edward *c.*1719-1794
Irish painter of fruit and flowers. In London by 1762; died there 1794. Exh. FS 1762-83; RA 1780-88; SA 1790-91. Many of his flower pieces are in watercolours.

(Strickland.)

HOG, James fl.1773
Exh. heads in crayons FS 1773, when pupil of the engraver, Caldwell. A James Hogg, born 28 January 1761, entered the RA Schools as an engraver 1780.

HOGARTH, William 1697-1764
Painter of portrait, history and 'modern moral subjects'; and equally important as an engraver. Born London 10 November 1697; died there 26 October 1764. He was the painter of some of the great masterpieces of British painting, and was the most energetic, controversial, and ultimately influential figure in the London arts scene of the 1740s, but his uncompromising and basically anti-academic temperament reduced his immediate influence and thwarted his major ambition to become the great history painter of his age, in succession to his father-in-law, Thornhill (q.v.). He was trained first as an ornamental engraver and began his independent career with satirical prints. He was a beautiful draughtsman (*A.P. Oppe, Drawings of H., 1948*) and learned painting at the Vanderbank Academy and by memorising everything he could set eyes on; his enchanting virtuosity in the use of oil paint suggests French experience.

Serious paintings begin 1728/9 with versions of 'The Beggar's Opera' and from then until the middle 1730s he specialised in small-scale conversation pieces and single portraits on the same scale. His most accomplished picture on this scale is 'Children playing "The Indian Emperor",' 1731/2 (Lady Teresa Agnew). He then embarked on his first series of modern moral subjects, now known only by the 1732 engravings — 'The Harlot's Progress'. These were not quite as wholly novel in subject matter as Hogarth pretended (Jan Steen was a notable precursor), but their popularisation by engravings made them appeal to the common public and especially to the middle classes, to whom Hogarth's art was increasingly addressed. He secured the passing of a copyright act before his next series, 'The Rake's Progress', engraved 1735 (Soane Museum). On Thornhill's death (1734) he inherited the equipment of the first Academy and established the St. Martin's Lane Academy which was extremely influential and run

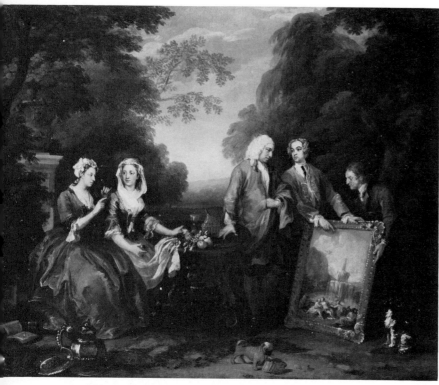

WILLIAM HOGARTH. 'The Fountaine family.' 18½ins. x 23½ins. c.1730-32. Philadelphia Museum of Art (John Howard McFadden Memorial collection).
Sir Andrew Fountaine was the leading 'connoisseur' of his day. He is here shown 'conoscing' a possible Panini of a 'fountain', shown him by his son-in-law, the auctioneer, Christopher Cocks.

WILLIAM HOGARTH. 'An unknown lady.' 29ins. x 24ins. s. & d. 1745. Walker Art Gallery, Liverpool.
This shows brilliantly Hogarth's virtuosity in the use of paint.

WILLIAM HOGARTH. 'Garrick as Richard III.' 75ins. x 98½ins. c.1745. Walker Art Gallery, Liverpool.
An experiment in theatrical 'history' painting, from Shakespeare's *Richard III*, act v, scene iii. Garrick's performance in this role (1741) initiated his career as the greatest actor of his age.

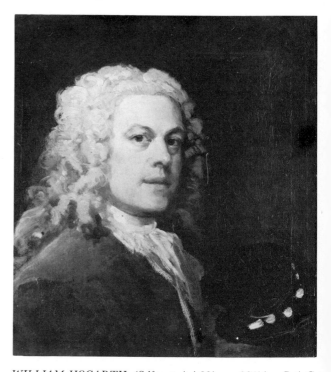

WILLIAM HOGARTH. 'Self portrait.' 22ins. x 20½ins. B.A.C. Yale.
The date is uncertain — perhaps 1735/40. It is authenticated by an early engraving by Samuel Ireland (who owned it).

176

on anti-academic lines. In 1735/6 he painted two large histories for St. Bartholomew's Hospital — but these did not provoke commissions for history painting and, for a time, Hogarth turned to portrait painting on the scale of life. His 'Captain Coram', 1740, presented to the newly founded Foundling Hospital, is one of the great landmarks in the history of the British portrait — a portrait of a middle class philanthropist, with all the weight and none of the pretentiousness of a state portrait. His finest portraits, mostly busts, date from the 1740s. In 1743 he visited Paris, where he could have seen the work of Chardin, the other great middle class painter of the century. From 1743 to 1745 he was painting the 'Marriage à la Mode' series (NG), which is his most sustained achievement, and he was also instrumental in getting his friend Jonathan Tyers to commission Hayman and others to paint the Vauxhall decorations. These, and the history, portrait and topographical pictures which (urged on by Hogarth) a group of artists presented to the Foundling Hospital provided the first opportunities for the works of contemporary painters to be seen by the public outside the artists' own studios.

By the later 1740s Hogarth had achieved the best of his work in painting. He turned to engraving of a more popular kind and to the writing (1748-53) of a theoretical work *The Analysis of Beauty*, which had rather a bad press — partly due to his own pugnacity and hostility to the upper class art pundits of the age. His last modern moral series 'The Election', was begun in 1754 (Soane Museum). His output of engravings was prodigious and extremely influential (*see Ronald Paulson, H.'s Graphic Works, 1965*). His powers as a painter remained unimpaired to the end, as his 'Sigismunda', 1759 (Tate Gallery), a programmatic attack on the craze for old masters, and the profoundly sensitive picture known as 'Hogarth's servants', painted for himself and without thought of public praise or blame (Tate Gallery), make clear. This last picture has never been surpassed as a revelation of the possibilities of the art of the portrait painter.

(Fullest biographical and background information: Ronald Paulson, 2 vols. 1971; fullest cat. of paintings: R.B. Beckett, H., 1949; fullest illustration: L. Gowing and R. Paulson cat. of Hogarth exh., Tate Gallery, 1971/2.)

HOLDBY fl.1777
An hon. exh. from a Reigate address of genre and classical and other landscapes, SA 1777.

HOLDITCH, J. fl.1785
Exh. 'Carp', RA 1785.

HOLLAGAN (HOLLOGAN), J. 1790-1809
or M.J.
Master J. Hollogan was an hon. exh. of heads in chalks SA 1790. M. (occasionally J. or M.J.) Hollagan (once Hollogan) exh. named views and one or two subject pieces RA 1795-1809. He was a scene painter at Covent Garden.

(Grant, iii.)

HOLLAND, ?Charles fl.1730s
Vertue (*iii, 56*) records a bust by Rysbrack of 'Mr Holland, Herald Painter' 1732. A full length of 'Sir Thomas Grosvenor' (d.1733) by one Holland is in Chester Town Hall. A full length of 'George I' by a Mr. Holland was given to the Guild of St. Luke, Dublin, by a Herald Painter (*Strickland*). A Charles Holland 'painter, of Surfleet' (Lincs.) was a member of the Gentleman's Society of Spalding in the early 18th century.

(Nichols, vi, 89.)

HOLLAND, John fl.1764-1767
Exh. crayons portraits SA 1764 and 1767. A John Holland of Ford Hall, Derbyshire (married 1777), was friend, copyist and executor to Wright of Derby (q.v.) and produced some competent portrait copies (*Nicolson, Wright, 137ff.*).

HOLLAND, Peter 1757-1812
Portrait and landscape painter. Born 1 March 1757; last recorded 1812. Entered RA Schools 1779; silver medal 1781. Exh. portraits RA 1781-82 and portraits, a miniature and a landscape at Liverpool 1784. He exh. landscapes from Liverpool at RA 1793 and was first vice-president of the Liverpool Academy 1810, where he exhibited in 1812.

(Long.)

HOLLOWAY, Thomas 1749-1827
Mainly known as an engraver, but he exh. crayon portraits SA 1777-78. Born London 29 July 1749; died February 1827. Entered RA Schools as an engraver 1773.

(Redgrave.)

FRANCIS HOLMAN. 'British men-o'-war in a rough sea.' 23½ ins. x 34½ ins. s. & d. 1778. Sotheby's sale 24.11.1965 (112).
An accomplished example of an unaccountably popular theme.

HOLMAN, Francis fl.1760-1790

A very competent painter of marine subjects. Resident of dockland; died 1790. He exh. quite ambitious shipping pieces FS 1767-72; RA 1774-84.

(Archibald.)

HOLWELL, W. fl.1790

Hon. exh. of a portrait and a landscape SA 1790.

HOME, Robert 1752-1834

Painter of portraits and of contemporary history. Born Hull 6 August 1752; died Cawnpore 12 September 1834. Entered RA Schools 1769 and had some instruction from Angelica Kauffmann. Studied in Rome 1773-78 and settled in Dublin by 1779. Exh. RA 1770-89 and 1797 and 1813. He

ROBERT HOME. 'The Honble. Mrs. Stewart.' 30ins. x 25ins. Signed with 'RH' in monogram and dated 1783. With Agnew's 1979. Painted in Dublin. Home's Irish portraits are more lively than those he painted in India. He likes the anatomically slightly odd arrangement of a draped leg as a foreground.

exhibited much and had a busy practice in Dublin until 1789, when he moved to London, before going to India in 1790. He had a very successful career in India, mainly as a portrait painter, in Madras, Calcutta and Lucknow; in 1825 he retired comfortably to Cawnpore. His portraits are rather wooden and less interesting than the sketches (engraved in 1794) made when accompanying the army during the Mysore war, and the two large history pictures (exh. RA 1797) painted at that time — 'Lord Cornwallis receiving the Mysore Princes as hostages' and 'The death of Colonel Moorhouse at Bangalore' (Nat. Army Museum). He is credited with a few fancy pictures.

(Strickland; Foster; Archer, 298ff.)

HONE, John Camillus 1759-1836

Miniature and portrait painter. Born London 1759; died Dublin 23 May 1836. A younger son and pupil of Nathaniel Hone (q.v.). Exh. portraits (and two still-lives) FS 1775-82 (sometimes as Camillus and sometimes as John); RA 1776-80. About 1780 he went to Calcutta, but returned and settled in Dublin *c.*1790 where he was appointed Engraver of Dies in the Stamp Office and abandoned painting.

(Strickland.)

NATHANIEL HONE. 'The Spartan Boy.' 30ins. x 25ins. Exh. RA 1775 (157). Private collection.
The sitter was Hone's son, Camillus: the 'Spartan Boy' concealed the fox under his cloak which showed no sign of its devouring him. Engraved in mezzotint by W. Humphrey 1775.

HONE, Nathaniel 1718-1784

Painter of portraits and occasional genre, and a miniaturist. Born Dublin 24 April 1718 (from a Presbyterian family of Dutch origin); died London 14 August 1784. Said to have been self-trained and to have started as an itinerant painter in England, perhaps mainly doing miniatures on enamel, at which he was very skilful, but an oil of 1741 shows him soundly trained in a Richardsonian style. He married money at York in 1742, which enabled him to settle in London, where he had good fashionable practice as a miniature painter *(Diaries, 1752/3 in BM)*. He was concerned in setting up the Incorporated Society of Artists and became a Director in 1766. Exh. SA 1760-68 being the first to

NATHANIEL HONE. 'The Honble. David Murray, M.P.' 29½ ins. x 24½ ins. Signed 'NH' in monogram and dated 1779. Christie's sale 13.3.1970 (141).
A very characteristic example with a lively expression and typical high-light in the eyes.

NATHANIEL HONE. 'A boy deliberating on his drawing.' 25ins. x 30ins. Exh. SA 1766 (63). Unlocated.
The sitter is again Hone's son, Camillus, who became a painter, and inspired his father to paint his most original and sensitive portraits.

show single figures of genre character of the kind soon termed 'fancy pieces' ('The Brick Dust Man', 1760, mezzotint by James Watson). He gave up miniatures during the 1760s and restricted his work to the scale of life, becoming a Foundation RA. Exh. RA 1769-84 in spite of a feud with the President, which reached a head over the refusal to exhibit in 1775 'The Conjuror' (Dublin Gallery) which is a well-researched critique of Reynolds' habit of cribbing his designs from Italian models. This led to Hone putting on (1775) the first 'retrospective one-man show' in the history of British painting. His portraits have a slightly excessive brightness in expression (effected by the high-light in the eyes) which makes them recognisable, even though they are sometimes attributed to Gainsborough. His signature is usually 'NH', lightly scratched on so that it is easy to erase. He produced a series of 'Self portraits', which are among his best works (NPG, Dublin, RA, Manchester, &c.). They owe something to Rembrandt in idea, but never show Hone as anything but a society figure. Certain fancy portraits of his son John Camillus (q.v.) have exceptional charm: SA 1766 'deliberating on his drawing'

(private coll.); RA 1769 'A piping boy' (Dublin), based on Giorgione. Another son, **Horace,** 1754-1825, was also a miniature painter; as was a brother, **Samuel,** b.1726. He also scraped about four mezzotints.

(Crookshank and Knight of Glin, 1978, 86-88.)

HOOPER, Miss **fl.1762**
Exh. flower pictures at FS 1762.

HOPKINS, W. **fl.1790s**
Portrait painter, copyist and perhaps pupil of Beechey. Copies of Beechey's royal portraits by him were at Burley-on-the-Hill, 20.6.1947.

HOPKINSON, Robert **fl.1762-1788**
Painted landscapes in oils and watercolours. Exh. SA 1762 and 1768; FS 1764-65; RA 1774, 1781 and 1788, latterly from Blyth, Notts.

HOPPNER, John 1758-1810

Society portrait painter and very occasionally painter of undistinguished mythological subjects. Born London 25 April 1758; died there 23 January 1810. Entered RA Schools 1775; gold medal 1782. Exh. RA 1780-1807. ARA 1793; RA 1795. Portrait painter to the Prince of Wales 1789. He modelled his portrait style at first with some skill on the later style of Reynolds, and his best portraits were mainly done before the early 1790s, when rivalry with the much abler and younger Lawrence became something of an obsession. His first royal portraits were three of the Princesses (RA 1785), which show that he had looked at Romney as well as at Reynolds, and he soon had a very large practice in Whig circles. His best and most attractive portraits are groups of children (Washington, Detroit, &c.), but his flashier works were much overpraised and overpriced during the years of 'Duveen' taste. He is well represented at the Tate Gallery.

(W. McKay and W. Roberts, J.H., 1909, supplementary vol. 1914.)

JOHN HOPPNER. 'Mrs. Jordan as Hippolyta.' 30ins. x 25ins Exh. RA 1791 (420). Formerly Lady Stern.
From Cibber's *She would and she would not*. Engraved in mezzotint by John Jones 1791, and one of Hoppner's more lively inventions, not dependent on Reynolds.

HOPSON, Henry fl.1780-1791

Irish portrait painter. Won medals in Dublin Society's School. Started on his own in Dublin 1786. His work is not known *(Strickland)*. A Henry Hopson entered RA Schools 1793, aged 25.

HORSLEY 1754-1778

A 'Master Horsley' exh. 'A head: in chalks', FS 1774. A J. or Thomas Horsley entered RA Schools 1778, aged 24. A W. Horsley exh. flowers, RA 1798.

HOULDITCH, J. fl.1784-1791

Exh. RA 'Larks and cat', 1784, and 'Game', 1791.

JOHN HOPPNER. 'The Honble. Leicester Stanhope' (1784-1862). 54ins. x 44ins. Christie's sale 7.5.1926 (42).
In execution and style this shows Hoppner as the heir of Reynolds, who had in fact painted the boy in 1788 at half length.

JOHN HOPPNER. 'Harriet, Lady Cunliffe.' 96ins. x 60ins. Traditionally 1784. Possibly exh. RA 1784. Sotheby's sale 1.2.1950 (119).
The painting shows Hoppner as the potential rival to Lawrence, who did not show his first full length until 1789.

HENRY HOWARD. 'The sixth trumpet sounds.' 35½ins. x 27ins. Signed. Royal Academy of Arts (Diploma Collection).
Presented as a Diploma work 1808, and presumably painted shortly before.

HOWARD, Henry 1769-1847

Painter of history and poetic genre, also of portraits. Born London 30 January 1769; died Oxford 5 October 1847. Studied for seven years from 1786 with Reinagle (q.v.) (one of whose daughters he later married) and entered RA Schools 1788. He received a gold medal 1790 for his 'Caractacus' which Reynolds (then nearly blind) praised extravagantly. In 1791 to Rome, where he made friends with Flaxman, who had some influence on his figure style; back via Vienna and Dresden 1794. Exh. RA 1794-1847; BI 1806-44. ARA 1801; RA 1808. Secretary to the RA 1811; Professor of Painting 1833. He had a steady practice in portraiture and did a good many book illustrations, but his main subject matter (to which he owed a rather exaggerated reputation) was classical and poetic, and he did a few decorations (E.C-M.), some in association with Stothard. Milton's Comus was a favourite source for his inventions, which are often in rather a 'Keepsake' style. There are several in the Soane Museum and the V & A.

(DNB; Redgrave.)

HOWARD, Hugh c.1676-1738

Irish portrait painter, who worked in London, also one of the first 'art experts'. Born Dublin 7 February 1675/6; died London 17 March 1737/8. He went to Holland with Lord Pembroke 1697 and thence to Rome, where he stayed until 1700. He was a favourite pupil of Carlo Maratta and also acquired a knowledge of virtù, which he put to good use on his return, after settling in London, by advising the Duke of Devonshire (and others) on their collections. He practised portrait painting in London c.1701-14, when he married an heiress and abandoned painting for more lucrative government employment. FRS 1696. He had a remarkable collection of prints, drawings and books.

(M. Wynne, Apollo, XC (Oct. 1969), 314-317.)

JOHN HOWES. 'Celadon and Amelia.' 20¾ins. x 15½ins. s. & d. 1795. Sotheby's sale 15.1.1964 (183/2).
The subject is from Thomson's Seasons. One of a pair of eccentric works by Howes, the other of which is illustrated in Grant, i, 105.

JOHN HOWES. 'Unknown gentleman.' 29½ins. x 24½ins. Signed. Sotheby's sale 19.5.1954 (100).
The painter was normally a miniaturist; the sitter seems to have been an antiquarian topographer.

LOUIS HÜBNER. 'Still life with vegetables.' 28ins. x 36ins. s. & d. 1751. Private collection.
A foreign painter of some distinction, working in provincial England.

HOWE, Loftus d.1760
Irish painter; worked and died in Limerick *(Strickland.)*

HOWES, John fl.1770-1795
Mainly a miniaturist but also painted portraits on the scale of life and occasional pastorals in the manner of Wheatley. Entered RA Schools 1770; won medal 1772 *(Long.)* Exh. RA 1772-93.

HUBER, J. fl.1785
Exh. a landscape at RA 1785.

HÜBNER, Louis fl.*c.*1740-1769
Still-life painter. Native of Berlin; settled at Norwich *c.*1740, where he died 1769. A 'Still life of vegetables', 1751 (private coll.) is of some distinction.

(Fawcett, 1978, 74.)

HUBRICHS, Miss fl.1769
Exh. a portrait in crayons, SA 1769.

HUDDESFORD, Rev. George 1749-1809
Portrait, and, as an amateur, still-life painter. Born Oxford October 1749; died London 1809. Entered RA Schools 1775 and studied under Reynolds. Exh. RA 1775 (portraits) and as hon. exh. 1786-87 (fruit pieces). His posthumous full length of 'Lord Lichfield as Chancellor' (Examination Schools, Oxford) is taken straight from Reynolds *(Poole, i, 142).* He took his BA at Oxford in 1779, took Orders and abandoned painting professionally. He had literary pretensions.

(DNB.)

HUDSON fl.1781
A '— Hudson' was hon. exh. of a portrait of a young lady, RA 1781.

HUDSON, Mrs. fl.1764
Exh. 'The hermitage in Richmond Gardens', FS 1764.

HUDSON, Thomas 1701-1779

Fashionable portrait painter. Born Devon 1701; died Twickenham 26 January 1779. He was a pupil of Richardson (q.v.), whose daughter he had married by 1725, and he practised a good deal in the West country as well as in London from 1730 to 1740. He must have also studied with attention the portraits of Van Loo (in London 1737-42), to whose fashionable practice he succeeded. He inherited the solemn prose of both Richardson and Van Loo and his work appealed to the more formal and old-fashioned sitters, who resisted the introduction into portraiture of the genial and 'human' element in character exploited by Highmore and Hogarth. The 'Theodore Jacobsen', which he gave to the Foundling Hospital 1746, illustrates his aims. He devised a series of stock poses, with standard clothes, pearl necklaces for ladies, &c., and his draperies were normally painted by Joseph Van Aken (d.1749) and his brother Alexander Van Aken (d.1757) — who also worked for Ramsay, Pickering and others — so that it is not always easy to distinguish (as Vertue reports) between the works of these artists. Hudson is only rarely concerned with the finer shades of character, but he was capable of it. He organised a number of remarkable groups — the 'Radcliffe Family', c.1742 (loan to National Trust at Dyrham); 'Benn's Club of Aldermen', 1752 (Goldsmiths Company); the 'Marlborough Family', c.1754 (Blenheim). As he was a Devonian the young Reynolds was apprenticed to him 1740-43, but without much benefit to either. He was also the teacher of Wright of Derby, Mortimer and others. He visited France and the Low Countries in 1748, and made a quick trip to Italy with Roubiliac in 1752, but his style remains unchanged. From 1742 to the middle 1750s, he was the most fashionable painter in London, rivalled only by Ramsay, and his studio turned out an enormous number of portraits. He exh. SA 1761 and 1766, but by then he had more or less given up painting, except for old friends, and had retired to prosperous ease at Twickenham. A few late portraits, ranging from 1757 to 1766, reveal some concessions to the new style of Reynolds and an unexpected capacity for interpreting character.

(Ellen Miles and Jacob Simon, Thomas Hudson exh. cat., Kenwood, 1979.)

THOMAS HUDSON. 'Alexander Van Aken.' 29½ins. x 24½ins. Sotheby's sale 12.3.1980 (140).
The younger of the Van Aken brothers, who were Hudson's drapery painters. Engraved in mezzotint by Faber Junior 1748. A typical type of artist's portrait.

THOMAS HUDSON. 'Miss Anne Isted.' 44½ins. x 57ins. s. & d. 1755. Sotheby's sale 12.10.1955 (89). Bought 1958 by University of Vermont, Burlington, Vt.
An example of Hudson's painting at the time Reynolds was beginning to impose his predominance.

THOMAS HUDSON. 'Benn's Club of Aldermen.' 93ins. x 121ins. s. & d. 1752. Goldsmiths' Company, London.
The most concentrated example of Hudson's 'civic' style.

TRAJAN HUGHES. 'Cat and fish.' 22½ ins. x 30½ ins. Signed. Christie's sale 28.1.1966 (138). His christian name, misread by Grant on another picture as 'Tregan', is quite plainly 'Trajan' on this.

HUGFORD, Ignazio **1703-1778**
Anglo-Florentine painter, restorer, faker and dealer. Born Pisa 1703 of English parents; died Florence 16 August 1778. He never came to England but played a considerable role with British artists and collectors in Florence.

(J. Fleming, Connoisseur, CXXXVI (Nov. 1955), 197-206; Bruce Cole, &c., Burlington Mag. CXIII (Sep. 1971), 500ff.)

HUGHES, R. **fl.1794-1799**
Exh. landscapes RA 1794-99 in the manner of Richard Wilson's Welsh views.

(Grant.)

HUGHES, Trajan **fl.1709-1712**
Still life and animal painter, whose work suggests some knowledge of Barlow. For a very elegant painting of a foxglove in a landscape, signed and dated 1712, see Grant *(iii, pl.10, as 'Tregan Hughes').*

HULLEY, H. **fl.1783-1800**
Irish landscape painter. Exh. RA 1783-87. In Bath 1787 and in Dublin 1790. A vaguely Morlandish landscape of 1800 was sold 29.10.1954, 100.

HUMBLE, Catherine **early 18th century**
A signed portrait of 'Rev. Nathan Wrighte' (private coll.) reveals an imitator of Dahl.

HUMPHRIES, W. **fl.1791-1793**
Exh. watercolour landscapes as a schoolboy SA 1791. Hon. exh. RA 1793 of two landscapes which may have been in oils.

HUMPHRY, Ozias **1742-1810**
Portrait painter in oils, crayons and miniature. Born Honiton 8 September 1742; died London 9 March 1810. ARA 1779; RA 1791. After some training in London at Shipley's Academy, 1757, and two years (1760-62) under Samuel Collins at Bath, he came to London as a miniature painter and exh. miniatures SA 1765-71. These are his best work, but a fall from a horse in 1771 upset his eyesight, and he went with Romney to Rome in 1773 and studied oil painting in Italy until 1777. Exh. RA 1779-83 rather wishy-washy life-size oils (some full lengths). He sailed for India in 1785, but, after unhappy experiences *(Foster)* he returned to London and again took up miniature painting. But failing eyesight led him to take to crayons, and in 1792 he was appointed 'Portrait Painter in Crayons to The King'. Exh. RA 1788-97. His crayons are unsatisfactory. He went blind in 1797. He sometimes signs with a monogram Ⓗ. He left a mass of largely plaintive letters and notebooks *(RA Library and BM).*

(G.C. Williamson, O.H., 1918.)

OZIAS HUMPHRY. 'The Ladies Waldegrave.' 90ins. x 57ins. Exh. RA 1780 (146). Christie's sale 21.7.1944 (88).
Long believed to be by Romney until a dramatic demonstration in Court that it had been identified by Horace Walpole as the picture shown at the RA 1780.

OZIAS HUMPHRY. 'Sir John Webb, Bart.' Pastel. 30½ ins. x 23½ ins. Christie's sale 1.8.1957 (57).
Sir John Webb succeeded to the Baronetcy 1763 and died 1797. Probably executed in the 1790s.

ROBERT HUNTER. 'William John, Lord Newbattle.' 50ins. x 39ins. 1762. Marquess of Lothian, Monteviot.
Engraved in mezzotint by Fisher 1769 as painted 1762. The sitter became 5th Marquess of Lothian in 1775. Painted in Dublin.

HUMPHRYS **fl.1771**
Exh. portraits at FS 1771.

HUNE(S), A.G. **fl.1785**
Exh. RA 1785 'Apollo fleaing Marcius' [*sic*].

HÜNNEMANN, Christopher **fl.1776-1793**
William
Portraitist in oils, crayons and miniature, and a professional copyist. Son of the Court Physician at Hannover. Came to London *c*.1776 and died there 21 November 1793. He was recommended to the King as a first-rate copyist and copies of Gainsborough's royal portraits are at Audley End and Hartlebury Castle. He was mainly employed as a miniaturist.

(Papendiek, 1887.)

HUNTER, Mary Anne *c*.**1752-after 1777**
(Mrs. Trotter)
Daughter of Robert Hunter (q.v.), she painted portraits and historical pictures and married John Trotter (q.v.) 1774. She exh. as Mrs. Trotter in 1775 and 1777.

HUNTER, Matthew **fl.1779-1829**
Irish portrait painter in crayons and miniature. Pupil at Dublin 1779 and won medals 1780-83. Last recorded in Dublin 1829 *(Strickland).*

HUNTER, Robert **fl.1752-1803**
Irish portrait painter. Said to have been born in Ulster; last recorded in Dublin 1803. He worked wholly in Dublin from at least 1752, and was the leading native portraitist there from 1753 to 1783. Little of his work is known after 1783 and he held an exhibition and sale of his work 1792. His signed works are very variable and he seems to have been influenced by the style of visiting painters and by the sight of paintings or engravings of contemporary English painters, ranging from Devis to Reynolds — a sort of Irish counterpart to Mason Chamberlin! He takes quite a good likeness.

(Strickland; Crookshank and Knight of Glin, 1978.)

HUQUIER, Jacques Gabriel **1725-1805**

French painter of small crayon portraits; also an engraver and printseller. Born Paris 1725 (son of Gabriel Huquier (1695-1772) also a painter and engraver); died Shrewsbury 7 June 1805 *(Redgrave).* He settled in England *c.*1770. Exh. fitfully at RA between 1771 and 1786; SA 1772. In 1783 his address is given as Cambridge, and he probably travelled the country painting neat small crayons portraits.

(Long.)

HURLESTON (HURLSTONE) **fl.1763-?1780**
Richard

Portrait and literary genre painter. Won premiums for drawings at SA 1763 and 1764. Entered RA Schools 1769 and became a pupil of Wright whom he accompanied to Rome 1774-76. Exh. portraits RA 1771-73. Killed by lightning while riding on Salisbury Plain, allegedly in 1777 *(Nicolson, Wright of Derby, 6)* but more probably 1780 as he exh. RA 1778 and 1780 (in 1780 a picture of Sterne's 'Maria', which was mezzotinted by W. Pether 1777).

HURTER, Johann Heinrich **1734-1799**

A much travelled painter of miniatures in enamel who exh. a crayon portrait at RA 1779. Born Schaffhausen 9 September 1734; died Düsseldorf 2 September 1799. Briefly in England and exh. RA 1779-81.

(Long.)

HUSON, W. **fl.1783**

Hon. exh. a portrait of a lady, RA 1783.

HUSSEY, Giles **1710-1788**

Fancied himself as a history painter but was mainly a draughtsman of profile portraits. Born Marnhull, Dorset, 10 February 1710; died Beeston, Dorset, 1788. From a Roman Catholic county family, he went to Italy with his teacher Damini, 1730, and remained there till 1737, winning prizes at Bologna and studying drawing and antiquities at Rome and Naples. Frequented Jacobite circles. He made very neat profile portraits in pen (the largest collection at Ugbrooke). On returning to London he set up as a painter but did practically nothing except two large figures of 'Bacchus' and 'Ariadne' (Syon House). In 1768 he retired into the country and took to theorising. His best drawings were all sold in the Duane sale 1787, Lugt 4181.

(Connoisseur, LXV (March 1923), 136-139.)

GILES HUSSEY. *'Self portrait.' 26½ins. x 20ins. Christie's sale 20.11.1953 (93).*
The evidence for the identification is unknown, but it may well be correct.

HUSSEY, Philip **1713-1783**

Irish portrait painter. Born Cloyne, co. Cork, 1713; died Dublin June 1783. Said to have had some training in England and the signed and dated 1746 'Edward O'Brien' (coll. Lord Inchiquin) suggests a connection with Mercier. He was later a central figure in the Dublin art world but recent attributions to him *(Crookshank and Knight of Glin, 1978)* are distinctly speculative.

HUTCHINSON, Samuel **fl.1770**

Hon. exh. of a South Welsh landscape, SA 1770.

HYDE **fl.1775**

Exh. a drawing in chalks FS 1775.

HANS HYSING. 'Sir Peter Halkett, 2nd Bart.' 30ins. x 25ins. s. & d. 1735. National Gallery of Scotland, Edinburgh (2159). An example of Hysing's work just about the time Alan Ramsay studied with him in London.

HYSING (HUYSSING), Hans 1678-1753

Portrait painter. Born in Stockholm 1678; died London 1753. Apprenticed in Stockholm at first to a goldsmith, 1691/4, and then to David Krafft. Settled in London 1700, where he studied under Dahl (q.v.) for many years. He was on his own by at least 1715 and dated works range from 1721 to 1739. His portraits are like those of Dahl, but sometimes livelier and more elegant. He painted the royal princesses (1730) and Sir Robert Walpole (Kings' College, Cambridge). Alan Ramsay worked briefly in his studio 1734.

(List of works: Nisser, 97-105.)

HANS HYSING. 'Unknown gentleman.' 92ins. x 56ins. s. & d. 1721. Christie's sale 17.6.1949 (105). One of a group of full lengths by Hysing (the only one signed) which belonged to the Earls of Ducie.

I

IBBETSON, Julius Caesar 1759-1817

Landscape painter in oil and watercolour; also illustrator and etcher. Born nr. Leeds 29 December 1759; died Masham 13 October 1817. More or less self-trained, partly by copying old masters for dealers. Exh. RA 1785-1815; BI 1811-18. Benjamin West (probably on the strength of his etchings) called him 'the Berghem of England', which was not unjust. His landscapes are mostly smallish and usually filled with lively figures or cattle; his touch is neat and some of his landscapes have a look of early Gainsborough. From his first being known (c.1784) to 1798 he was based on London but made a number of visits or tours with distinguished patrons (Wales, the Isle of Wight). His subject matter is sometimes similar to Morland's (rustic peasants and sailors' life in later 1790s) and his production of watercolours was very abundant. After some unsettled years he was based largely on the Lakes from 1799 to 1804 and then at Masham from 1805, where he painted some of his best oil landscapes and a few small-scale portraits on copper. He was capable of more serious work, such as 'The burial of Col. Cathcart in Java', RA 1789, which he witnessed; but he kept almost wholly to his own style, which was more natural than de Loutherbourg's, and more civilised than Morland's. He published *Painting in Oil*, 1803.

(Rotha Mary Clay, J.C.I., 1948.)

JULIUS CAESAR IBBETSON. 'On the Greta.' 28ins. x 41½ins. s. & d. 1778. Christie's sale 1.2.1952 (14).
A 'landscape with figures' of a kind of which Ibbetson produced an enormous number of examples.

IMMANUEL, M. **fl.1783-1798**
Exh. 'Landscape and ruins', FS 1783. Painted portraits and gave lessons in the 1790s at Norwich and Yarmouth.

(Fawcett, 1978.)

IRELAND, William **fl.1764-1783**
Still-life painter. Exh. SA 1764-65; FS 1780-83.

IRVINE, James **1757-after 1803**
Started as a history painter, but his main activity was as a dealer in Rome. Born 18 March 1757; last documented in Rome 1803. Entered RA Schools 1777. Exh. RA 1787 a 'Ganymede' (Marischal College, Aberdeen) painted in Rome 1786, which reveals him a pupil there of Gavin Hamilton; also 1794 (another 'Ganymede' and portraits). Buying old masters for Buchanan and others in Rome 1803.

JULIUS CAESAR IBBETSON. 'Scene from The Taming of the Shrew, *act iv, scene i.' 31ins. x 22ins. Unlocated.*
Painted for Boydell's Shakespeare Gallery and engraved by A. Young *c.*1798.

ISAACS, Miss **fl.1771-after 1779**
Painted figure subjects, still-life portraits in crayons and miniatures. Exh. FS 1771-74. Went to India 1778 as a miniaturist, where she married in 1779 Alexander Higginson — taking the Christian name of Martha.

(Foster; Long.)

J

JACKSON, Arthur fl.1770

Exh. FS 1770 'Painting', 'Poetry', 'Music' and 'The Patron', calling himself a pupil of Piezzetta [*sic*].

JACKSON, William 1730-1803

Musician and composer; amateur landscape painter. Born Exeter 28 May 1730; died there 12 July 1803. He was a close friend of Gainsborough, with whom he exchanged music for painting lessons in the earlier 1760s, and whose landscapes he copied. He had aspirations to the profession of painting and exh. RA 1771, but abandoned them when he became organist of Exeter Cathedral 1777.

(*John Hayes, Connoisseur, CLXXIII (Jan. 1970), 17-24.*)

JAGGER, Benjamin fl.1773

Carver and gilder at Norwich; advertised that he taught oil painting 1773.

(*Fawcett, 1979.*)

JAMES fl.1776-1783

A Mr. James from Peterborough exh. FS 1776 ten paintings, mostly landscapes and some with historical figures; also a landscape in 1783.

JAMES, George fl.1755-1795

Portrait painter. Born in London; died in France early in 1795 (in prison). Pupil of A. Pond (q.v.). He went early to Italy and was in Naples 1755 and then in Rome until 1760, when he settled in London and was at first much assisted by B. Rebecca (q.v.). Exh. FS 1762-63; SA 1764-69; RA 1770-79 and 1789-90 (from Bath). ARA 1770. Apart from a large 'Death of Abel' (1764), he showed only portraits. About 1780 he moved to Bath, married money, and soon gave up painting. Latterly he lived in France. At his best — 'The Misses Walpole', SA 1768 — he is an attractive painter, but he was not much employed.

(*Walpole Soc. XXXVI, 41, n4.*)

JAMES, William fl.1754-1771

Painter of topographical views and picture dealer. Reputed (*Edwards*) to have been assistant to Canaletto, when he was in London (i.e. before 1754). He no doubt copied Canaletto but seems rather to derive from Scott. Exh. SA 1761-68; RA 1769-71. Except for views of Egyptian Temples (1768-70) his exhibits were all views of London. He is a rather pedestrian imitator of Samuel Scott.

JAMESON, G. fl.1734

Signed and dated 1734 a portrait of 'Michael Hubert' (sold 24.5.1957, 12) in the manner of Highmore.

GEORGE JAMES. 'The three Misses Walpole.' 69½ ins. x 60½ ins. s. & d. 1768. Exh. SA 1768 (70). With Agnew's 1970. An example of the charm and talent which James was capable of displaying, if he had not been so idle.

JANSON fl.1782

Mr. Janson (or Jansen) Junior exh. 'Daphne and Apollo', FS 1782.

JARVIS fl.1780

Exh. a 'Landscape with a waterfall', FS 1780.

JARVIS, Charles See JERVAS, Charles

JEAN, Philip 1755-1802

Miniaturist who occasionally painted on the scale of life. Born St. Ouen, Jersey, 1755; died Hempstead, Kent, 12 September 1802. His style is not unlike that of Hoppner (q.v.). Exh. RA 1787-1802.

(Long.)

JEFFERYS, James 1751-1784

Historical painter and draughtsman. Baptised Maidstone 28 May 1751; died London 31 January 1784. Son and pupil of William Jefferys (q.v.). Studied engraving with Woollett 1771. Entered RA Schools 1772; gold medallist 1774; sent as travelling scholar to Rome 1775-78. Exh. SA 1773-74 (drawings); RA 1775 and 1783. He was

WILLIAM JEFFERYS. 'C. Otway of Romden, Kent.' 29ins. x 24ins. Christie's sale 28.7.1955 (53).
A Kentish artist in the Hayman tradition. This was conceivably SA 1775 (124).

THOMAS JENKINS. 'Francesco Geminiani.' 39¼ ins. x 29½ ins. Earl of Wemyss and March, Gosford.
Engraved in mezzotint by McArdell. Presumably painted in London before 1753, when Jenkins settled in Rome. Geminiani (d.1762), a distinguished musician, spent many years in London.

powerfully influenced by Mortimer and Barry (qq.v.) before going to Rome and by Fuseli and Gavin Hamilton (qq.v.) in Rome. His surviving work is mainly of drawings of neo-classical themes. His one painting is 'The Siege of Gibraltar', RA 1783 (Maidstone Museum). He showed promise of being a remarkable and eccentric artist.

(T. Clifford and Susan Legouix, Burlington Mag., CXVIII (March 1976), 148-157.)

JEFFERYS, William 1723 (or 1730)-1805

Painter of portraits, still-life, &c. Born and died at Maidstone. Father of James Jefferys (q.v. for bibliography). Pupil of Hayman. Exh. FS 1766-75. An artist of very modest and provincial quality.

JEMELY, James fl.1723

Portrait painter in Scotland in a feebler variant of Medina's (q.v.) style. In 1723 he received £10 for a 30 by 25 ins. portrait. See also: GEMELL.

(B. Balfour-Melville, The Balfours of Pilrig, 1907, 71.)

JENKINS, Thomas 1722-1798

Began as a painter (history and portrait) before becoming a dealer in pictures and antiquities, banker and *éminence grise* in British artistic circles in Rome. Born Sidbury, Devon; died on landing at Yarmouth 1798. He studied in London under Hudson (q.v.) and was listed as an 'eminent painter' in the *Universal Magazine*, November 1948. In Rome by 1753, living in the same house as Richard Wilson. His portrait of 'Lord Dartmouth' 1754 survives and was done in Rome, but the engraved 'Francesco Geminiani' (Gosford) was presumably done in London. He became an honorary Accademico di S. Luca in Rome 1761 and ceased to practise as a painter. He remained in Rome until shortly before his death.

(B. Ford, Apollo, XCIX (June 1974), 416-425.)

JENNINGS, Samuel fl.1789-1834

Exh. all sorts of pictures RA 1789-1834; BI 1811-34. Latterly they had religious subject matter. Entered RA Schools 1790.

JENNINGS, W.G. fl.1797-1806

Exh. views of named places, RA 1797-1806.

CHARLES JERVAS. 'Dean Swift.' c.1718. Formerly Chesterfield House Library. Christie's sale 29.6.1951 (48).
A good example of a pattern much repeated by Jervas. Bought as a half length by Lord Chesterfield at Earl of Oxford sale 1741/2 and cut down. The set of Chesterfield House Library portraits were all bought and given to the Sterling Library of London University.

CHARLES JERVAS. 'John, 2nd Duke of Montagu.' 93¾ins. x 51ins. Buccleuch collection. Boughton House, Northants.
Probably from the 1720s. He was made KG 1718 and is in Garter Robes.

JERVAS, Charles c.1675-1739

Fashionable portrait painter. Born in Ireland c.1675; died London 2 November 1739. He studied for a year under Kneller and had made copies of various pictures at Hampton Court by 1695. He had started on his travels by 1699, when he was in Paris, and had settled in Rome by the end of 1703, where he studied the old masters, made many copies, and remained until 1708. Settled in London by 1709 and married money. He became famous almost overnight thanks to his assiduous friendship with Steele, Pope, Swift and the literary world,

CHARLES JERVAS. 'Honble. Jane Seymour-Conway.' 34ins. x 64ins. Christie's sale 20.5.1938 (16).
The lady was a sister of the 1st Marquess of Hertford and her dates were c.1711-49. Jervas was a conscious imitator of Van Dyck's drapery techniques.

whose portraits he painted. He remained based on London until his death, but made a number of visits to Ireland of some length. He had a number of standard poses, which he repeated, and he refined his drapery style by copying all the Van Dycks he could find. He succeeded Kneller as Principal Painter to the King October 1723. His best portraits are not undistinguished and have an air of breeding, but his women have nearly all the same bird-like face. He does not sign his pictures and his name is often taken in vain.

(Vertue; Strickland.)

JERVIS, John fl.1765
Said to have signed and dated 1765 a very provincial portrait of a young lady, sold 17.6.1955, 55/2.

JOHNSON, F. fl.1797
Hon. exh. of 'Snipes', RA 1797.

JOHNSON, T. fl.1798
Exh. a portrait at RA 1798.

JOL(L)I, Antonio c.1700-1777
Painter of topographical views and scene painter. Born Modena c.1700; died Naples 29 April 1777. He had worked with one of the Bibbienas and with Pannini at Rome before settling in Venice as a scene painter c.1735. After 1742 came, via Germany, to London where he became scene painter at the King's Theatre 1744-48 and painted topographical overdoors and decorations for several houses. The surviving one is Heidegger's House, Richmond, c.1745 (E.C-M., Burlington Mag., LXXVIII (April/May 1941), 105, 155ff.). He also painted London views which have been confused with those of Canaletto and Scott. To Madrid 1749; 1754-62 shuttling between Venice and Naples; settled in Naples 1762 for the rest of his life, where he painted views for British clients.

(E.C-M.; Urrea.)

JOLLY, William fl.1764-1809
Irish landscape and scene painter. Entered Dublin Schools 1764 and was painting scenery there from 1770. Exh. a landscape in Dublin 1769.

(Strickland.)

JONES, B. fl.1774
Exh. crayons and miniatures FS 1774.

ANTONIO JOLI. '*The Thames at Richmond.*' *15ins. x 28½ ins. Signed. Sotheby's sale 16.11.1949 (142/1).*
Joli, like Canaletto, often repeated favourite designs such as this.

THOMAS JONES. '*The Bard: from Gray's Ode.*' *45½ ins. x 66ins. Exh. SA 1774 (123). National Museum of Wales.*
Engraved in mezzotint by J.R. Smith 1775. It owes more in style to Mortimer than to Jones' teacher, Richard Wilson.

WILLIAM JONES. 'Robert Neale M.P.' 95ins. x 57ins. Signed on the back 'Guliel s.Jones pinxit' and dated 1726. Christie's sale 9.4.1937 (7).
One of a group of four portraits of the Neale family of Corsham. He was perhaps a local Wiltshire artist.

JONES, J.S. fl.1710
A portrait of 'Mrs Francis Stephens' signed 'J.S. Jones P. 1710' is reported *(Somerset and Dorset Notes and Queries, XIV (1915), 79).*

JONES, Thomas 1742-1803
Landscape painter. Born Trevonen 26 September 1742; died Pencerrig 9 May 1803. Pupil of Richard Wilson 1763-65. Entered RA Schools 1769. Exh. SA 1765-80 and was much engaged in the affairs of the Society of Artists; RA 1784-88 and 1798. He was friendly with Mortimer and his best pictures before 1776 are his landscape backgrounds to Mortimer's figures. He was in Rome and Naples

1776-83 and his *Memoirs* of this period *(Walpole Soc., XXXII, 1951)* are of considerable interest. He painted a number of rather heavy Italian views on commission, but also produced landscape sketches, painted out of doors, which are wonderfully fresh and recall those of Valenciennes. After returning to London he gave up painting professionally but occasionally painted imitations of Wilson.

(J. Jacob, Jones exh. cat., Kenwood, 1970.)

JONES, William fl.1726
Portrait painter of a provincial character, who signs (on the backs) 'Guliel s.Jones'. His portraits of the Neale family of Corsham sold 9.4.1937, 6-9 *(C.H. Collins Baker, Connoisseur, LXVIII (Jan. 1924), 13-14).*

JONES, William fl.1744-1747
Irish painter of landscape, portrait and history. Died 1747. Known only from a few engravings *(Strickland)* and one landscape *(Crookshank and Knight of Glin, 1978, 62).* Hardly the same painter as the last.

WILLIAM JONES. 'Still life of fruit, with a bullfinch.' 34½ins. x 28½ins. Signed 'Bath 1775'. Christie's sale 10.2.1967 (91).
Jones' somewhat naïf arrangements of fruit seem to have been very popular.

JONES, William fl.1764-1777

Still-life painter of a certain pleasing *naiveté*. Exh. FS 1764 (from London), 1765 (from Derby), 1769 (from Bath); RA 1770-71 (from Bath). He settled at Bath 1769 (and was still there 1774) and also sold old masters *(W. Whitley, Gainsborough, 92)*. Later he moved to Newcastle *(T. Bewick, Memoir, 74)*. Four pictures, three of them dated 1777, are at Gosford.

JOSEPH, George Francis 1764-1846

Portrait and history painter. Born ?Dublin 25 November 1764; died Cambridge 1846. Entered RA Schools 1784. Exh. RA 1788-1846; BI 1806-34. ARA 1813. He won a gold medal 1792 for a Shakespearean scene, but he was mainly a rather dull portraitist. He also painted many fancy pictures, some miniatures, and designed book illustrations.

(DNB.)

PIERRE JOUFFROY. 'Unknown gentleman.' 30½ ins. x 24½ ins. s. & d. 1766. Christie's sale 1.11.1946 (80).
Painted during Jouffroy's brief visit to England 1765/7. The sitter may have been a foreign diplomat.

JOUFFROY, Pierre fl.1742-1767

Portrait painter and painter on glass. From Nancy. In 1742 appointed Court Painter to Stanislas Leczynski, 'King of Poland'. He visited England 1765-67. Exh. SA 1765-66; FS 1767 — one of these portraits was probably the 'gentleman' of 1766 in the Buccleuch sale 1.11.1946, 80.

(Th.-B.)

JUDD, John fl.1774-1779

An amateur landscape painter from Chelmsford, of a very tame rural sort. Hon. exh. SA 1774; RA 1775-79.

(Grant, iii, 6.)

199

K

KACHLER, T.T. fl.1775
Exh. a portrait RA 1775.

KAUFFMANN, Angelica 1741-1807
Painter of historical and poetical subjects and portraits. Born Coire, Switzerland, 30 October 1741; died Rome 5 November 1807. In England 1766-81 and Foundation RA 1768. One of the odder artistic phenomena of her time, as she was admired far beyond her artistic deserts and seems to have charmed, at different times, Winckelmann, Reynolds, Goethe and Canova. Her situation was illustrated by the exh. 'Angelika Kauffmann und ihre Zeitgenossen', Bregenz and Vienna 1968/9. Her ladylike neo-classicism appealed equally to royalty, Robert Adam and the public and was much fostered by prints by Bartolozzi and others. Daughter and pupil of Joseph Johann Kauffmann (q.v.), she received academic training in various North Italian cities and latterly at Florence (1762) and Rome (1763), where she painted 'Winckelmann', 1764 (Zurich) and became very friendly with Dance (q.v.) and whence she sent a portrait of 'Garrick' to the FS 1765 (Burghley House). She settled in London 1766 and was an immense success. Exh. FS 1765-66; SA 1768; RA 1769-1797 an immense number of poetic and historical scenes, beginning with subjects from Homer and Virgil in 1768. She did a certain amount of decorative painting for Robert Adam, 'Athenian' Stuart and others (E.C-M.). She also painted many portraits, often on a conversation scale, and continued to do these after she had retired to Rome, especially of British sitters. In 1781 she married Antonio Zucchi (q.v.) and retired, at first to Venice (1781) and then to Rome, where she lived for the rest of her life and ran a blue-stocking Salon of which Goethe and Canova were at times to be ornaments. She kept an incomplete list of her works (published in Lady Victoria Manners and G.C. Williamson, A.K., 1924). She painted numerous self portraits and was something of a forerunner to Madame Vigée-Lebrun.

(Cat. of A.K. exh., Kenwood, 1955.)

KAUFFMANN, Joseph Johann 1707-1782
Swiss painter of religious history pictures. Born Schwarzenberg 27 February 1707; died Venice 11 January 1782. Father and teacher of Angelica Kauffmann (q.v.). He followed his daughter to London 1767 and left with her for Venice 1781. Exh. RA 1771-79, mainly pictures of religious themes, which, probably mercifully, have not been identified.

(Th.-B.)

KEABLE, William See KEEBLE, William

ANGELICA KAUFFMANN. 'Alexander, 4th Duke of Gordon.' 35ins. x 27ins. s. & d. 1774. Christie's sale 14.7.1939 (117). Angelica's portraits usually have a slightly 'foreign' air.

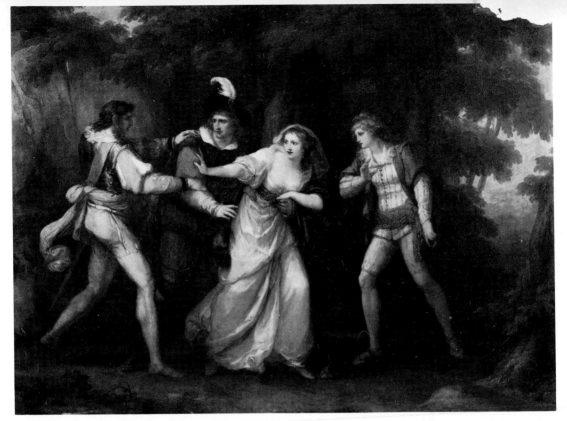

ANGELICA KAUFFMANN. 'Scene from Two Gentlemen of Verona, *act v, scene iii.' 61¼ ins. x 85½ ins. s. & d. 1788. Christie's sale 18.6.1978 (102).*
Painted for Boydell's Shakespeare Gallery after Angelica had settled in Rome. It was engraved by L. Schiavonetti.

ANGELICA KAUFFMANN. 'Genius.' Painted for the Lecture Room at Somerset House, Royal Academy of Arts.
Now in the entrance hall of Burlington House. One of four ovals, the others being 'Painting', 'Design' and 'Composition', which illustrate Angelica's conventional mind.

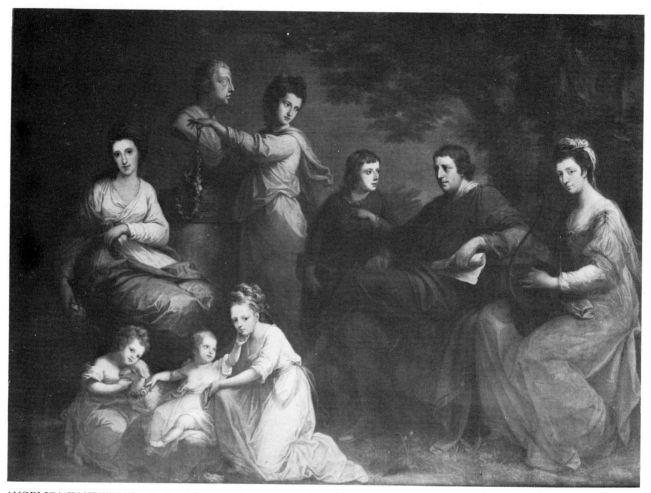

ANGELICA KAUFFMANN. 'Earl and Countess Gower and their family.' 59ins. x 82ins. Painted 1772. Christie's sale 22.10.1948 (34). Angelica's frieze-like arrangements of family groups differentiate them from English conversation pieces and approach the neo-classical.

KEAN, Michael **1761-1823**
Irish painter of crayon portraits and miniatures. Born Dublin 16 October 1761; died London November 1823. Entered Dublin School 1771 and practised there until he came to London and entered RA Schools 1784. Exh. RA 1786-90, when he became a partner in the Derby china factory and gave up painting *(Long)*. A Michael Kean, a 'mathematics and drawing master' who exh. land-scape FS 1765-67, probably did not paint in oils.

KEARSE, Mrs. See LAWRENCE, Miss Mary

KEARSLEY, Thomas **1773-c.1801**
Portrait painter. Entered RA Schools 1790, and exh. RA 1792-1801. A few of his portraits have been engraved.

KEATE, Georgiana Jane **1770-1850**
Hon. exh. of a variety of subject pictures SA 1791. She was the daughter of George Keate *(Mallalieu)*, an assiduous amateur landscape painter in water and body colour (1729-97). She married John Henderson (1764-1843); and died 8 January 1850. They were patrons of artists.

(DNB s.v. George Keate.)

KEATING, George **fl.1775-1776**
'Master George Keating' exh. heads in chalks, FS 1775-76.

KECK, Susan **1746-1835**
Hon. exh. of a crayon portrait RA 1771 (also anonymously 1769-70). She married (1771) Francis Charteris, *de jure* Lord Elcho (1749-1808).

KEEBLE, William ?1714-1774

Portrait painter. Perhaps of East Anglian origin; buried Bologna 12 January 1774. A probable 'Self portrait' of 1748 (BAC Yale) is in the style of Penny (q.v.) and a small-scale full length of the same period is also known, both signed 'W. Keable'. In 1754 a member of the St. Martin's Lane Academy. By at least 1761 at Naples (where his name was phoneticised as 'Ghibel') where he painted a portrait of 'Castruccio Bonamici' *(Mostra del Ritratto storico Napoletano, 1954, no.88).* He settled in Bologna 1765 in the house of Domenico Gandolfi, and became Accademico della Clementina 1770. Several Bolognese portraits are known.

(Guido Zucchini, Giornale d'Emilia, 22 Feb., 1948.)

KEELING, Michael 1750-1820

Portrait painter. Born 22 November 1750; died nr. Stone, Staffs., 1820. Entered RA Schools 1772. Exh. RA occasionally 1782-1809. Two or three of his portraits were engraved. Redgrave says his works were "well esteemed in Staffordshire".

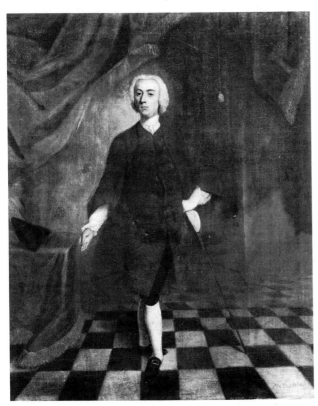

WILLIAM KEEBLE. 'Unknown gentleman.' 29½ ins. x 24½ ins. Signed 'Keable'. Christie's sale 17.3.1967 (151).
Probably from the late 1740s or early 1750s. Keeble is a candidate for small whole lengths which are not by Devis or Penny.

KEENAN, John c.1785-c.1819

Irish painter of portraits and miniatures. Pupil and assistant of Robert Home (q.v.) in Dublin. Moved to London c.1790. At Bath 1792 and largely intinerant until he settled at Windsor 1803, where he became 'Portrait painter to Queen Charlotte' 1809. He returned to Dublin c.1817, where he last exhibited 1819. At his best he is said to resemble Raeburn. His wife also sent landscapes to the RA 1807-1813.

(Strickland.)

KELSEY, Francis fl.1776

'Master Francis Kelsey' exh. FS 1776 'A chimney-sweeper; in chalks'.

KEMAN, Georges Antoine 1765-1830

Alsatian portrait painter, but chiefly miniaturist. Born Sélestat 7 August 1765; died there 1830. Trained in France. Entered RA Schools 1793. Exh. RA 1793-1807. He worked in Bristol 1796-1807, and left England for good in 1816.

(Foskett.)

KENNION, Edward 1744-1809

Landscape painter, mainly in watercolour *(Mallalieu),* but also used oil. Born Liverpool 15 January 1743/44; died London 14 April 1809. In business in the West Indies until he settled in London as a drawing master 1787. Exh. SA 1790-91; RA 1790-1807.

(Walpole Soc., vi, 87/8.)

KENT, John fl.1771-1773

Exh. landscapes of Italian scenes (Sicily, Corsica, &c.) RA 1771-73. They owe a certain amount to Richard Wilson.

(Grant, iii, 13.)

KENT, William 1685-1748

Architect, decorator and designer of the greatest distinction; also decorative history painter of mediocre quality. Born Bridlington, Yorks., 1685, son of William Cant; died London 12 April 1748. Sent to Italy 1709 by a consortium of Yorkshire gentlemen to learn painting and produce copies of old masters. Studied under Benedetto Luti and was generally influenced by Maratta and his followers. Won a prize for painting from Accademia di S. Luca 1713. Settled in Rome until 1719 — with visits to the Veneto, Naples, &c. His main Roman work was the ceiling of S. Giuliano dei Fiamminghi 1717. In 1719 accompanied Lord Burlington back

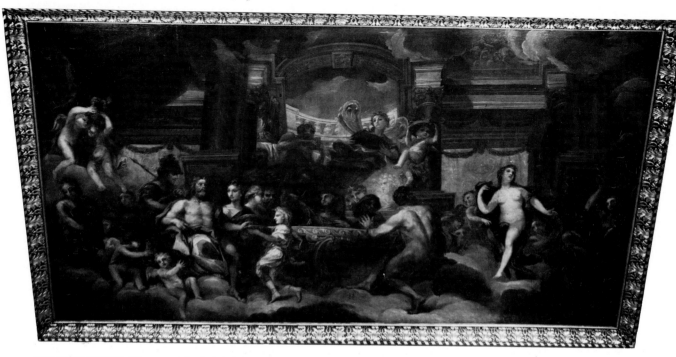

WILLIAM KENT. 'Banquet of the Gods.' Ceiling in Royal Academy of Arts, Burlington House.
Painted 1719/20 for the 3rd Earl of Burlington. It is a good deal less undistinguished than most of Kent's decorative painting.

to London and remained an ornament of Burlington House and its society for the rest of his life. Painted ceilings at Burlington House 1719/20; much decoration for Kensington Palace 1721-27, but Lord Burlington wisely deflected Kent's interests increasingly to decoration (of every sort), architecture, and garden design — in all of which he was one of the most powerful and creative influences of the century. The gardens at Stowe and Rousham are also among his most splendid achievements. As a painter, his work is never better than mediocre, but his small 'Battle of Crecy' (Royal Collection) and two companion pictures (1729) are the earliest medieval history subjects in British 18th century painting. He was made face painter to the King 1739/40 but George II was too sensible to sit to him.

(E.C-M.; Colvin for list of architectural works.)

KENTISH, P. fl.1783
Exh. FS 1783 'Entrance to a Country Village'.

KERR See CARR, J.

KETTLE, Henry ?1704-c.1773
House painter and occasional artist, father of Tilly Kettle (q.v.). Exh. SA 1772 'A cilindrical picture: one side a conversation, the other a sleeping Venus.'

KETTLE, Tilly 1734/35-1786
Portrait painter. Born London 31 January 1734/5; died near Aleppo, *en route* for India, 1786. Studied at Shipley's, St. Martin's Lane and Duke of Richmond's Academies. His work begins *c.*1760. Exh. FS 1761; SA 1765-76; RA 1777 and 1781-83. His earliest portraits show an early and skilful imitation of Reynolds. About 1762 to 1764 touring the Midlands painting portraits with introductions from Sir Richard Kaye. In good portrait practice in London 1764-69 when he went to India, the first serious portrait painter to do so. In India 1769-76, where he made a considerable fortune painting Nabobs and Native Princes. His practice slumped between 1776 and 1783. Briefly visited Dublin and Brussels and died near Aleppo while returning to India to recoup his fortune. At his best he is an excellent portrait painter of the second rank, easily recognisable.

(Milner, Walpole Soc., XV, 1927; Archer.)

TILLY KETTLE. 'Master George Edward Graham (later Foster-Pigott)'. 49½ins. x 39½ins. c.1774. Wimpole (National Trust).
A portrait of his sister is signed and dated 1774. They were painted in India.

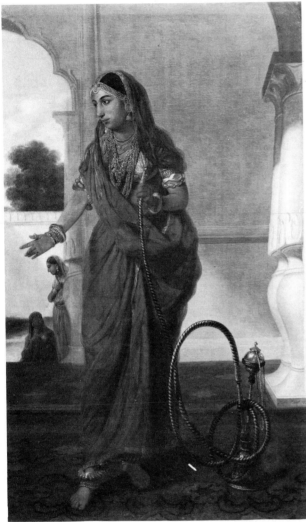

TILLY KETTLE. 'An Indian girl in red.' 78ins. x 48ins. s. & d. 1772. B.A.C. Yale.
She appears to be inviting a visitor to smoke a hookah or narghile. Kettle's interpretation of upper class Indian life is sympathetic.

TILLY KETTLE. 'Mr. Lyte.' 29ins. x 24ins. s. & d. 1769. Christie's sale 28.3.1947 (112).
This shows Kettle's characteristic football-shaped head.

THOMAS KEYSE. 'A fruit piece.' 27½ ins. x 60½ ins. s. & d. 1766. Christie's sale 1.5.1964 (156).
This may have been 'a fruit piece' exh. SA 1766 (84).

KEYMER, Matthew H. fl.1787-18(

Yarmouth portrait painter, from a Quaker famil
Exh. a portrait and a 'winter scene' RA 1787. F
moved briefly to Norwich 1787, but returned
Yarmouth, where he presented a portrait
'Nelson' to the Town Hall, 1805.

(A.S. Brown, Eastern Daily Press, 13 Apr., 1959.)

KEYSE, Thomas 1720-18(

Still-life painter. Born Gloucester 1720; die
Bermondsey 8 February 1800. Exh. FS 1761-7
SA 1765-68; RA 1799. Awarded a premium by S
1764 for a method of fixing crayon drawings. Fro
c.1770 he was the owner of Bermondsey Spa, whe
he had a permanent exhibition of his still-li
paintings, notably 'A Butcher's Shop' on the sca
of life *(Whitley, ii, 349/50)*. He mainly painted fru
and flower pieces, which are highly accomplishe
and often signed in bold capitals.

KILLINGBECK, Benjamin fl.1763-178

Portrait and sporting painter, probably
Yorkshire origin, and conceivably the 'Mr Jam
Killingbeck, an eminent painter and limner'

BENJAMIN KILLINGBECK. 'Portrait of a countryman.' 28½ i
x 23½ ins. s. & d. 1772. Sotheby's sale 18.3.1964 (49).
A very rare example of a genuine provincial portrait in a lo
setting.

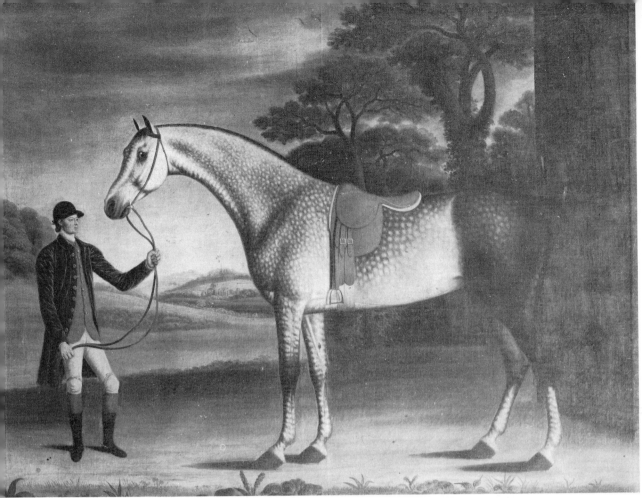

BENJAMIN KILLINGBECK. 'A hunter held by a groom.' 39½ins. x 49ins. s. & d. 1775. Christie's sale 16.6.1961 (69).
An example of Killingbeck's native Yorkshire style before he had come into contact with Stubbs.

Pontefract, who married a clergyman's widow here in 1769. (The date on a sporting picture of 1751 may be doubted.) Exh. FS 1769-82; SA 1777-83; RA 1776-89 — with London addresses. Two portraits (sale, S. 28.2.1962, 104/5) are Hudsonish, and there are clumsy mezzotints, drawn and engraved by him, of prominent men 1780-82. He had a good practice in horse pictures, and the best, of c.1776, show some awareness of those of Stubbs, with whose work he was familiar at Wentworth Woodhouse, where he was paid ten guineas for a 'Brood mares and foals' 1776 *(Antique Collector, April/May 1972, 80).*

KING, J. **fl.1796-1797**
Exh. 'Ruins' and named views, RA 1796-97.

KING, Margaret **fl.1779-1787**
Exh. portraits, mainly crayons, RA 1779-87.

KING, Thomas **fl.1756-c.1769**
Portrait painter. A shiftless pupil of Knapton (q.v.) *(Edwards).* There are mezzotints after four of his portraits and a signed 'Mrs Perry' (sale 14.2.1938, 30) is like H. Van der Mijn in style.

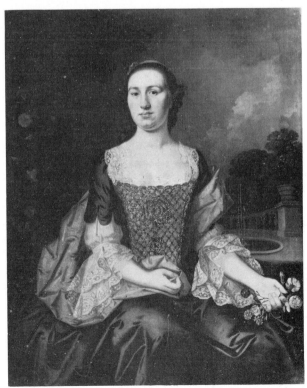

THOMAS KING. 'Mrs. Perry.' 49ins. x 39ins. Signed. Christie's sale 14.2.1938 (30).
Drapery, flowers, and setting all suggest a study of contemporary Dutch painters.

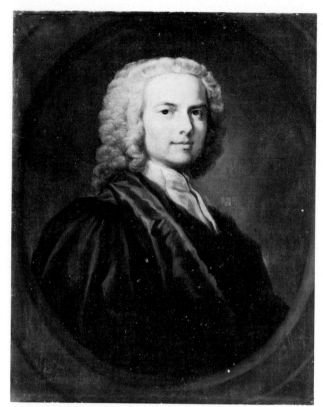

GEORGE KNAPTON. 'James Upton.' 29ins. x 24ins. s. & d.
1740. Sotheby's sale 17.2.1932 (74).
A good example of an academic portrait.

KING, Hon. Wilhelmina fl.1770-1795
Hon. exh. SA 1770-73 (flowers and feathers); RA
1775 (a perroquet). She was daughter of 5th Lord
King. Married Admiral George Murray 1784; died
1795.

KIRBY, John Joshua 1716-1774
Topographical draughtsman and occasional land-
scape painter. Born Parham, Suffolk, 1716; died
Kew 20 June 1774. He had a coach and house
painter's business at Ipswich c.1738-55, where he
became a close friend of Gainsborough. He
published a book on perspective and taught
perspective drawing to George III when Prince of
Wales who, in 1760, appointed him Clerk of the
Works at Kew and 'Designer in Perspective to His
Majesty'. Exh. SA 1761-70, including two land-
scapes said to be the work of the King. At the time
of the creation of the Royal Academy, Kirby was
made President of the SA 1768-70.

(Edwards.)

KIRK, Thomas 1765-17?
Historical painter and illustrator. Born 17 Octob
1765; died London 18 November 1797. Pupil
Cosway; entered RA Schools 1784. Exh. R
1785-96. He also engraved a number of his ow
poetical or historical compositions and ga
promise of being one of the best painters of t
Boydell group. His 'Scene from Titus Andronicu
is at Stratford.

KIRKBY, Thomas 1775-c.18
Painter of portraits, fancy pieces and landscap
Entered RA Schools 1795. Exh. RA 1796-1846;
1808-47; addresses always London except for 18
(Lichfield). He painted a number of portraits
Oxford University and Colleges 1825/6. His style
undistinguished.

KIRTLAND, G. fl.1791-17?
Exh. 'Portraits of country people' from
Woodstock address RA 1791. Presumably also t
'— Kirtland' who exh. 1798 'The dissection of t
bone and cartilages of a horse's foot (
publication)'.

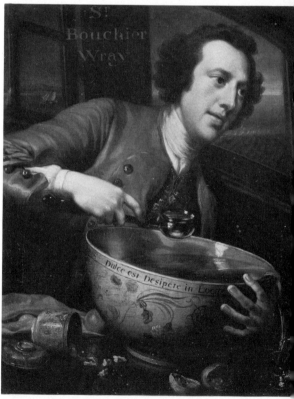

GEORGE KNAPTON. 'Sir Bourchier Wray.' 28½ ins. x 23½
Painted in 1744. Society of Dilettanti, London.
One of the twenty-three portraits of members of the Socie
many of them in masquerade costume, painted by Knap
between 1741 and 1749.

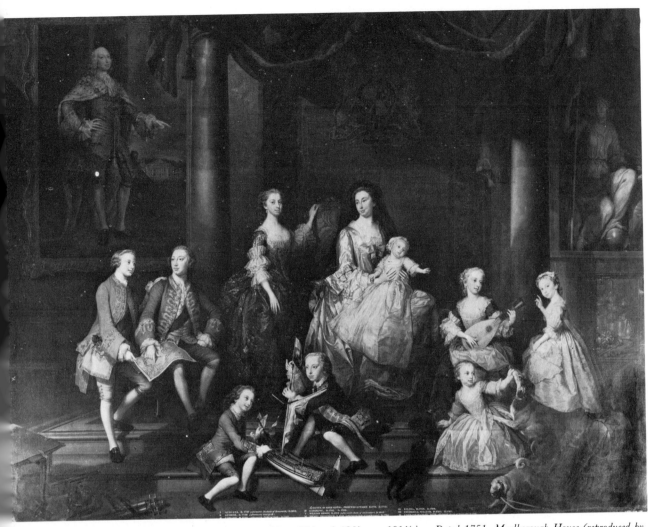

GEORGE KNAPTON. 'Augusta, Princess of Wales, and her children.' 138ins. x 181½ins. Dated 1751. Marlborough House (reproduced by gracious permission of Her Majesty The Queen).
In the background at the left is a portrait of Frederick, Prince of Wales, who had died 1751, shortly before the picture was painted.

KITCHINGMAN, John c.1740-1781

Mainly a miniaturist, but also painted portraits and pictures of shipping. Died London 28 December 1781. He won many premiums for drawings 1762-70 at Society of Arts. Exh. FS 1766-69 (miniatures). Entered RA Schools 1769. Exh. RA 1770-81. In 1781 he exh. four pictures of the life of a smuggling cutter (engraved by Pouncey).

(Edwards; Long.)

KIVERLEY fl.1738-1789

Irish landscape painter and picture dealer. Was in Italy buying pictures c.1738/40. Died Dublin 1789.

(Strickland.)

KNAPTON, George 1698-1778

Portrait painter in oils and crayons. Born London 1698; died there 1778. Apprenticed to Richardson (q.v.) 1715-22; subscriber to St. Martin's Lane Academy. In Italy 1725-32. He began c.1732 doing crayon portraits, of which he was one of the first fashionable practitioners (a group is at Chatsworth). Foundation member and official painter to the Dilettanti Society 1736, and painted twenty-three portraits (mostly in fancy dress) of the members 1741-49 (G. Macmillan, *The Society of Dilettanti: Its Regalia & Pictures, 1932*). He resigned as painter to the Society in 1763, but seems to have given up painting c.1755. His portraits are distinguished and somewhat aloof (e.g. 'Earl of Burlington', 1743, at Chatsworth). A very large group of 'The Princess of Wales and her eight children', 1751, is in the royal collection. In 1765 Surveyor and Keeper of the King's Pictures.

Sir GODFREY KNELLER. 'Richard Lumley, Earl of Scarbroug
36ins. x 28ins. Signed 'GK' in monogram, and dated 1717. Natio
Portrait Gallery (3222).
One of the series of Kit-Cat Club portraits (from which t
portrait size, 36ins. x 28ins., became known as 'kit cat size
Many of Kneller's best and most sensitive pictures we
painted before 1700, but this series is among his finest.

KNELLER, Sir Godfrey 1646-172

The most successful and prosperous court ar
society portrait painter of his age; also a
occasional painter of religious histories. Bor
Lübeck 6 August 1646; died London 26 Octob
1723. He studied under Bol (and ?Rembrandt) i
1660s. In Rome and Venice 1672-75. Settled i
England 1676 and was soon employed at Cour
Appointed Principal Painter to William and Ma
(jointly with Riley) 1688; on Riley's death in 169
he continued alone and retained that office until h
death. Knighted 1692, made a baronet 171!
Kneller was the great master of the Englis
baroque portrait. At his best he achieves a splendi
likeness and has great power of interpretin
character as well as virtuosity of handling. The ou
put of his studio was enormous; but very many
his sitters had little personal character and the per

LEONARD KNYFF. 'Clandon House and Park.' s. & d. 1708. Clandon Park (National Trust).
Knyff specialised in birds' eye views of houses and parks — a genre which was also popular in engravings in the first years of th
century, but unhappily died out.

LEONARD KNYFF. 'Arthur, 3rd Viscount Irwin.' 104 ½ ins. x 108 ½ ins. Documented as paid for (£35) in 1700. Temple Newsam House (Leeds City Art Galleries).
Long thought to be by Francis Barlow (d.1704), from whose sporting landscapes the background is derived.

wig made for monotony in male portraits. Kneller's best portraits date before 1702 and neither Queen Anne nor George I were inspired patrons, but the series of portraits of Members of the Kit-Cat Club (NPG) c.1703-21 are of immense historical value and often penetrating likenesses of the major figures of Whig Society. He was the first Governor of the first Academy in England 1711. He often signs and dates his pictures, sometimes with a monogram 'GK'.

(J. Douglas Stewart, cat. of the Kneller exh., NPG, 1971; the same author has a book, with cat. of works, in the press.)

KNIGHT, Miss fl.1790
Exh. a 'Niobe', RA 1790.

KNYFF, Leonard 1650-1722
Painter of fowls, dogs, and panoramic views of country houses; also picture dealer. Born Haarlem 10 August 1650; died London 1722. Trained in Holland as a still-life painter; settled in London by 1681, where he remained except for occasional returns to Holland; made a denizen 1694. Made drawings for Kip's *Britannia Illustrata*, 1707/8, and similar panoramic views of houses and estates (two of 'Hampton Court, Herefordshire' at BAC Yale). Later was much influenced by Francis Barlow, e.g. 'Blackgame, rabbits, &c.', (BAC Yale).

(Hugh Honour, Burlington Mag., XCVI (Nov. 1954), 337/8; Harris.)

KOBELL, Hendrik **1751-1779(?1782)**
Dutch marine painter. Born Rotterdam 13 September 1751; died there 3 August 1779 (or 1782). Briefly in London as a young man and exh. 'A sea fight', FS 1770. Later in France and Batavia.

KRAMER, J.H. **fl.1765-1775**
Exh. landscapes and portraits. SA 1765 and 1768; FS 1770-71; RA 1775. He was probably not the Johann Helferich Cramer (1730-after 1783) official copyist to the Landgraf of Kassel.

FRANCIS KYTE. 'An old lady.' 30ins. x 25ins. Signed. 'F. Kyte pinx /1741'. With P. & D. Colnaghi 1956.
The sitter was 'E.F.B./AET 72'. This was thought to be by Gainsborough until the signature appeared after cleaning, and is not unworthy of him at about this date.

KYTE, Francis **fl.?1710-1745**
Portrait painter; supposedly the same as the mezzotint engraver *(Chaloner-Smith, ii, 789ff.)* who changed his name to 'Milvus' after being caught forging a bank note (fl.1714-1733). He signed and dated some rather good portraits in the 1740s, which are much in the style of George Beare (q.v.). Three of 1744 of members of the Goldney family in sale S, 26.10.1966, 296 and 300 as 'F. Kyle'.

THOMAS JONES. 'Buildings in Naples.' 5 ½ ins. x 8 ½ ins. 1782. National Museum of Wales, Cardiff.
This is one of Jones' very fresh direct studies from nature, probably painted out of doors and similar to studies painted in Rome by Valenciennes at about the same time.

L

LA CAVE See LE CAVE, Peter

LADD, Anne **1746-1770**
Exh. fruit pieces SA 1769-70 *(Redgrave)*.

LAGUERRE, Louis **1663-1721**
History painter and occasional painter of easel pictures. Born Versailles 1663; died London 20 April 1721. Trained at the French Académie under Charles Le Brun. Came to England 1683; at first assistant to Verrio but on his own from 1687. He was the great rival to Thornhill (q.v.) in the field of history painting and the decoration of great houses and was an artist of high competence. Surviving major history paintings from after 1700 are at Marlborough House, Petworth, and Blenheim. He was a Director of the Academy founded by Kneller in 1711 and was very influential in training the first generation of Georgian painters. A *modello* for the destroyed painting at Devonshire House, 1704, is at BAC Yale. The monochrome decoration of St. Lawrence's, Whitchurch, is about 1716. His son **John** (d. 1748) did some decorative painting and was a scenery painter (1733), but gave it up for singing *(Vertue, v,68)*.

(E.C-M.)

LALLEMAND, Jean Baptiste **1716-1803**
French painter. Visited England and exh. a still-life at SA 1773. He is presumably the Dijon landscape and genre painter in Paris 1745, returned from Italy 1761, who is not otherwise known for still-life.

LAMBERT, Barrodell **fl.1747-1789**
Painted a picture of a shipwreck of 1747 (engraved). He was living at Lewes and died there 1789 *(Sussex Arch. Colls., XC (1952), 150)*.

LOUIS LAGUERRE. 'The Transfiguration.' After 1715. Apse of St. Lawrence, Whitchurch (Little Stanmore).
Derived, at a very long remove, from Raphael.

GEORGE LAMBERT. 'Kirkstall Abbey.' 45½ins. x 43ins.
s. & d. 1747. B.A.C. Yale.
Lambert does not normally show such detailed views of
buildings, but the foreground landscape and figures are in his
normal style.

GEORGE LAMBERT. 'Classical landscape.' 49ins. x 37ins.
s. & d. 1748. Christie's sale 16.4.1937 (41).
Derived in style from Gaspard Poussin, but not a close
imitation.

LAMBERT, George 1700-1765

Painter of topographical and imaginary land-
scapes; also an eminent scenographer. Born 1700
(Vertue); died London 30/31 January 1765. He is
first mentioned in 1722 imitating the manners of
his teacher, John Wootton (q.v.) and of Gaspard
Poussin, and he continued to paint Gaspardesque
landscapes throughout his life. He also worked as a
scenographer from 1726 until his death and was a
founder of the Beef Steak Club. He was associated
in the 1730s with Hogarth and Samuel Scott, who
painted figures and water in his 'Views of
Westcombe House' (Wilton), which, after
Siberechts, are the earliest consciously pictorial
views of English houses and parks. He also painted
the landscape in Hogarth's big paintings for St.
Bartholomew's Hospital 1735/6 and has some
claims to the title of 'Founder of British Landscape
Painting'. A good example of 1733 is in the Tate
Gallery. He was the first Chairman of the Society
of Artists 1761, and was elected its first President
shortly before his death.

(Elizabeth Einberg, cat. of Lambert exh., Kenwood, 1970.)

GEORGE LAMBERT. 'Classical ruin with figures.' 20½ins. x
26½ins. s. & d. 1725. Sotheby's sale 12.11.1980 (68).
The earliest known dated Lambert, and a very close imitation
of the manner of Gaspard Poussin.

215

LAMBERT, James, Sr. 1725-1788
Landscape painter and musician. Born Willingdon, Sussex, 29 December 1725; died Lewes 7 December 1788. Probably trained by the Smiths of Chichester (q.v.), to whom he was related. He painted pleasant landscape of the Sussex scene. Exh. FS 1768-73; RA 1774-78 (from Lewes). He taught painting at Lewes.

(W.H. Challen, Sussex Arch. Colls., XC (1952), 137ff.)

LAMBERT, James, Jr. 1741-1799
'Coach and sign painter' (on his trade card). Born Cliffe, Lewes, 21 September 1741; died there 17 March 1799. Nephew and pupil of James Lambert (the Elder) (q.v.), and he in fact painted some competent Sussex landscapes — though he called himself a 'coach and sign painter' — and he exh. still-lives and flower pieces FS 1769-73; RA 1774-78.

(W.H. Challen, Sussex Arch. Colls., XC (1952), 127ff.)

LANCEY, T. fl.1793-1799
Exh. views RA 1793/4 and 1798/9 from an address at Greenwich.

LANDON, John fl.1794-1827
Competent amateur landscape painter of eclectic taste. Exh. RA 1797 (as '— Landon'); hon. exh. 1798-1827 *(Grant, with picture of 1794)*. Also exh. BI 1810 from Enfield. A **T. Landon** from Cheshunt also exh. RA 1795 and seems to have been a kinsman.

LANE, Anne Louisa fl.1769-1782
Miniaturist and occasional portraitist in oil. Hon. exh. SA 1769-76; RA 1778-82. Horace Walpole calls one of her exhibits 'very paultry'.

LANE, William c.1747-1819
Portraitist in oil and chalks. Died London 4 January 1819 in his seventy-third year. Began as a gem cutter, but exh. portraits RA 1785-1815 and became a popular portrait draughtsman.

(Redgrave.)

EDWARD LANGTON. 'Still life of dead game.' 39ins. x 48ins. s. & d. 1751. Christie's sale 21.6.1957 (133).
This very competent artist does not seem to have exhibited.

LANGE, John fl.1741
Signed and dated 1741 two topographical views of Castle Hill, Devon, which are now destroyed.

(Harris, pls. 186 a and b.)

LANGTON, Bennet 1737-1801
A portrait of two Langton children (sold 20.3.1953, 148) was said to be by this friend of Dr. Johnson (for whom see *DNB*). It was probably by R. Brompton.

LANGTON, Edward fl.1737-1751
Still-life painter; apprenticed 12 September 1737 for seven years to Peter Andreas Rysbrack. A signed and dated still-life of 1751 sold 21.6.1957, 133.

LANSCROON, Gerard fl.1678-1737
Historical wall painter. Probably native of Malines; died London August 1737. First recorded in England as assistant to Verrio at Windsor 1678. Working on his own from 1692. Surviving wall paintings from after 1700 are at Powis Castle (1705) and Drayton (1710). His style is like that of Verrio with very little personal variation.

(E. C-M., i.)

SIR HENRY RAEBURN. 'Sir John Sinclair, 1st Bt. of Ulbster.' 93½ins. x 60½ins. Scottish National Gallery, Edinburgh.
He is wearing the uniform of the Rothesay and Caithness Fencibles, which he raised in 1794. In his earlier works Raeburn painted impressive landscape backgrounds in a very broad style, which he abandoned after 1800.

Typical for its somewhat ambiguous subject, and the general imitation of tapestry.

LATHAM, J. **fl.1787-1791**

Still-life and flower painter, sometimes in water-colours. Exh. RA 1787-91.

LATHAM, James **1696-1747**

Irish portrait painter from a Tipperary family. Died Dublin 26 January 1747. Master in the Antwerp Guild 1724/5; appears to have settled in Dublin c.1725. His career is undocumented but he seems to have been the best native portrait painter in Dublin until his death. His style is close to that of Highmore and he probably visited London in the early 1740s. There are lists of portraits known from engravings *(Strickland)*. The one certain known example is 'Bishop Berkeley' (Trinity College, Dublin).

(Likely attributions, Crookshank and Knight of Glin, 1978.)

LAROON, Marcellus **1679-1772**

Painter of rococo conversations, fancy pictures, stage scenes and occasional portraits. Born Chiswick 2 April 1679; died Oxford 1 June 1772. Son and pupil of Marcellus Lauron (d.1702) portrait painter and, for a time, assistant to Kneller; probably also early influenced by the low life pictures of Egbert van Heemskerk (d.1704). His main career was military until he retired, as a Captain, 1732, after extensive travels in the Low Countries and to Venice. But there are drawings as early as 1707 and he spent some time in Kneller's Academy c.1712. His most original work is from the 1730s onwards and consists mainly of small rococo fancy pictures, which show a strong French influence (Watteau engravings, &c.) and a study of Teniers. He was more an amateur than a professional artist, but consorted much with artists and with the stage and musical worlds. His odd technique suggests stained tapestry. He is a lively draughtsman of 'Hogarthian' figures, but completely lacks any moralising intentions. His conversations and musical parties are hardly of identifiable people. He seems to have settled in Oxford in the later 1750s. He is abundantly represented in BAC Yale.

(Robert Raines, M.L., 1966.)

JAMES LATHAM. 'Colonel Charles de la Bouchetière.' 48¾ ins. x 37½ ins. Said to be inscribed on the back. Christie's sale 23.6.1978 (110).
The sitter died in 1731. Latham was the nearest an Irish painter ever got to Hogarth.

LA TOUR, Maurice Quentin de **1704-1788**

French pastel painter. Born St. Quentin 5 September 1704; died Paris 16/17 February 1788. The most successful and brilliant of the French portraitists in crayons. *Agréé* at the French Academy 1737. He is said to have practised successfully in London 1725-27, under the patronage of Sir Robert Walpole, but no works are known; visited London also 1751.

(A. Besnard and G. Wildenstein, La T., 1928.)

LAURENCE, William **fl.1743**

Irish portrait painter. Known only from mezzotint by Andrew Miller of a portrait of 'James Annesley' inscribed 'Wm. Laurence Dublin Pinxt' *(Strickland).*

LAURENSON See LAWRANSON, Thomas

LAURIE, R.H. **fl.1796-1801**

Exh. pictures of shells (not always in oils), RA 1796-1800 and, in 1801 'Smugglers on the look-out'.

LAWRANSON, Thomas **fl.1733-1777**

Painter of portraits, miniatures and occasional landscapes. Said to be of Irish origin. Exh. SA 1764-77 (in 1774 a portrait said to have been painted in 1733). Feeble portrait in *Connoisseur (July 1912, 129).*

LAWRANSON, William **fl.1760-c.1783**

Painter of portraits in oils and crayons, and of poetic genre. Son of Thomas Lawranson (q.v.). Won premiums for drawings at SA in seven successive years (1760-66); entered RA Schools 1769. Exh. SA 1760-73; FS 1763 (crayon portraits); RA 1774-80. Several good mezzotints by Jones after his portraits of *c.*1780-1783, especially of stage characters, show some Reynolds influence. His 'Palemon and Lavinia' (engr. J.R. Smith) in the manner of Wheatley, sold 9.5.1947, 159.

LAWRENCE, George ***c.*1758-1802**

Irish portrait painter in crayons, miniature, and (very rarely) in oil. Pupil in Dublin 1771; practised in Dublin and Kilkenny (1787); last exh. 1802.

(Strickland; E.A. McGuire, Connoisseur, XCVII (Apr. 1936), 206.)

LAWRENCE, Miss Mary **1794-c.1830**

Flower painter, often in watercolours *(Mallalieu).* Exh. RA 1794-1830 (after 1813 as Mrs. Kearse).

Sir THOMAS LAWRENCE. 'Lady Gardiner of Tackley Park, Oxon.' Pastel. 11½ ins. x 9½ ins. Dated 1 Jan. 1787 on back. Sotheby's sale 23.3.1966 (12).
In his early pastels Lawrence initiated the flashy style he was to develop in oil portraits in the 1790s.

LAWRENCE, Thomas **fl.1770-1776**

Hon. exh. of landscapes of the London area SA 1770-76.

LAWRENCE, Sir Thomas **1769-1830**

The most remarkable British portrait painter of his age. Born Bristol 13 April 1769; died London 7 January 1830. ARA 1791; RA 1794; PRA 1820. He was an infant prodigy, taking remarkable pencil likenessses at the age of ten. By 1780 the family had settled in Bath and Lawrence began crayon portraits, probably with some guidance from William Hoare (q.v.). He taught himself in these years, copying anything he could find, and came to London 1787 when he attended the RA Schools for three months. Exh. RA 1787-1830. He showed his first oil portrait in 1788, his first full length in 1789, and burst on the world in 1790 (the last year in which Reynolds exhibited) with the full lengths of 'Queen Charlotte' (NG) and 'Miss Farren' (New York) which are masterpieces in a new romantic style.

In 1792 he was made Painter in Ordinary to the

King in succession to Reynolds, and, although there was much talk in the press of rivalry with Hoppner or Beechey (qq.v.), his portraits of the 1790s have a bravura and vivacity, with a strong feeling for character, which mark them as the quintessential statement of that age. He had at this time some aspirations to history painting in the grand manner which worked itself out in 'Satan summoning his Legions', RA 1797 (Royal Academy), which he transferred in some portraits of the actor 'Kemble as Coriolanus', RA 1798, but he was kept too busy as a society portrait painter to exploit this, and a good deal of studio assistance begins after 1800. He turned to a study of the old masters (and formed the greatest collection of old master drawings of the age) and his sophisticated portrait groups begin about 1806.

His work epitomised the Regency Style and he was enabled to raise it to something greater by the commission from the Prince Regent to paint all the principal actors in the downfall of Napoleon, which became the great series of portraits in the Waterloo Chamber at Windsor (1814-20), painted in London, Aachen, Vienna and Rome, which gave him a reputation as the first portrait painter in Europe, and the opportunity to see the work of Velasquez and others, which deepened the resources of his art. He gives perhaps too favourable an account of some of his sitters, and some of his later children's portraits, e.g. 'Master Lambton', RA 1825, anticipate Hollywood, but he is capable of being a great artist.

(K. Garlick, L., 1954; also in Walpole Soc., XXXIX (1964), with full cat.)

LEAKE, Miss　　　　　　　　　**fl.1780-1785**
Hon. exh. of flower pictures, RA 1780-85.

LEAKE, Henry　　　　　　　　　**fl.1764-1766**
Portrait painter. Native of Bath where he was a pupil of William Hoare (q.v.). Exh. SA 1765-66 with a London address. He is said to have gone to India and died early, but this is not confirmed. A portrait of his cousin 'Mrs Ditcher' (daughter of Samuel Richardson) is said to be signed on the back with a monogram 'HLP' and the date 1764.

Sir THOMAS LAWRENCE. 'Richard Payne Knight.' 50ins. x 40ins. Exh. RA 1794 (181). Whitworth Art Gallery, University of Manchester.
One of the leading writers on artistic matters of his day and characterised by Lawrence with a certain sympathetic pretentiousness.

Sir THOMAS LAWRENCE. 'General Sir Charles Grey' (later 1st Earl Grey). 50ins. x 40ins. Exh. RA 1795 (131). Private collection. A much more straightforward characterisation than the preceding illustration.

Sir THOMAS LAWRENCE. 'Miss Emily de Visme' (later Mrs. Henry Murray). 50ins. x 39ins. Engraved 1794. Christie's sale 31.5.1935 (12). Engraved by W. Bond, 1794 as 'The Woodland Maid'. An example of Lawrence's fetching portraits of children, on which his reputation rests unduly.

LE CAVE, Peter fl.*c.*1790-1810
A feckless and feeble imitator of the rural manner of Morland, Ibbetson, or even Cuyp. Worked abundantly in watercolour and pastel as well as in oils.

(*B.S. Long, Walker's Quarterly, July 1922; Grant.*)

LE CLERC, Jacques Louis 1769-after 1796
Born ?Lyon 11 October 1769; entered RA Schools 1788; returned to France 1796 and entered Ecole des Beaux Arts. His work is not known.

LEE, Anthony fl.*c.*1724-1767
Irish portrait painter and copyist. Died Dublin June 1767. Said to have been working in 1724, but his earliest known dated portrait is of 1735 (Dublin). His manner is not unlike that of Highmore.

(*Strickland; Crookshank and Knight of Glin.*)

LEGAT, Francis 1761-1809
Mainly an engraver, especially for Boydell (*Redgrave*). Born Scotland 8 March 1761; died London 7 April 1809. Entered RA Schools 1783 as an engraver, after study at Edinburgh. Exh. RA 1796 'A girl and pigeons', and 1800, 'Maternal Solicitude', which seem to have been oil pictures.

LEIGH, Jared fl.1761-1769
Painter of seaports, &c. Died London 1 May 1769 'in the prime of life' (*Edwards*). Exh. FS 1761-67. He was an attorney in Doctors' Commons and painted for amusement. His exhibits sound like variations on themes by Vernet.

LEIGNES fl.1774-1780
Brother and sister amateur artists, mainly in chalks and crayons. He was aged twelve in 1776, she thirteen. Hon. exh. 'Master Leignes' SA 1776; FS 1776 and 1780. 'Miss Leignes' FS 1774-80; SA 1776.

221

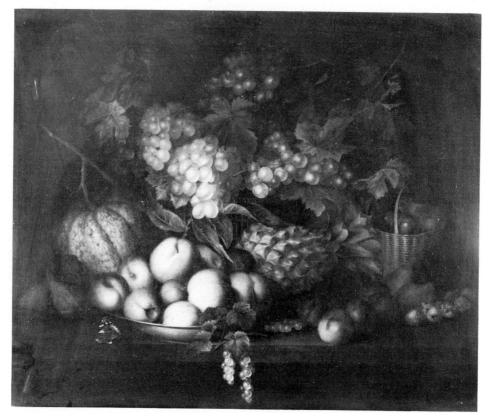

CHARLES LEWIS. 'Still life of fruit.' 24½ ins. x 29½ ins. s. & d. 1778. Christie's sale 17.3.1967 (15). Painted in Dublin.

LEIVERS, William **fl.1776-1779**
Probably a local Nottinghamshire painter. A portrait of 'John Cleaver' the Duke of Portland's agent, signed and dated 1776, is reported in *Goulding and Adams (p.341)*. He was also an hon. exh. of animal pictures RA 1779.

LENT(H)ALL **fl.1694-1702**
London portrait painter of some repute; considered for a portrait of Queen Anne for Guildhall, 1702 *(Burlington Mag., CVI (July 1964), 308)*. Portraits of the second (d.1694) and third wives of the 1st Lord Fermanagh are at Claydon in an individual and slightly vulgar Knellerish style.

LESAC **fl.1730**
French portrait painter who visited Dublin briefly in 1730.

(Strickland.)

LESCALLIER, Antoine *c.1739(or 1743)-after 1777*
Born Lyon *c.1739* (or 1743) where he won prizes in 1757. Admitted to Ecole des Beaux Arts, Paris, 1765. Exh. RA 1777 'A French Kitchen'.

(Audin and Vial.)

LEWIS **d.1803**
A Mr. Lewis, painter of Hull, is recorded as dying there 24 April 1803 *(Gentleman's Mag.)*.

LEWIS, Charles **1753-1794**
Still-life painter, especially of fruit. Born Gloucester 1753; died Edinburgh 12 July 1794. Apprenticed to a Birmingham japanner. Exh. fruit pieces SA 1772, with a London address. Moved to Dublin, where he briefly tried the stage (1776), but was painting still-lives 1777 to *c.1784*. Again in London, where he exh. RA 1786 and 1791; SA 1790. Then to Edinburgh, where he died. His fruit pieces are well designed and well painted.

(Strickland.)

LEWIS, John **fl.1739-1769**
Portrait painter and scene painter, active in both England and Ireland. Perhaps Lord Egmont's tenant in London 1739-45 *(Egmont, iii, 89 and 308)*. Scene painter in Dublin 1750-57, where he painted 'Peg Woffington' and 'Thomas Sheridan', both 1753, (both NGI). Exh. SA 1762 (portraits). His last dated portrait is 1769.

(Strickland; Crookshank and Knight of Glin.)

LEWIS, John fl.1767-1776

Topographical landscape painter. Exh. SA 1767-76, views mainly of Wales and Devonshire. His style is like that of Smith of Derby.

(Grant.)

LEWIS, Judith fl.1755/56

A pair of 'sporting conversations' of considerable elegance, signed and dated 1755 and 1756, were sold 24.6.1960, 87, which show the painter to have been probably a pupil of John Wootton.

L'HEUREUN, Miss C.L. fl.1796

Hon. exh. RA 1796 of two pictures of fruit (probably not in oils).

LILLY, Edmund fl.1702-1716

Portrait painter. Buried Richmond, Surrey, 23 May 1716. He painted a number of portraits of 'Queen Anne' in a style closely related to Kneller and Dahl, of which full lengths of 1703 (Blenheim) and 1706 (Lord Clarendon) are the most important.

(DNB.)

JOHN LEWIS. 'Mrs. Dorothy Myddelton.' 49ins. x 39ins. s. & d. 1762. Christie's sale 18.12.1936 (85).
The backdrop indicates Lewis's practice as a scene painter.

JUDITH LEWIS. 'A sporting conversation.' 22½ins. x 39ins. s. & d. 1756. Christie's sale 24.6.1960 (87/2).
One of a pair of accomplished pictures signed by this otherwise unknown lady artist. The horses suggest Flemish models.

F. LINDO. 'Sir Robert Gordon of Gordonstoun.' 28½ ins. x 23¾ ins. s. & d. 1761. Sotheby's sale 13.5.1953 (61).
Said to be of English (perhaps Jewish) birth, but all his known signed portaits were painted in Scotland.

LINDO, F. fl.1755-1765
Portrait painter in oils and crayons. There is a tradition that he came from Isleworth. He painted a good many portraits in Lowland Scotland and in Aberdeenshire 1760-62, both busts and small scale whole lengths. He might have been a pupil of Hayman (q.v.) and he usually manages to make his sitters look rather 'common'.

LINDOE, David fl.1794-1800
More or less an amateur landscape painter. Pupil of Farington 1795-97 (*Diary, 4 Dec. 1794*). Exh. west country landscapes RA 1797-98, but probably abandoned the art.

LION, Pierre-Joseph 1729-1809
French portrait and landscape painter, mainly in crayons. Born Dinant 7 May 1729; died there 1 September 1809. Pupil of Vien. Court painter at Vienna 1760. Visited London briefly 1770-71. Exh. SA 1771 (including 'Two daughters of General Carpenter', mezzotint by J. Watson 1772). He was patronised by the Duke of Newcastle, and did a very competent crayon of his steward, 'Mr. Viotti' 1770. He retired to Dinant and gave up painting 1790.

LIOTARD, Jean-Etienne 1702-1789
Leading international painter of pastel portraits; also painted infrequently in oil and miniature. Born Geneva 22 December 1702; died there 12 June 1789. Trained under Massé in Paris, where he remained until 1736. From 1736 he was largely peripatetic — Naples, Rome, Constantinople 1738-43, Lyons, Paris, Vienna, &c. In Constantinople he grew a beard and wore Turkish dress, which gave him good publicity. His visits to England were from 1753 to 1755, when he did very good business and painted all the children of the Prince of Wales (Windsor Castle), leaving for Holland in 1755, where he married in 1756. He again came from Holland to London in 1772. Exh. RA 1773-74. His technique is very accomplished and his likenesses were sometimes embarrassingly accurate; he had a formative influence on Francis Cotes.

(F. Fosca, L., 1928, and a larger work, Lausanne/Paris 1956; R. Loch and M. Röthlisberger, L'opera completa di L., Milan, 1978.)

PIERRE-JOSEPH LION. 'Monsieur Viotti.' Pastel. 24½ ins. x 19ins. Signed 'London 1770'. Christie's sale 4.6.1937 (2).
The sitter was steward to the Duke of Newcastle, from whose collection the picture comes.

LISTER, Miss fl.1784
Hon. exh. RA 1784 of 'The Forge Valley, near Scarborough'.

LITCHFIELD, Miss E.C. fl.1796-1799
Hon. exh. of landscapes RA 1796-99.

LIVESAY, Richard 1753-c.1823
Painter and engraver; he painted portraits, domestic subjects and occasionally miniatures and marine pictures. Born 8 December 1753; died Southsea c.1823. Entered RA Schools as draughtsman 1774, but exh. paintings 1776-1821. He lived at Mrs. Hogarth's house from 1777 to 1785 and did copies and engravings after Hogarth; later he became pupil and assistant to Benjamin West, for whom he painted copies at Windsor, where he moved in 1790. He taught drawing to some of the younger royal children 1790-93. His best paintings are some small-scale full lengths of these years of Eton boys in montem dress. From 1796 he was drawing master at the Royal Naval College at Portsea, and painted and engraved some marine subjects.

(DNB; Long.)

JEAN-ETIENNE LIOTARD. 'Prince Frederick William' (1750-65). Pastel. 17¼ins. x 14ins. Windsor Castle (reproduced by gracious permission of Her Majesty The Queen).
One of a set of pastel portraits of the children of Frederick, Prince of Wales, done in pastel by Liotard 1754/5.

LLEWELLYN fl.1780
Exh. FS 1780 'The bard, from Gray's ode: a sketch'.

LLOYD, Mrs. Hugh See MOSER, Mary

LOCK, William 1767-1847
Amateur painter of historical subjects, son of the elder William Lock of Norbury (1732-1810). Born 1767; died Paris 1847. Farington *(Diary 5 July 1803)* says his paintings were terrible. He gave up painting in 1789 on visiting Rome.

LONGASTRE See DE LONGASTRE

JEAN-ETIENNE LIOTARD. 'Princess Caroline Matilda' (1751-75). Pastel. 17¼ins. x 14ins. 1754/5. Windsor Castle (reproduced by gracious permission of Her Majesty The Queen).
Companion to the preceding illustration. The unfortunate Princess became the wife of Christian VII of Denmark.

RICHARD LIVESAY. 'George Montagu dressed as a salt bearer at Eton Montem.' 29½ ins. x 24½ ins. s. & d. 1790. Private collection. For salt bearers at Eton Montem see Dandridge, page 101.

LOUTHERBOURG, 1740-1812
Philippe Jacques de

Landscape and history painter; also scene painter. Born at Basel 31 October 1740; died Chiswick 11 March 1812. Entirely French trained; studied under Carle van Loo and Casanova. *Agréé* at the Paris Academy 1762 and *Académicien* 1767. Diderot's account of his work at the Salon of 1767 *(ed. Seznec 1963, 273)* sums up: "He has prodigious talent and has looked much at Nature, not directly but through the eyes of Berghem, Wouvermans and Vernet". This talent and international experience he brought to England in the service of Garrick at Drury Lane and he revolutionised stage scenery in England. In the same area he pioneered pantomime, panoramas, dioramas, &c. and had an immense success with his *Eidophusikon* (started in 1781) which fascinated Gainsborough and Reynolds *(Rüdiger Joppien, Die Szenenbilder P. J. de L., doctoral thesis, Cologne, 1972)*. Exh. RA 1772-1812. ARA 1780; RA 1781. Historical Painter to the Duke of Gloucester 1807. His output of landscapes was extremely varied and influential, ranging from English rural scenes in the manner of Morland — sometimes with almost Rowlandson figures, as in

the 'Midsummer afternoon with a Methodist preacher', 1777 (Ottawa), romantic views of Snowdon, after a visit to Wales in 1786, to stagey views of the Danube. In the 1790s he became involved in mystical ideas and his 'A philosopher in a ruined Abbey', 1790 (BAC Yale) is the quintessence of a new romantic style; while in 1793/4 he produced two enormous historical pictures of great dramatic power — the 'Grand attack on Valenciennes' (Easton Neston) and 'The Battle of the Glorious 1st June' (Greenwich). At the end of the 1790s he was making a great many designs for Macklin's Bible (8 vols., 1791-1800). Some of his later landscapes of scenes of violence in Nature, such as the 'Storm and Avalanche', RA 1804 (Petworth), were the only pictures which could be considered in competition with the young Turner. His works were exhibited after his death by his widow at the BI 1813/4. He is one of those major secondary figures who played an important part in forming and changing the pattern of the arts in England.

(Rüdiger Joppien, cat. of the de Loutherbourg exh., Kenwood 1974; Archibald.)

PHILIPPE JACQUES DE LOUTHERBOURG. 'A philosopher in a ruined Abbey.' 34ins. x 27ins. s. & d. 1790. B.A.C. Yale. A quintessential example of early Anglo-German romanticism.

PHILIPPE JACQUES DE LOUTHERBOURG. 'Outside an Inn, with many figures.' 38¼ ins. x 50¾ ins. s. & d. 1784. B.A.C. Yale.
Perhaps exh. RA 1784 (128) as 'An Inn, with a waggon, morning.' An example of de Loutherbourg's Rowlandson manner.

LOWE, Mauritius **1746-1793**
A very bad history and portrait painter; also a
miniaturist. Born 1746 (a natural son of the 2nd
Lord Southwell); died London 1 September 1793.
Pupil of Cipriani. Entered RA Schools 1769 and
was awarded a gold medal for a history picture.
First RA travelling scholar; sent to Rome 1771, but
the scholarship was discontinued 1772 owing to his
indolence and incompetence. Exh. SA 1766-69
(miniatures); RA 1770 (a portrait) and 1777-86
(mainly drawings, but an enormous 'Deluge' was
reluctantly hung 1783, at the insistence of Dr.
Johnson, who mistakenly befriended him). Died in
squalor.

(Redgrave.)

LOWRY, Strickland **?1737-c.1785**
Provincial portrait painter and engraver of
topographical landscapes. Born at Whitehaven;
said to have died at Worcester. Redgrave says he
practised also in the Midlands and had some local
reputation as a portrait painter, and that he went to
Ireland about 1768. He seems to have worked at
Dublin and in Northern Ireland. He made
engravings for *The History and Antiquities of
Shrewsbury*, 1779.

(Confused account in Crookshank and Knight of Glin, 1978.)

LUCAS, William **1762-after 1780**
Exh. crayon portraits FS 1772 (when aged ten) and
1780. He was a pupil of William Burgess.

LUCY, Charles 1692-c.1736

Portrait painter of British origin. Born London 1692; went to Florence 1705, where he studied with Pietro Dandini; then eight years with Cignani at Forli; then to Bologna, where he became a specialist in portraiture. Known only from mezzotints by Alexander van Haecken, done in London 1735/6, of the singers 'Farinelli' and 'Gizziello', who were then in London.

(Pietro Guarienti's enlarged edn. of P.A. Orlandi's Abecedario Pittorico, Venice, 1753, 355.)

LÜDERS, David c.1710-1759

German portrait painter. Born Hamburg c.1710; died Moscow 1759. He was in England c.1748-55. A huge and rather laughable group of the Perry family, 1752, is at Penshurst. McArdell did a mezzotint of his 'George III as Prince of Wales', 1753.

(Th.-B.)

EDWARD LUTTRELL. 'Portrait of an ?artist.' Pastel. 14¾ins. x 12ins. Signed. Sotheby's sale 13.10.1954 (11).
Most dated Luttrells are from before 1700, but this, which perhaps portrays a fellow artist (?or himself), is probably later.

LUMLEY, George fl.c.1700-1716

Amateur Yorkshire portraitist in crayons and mezzotint engraver *(Chaloner Smith, ii, 825-828)*. He was a kinsman of Ralph Thoresby, who sat to him for his portrait in crayons, 1710 *(Diary of R. Thoresby, 1830, i, 440, and ii, 80).*

LUNY, Thomas 1759-1837

Marine painter. Born London 1759; died Teignmouth 30 September 1837. A very abundant and perfectly competent producer of pictures of naval actions, coast scenes and views of shipyards. His naval details show specialised knowledge. Apparently a pupil of Francis Holman (q.v.). Exh. SA 1777-78; FS 1783; RA 1780-1802 and 1837; BI 1825. He retired to Teignmouth c.1810, where he continued to paint assiduously in spite of being crippled in both hands and legs. A catalogue of 295 of his pictures is in the *Report and Transactions of the Devonshire Association,* 1888.

(Archibald.)

LUPTON, Robert fl.1774

Exh. 'A Deception', FS 1774.

LUTTRELL, Edward fl.1680-1724

Painter of crayon portraits, often on copper, and one of the pioneers of mezzotint engraving *(Chaloner Smith, ii, 288ff.).* Said to have been born in Dublin; he was alive in 1723 *(Vertue, iii, 12)* and there is an alleged date of 1724 on a pastel. He seems to have discovered his technique largely on his own. Pastel portraits begin c.1680 and some are signed 'EL' in a monogram. He was a director of Kneller's Academy 1711. He also did heads after Rembrandt and the V & A has a 'Last Judgment' in crayons on copper after Christopher Schwarz. Several crayons are in NPG.

(Patrick Noon, English Portrait Drawings and Miniatures, BAC Yale, 1979, 11.)

LUYTEN, B. fl.1752

Signed and dated two views of Leicester House, 1752 (Penshurst). They resemble the work of Samuel Wale.

LYON, David fl.1774

Exh. sporting pictures at FS 1774.

LYTTELTON, Elizabeth, Lady 1716-1795

Amateur painter of portraits in crayons and oils. Separated wife (and, after 1773, widow) of 1st Lord Lyttelton. Hon. exh. SA 1774 and RA 1771, 1775 and 1780.

B. LUYTEN. 'Leicester House.' s. & d. 1752. Viscount De L'Isle, V.C., K.G., Penshurst Place.
This competent topographical painter, whose work is like that of Samuel Wale, is not otherwise known.

M

MACBURNEY, James **1678-after 1744**
Professional portrait painter at Chester in 1730s.
Born Hanwood, Salop, May 1678. Pupil of Dahl,
but did not settle to a professional career until after
a second marriage in 1721 at Shrewsbury.
Changed his name to Burney *c.*1726; father of the
great musicologist Charles Burney (1726-1814). In
the 1730s had some success as a painter at Chester
and was patronised by Lord Cholmondeley.

(Percy Scholes, The great Dr. Burney, 1948, 1-3, 10.)

McFERGUS **fl.1783**
Exh. a landscape at FS 1783.

McILRAITH, Andrew **alive 1715-1753**
Burgess painter at Edinburgh. Painted a portrait of
'Bishop Burnet' for Marischal College, Aberdeen,
1723; signed a 'Sir Lawrence Mercer', 1725.

MACKAY, Richard **fl.1775 and 1790**
'Master Richard Mackay' exh. 'a head in chalks'
FS 1775. 'Mr. Macky' exh. an Irish landscape and
'The Fair Sisters', SA 1790.

MACKENZIE, Charles **fl.1769-1801**
Irish landscape painter. Student in Dublin 1769,
and exh. there 1801. Said to have been 'idle but
talented'.

(Strickland.)

McLAUCHLAN, Archibald **fl.1762-after 1770**
Scottish portrait painter. Matriculated Glasgow
University 1762. Pupil there of Foulis Academy —
his 'Jane, Countess of Hyndford' signed
'1766/Academy Glasgow' (sale S, 12.1.1966, 160)
in style like Mosman (q.v.). A large 'Family of
John Glassford' at Glasgow (*W.J. Macaulay, Scottish
Art Review, III (1951), 14ff.*).

McLAURAITH See McILRAITH, Andrew

MACPHERSON, Giuseppe **1726-after 1786**
Portrait and miniature painter at Florence. Born
Florence 19 March 1725; still alive 1786. Pupil of
Batoni at Rome and said to have had a large
practice among visiting Englishmen in Italy. 'Self
portrait' of 1778 in Uffizi; copies in miniature
1773-86 after Uffizi artists' self portraits at
Windsor.

(J. Fleming, Connoisseur, CCXLIV (Nov. 1959), 166/7.)

McPHISK **fl.1783**
Exh. a landscape at FS 1783.

McQUOID, S. **fl.1774-1783**
Exh. a number of figure paintings, mainly in
chairoscuro, and some 'pieces of shipping', FS
1774-83.

*ARCHIBALD McLAUCHLAN. 'Jane, Countess of Hyndford.'
27¾ins. x 23¾ins. s. & d. '1766/Academy Glasgow'. Sotheby's sale
12.1.1966 (160).*
One of the few known signed examples of a picture from the
Foulis Academy at Glasgow. It has no very positive character.

MADDEN, Wyndham **fl.1766-1775**

Irish landscape and portrait painter in oils and crayons. Known only from mezzotint by W. Dickinson after portrait of 'Lord Lifford', 1775.

(Strickland.)

MALCOLM, James Peller **1767-1815**

American artist; mainly an engraver but also painted landscapes. Born Philadelphia August 1767; died London 5 April 1815. Studied engraving in Philadelphia and came to England *c.*1789 to study landscape and historical painting. Exh. landscapes at RA 1791. Returned to engraving in London.

(Groce and Wallace.)

MANINI, Cavalier Gaetano **fl.1755-1775**

An absurd Milanese history painter and miniaturist. Worked in England as a miniaturist from 1755 *(Long).* Exh. pretentious historical subjects FS 1761-72; SA 1762-75; the most preposterous being an allegory of George III founding the Royal Academy "in imitation of the School of Athens", FS 1772.

MANNIN, James **fl.1746-1779**

French painter in Dublin of landscapes and flowers. Died in Dublin 1779. Appointed to teach landscape and ornamental drawing in Dublin Academy's School 1746 and continued until his death. Won premiums for landscapes in 1763 and 1770.

(Strickland.)

MANSKIRCH, Franz Joseph **1768-1830**

German painter of landscapes (in oil and water-colours) and of military scenes. Born Ehrenbreitstein 6 October 1768; died Danzig 16 March 1830. Trained in the Rhineland; came to England and exh. landscapes at RA 1793-1807 (his English watercolours are in an unexpectedly British idiom). Perhaps returned to Germany before another visit, in which he exh. scenes of military events RA 1812-19; BI 1815/6. He was in Danzig in 1822 and worked at Frankfurt before returning there.

(Th.-B.; Grant.)

MANUEL **fl.1771-1783**

Exh. a coach panel at FS 1771, and 'Cattle: in oil', FS 1783.

GIUSEPPE MARCHI. 'Major John Jones.' 35ins. x 27ins. Painted 1768. Sotheby's sale 24.11.1965 (85).

The brother of the painter, Thomas Jones, a close friend of Marchi. This is one of the very few pictures known to have been painted by Marchi during the short period when he was on his own in Wales and had briefly deserted Reynolds' studio.

MARCHI, Giuseppe **fl.1752-1808**

Portrait painter and mezzotint engraver; the principal assistant to Sir Joshua Reynolds. Born Rome (the date is usually given as 1735 but he told Farington 12 January 1795 that he was then "73 or 74"). Reynolds brought him back from Italy in 1752; died London 2 April 1808. He studied at the St. Martin's Lane Academy. His mezzotints begin 1766 and, although he had some sort of independent life as a portrait painter and exh. SA 1766-75 (portraits and mezzotints) and became a Director of the SA 1775 (even attempting to start a portrait practice in Wales 1768/9) his artistic career for forty years was as the mainstay of Reynolds' studio, looking after his sitterbooks, laying in his pictures, and producing copies. How much he did is mysterious, but he alone understood Reynolds' odd technical operations and, after Reynolds' death, he alone was really capable of restoring his pictures. His few known independent portraits, e.g. 'Thomas Jones' (Cardiff) and 'John Jones', (sold S, 24.11.1965, 85) are wholly in the style of Reynolds, but feebler. His mezzotints after Reynolds are excellent.

WILLIAM MARLOW. 'View of Tivoli.' 29½ ins. x 24½ ins. Private collection.
One of a group of pictures probably painted immediately after Marlow's return from Italy in 1766. The view has been somewhat modified in the interests of the picturesque.

MARINARI, Gaetano fl.1784-1834
Italian scenery painter of considerable virtuosity; native of Florence. He worked for the King's Theatre, Haymarket 1784-1804, and for Drury Lane 1794-1834. In Dublin 1809/10.

(E. C-M.)

MARKHAM, R. fl.1798-1808
Hon. exh. of a 'View of Freshwater', RA 1798; and 'A Bacchante', RA 1808. A 'W. Markham Junior' was the hon. exh. RA 1797 of a view of 'Brockwell Hall, near Dulwich'.

MARLOW, William 1740-1813
Topographical and picturesque landscape painter in oils and watercolours. Born Southwark 1740; died Twickenham 14 January 1813. Apprenticed to Samuel Scott (q.v.) August 1754, for five years, where he got his topographical training, but he also studied at the St. Martin's Lane Academy and must have paid close attention to the work of both Richard Wilson (q.v.) and Vernet. He seems to have toured England extensively and from 1765 travelled leisurely through France to Florence, Rome and Naples; returning to England 1766. Exh. SA 1762-90; RA 1788-96 and 1807. By about 1785 he had retired to Twickenham and painted only for his amusement. He made many drawings in France and Italy, which served him for paintings, often repeated, for the rest of his life. He also painted views of country houses (e.g. 'Castle Howard', 1772). His tone is often silvery, but his range is considerable and he can sometimes be confused with Wilson.

(Cat. in hand by Michael Liversidge; do. (etchings) Burlington Mag., CXXII (Aug. 1980), 549ff.)

MARRIS, Robert 1750-1827
Landscape painter, mainly in watercolour, but occasionally in oil. Died Chelsea 29 April 1827, 'aged 77'. Probably pupil of Arthur Devis, one of whose daughters he married, but his landscape style is that of Anthony Devis (q.v.). Exh. FS 1770 (from Devis's house); SA 1774 and 1790 (misprinted 'Morris'); RA 1780-84 (drawings). He was the first teacher of Richard Corbould (q.v.), 1773.

(S.H. Pavière, The Devis family of Painters, 1950, 142ff.)

MARSH, Robert 1768-after 1791
Portrait painter. Born 15 February 1768. Entered RA Schools 1787. Exh. two portraits SA 1791 from an address at Hoxton.

MARSHALL, Benjamin 1767-1835
The most distinguished sporting painter in the generation after Stubbs. Born Leicestershire 1767; died London 24 July 1835. Apprenticed to L.F. Abbott 1791-94, but transferred his interest from portraiture to sporting pictures for the *Sporting Magazine*. Exh. fitfully at RA 1800-19. He moved from London to Newmarket in 1812. His best pictures date from before a coaching accident in 1819 and he can achieve a remarkable breadth of panoramic landscape. He specialised in racing rather than hunting pictures.

(Aubrey Noakes, B.M., Leigh-on-Sea, 1978.)

WILLIAM MARLOW. 'View of Malton.' 19½ins. x 29¾ins. Private collection.
Marlow's best English views, such as this, are closer to nature than his views of France or Italy.

BENJAMIN MARSHALL.
'A sportsman with a pointer.'
27½ins. x 36ins. s. & d.
1799. Christie's sale
12.10.1945 (54).
Conceivably a self portrait.
The vast horizon is very
characteristic of Marshall.

MARTELL, Isaac　　　　**fl.1780-1789**
Painter of still-life, and especially of wild birds. Exh. SA 1780 and 1783; RA 1781-89; always from addresses in the East End of London.

MARTIN, David　　　　**1737-1797**
A leading Scottish portrait painter. Born Anstruther 1 April 1737; died Edinburgh 30 December 1797. He became a pupil of Allan Ramsay in London *c*.1752; was with Ramsay in Italy 1755-57, and was his chief assistant and copyist in the 1760s. He was very active in the SA; won premiums for chalk drawings 1759 and 1761, became Treasurer 1772 and Vice-President 1776. Exh. SA 1765-78; RA 1779 and once from Scotland 1790. He settled in Edinburgh *c*.1783 and, in 1785, was appointed 'Portrait painter to the Prince of Wales in Scotland' (as he often signed his pictures). He was one of the first resident painters in Edinburgh to earn a good living, but his dominant position there was encroached upon by Raeburn in the early 1790s. He also scraped mezzotints in the 1760s. He was good at interpreting the Scottish face and had learned a good deal from Reynolds as well as from Ramsay, but his execution of the hands is often slovenly.

MARTIN, Elias　　　　**1739-1818**
Swedish landscape and portrait painter. Born Stockholm 8 March 1739; died there 25 January 1818. Studied in Paris under Vernet 1766-68. To London 1768. Exh. SA 1768. Entered RA Schools 1769. Exh. RA 1769-1780 and 1790. ARA 1770. He was mainly a topographical and picturesque landscape painter — more often in watercolour than in oils — but also painted some life-size and some small scale portraits. He returned to Sweden 1780 with a commission from the King to make topographical drawings, and became a member of the Stockholm Academy 1781. He was back in England 1788-91, latterly at Bath, whence he sent sentimental genre pictures to RA 1790. From 1791 again in Stockholm, where he painted religious themes as well as picturesque landscapes. He built a gallery for his own works in 1806, but had little success in later life. Some of his watercolours are attractive.

(E. C-M.; Nils Lindhagen, cat. of the Martin exh., Stockholm, 1950.)

GABRIEL MATHIAS. 'John Chute.' 50ins. x 40ins. s. & d. 1758. The Vyne (National Trust).
One of the very few known works by this pupil of Batoni before he gave up painting for business.

MARTIN(E), P.　　　　**fl.1733-1740**
British painter of crayon portraits at Florence 1733-40. He painted three such (two of which are at Mellerstain) for Lady Grisel Baillie for 12 carlins each. He is mentioned in a silly story about a duel in Horace Walpole's letter to West, 27 February 1740. His abilities were modest.

MARTIN, William　　　　**1752-*c*.1831**
Flimsy historical painter. Born Norwich August 1752; last exh. 1831. Entered RA Schools 1772. Pupil and assistant to Cipriani until at least 1784. He won a gold pallette for a historical drawing 1776, and a premium for landscape from Society of Arts 1780. Exh. RA (fitfully) 1775-1800 and 1807, 1810, 1812 and 1816; BI 1809, 1825, 1828 and 1831. In 1787 he presented two huge history pictures to the City of Norwich, which were engraved by Bartolozzi. He occasionally painted portraits, but his exhibits were mainly compositions in the tradition of Angelica Kauffmann. He somehow acquired in 1810 the title of 'History Painter to King George III'!

(Fawcett.)

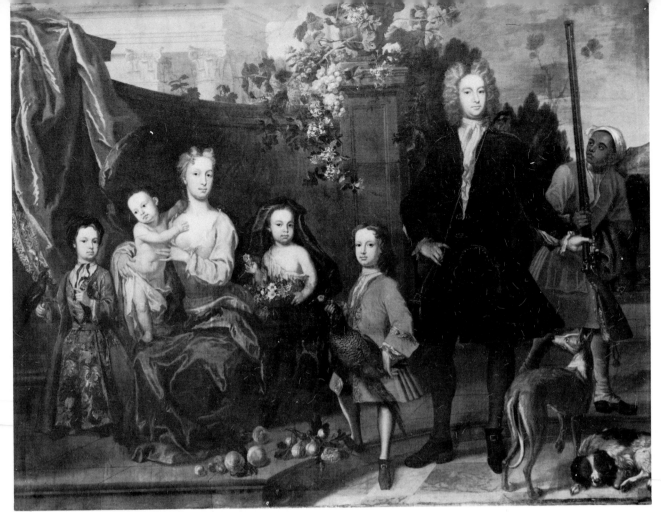

JAMES MAUBERT. 'Edward Bathurst and family.' 94ins. x 121ins. Painted c.1714/5. Sotheby's sale 23.6.1971 (90).
Traditionally by Maubert, who painted another Bathurst family group. It includes the honeysuckle which Maubert liked to introduce into his portraits.

MASON, Rev. William 1724-1797
Literary character and amateur painter. Born Hull 12 February 1724; died Aston, nr. Sheffield, 5 April 1797. He was Precentor of York; a friend of Horace Walpole and friend and biographer of Reynolds. Exh. (drawings) RA 1782, 1783 and 1786; and painted, 1764, a 'Good Samaritan' of astonishing feebleness as the 'altarpiece' for the church near the house at Nuneham Courtenay.

(A candidate for praise, exh. cat., York Festival, 1973.)

MASQUERIER, John James 1778-1855
Society portrait painter in oils and pastel, and occasional painter of history pictures and landscapes. Born London 23 October 1778; died Brighton 13 March 1855. His family was of French origin and he was taken to Paris 1789 and studied there under Vincent and Carle Vernet. He returned to London at the Revolution and entered RA Schools 1792. Exh. RA 1795-1838; BI 1807-44. He became a pupil and assistant to Hoppner 1796-99, and his earlier portraits are exercises in a smudgy variety of Hoppner's style. He travelled a good deal in Ireland and the Midlands, and visited Paris for two months in 1800, bringing back a portrait of Napoleon, which was a great success in London. In 1802 he made his first visit to Scotland and stayed with Raeburn, the least valuable qualities of whose style became the model for his later portraits. He was a very successful and a very indifferent portrait painter, mainly in pastel. He retired to Brighton in 1823, but sent a number of feeble subject and history pictures to BI until 1844.

(R.R.M. See, Masquerier and his circle, 1922.)

MATHIAS, Gabriel 1719-1804
Painter of portraits and figural genre. Born December 1719; died Acton 1804. Studied under Ramsay 1739; in Rome 1745 to 1748, where he studied under Batoni. He is listed as 'an eminent painter' in London in the *Universal Magazine*, 1748. Exh. FS 1761-62 but soon afterwards gave up painting on being given an office in the Privy Purse. There are two mezzotints after his pictures by Faber Jr. and one by McArdell. A signed portrait of 'John Chute' 1758 is at The Vyne.

(Farington's Diary, 14 June 1795.)

CHARLES MAUCOURT. 'An unknown man, perhaps an actor.' 33ins. x 26½ins. s. & d. 1764. Christie's sale 5.3.1937 (153). The painter may well have been German; the sitter has been variously called 'Garrick' and 'Foote'!

MATHISON, Andrea fl.1771-1775
Landscape painter. Pupil of Hodges 1771-73. Exh. FS 1771; RA 1772-75.

MAUBERT, James 1666-1746
Portrait painter. Possibly born in Ireland; died London October 1746, 'aged 80'. First studied under Gaspar Smitz in Dublin, but his known portraits show that Kneller and Dahl were the chief influences on his style. His predilection for honeysuckle *(Vertue)* is shown in his two known groups: Cirencester Park and sale S, 23.6.1971, 90. He also specialised in copying (often in small ovals) portraits of British poets.

(Collins Baker, Lely &c., ii, 71/2.)

MAUCOURT, Charles fl.1761-1768
(or Claudius)
Portrait painter and miniaturist; scraped one mezzotint. Said to have been born in Germany; died London January 1768. Exh. SA 1761-67. A vaguely Zoffanyish portrait of 1764 sold 5.3.1937, 153.

MAURITZ See MORITZ, C.

MAWBRYE, E. fl.1782
Exh. a portrait RA 1782.

MAXWELL, George 1768-1789
Landscape painter. Born 1768; died 28 December 1789. Exh. RA 1787-89 landscapes which Redgrave says were favourably noticed by Sir Joshua Reynolds.

MAY, Charles fl.1770-1776
A 'Charles May' entered RA Schools 1770 and exh. FS 1771-73 portraits, most of which were said to be drawings. He is probably the same as the 'Mr. May' who exh. portraits at FS 1774-76 from various addresses. At RA 1778 he exh. a portrait of 'Mr. Dunkerly'.

MAYNARD, Thomas 1752-c.1812
Portrait painter. Born 1752; last exh. 1812. A youthful pupil of Arthur Devis (q.v.). Exh. a drawing as 'Master Maynard' FS 1764. Entered RA Schools 1772. Exh. FS 1770 and 1775; RA 1777-1812. He had a respectable London practice for smallish heads, rather in the style of Walton.

THOMAS MAYNARD. Called 'William Pitt, the Elder.' 23½ins. x 19½ins. s. & d. 1797. Christie's sale 29.3.1963 (39). Maynard specialised in small heads, of about this size, for small houses, just as his teacher, Devis, had specialised in small full lengths.

MAYOR, Barnaby fl.1767-1774
Topographical landscape artist. Died 8 July 1774.
Exh. SA 1767-74. Some of his landscapes may have
been in oils, but most were in watercolours.

MEAD, Miss fl.1778
Hon. exh. of 'two portraits in crayons', RA 1778.

MEASE, J. fl.1797-1798
Exh. two portraits of horses, RA 1797-98.

MEDICI, Clemente fl.c.1727
Recorded by Vertue as painting landscape frescoes
at Faringdon house, which no longer survive. One
was dated 1727.

(E.C-M.)

MEDINA, Sir John Baptist de 1659/60-1710
Portrait and history painter. Born Brussels, from a
Spanish family; died Edinburgh 5 October 1710.
Knighted in Scotland 1707. Pupil of Duchatel in
Brussels; he came to London 1686, where he soon
adopted a portrait style very close to that of
Kneller. He settled in Edinburgh about 1693/4 and
had an immense success, painting the portraits of
most of the nobility of Scotland *(J. Fleming,*

*Sir JOHN MEDINA. 'Self portrait.' 30ins. x 25ins. Scottish
National Portrait Gallery, Edinburgh.*
Probably painted about the time he was knighted (1707).

Connoisseur, CXLVIII (Aug. 1961), 23-25). He
affects particularly red and blue draperies. His few
portraits of people with no social pretensions, e.g.
two of his own children (Gosford) and 'Aytoun' the
butler (Wemyss Castle), show realistic powers
which almost anticipate Hogarth. An 'Apelles and
Campaspe' (Gosford) is his only history picture
known to survive. His series of portraits at
Surgeons' Hall, Edinburgh (*c.*1697ff.) is
remarkable *(D. Mannings, Medical History, 23
(1979), 174-190).*

His eldest son, **John** II (born before 1686; died
Edinburgh 1 December 1764) carried on, with
much less success, using his father's 'postures'. His
work is undistinguished. His son, **John** III (born
1720; died Edinburgh 27 September 1796) exh. SA
1772-74. He was chiefly a copyist and restorer.

MEDLEY, Samuel 1769-1857
At first a painter of religious histories (his father
was a Baptist minister), but later of portraits and
animal pictures. Born ?Watford 22 March 1769;
died Chatham 10 August 1857. Entered RA
Schools 1791. Exh. RA 1792-1805, when he gave
up painting and became a successful stockbroker.

(DNB.)

*SAMUEL MELLER. 'John Morgan.' 48ins. x 38½ins. s. & d.
1702. Christie's sale 20.10.1961 (10).*
His style suggests the work of a drapery painter.

MELBOURNE See **MILBOURNE**

MELLE, Francisco **fl.1773-1775**
Painter of history, frescoes and miniatures. Exh.
FS 1773-75; SA 1774, as 'Painter in fresco to the
King of Portugal' — but not otherwise recorded in
that role.

MELLER, Samuel **fl.1702**
Signed and dated 1702 portraits of two Welsh
sitters sold 20.10.1961, 10 and 11. His style is like
that of Dahl (q.v.).

MELLISH, Thomas **fl.1761-1766**
Exh. landscapes at SA 1761 and 1763; FS 1766.
They included moonlight and shipping pieces.

MEQUIGNON, Peter **1769-1826**
Portrait and history painter. Born Dublin 7
January 1769; died London 26 September 1826.
Trained first in Dublin, then entered RA Schools
1788. Exh. RA 1791 and 1793 (portrait drawings),
and 1825-26 (portraits). In between he was at
Dublin and Belfast (1802). He seems to have been
a pretty feeble artist.

(Strickland.)

MERCIER, Charlotte **1738-1762**
Portrait painter in oils and crayons. Baptised
London 10 May 1738; died there 21 February
1762. Daughter and pupil of Philip Mercier (q.v.)
whose works she seems to have imitated. A crayon
portrait of 1755 is at Mapledurham. She is said to
have gone to the bad.

*(J. Ingamells and R. Raines, cat. of Philip Mercier exh., 1969,
54.)*

MERCIER, Dorothy **fl.1735-1768**
Portrait painter and flower and miniature painter.
Née Clapham; married Philip Mercier (q.v.) as his
second wife 1735. Exh. SA 1761 flower pieces and
miniatures. She set up as a printseller and engraver
in 1762 and retired in 1768.

*(J. Ingamells and R. Raines, cat. of Philip Mercier exh., 1969,
53.)*

MERCIER, Philip **?1689-1760**
Painter, of French Huguenot origin, of portraits
and fancy pictures; also engraver. Born Berlin
1689 (or 1691); died London 18 July 1760. Trained
in Berlin, partly by Pesne, and in some way
obtained considerable familiarity with the work of
Watteau, some of whose pictures he engraved (and
perhaps forged) in the 1720s. Probably came to
England 1716, where he married 1719, and visited
France before he held a sale of pictures 'collected
abroad' in 1724. He was patronised by Hanoverian
courtiers and painted the first conversation pieces
1725/6. On arrival of Frederick, Prince of Wales
from Hanover, he became 'Principal Portrait
Painter' to the Prince (1729-36) and Library
Keeper (1730-38), but was dropped for private
reasons. In London 1737-39 he produced the first
'fancy pictures', mainly single figures, which owe
something to Chardin, and a set of which was
engraved by Faber. These were new and began a
vogue. He settled at York 1739-51 (with brief visits
to Ireland 1747 and Scotland 1750) where he
painted many of the Yorkshire gentry and did
further good business in fancy pictures, with
popular sentimental groups as well. He visited
Portugal for a year (1752) but later settled in
London and largely concentrated on fancy pieces,
some of which he exh. SA 1760, just before he died.
He was an important figure in the introduction of
French taste into England.

*(J. Ingamells and R. Raines, cat. of Philip Mercier exh., York
and Kenwood, 1969; do. in Walpole Soc., XLVI, 1978.)*

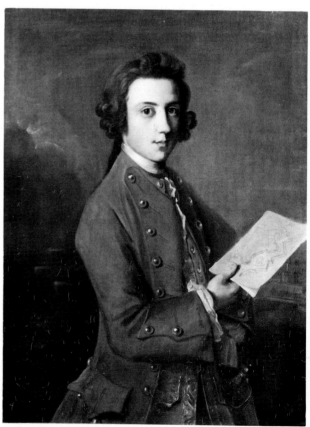

*PHILIP MERCIER. 'A young officer.' 36ins. x 28ins. s. & d.
1748. Christie's sale 25.11.1960 (172).*
The lively and slightly self-conscious expression differentiates
Mercier from Ramsay.

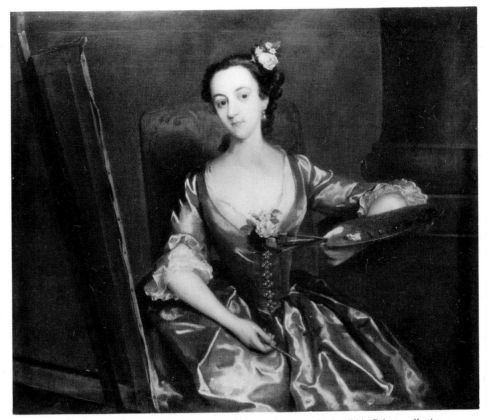

PHILIP MERCIER. 'Lady Anne Wentworth.' 44ins. x 54ins. s. & d. 1741. Private collection.
The sitter was an accomplished amateur painter and probably took lessons from Mercier.

MESSING, John　　　　　**1756-after 1774**
Born 4 May 1756. Entered RA Schools 1772. Exh.
a portrait of a dog RA 1773; a landscape SA 1774.

METZ, Conrad Martin　　　　**1749-1827**
German painter and engraver. Baptised Bonn 11
November 1749; died Rome 16 December 1827.
Son of Johann Martin Metz (q.v.) with whom he
came to England; entered RA Schools 1772
winning a silver medal 1780. Also a pupil of
Bartolozzi. Exh. RA 1781-94; SA 1783, mainly
drawings of historical subjects. Lived in Rome
after 1801.

(Th.-B.)

METZ, Gertrud　　　　**1746-c.?1793**
Painter of fruit and flower pictures. Baptised Bonn
15 January 1746. Sister of last, whom she
accompanied to England. Exh. SA 1772; RA
1773-74. She perhaps returned to Germany after
1774, but a 'Miss Metz' exh. 'Blind man's buff',
RA 1793.

*PHILIP MERCIER. 'Lady Jenkinson.' 99½ ins. x 59½ ins.
s. & d. 1742. Temple Newsam House (Leeds City Art Galleries).*
Mercier had a more extensive practice in portraits on the scale
of life when he was settled in York than at any other period.

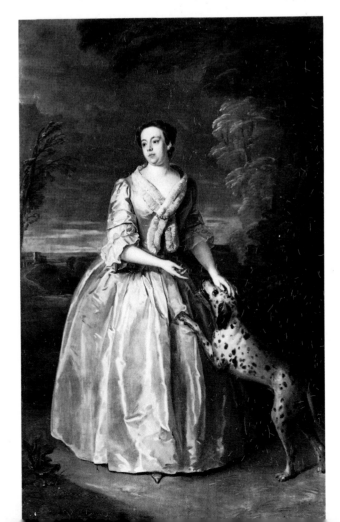

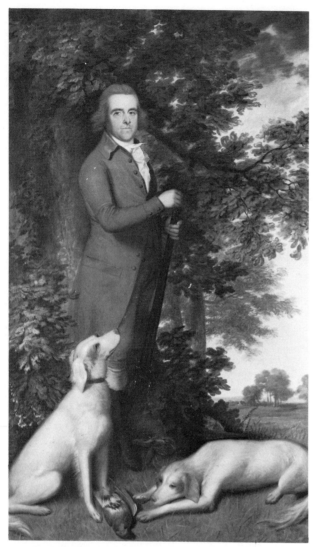

JAMES MILLAR. 'Unknown gentleman.' 93ins. x 57ins. s. & d. 1790. Christie's sale 3.2.1950 (122).
An interesting image of a provincial sportsman.

METZ, Johann Martin 1717-c.1790
German painter of portraits and still-life subjects. Baptised Bonn 29 November 1717; died Cologne c.1790. Father of the last two; in the service of the court at Bonn and later at Cologne. Came to England c.1772 and exh. portraits SA 1774-75, but soon returned to Germany, where he painted floral decorations and topographical landscapes.

(Th.-B.)

METZ, S. fl.1791
Probably a son of C.M. Metz (q.v.). Exh. (from same address as C.M. Metz) 'Phillis and Chloe', RA 1791.

MEYER, Hendrik (de) 1737-1793
Dutch landscape painter and engraver. Born Amsterdam 12 May 1737; died London February 1793. Trained at Haarlem. His paintings are mainly in watercolour and in the style of A. van Ostade. He first visited England 1775 and finally returned c.1789. Exh. RA 1790-92.

Another H. Meyer exh. RA 1804.

MILANESE, Il fl.1777-1779
A painter with this nickname exh. RA 1777-79 three pictures in which Venus featured, which sound distinctly odd.

MILBOURNE, Henry 1781-c.1826
Landscape painter. Born 1781; last exhibited 1826. Possibly son of John Milbourn(e) (q.v.) since he appears in early catalogues as 'Milbourne Junior'. Exh. RA 1797-1823; BI 1807-26. He did not enter the RA Schools until 1816, 'aged 35'. Up to 1800 his exhibits are mainly of scenes in Wales.

(Grant, iii, 21.)

MILBOURN(E), John fl.1763-after ?1789
Portrait painter in oils and crayons; also painted genre. Won premiums for drawings at Society of Arts 1763-65. Pupil of Cotes (q.v.). Entered RA Schools 1769. Exh. crayon portraits RA 1772 and 1774. Perhaps the painter of some grisaille religious scenes in the chapel at Greenwich c.1779; and scene painter at Covent Garden 1783-89. He seems also to have been a picture restorer.

(E.C-M.)

MILLAR, F. fl.1785
A 'Portrait of a lady' sold 19.11.1937, 133, was inscribed on the back 'by F. Millar pinx./1785'. It was like a more provincial L.F. Abbott.

MILLAR, James fl.1763-1805
Birmingham portrait painter. First in Birmingham Poor Law Levy Books 1763; died Birmingham 5 December 1805. He was the leading portrait painter in Birmingham during the last quarter of the century and has a considerable range of style — from life-size full lengths to small-scale conversation pieces. Birmingham Gallery has six portraits ranging from 1774 to 1797. Exh. SA 1771; RA 1784, 1786, 1788 and 1790, always from Birmingham.

(Information from City Art Gallery, Birmingham.)

MILLAR, William fl.1751-1775

Lowland Scottish portrait painter. Dated works are
known from 1751 (a copy of Ramsay) to 1775. He
also copied a Gavin Hamilton portrait and visited
Ramsay in London 1759 — but was not his pupil.
He was perhaps the best native portrait painter in
Edinburgh in the 1760s, but his style is only a
development from Ramsay's earlier manner, with-
out concessions to the new style of the age of
Reynolds.

MILLER family fl.1760s-1790s

Johann Sebastian Müller, who, by 1760, had taken
the name of **John** Miller, was born at Nuremberg
*c.*1715 and died at Lambeth June 1792. By 1768 he
had settled at Dorset Court, London, where, at
different times, four artist sons also lived with him.
He was trained in Germany as an engraver, settled
in England in the early 1740s, and became an
extremely prolific engraver of every sort of subject
from history to portrait and flowers. He also faked
old master paintings.
*(Hammelmann, 63/4; do. Country Life, CL (2 Sep.1965),
560/1; DNB.)*

Most of the paintings exhibited by the family
appear as by 'Mr. Miller' or 'J. Miller' and they

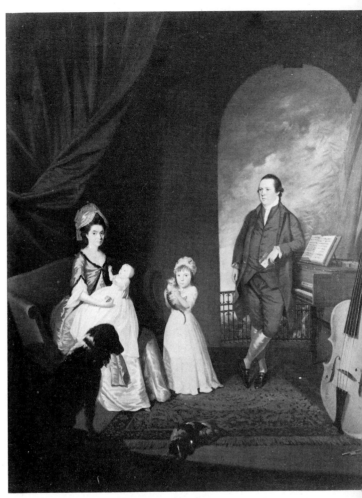

*JAMES MILLAR. 'A family group.' 49ins. x 39ins. Signed.
B.A.C. Yale.*
An opulent Birmingham family of some pretensions, with its
pets. Probably from the 1780s.

are not altogether capable of being disentangled. A
good many of those exh. SA 1762-80 and RA
1782-85, are no doubt by the father and 'A country
alehouse', SA 1770, is reproduced in *Grant*. The
father's great work was the three volume edition of
Linnaeus (1777) and the botanical paintings are
either his or the work of one of his sons — **John
Frederick,** exh. SA 1768-?80.

A second son, **James** (working 1773-91) exh. SA
1773-91; RA 1781-88 showed town or country
views of buildings near London, but these seem all
to have been in watercolours *(Mallalieu)*. A third
son, **Richard,** is only known as having been a 'por-
trait and landscape painter' who died in Calcutta
1789 *(Foster)*.

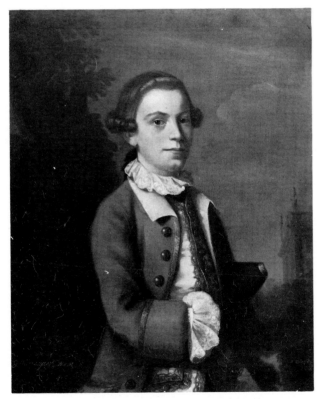

*WILLIAM MILLAR. 'G. Warrender, At 13.' 30ins. x 25ins.
Signed. Sotheby's sale 23.1.1957 (163/1).*
It is not clear who the sitter is. Painted in Edinburgh, probably
in the 1750s.

MILLER, William *c*.1740-*c*.1810
Portrait and history painter. His dates are given by
Redgrave as *c*.1740 to *c*.1810. He could have been
the 'Mr. Miller' who exh. portraits FS 1768 and a
'Battle piece', 1769, 'on the way to Rome'. He is
only recorded for certain as exh. SA 1780-83; RA
1788-1803. He did one picture for Boydell's
Shakespeare Gallery. A number of his portraits
and historical compositions are engraved.

MILLS **fl.1783**
Exh. 'A Castle on the Banks of a River', FS 1783.

MILTON, John **fl.1767-1776**
Landscape and marine and sporting painter. Exh.
FS 1767-76; SA 1773-74. Many of his exhibits
sound like exercises in the manner of Vernet. They
were sent in from a variety of addresses in Kent
and London, ending in Peckham; some were
engraved.

MINSHUL, Captain **fl.1772-1773**
Hon. exh. of two paintings SA 1772 and 1773 of
sociological content — 'A Macaroni's dressing
room' and 'A View of Greenwich Hill on Whitson
Monday'.

MITCHELL, Michael **fl.1700-1750**
Primitive Irish portrait painter; son of a Lord
Mayor of Dublin (d.1699); died Dublin 23 August
1750. He was employed on royal portraits for the
Corporation of Dublin and painted a rather severe
portrait of the foundress of the Steevens Hospital.

(Crookshank and Knight of Glin, 1978, 33.)

MITCHELL, Thomas **1735-1790**
Skilful painter of marine and naval subjects. Born
1735; held appointments in the dockyards at
Chatham and Deptford; died 18 January 1790 as
Assistant Surveyor to the Navy. An early con-
versation piece, painted in Ireland, is signed and
dated 1757. Exh. FS 1763-80; RA 1774-89.

(Archibald.)

MONAMY, Peter **1681-1749**
Painter of marine subjects. Baptised London 12
January 1680/1; died there February 1748/9.
Apprenticed to a housepainter in London in 1696
for seven years. Admitted to the livery of the
Painter-Stainers' Company 1726 with the gift of a
seapiece. He modelled his style on that of W. van
de Velde (d.1707), and specialised in the kind of

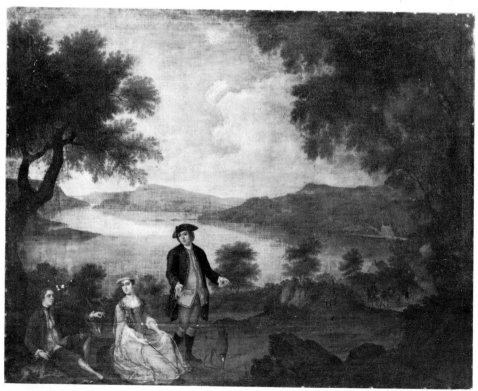

*THOMAS MITCHELL. 'Sir John and Lady Freke and a friend in Ireland.' 47¾ ins. x 60½ ins. s. & d.
1757. Sotheby's sale 9.7.1980 (36).*
A sort of Irish Devis 'conversation' by a painter who later specialised in marine painting.

PETER MONAMY. 'The landing of a royal passenger.' 29½ ins. x 45ins. Signed. Formerly the late Sir George Leon. Very much in the spirit of the younger Willem van de Velde.

marine picture van de Velde painted (especially 'calms') including naval battles. He was the best painter of sea pieces of his generation and is well represented at Greenwich.

(Archibald.)

MONARCHY fl. 1783

Exh. FS 1783 two landscapes, one 'A view of a mountain in Italy'. His improbable name might be a corruption of 'Monaci'.

MONTAGAANT fl. 1783

Exh. 'a pointer', FS 1783.

MOON fl. 1764-1787

Maritime painter from Liverpool; recorded as arriving in Rome in 1764 and leaving in 1767.

(Hayward List.)

MOORE, Charles fl. 1768-1773

Portrait and history painter. Exh. FS 1768-73; 1768-70 as 'Master Charles Moore' and only chalk or chiaroscuro drawings; thereafter portraits and classical histories and one Tahitian subject.

MORAN, John fl. c. 1764

A clearly incompetent Irish portrait painter; won a premium from the Dublin Society 1763; otherwise only known from a disastrous restoration.

(Strickland.)

MORE, Jacob c. 1740-1793

Neo-classic landscape painter of Scottish origin. Born Edinburgh c.1740; died Rome 1 October 1793. He was a pupil in Edinburgh of the Norie firm, in a landscape tradition vaguely deriving from Claude and Gaspard Poussin. He began with picturesque Scottish lowland landscapes, and had clearly looked with attention at Vernet. Exh. SA 1771 Scottish landscapes (one perhaps now at Edinburgh). Soon afterwards went via France to Rome where he was settled by 1773 and collected material for three years before he resumed painting. Exh. SA 1775-77 Campagna landscapes. He acquired a great reputation in Italy, and not only among foreign visitors, and was absurdly considered a sort of 'Scottish Claude'. He designed a *giardino Inglese* for Prince Borghese, and his peak period was in the 1780s, when he exh. RA 1783-89,

JACOB MORE. 'Classical landscape with Nessus and Dejanira.' Oval. 40ins. x 54ins. s. & d. 1786.
Christie's sale 18.11.1960 (101).
A deliberate attempt at the imitation of Claude, but rather further from the original than
contemporary admirers thought.

JACOB MORE. 'The last days of Pompeii.' 59½ins. x 79ins. s. & d. 1780. Exh. RA 1781 (15).
National Gallery of Scotland, Edinburgh (290).
Vesuvius in eruption: the whole scene is the colour of flame.

DAVID MORIER. 'William Augustus, Duke of Cumberland' (1721-65). 49ins. x 39½ins. Christie's sale 20.7.1956 (124). The Duke was Morier's chief patron. He specialised in the accurate delineation of uniforms.

and presented in 1784 a remarkable 'Self portrait' to the Uffizi collections. His 'Last days of Pompeii' was probably RA 1784 (Edinburgh). Goethe, accompanied by Angelica Kauffmann, visited him 3 July 1787 and greatly admired a huge 'Deluge' which was RA 1788. But his surfaces are rather linolear and one is baffled that Reynolds is said to have remarked that 'he was the best painter of air since Claude'.

(D. Irwin, Burlington Mag., CXIV (Nov. 1972), 775-779; Irwin, 1975.)

MORESBY, Miss **fl.1778**
Hon. exh. of a portrait in crayons, FS 1778.

MORGAN, Miss **fl.1791**
Hon. exh. of a whole length female portrait, SA 1791.

MORIER, David *c.1705-1770*
Swiss painter of military subjects. It is more likely that he was born at Berne *c.1705 (Redgrave)* than at Vevey 1736 *(Brun)*; died London January 1770. Both sources agree that he came to London *c.1743*. He was in the service of the Duke of Cumberland by 1748, for whom he painted an immense series of pictures of soldiers in the uniforms of the British

COLIN MORISON. 'Andromache offering sacrifice to Hector's shade.' 24ins. x 29½ins. c.1760. Christie's sale (at Cullen House) 22.9.1975 (571).
Morison's only known painting. It is in Gavin Hamilton's neoclassical manner, rather than that of his teacher, Mengs.

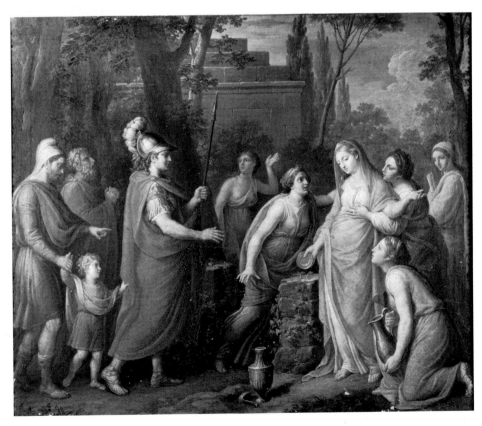

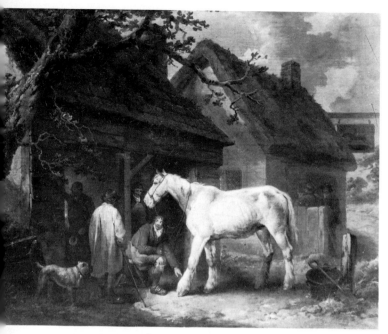

GEORGE MORLAND. 'A farrier's shop.' 28ins. x 36ins. s. & d.
1793. City of Manchester Art Galleries.
A very characteristic Morland rural scene, in an idiom
ultimately derived from Teniers.

and allied armies between 1751 and 1760 (Haswell-
Miller and Dawnay, Nos. 66-186). They are gauche
but valuably accurate in the matter of uniforms.
Morier also painted the horses in the equestrian
portraits of Richard Brompton (q.v.). Exh. SA
1760-68.

MORISON, Colin **1732-1810**
Scottish neo-classic painter and sculptor, who
ended up as an art dealer and antiquarian in
Rome. Born Deskford, Aberdeenshire, 1732; died
Rome 1810. Graduated from Kings College,
Aberdeen 1753; settled in Rome 1753 and was
working under Mengs 1758. His only known
painting is 'Andromache's sacrifice', c.1760
(formerly at Castle Grant) (B. Skinner, Burlington
Mag., XCIX (July 1957), 238). He gave up painting
and became an antiquarian 1763 (J. Fleming, Adam,
153/4). He exh. a piece of sculpture RA 1778.

MORITZ, C. **fl.1778-1783**
Exh. portraits RA 1778-83.

MORLAND, George **1762/63-1804**
Master of sentimental genre, picturesque land-
scape, and scenes from rural life. Born London —
the date usually given is 26 June 1763 but, on
entering the RA Schools 1784 as 'George Charles
Moreland' he gave his date of birth as 26 May

1762; died London 29 October 1804. Son of Henry
Robert Morland (q.v.) to whom he was
apprenticed for seven years from 1777, being kept
in durance and made to produce copies and for-
geries of Dutch landscapes — at which he became
extremely adept. He was very precocious,
naturally gifted, and naturally dissolute. His early
drawings were exh. RA 1773 ('Honorary'); FS
1775-77; SA 1777; RA 1779-80. His oils were
shown FS 1782; SA 1783 and 1790-91; RA
1781-1804. The first of the many engravings after
him was published in 1780; many of these were by
his brother-in-law, William Ward. Morland
specialised in small pictures of sentimental genre
and childhood subjects up to about 1788; his larger
rustic scenes and numerous pictures of smugglers
and wreckers only begin in the 1790s. He was per-
haps somewhat influenced by de Loutherbourg
(q.v.), but his rural scenes are mainly out of his
head and done without renewed recourse to nature.
The best of them are remarkable in execution and
wonderfully true in tone, and the total absence of
any intellectual qualities have made them always
very popular. He was endlessly copied and faked

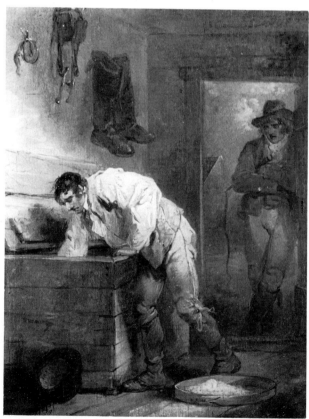

GEORGE MORLAND. 'A groom measuring grain.' 11ins. x
9½ins. s. & d. 1791. Christie's sale 12.2.1971 (48).
A good illustration of Morland's lively and spirited technique
as well as his surety of tone.

and his pictures (even genuine ones) have more often been falsely signed than those of any other painter. He also produced in his later years an enormous number of pot-boilers. He was one of the first to avoid direct patronage and commissions and to paint purely at his own sweet will. His executive talent was astonishing, and although in later life he can rarely have been sober and was usually either hiding from creditors or in prison, this can hardly be detected in his genuine pictures.

(Anecdotal literature abundant: David Thomas, cat. of the Morland exh., Arts Council, 1954; David E. Winter, Ph.D. thesis, Stanford University, 1978.)

MORLAND, George Henry

The putative father of Henry Robert Morland (q.v.). Although he appears in *DNB*, his existence has been plausibly doubted by Martin Davies *(NG cat., The British School, 1946, 101)*. There was, however, a 'Moreland' who signed a portrait of 'Lady Cottrell', *c.*1705 (formerly at Aynhoe), in a Closterman style, which suggests he may be the 'Henry Morland' who signed a 1675 group portrait in the Bruges Gallery.

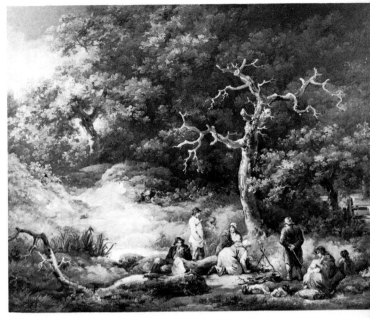

GEORGE MORLAND. *'Gypsies round a camp fire in a wooded landscape.' 19¾ins. x 26ins. Signed. Bristol City Art Gallery.*
Gypsies were favourite subject matter for Morland, and he inserted them with remarkable freshness into a wooded landscape of this sort.

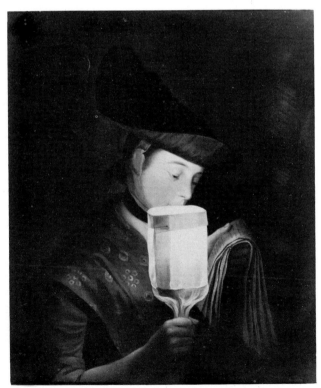

HENRY ROBERT MORLAND. *'The pretty ballad singer.' 26ins. x 22½ins. Christie's sale 17.3.1939 (47).*
Engraved by P. Dawe. Morland often repeated this composition. A version in crayons was exh. SA 1764, and one in oils FS 1768.

HENRY ROBERT MORLAND. *'A lady's maid soaping some fine linen.' 29ins. x 24½ins. Christie's sale 19.6.1970 (52).*
A much repeated design, of which versions were exh. FS 1774, 1775, 1776 and 1782. Often wildly called 'The Countess of Coventry'.

MORLAND, Henry Robert **?1719-1797**

Painter of portraits in oil and crayons and of fancy pictures; also forger, dealer and restorer. Born 1719 (he told Farington he was 76 on 15 June 1795; other dates given are 1712 and 1716); died London 30 November 1797. Father of George Morland (q.v.). He was already in serious practice by 1754 and exh. SA 1760-83; FS 1763-82; RA 1771-73, 1779, 1781, 1786 and 1792. His portraits are rather dull, but he produced a series of fancy pictures, which were popular in engravings and were much repeated in oils (especially 'laundresses' and 'children with lanthorns'), which carry on the tradition of Mercier.

(Martin Davis, NG cat., The British School, 1946, 101/2.)

MORLAND, Maria

Sister of George Morland (q.v.). She married (August 1786) the engraver William Ward. Exh. RA 1785-86 'a child hugging a Guinea-pig' and 'a girl washing', no doubt in the style of her brother.

MORPHEY, Garret **fl.1680-1715/16**

Irish Jacobite portrait painter. Died Dublin (will of 1715 proved 1716). One of the first serious portrait painters in Dublin. Working Yorkshire 1686-88 but after that in Dublin. His latest known dated work is 1707. He may well have seen portraits by Netscher in the Netherlands, but was also familiar with those of Wissing and Kneller.

(Crookshank and Knight of Glin, 1978.)

MORRIS **fl.c.1750**

A 'Landscape in the manner of Berghem' appears in the inventory c.1750 of the 1st Duchess of Northumberland, sold S, 26.3.1952, 107.

MORRIS, Mrs. **fl.1780**

Exh. a 'View of a mill in Devonshire', SA 1780, from a Chelsea address.

MORRIS, Arthur **1773-c.1794**

Portrait painter, especially of children. Born 6 May 1773. Entered RA Schools 1787. Exh. RA 1788-94.

MORRIS, Benjamin **fl.c.1742**

Probably an amateur. He painted a crayon portrait of 'Beau Nash', c.1742 (National Rheumatic Hospital, Bath).

(Kerslake, 192.)

MORRIS, Daniel **1776-after 1798**

Entered RA Schools 1794, aged 18. Exh. RA 1798 a portrait of 'Mr. Warford'.

MORRIS, Robert See MARRIS, Robert

JOHN HAMILTON MORTIMER. 'Caius Marius on the ruins of Carthage.' Wood. Very large. Exh. SA 1774 (165). Major J.W. Chandos-Pole, Radburne Hall.
A theme from Otway's *Caius Marius*. One of a pair of pictures (with the next plate) illustrating the disavowal of military heroes, rather puzzlingly commissioned for the decoration of a room by Col. Edward Sacheverell Pole.

JOHN HAMILTON MORTIMER. 'Belisarius.' Wood. Very large. Exh. SA 1772 (215). Major J.W. Chandos-Pole, Radburne Hall.
Companion to the previous plate; both show the influence of Salvator Rosa.

MORRIS, Thomas 1771-after 1794

Entered RA Schools 1788, aged 17; presumably brother of Arthur Morris (q.v.), as they both always exh. from the same address. Exh. portraits RA 1791-94.

MORTIMER, John Hamilton 1740-1779

Painter of historical and romantic literary themes, also of portraits and conversation pieces. Born Eastbourne ?17 September 1740; died London 4 February 1779. Studied briefly with Hudson c.1757, and with Pine, 1759, and at the Duke of Richmond's Academy. Won five premiums from the Society of Arts 1759-62, and prizes for oil historical paintings 1763 and 1764 — this last for 'St. Paul preaching to the Britons' (Town Hall, High Wycombe). Exh. SA 1762-77; FS 1763/4 and 1767. Elected ARA 1778. Exh. RA 1778 and 1779. He was very active in the progressive group of the Society of Artists and was elected President in 1774. His two prize-winning histories were shown at the FS but his main exhibition platform was at the Society of Arts where he showed in the main portraits and conversation pieces in a style related to Zoffany's up to 1770, when he took to specialising in romantic subjects with incantations and banditti scenes in a style derived from Salvator Rosa. In 1769 and 1770 he collaborated with Thomas Jones whose landscapes formed the background to ambitious scenes with 'Dido and Aeneas' (Hermitage, Leningrad) and the 'Death of Orpheus' (BAC Yale). A life of perhaps excessive Bohemianism was mitigated by his marriage in 1775. His major works were in the 1770s: ceiling decorations (with Wheatley and Durno) for Brocket Hall 1771/3; grand historical pictures ('Belisarius', SA 1772; and 'Marius on the ruins of Carthage', SA 1774) for Radburne Hall; and the drawings for many banditti and 'monster scenes' which appeared in etchings in 1778. He was just getting into his stride, after becoming ARA in 1778, when he suddenly died and a group of pictures was shown posthumously RA 1779. His best conversation piece was the 'Drake family', RA 1778 (ex. Shardeloes), and he was moving into medieval subjects at the time of his death. Etchings from Shakespearean characters and other poetical illustrations also date from the mid-1770s onwards. Mortimer had greater promise as a romantic artist than any other painter of his generation.

(B. Nicolson, cat. of Mortimer exh., 1968; John Sunderland, work in progress.)

JOHN HAMILTON MORTIMER. 'Sergeant-at-Arms Nicholas Bonfoy (d.1775) and his Deputy, John Clementson.' 40ins. x 50ins. B.A.C. Yale.
Painted in the earlier 1770s. A third figure of Bonfoy's son, has now reappeared at the left, but the picture was probably planned without him.

JOHN HAMILTON MORTIMER. 'A bandit taking up his post.' 14ins. x 10¼ ins. Signed in monogram. Courtesy of the Detroit Institute of Arts.
Banditti (derived from Salvator Rosa) were a favourite theme with Mortimer. Middle or later 1780s.

WILLIAM MOSMAN. 'Thomas, 9th Earl of Cassilis.' 95ins. x 58ins. s. & d. 1746. Culzean Castle (National Trust for Scotland). Painted when Sir Thomas Kennedy, 4th Bart. of Culzean. Mosman still shows evidence of his Roman training, but he is less smart than comparable early Ramsay full lengths are.

JEAN-LAURENT MOSNIER. 'George, 7th Marquess of Tweeddale.' 95ins. x 57ins. s. & d. 1794. Private collection. During his six years in Britain, Mosnier painted portraits in an acceptable British tradition, with only slight traces of his French training.

MORTIMER, Roger **1700-1769**
Itinerant painter of religious histories and portraits in East Sussex; uncle of John Hamilton Mortimer (q.v.). Indifferent paintings in churches at Hastings and Aylesbury are known.

(E.C-M.)

MORTON, J. **fl.1791-1807**
Exh. fitfully at RA 1791-1807, mainly landscapes, but he sometimes lapsed into flowers. It is not certain that the landscapes were in oil.

MOSER, Mary **1744-1819**
Essentially a flower painter, but occasionally deviated into history and portrait. Born London 27 October 1744 *(Brun);* died there 2 May 1819. Daughter of the medallist George Michael Moser (1704-83), the first Keeper of the Royal Academy. She was very precocious and won a premium and special silver medal 1759 from the Society of Arts. Exh. SA 1760-68 flower pictures in watercolours. Foundation RA 1769. Exh. RA 1769-92 and, after her marriage in 1793, as Mrs. Hugh Lloyd, 1797-98, 1800, 1802, latterly as hon. exh. of history pictures. Her major work was a whole room of flower pictures for Queen Charlotte *c.*1795 at Frogmore, which survives.

(J.T. Smith, Nollekens and his times; E.C-M.)

MOSMAN, William **fl.1731-1771**
Scottish portrait painter. Possibly a native of Aberdeen; died near Aberdeen 26 November 1771. Possibly studied briefly with Aikman in London, but in Rome *c.*1732-38, where he studied under Francesco Imperiali. He returned from Rome shortly before Ramsay did, but with a much less sophisticated manner. Although said to have worked in Edinburgh for a time, he had settled in Aberdeen by the early 1750s, and his chief clients even in 1738/41 were from the North East (several portraits at Kinnaird Castle). By 1749 his portraits were more a Scottish version of Hudson. Later portraits are rare, although Mosman ran a Drawing School at Aberdeen in the 1760s.

MOSNIER, Jean-Laurent **1743-1808**
French portraitist and miniature painter. Born ?Paris 1743; died St. Petersburg 10 April 1808. Successful miniaturst and portrait painter in the manner of Mme. Vigée-Lebrun. *Agréé* at the Paris

GEORGE MULLINS. 'Pastoral landscape.' 40ins. x 50ins. s. & d. 1773. Christie's sale 20.12.1950 (142).
An extremely mixed style of landscape: some traces of Gaspard Poussin, but also some anticipations of Ward.

251

Académie 1786 and full member 1788. One of the first *émigré* painters to come to London at the time of the Revolution (1790). Exh. RA 1791-96. His English portraits are like slightly Frenchified Hoppners, 'Lady Callander and son', RA 1796, being the most ambitious, and he had good business. He prospered equally at Hamburg, and at St. Petersburg 1797-1801, where he became a court painter to the Tsar and Professor at the Academy.

(G. Marlier.)

MOWSON, J. fl.1797-1808
Exh. pictures of romantic literary themes fitfully at RA between 1797 and 1808.

MOY fl.1690-1740
Dutch landscape painter who came to England in the time of William III and eventually settled in Ireland. Died in Dublin between 1740 and 1750.

(Strickland.)

MUDGE fl.1783
'Mr. Mudge, Chelsea' exh. a landscape FS 1783.

MÜLLER, John Sebastian See MILLER family

MULLER, Robert 1773-*c*.1800
Portrait painter. Born 13 July 1773. Entered RA Schools 1788. Exh. RA 1789-1800, portraits (three of the royal family). Some portraits are engraved.

MULLINS, George fl.1756-1775
Accomplished Irish landscape painter. Pupil of James Mannin in Dublin *c*.1756. Probably died London 1775. Exh. in Dublin 1765-69, when his major commission was four Wilsonesque landscapes for Lord Charlemont, 1768 (Dublin Gallery). To London 1770. Exh. RA 1770-75. He painted decorative ceiling paintings for Chirk Castle 1773, and a slightly Vernetesque landscape (1772) is at Oxford.

(E. C-M; Crookshank and Knight of Glin, 1978.)

MUMFORD, Henry fl.1707-1712
Painter at Norwich (having previously been in London and Holland), willing to undertake any sort of painting, as advertised 1707-12.

(Fawcett, 71/2.)

MUNN, James fl.1774
Exh. SA 1774 'A dandelion; in oil'. A 'Mr. Munn' also exh. FS 1764 a portrait and a landscape — and drawings elsewhere. He may have been father to the watercolour painter, Paul Sandby Munn (1773-1845) for whom see *Mallalieu*.

MUNTZ, Johann Heinrich 1737-1798
All-purpose artist of Swiss origin and rather slender executive powers. Born Mulhouse 1737; died Kassel 1798. An engineer in the French army till 1748. Found in Jersey 1755 by Richard Bentley and sent as a tame artist to Horace Walpole, who employed him on some decoration at Strawberry Hill and encouraged John Chute to employ him at The Vyne. His extant topographical works at The Vyne are either trivial or copies or pastiches of Teniers, Gaspard and Paul Brill. Walpole sacked him in 1759. He made experiments in encaustic painting 1759/60, one of which he exh. SA 1762. He was later active in Italy and Poland.

(E. C-M.)

MURPHY See MORPHEY, G.

MURPHY, Miss fl.1783
Exh. 'Venus and Cupid', FS 1783.

MURRAY, David fl.1733
A sort of Scottish Wootton. A picture of 'The Caledonian Hunt', signed and dated 1733, is at The Binns.

MURRAY, R. fl.1763-1770
Painter of portraits in oil and miniature. Exh. SA 1763; FS 1765-70. Redgrave records an engraving after a picture 'The Enchantress'.

MURRAY, Thomas 1663-1735
Portraitist. Born 1663, probably in Scotland; died London 1 June 1735 (in *Gentleman's Mag.* falsely as 'John'). Pupil of Riley; his better portraits (mostly of before 1700) are very like those of Closterman: a good many were engraved *(Chaloner-Smith)*. He used drapery painters and assistants abundantly and latterly had a very good practice among the clergy, professions, and in academic circles, and prospered exceedingly — but did not deserve to.

MURRAY, W. fl.1792
Signed a small portrait, in the manner of Opie, of 'S. Herrick', 1792 (sold 22.10.1948, 148).

THOMAS MURRAY. 'Unknown gentleman.' 47ins. x 37ins.
s. & d. 1714. Christie's sale 9.4.1954 (44).
Slightly smoother in style than the contemporary portraits by
Kneller.

THOMAS MURRAY. Called 'Henrietta d'Auverquerque' (Countess
of Grantham), d.1724. 87ins. x 51ins. Signed. Christie's sale
16.10.1953 (99).
From Panshanger. Probably not far from 1700.

W. MURRAY. 'S. Herrick' (b.1771). 24ins. x 19ins. Signed (or
inscribed) '1792'. Christie's sale 22.10.1948 (148).
This painter is not otherwise known.

N

NAISH, John **1771-after 1791**

Miniaturist and sporting painter. Entered RA Schools 1791, aged 20. Exh. RA 1790-95 (miniatures). A picture of a spaniel, signed and dated (?1791) on back sold S, 21.11.1979, 23.

NASMYTH, Alexander **1758-1840**

Painter at first of conversation groups; later almost wholly of landscapes. Born Edinburgh 9 September 1758; died there 10 April 1840. Studied at Trustees Academy, Edinburgh, and was assistant to Ramsay in London (who was then doing little painting) from 1774 until he settled in Edinburgh as a portrait painter 1778. To Italy 1782 and in Rome 1783-85, where he first became interested in landscape. In Edinburgh from 1785, at first specialising in conversation groups. Friendship with Burns and a taste for the picturesque led him increasingly to landscape painting, and, by the mid-1790s, when he had started a drawing school, he painted only landscapes. He was one of the chief founders of the Scottish picturesque landscape school — though he also kept an eye on Claude. He had a great many children, all of whom helped in the family's paintings, which, in the later years of Alexander's life, became rather a depressing factory. Exh. RA 1813-26.

(Peter Johnson and Ernle Money, The Nasmyth family of Painters, 1977.)

NAYLOR, T. **fl.1788**

Exh. two shipping pictures, RA 1788.

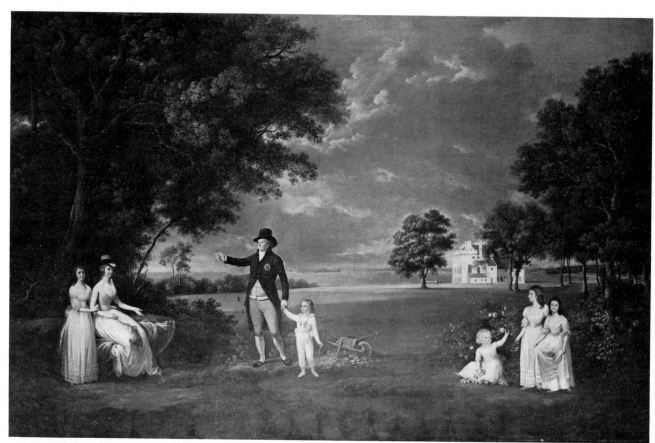

ALEXANDER NASMYTH. 'The 3rd Earl of Rosebery and his family.' 60ins. x 86ins. c.1786. Earl of Rosebery. Dalmeny House, South Queensferry.
In the tradition of David Allan, but a little more sophisticated.

NEBOT, Balthasar fl.1730-after 1765
Painter of urban genre and topographical landscape; of Spanish origin. Married in London 1729/30. He specialised at first in London topographical scenes and fish stalls in the manner of Angillis. In the 1760s (? as late as 1770) he was painting topographical views in Yorkshire; seven of the Park at Studley Royal and of Fountains Abbey were at Fountains Hall.

(Grant, i and iii; Collins Baker, Connoisseur, LXXV (May 1926), 3-6.)

NEEDHAM, E. fl.1786-c.1798
Portrait painter. Exh. RA 1786, 1788 and 1790 (from a Chesterfield address). There is a J.R. Smith mezzotint of 1798 after a portrait of 'Col. Athorpe' from a Sheffield family.

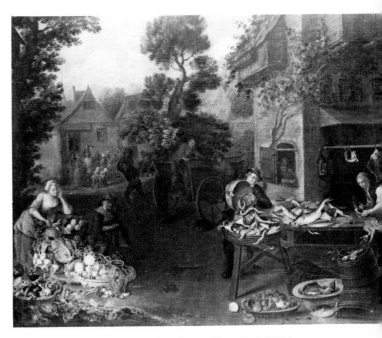

BALTHASAR NEBOT. 'Fish and vegetable stalls.' 21½ ins. x 26½ ins. s. & d. 1735. Christie's sale 25.10.1957 (41).
Nebot in this phase is hardly to be distinguished from Pieter Angillis.

BALTHASAR NEBOT. 'The River Skell at Studley Royal.' 29¼ ins. x 43½ ins. s. & d. 1762. Christie's sale 11.4.1980.
One of a group of topographical views painted of the scenery round Studley Royal. This is the only one to be signed.

A. NELSON. 'A view of Dover Castle.' 22ins. x 42ins. Signed. Christie's sale 3.5.1946 (27/1).
This could have been 'A view near Dover' exh. SA 1767 (112), but Nelson repeated the subject a number of times.

NELSON, A. fl.1765-1773
Landscape painter of Kentish scenes. His name is in the 1765 and 1773 lists of the SA. Exh. SA 1766-71 landscapes mostly of Canterbury and Dover areas. He is a pleasant artist who one might guess was a pupil of G. Lambert.

(Grant, iii.)

NELSON, A. fl.1790
Exh. RA 1790 two views in the Windward Islands.

NEVAY, James fl.1755-1796
Scottish history painter and professional copyist in Rome. Native of Edinburgh; in Rome 1755 and still there 1796 *(Farington Diary, 25 Feb., 1796)*. He was receiving instruction from Mengs 1758 and completed one history picture, 'Agrippina with the ashes of Germanicus', 1769, exh. SA 1773. He settled down as one of the entrenched copyists in Rome working for British visitors, and also did some teaching. His copies are deplorable. Exh. drawings (copies) SA 1790-91; RA 1773.

NEWMAN, F. fl.1793
Exh. 'Ruins' and 'Roses, from nature', RA 1793.

NEWTON, Francis Milner 1720-1794
Portrait painter. Born London 1720; died near Taunton 7 August 1794. Pupil of Tuscher (q.v.) and active at St. Martin's Lane Academy. He was the sort of person who becomes a committee secretary, and was so in 1755 to schemes for an Academy; in 1765 to the Incorporated Society of Artists. RA 1768 and its first secretary 1768-88. Exh. portraits SA 1760-68; RA 1769-74, but they seem to have been completely undistinguished.

(Edwards.)

NEWTON, W. fl.1783-1784
Exh. pictures of fruit, RA 1783-84.

NICHOLAS, P. fl.1783-1788
Hon. exh. of marine subjects and topographical views at RA between 1783 and 1788.

NICHOLLS, Joseph fl.1730s
Illustrator and painter of topographical views in the manner of Samuel Scott. Some of his views of the City of London were engraved 1738. For his illustrations see *Hammelmann*. There is confusion over Twickenham views said to be signed and dated 1726, but probably painted after 1755.

(BAC cat., Country Houses in Great Britain, 1979, 38ff.)

NICHOLSON, Francis 1753-1844

Yorkshire landscape painter, primarily in water-colours. Born Pickering 14 November 1753; died London 6 March 1844. He painted landscapes in oils, also horses and still-life when living at Whitby 1783-92, where he first took up watercolours. Exh. RA 1789-1804; SA 1791. By 1804 he was settled in London and very active in watercolour politics. At the end of his life he also made unwise technical experiments with oils. His Yorkshire oil landscapes are much in a watercolour tradition.

(Mallalieu.)

NICKOLLS See NICHOLLS, Joseph

NINHAM, W. fl.1797

Exh. a portrait RA 1797.

NISBET, J. fl.1769

A local Banff portrait painter. In 1769 he signed some copies after Ramsay of portraits of the Earl of Fife and his wife (sale, 19.6.1942, 8). A 'Nisbet' also exh. two landscapes as hon. exh. SA 1763.

NISTRI See TONELLI, Anna

NIXON, James *c.*1741/42-1812

Miniaturist and very occasional painter of portraits and subjects in oil. Born *c.*1741/2; died Tiverton 9 May 1812. Exh. SA 1765-71. Entered RA Schools 1769. Exh. RA 1772-1807. ARA 1778 and 'Limner to the Prince of Wales' 1801. Worked mainly in London but was in Edinburgh 1795-98.

(Long.)

NIXON, John fl.1781-1818

A merchant by profession and an amateur painter and good caricaturist. Died Ryde, Isle of Wight 1818. Hon. exh. RA 1781-1813. Most of his work is in watercolour and in a vein recalling Rowlandson.

(Mallalieu.)

NIXON, Rev. Robert 1750-1837

Amateur landscape painter; brother of the last. Hon. exh. of drawings SA 1790-91; RA 1792-1808, from Foots Cray, where he was curate 1784-1804. He was one of the first to recognise Turner's gifts and to befriend him.

(DNB; Mallalieu.)

NOBLET, Madame du See VILLEBRUNE, Mary de

JOSEPH FRANCIS NOLLEKENS. 'A musical party.' Copper. 18¾ins. x 24¾ins. Signed. Sotheby's sale 28.11.1973 (38).
Nollekens liked to paint musical parties of this sort, often in fanciful settings of extravagant grandiosity.

NODDER, Richard Polydore fl.1793-1820

Painter of sporting pictures and objects of natural history, which he exh. RA 1793-1820. Son of Frederick Polydore Nodder, Botanic Painter to Queen Charlotte, whose engraved publications he completed.

(Mallalieu.)

NOLLEKENS, Joseph Francis 1702-1747/48

Painter of conversations and galant and childish genre. Christened Corneille François. Born Antwerp 10 June 1702; died London 21 January 1747/8. Usually known as 'Old Nollekens' since he was the father of the sculptor Joseph Nollekens, but he was in fact son and pupil of another painter, J.B. Nollekens. His son told Farington *(Diary, 29 Jan. 1803)* he had been a pupil of Watteau and he certainly specialised in England in imitations of the work of Watteau and Pater (especially genre scenes in which children are involved). He is said to have come to England in 1733 and worked with Pieter Tillemans (q.v.). His great patron was Lord Tilney, at whose sale at Wanstead House his chief works appeared, 8th day, 19.6.1822 *(Smith's 'Nollekens', ii, 41).* His *scènes galantes* are curiously clumsy imitations of his French models.

(E.C-M.)

NORIE, James, Sr. 1684-1757

Founder of a firm of Edinburgh landscape painters and decorators. Said to have been born in Morayshire (though of an Edinburgh family) 1684; died Edinburgh 11 June 1757. He and his son, **James, Jr.** (1711-36), both signed the founding document of the Edinburgh School of St. Luke, 1729. Two of his easel pictures of 1736 are in the Edinburgh Gallery. His decorative style derives from Gaspard Poussin and Salvator Rosa. A second son, **Robert** (d.1766) was the father of succeeding generations and the firm survived until 1850 and did a good deal of decorative work in Edinburgh houses.

(E.C-M.; Irwin, 1975.)

NORTH, Anne, Lady 1740-1797

Amateur portrait painter. She was Anne Speke, married (1756) the Prime Minister, Frederick, Lord North (later 2nd Earl of Guildford). She signed 'A. North/1779' a life-size full length of her daughter, who became Lady Glenbervie, very much in the manner of M.W. Peters, sale S, 18.3.1964, 88.

ANNE, Lady NORTH. 'Lady Glenbervie.' 88½ ins. x 58ins. Signed 'A.North/1779'. Sotheby's sale 18.3.1964 (88).
Evidence of the remarkable competence of certain aristocratic amateur painters. Lady North was the wife of the Prime Minister and the sitter was her daughter, whose husband was made Lord Glenbervie 1800. One wonders if she was a pupil of M.W. Peters.

NORTHCOTE, James 1746-1831

Painter of portraits, histories, fancy pictures, and animal pictures in the vein of Snyders. Born Plymouth 22 October 1746; died London 13 July 1831. After diligent self-training while apprenticed to a trade, he came to London 1771, entered the RA Schools and became pupil and resident assistant to Reynolds from 1771 to 1775. Exh RA 1773-76 a few portraits and practised portraiture at Plymouth until he had made enough money to go

to Italy in 1777. In Rome 1777-80 (and was asked to give a 'Self portrait' to the Uffizi collection). He settled for good in London 1781 and turned out a steady stream of portraits and, from 1783, fancy pictures. His grandiose history pictures, many for Boydell's Shakespeare Gallery — which were his pride — begin 1786. ARA 1786; RA 1787. Exh. RA 1773-1828; BI 1806-31. His work is very fully documented from his own list of his paintings (S. Gwynne, Memorials of an Eighteenth Century Painter, 1898), and a surprising number of his history pictures and fancy subjects were engraved. Northcote was more interesting as a personality than as a painter, he was highly intelligent, but his drawing, sense of tone and use of paint, are all rather unsatisfactory, and his historical pictures often turgid — with quotations from Antiquity or Italian models made in Reynolds' spirit, but without his taste. Some of his portraits (e.g. of his brother) are not undistinguished. He wrote a valuable *Life of Sir Joshua Reynolds*, 1813, and his conversations with Hazlitt and James Ward have been published (1894 and 1901). Most categories of his work can be seen in the Exeter Gallery.

NORTHCOTT, Nathaniel fl.1704

Presumably an ancestor of James Northcote (q.v.). He was paid in 1704 for a portrait of 'Queen Anne', which was formerly in Plymouth Guildhall.

JAMES NORTHCOTE. 'A lady as St. Cecilia.' 47ins. x 39ins. s. & d. 1777. Christie's sale 11.7.1958 (29).
One of the portraits Northcote painted at Plymouth after five years in Reynolds' studio and just before leaving for Italy.

JAMES NORTHCOTE. 'The modest girl and wanton fellow-servant in a gentleman's house, 1794.' 28ins. x 35ins. Exh. RA 1796 (228). Christie's sale 28.2.1930 (147).
See the next plate for a companion. There were four pictures in all in the series.

JAMES NORTHCOTE. 'The modest girl receives the honourable addresses of her Master, 1794.' 28ins. x 35ins. Exh. RA 1796 (240). Christie's sale 28.2.1930 (147).
The previous plate and two more formed a series telling a 'moral tale' after the manner of Hogarth.

259

JAMES NORTHCOTE. *'Beggar boy with a monkey &c.' 61ins. x 49ins. Painted 1784. Christie's sale 5.6.1953 (96).* Engraved by W. Ward. Possibly exh. RA 1785 (142) as 'The charity'. This kind of upper-class social genre became popular in the late 1780s.

JAMES NORTHCOTE. 'Death of John of Gaunt, from Richard II, act ii, scene i.' 66ins. x 53ins. Painted 1793. Christie's sale 10.12.1954 (33).
Painted for Woodmason's Shakespeare, which was a rival to Boydell's Shakespeare Gallery.

NORTON, Christopher fl.1760-1799

Copyist and engraver. Studied at St. Martin's Lane Academy and won a premium from the Society of Arts 1760; died 1799. He lived mostly in Rome, where he was a partner of James Byres (q.v.). Known only as a copyist and engraver, but Dance's portrait of him (Aberdeen) shows him as a painter. A 'Norton' exh. a Seapiece, SA 1760.

(Apollo, XCIX (June 1974), 461, 37.)

NUNE See DENUNE

NURSEY, Perry fl.1799-1801

Painter of romantic landscapes. Exh. RA 1799 and 1801 *(rep. in Grant, iii)*. For a tribe of amateur Nursey painters see *Mallalieu*.

O

OATES, Mark *c.*1750-after 1821

Cornish amateur painter, who entered the Navy; schoolfellow of Opie (q.v.). He painted an altar-piece formerly in Falmouth Parish Church. Hon. exh. of portraits RA 1789 (as 'Lieut. Oates') and 1821 (as 'Capt. Oates').

(A. Earland, Opie, 1911, 4.)

O'BRIEN fl.1778

Graves says an O'Brien, from a Dublin address, exh. 'Venus soliciting Vulcan to make armour for her son', FS 1778, but it is not in most copies of the catalogue. He can hardly have been the same as the Irish watercolour landscape painter, James George O'Brien (fl.1779-1819), who changed his name in London to Oben *(Mallalieu)*.

O'FAGEN fl.1778

Exh. FS 1778 two landscapes 'in the style of Salvator Rosa' and a picture of Sancho Panza.

OGIER, Peter 1769-after 1800

Painter of portraits and miniatures. Entered RA Schools as an engraver 1789, aged 20. Exh. portraits RA 1793 and 1796 (one miniature) and hon. exh. 1800 (miniature).

OLIVE, T. fl.1772-1773

Exh. three portraits (one 'a small life') and a 'conversation', SA 1772-73. There is an etching after his portrait of 'Thomas Eldridge' of *c.*1780 *(O'Donoghue).*

OLIVER, Archer James 1774-1842

Fashionable portrait painter up to *c.*1820, when his health and practice failed. Born 1774; died London 1842. Entered RA Schools 1790 and exh. abundantly 1791-1841; BI 1809-41. His later exhibited works were mainly small still-life pictures and sketches for histories. ARA 1807. Briefly Curator of Painting at RA Schools (1835), he latterly lived largely on RA charity. Another 'Oliver' exh. a portrait RA 1791.

OL(L)IVIER, Michel-Barthélemy 1712-1784

French painter of conversations and history. Born Marseilles 1712; died Paris 1784. *Agréé* at French Academy 1766. He visited London and exh. RA 1772 (two histories, previously shown at Salons, and four pictures of an English, French, Scots and Spanish family in conversation, but this bid for patronage did not succeed); SA 1773. He is quite a neat painter.

O'NEAL, Jeffrey Hamet fl.1763-1772

Irish painter, mainly of miniatures, which he exh. SA 1763-72. He is said by Redgrave also to have painted 'birds, flowers, and small conversations.'

OPIE, John 1761-1807

Portrait and history painter. Born St. Agnes, Cornwall, May 1761; died London 9 April 1807. The son of a carpenter, he had a powerful passion for art and was discovered by William Wolcot who trained him in the art of realistic portraiture and

JOHN OPIE. 'George William, Marquess of Lorne.' 50ins. x 40ins. c.1784. Duke of Argyll, Inveraray Castle.
The sitter was later 6th Duke of Argyll. One of four companion portraits by Opie of the children of the 5th Duke.

encouraged him to paint naturalistic heads of rustic types in a manner suggestive of Spagnoletto. His early Cornish portraits *c.*1775-80 have unaffected virtues of a high order *(Connoisseur, Oct. 1934, 245-251)*. 'A boy's head', exh. SA 1780, as 'having never seen a picture' caused something of a sensation. Wolcot brought him to London 1781 and released him on the world as 'the Cornish Wonder'. Exh. RA 1782-1807. ARA 1787; RA 1788. Professor of Painting at RA 1805. He had almost instant success and had an abundance of portrait commissions for the rest of his life, though he had none of the graces of a society painter. His best portraits of the 1780s, where flattery was not called for and the sitter had character, are his finest, and he was also excellent with children (e.g. those at Inveraray). His first subject picture with several figures — 'A School', RA 1784 (Loyd coll.) — is a landmark and provoked the comment: "could people in vulgar life afford to pay for pictures, Opie would be their man." But Opie had a lively intelligence and moved on to more grandiose histories — 'the Assassination of James I of Scotland', RA 1786, and 'Assassination of Rizzio', RA 1787, both bought by Boydell and given to the Guildhall (now destroyed) — which made his reputation and won him election to the Academy. His pictures of this character were the most distinguished of their day, better contrived and less turgid than Northcote's and less bizarre than Fuseli's. He painted three for Macklin's Poets Gallery, four for Macklin's Bible, seven for Boydell's Shakespeare Gallery and eleven for Bowyer's Historic Gallery as well as a number of novelettish subject pieces; he also turned out a very large number of portraits. His posthumously published *Lectures on Painting* are also of interest. He lacked the graces, but was one of the ablest English painters of his time.

(Ada Earland. J.O. and his circle, 1911, with cat.)

ORAM, Edward fl.1766-1799
Landscape and scene painter; son of William Oram (q.v.). Assistant in management and scenery to de Loutherbourg (q.v.) at Drury Lane. Painted small woodland landscapes in a Wynantsy manner. Exh. SA 1766; RA 1775-99.

(Grant.)

ORAM, William fl.1745-1777
Landscape and decorative painter. Will proved London 17 March 1777. Father of Edward Oram (q.v.) and known as 'Old Oram'. Trained as an architect, but early took to landscape in a style possibly derived from Wootton. His landscapes are now only known from engravings. Master Carpenter at the Office of Works 1748-77.

(Colvin.)

ORME, Daniel 1767-after 1832
Miniaturist and engraver; occasional painter of oil portraits. Born Manchester 25 August 1767; died Buxton after 1832. Studied engraving at RA Schools 1785. Exh. portraits and miniatures RA 1797-1801, but his chief activity was as an engraver, often of his own portraits. Worked at London until 1814, when he returned to Manchester.

(Long.)

ORME, William fl.1797-1819
Landscape painter and drawing master; brother of Daniel Orme (q.v.). Born Manchester. Exh. RA 1797-1819.

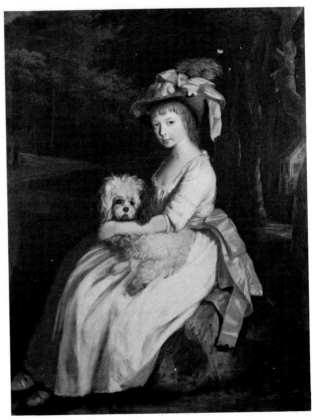

JOHN OPIE. 'Lady Charlotte Campbell.' 50ins. x 40ins. c.1784. Duke of Argyll, Inveraray Castle.
Companion to previous plate. This series is the most attractive of Opie's portraits of children.

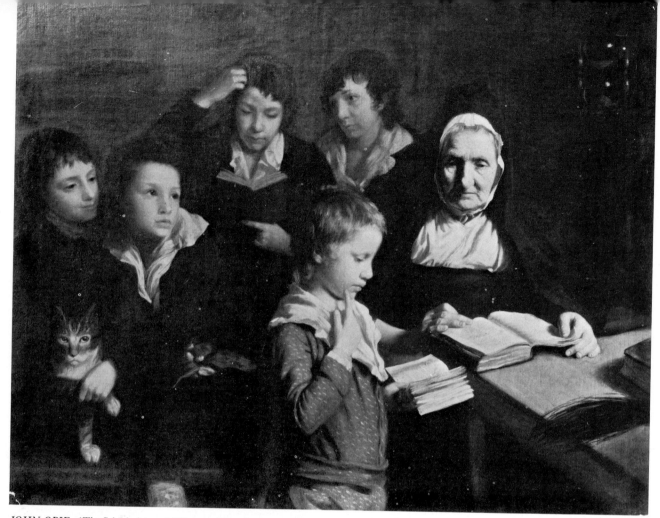

JOHN OPIE. 'The Schoolmistress.' 39ins. x 49ins. Exh RA 1784 (162) as 'A School'. In the Loyd collection.
One of the earliest examples of rural subject matter treated seriously.

OTTLEY, William Young 1771-1836

Amateur painter, collector, and writer on art. Born nr. Thatcham 6 August 1771; died London 26 May 1836. Pupil of the elder Cuitt (q.v.), studied at RA Schools 1788. He was in Italy 1791-1801, studying and collecting, where he formed one of the most important collections of early Italian paintings *(Italian Studies presented to E.R. Vincent, 1962, 272).* His writings on art begin 1805. Hon. exh. RA 1823 (a study in chiaroscuro). Keeper of Prints and Drawings at British Museum, 1833.

(DNB.)

OUGHT, William 1753-1778

Portraitist in oil and crayons. Born 5 November 1753; entered RA Schools 1771. In 1768/9 he is called 'pupil of (Daniel) Dodd'. Exh. FS 1768-78.

OWEN, Samuel 1768/69-1857

Painter of marine subjects, mainly in watercolour. Born 1768/9; died Sunbury on Thames 8 December 1857. Exh. occasionally RA 1794-1802, apparently oil paintings. He continued to paint in watercolour up to at least 1810, but soon abandoned painting.

(Mallalieu.)

OWEN, William 1769-1825

Painter of portraits and sentimental rustic subjects. Born Ludlow 1769; died London 11 February 1825. He came to London 1786 and was apprenticed to Catton (the RA coach painter) for seven years *(Farington Diary, 3 July 1802),* but developed a taste for figure painting and entered the RA Schools 1791. Exh. RA 1792-1824. ARA 1804; RA 1806. Portrait painter to the Prince of Wales 1810 (on the death of Hoppner); 'Principal Painter to the Prince Regent' 1813, but by then he had a distinguished list of sitters, and was the best interpreter of the soberer side of the Regency, lacking entirely Lawrence's flashy brilliance. He was at his best with elderly sitters. He was seriously crippled after 1820 and unable to do much work. A number of his rustic subjects made popular engravings.

P

PACK, Faithful Christopher *c.*1759-1840
Bad painter of portraits (in oil, crayons and
miniature) and landscapes. Born at Norwich, of a
Quaker family; died London 25 October 1840.
Worked for about a year with Reynolds *c.*1782 as a
copyist; then at Liverpool 1783-86. Worked,
taught and exhibited at Dublin *c.*1787-96, then
Bath, then Dublin again 1802-21, when he settled
in London; latterly a chiropodist. Exh. RA
1786-87, 1796, 1822 and 1840 (a 'Self portrait'
painted in 1787!); BI 1825-39, landscapes in oil
and watercolours.

(Long; Mallalieu.)

PAERT See PEART

PAGE, Thomas fl.1720
A Thomas Page Jr. of Beccles, Suffolk, published
at Norwich 1720 *The Art of Painting* which reports
that he had studied 'in his junior days, some years
ago' in Kneller's Academy in London. In 1737 a
'Rev. Thomas Page' was Rector of Beccles.

(Talley, Bardwell.)

PAILLOU, Peter, Sr. fl.*c.*1744-*c.*1780
Specialist in bird painting. Exh. FS 1763; SA 1778.
He worked for many years for Thomas Pennant. A
pair of signed pictures of 1774, in a style deriving
ultimately from Oudry, was sold 23.3.1979, 8.

(Foskett.)

PAILLOU, Peter, Jr. 1757-after 1831
Mainly a miniaturist but also painted small-scale
portraits in oil. Born 1 December 1757; pre-
sumably son of last. Entered RA Schools 1784.
Exh. RA 1786-1800. Later in Scotland; in Glasgow
1820.

(Foskett.)

PALMER, William 1763-1790
Portrait painter in oil and crayons. Born Limerick
18 November 1763; died Bruff, near Limerick 26
July 1790. Studied in Dublin 1781. Entered RA
Schools 1783, and was a pupil of Reynolds. Exh.
RA 1784-88, when he returned to Limerick. His
portrait of 'Amos Cottle', 1787 (NPG) has lively
character and an engraved subject piece 'Louisa',
1788, suggests he had looked at Wheatley.

*(Strickland; C.K. Adams, Connoisseur, LXXXVIII (July
1931), 3-5.)*

PARKE, Benjamin fl.1794-1807
Landscape painter. Occasionally exh. views of
named places RA 1794-1807.

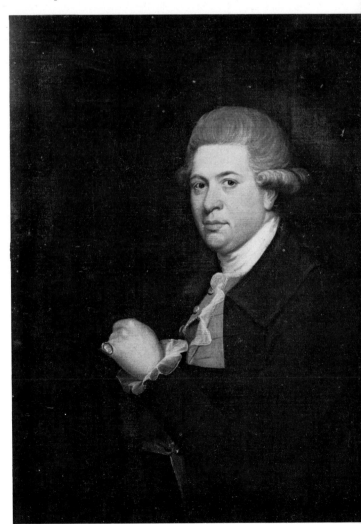

THOMAS PARKINSON. *'Joseph Dymond of Blythe.'* 35½ ins. x
27ins. s. & d. 1781. Christie's sale 4.6.1943 (136).
Perhaps a provincial version of Romney's style.

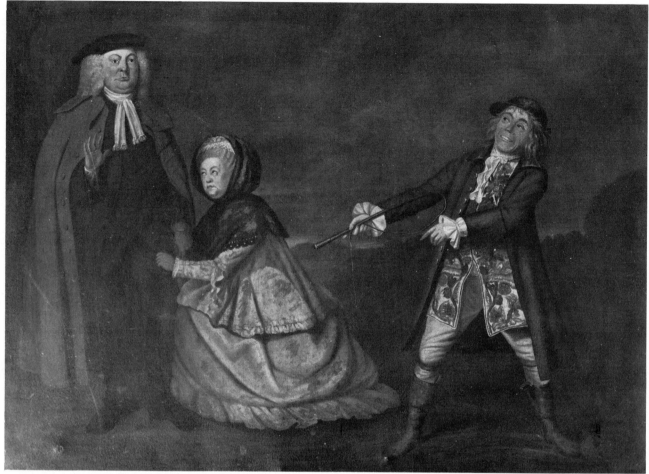

THOMAS PARKINSON. 'Shuter with Quick and Mrs. Green in She Stoops to Conquer, *act v, scene i.' 30½ins. x 40½ins. Engraved in mezzotint by Laurie, 1776. Sotheby's sale 15.7.1964 (91).*
Alleged to be RA 1774 (356), but not in early copies of the catalogue. Parkinson also showed theatre scenes in 1775 and 1776.

PARKER, John *c.*1730-*c.*1765
Pretentious history painter with neo-classical leanings. Born *c.*1730 *(Redgrave)*; died London *c.*1765. Pupil of Benefial in Rome, where he painted an altarpiece in S. Gregorio al Celio *c.*1749, and 'Director', 1752, of the abortive British Academy in Rome founded by his patron Lord Charlemont. Accademico di S. Luca, Rome, 1756. Produced enormous history paintings 1755-58 *(List in Hist. MSS. Commission Charlemont Papers I, 1891).* He returned to London 1762 and exh. FS 1763, his 'Self portrait' and 'The Assassination of Rizzio'. His histories are mercifully unknown.

PARKER, John fl.1762-1777
Landscape painter. Won premiums for drawing from SA 1762/3. Exh. birds and still-life in crayons FS 1762-64. In 1765 became a pupil of Smith of Chichester (q.v.) and painted landscapes in his manner until he went to Rome in 1772. Exh. FS

1765-73; RA 1770-71 and 1776 (landscapes with classicial figures). A J. Parker who exh. a portrait RA 1785 was presumably another artist.
(Grant.)

PARKER, W. fl.*c.*1730
A life-size full length of 'Sir James Reynolds' (died 1739), as Lord Chief Baron of the Exchequer, by W. Parker, was given to the Guildhall, Bury St. Edmunds in 1796. It is a competent work in the style of Dahl (q.v.).

PARKINSON, Thomas 1744-*c.*1789
Painter of portraits in oil and crayons and of occasional theatrical groups. Born ?Oxford 10 December 1744. Entered RA Schools 1772. Exh. FS 1769-70 (mostly crayons); SA 1772-73; RA 1774-89. His figures tend to be rather wooden. An engraved 'Scene from *She stoops to conquer,*' RA 1774, was sold S, 15.7.1964, 91.

PARMENTIER, Jacques 1658-1730

French-born historical and decorative painter; also painted altarpieces and portraits. Born ?Paris 1658; died London 2 December 1730. Trained under Lafosse. First in England 1676/7, where he assisted a variety of decorative historical painters up to 1700, with an interruption in 1698, when he was a member of the Guild at The Hague. He was active in Yorkshire *c.*1701-*c.*1721, mainly as a portraitist, and was a member of the circle of *virtuosi* at York *(Diary of Ralph Thoresby, 1830).* Also painted altarpieces in Leeds and Hull. Came to London on the death of Laguerre (1721) but did not have much business. His Yorkshire portraits look more English than French and are not of much distinction.

(E.C-M., i, 256/7.)

JACQUES PARMENTIER. Called 'Sir Francis Chaplin.' 27½ins. x 23ins. s. & d. 1713. Christie's sale 6.3.1942 (41).
Probably painted in Yorkshire and of an unknown sitter (Chaplin d.1680).

WILLIAM PARRY. 'Sir Joseph Banks, Daniel Charles Solander, and Omai.' 59ins. x 59ins. c.1776. Christie's sale 2.4.1965 (35). An exercise in the spirit of Reynolds.

PARRY, William 1742-1791

Portrait painter and a skilful copyist of old masters. Born London 1742; died there 13 February 1791. Son of a famous blind Welsh harper and long patronised by Sir Watkin Williams-Wynn. He studied at most of the London academies and won six premiums for drawings at the SA 1760-66. Exh. FS 1762-63 (in 1763 a drawing of the inside of the Duke of Richmond's Academy). A pupil of Reynolds 1766 and entered RA Schools 1769. Exh. SA 1766-70; RA 1776-79 and 1788. ARA 1776. He worked briefly in Wales before going to Rome from 1770 to 1775; and again later until he returned to Rome in 1780. He was only briefly in London (1788) until he returned from Rome to die in 1791. He never fulfilled his considerable promise. His most ambitious portrait, with a good deal of Reynolds in its style, is a group of 'Sir Joseph Banks, Solander & Omai' of *c.*1776, Vaughan sale, 2.4.1965, 35.

(Edwards.)

THOMAS PATCH. 'The Arno at Florence with the Ponte S. Trinita.' 34½ ins. x 47ins. Christie's sale 27.3.1953 (60).
Patch's Florentine views, painted for British tourists, were a sort of parallel to Canaletto's views of Venice.

PARS, Miss Anne fl.1766-1786
Hon. exh. of a crayons portrait at RA 1786. She
was sister to William Pars and won premiums for
drawing from the Society of Arts 1764-66.

PARS, William ?1742-1782
Portrait and history painter; but best known for his
watercolours of Greece, the Troad, and the Swiss
Alps. Born London 2 December 1742 (?1744); died
Rome October 1782. Trained to portrait and his-
tory at Shipley's, St. Martin's Lane and Duke of
Richmond's Academies, he won thirteen
premiums for all sorts of work from the SA 1756-64
(the last for a historical picture). Exh. SA 1760-61;
FS 1761-64. Accompanied the Dilettanti Society's
expedition to Greece and the Troad 1764-66 as
topographical draughtsman *(A. Wilton in Richard
Chandler's Travels in Asia Minor, ed. Edith Clay,
1971)*; and then Lord Palmerston's travels,
especially in the Swiss Alps. Entered RA Schools
1769. Exh. RA 1769-76. ARA 1770. The Swiss

views shown in 1771 were among the first samples
in England. From 1773 he showed portraits,
mainly large and small full lengths, but none have
been certainly identified. He went to Rome on a
student's pension from the Dilettanti Society 1775,
and there died. His brother Henry (1733-1806) ran
what had been the St. Martin's Lane art school for
the last forty years of his life.

(Mallalieu.)

PARSONS, Francis fl.1763-1804
Portrait painter. Died London 1804. Exh. SA
1763-83 and became Treasurer of the SA 1776. His
portraits were indifferent and he ended up as a
dealer and picture cleaner.

(Edwards.)

PARSONS, T. fl.1754
A portrait of 'Edward, Lord Leigh' at Stoneleigh
Abbey is signed 'T. Parsons pinxit Jan. 20.1754'.

PARSONS, William **1735-1795**

Amateur painter and well-known comic actor. Born Maidstone 1735; died London 3 February 1795. He won premiums for drawings at Society of Arts 1757-60. Redgrave alleges he was the 'Mr. Parsons' who exh. still-lifes at FS 1765 and a landscape at SA 1773 (hon. exh.). His stage career began in 1763.

PARTRIDGE, J. **fl.1781-1792**

Exh. 'Larks', 'Flowers' and two portraits, RA 1781, 1790-92.

PASSALL **fl.1783**

Exh. a 'Sunset', FS 1783.

PATCH, Thomas **1725-1782**

Painter of caricatures and Italian landscapes; also engraver. Baptised Exeter 31 March 1725; died Florence 30 April 1782. He showed an early passion for caricature, received some artistic training in London, and worked in Vernet's studio in Rome from 1747 to 1753, where he painted landscapes in Vernet's style. He was forced to leave Rome for Florence (probably on grounds of 'moral turpitude') in 1755, where he lived for the rest of his life warmly patronised by Sir Horace Mann. Apart from grand tourist views of Florence, his speciality was in caricature groups, of an unmalicious kind, featuring Anglo-Florentine society. The earliest of these are of 1760 (National Trust, Dunham Massey) and they are of high sociological, though not very high artistic, interest. His landscapes are rather hard and airless. As an engraver he was a pioneer in the illustration of the frescoes of early Italian painters (Masaccio, &c., at the Carmine, 1770; Giotto and Fra Bartolommeo, 1773).

(F.J.B. Watson, Walpole Soc., XXVIII (1940), 15-50, with cat. of paintings.)

THOMAS PATCH. 'A party at Sir Horace Mann's in Florence.' 47ins. x 37ins. c.1765/68. B.A.C. Yale.
The room is somewhat fanciful, since no one would have a bust of Patch himself over their mantelpiece! The portrait next to it is of Mann. Lord Tylney (seated) is the only caricature figure identifiable with certainty.

RICHARD MORTON PAYE. 'An artist sketching by candlelight.'
28½ins. x 23ins. Upton House (National Trust).
Perhaps from the later 1780s, it shows an awareness of Dutch
painters such as Dou or Schalcken.

PATON, Richard 1717-1791

Painter of maritime scenes and naval occasions.
Born London 1717; died there 7 March 1791. Exh.
SA 1762-70; RA 1776-80. Some of his more
ambitious scenes are engraved and the figures in
some of these are by Mortimer or Wheatley. He
entered the Accounts Office of the Navy in 1742.

(Archibald.)

PATOUN fl.mid-18th century

A 'gentleman who lived at Richmond, not an
artist' who painted a portrait of 'Madame de
Montespan' which he gave to the Earl of
Hardwicke (1690-1764).

(Earl de Grey cat., 1834, no.108.)

PATTERSON, Samuel 1765-after 1789

Born 16 November 1765; entered RA Schools
1784. Exh. RA 1789 a 'Portrait of an artist' from
the address of the Sun Fire Office, which suggests
his later profession.

PAUL, Bernard 1737-1820

In England a portrait painter in crayons. Born
Ghent 1737; died there 1820. In the Guild at The
Hague 1763. Exh. SA 1766-67; and at Norwich
1767-68 *(Fawcett, 76)*. He was back in Ghent by
1771, where he also painted religious pictures.

(Cat. du Musée des Beaux Arts, Gand, 1937.)

PAVILLON, Charles fl.1768-1772

History painter. Died Edinburgh 14 June 1772.
Exh. SA 1768 and 1770 (latterly from Edinburgh).

PAXTON, John fl.1765-1780

Portrait and history painter. Buried Bombay 19
February 1780. Said to have been a product of the
Foulis Academy, Glasgow. Member of Society of
Artists, London 1765. Exh. a 'Samson' SA 1766
from Rome. Exh. RA 1769-70 and SA 1771-76,
mainly portraits and with a preference for small-
scale full lengths. He went to Madras 1776.
Another 'J. Paxton' exh. fancy pictures RA 1802
and 1807.

(Forster.)

PAYE, Richard Morton fl.1773-?1821

Began as a chaser and wax modeller; painter of
portraits and miniatures, but best in pictures of
domestic and rustic genre. Born at Botley
(?Boxley), Kent; said to have died in London
December 1821. An elusive artist of distinguished
quality, now best known from engravings after his
attractive genre scenes with children *(mostly
reproduced by E.W. Clayton, Connoisseur, XXXVII
(Dec. 1913), 229-236)*, which have some affinity
with Walton. Exh. RA 1773-1802 (at first portraits
and wax models); FS 1783; SA 1783-91; BI 1807
and 1815 (the last when crippled and only able to
use his left hand). His best period was about
1785-95. 'The artist sketching by candlelight'
(National Trust, Upton House) suggests a
knowledge of Wright of Derby. His later years
were clouded by ill-health (and an unsociable
temperament), and in 1812 he was in great distress
and helped by the Academy.

(DNB.)

PAYNE, Rev. John 1700-1771

Irish amateur painter in oils and watercolours,
especially of flowers. Born Dublin 1700; died there
26 May 1771 *(Strickland)*. His father, **William**
Payne (fl.1697-1715) is said to have been a portrait
painter in Dublin but his work is unknown.

PAYNE, Thomas fl.1762-1767

Exh. landscapes, sometimes with historical figures, FS 1762-63; SA 1765-67.

PAYNE, William fl.1776-1830

Popular and mannered watercolour landscape painter *(Mallalieu)*, who also practised in oils. At first an engineer in Plymouth. His early exhibits (SA 1776 and 1790; RA 1786-90) seem all to have been watercolours, and he settled in London 1790 and became at once a fashionable teacher of an easy watercolour technique. He later also painted very large and small Devonshire views in oils, of some merit. Exh. BI 1809-30; RA 1821-22.

(Grant.)

PEART, Henry, Jr. fl.1698-1741

Professional copyist in East Anglia; son of a much better known professional copyist, Henry Peart, Sr. (d.*c.*1698). He was paid for a copy in the Earl of Bristol's accounts 1731 and was still alive 1741.

PEAT, Thomas fl.1791-1830

Mainly a miniaturist, but his earlier exhibited portraits seem not to have been miniatures. Exh. RA 1791-1805. He later worked at Bath, Leamington and Bristol.

(Long.)

PEETERS See PIETERS, Jan

WILLIAM PAYNE, 'Coast scene with fisher folk.' 21½ins. x 31ins. s. & d. 1798. Christie's sale 10.7.1959 (49). Payne's relatively infrequent oils are composed like his watercolours.

PEALE, Charles Wilson 1741-1827

American portrait painter, miniaturist and engraver. Born Maryland 15 April 1741; died Philadelphia 22 February 1827. He was briefly in England 1767-69 studying under Benjamin West (q.v.), and exh. miniatures at SA 1768. Returned to Annapolis 1769.

(Groce and Wallace.)

PEARCE, William 1764-c.1799

Painter of miniature portraits and rustic genre. Born 1764; entered RA Schools 1792. Exh. RA 1798-99 (miniatures). His 'Milkmaid' (mezzotint by C. Turner) is in the style of Wheatley (q.v.).

(Grant.)

PEARSON, William fl.1798-1813

?Shropshire landscape painter in oils and watercolours. Exh. RA 1799-1804. He also etched.

(Mallalieu; Grant.)

PELHAM, Henry 1749-1806

Miniaturist, painter and engraver. Born Boston, U.S., 14 February 1749; drowned Ireland 1806. Half-brother and pupil of J.S. Copley (q.v.). Left Boston for London 1776. Exh. RA 1777 ('Finding of Moses') and miniatures in 1778. Left for Ireland *c.*1779 where he took to engraving and map-making.

(Strickland.)

PELHAM, Peter 1697-1751

Mezzotint engraver and, in America, portrait painter. Born London 1697; died Boston December 1751. Father of Henry Pelham (q.v.). Pupil of the engraver J. Simon in London. Emigrated to America in 1727, where he produced the first mezzotints and made some portraits in the style of Kneller.

(Groce and Wallace.)

PELLEGRINI, Domenico **1759-1840**

Italian portrait and history painter. Born Galliera (Bassano) 19 March 1759; died Rome 4 March 1840. Trained in Venice and then under D. Corvi in Rome (1784). He came to London 1792, where he entered the RA Schools 1793 and was encouraged by Bartolozzi (whose portrait of 1794 by Pellegrini is at Venice). Exh. RA 1793-1803. Briefly in Lisbon where he painted 'Lord St. Vincent', 1806 (Greenwich). Exh. a 'Holy Family' BI 1812. Later settled in Rome. His English portraits are very much in a British style.

(Carlo Donzelli, I Pittori Veneti del Settecento, 1957.)

PELLEGRINI, Giovanni Antonio **1675-1741**

Ventian rococo history and decorative painter. Born Venice 29 April 1675; died there 2 November 1741. Influenced by Sebastiano Ricci. He was an immensely prolific painter of decorative histories and mythologies in a style which he practised, among many other places, at Vienna, Düsseldorf, Paris and the Low Countries. He was in England 1708-13, being brought over, with Marco Ricci, by the Earl of Manchester. He was involved in the setting up of the Academy in London in 1711 and his main works in England were at Kimbolton, Castle Howard and Narford. He was again briefly in England in 1719, between stays in Holland and Paris.

(E.C-M.)

PELLICINI **fl.1779**

Exh. FS 1779 'Landstorm' and 'A house on fire'.

PELLS, Mrs. **fl.1774**

Exh. SA 1774 'An artificial pot of pinks'.

PENNINGTON, John **1773-1841**

Liverpool landscape painter. Born Liverpool 27 June 1773; died there April 1841. Founder member of the Liverpool Academy 1810.

(Walker Art Gallery, Merseyside cat.)

There were ceramic painters of the same name at Liverpool and a 'Pennington Junr' exh. crayon portraits at FS 1764.

DOMENICO PELLEGRINI. 'Lady Hamilton' (Emma). 29½ ins. x 25½ ins. s. & d. 1791. Sotheby's sale 19.4.1957 (92).
Emma left Naples in April 1791 and was married to Sir William Hamilton in London in September. This was probably painted in London, where Pellegrini is usually said to have arrived in 1792.

PENNY, Edward **1714-1791**

Painter of portraits, histories, and subject matter with a moral content. Born Knutsford, Cheshire 1 August 1714; died Chiswick 15 November 1791. Studied with Hudson and then under Benefial at Rome. He returned to England 1743 and practised first in his home area, but soon came to London where he began by specialising in small-scale full lengths similar to those later produced by Zoffany (q.v.). By 1748 he was already listed as 'an eminent painter' in the *Universal Magazine*. Exh. SA 1762-68, becoming Vice-President 1765. Foundation member of RA, becoming Professor of Painting 1769-83. Exh. RA 1769-82 (when he gave up the practice of painting). He was one of the first to select for his subject matter incidents which exemplified virtuous actions, and his 'Death of

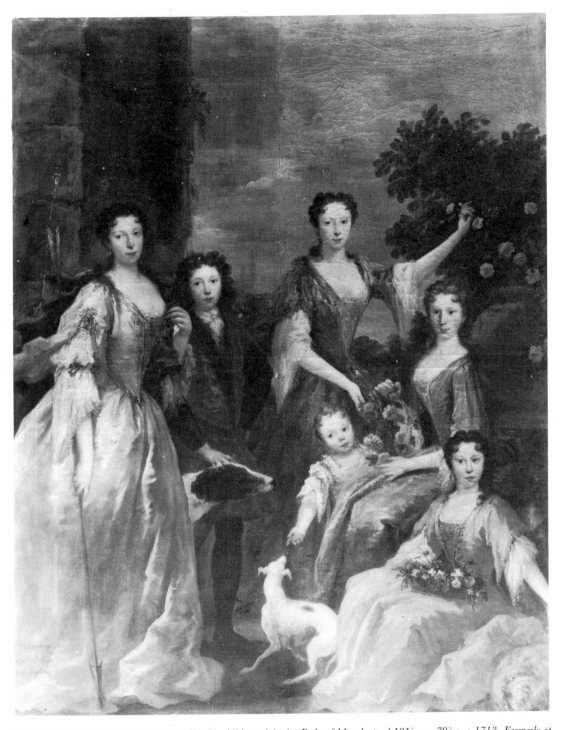

GIOVANNI ANTONIO PELLEGRINI. 'Six children of the 1st Duke of Manchester.' 101ins. x 79ins. c.1713. Formerly at Kimbolton Castle.
Charles, 4th Earl (later 1st Duke) of Manchester had brought Pellegrini over from Venice in 1708 and employed him in portraits as well as decorative historical paintings.

EDWARD PENNY. 'William Drake.' 33ins. x 27½ins. s. & d.
?1758. Private collection.
Penny was the chief rival to Zoffany in small whole lengths of
this sort, but signed examples are very few and this is the best
known to me.

GIOVANNI ANTONIO PELLEGRINI. 'Two Cupids and an
Earl's crown.' Ceiling painting in oil. Painted about 1710. Kimbolton
Castle.
Most of the decorative paintings at Kimbolton have been
dispersed.

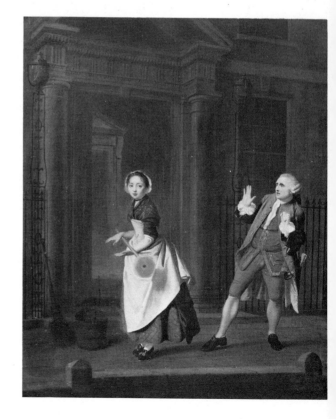

EDWARD PENNY. 'A scene from Swift's description of a city
shower.' 29½ins. x 24½ins. Exh. SA 1764 (82). Sotheby's sale
23.11.1966 (54).
Penny specialised in innocent genre of this sort.

EDWARD PENNY. 'William ffarington.' 29ins. x 24ins. s. & d. (on the back) 1744. Christie's sale 16.11.1962 (58).
At this date, in his native Lancashire and soon after returning from Italy, Penny still signed his name 'Pennee'.

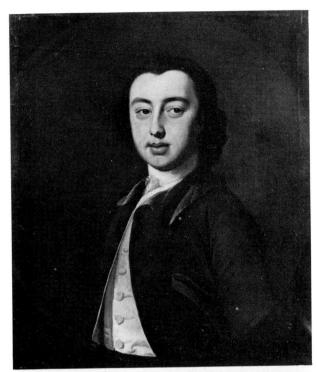

Wolfe', SA 1764, and 'Lord Granby relieving distress', SA 1765, both of which he presented to the University of Oxford 1787, were extremely popular in engravings. He has affinities with Mortimer (q.v.), but is much gentler, and his Academy pictures range from 'Imogen', 1770 (Stratford), 'The Virtuous comforted' and 'The Profligate punished', 1774 (both BAC Yale), to 'The Penance of Jane Shore', 1776 (Birmingham). At the end they became very tame indeed — 'The distraining of widow Costard's cow', 1782 (BAC Yale), but they are a consistent attempt at *la peinture morale*.

(DNB.)

A 'J. Penny' exh. among the miniatures at RA 1788 two scenes of the same sort of character which suggest a connection with Edward Penny.

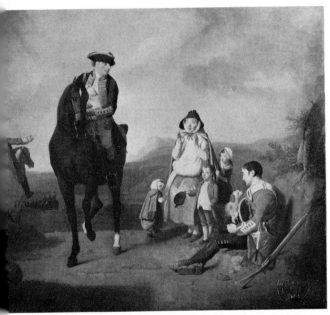

EDWARD PENNY. 'The Marquess of Granby relieving a distressed soldier and his family.' 40ins. x 50ins. s. & d. 1764. Exh. SA 1765 (96). Ashmolean Museum, Oxford.
Penny specialised in what Diderot called *la peinture morale*. This is one of two pictures he presented in 1787 to the Bodleian Library, which then was the only public gallery in England.

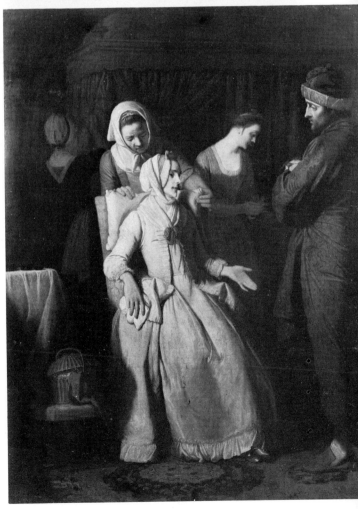

EDWARD PENNY. 'The Virtuous comforted by Sympathy and Attention.' 49½ins. x 39½ins. RA 1774 (207). B.A.C. Yale.
Another example of *la peinture morale*, which was accompanied at the RA 1774 by 'The Profligate punished by Neglect and Contempt' (also at Yale).

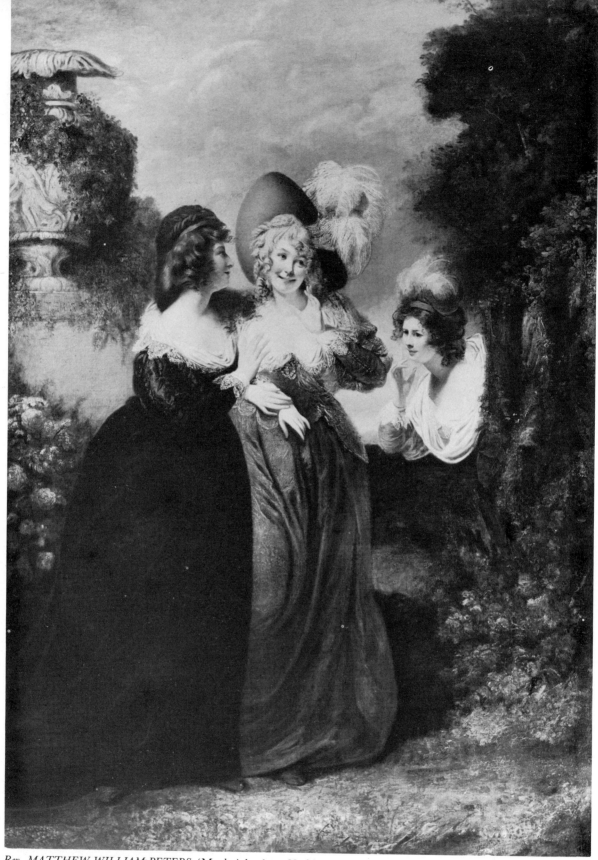

Rev. MATTHEW WILLIAM PETERS. 'Much Ado about Nothing, *act iii, scene i.*' *102ins. x 72ins. Engraved 1790. Formerly with A.L. Nicholson.*
Painted for Boydell's Shakespeare Gallery; engraved by J. Heath.

PENNY, J.S.
Occasional hon. exh. of flower pictures RA 1793-1813.

PERCIVAL, Master Charles **1756-1840**
Exh. SA 1770 'A view of Enmore Castle in Somersetshire. He was a son of the Earl of Egmont and became the 2nd Lord Arden.

PERNOTIN, B. **fl.1786-1797**
Painter of light history and genre scenes. Exh. RA from 1786 (very abundantly) to 1797. His subject matter sounds Angelica Kauffmannish. He is presumably the Pernotin recorded at Paris 1778-86.

PEROTTI, Angelica **fl.1772-1775**
Exh. crayon portraits at RA 1772 and 1775. From the same address, in 1775, **Pietro** Perotti exh. two subjects in chiaroscuro.

PERRONEAU, Jean-Baptiste **?1715-1783**
French portraitist in crayons and oil. Born Paris ?1715; buried Amsterdam 20 November 1783. After Quentin de la Tour, he was the most distinguished French pastellist of the century and his powers of interpreting character are of a very high order. *Agréé* at the French Academy 1753. From 1755 he lived a highly peripatetic life, most often in Holland as well as in provincial France. He was also in Italy (1759) and in Russia (1781), and visited England in 1761 where he exh. four pastel portraits at SA 1761 and was paid (January 1761) 17 guineas by the Duke of Montagu for a portrait.

(L. Vaillat and P. Ratouis de Limay, J-B. P., Paris and Brussels, 1923.)

PERRY, John **1767-after 1841**
Portraitist. Entered RA Schools 1791, aged 24; last recorded as engraving one of his own portraits 1841. Exh. RA 1791 a portrait, and 1809 'The gloveress'.

PETERS, Rev. Matthew William 1741/42-1814
Painter of portraits, historical and fancy pictures, and pin-ups in oil and crayons. Born Freshwater, Isle of Wight, 1741/42; died Brasted, Kent, 20 March 1814. Taken to Dublin as an infant and first won drawing prizes there 1756/8; a pastel of his teacher Robert West (q.v.) making a drawing of him, 1758, is in Dublin Gallery. To London where he studied under Hudson (q.v.) and won a premium at the Society of Arts 1759. Sent to Italy

Rev. MATTHEW WILLIAM PETERS. Formerly called 'Kitty Fisher.' 24ins. x 29½ins. Former J.P. Morgan collection, New York.
One of a pair of companions of languishing ladies painted by Peters in the 1770s. The other was, equally absurdly, called 'Mrs. Jordan'. Kitty Fisher died 1767.

Rev. MATTHEW WILLIAM PETERS. 'George Finch, later 9th Earl of Winchilsea.' 29ins. x 23½ins. Signed, dated (in a later hand) 1768. Christie's sale 20.6.1947 (71).
Peters acquired from Italy a taste for Venetian technique and lighting, which was unusual for visiting British painters.

for training by the Dublin Society, he worked in Batoni's Academy at Rome (1762) and was a member of the Florence Academy (1763) and was back in Dublin c.1765, but found little business. Member of the London Society of Artists 1765. Exh. SA 1766-69 (portraits only, some in crayons). Oil portraits of c.1768 show some influence of Reynolds and a buttery impasto. Exh. RA 1769-85. ARA 1771; RA 1777. He was in France and Italy 1772-76, copying Rubens at Paris (1775) and Correggio at Parma and spending two years in Venice, where he studied Venetian colouring. In Paris he became friendly with Vincent and must have looked at Greuze's pin-ups, from which he devised his own variant of mildly *risquées* smiling ladies on bed or sofa. These date mainly 1776-79 and were popularised by engravings; they earned him a certain reputation which was criticised when he entered the Church. He became a freemason 1769 and was ordained priest 1781 and deacon 1782, and gradually gave up painting to rely on these sources of influence.

He resigned from the RA 1788 and had already exh. 1782 'An Angel carrying the Spirit of a Child to Paradise' (Burghley House) to mark a change of style. But he painted five pictures for Boydell's Shakespeare Gallery, 1786-90; and others for Woodmason's Irish Shakespeare Gallery, 1793, the most striking of which, 'The suicide of Juliet' (Folger Library, Washington), is a fully romantic work. His later devotional works, such as 'The Resurrection of a Pious Family', were popular in engravings but are better forgotten. He exh. BI 1807 a 'Fortune Teller' — a subject he had first shown in 1785. He is original both in a technique derived from Rubens, Baroccio and the Venetians, and in the French affinities of his subject matter; and his pinkish tonality is often positively pretty.

(Lady Victoria Manners, M.W.P., 1913, with sketchy cat.; Strickland.)

PETHER, Abraham 1756-1812
Landscape painter, especially of moonlight scenes. Born Chichester 1756; died Southampton 13 April 1812. Pupil of George Smith (q.v.) of Chichester, whose style he enlarged by some imitation of Richard Wilson (q.v.). From about 1784 he specialised a good deal in moonlit scenes, perhaps in deliberate imitation of Vernet, so that he became known as 'Moonlight Pether'. He attempted Italianate as well as English landscapes. Exh. FS 1773-83; SA 1777-80 and 1790-91; RA 1784-1811.

(Grant.)

ABRAHAM PETHER. 'A wooded river landscape, with figures on a footbridge.' 24ins. x 27½ins. s. & d. 1785. Christie's sale 18.11.1966 (1).
It owes something to Dutch painters such as A. van Everdingen, but translated into an English idiom.

PETHER, William c.1738-1821
Mezzotinter of great distinction, pupil and partner of Thomas Frye; he also painted miniatures and portraits in oil and crayons. Born Carlisle c.1738; died Bristol 19 July 1821. Cousin of Abraham Pether (q.v.). He won premiums for drawing (1756) and for mezzotint (1760 and 1767) at Society of Arts. Exh. FS 1761-63 (mainly crayons); SA 1764-80 (all sorts); RA 1781-94. Based on London until 1776; then Richmond, Surrey 1777; Nottingham, 1780; London again until he moved to Bristol c.1804.

(Long.)

PETTON, R. fl.1723
Portrait painter. Signed and dated 1723 a portrait of 'George Heathcote' in the manner of Dahl, sold 9.11.1951, 140.

R. PETTON. 'George Heathcote.' 29ins. x 24ins. s. & d. 1723.
Christie's sale 9.11.1951 (140).
A painter not otherwise known.

PHELPS, Richard *c.*1710-1785

Local Somerset painter; mainly portraitist and copyist. Native of Porlock; died there 12 July 1785 (brass in Porlock church). He also painted inn signs and repaired altarpieces. Exh. SA 1764. His portraits are in a very provincial Hudsonish style; several are at Dunster Castle. He collaborated in paintings with C.W. Bamfylde (q.v.).

(Sir H.C. Maxwell-Lyte, A History of Dunster, 1909.)

PHILIPS, Charles 1708-1747

Fashionable portrait painter, especially in small scale whole lengths and conversations; he also worked on the scale of life. Probably born and died in London; son of Richard Philips (q.v.), who was presumably his teacher, but he consciously looked (without much understanding) at the work of Watteau. During the short period, *c.*1730-34, when conversation pieces were popular with the aristocracy, Philips' doll-like groups were the most fashionable, particularly among the Prince of Wales' set — but his quality is greatly inferior to Hogarth. He also did many small scale single full lengths, and later expanded the same style to the scale of life — but with less success. His last important works are the life-size full lengths of the Prince and Princess of Wales, 1737 (Windsor, Warwick Castle, &c.).

(DNB.)

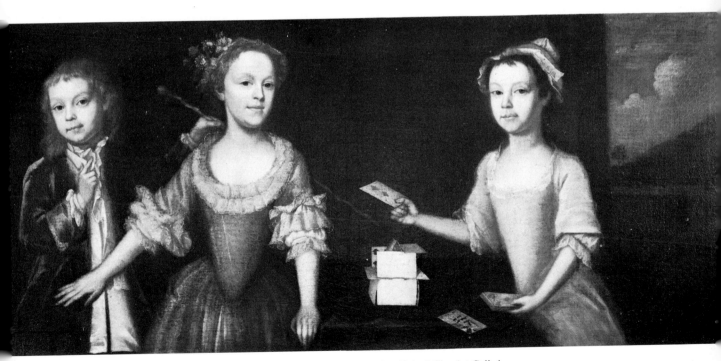

RICHARD PHELPS. 'Three children of Rev. Walter Burton.' 30ins. x 68½ins. Bristol City Art Galleries.
The family was of Sutton Montis, Somerset. Phelps was a sort of provincial Highmore and had a fair practice in Somerset.

CHARLES PHILIPS. 'A party at Lord Harrington's House.' 40ins. x 50ins. c.1730/34. B.A.C. Yale.
The most numerous of Philips' 'conversations'; he was much more popular with the aristocracy than Hogarth.

CHARLES PHILIPS. 'Lady Anne Wentworth and Lord Higham.' 44ins. x 54ins. s. & d. 1738. Private collection.
When conversations with miniature figures ceased to be fashionable, Philips took to the more lucrative task of painting on the scale of life.

*CHARLES PHILIPS. 'Frederick, Prince of Wales' (1732).
17¾ins. x 13¼ins. B.A.C. Yale.*
Painted when the Prince was twenty-five, according to a
contemporary inscription.

PHILIPS, Richard *c.*1681-1741
Portrait painter. Died London October 1741 'aged
about sixty' *(Vertue, iii, 105)*. Father of Charles
Philips (q.v.). His style was perhaps derived from
Richardson.

PHILLIMORE, C. fl.1796
Hon. exh. of 'A pug dog', RA 1796.

PHILLIPS, Thomas 1770-1845
History painter, and, after 1808, fashionable por-
trait painter. Born Dudley 18 October 1770; died
London 20 April 1845. Studied first under the
glass-painter Eginton at Birmingham. Entered RA
Schools 1791, and then briefly assistant to
Benjamin West (q.v.). Exh. RA 1792-1846. ARA
1804; RA 1808. He exh. history pictures at first,
but painted only portraits after 1808. He was a
very successful and prolific painter of portraits of
the academic and fashionable classes.

PICARD, John d.1768
The *Gentleman's Magazine (1768, 590)* records the
death on 2 December of 'John Picard, a celebrated
painter in Canterbury'.

PICKERING, Edward fl.1711-1720
Vertue *(vi, 170)* lists an Edward Pickering as a sub-
scriber to the St. Martin's Lane Academy, 1720.
He was presumably the 'Mr. Pickering' who
subscribed to Kneller's Academy 1711.

PICKERING, Henry fl.1740-*c.*1771
Portrait painter; at his best hardly to be
distinguished from Hudson. Died at Manchester
(will dated 1759, proved 1771). Mentioned by
Vertue *(iii, 130)* as having returned from Italy 1740
and, like Hudson, employing Van Aken (d.1749)
as his drapery painter. Signed and dated full
lengths, 1741 (Nottingham) and 1746 (Nostell
Priory), are good examples of Pickering/Van Aken.
His largest known work is the 'Dixie family group',
1755 (sale 18.3.1977, 105). Dated works range
from 1740 to 1770. Probably based on London in
1740s; in the 1750s he seems to have ranged over
Yorkshire, Lancashire, Cheshire and North Wales,
and was probably based on Manchester. A Henry
Pickering resident at Liverpool 1781 and 1790 may
have been a son.

(Walker Art Gallery, Merseyside cat., 1978.)

PICKETT, W. fl.1792-1820
Exh. landscapes at RA 1792-1820. Some were per-
haps in oil; there were also two portraits.

PIERIE, William fl.1768-1775
When a Lieutenant in the Artillery made a drawing
of 'Niagara Falls', 1768, from which Richard
Wilson (q.v.) did a painting that was engraved. As
a Captain, was hon. exh. SA 1775 of a 'View of
Inveraray'.

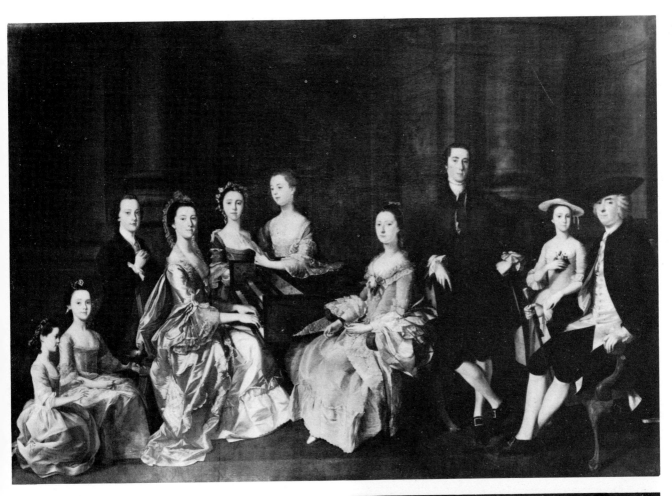

HENRY PICKERING. *'The family of Sir Wolstan Dixie.'* 112ins.
x 158ins. s. & d. 1755. Sotheby's sale 29.5.1963 (134).
The largest family group by Pickering known. Sir Wolstan
Dixie, of Market Bosworth, Leicestershire, was perhaps his
most important patron.

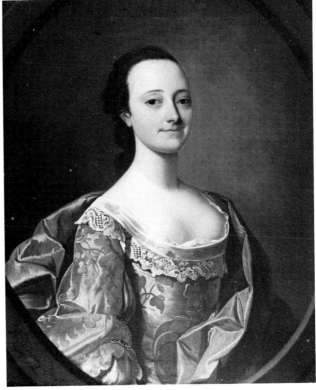

HENRY PICKERING. *'Unknown lady.'* 30ins. x 25ins. s. & d.
1759. Christie's sale 17.3.1978 (73).
The slightly smug expression differentiates Pickering from
Hudson.

ROBERT EDGE PINE. '?Mrs. Backwell and her daughters.' 99ins. x 75ins. Sotheby's sale 23.3.1955 (12) as Cotes, in 1972 as Pine. Probably mid-1770s. All the figures show Pine's favourite three-quarter view.

PILLEMENT, Jean-Baptiste 1728-1808

Painter of artificial landscapes in oil, pastel and gouache; also decorator with a taste for *chinoiseries*. Born Lyons 24 May 1728; died there 25 April 1808. Trained as a designer for the Gobelins; worked in Madrid and Lisbon before coming to London, where, in 1757, he did decorative paintings for Garrick in London and at Hampton (sold at Hampton 1823). Exh. SA 1760-61 and 1773 (on a visit) and FS 1779-80 (from abroad). He was in England perhaps *c*.1751-61 and his gaudy and unrealistic landscapes, in imitation of Berghem or Vernet, &c., had considerable success.

(Audin and Vial, 1919, ii, 121/2.)

PINE, Robert Edge *c*.1730-1788

Portrait and history painter. Born London, probably in the 1720s, son of the engraver, John Pine (1690-1756); died Philadelphia 12 November 1788. It is possible he may be the 'young Pine' who was 'brushing off [crayons] at a guinea a piece' in 1742 *(Vertue, iii., 110),* but this may have been a

PIETERS, Jan *c*.1667-1727

Drapery painter, portrait painter and restorer. Said to have been born Antwerp 1667; died London September 1727. Studied under Eckhardt. Came to London *c*.1685 and was drapery painter and assistant to Kneller up to 1712; then general drapery painter and restorer. Teacher of George Vertue.

(Vertue, iii, 33.)

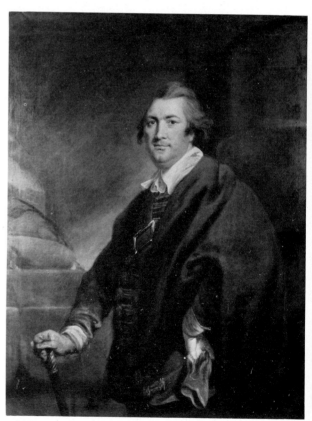

ROBERT EDGE PINE. 'Robert Bontine Cunningham Graham.' 48½ins. x 39ins. Artist's name on the back; date 1771 on the front. Christie's sale 12.3.1937 (123).
The look as if a small slice had been taken from the sitter's right forehead is very characteristic.

ROBERT EDGE PINE. 'The Duke of Northumberland laying the foundation stone of the Middlesex Hospital in 1755.' Exh. FS 1761 (78).
Middlesex Hospital, London.
The Duke considered himself the handsomest man in London and liked presenting his portrait to public institutions.

brother, **Simon** (died Reading 1772), later a miniature painter at Bath. Robert is listed in London as an 'eminent painter' in the *Universal Magazine (Nov., 1748,)* and, in 1759, painted, without sittings, a very remarkable, and sinister, portrait of 'George II' (Audley End). He won the top premiums from the Society of Arts 1760 and 1763 for subjects from English history. Exh. FS 1761-63; SA 1760-71; RA 1772, 1780 and 1784. He was one of the first to do portraits of actors in character parts and some of his best portraits were engraved in mezzotint by Dickinson. The 'Earl of Northumberland laying the foundation of Middlesex Hospital', FS 1761, (Middlesex Hospital) is nearly as 'advanced' as a Reynolds of that date, but Pine took to painting 'radical' subjects, e.g. 'Earl Warren resisting the *Quo Warranto* statute', SA 1771 (National Trust, Sudbury Hall), and such political characters as Wilkes, so that he was not appointed a foundation member of the Royal Academy *(cf. J. Sunderland, Burlington, Mag., CXVI (June 1974), 317ff.)*. He lived in Bath 1772-79 and held an exh. in London 1782 of Shakespearean history pictures, which anticipated Boydell but was not a success (they were eventually destroyed in a fire at Boston). In 1783 he migrated to the United States and had settled at Philadelphia by 1784, where he was at times assisted by Charles Wilson Peale (q.v.). He brought a letter of introduction to George Washington, whom he painted, and developed a large portrait practice in the United States *(Robert Stewart, R.E.P., a British Portrait Painter in America 1784-1788, exh. cat. Nov. 1979, NPG, Washington)*. He was one of the best English portraitists of the second rank, but has an odd habit of showing heads in three-quarter profile with the top corner seemingly sliced off.

(Dictionary of American Biography, XIV.)

NICHOLAS POCOCK. 'Bristol harbour.' 22½ ins. x 32ins. s. & d. 1785. Bristol City Art Gallery.
Pocock was capable of painting very competently more than purely marine subjects.

PINGO, Henry **fl.1772-1773**

Called himself a 'pattern drawer', and painted flower pieces in oils and watercolours, which he exh. FS 1772-73. He came from a family of seal engravers and was probably a son of Thomas Pingo (d.1776) engraver to the Mint.

PITSALA See PIZZALA, Francesco

PIXELL, Maria **fl.1793-1811**

Amateur painter of landscapes in oil and watercolour. Said to have been a pupil of Sawrey Gilpin (*Redgrave*). Hon. exh. RA 1793-1811; BI 1809-11 from a Wargrave address.

PIZZALA, Francesco **d.1769**

Italian decorative painter. Died London 10 November 1769. He did some work for Robert Adam at Shelburne House.

(E.C-M.)

PLATT, William **1775-after 1796**

Entered RA Schools as an engraver 1792. Exh. RA 1793 and 1796 two paintings of literary genre.

PLIM(M)ER, John **fl.1755-1760/61**

Landscape painter. Born Blandford; died Rome 1760/1. He arrived in Rome 1755 and was a pupil of Richard Wilson (q.v.) 1755/6; visited Naples 1757; lodged with Thomas Jenkins at Rome 1758-60. His pictures are pastiches of Claude and Wilson.

(Basil Skinner, Burlington Mag., XCIX (July 1957), 237ff.)

POCOCK, Nicholas **1741-1821**

Marine and landscape painter, the landscapes mainly in watercolour (*Mallalieu*). Born Bristol 2 May 1741; died Maidenhead 19 March 1821. He began as a merchant sea captain but early took to painting marine subjects at Bristol. Moved to London, where he was very active in the watercolourists' world, but also painted large oil views of dockyards and sea fights, which are abundantly represented at Greenwich. Exh. RA 1782-1815; BI 1806-10.

(Archibald.)

ANTONIO POGGI. 'Lord Heathfield.' 17¼ins. x 13¾ins. Engraved by Bartolozzi. Sotheby's sale 23.11.1966 (57).
Lord Heathfield was Governor of Gibraltar from 1775 and sustained the famous siege 1779-83. This picture, the only portrait by Poggi known, is said to have been painted at Gibraltar in 1783 and was engraved 1788.

POGGI, Antonio **fl.c.1769-after 1803**

Italian portrait and history painter and fan painter. He came to England with General Paoli c.1769. He practised portraiture at Plymouth, 1775, where he married an English wife. Exh. RA 1776 (from Rome) and 1781 a 'Venus and Cupids'. He had an exh. of fan pictures in London 1781, for the catalogue of which Reynolds wrote an introduction. He visited Gibraltar 1783, where he painted 'Lord Heathfield', engraved by Bartolozzi, sold S. 23.11.1966, 57. His portrait style is decidedly English. He later became a dealer and was concerned with the sale of Reynolds' drawings in 1796.

(Whitley.)

POITIER, Charles fl.1772-1797

An Englishman who retired from the army in Ireland in 1777, and acquired a certain reputation as an animal painter. He died in Ireland 1797. He exh. a portrait of a horse in Dublin 1777.

(Strickland.)

POITVIN, J. fl.1767

Exh. 'A Dutch Mastiff', FS 1767.

POLLARD, Robert 1755-1838

Landscape painter and better known as an engraver. Born Newcastle 1755; died London 23 May 1838. First apprent' :d to a silversmith and then said to have been a pupil of Richard Wilson (q.v.). Exh. FS 1783. He was the last surviving member of the Society of Artists, whose papers he handed over to the RA 1836 *(Walpole Soc., VI, 114)*.

(Redgrave.)

ARTHUR POND. 'Unknown gentleman.' 30ins. x 29ins. 1746. Sotheby's sale 19.10.1960 (63/2).
One of a pair, one of which was signed and dated 1746. Pond painted more portraits in pastel than in oils.

POND, Arthur *c.*1700-1758

Portrait painter in oils and crayons and better known as an etcher and engraver. Subscriber to and studied in the Vanderbank Academy 1720. To Rome *c.*1725-27. He took to crayons portraits on his return and was one of the most fashionable crayon portraitists by 1734. His work is difficult to distinguish from that of Knapton in this medium and he joined with Knapton in print publishing in the 1730s. He had a great reputation for connoisseurship and became FRS and FSA in 1752. His oil portraits are mostly rather pedestrian and in a Richardsonian style.

(Vertue.)

POOLEY, Thomas 1646-1722/23

Portrait painter in Ireland. Born Ipswich 1646; died Dublin early in 1722/3. He was copying Lely in London *c.*1674 and was settled in Dublin with a good practice by 1682.

(Crookshank and Knight of Glin, 1978, 21.)

POPE, Alexander 1680-1744

The celebrated poet; was also an amateur painter and studied long under his friend, Charles Jervas (q.v.) but the results were undistinguished.

(M.R. Brownell, A.P. and the Arts in Georgian England, 1979.)

POPE, Alexander 1763-1835

Portrait painter in crayons and miniature and later in watercolours, but best known as an actor. Born Cork 1763; died London 22 March 1835. Studied in Dublin 1776/7 and briefly under H.D. Hamilton (q.v.) in London, whose style in crayons portraits was the basis of his own. He came to London and exh. RA 1785-1821 and also started his career as an actor in 1785. His best crayons portraits, of *c.*1790/1 are rather smart and flashy. In 1807 he married, as his third wife, Clara Maria Leigh (d.1838) widow of Wheatley, who was an amateur artist and exh. RA 1796-1838 portraits, domestic subjects and miniatures.

(Crookshank and Knight of Glin, 1978.)

*ALEXANDER POPE. 'Unknown lady.' Pastel. 10ins. x 8ins.
s. & d. 1790. Sotheby's sale 8.11.1961 (62/1).*
Smart variation on the style of his teacher, H.D. Hamilton.

POPE, Thomas d.1775
Irish miniature painter and copyist. Died Dublin
26 September 1775. Father of the last and also of
Somerville and Thomas Pope-Stevens (qq.v.).

POPE-STEVENS, Justin See STEVENS, Justin

POPE-STEVENS, Somerville fl.1764-1818
Irish landscape and flower painter; elder brother of
Alexander Pope (q.v.). Studied in Dublin 1764;
probably died there 1818. After 1772 he took the
name of Pope-Stevens. He exh. landscapes in
Dublin up to 1772 and in 1800, and, as an
amateur, fruit pieces in 1809 and 1812.

(Strickland.)

POPE-STEVENS, Thomas fl.1771-1780
Brother of the last. Exh. portraits and landscapes in
Dublin 1771-80.

(Strickland; Crookshank and Knight of Glin, 1978, 83.)

PORTER, Sir Robert Kerr 1777-1842
History painter, watercolourist, soldier and
'diplomatist'. Born Durham 1777; died St.
Petersburg 4 May 1842. Entered RA Schools 1791,
aged 13, and produced some altarpieces 1793-98.
Exh. RA 1792-1805. From 1800ff. he produced
some enormous battle panoramas which were
shown at the Lyceum Theatre, and in 1804 he was
appointed Historical Painter to the Emperor of
Russia. Leaving Russia in 1813, he was knighted
by the Prince Regent. He travelled in Persia
1817-20 and was consul in Venezuela 1826-41.

(Redgrave.)

PORTER, William 1776-after 1802
Portrait painter in oils and crayons. Entered RA
Schools 1791. Exh. 1788 crayons, 1799-1802
predominantly Scottish portraits.

POTIER, T. fl.1778
An Antwerp painter who put on an exhibition of
his landscapes at Norwich 1778.

(Fawcett, 79.)

POWELL, Cordall fl.1768-1788
Amateur landscape painter. Hon. exh. SA 1768-80
(in 1780 also portraits); RA 1783, 1786 and 1788.
His landscapes are neat and competent and some
were engraved.

(Grant.)

POWELL, John fl.1769-1785
Portrait painter. Entered RA Schools 1769;
assistant to Reynolds 1778, whose pictures he
sometimes copied in small. Exh. RA 1778-85.

POWELL, Joseph fl.1796-c.1834
Landscape painter in oils and (mainly) water-
colour. Exh. RA 1796-1833, at first oils in a style
suggestive of Barret *(Grant)*. Later he was
prominent as a teacher of watercolour painting.

(J. Mayne, Burlington Mag., XC (Sep. 1948), 267.)

POWELL, Martin fl.1687-1711/12
Provincial portrait painter at Oxford. Died Oxford
1711 or 1712 *(Poole, iii, 218 n.)*.

POWEL(L), S. fl.1799
Exh. a number of landscapes RA 1799.

PRATT, Matthew **1734-1805**

American portrait painter. Born Philadelphia 23 September 1734; died there 9 January 1805. He studied in London under Benjamin West (q.v.) 1764-66, exhibiting SA 1765-66 a 'fruit piece' and a group portrait. He then worked at Bristol until he returned to America 1768.

(William Sawitsky cat., New York, 1942.)

PRICHARD, Christopher **fl.1712**

Irish painter known by document only.

(Strickland.)

PRINGLE, Alexander **fl.1761**

Signed and dated 1761 'Two children with a basket of flowers' in Mrs. Ionides sale S, 29.5.1963, 135.

PROCTOR, Thomas **1753-1794**

Portrait and history painter, sculptor. Born Settle, Yorks., 22 April 1753; buried Hampstead 13 July 1794. Entered RA Schools 1777 and won prizes for history pictures 1782-84. Exh. FS 1780; SA 1780 and 1790; RA 1780-94 (sculpture in 1785-86 and 1792). He had very great promise, especially as a sculptor but died just as he was awarded the first Academy travelling fellowship to Rome.

(Smith's 'Nollekens', ii, 62-66; Gunnis.)

HERBERT PUGH. 'Pastoral landscape with a shepherd and goats.' 16½ins. x 22½ins. s. & d. 1761. Christie's sale 1.2.1957 (43). A dash of Wilson and perhaps a dash of Gaspard Poussin: wholly derivative.

PUGH, C.J. **fl.1795-182**

A watercolourist who exh. landscapes at RA 1795-1829.

PUGH, Herbert **fl.c.1758-c.178**

Landscape and occasional genre painter. Born i Ireland; died London c.1788. He came to Londo c.1758 and won a premium from the Society of Art for a landscape in oil 1765. Exh. SA 1760-76 land scapes, both topographical and fancy, town scenes and a few 'Hogarthian' genre scenes (whic Edwards thought vulgar). His best naturalistic land scapes (one of 1767 at Easton Neston) have some thing of Richard Wilson (q.v.) about them. Gra reproduces a landscape, said to be signed 'C. Pug 1759', which he supposes the work of a brother.

PURDON, George **1759-after 177**

Portrait painter. Born 25 May 1759. Entered R Schools 1776. Exh. drawings and watercolours F 1772-75 (at first as 'Master George Purdon'); S 1777 an oil portrait.

PYBOURNE, Thomas **1708-after 173**

Horse painter. Signed a picture of 'Childers' in th manner of Wootton, sold S, 10.3.1965, 144.

(Egerton.)

PYE, John **1746-after 178**

Mainly an engraver and entered RA Schools 177 aged 31 as an engraver, but he exh. landscapes R 1780-89, most of which were certainly watercolou though a few may have been oils. A 'J. Pye' ex an 'Orpheus and Eurydice' at RA 1803.

PYE, Thomas **1756-after 179**

Irish portrait and history painter in oils an crayons. Studied in Dublin 1770-74 and exh. ther portraits in oils and crayons 1774-75. Entered R Schools 1775. Exh. RA 1776 a portrait of a chil Then to Rome, where he is recorded in 1794 an 1796 planning to be a history painter.

(Strickland.)

PYLE, Robert **fl.1760-176**

Painter of portraits and fancy figure subjects. Exh FS 1761-63; SA 1766. Several of his pictures ar engraved, especially female figures representin the Seasons or the Senses. His most ambitiou work was 'Henry Keene and his friends in th Guildhall at High Wycombe' 1760 (destroyed b fire at Buxted Park, 1940). His figures are very sti and wooden.

ROBERT PYLE. 'Henry Keene and his friends.' 39½ins. x 53½ins. s. & d. 1760. Destroyed by fire at Buxted Park 1940.
The setting is the Guildhall at High Wycombe (see *Country Life,* 27.iv.1945, and 18.vii.1947, 136/7).

Q

MARTIN FERDINAND QUADAL. '?William Russell of Brancepeth.' 82ins. x 56ins. s. & d. 1779. Sotheby's sale 12.3.1958 (100).
Quadal was a specialist in animal painting, but was quite good with masters who looked like their dogs.

QUADAL, Martin Ferdinand　　1736-180[
Painter of portraits and animals, and occasionall[
of genre. Born Czechoslovakia 28 October 173[
died St. Petersburg 2 January 1808. He wa[
extremely peripatetic and his main repute was a[
an animal painter — but he painted life-size po[
traits of dogs with their owners quite well, e.[
'William Russell', 1779 (formerly at Burwarto[
House). He was in London 1772/3, staying wit[
E.F. Cunningham (q.v.). Entered RA Schoo[
1773 (giving his age as 28). Exh. RA 1772-73, 179[
and 1793; SA 1791 (genre pictures). He seems t[
have been in Yorkshire from *c.*1777 to 1779, whe[
he appears in Dublin. At Rome and Naples 178[
Vienna 1787; Bath 1791; again in London 179[
By 1794 he was in Holland, on his way to Russi[
where he became a teacher at the Academy.

QUEENSBERRY, Catherine,　　1701-177[
Duchess of
Vertue *(iii, 115)* says "I have heard the Duchess [
Queensborough honours the art with her penc[
and paints in crayons with great affection" (1732[

QUIGLEY, D.　　　　　fl.*c.*1764-177[
The only Irish sporting painter of the mid century[
His style is a feeble imitation of Seymour (q.v.[
Signed and dated pictures are known of 1764 an[
1773.

(Crookshank and Knight of Glin, 1978.)

QUITER, Hermann Heinrich　　fl.1700-173[
German portrait painter, son of a Court painter [
the same name at Kassel; died Brunswick 173[
Said to have been a pupil of Maratta at Rom[
*c.*1700. His 'George I' at Blenheim appears to hav[
been painted in Germany in 1705, but either he o[
his brother, Magnus (1694-1744) is said to hav[
come to London *c.*1709 and worked with Kneller[

R

R., W. **fl.1731**

A group of portraits, dated 1731, similar to the work of Giovanni Battista Bellucci (q.v.) and signed 'W.R.' belong to the Earl of Kintore in Aberdeenshire.

RAEBURN, Sir Henry **1756-1823**

Scottish portrait painter. Born Stockbridge, Edinburgh 4 March 1756; died Edinburgh 8 July 1823. The most Scottish of Scots portrait painters. He had some instruction in art from David Deuchar but was largely self-trained, beginning with miniatures, but soon painting only on the scale of life. The full length 'George Chalmers' (Dunfermline Town Council) is said to be 1776 and to mark his precocious beginnings. Passing through London, where he was encouraged by Reynolds, he was in Rome from 1784 to 1786 and established himself in Edinburgh in 1787. By the time of David Martin's death (1797) Raeburn had eclipsed him as the leading portrait painter in Edinburgh. He briefly visited London with a view to settling there in 1810, but was wisely dissuaded and continued to dominate the Edinburgh scene until his death. His comparative isolation from the changing fashions of the London scene, made him the ideal portraitist of the legal and academic pundits of Edinburgh, whose ethos he shared. At the same time he interpreted sympathetically the Scottish female face and the more flamboyant examples of Highland character such as 'Sir John Sinclair', 1794/5 (Edinburgh) and 'The Macnab' (Messrs. Dewar's). Some of his earlier works have interesting landscape backgrounds: 'Dr. Nathaniel Spens', 1791-93 (Company of Archers, Edinburgh) and 'Sir John and Lady Clerk', RA 1792 (Sir Alfred Beit); but he felt increasingly that nothing should be allowed to distract from the head as the seat of character and he painted this with increasing technical *bravura*. His groups of children are popular and fetching but not among his best works. Exh. RA 1792-1823. ARA 1812; RA 1815. He became President of the Society of Scottish Painters 1812; knighted 1822; King's Painter for Scotland 1823.

(Irwin, 1975, the least unreliable account.)

RAIGERSFIELD, Jeffrey **c.1770-1844**

Hon. exh. of marine subjects RA 1798, 1801, 1809, 1811. He died a rear-admiral.

(Archibald.)

RALPH, Benjamin (? Richard) **fl.1763-1775**

Hon. exh. SA 1763-70; FS 1775, chiefly of moonlight or evening scenes.

RALPH, George Keith **1752-c.1798**

Portrait and history painter. Born September 1752. Entered RA Schools 1775. Exh. RA 1778-98; SA 1790. His most ambitious work is a competent full length 'Alderman John Spink', 1791 (Guildhall, Bury St. Edmunds). Three of his portraits were engraved at Bury 1788. In 1794/5 he calls himself 'Portrait Painter to the Duke of Clarence'. A 'G. Ralph' also exh. a portrait RA 1796 and a history 1803.

GEORGE KEITH RALPH. *'A.N. Mosley.' 50ins. x 40ins. s. & d. 1788. Christie's sale 27.10.1950 (137).*
'Signature' and date are perhaps rather inscriptions. At that date Ralph had a provincial practice at Bury St. Edmunds.

JOHANN HEINRICH RAMBERG. 'The thoughtless brother.' 47ins. x 59ins. s. & d. 1787. Christie's sale 10.12.1948 (140).
Ramberg manages to give a slightly Germanic air to his rustic children.

RAMBERG, Johann Heinrich 1763-1840
Hannoverian subject painter and engraver. Born
Hannover 22 July 1763; died there 6 July 1840.
Trained at Hannover, he came to England at the
invitation of George III in 1781 and entered RA
Schools. Perhaps a pupil of Benjamin West. Exh.
RA 1782-88. He painted rustic genre and scenes
like 'The sailor's farewell'. He made drawings,
which were engraved, of the RA Exhibitions in
1787 and 1788. He left England in 1788 after
painting a picture for the Shakespeare Gallery, and
devoted himself to engraving and etching.

RAMSAY, Allan 1713-1784
Fashionable portrait painter of Scottish birth. Born
Edinburgh 2 October 1713; died Dover (returning
from Italy) 10 August 1784. Son of the Edinburgh

poet, Allan Ramsay, he started drawing the human
face 1729 but can have received little professional
help in Edinburgh. He studied for some months
with Hans Hysing (q.v.) in London 1734 and spent
1736-38 in Italy, where he studied under Imperiali
in Rome and drew at the French Academy there
and under Solimena in Naples. In Italy he learned
how to draw hands and devise graceful postures
and, when he settled in London in 1738 on his
return, he soon became the most elegant of the
native British portrait painters. He was at first
much patronised by the Scottish nobility in London
and, in the summers up to 1755, he maintained a
studio in Edinburgh as well. Almost at once he
employed Joseph Van Aken (q.v.) as drapery
painter, but his drawings of hands and costume (all
in NG of Scotland) with instructions to Van Aken

ALLAN RAMSAY. *'Self portrait.' Oval. 24ins. x 18¼ ins. National Portrait Gallery (3311).*
Probably about 1739, soon after his return from Italy. There is still a suggestion of Solimena about it.

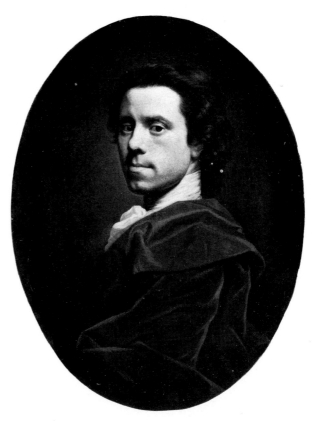

ALLAN RAMSAY. *'Richard, 3rd Earl Temple.' 93ins. x 57ins. s. & d. 1762. Christie's sale 5.4.1946 (54).*
Painted after Ramsay had given up portraits of ordinary clients, and at a time when the rivalry of Reynolds had begun to be serious. Ramsay was concentrating on elegance.

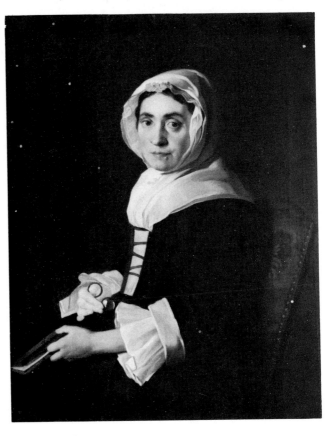

ALLAN RAMSAY. *'Mrs. William Adam.' 35½ ins. x 27½ ins. s. & d. 1754. B.A.C. Yale.*
The mother of the architects Robert and James Adam. When painting a friend of the professional classes Ramsay takes much more trouble than with his society portraits.

show that he took much more trouble than Hudson (q.v.). Many of his Ramsay/Van Aken portrait heads of the 1740s are hardly distinguishable from the Hudson/Van Aken heads of the same decade, but his more ambitious full lengths, such as 'Dr Mead', 1746 (Thomas Coram Foundation) and 'The Macleod of Macleod', 1748 (Dunvegan Castle) show that he was the most accomplished fashionable portrait painter of his generation until the advent of Reynolds *c*.1755. Alone of his generation he reacted to the novelty of Reynolds' style and revisited Rome 1755-57. Horace Walpole in 1759 considered that Ramsay and Reynolds were the two portrait painters of the age and that Ramsay excelled in women, Reynolds with men. In 1757 Ramsay painted the 'Prince of Wales' for Lord Bute (and a whole series of full-length portraits 1758-62); when the Prince became George III, Ramsay was made King's Painter in 1761. He then gave up private commissions except for

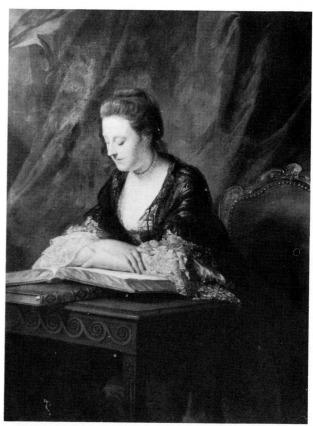

ALLAN RAMSAY. 'Emily, Duchess of Leinster.' 49ins. x 39ins. Redone signature and date of 1765. Walker Art Gallery, Liverpool. A deliberate lesson in refinement to Reynolds. Ramsay's portraits are always a little distance into the picture space.

friends and busied himself mainly in turning out copies of the standard royal portraits with the help of assistants. He visited Paris in 1765 and a few of his later private portraits, e.g. 'Lady Holland', 1766, show the influence of La Tour and Nattier. About the time the Academy started (1769) he more or less gave up painting (except for the royal portrait factory) having suffered some injury to his right arm which inhibited it. His later years were largely devoted to pamphleteering and scholarship.

(Alastair Smart, The Life and Art of A.R., 1952.)

RAMSEY, T. fl.1755
Signed and dated 1755 a competent topographical view.

(Harris, 213.)

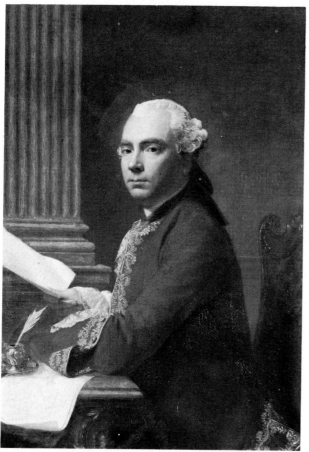

ALLAN RAMSAY. 'Robert Wood' (1717-71). 39ins. x 29ins. s. & d. 1755. National Portrait Gallery (4868). The discoverer (with Henry Dawkins) of Palmyra. A masterpiece by Ramsay painted just the moment that Reynolds impinged on the London scene.

RAOUX, Jean **1677-1734**
French painter of fancy pictures, histories &c. Born Montpellier 1677; died Paris 10 February 1734. Pupil of Bon Boulogne; *agréé* at Paris Academy 1716. He came to London briefly in September 1720 where he painted 'Charles I taking leave of his children' (signed and dated 1722; Duke of Leeds sale 1961) in a series (which was engraved), with Tillemans, Angillis, Parrocel and Vanderbank.

RATHBONE, John *c.***1750-1807**
Extremely prolific painter of nondescript landscapes in oil and watercolour. Born in Cheshire *c.*1750; died London 1807. He was living at Preston when he exh. at Liverpool 1774. The foolish nickname 'The Manchester Wilson' suggests that he worked at Manchester before settling in London. Exh. RA 1785-1806; SA 1790. He was a boon companion to Morland (q.v.) who sometimes painted figures in his landscapes, as well as to Ibbetson, and his very abundant (and often signed) landscapes are in the vein of those two painters. Their quality is very uneven.

(Grant.)

RAWLINSON, James *c.***1768-1848**
Derbyshire portrait painter. Native of Derby; died 25 July 1848. Pupil of Romney. Exh. RA 1798 (from Derby) a 'Portrait of an old woman knitting'. His only portrait of note is the engraved 'Erasmus Darwin' of 1801, sold S, 17.4.1957, 151, which recalls Wright of Derby as well as Romney.

RAYMOND, John **fl.1769-1784**
Portrait painter. Entered RA Schools 1769. Exh. FS 1772 'A music master and scholar'. Died 25 August 1784.

RAYNER, Robert **fl.1774**
Exh. FS 1774 'A Monk at devotion'.

RAYNER, Thomas **fl.1774**
Exh. FS 1774 'Dutch choristers'.

READ, Alexander **1752-after 1770**
Born March 1752. Entered RA Schools 1770. Exh. SA 1770 'A head of Mr Ouchterlony born in the year 1691'.

READ, John **fl.1773-1783**
Provincial painter of birds and wild life. Exh. SA 1773-83 as 'Mr Read of Bedford'.

JOHN RATHBONE. 'Hilly landscape with a bridge.' 19ins. x 23½ins. s. & d. 1799. Christie's sale 30.1.1948 (67).
An example in which Rathbone is very close to Ibbetson.

KATHERINE READ. 'Catherine, Duchess of Queensberry.' Pastel. 25ins. x 20ins. Buccleuch collection, Drumlanrig Castle, Dumfriesshire.
Miss Read was at her best with Scottish sitters of strong character.

READ, Katherine **1723-1778**
Fashionable portrait painter in crayons; also worked occasionally in oils and as a miniaturist. Born in Forfarshire 1723; died (on shipboard returning from India) 13 December 1778. She was already painting portraits in 1745. After the '45 she went to Paris and studied under Quentin de la Tour; later, in Rome 1751-53, where she studied under L.G. Blanchet and decided to concentrate on portraiture. She may also have studied briefly under Rosalba Carriera at Venice. She settled in London 1754 and was well patronised at once by the Scots, but soon became a very fashionable portraitist and was favoured with the patronage of Queen Charlotte (1761). Exh. SA 1760-72; FS 1761-68; RA 1773-76. There are good mezzotints of a number of her portraits up to 1772. Her prices for single figures were £20 in 1772 and rose to £31 10s. in 1775 (when she was charging £157 10s. for a full length in oils). She went to India in 1777, with her niece Helena Beatson (q.v.), who married in 1777 and gave up art. She did a few portraits in India, but sailed for home in 1778 and died on the voyage *(Foster)*. She was especially successful with children's portraits; her oil portraits show the influence of Reynolds.

(Lady Victoria Manners, Connoisseur, LXXXVIII (Dec. 1931), 376-386; LXXXIX (Jan. 1932) 35-40; (March 1932) 171-178.

READ, Matthias **1669-1747**
All-purpose and decorative painter at Whitehaven.

(W. Jackson, 1892, i, 89ff.; Harris, 99, 152-3.)

READ, William **fl.1778**
Exh. 'Portrait of an artist' SA 1778, and a miniature RA 1778. A 'W. Read' also exh. 'Subjects from Shakespeare's Henry IVth' RA 1808.

REBECCA, Biagio **1735-1808**
Decorative and historical painter. Born Osimo, Marche 1735; died London 22 February 1808. Studied at Accademia di S. Luca, Rome, where he became friends with Benjamin West, and with George James (q.v.) with whom he came to London as an assistant, 1760, but with whom he soon quarrelled. Entered RA Schools 1769. Exh. RA 1770-72. ARA 1771. He painted decorations for Adam, Wyatt and Holland. As well as history subjects, he specialised in grotesques and chiaroscuros. Examples of his decorative work survive at Audley End, Harewood, Kedleston and Kenwood. He designed the figures for Peckitt's stained glass on the North side of New College Chapel, Oxford, 1772.

(E.C-M.)

REDMOND, Thomas **?c.1745-1785**
Provincial miniaturist and portrait painter in oils and crayons. Born in Breconshire; died Bath 1785 *(Edwards)*. Studied briefly at St. Martin's Lane Academy. Exh. FS 1762-66; SA 1767-71; RA 1775-83 (mainly miniatures). He was settled in Bath from at least 1769.

(Long.)

REED **fl.c.1722**
Painted religious wall paintings c.1722 in St. Andrew's, Penrith (now destroyed).

(J. Walker, History of Penrith, 1858.)

REED, E. **fl.1774-?1801**
Landscape painter. Exh. SA 1774; presumably the 'Mr Reed' exh. FS 1776 and 1783; probably also exh. RA 1794 and 1801 from Walthamstow and Camberwell.

REINAGLE, Philip **1749-1833**
At first a portrait painter; later specialised in animal painting and sporting pictures, botanical subjects and landscape. Born Scotland, ?Edinburgh, 1749 (the son of a Hungarian musician); died Chelsea 27 November 1833. Entered RA Schools 1769. In the 1770s assistant to Ramsay in his factory for the repetition of royal portraits. Exh. RA 1773-1827; BI 1806-29. ARA 1787; RA 1812. From 1780, for a year or two, he visited Norwich and painted conversation pieces in the manner of Walton. His picture of his own children, RA 1788 (National Trust, Upton House) was long mistaken for Peters. Later he took to painting animals in the manner of Snyders (e.g. his diploma picture 1801), landscapes in the style of the Dutch masters (of which he was a skilful imitator and restorer) and sporting pictures in a landscape setting. Two daughters, **Fanny** (exh. RA 1799-1820; BI 1807-11) and **Charlotte** (exh. RA 1798-1808; BI 1807-21) painted portraits, miniatures, copies of old masters, and landscapes.

PHILIP REINAGLE. 'General Bandbox, held by Beckett at Birdsall.' 50ins. x 60ins. s. & d. 1792. Lord Middleton, Birdsall.
One of a pair. This picture shows Reinagle's virtuosity as portrait, sporting and landscape painter.

REINAGLE, Ramsay Richard **1775-1862**
Painter of portraits, panoramas, landscapes and sporting pictures; also an abundant watercolour painter up to about 1813. Born London 19 March 1775; died Chelsea 17 November 1862. Son and pupil of Philip Reinagle (q.v.) he precociously exh. 'Dead Game', RA 1788. Exh. very abundantly at RA 1788-1857; BI 1807-54. ARA 1814; RA 1823 (but his diploma was withdrawn 1848 for indiscretion). Travelled under difficulties 1793-98 in Holland and Italy (Rome, Naples and Florence, of which he produced panoramas 1802-6). Assistant to Hoppner (q.v.) *c.*1810 and painted most of the versions of Hoppner's portrait of 'Pitt'. His best portraits, between Hoppner and Lawrence in style, are very competent, e.g. 'Thomas Coke', 1815 (Holkham). He was much concerned with dealing and restoring old masters, and fell on bad times after 1848. His landscapes are remarkably close to nature and very competently unpoetical.

REMSDYKE See RYMSDYK A. van

RENALDI, Francesco **1755-after 1798**
Portrait and history painter. Born January 1755; last recorded 1798. Entered RA Schools 1777. Exh. RA 1777 (crayon portrait), 1784-85, 1791 (from Calcutta), 1797-98; SA 1778. He was in Rome and Naples 1781, where he became friendly with Thomas Jones (q.v.). He was in India 1786-96. If the 'Palmer family', *c.*1786 (India Office) is by him, it is his best work, as most of his Indian 'conversations' are very feeble. Back in London 1796. His last work is 'The artist with the family of Thomas Jones', RA 1798 (Cardiff).

(Archer, 1979, 281ff, and Apollo, CIV (Aug. 1976), 98-105.)

RENNELL, Thomas **1718-1788**
Devonshire portrait and (bad) landscape painter. Born Chudleigh 1718; died Dartmouth 19 October 1788. Pupil of Hudson (q.v.). Lived later in Exeter, Plymouth and Dartmouth and was astonishingly idle. He is known only from Fisher's mezzotint of his 'John Huxham'.

(Northcote, Life of Reynolds, 1815, supplement, Vn.)

REY **fl.1763**
Exh. landscapes SA 1763.

REYNELL, Thomas **fl.?1788**
A picture of an 'Old lady teaching children the alphabet', in the manner of Opie, signed and dated 1788 was sold S, 28.1.1953, 158. This cannot have been by Thomas Rennell (q.v.).

REYNER, Christopher **fl.1735**
Face painter at York. Petitioned for release from prison for debt, 1735. His son, another Christopher, was apprenticed in 1736 to James Carpenter of York, painter stainer.

(Leeds Art Calendar, no.42, 1959, 20.)

REYNOLDS **fl.*c.*1778**
A 'Mr Reynolds late of Dublin deceased' (1797) painted a portrait of 'David McBride' (d.1778) which was later engraved by J.T. Smith.

(Strickland.)

REYNOLDS, Frances **1729-1807**
Amateur portrait and miniature painter. Born Plympton 6 June 1729; died London 1 November 1807. Sister, and for long also housekeeper, to Sir Joshua Reynolds (q.v.), whose portraits she sometimes copied, to her brother's embarrassment. Her portrait of 'Samuel Johnson', 1783, is alleged to be that at Trinity College, Oxford.

THOMAS REYNELL. 'Teaching the alphabet.' 32¼ ins. x 36½ ins. s. & d. 1788. Sotheby's sale 28.1.1953 (158).
The work of an unknown painter who had clearly been influenced by the Opie schoolmistress of 1784, page 264.

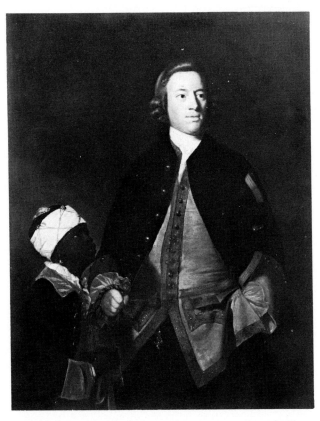

Sir JOSHUA REYNOLDS. 'Lieutenant Paul Henry Ourry.' 50ins. x 40ins. c.1746/7. Saltram (National Trust).
One of the best of Reynolds' portraits before he went to Italy, painted at Plymouth Dock. It is almost the only known example of a 1st Lieutenant R.N.'s uniform. (Ourry became a Commander 1756, Captain 1757.)

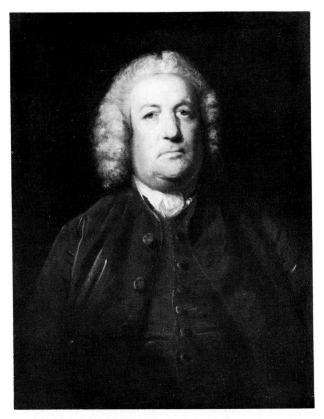

Sir JOSHUA REYNOLDS. 'Unknown gentleman, 1755.' 30ins. x 25ins. Signed 'JR/1755'. With Agnew's 1980.
At one time called 'the Dean of Durham' — but he is not a cleric. It shows that Reynolds had looked attentively at Hogarth's portraits.

REYNOLDS, Sir Joshua 1723-1792

Portrait and history painter; the dominant artistic personality of the age of George III and the first President of the Royal Academy. Born Plympton, Devon 16 July 1723; died London 23 February 1792. Apprenticed to Hudson (q.v.) 1740-43. Practised in Devonshire and London 1743-49, when he sailed for Italy. In Rome 1750-52, where he studied intensively the style of the great masters. Returned via Florence and the North Italian cities and Paris, and settled in London 1753 for the rest of his life. Well before the first public exhibition was held in 1760 he had established himself as the leading portrait painter in London, master of a new style, either heroic or intimate (which had been anticipated by Hogarth and Ramsay) which for the first time interprets character as we understand it today. When George III established the Royal Academy in 1768, Reynolds was the only possible candidate for the Presidency — even though the King found his style and his personality unsympathetic — and he was knighted in 1769. Exh. SA 1760-68; RA 1769-90 (when he went blind).

Hogarth and Reynolds were the only two egg-heads in the British painting scene in the 18th century. Hogarth made no impact on the classes who dispensed patronage and was impatient with them. Reynolds was determined to win their support and to raise the status of the artist in British society — and in this he was successful. His success was based on the creation of a kind of portrait which could hold its own in company with the old masters who were fashionable with the nobility (e.g. Guido Reni) and which would echo the classical statuary which was finding its way into British collections. The portraits which he sent to the public exhibitions tended to stress this style, e.g. 'Elizabeth, Duchess of Hamilton and Argyll', SA 1760; 'Lady Blake as Juno', RA 1769, and at the same time to set an example to the more youthful exhibitors of what he hoped they would do. At

Sir JOSHUA REYNOLDS.
'Mary, Viscountess Dudley and
Ward.' 115½ ins. x 65½ ins.
Paid for 1763. With Agnew's
1980.
The most spectacular
example of the not very
promising subject 'a peeress
in robes'. The robes may
well have been painted by
Peter Toms (q.v.), but are
of great virtuosity.

the same time, in his annual *Discourses* (best edition ed. Robert Wark, Yale, 1975) at the Academy prize-givings, he preached an accepted theory (which didn't bear much resemblance to his own practice) which he thought would be acceptable to the collecting classes. His less grandiose portraits he often enriched by poses based on well-known old masters, a procedure which Horace Walpole defined as 'wit'. Even when we cannot identify the 'model', e.g. 'Georgiana, Lady Spencer and her daughter', 1760/1, the impressiveness of the image is immensely enhanced by the suggestion of belonging to the great European tradition. The echoes of both Titian and Rembrandt in his own 'Self portrait', *c.*1773, painted for the Royal Academy, sum up this aspect of his art. The best of his unexhibited single heads, painted in a vein which continues the tradition of Hogarth, reveal an extraordinarily sharp eye for likeness. The buttery texture of Reynolds' paint is often agreeable, but he was so prone to experiment with paint mediums that both colour and surface have often deteriorated.

There is often also a problem of how much (apart from the face) in Reynolds' portraits, was the work of the drapery painter or of a studio assistant. From about 1771 onwards he also produced (and sometimes exhibited) a number of fancy pictures, which became very popular in engraving and of which a surprising number of rather competent copies survive. He also tried his hand, from the mid-1770s onwards, in history pictures, of which the least disastrous is 'The infant Hercules', RA 1788 (Leningrad) painted, for an enormous price, for the Empress of Russia. After a visit to the Netherlands in 1781, and a renewed study of Rubens, some of Reynolds' exhibited portraits become more simple, e.g. 'Lavinia, Viscountess Althorp', RA 1782, and are among the most natural and entrancing of the century. Reynolds never learned how to draw properly and his surviving drawings *(Luke Herrmann, Burlington Mag., CX (Dec. 1968), 650ff.)* are mainly excerpts from the pictures of old masters.

Reynolds' professional career is very fully documented. Two of his ledgers survive *(Walpole Soc., XLII, 1970)* and a great many of his sitter and appointment books (all but one of the survivors in the RA Library; only the earliest (1755) at Plymouth has been fully published *(Walpole Soc., XLI, 1968)*. There is a selective bibliography in Ellis Waterhouse, *Reynolds,* 1973, but the largest selection of illustrations is still Ellis Waterhouse, *Reynolds,* 1941.

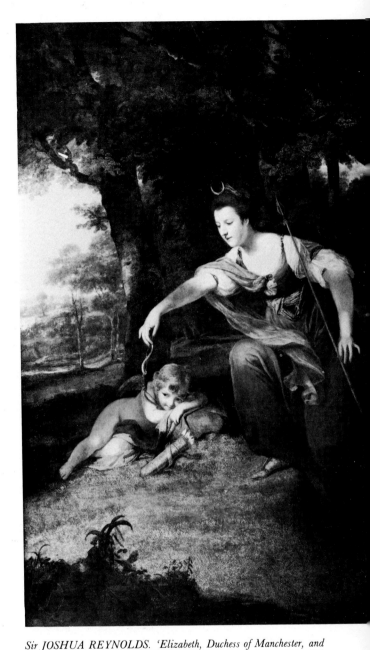

Sir JOSHUA REYNOLDS. 'Elizabeth, Duchess of Manchester, and George, Viscount Mandeville (1763-72).' 100ins. x 66ins. Exh. RA 1769 (89). National Trust, Wimpole.
Exh. as 'in the character of Diana disarming love' (the figures taken from an Albano in the Louvre). It was the first item in Reynolds' contribution to the first Academy exhibition, as a sample of what he thought aristocratic portraiture should be!

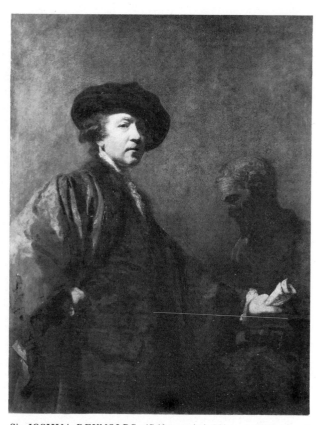

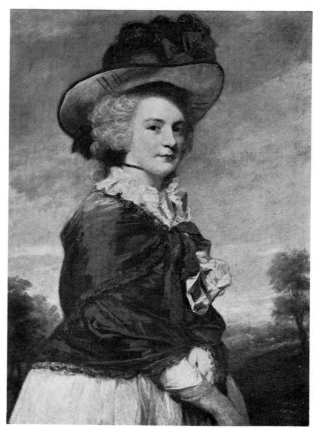

Sir JOSHUA REYNOLDS. 'Self portrait.' 50ins. x 40ins. Royal Academy of Arts.
Probably 1773 (when he was made LL.D. at Oxford). There are deliberate echoes of Titian and Rembrandt and the bust in the background is of Michelangelo.

Sir JOSHUA REYNOLDS. 'Mrs. Thomas Meyrick' (Miss Keppel). 37½ins. x 29½ins. 1782. Ashmolean Museum, Oxford.
She was sitting in 1782. Reynolds had visited Flanders in 1781 and been influenced by the unaffected naturalness of Rubens' best portraits.

Sir JOSHUA REYNOLDS. 'The Ladies Waldegrave.' 55ins. x 65½ins. Exh. RA 1781 (187). Edinburgh, National Gallery of Scotland (2171).
The daughters of James, 2nd Earl Waldegrave; painted for their great-uncle, Horace Walpole, 1780/1. They are shown making lace.

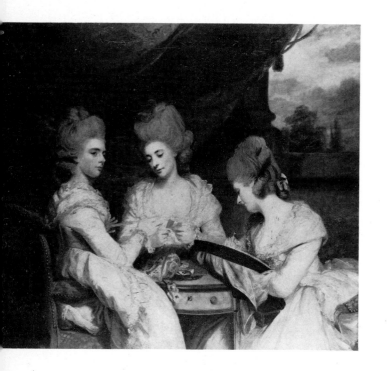

Sir JOSHUA REYNOLDS. 'Members of the Society of Dilettanti (1).'' 77½ins. x 59ins. 1777-79. The Society of Dilettanti.
This pair of pictures (see also page 324), though framed separately, forms a continuous composition. The moment chosen is the introduction of Sir William Hamilton as a member of the Society and the drinking of his health. All the officers of the Society are in their official robes.

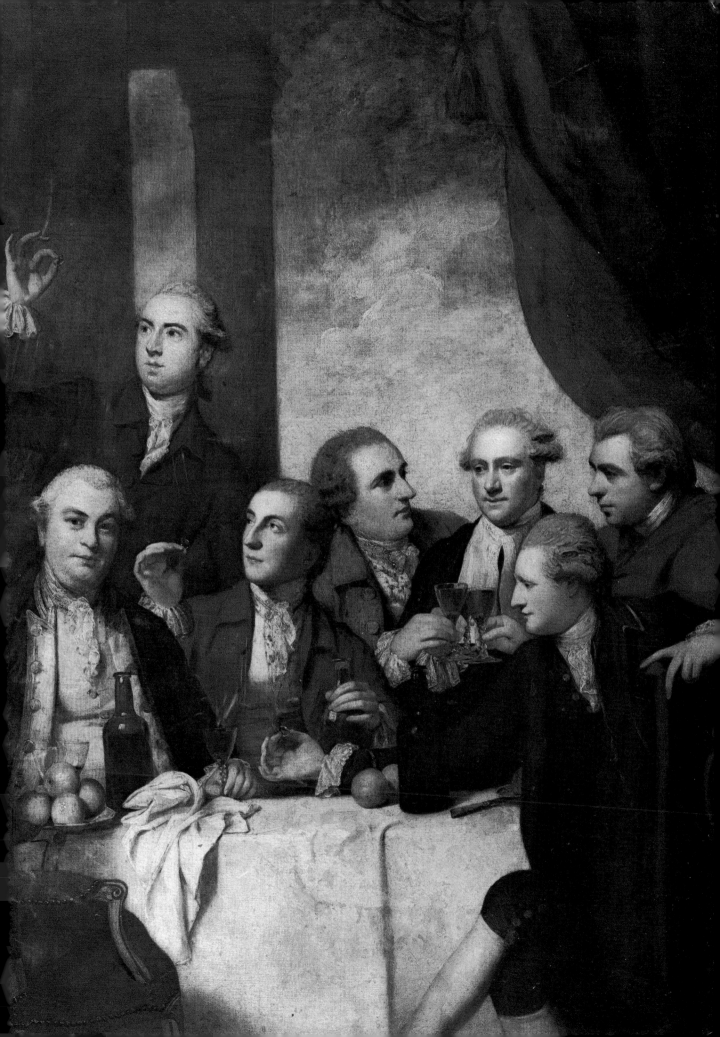

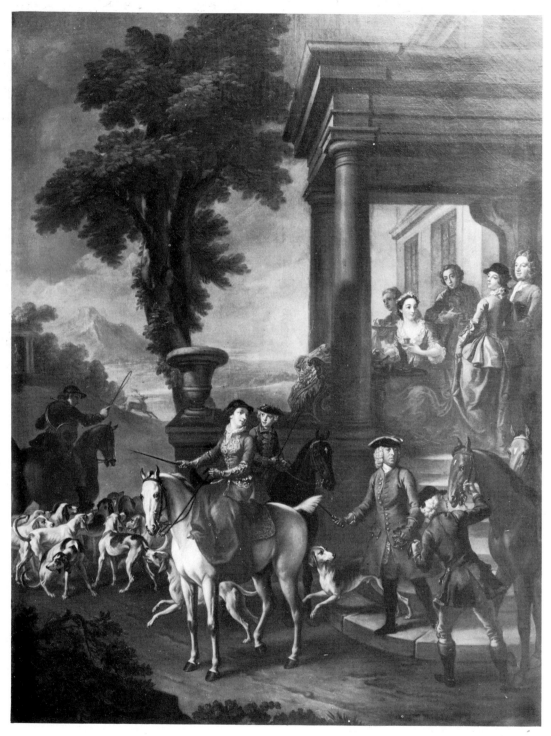

PETRUS JOHANNES VAN REYSCHOOT. 'Sporting conversation.' 92ins. x 70ins. s. & d. 1743. Sotheby's sale 13.3.1963 (73/1).
One of a pair which show that Reyschoot had looked at the work of Hayman, Nollekens and Wootton.

REYNOLDS, Samuel William　　　1773-1835
Best known as an engraver, but also an occasional portrait and landscape painter. Born ?London 4 July 1773; died there 13 August 1835. Studied painting under Hodges. Exh. RA 1797-1827 (at first portraits, but, after 1799, 'studies from nature'); BI 1806-34. He was an extremely accomplished engraver (*Alfred Whitman, S.W.R., 1903*) and his landscapes are now uncommon, but they are remarkably fresh and anticipate those of Constable. He was patronised by Samuel Whitbread and the best of these landscapes are at Southill.

(DNB.)

REYSCHOOT, Petrus Johannes van 1702-1772
Flemish portrait, history, and sporting painter. Born Ghent, from an artist family, 1702; died there 28 February 1772. He was known in Ghent as 'the Englishman' to distinguish him from a brother. Possibly the Reyschoot who won a prize at the Paris Academy 1730. His signed and dated works painted in England range from 1736 to 1743. His portrait style is a compound of Hudson (q.v.) and Van Loo and his sporting conversations show an affinity with Hayman (q.v.). He seems to have toured the provinces to some extent and is variously named 'Rischoot' or 'van Risquet'.

(E.C-M.)

RIARIO, Francesco　　　fl.*c.*1730
Italian history painter, who worked in London for Lord Carpenter (d.1731/2). He 'was a rare doctor of pictures' *(Vertue, iii, 80).*

(E.C-M.)

RICCI, Marco　　　1676-1730
Venetian painter of landscape and *capricci,* and stage decorator. Baptised Belluno 5 June 1676; died Venice 21 January 1729/30. Nephew and pupil of Sebastiano Ricci (q.v.). Brought to London 1708, with Domenico Pellegrini (q.v.), by the Earl of Manchester. Designed scenery for several operas until 1710. Returned to London with Sebastiano Ricci 1711/12-16. In England he specialised in landscape overdoors, for Castle Howard and the Earl of Burlington. He also painted similar landscape *capricci* as easel pictures on canvas or thin leather in gouache (many of which are at Windsor, but not done in England).

(E.C-M.)

PETRUS JOHANNES VAN REYSCHOOT. 'John Cotton.' 32½ins. x 26ins. s. & d. 1742. Christie's sale 1.7.1938 (107). Van Reyschoot had quite a good portrait practice among Midland gentry.

RICCI, Sebastiano　　　1659-1734
One of the pioneers of Venetian Settecento painting. Baptised Belluno 1 August 1659; died Venice 15 May 1734. Educated all over Italy and especially influenced by Veronese and Luca Giordano's Venetian works. Came to England with his nephew Marco Ricci 1711/2 and remained till 1716, hoping to be employed in the major decorative works which were eventually given to Thornhill. His chief works in London were paintings and ceilings for Burlington House (still there) and the dome of the apse in Chelsea Hospital Chapel.

(E.C-M.)

SEBASTIANO RICCI. '*Cupid before Jupiter.*' *Probably 1715/6. London, Royal Academy of Arts.*
Ceiling painting for the original Burlington House: still *in situ.*

RICCIARDELLI, Gabriello fl.1741-1777

Neapolitan painter of decorative and topographical landscapes, and engraver. Pupil of Orizonte at Rome for two years. Employed at Court in Naples *c.*1741. Worked in Dublin from 1753 to after 1759. Last recorded exhibiting in the Strand in London 1777.

(Strickland; Crookshank and Knight of Glin, 1978.)

RICHARDS fl.1769-1783

A 'Mr Richards' exh. landscapes and occasional subject pictures at FS 1769-75 and 1783. He cannot have been John Inigo Richards (q.v.), the newly appointed Academician (as Graves suggests), but he might have been his father, who painted the decorative scroll-work 1735/6 for Hogarth's pictures in St. Bartholomew's Hospital.

(E.C-M.)

JOHN INIGO RICHARDS. *'View in a town with Roman ruins.'* *27ins. x 41½ins. s. & d. 1763. Christie's sale 28.3.1947 (109).* Possibly a composition for a stage setting. It is in the manner of Poussin Lemaire.

RICHARDS, Edward fl.1771-1775

Kent landscape painter. Exh. FS 1771-75 mainly with an address at Charlton, Kent.

RICHARDS, J. fl.1781-1800

Exh. landscapes, mainly in watercolours, at RA between 1781 and 1792 and 1800.

RICHARDS, John Inigo 1731-1810

Landscape and scene painter. Born London 1731 (*Farington 5 Jan., 1794*); died there 18 December 1810. Exh. SA 1762-68 topographical and plain rural landscapes. A foundation RA 1768 and exh. RA 1769-1809, rather infrequently after becoming secretary in 1788. He was a very successful scene painter and was principal painter at Covent Garden 1777-1803. Exh. some scenes from his stage settings, 'The Maid of the Mill', SA 1765 (BAC Yale). He also painted views of country houses, e.g. 'Halswell', SA 1764 (Cardiff), and anticipations of the picturesque, 'A cascade', 1770 (Stourhead) but he was an unadventurous landscape painter.

(E.C-M.)

JOHN INIGO RICHARDS. *'Two gentlemen contemplating a waterfall.'* *31½ins. x 25ins. s. & d. 1770. Stourhead (National Trust).*
A fairly early example of the admiration for picturesque scenery. At the RA 1769 Richards had also exh. 'A cascade at Hestercombe'.

RICHARDSON, Alice fl. 1776 (1769-1775)

Exh. three crayons portraits at RA 1776. She was presumably the 'Mrs Richardson' who exh. crayons SA 1769-75.

RICHARDSON, Daniel fl. 1783-1830

Still-life painter. Exh. RA 1783; 1799-1802, and between 1820 and 1830. He worked and exh. in Dublin 1809-19, where he had some success.

(Strickland.)

RICHARDSON, Jonathan, Sr. *c.* 1665-1745

The leading native-born portrait painter of the first forty years of the century, also a writer on art and literary topics. Born London 1664/5; died there 28 May 1745. Pupil of Riley 1688-91 and eventually his heir. He helped to found the 1711 Academy; he and Jervas (q.v.) were the busiest native-born portrait painters in rivalry with Kneller and Dahl. Jervas excelled with women's portraits and Richardson was best with men. His works are sound, solid, good likenesses, and unpretentious.

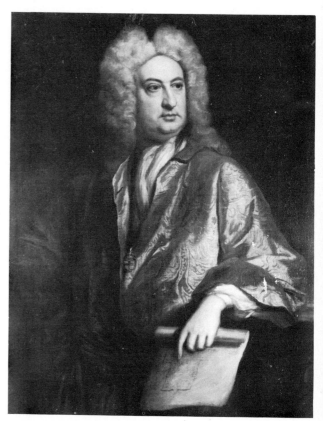

JONATHAN RICHARDSON. 'Sir John Vanbrugh.' 41¼ ins. x 33¼ ins. s. & d. 1725. College of Arms, London.
Vanbrugh was Clarencieux Herald and is wearing his badge of Office. The plan he holds is inscribed 'Blenheim' which was his most remarkable design.

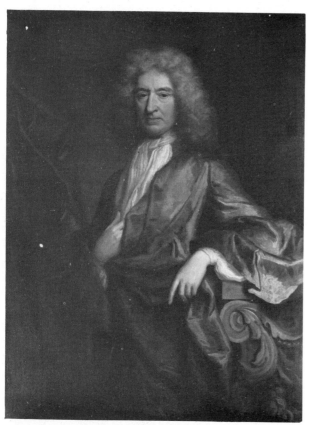

JONATHAN RICHARDSON 'Edward Colston' (1636-1721). 50ins. x 40ins. Documented as paid for (£17 11s.) in 1702. City Estates Committee, Bristol.
This early portrait still shows traces of Richardson's master, Riley, and is independent of Kneller in style.

Dated examples range from 'Edward Colston', 1702 (Corporation of Bristol) to 'Frederick, Prince of Wales', 1736 (Warwick Castle). There are many oil portraits, and even more drawings, of himself *(Kerslake, 230/1)*. His writings — especially the *Theory of Painting*, 1715, and, in collaboration with his son, the account of the works of art the grand tourist should see in Italy, 1722 — were immensely influential and fired Reynolds with the desire to become a painter. His prices in 1720 were 20, 40, and 70 guineas (for heads, half lengths and whole lengths). He owned one of the greatest collections of old master drawings. He retired from painting in 1740. Sale 1746; Lugt 653.

(DNB.)

RICHARDSON, Jonathan, Jr. 1694-1771

Amateur portrait painter and writer. Born London 1694; died there 10 June 1771. Son of Jonathan Richardson, Sr. (q.v.), whom he assisted in his literary and perhaps also in his artistic activities. He was one of the first to promote 'connoisseurship'.

RICHBELL, Captain Thomas fl.1792-1825

Hon. (except 1792) exh. RA between 1792 and 1825, of occasional pictures of marine subjects of no great distinction. He was promoted Captain in 1802.

RICKARDS, R. fl.1794

Hon. exh. RA 1794 of a view of Caerphilly Castle.

RIDDELL, R.A. fl.1793

Hon. exh. RA 1793 of a view of Dumfries.

RIDE, T. See RYDER, Thomas

RIEBENSTEIN, F. See RUBENSTEIN, F.

RIGAUD, Elizabeth Anne 1776-1852

Painter of portraits and themes from literature. Born London 30 May 1776; died there 20 April 1852. Daughter, and no doubt pupil, of J.F. Rigaud (q.v.). She exh. portraits of ladies and scenes from Thomson and Pope at RA 1797-1800. She seems to have given up painting on marrying Joseph Meymott, 1800.

RIGAUD, John Francis 1742-1810

Portrait and history painter and painter of mythological decorations. Born Turin 18 May 1742; died at Packington Hall 6 December 1810. Trained all over Italy; member of the Bologna Academy 1766. He met Barry (q.v.) in Rome and came to England with him 1771. Exh. RA 1772-1810; BI 1806-10 (and posthumously 1812, 1813 and 1815). ARA 1772; RA 1784. His decorative works (except in Great Packington Church) have all been destroyed (E. C-M.). He painted small pictures, in the style of W. Hamilton or Cipriani (qq.v.), for Boydell's Shakespeare Gallery, and huge ones for Bowyer's Historic Gallery. But his best works are his portraits, in a naturalistic and unflattering style, of which two group portraits (each of three Royal Academicians, RA 1777 and 1782) are in the NPG. His father's name was Dutilh.

(DNB, based on a biography by his son, now in Yale University Library.)

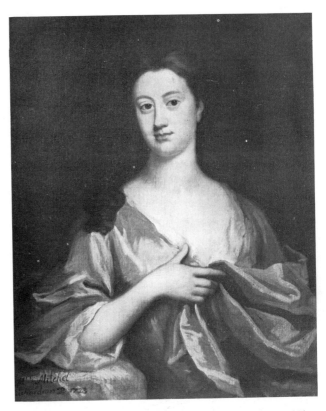

JONATHAN RICHARDSON. 'Mrs. Mitchell.' 30ins. x 25ins. s. & d. 1723. Lord Binning, Mellerstain.
The sitter was daughter of Bishop Burnett. Certain female portraits by Richardson are uncommon.

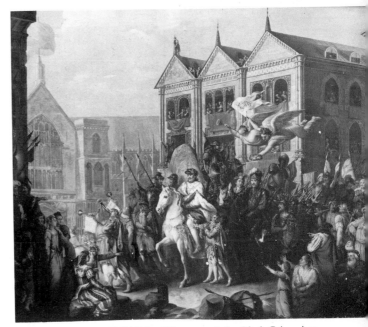

JOHN FRANCIS RIGAUD. 'The entry of the Black Prince into London with his royal prisoner.' 35½ins. x 44ins. s. & d. 1774. Exh. RA 1775 (243). Christie's sale 28.7.1955 (174).
An example of English 18th century medievalism, anticipating what became known in France as *le style Troubadour*.

311

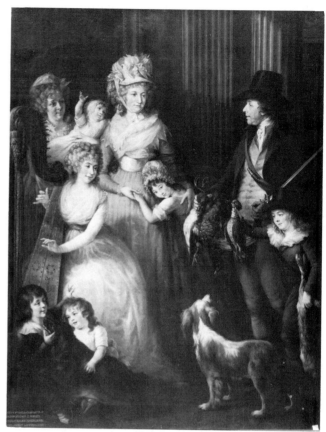

JOHN FRANCIS RIGAUD. 'The 4th Earl of Abingdon and his family.' 92ins. x 72ins. s. & d. 1793. Exh. RA 1797 (116). Sotheby's sale 18.7.1962 (177A).
The Berties were a musical family for whom Rigaud painted a number of large family portraits.

JOHN FRANCIS RIGAUD. 'Scene from Romeo and Juliet.' 30½ins. x 21½ins. s. & d. 1796. Christie's sale 13.7.1945 (143). One of the small pictures painted for Boydell's Shakespeare Gallery; engraved by J. Stow.

JOHN FRANCIS RIGAUD. 'Sir William Chambers, Joseph Wilton, and Sir Joshua Reynolds.' 46½ins. x 56½ins. s. & d. 1782. Exh. RA 1782 (111). National Portrait Gallery (987).
Portraits of three fellow Academicians: they are shown, as named, left to right.

RIGAUD, Stephen Francis Dutilh **1777-1861**
Occasional portrait and history painter, but mainly a watercolourist *(Mallalieu).* Born London 26 December 1777; died January 1861. Son of J.F. Rigaud (q.v.). Entered the RA Schools 1791. Exh. RA 1797-1848; BI 1806-18 and 1850-52.

RIGNY, Chevalier de **fl.1795-1799**
No doubt a French émigré. Exh. landscapes at RA 1795 and 1799.

RILEY, See RYLEY, C.R.

RINTOUL, William **fl.1791**
Exh. a seapiece, SA 1791. Watercolour sea views are known up to 1826 *(Mallalieu).*

RISING, John **1753-1817**
Painter of portraits and genre from common life; also restorer and professional copyist. Born June 1753; died London March 1817. Entered RA Schools 1778. Exh. RA 1785-1814; SA 1790; BI 1807-15. His portraits show at first a study of late Reynolds and then of Romney. Several are engraved. He is said to have been friendly with Reynolds and he later specialised in restoring and copying his works. Many of these copies (one is at Waddesdon) are listed in his posthumous sale 2.5.1818.

RISQUET, van See REYSCHOOT, P.J. van

RITTS (RITZ), Valentine **fl.1709-1745**
Professional copyist and painter of portraits, &c. Lived at Cambridge for some fifty years before his death there in 1745. A 'Trompe l'oeil', 1709, in the manner of E. Collier, was sold S, 1.3.1967, 137.

(Country Life, 8 Oct., 1948, 725ff.)

RIVIERE, Daniel *c.***1779-after 1800**
Entered RA Schools (as an engraver) 1800 'aged 19/20' and won a silver medal in 1800. Exh. 'Roman instruction', RA 1799.

ROBERTS, Miss Alice **fl.1777**
Exh. SA 1777 a crayon portrait 'in the character of Rubens' wife'.

ROBERTS, C.F. **fl.1791**
Exh. SA 1791 a portrait of a 'Country Lady'. The 'Mr Roberts' who exh. FS 1780 fancy pictures and historical subjects, and who is identified with this C.F. Roberts by Graves, was no doubt another person.

JOHN RISING. 'Hester, Dowager Countess of Charleville' (d.1789). 30ins. x 25ins. c.1787/9. Private collection.
Rising was a student of Reynolds in the 1780s and became the most skilful restorer of his pictures.

ROBERTS, James **1753-*c.*1809**
Portraitist of figures in small scale in oils and watercolours; also a miniaturist. Entered RA Schools 1771. Exh. RA 1773-99. His portraits are mainly of actors in character parts and he made some stage scenery. Feeble examples of his style are at the Garrick Club. He is said to have practised as a drawing master at Oxford *c.*1784-94, and is last recorded as publishing *Introductory lessons...in watercolours,* 1809.

(Mallalieu.)

ROBERTS, Samuel **1757-after 1782**

Painter of still-life. Born February 1757. Entered RA Schools 1782. Exh. RA 1778-82, mainly pictures of fish.

ROBERTS, Thomas **1748-1778**

Irish romantic landscape painter. Born Waterford 1748; died at Lisbon March 1778. Pupil of Mullins (q.v.) and others. He won a prize at the Dublin Society's School 1763. Exh. Dublin 1766-77 and in London FS 1771; SA 1775 and 1777. He was well patronised by the Irish nobility and, in addition to pictures in the style of Vernet, painted horse portraits, views of country houses and was the best painter of his day of Irish romantic landscapes.

(Crookshank and Knight of Glim, 1978.)

ROBERTS, Thomas Sautelle **1764-1826**

Irish landscape and sporting painter in oil and watercolour. Born Waterford 1764; died Portobello 1826. Youngest brother of the last (and took the name of Thomas after his death). Won a medal at the Dublin School 1779. Entered RA Schools 1791 and remained in London until 1799. Exh. RA 1789-1811 and 1818; BI 1807-18; in Dublin 1800-21. He was a foundation RHA 1823, but was incapacitated for painting by an accident about that time. He worked mainly in watercolour and published aquatints of his Irish views, which are much more prosaic and less interesting than those of his brother. A sister also painted landscapes.

(Strickland.)

THOMAS ROBERTS. 'Stormy landscape.' 43½ins. x 59ins. s. & d. 1775. Christie's sale 23.6.1950 (53/2).
An eclectic Irish landscape painter of much talent, who tempered the style of Vernet with Dutch elements.

W. ROBERTSON. 'Prince Charles Edward Stuart.' 29 ¼ ins. x 24 ½ ins. Signed. Sotheby's sale 30.6.1948 (22).
A sort of Jacobite Devis of the '45, whose only known works are this and a 'Flora Macdonald'.

ROBERTSON, George **1749-1788**

Landscape painter (mainly in watercolour) and history painter. Born London 1749; died Newington Butts 26 September 1788. Studied at Shipley's Academy, won premiums from Society of Arts 1760/1. He studied landscape in Italy and exh. RA 1772 (Italian views); SA 1773-83 (and posthumously 1790). He accompanied William Beckford of Somerley to Jamaica 1774, for whom he painted a number of views which were later engraved, and he exhibited many at SA (*Caribbeana, i, 1910, 187*). Later he became a successful drawing master in London (*Edwards*). His portrait by Rigaud, with landscape by himself, is at BAC Yale.

(*R.B. Sheridan, Register of the Museum of Art, University of Kansas, iii (Winter 1967), 14ff.*)

ROBERTSON, W. **fl.c.1745**

A small whole length of 'Prince Charles Edward Stuart', signed 'W. Robertson ad vivum pinxit' was sold S, 30.6.1948, 22. Another exists of 'Flora Macdonald'. The style is reminiscent of that of Charles Phillips.

ROBINEAU, Auguste **fl.1785-1816**

French portrait painter. Exh. four portraits RA 1785 (as 'A. Robineau'). '— Robineau' also exh. portraits at RA 1788, but this may have been the J. Robineau whose portrait of 'Mendoza' was mezzotinted by H. Kingsbury 1789. Auguste exh. at the French Salon 1791 and 1799 and is said to have been traceable in Paris up to 1816 (*Th.-B.*). His father ?**Charles Jean** painted small full lengths of and for George IV (as Prince of Wales) 1787 and there is also one of 'C.F. Abel', 1780 (Kew Palace).

(*Millar, 1969, 109.*)

ROBINSON, Archibald **fl.1767**

Hon. exh. of 'View of a farm from nature', SA 1767.

ROBINSON, Hugh **1756-1790**

Portrait painter. Born Malton September 1756; died 1790. Entered RA Schools 1779 and certainly looked at Reynolds and Romney and perhaps at Opie's beginnings in 1782. Exh. RA 1780 and 1782 and left for Italy 1783. He started to come home by horse in 1790 but died on the road and his Italian pictures were all lost at sea (*The Athenaeum, 12 March, 1881*). His surviving works, which show great promise, all belong to the Teesdale family.

ROBINSON, Isaac **d.1772**

The death of Isaac Robinson, 'portrait painter', is recorded by the *Gentleman's Magazine (10 Aug., 1772).*

ROBINSON, John **c.1715-1745**

Portrait painter. Born c.1715; died London 1745. Apprenticed to Vanderbank for five years, 23 June 1737 (but Vanderbank died 1739). He took Jervas' (d.1739) house and studio in London and was doing very well when he suddenly died (*Vertue, iii, 124/5*). His 'Lady Georgiana Spencer' (Althorp) is listed as Robinson in 1746 and shows a more refined version of Vanderbank's style.

ROBINSON, Matthew **1694-1778**

Father of the famous Mrs. Elizabeth Montagu. Well-known as an amateur painter (*Goulding and Adams, 476*) but only watercolour landscapes are known.

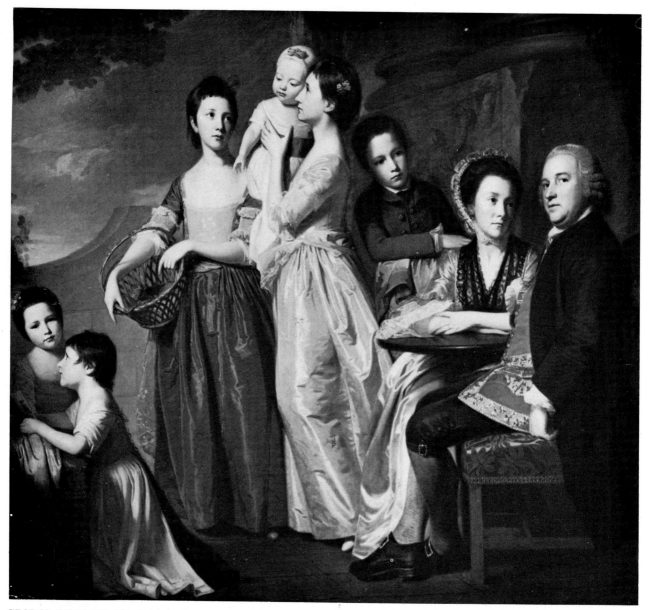

GEORGE ROMNEY. 'The Leigh family.' 72¾ ins. x 79½ ins. Exh. FS 1768 (180). National Gallery of Victoria, Melbourne (Felton Bequest, 1959).
One of Romney's few exhibited pictures, before he went to Italy. It was adversely (and quite unfairly) criticised by Garrick, perhaps at the instigation of Reynolds.

ROBINSON, Matthew **fl. 1725**
'Matthew Robinson, painter, son of William Robinson of Chester, painter, defunct' was admitted a Freeman of the City of Chester 30 January 1724/5.

(Lancashire and Cheshire Record Soc., LV (1908), 271.)

ROBINSON, Thomas **d. 1734**
Portrait painter. Died London 11 December 1734. He was a man of some intellectual distinction who went blind in his later years. He was the father of the singer Anastasia Robinson, who eventually married the 3rd Earl of Peterborough.

(Mrs. Delany's Autobiography 1861, i, 72ff.; Redgrave.)

GEORGE ROMNEY. 'Lady Hamilton as a Bacchante.' 49½ ins. x 39ins. Unfinished. Formerly with Duveen.
One of Romney's later interpretations of his 'divine Emma', which were his type of 'fancy picture'.

ROBINSON, Thomas fl. *c.* 1785-1810

Portrait, historical and landscape painter. Born near Lake Windermere (he often signs 'Robinson of Windermere'); died Dublin 27 July 1810. Pupil of Romney *c.* 1785. He worked entirely in Ireland. From 1790 in Dublin, when his prices were 4, 10 and 20 guineas; 1801-8 in Belfast; then again in Dublin, where he was President of the Society of Artists 1809/10. His style is variable: his largest historical work is in the Belfast Harbour Office.

(Crookshank and Knight of Glin, 1978.)

ROCCA, Andrea fl. 1771

Exh. crayon portraits at RA 1771.

ROGERS, George 1718-1792

Amateur landscape painter in oil and watercolour. Born Southampton 1718; died there 26 September 1792. He married a daughter of Jonathan Tyers, proprietor of Vauxhall Gardens. Hon. exh. SA 1761-62; RA 1788 (one shown 1793 must be by another hand). *Edwards* says his landscapes were of some merit.

(Grant.)

ROMA, Spiridione *c.* 1735-1787

Portraitist, decorative and history painter. Born in Corfu; died London 1787. He came to England *c.* 1770 and did decorative painting in the chapel at The Vyne. He later set up as a portrait painter in London, but his chief business was restoring pictures for the City Companies. A historical ceiling, 1778, survives in the Commonwealth Relations Office *(E.C-M.)*. Exh. portraits at RA 1774-75; and drawings of historical scenes 1777-78.

(Gentleman's Mag., Aug. 1789, 701ff.)

ROMNEY, George 1734-1802

Fashionable portrait painter, with great aspirations to history painting. Born Beckside, nr. Dalton-in-Furness, 15 December 1734; died Kendal 15 November 1802. Apprenticed to Christopher Steele (q.v.) at Kendal, York and Lancaster 1755-57, who taught him a neat style and a sense of clear colour. Painted at Kendal 1757-62, notably small full length portraits, and was good at taking a likeness by the time he settled in London 1762. Won premiums for historical paintings from Society of Arts 1763 and 1765. Exh. FS 1763-69; SA 1770-72. 'The painter's brothers', FS 1766 (BAC Yale) and 'The family of Mr Leigh', FS 1768 (Melbourne), show already a tendency towards the neo-classical, which was reinforced by study in Italy 1773-75 (mainly Rome, but also Parma and Venice). Returning to London he took Cotes' rather grand house in 1776, and soon, with Reynolds and Gainsborough, became the third of the fashionable portrait painters, with a very good business. His prices remained below those of the other two — for 30 by 25 portraits he charged 15 gns. (1775), 20 gns (1781), 25 gns (1787), 30 gns (1789) and 35 gns (1793); double for half lengths, and double again for whole lengths. His appointments books survive from 1776 until 1795 *(H. Ward and W. Roberts, R., 1904)*. He never exhibited at the RA (partly owing to the hostility of Reynolds) and had no need to. His patterns (which are like those of fashionable photographers of a later age) are very effective and changed little. His best years were 1775-80 and the most ambitious masterpiece of these years is 'The children of Earl Gower', 1776/7 (Art Gallery, Kendal). In 1781 he first encountered Emma Hart (who became Lady Hamilton in 1791 and gave up sitting) and was hypnotised by her beauty and adaptability as a model. The very numerous portraits of her, many impersonating mythological or allegorical characters, are the most famous, but not the best of his pictures. He is best with youthful sitters, of

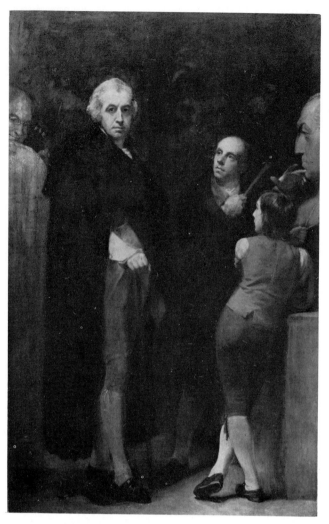

GEORGE ROMNEY. 'Flaxman modelling the bust of Hayley.'
89ins. x 57ins. Unfinished; painted 1797-1802. B.A.C. Yale.
Even at the end of his life, when his heart was in the subject,
Romney could produce a distinguished likeness.

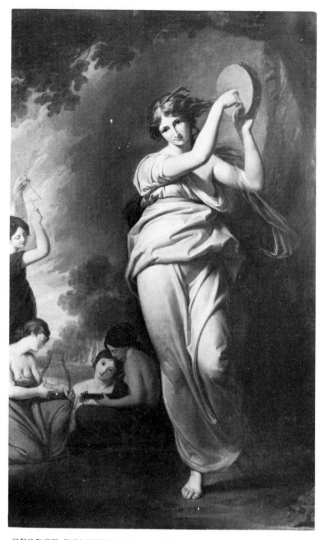

GEORGE ROMNEY. 'Mirth.' 93ins. x 56½ins. Exh. SA 1770
(112). With Agnews 1969.
Romney always had hankerings after 'history' pictures. This
was an early, neo-classic, attempt at L'Allegro, which had a
companion.

either sex, of no very pronounced character.

There is a falling off in quality after 1785 in all but a few of his works and, by 1798, when he sold his house to Shee (q.v.) and retired to Kendal, he was more or less imbecile. His passion for history painting was mainly displayed in very numerous drawings, of which a very large number are in the Fitzwilliam Museum, Cambridge (exh. cat., P. Jaffé, 1979).

ROMNEY, Peter **1743-1777**
Portrait painter, mainly in crayons. Born near Dalton-in-Furness 1 June 1743; died Stockport May 1777. Younger brother and pupil 1759-62, of George Romney (q.v.). He practised mainly in the Manchester area from 1767 (with interludes at Liverpool, 1769, Ipswich, and Cambridge 1774), but was feckless and unbusinesslike.

(Rev. J. Romney, Memoirs..., 271-311.)

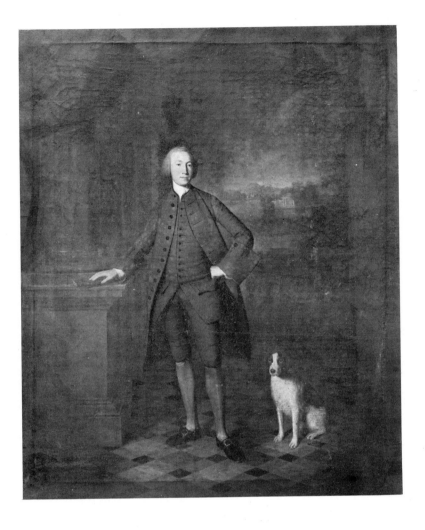

GEORGE ROMNEY. 'Rev. Daniel Wilson.'
*41½ ins. x 34½ ins. s. & d. 1760. Sotheby's sale
20.11.1963 (124).*
An example of Romney's early style, modelled
on Christopher Steele, before he came to
London.

ROOKER, Michael (Angelo) **1747-1801**

Topographical painter in watercolour and oils; also
engraver and scene painter. Born London 25
March 1747 *(Farington, 4 March, 1801);* died there 3
March 1801. Son and pupil of the engraver
Edward Rooker. Studied landscape under Sandby
(q.v.), whose style he adopted, and who added
'Angelo' to his names! Won premiums for drawing
at Society of Arts 1759 and 1760. Entered RA
Schools 1769, ARA 1770. Exh. SA 1763-68
(mainly watercolours); RA 1769-1800. He
designed the Oxford Almanachs (at first with his
father) 1769-88 and sometimes made oil paintings
from the same compositions. From 1788 he made
an annual tour in the country and produced a great
stock of watercolours of famous abbeys, public
buildings, &c., from which he sometimes also
made·oil paintings. He was one of the ablest and
neatest of topographical painters: his oils often
have the tonality of watercolours.

(Mallalieu.)

ROPER, Richard **fl.*c.*1735-*c.*1775.**

Sporting and still life painter; also painted portraits
in oils and crayons. Exh. SA 1761-62; FS 1763-65.
There is a rather nondescript portrait of 'Henry
Bankes', 1764 (Kingston Lacy).

(Egerton.)

ROSS, George **fl.*c.*1710**

Portrait painter in Scotland. A quite professional
portrait of 'Col. John Somerville' of *c.*1710 at
Hopetoun is listed as by George Ross in 1733.

ROSS, J. **fl.*c.*1770s**

Signs some sporting pictures and a pastoral land-
scape (sale S., 2.2.1966, 162) which is a parody of
Gainsborough. It is unlikely that he was the same
as the James Ross, the engraver and topographical
draughtsman, who died at Worcester 16 September
1821, aged 76 *(Redgrave).* A James Ross also
painted hunting scenes *c.*1729-32 *(Egerton).*

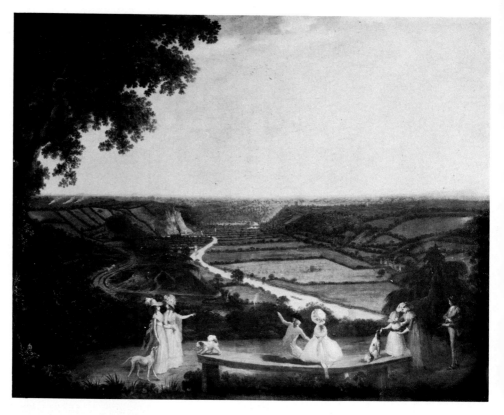

MICHAEL ANGELO ROOKER. 'A family in a landscape.' 38ins. x 48ins. s. & d. 1799. Christie's sale 30.10.1942 (108).
Figures, even on this scale, are an unusual element in Rooker's landscapes or townscapes.

ROSS, Thomas fl.1730-1746

Provincial portrait and landscape painter and decorative painter; perhaps from Bury St. Edmunds. A landscape of 1741 is of some merit, *(Grant, iii, pl.14)*. A signed portrait of 'William Shenstone', 1738 (NPG) and other portraits in a sub-Highmore style are known.

(List in E.C-M. who may be conflating two or more painters called T. Ross or Rosse.)

ROSS, William fl.1753

A portrait no better than an American 'primitive' of 'Lewis Rose of Culmony' at Kilravock House, is signed 'Wm. Ross pinxit 1753'. *(SNPG)*.

THOMAS ROSS. 'William Shenstone.' 30ins. x 22¼ins. s. & d. 1738. National Portrait Gallery (4386).
Presumably painted in the Midlands. Few signed portraits have so far been recorded.

JOHN JAMES ROUBY. 'A British officer at Naples.' 33ins. x 24ins. Signed on the stretcher, and dated 1792. Christie's sale 22.7.1938 (115).
Vesuvius, in the background, establishes the setting; the pose is more 'relaxed' than in military portraits painted at home.

ROTH, George fl. *c.* **1742-1778**
Professional drapery painter, probably of German origin. Probably the 'Root' *(Vertue, iii, 110),* who finished Van Loo's pictures in 1742 and then set up on his own. After Van Aken's death (1749) painted draperies for Hudson; worked for Ramsay 1767/8 and may have made copies for Reynolds. From 1752-78 lived at 51/2 Great Queen Street *(information from Anthony Oliver).* Exh. FS 1775.

He probably had two painter sons. **George Jr.,** who scraped some mezzotints (two after his own pictures) and exh. portraits and miniatures SA 1768-76 (in 1776 from Bath); a 14 by 11ins. full length lady, like a feeble Cosway, is dated 1784 on the back. **William,** born 15 December 1754. Entered RA Schools 1771. Exh. portraits and subject pictures SA from 1770 (from Reading) to 1777; FS 1775. It was probably he who copied Royal portraits for Reynolds in 1789 *(Farington, 17 April, 1794).*

ROUBY, John James **1750-1812**
Portrait and history painter. Born Plymouth 1750; died Rome 21 August 1812. In Rome by 1776 and studied with Hackert and Mengs. He married an Italian acrobat in 1779 *(Jones, Memoirs, 91)* and became a Catholic. He frequented the circle of Goethe and Angelica Kauffmann. With Catel (for the landscape) he made a copy of Carstens' 'Golden Age' (Thorwaldsen Museum, Copenhagen). His portrait of a British officer, painted at Naples 1792 (Lord Berwick sale, 22.7.1938, 115) is still predominantly English.

(Th.-B.)

ROURKE, Nathaniel **fl. 1773-1777**
Irish portrait painter. Pupil at Dublin 1773, and exhibited there once only, in 1777.

(Strickland.)

ROUW, Henry **1775-*c.* 1834**
Occasional painter of portraits, pictures of insects, &c. Mainly a monumental sculptor. Born 1775; last dated monument 1834. Younger brother of Peter Rouw, the Younger (1770-1852), gem-modeller and monumental sculptor. Entered RA Schools as a painter 1794. Exh. RA 1796-1803 and 1821 a few portraits and other works in paint, some probably in oil. Latterly, like his brother, he worked as a tomb sculptor.

(Gunnis.)

ROYER, Pierre Alexandre **fl. 1769-1796**
French landscape painter, mostly of topographical views. Probably born in Paris. Member of the Paris Guild of S. Luke 1769. Visited England and exh. RA 1774-77; SA 1778 (including some views of Garrick's Villa at Hampton). Later exh. Salon, Paris 1791-96 — where he was still showing views of London.

RUBBI See ROUBY, J.J.

RUBBIGLIARD, Vincenzo **fl. 1776-1777**
Exh. two portraits and a view of 'the interior of the English coffee house in Rome', RA 1776-77.

RUBENSTEIN, Francis **d. 1762**
Still-life, portrait and drapery painter; member of the St. Martin's Lane Academy *(Edwards).* Exh. SA 1760-61 (still-life subjects). His posthumous sale, 9.3.1762, included a number of pictures by Worlidge.

RUDYARD, Henry fl.1769-1773

Hon. exh. of views, two of which were of Boulogne and Furnes, SA 1769-73.

RUMPF, G.C. fl.1775

Exh. SA 1775 'The Halt of an Asiatick Caravan'.

RUNCIMAN, Alexander 1736-1785

Scottish historical and landscape painter, and etcher. Born Edinburgh 15 August 1736; died there 21 November 1785. Apprenticed to the decorative firm of Norie (q.v.) at Edinburgh, he became independent in 1762 and developed a proto-romantic interest in landscape. He went to Rome 1766 with a view to studying landscape, but was converted to history painting and became friendly with Fuseli and Barry (qq.v.), by whom he was much influenced. He remained in Italy (Rome and Naples) until 1771 and produced remarkable landscape drawings (the best in NG of Scotland). Briefly in London 1772. He became Master of the Trustees Academy in Edinburgh in 1772, which he transformed from an instrument of commercial design into an Art Academy on the European model. Exh. FS 1762, 1767 and 1780; RA 1772-82. In Rome Runciman became interested in Shakespearean as well as classical themes for history painting, but his major work was a series of Ossianic scenes for the great hall of Penicuik House, 1773. These were destroyed by fire but can be partly reconstructed from drawings in NG of Scotland. There is also a remarkable portrait of 'Lord Buchan', 1784 (Perth Gallery). Runciman also produced a series of neo-classical etchings.

(Life and cat. by Duncan Macmillan in progress.)

ALEXANDER RUNCIMAN.
'David, Earl of Buchan'
(1742-1829). 25ins. x 30ins.
Perth, Art Gallery.
Probably about 1784. Lord Buchan was a prominent patron of literary and cultural activities, and somewhat given to 'enthusiasm'.

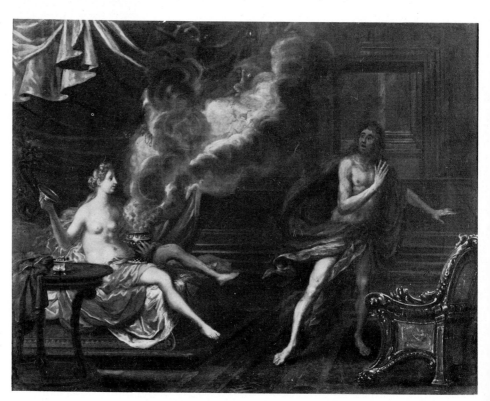

ALEXANDER RUNCIMAN.
'Pandora opening the box.' 29½ ins. x 39ins. s. & d. 1771. Christie's sale 19.12.1938 (118).
Probably painted in Rome and still under the influence of Fuseli.

RUNCIMAN, John **1744-1768**

Scottish romantic history painter. Born Edinburgh 1744; died Naples 1768. Younger brother and probably pupil of Alexander Runciman (q.v.), he followed him to Rome in 1767, but died in Naples 1768 after destroying, in a fit of self-depreciation, all his recent work. He had a higher level of poetic imagination than his brother, and his 'King Lear', 1767 (NG of Scotland), which owes nothing to stage tradition, is a romantic scene far in advance of its time. Very little of his work survives and mostly in the NG of Scotland.

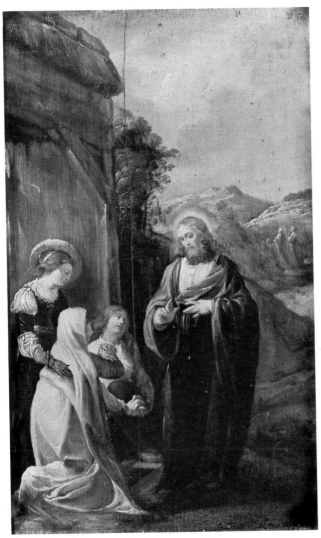

JOHN RUNCIMAN. 'Christ and the Maries.' Wood.- 10½ ins. x 6½ ins. Artist's name inscribed on the back. Christie's sale 19.5.1939 (72).
In a technique similar to that used in Rubens' sketches; probably painted before leaving for Rome in 1767.

RUSCA, Cavaliere Carlo Francesco 1696-?1769

Court portrait painter of Italian-Swiss origin. Born Torricella, nr. Lugano 1696; died Milan 1769 (or 1760). He studied law at Turin, but took to portrait painting and was employed by the Turin Court by 1722; later studied with Amigoni at Venice. Much employed at German Courts (Cassel 1733-36; Berlin 1737 — where he was probably made a 'cavaliere'; Wolfenbüttel and Brunswick). Sent to Hannover to paint 'George II', his modest talent pleased the King, who persuaded him to come to London, where he had some success 1738/9. He settled in Milan 1740. His 'Lady Mary Wortley-Montagu as the Magdalen', 1739, is now in HBM Embassy, Ankara.

(Brun.)

RUSSEL, Anthony *c.*1660-1743

Portrait painter. Born London *c.*1660; died there July 1743. Pupil of Riley in 1680. He practised portraiture up to his death as a minor competitor to Richardson and Murray (qq.v.). There is a mezzotint by John Smith after his 'Dr Sacheverell', 1710 (?at Stanton Harcourt).

RUSSEL, James *c.*1720-1763

Portrait painter and 'antiquary' in Rome. Born London *c.*1720; died Rome August 1763. He went out to Rome as a painter 1740 and studied with Imperiali, but soon became an 'antiquary' and specialist in guiding British (and especially Jacobite) visitors round the sights. His one certain conversation piece, 1744 (formerly at Shardeloes), is the earliest such picture with English sitters, painted in Rome (*R. Edwards, Burlington Mag., XCIII, (April 1951), 126).* He published anonymously, 1748, *Letters from a Young Painter Abroad to his Friends in England.*

RUSSELL, John **1745-1806**

Predominantly a painter of portraits and fancy subjects in crayons, but also painted portraits in oils. Born Guildford 29 March 1745; died Hull 20 April 1806. He won premiums from the Society of Arts for drawings 1759 and 1760. Studied crayon painting with Cotes up to 1767. Entered RA Schools 1770. Exh. SA 1768; RA 1769-1806 (very abundantly). ARA 1772; RA 1788. As early as 1764 he was converted to Methodism and religion played a large part in his life, but is oddly little reflected in his highly fashionable crayons portraits. Though based on London he spent several

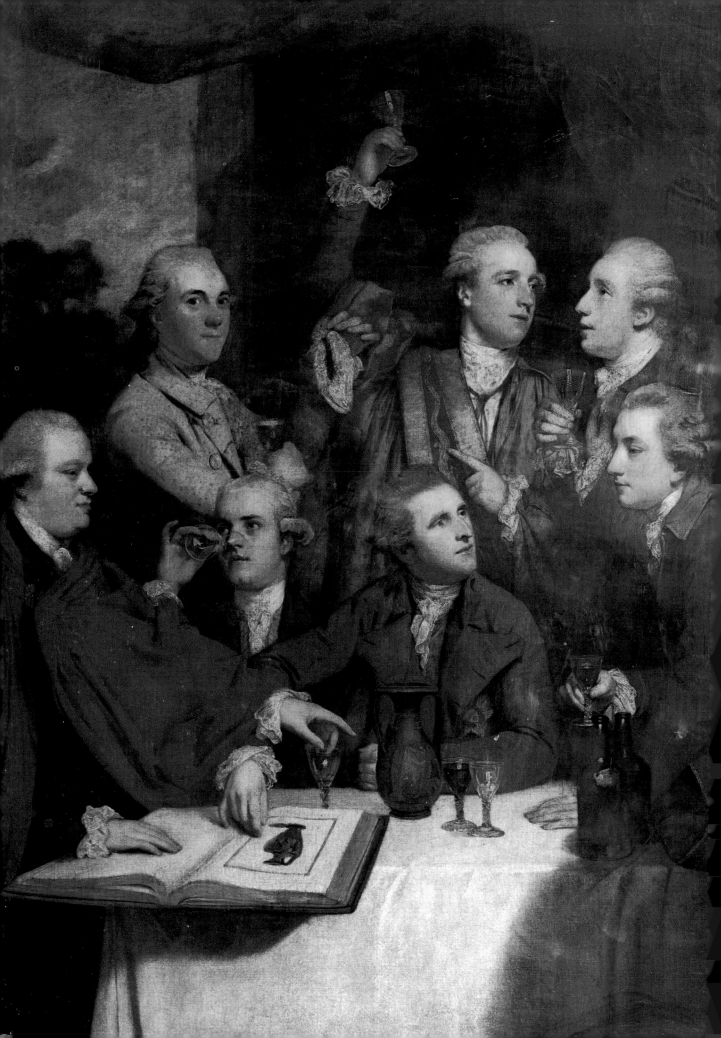

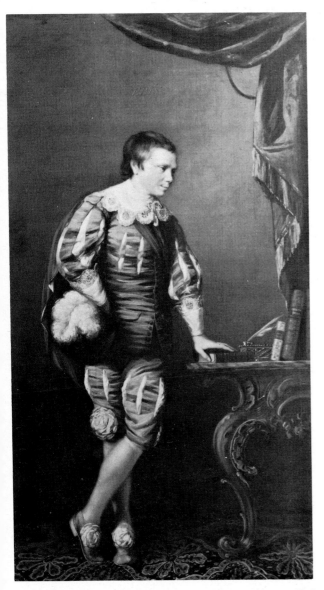

JOHN RUSSELL. 'Philip Stanhope.' 70¾ ins. x 41ins. s. & d. 1765. Sotheby's sale 3.2.1954 (59).
One of the most important of Russell's rather infrequent oils. The sitter was the natural son of the 4th Earl of Chesterfield and the unhappy recipient of his too famous letters.

Sir JOSHUA REYNOLDS. 'Members of the Society of Dilettanti (2).' 77½ ins. x 59ins. 1777-79. The Society of Dilettanti.
Hamilton is pointing to the famous volume which catalogues his first collection of Greek vases. The President (at the left) is Sir Watkin Williams Wynn. Reynolds catches to perfection the flavour of the civilised enjoyment of the ancient world of the 18th century 'dilettante' (see also page 305).

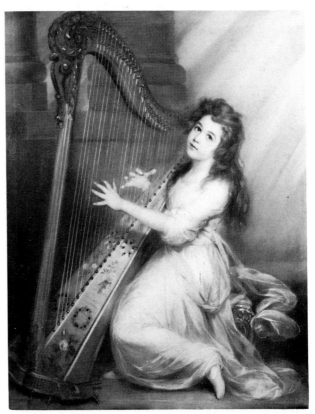

JOHN RUSSELL. 'Miss Emily de Visme' (Lady Murray). Pastel. 53½ ins. x 43½ ins. Engraved by W. Bond 1795. Sotheby's sale 15.3.1967 (19).
For a Lawrence of the same sitter of 1794, see page 221. Her parents seem to have been keen to advertise her precocious charms.

months in most years travelling the country and doing portraits in the provinces, after 1790 largely in Yorkshire. His oil portraits are dull, but he perfected his technique in crayons (and in their manufacture) to a very high pitch, publishing an *Elements of Painting with Crayons*, 1772. He studied Rosalba as well as Cotes (q.v.) and blended his colours with the finger with remarkable skill. In 1790 he was appointed 'Crayon Painter to the King and to the Prince of Wales'.

(G.C. Williamson, J.R., 1894.)

RYAN, Francis **fl. 1756-1788**
Irish portrait painter. Member of the Guild of St. Luke, Dublin, from 1756 to 1788.

(Strickland.)

RYCK, John de **fl. c. 1710**
A portrait in Archers' Company uniform of before 1713 (Archers Hall, Edinburgh) is signed 'John de Ryck Fecit' and is competent professional work.

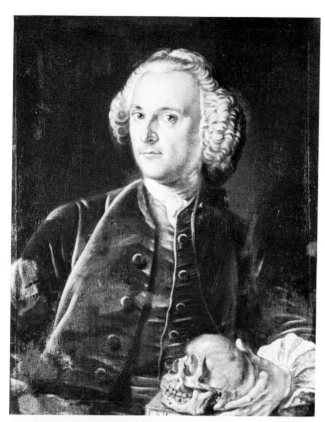

ANDREAS VAN RYMSDYK. 'Dr. William Barrett, 1764.' 30ins. x 25ins. Bristol, City Art Galleries.
Traditionally painted 1764. The sitter was a surgeon and antiquary at Bristol, and this would have been painted before van Rymsdyk settled in London.

RYDER, Thomas 1746-1810

Mainly a successful engraver. Born 1746; died 1810. Exh. drawings, as a pupil of Basire, FS 1766-67. Apparently entered RA Schools 1772 as 'Thomas Ride', but soon took to engraving for Boydell's Shakespeare Gallery and after Angelica Kauffmann and others. Shortly before 1775 he collaborated with Ryley (q.v.) in the Long Gallery at Castletown in Ireland, where he painted the grotesques.

(Crookshank and Knight of Glin, 1978.)

GERARD RYSBRACK. 'Dog and dead game.' 37½ins. x 61ins. Signed. Christie's sale 17.4.1935 (121).
One of a pair of signed pictures. They are in a more typically Flemish tradition than his brother's.

PIETER ANDREAS RYSBRACK. 'Richmond Ferry.' 35ins. x 46ins. Signed c.1730. With Leger's 1980.
Rysbrack adapted a Flemish topographical tradition to the British scene.

RYLEY, Charles Reuben *c.*1752-1798

Painter of small literary histories; also decorator and book illustrator. Born London *c.*1752; died there 1 October 1798. Entered RA Schools 1769 and was a pupil of Mortimer. Won a premium from the Society of Arts for drawing 1770 and the RA gold medal for a history painting, 1778. Exh. RA 1778-98; FS 1783. About 1775, with Thomas Ryder (q.v.) he painted the Long Gallery at Castletown in Ireland. He was also an inexpensive decorator and excelled with grotesques *(E.C-M.).* Two small scenes from the 'Vicar of Wakefield' are at BAC Yale.

RYMSDYK, Andreas van **1754-1786**

Painter of portraits in oil and miniature; also engraver. Born 1754 (he won a premium 1765 'aged 11'); died Bath 13 November 1786. Son of John van Rymsdyk (said by *Edwards* to have painted portraits at Bristol 1760-70) with whom he published engravings of natural history objects in *Museum Britannicum* 1778. Won premiums at the Society of Arts for drawings and mezzotint 1765-67. Exh. SA 1769 and 1776; RA 1775 and 1778 (miniatures). He was painting portraits at Norwich 1781 *(Fawcett).* What seem to be competent copies after Batoni of 'Hugh, 2nd Duke of Northumberland' at Syon and Middlesex Guildhall have always been labelled 'Rymsdyke'.

(Long.)

RYSBRACK, Gerard **1696-1773**

Still-life painter. Born Antwerp 19 December 1696; died there 25 May 1773. Youngest brother of the sculptor John Michael Rysbrack (1694-1770). Master at Antwerp 1725. He worked in London and returned to Antwerp after his brother's death. A pair of competent, signed, 'Dogs with dead game' were sold 17.4.1935, 121.

RYSBRACK, Pieter Andreas *c.* **1684-1748**

Landscape and still-life and animal painter. Born Paris *c.*1684; died London October 1748. Eldest son of Peeter Rysbrack (1665-1729) an Antwerp landscape painter with a Gaspardesque style, and brother to Gerard (q.v.) and the sculptor John Michael Rysbrack — with whom he probably first came to London in 1720. Master at Antwerp 1710-11. In England he painted topographical and panoramic landscapes in the manner of Tillemans, many of which were engraved, and rather competent still-life arrangements of dead game, &c.

(Vertue).

RYVES, Thomas **d.1788**

Hon. exh. SA 1762 of 'A head in the manner of Rubens'. He was probably Thomas Ryves of Ranston, Dorset, elected FRS 1760; died 1788.

PIETER ANDREAS RYSBRACK. 'A bag of game.' 23½ins. x 43ins. s. & d. 1738. Christie's sale 19.2.1954 (133).
Rysbrack was a neat arranger of original still-life compositions.

S

SADLER, William fl.*c.*1765-*c.*1788

Portrait, history, &c. painter, of English origin, in Dublin, where he entered the Drawings School 1765 and died *c.*1788. He painted portraits in crayons, oil and miniature, and also scraped some mezzotints.

(Strickland.)

SAILMAKER, Isaac 1633-1721

Marine painter of modest talent. Born Scheveningen 1633; died London 28 June 1721. He worked in England from the 1640s ''painting views, small and great, of many seaports and ships about England'' *(Vertue, i, 74)*. Attributed pictures are at Greenwich.

(Archibald.)

St. MICHEL See SAN MICHEL, G.

SALISBURY, J. fl.1783-1784

Wiltshire portrait painter. Exh. from addresses at Westbury (FS 1783) and Dilton Marsh (RA 1784), both near Longleat, where three portraits survive. They are competent works in the style of T. Beach (q.v.).

SAMUEL, George fl.1785-*c.*1823

Landscape painter in oils and watercolours. Lived in London and died soon after 1823. Mainly a watercolour painter in the manner of Sandby, but some large oil landscapes of his later years, e.g. 'Greenwich', 1816 (Yale University Gallery) have considerable merit. Exh. RA 1785-1822; BI 1807-23.

(Grant.)

SAMUEL, Richard fl.1770-1787

Portrait and history painter. Entered RA Schools 1770. Died London 26 July 1787. He won awards for drawings at Society of Arts 1777 and 1779, and was its Assistant Secretary from 1779. Exh. RA 1772-81; SA 1775. He painted Kauffmannish neo-classical compositions. A portrait of 'Robert Pollard', 1784 is in NPG. A '— Samuel' who exh. a portrait RA 1785 was perhaps another painter.

(Redgrave.)

J. SALISBURY. 'Elizabeth, Lady Weymouth.' 30ins. x 25ins. Exh. RA 1784 (137). Marquess of Bath, Longleat.
A local Wiltshire painter, but he would seem to have had good professional training.

SANDBY, Paul 1730-1809

Landscape painter, mainly in watercolour and gouache; an occasional landscape painter in oil. Born Nottingham 1730; died London 9 November 1809. Younger brother of the architect Thomas Sandby, with whom he came to London 1747. Worked with the survey of Scotland 1747-52, and learned etching at Edinburgh. In London (and Windsor) from 1753 where he became one of the great pioneers of natural English landscape painting in watercolours. He was a popular drawing teacher and had a number of upper-class amateurs as pupils. He was also the first to use the aquatint process in England. Exh. SA 1760-68. Foundation RA. Exh. RA 1769-1809; BI 1806-8. The largest collection of his work is at Windsor *(A.P. Oppé, Sandby Drawings at Windsor Castle, 1947)*. His oil landscapes are infrequent and have

PAUL SANDBY. 'Hackwood Park.' 39½ ins. x 49¼ ins. Inscribed with the painter's name. Christie's sale 21.11.1980 (128). A watercolour of the same subject was engraved in 1775. Sandby was a very capable oil landscape painter but preferred other mediums. This picture has been acquired by B.A.C. Yale.

the same faithful topographical character as his watercolours; most were the work of his last few years. Part of a painted room from Drakelowe, 1793, is in the V & A.

(*Herrmann.*)

His second son, **Thomas Paul** (d.1832), who succeeded his father as drawing master at the RMA Woolwich 1796, exh. what may have been an oil landscape, RA 1792.

SANDERS, John, Sr. fl. *c.*1750-*c.*1783
Portrait painter in oil and crayons, and history painter. His son ceases to call himself 'Jr' in 1784. Exh. RA 1771-74. His 'A Philosopher', RA 1771, was probably a picture sold 10.2.1967, 121, which suggests training abroad. Two watercolours of interiors at the Foundling Hospital, near to which he lived, RA 1774, are on loan to the Thomas Coram Foundation and show an attractive talent.

SANDERS, John, Jr. 1750-1825
Portraitist and all-purpose painter, son of the last. Born London 1750; died Clifton 1825. Exh. RA 1775-88, and conceivably up to 1824 — but there is much confusion with a mezzotint engraver and a miniaturist 'Joseph Saunders'. Painted portraits in oil and crayons, history, topographical views, &c. Entered RA Schools 1769. Settled at Norwich 1777-81 (*Fawcett, 81-82*). Again in London, until he settled in Bath 1790. Portraits of *c.*1780 suggest Angelica Kauffmann, but his 'Countess of Radnor', 1821 (Longford Castle) owes a good deal to Lawrence.

(*DNB.*)

SANGER, John fl.1763-1773
Exh. SA 1763-73 landscapes with figural themes suggestive of Claude.

SAN MICHEL, Giuseppe fl.1756-1785

Piedmontese portrait painter. Paid 1756 for a portrait of a Savoy princess (for her nurse) *(Vesme, 961)*. Exh. six portraits RA 1785 (as 'Chevalier de St. Michel').

SARGENT, H. fl.1795-1796

Exh. a portrait and 'Edwin and Angelica', RA 1795 and 1796. His name is in the index only for 1797, so he may have died.

SARTORIUS family fl.*c*.1723-*c*1829

Four generations of rather dreary and very prolific horse and sporting painters, whose exhibition records it is impossible to sort out.

They are: **John**, born Nuremberg *c*.1700; died London ?*c*.1780. His first known horse picture in England is of *c*.1723. Possibly exh. FS 1780; RA 1780. His son **Francis**, born London 1734; died there 5 March 1804. His first known work *c*.1758. Exh. FS 1768-83; RA 1775-90. Francis' son **John**

Nost, born London 25 May 1759; died 1828. Exh. FS 1778-83; RA 1781-1824, and his son **John Francis**, *c*.1775-1831. Exh. RA 1797-1829. There was also a **G.W. Sartorius**, who exh. 'A fruit piece', FS 1773 and by whom a signed fruit piece was sold S, 19.10.1966, 173.

SAUNDERS 1682-*c*.1735

Provincial crayon portrait painter. A 'Self portrait' in NPG bears a re-done inscription 'Saunders Ipse Pinxit. Aetatis 50 / November the First Anno 1732'. He was working in the Cambridge area in the 1720s (a signed example is at Emmanuel College).

(Memoirs of a Royal Chaplain (Edmund Pyle), ed. A. Hartshorne, 1905.)

SAUNDERS, John See **SANDERS, John, Jr.**

SAUVEUR fl.1772

Exh. a landscape and portraits, SA 1772.

JOHN SANDERS, Sr. 'A Philosopher.' 31½ins. x 25¾ins. s. & d. 1771. Christie's sale 10.2.1967 (121).
Presumably the picture exh. RA 1771 (178). Perhaps a study from the same model that sat to Reynolds for a number of fancy heads.

JOHN SANDERS, Jr. 'Miss Catherine Bellman' (later Mrs. Thomas Decker). 35½ins. x 28ins. s. & d. 1777. Christie's sale 22.12.1932 (106).
Perhaps an East Anglian painter: the lady's husband was a Norwich clergyman.

SAUNDERS. 'Unknown man.' Pastel. Signed 'Saunders pinxit/1726'. Unlocated.
The work of a provincial, perhaps itinerant, pastellist: possibly done at Cambridge.

SAXON, James fl.1795-1817

Portrait painter, especially of actors in character parts. Born Manchester; said to have died *c.*1817 *(Redgrave).* Exh. RA 1795-96, 1806-9, 1814 and 1817. Said to have worked in Edinburgh *c.*1803-5, where he painted Sir Walter Scott and his wife, St. Petersburg, ?after 1809, and Glasgow, shortly before his death. Some of his portraits are engraved.

SAYER fl.1783

Exh. flower pictures at FS 1783.

SCADDON, Robert fl.1743-1774

Portrait and miniature painter and mezzotint engraver. He scraped a mezzotint in 1743. A full length of 'William Rice', signed and dated 1744, in the manner of Hudson, was sold 31.3.1933, 104; and a miniature, dated '74, was sold 3.8.1978, 133.

SCARLET, James fl.1769-1770

Exh. FS 1769-70, children's portraits with animals or accessories, described as a pupil of James Stuart (q.v.). A James Scarlet died at Rochester 11 June 1772.

SCHAAK, J.S.C. fl.1760-1770

Portrait and subject painter, sometimes listed as 'J.H. Schaak'. He is conceivably the John Schaak of Delft who became a denizen 1731. Signed and dated portraits of English sitters range from 1760 to 1770. Exh. FS 1761-64; SA 1765-69. His small equestrian portraits are like those of Morier (q.v.).

A group of signed and dated portraits, 1767-70, of the St. Aubyn family suggest a knowledge of Cotes; there is a large and clumsy family group of 'Mr & Mrs Wyman and Miss Powles', 1768 at Montreal.

ROBERT SCADDON. 'William Rice.' 59ins. x 42½ins. s. & d. 1744. Christie's sale 31.3.1933 (104).
The spelling of his name (not clear in the signature) is confirmed by an engraving of 1743. He could have been a pupil of Hudson.

J. SCHAAK. 'An officer on horseback.' 49ins. x 39ins. s. & d. 1762. Christie's sale 14.4.1944 (74). Possibly a painter of Dutch origin. His signed portraits vary in style but have no close affinities in England.

SCHALCH, Jan Jacob **1723-1789**
Swiss landscape painter. Born Schaffhausen 23 January 1723; died there 21 August 1789. In England 1754-63; at The Hague 1763-70. Exh. SA 1761. A view of 'Laughton Church, Lincs.' signed and dated 1756, in a pleasant style not unlike Lambert, was in the Duchess of Kent sale 14.3.1947, 52.

(Th.-B.)

SCHEFFER, F. **fl.1707-1711**
Portrait painter. The original of a much copied portrait of 'Bishop Ken', signed and dated 1711, is in the Bishop's Palace, Wells, and a female portrait, in the style of Dahl, signed and dated 1707,

was sold 23.11.1973, 113, as 'T. Scheffer'. He has been confused with a possibly mythical 'N. Scheffers', a Dutchman who is said to have worked for Verrio at Hampton Court.

SCHEPPELEN **fl.1768**
Exh. a portrait, SA 1768.

SCHIFFER See SCHEFFER, F.

SCHMUTZ, Rodolphus **1670-c.1715**
Swiss portrait painter. Born Regensberg, Zurich, 2 January 1670; died London 1714/5. He worked in London in the style of Kneller from 1702 *(Vertue, i, 48).*

JAN JACOB SCHALCH. 'Laughton Church, Lincs.' 40ins. x 58ins. s. & d. 1756. Christie's sale 14.3.1947 (52).
A Swiss painter who assimilated the English landscape tradition of the 1750s very easily.

SCHOONJANS, Anthonie *c.*1655-1726
Flemish religious and decorative history painter, and portraitist. Pupil of Erasmus Quellinus at Antwerp 1668/9; died Vienna 13 August 1726. Studied many years in Italy; worked at Vienna from 1693 and later in Denmark and Germany. Painted a staircase (destroyed) in Little Montague House, London, probably before 1716 *(Vertue, iii, 36).*

SCHRÖDER, Georg Engelhard 1684-1750
Swedish court portrait painter. Born Stockholm 30 May 1684; died there 17 May 1750. Studied with Kneller for three years before 1702; then Paris and Italy. Worked at St. Martin's Lane Academy, London, *c.*1720-24, when he returned to Sweden as court painter.

(Nisser, 68ff; Thoresby Soc., XXI (1912), 121.)

SCHRODER, H. fl.1793
Exh. three portraits at RA 1793.

SCHUERMANS, Jan fl.1710
A group of five very provincial portraits, signed and dated 1710 on the back, and probably painted in Kent, were in the Streatfield sale 25.3.1966, 52-54.

SCHWANFELDER, Charles Henry 1774-1837
Landscape, portrait and sporting painter. Born Leeds 11 January 1774; died London 9 July 1837. His career was spent wholly at Leeds and his main occupation was as a sporting painter, but he was also a competent landscape painter and an adequate portrait painter. In his earlier years he exhibited at Leeds. Exh. RA London 1809-35; BI 1815-19. In 1816 he was appointed 'Animal painter to the Prince Regent'. His work is fully represented in the Leeds Art Gallery.

(DNB; Grant.)

SCHWARTZ fl.1768
Exh. a portrait at SA 1768.

SCHWEICKHARDT, Hendrik Willem
1746-1797

Dutch landscape and decorative painter and etcher. Born Hamm, Westphalia, 1746; died London 8 July 1797. Pupil of Girolamo Lapis at The Hague, where he worked from 1775; in RA catalogues after 1791 he is called 'Director of the Academy at The Hague'. He settled in London 1786 and exh. RA 1786-96. He specialised in Dutch winter landscapes in a 17th century tradition.

(Grant.)

SCORE, William
fl.1778-c.1815

Portrait and, later, topographical landscape painter. Born in Devonshire. Assistant to Reynolds *c.*1778-84, and said by Northcote to have painted the Dulwich replica of 'Mrs Siddons as the Tragic Muse'. Exh. portraits RA 1781-94 and scraped a mezzotint of his own portrait of 'John Quick', 1791. He later visited Scotland and exh. landscapes in Dublin in 1812 and 1815.

(Strickland.)

JAN SCHUERMANS. 'Mary, wife of Richard Beard.' 50ins. x 40ins. s. & d. 1710 on the back. Christie's sale 25.3.1966 (53)/2. One of a group of portraits in the same sale, all signed and dated 1710 on the back. They suggest a Dutch training and may have been painted in Kent.

SAMUEL SCOTT. 'Old London Bridge.' 31ins. x 59ins. Painted 1749. Bank of England, London. Companion with the next plate: both were painted for Sir Edward Littleton in 1749. The subject was a very popular one with Scott for overdoors.

SAMUEL SCOTT. 'The building of Westminster Bridge.' 31ins. x 59ins. Painted 1749. Bank of England, London.
Companion to the previous plate, and also a much repeated design. The drawing from which this was taken was probably made in 1746.

SCOTT **fl. 1786**
Hon. exh. of views of Dover and Boulogne, RA 1786.

SCOTT, Edmund **1758-*c*. 1810**
Portraitist in crayons; but chiefly an engraver in the dotted manner. Born London 28 March 1758; died *c*. 1810 *(Redgrave).* Exh. crayon portraits as 'Master Edmund Scott' FS 1774-75. Entered RA Schools as an engraver 1781 and was a pupil of Bartolozzi. He was appointed 'Engraver to the Duke of York' *c*. 1789.

SCOTT, J. **fl. 1770-1790**
Exh. a flower piece at RA 1790. He is probably the '— Scott' who also exh. two tablets of flowers for chimney pieces FS 1770.

SCOTT, Samuel **_c_. 1702-1772**
Painter of marines and topographical river landscapes, of which he also did versions in watercolour. Born London *c*. 1702; died Bath 12 October 1772. He began *c*. 1725 as a deliberate imitator of Willem van de Velde (q.v.), painting naval engagements and more tranquil views of shipping, at which he achieved a very high level of competence, culminating in pictures, *c*. 1747-49, of 'The first Battle of Finisterre' (Tate; BAC Yale,

&c.). He had made drawings of the London waterfront before Canaletto's arrival in 1746, and soon afterwards became the native specialist in London river views, of which he made many variant versions for overdoors, &c. Exh. SA 1761-65; RA 1771 (from Bath). His health declined in 1765 and he had a sale of his sketches 4.4.1765, Lugt, 1445, and painted little afterwards. He moved in 1765 to Twickenham and later (1765-69) to Ludlow; eventually settling at Bath in 1769. Sawrey Gilpin (1749-56) and Marlow (1754-59) were his pupils (qq.v.). His final sale was 13.1.1773.

(Documents listed in Scott Bicentenary cat., Guildhall, 1972; R. Kingzett, catalogue raisonné, forthcoming in Walpole Soc.)

SCOUGALL, John **_c_. 1645-1730**
Leading Scottish portrait painter in Edinburgh. Died Prestonpans 1730 'aged 85'; he gave up painting *c*. 1715. His early works have a certain quality. He was known as 'Old Scougall'. His son **George** painted portraits for Glasgow Town Council 1715-24, and is almost beneath consideration.

(Waterhouse, 122-123.)

SEAR **1762**
Probably D. Serres (q.v.), *Italian Studies, XIV (1959), 9.*

SAMUEL SCOTT. 'The taking of two French Privateers by the Bridgewater and Sheerness in 1743.' 47ins. x 84ins. Painted about 1746. Sotheby's sale 12.11.1980 (108).
A considerable number of Scott's most ambitious works are naval battles.

SEATON See SETON, J.T.

SEEMAN, Enoch *c.*1694-1745

Portrait painter. Born Dantzig *c.*1694; died London March 1744/5. Trained by his father, who brought him young to London. He was in good practice by 1717, when he painted full lengths of 'George I' (Middle Temple) and 'Elihu Yale' (Yale). He was a good portrait copyist and long retained a high position in the second flight of portrait painters. His prices were modest (20 guineas for a full length in 1732). His last and largest work is the 'Lady Cust and nine children', 1743 (Belton). A son, **Paul,** is recorded as a painter but his work is not known.

ENOCH SEEMAN. '?Charles Orlando Gore.' 46½ins. x 48ins. s. & d. 1736. Christie's sale 18.4.1947 (101).
Seeman had a very large practice and his sitters all look very like one another.

ISAAC SEEMAN. 'Lord Chancellor Thomas Wyndham.' 49ins. x 39ins. s. & d. 1739. Christie's sale 9.4.1937 (54).
Isaac's portraits are a little harder than his brother Enoch's, and much less frequent.

SEEMAN, Isaac fl.1720-1751

Portrait painter. Born Dantzig; died London 4 April 1751. Younger brother of Enoch Seeman (q.v.), whose style he followed closely and to whose practice he succeeded, but his work is much less abundant.

SEGUIER, William 1771-1843

Occasional painter of town topographical views. Born London 1771; died Brighton 5 November 1843. He learned something from Morland (q.v.) and painted a few town views, but soon gave up the practice of painting for the restoration of pictures, advising collectors, and playing the role of *éminence grise* in the London art world. He was the first Keeper of the National Gallery.

(Redgrave.)

SÉNÉCHAL, Alexandre 1767-after 1795

Entered RA Schools 1795. Exh. a portrait RA 1795.

SENN fl.1773-1775

In an account book of the Rev. Robert Carter (later Carter-Thelwall) of Redbourne, Lincs., are payments to Senn from 1773 to 1775 for '12 Apostles, 3 landscapes', 'panels of coats of arms' and 'a plan of Redbourne' *(Lincoln Record Office)*.

DOMINIC SERRES. 'Shore scene with shipping and bathers.' 29ins. x 52ins. s. & d. 1765. Christie's sale 20.12.1942 (148).
A rather unusual exercise in the style of Vernet and much more in a French tradition than Serres' normal marine pictures.

SERRES, Dominic 1722-1793

Marine and landscape painter. Born Auch, Gascony 1722; died London 4 November 1793. He came from a good French family and his name appears to have been pronounced to rhyme with 'pear' rather than 'cherries'. He had some maritime experience and came to England c.1758 as a prisoner of war and took to painting. He painted some views of country houses and then received some instruction in sea painting from Brooking (q.v.) and soon made it his speciality. Exh. FS 1761-64; SA 1765-68. Foundation RA. Exh. RA 1769-93. He was appointed 'Marine Painter to the King' 1780; Librarian of the RA 1792. All four of his daughters seem to have painted, mainly in watercolours, and were occasional hon. exh. at the RA: 'Miss Serres' in 1783 (landscape), 1797 and 1800 (flowers); 'Miss A.C. (or A.E.)', 'Joanna' and 'S. Serres' showed drawings.

(Archibald.)

SERRES, Dominic M. *c.*1761-after 1804

Landscape and occasional portrait painter: also drawing master. His known works are mainly in watercolours. Younger son of Dominic Serres (q.v.). Exh. RA 1781-87 (when he went abroad to France and Italy), and 1804 (when he became incapable).

SERRES, John Thomas 1759-1825

Landscape and marine painter. Born December 1759; died London 28 December 1825. Elder son of Dominic Serres (q.v.) who no doubt taught him. He began as a straight landscape painter and as 'Master Serres' was an hon. exh. at RA 1776-79 but was professional from 1780. In 1793 he succeeded his father as 'Marine Painter to the King' and became marine draughtsman to the Admiralty. He visited France and Italy (Rome and Naples) 1790/1, but made a disastrous marriage (1791) with Olivia Wilmot (q.v. as Olivia Serres), whose eccentricities ruined his career. He was in Edinburgh 1808 to c.1815, but returned to London. Exh. RA to 1820; BI 1806-25.

(Archibald.)

JOHN THOMAS SETON. 'William Fullerton of Carstairs and Captain Lowes.' 29½ ins. x 24½ ins. s. & d. on the back 1773. National Gallery of Scotland, Edinburgh (1837).
Zoffany's name had been falsely inscribed on the face of the picture, and Seton's works of this kind were certainly in conscious imitation of Zoffany's.

SERRES, Olivia 1772-1834

Landscape painter. Born Warwick 3 April 1772 (*née* Olivia Wilmot); died London 21 November 1834. She married her teacher, John Thomas Serres (q.v.) in 1791, whose life she ruined by proclaiming herself 'Princess Olive of Cumberland'. She was quite a competent painter of romantic landscapes and a most voluminous writer of nonsense. Exh. RA 1793-1808; BI 1806-11.

(Grant.)

SERVANDONI, Niccolo 1695-1766

Scene painter, architect and deviser of court festivities. Born Florence 2 May 1695; died Paris 19 January 1766. He studied painting under Panini at Rome, and also architecture. He was first in London c.1722-24, when he settled at Paris, and later 1747-50 when he was much employed in scene painting and a variety of ephemeral decorations.

(E.C-M.; Audin and Vial.)
Some Paninesque compositions, chiefly in watercolours, by one of his sons, were exh. FS 1774 and SA 1775-78.

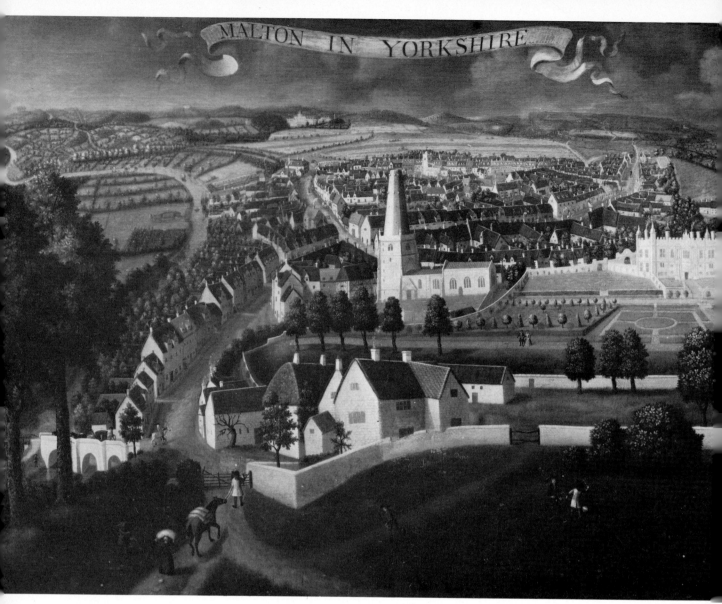

JOHN SETTERINGTON. 'View of Malton.' 39½ins. x 56ins. Signed. Private collection.
A rather late survival of the bird's eye view tradition.

SERVANT, J. fl.1764-1768
Two large landscapes, one a view near Naples,
were exh. FS 1764 by '— Servant'. A portrait of
the '7th Earl of Traquair', signed 'J. Servant
1768', is at Traquair House. It is very provincial in
style.

SETON, John Thomas fl.1758-1806
Portrait painter. Probably born London *c.*1738; he
was still alive at Edinburgh 1806. Son of Christopher
Seaton, gem engraver. Pupil of Hayman (q.v.) and
studied at St. Martin's Lane Academy. In Rome
1758-59 *(Walpole Soc., xxxvi, 74)*. Exh. SA 1761-69
(in 1766 from Bath); 1772 (from Edinburgh); 1777
(from India); RA 1774 (from India). He exh. a
number of small scale full lengths and con-
versations; signed examples are closer to Zoffany
than to Hayman and anticipate David Allan in

Scotland. In Edinburgh 1772-76, where his scale of
life portraits anticipate those of David Martin
(q.v.). At Calcutta 1776-85 where he had a good
portrait practice *(Foster)*. He was back in
Edinburgh 1785-1806, but dated works are not
known.

(Archer, 99-107.)

SETTERINGTON, John fl.*c.*1728-*c.*1750
Yorkshire topographical painter in a heraldic style
of considerable charm. A 'View of Malton', signed
'Jnº. Setterington pinx.' was at Wentworth
Woodhouse.

(Harris, 192-193.)

SEVERN, Benjamin fl.1766-1772
Exh. a portrait SA 1766 and another RA 1772.

SEYMOUR, Edward fl.1743-1757

Portrait painter in a retarded Kneller tradition. Died Twickenham January 1757. A number of portraits, dating 1743-45, of the Fonnereau family of Ipswich, are signed 'E. Seymour de Twickenham'.

SEYMOUR, James c.1702-1752

Horse painter. Born London c.1702; died there 30 January 1752. Son of a banker and one of the early rivals of Wootton (q.v.), but with less variety of style. He subscribed to the St. Martin's Lane Academy 1720. He lived so extravagantly at Newmarket that he caused his father, a wealthy banker, to die bankrupt in 1739. His most ambitious work is 'A kill in Ashdown forest', 1743 (Tate Gallery).

SHACKLETON, John fl.1742-1767

Portrait painter. Married, and settled in London 1742; died there 17 March 1767. Conceivably a pupil of Richardson (q.v.). His portrait of 'John Bristow', 1746 (Maidenhead Mus.) is rather advanced in style. Succeeded William Kent, 1749, as Principal Painter in Ordinary to George II, whose official portraits he painted (good example in Edinburgh NPG). He was, by accident, kept in office under George III (but Ramsay painted the official portraits). His 'Henry Pelham and Secretary', 1752 (H.M. Treasury), is very close in style to Hoare.

(J. R. Fawcett-Thompson, Connoisseur, CLXV (Aug. 1967), 232-239.)

SHARPLES, James c.1751-1811

Portrait painter, mainly in crayons. Born in Lancashire c.1751; died New York City 26 February 1811. Said to have been a pupil of Romney (q.v.). Exh. Liverpool 1774; RA 1779 (from Cambridge), 1783 (from Bath) and from London up to 1785. From c.1793 to 1801 he did a professional business in Philadelphia and New York with small crayon portraits. Later again at Bath from 1801 to 1809, when he joined his sons in New York. His pupil and third wife, Ellen Wallace (born 4 March 1769; married 1787; died Bristol 14 March 1849) made copies of her husband's crayons. Three of his children also practised pastel painting and many works by all the family are at Bristol.

(DNB; Groce and Wallace.)

JAMES SEYMOUR. 'General Robert Douglas.' 24¾ ins. x 30¼ ins. s. & d. 1751. Sotheby's sale 16.7.1958 (48). This has slightly more character than most of Seymour's portraits.

SHAW, James fl.1769-1784

Portrait painter. Born Wolverhampton; died London c.1784. Entered RA Schools 1769 and was a pupil of Penny. Exh. RA 1776 and 1784. A portrait of '6th Earl of Stamford as a boy', 1773 (Dunham Massey, National Trust), is like a clumsier Wright of Derby.

(Redgrave.)

SHAW, Joshua c.1776-1860

Landscape and flower painter and copyist. Born Billingborough, Lincs.; died Burlington, New Jersey, 8 September 1860. He began under a sign painter at Manchester, and later did a good business at Bath in landscapes, overdoors, &c. in the style of Barker. Exh. RA 1802-14; BI 1810-17. He migrated to USA in 1817.

(Groce and Wallace.)

SHAW, William fl.1758-1772

Horse painter. Died London c.1772. Exh. SA 1760-72.

SHEA, John fl.1766

Irish landscape painter; awarded a premium for landscape by the Dublin Society 1766.

(Strickland.)

Sir MARTIN ARCHER SHEE. 'Self portrait.' 29¼ins. x 24ins. Painted 1794. Exh. RA 1795 (135). National Portrait Gallery (1093).
At this date Shee seems to have studied both Opie and Hoppner.

SHEE, Sir Martin Archer 1769-1850

Portrait painter and occasional painter of historical figure subjects. Born Dublin 20 December 1769; died Brighton 19 August 1850. He studied in Dublin under West 1781-83 and won all the premiums. He began with crayon portraits but had switched to oils before settling in London 1788, where he studied briefly at RA Schools 1790. ARA 1798; RA 1800; PRA (and knighted) 1830, on Lawrence's death. Exh. RA 1789-1845; BI 1807-41. His earlier portraits, which are the most distinguished, e.g. 'W.T. Lewis', RA 1792 (NG), owe a good deal to Lawrence (q.v.), but he was later criticised by Haydon as being responsible for 'the tip-toe school'. He soon had a considerable fashionable practice, including the royal family. He had a good presidential manner and wrote *Rhymes on Art*, 1805, and other poetical works.

(Strickland, incl. long list of works.)

JOHN SHACKLETON. 'King George II.' 93ins. x 56ins. s. & d. 1755. Scottish National Portrait Gallery, Edinburgh (221).
This was the standard portrait of the King, issued to Ambassadors in the later years of George II's reign.

SHEE, Peter fl.1752-1767

Irish landscape and historical painter and house painter. First recorded in Dublin 1752, where he died September 1767. He painted allegorical works and landscapes in the manner of Claude.

(Strickland.)

SHEELS fl.1783

Exh. a landscape at FS 1783.

SHEERS, William fl.1773

Exh. chalk drawings at FS 1773.

SHELDON fl.1774-1775

Exh. portraits and a fruit piece at FS 1774-75.

SHELDRAKE, J. fl.1780

Exh. 'Maria, from Sterne', RA 1780.

Sir MARTIN ARCHER SHEE. 'Arthur Annesley (1785-1863), later 10th Viscount Valentia, and his brother Charles (1787-1863).' 72ins. x 47ins. Christie's sale 1.12.1961 (82).
The names of the sitters have often been given wrongly. This seems to have been exh. RA 1793 (64).

SHERIDAN, J. **1764-1790**

Portrait painter of Irish origin; native of Kilkenny. Died London 1790. Trained in Dublin but came too early to London for success. Entered RA Schools 1789, aged 25. Exh. RA 1785 (as 'R. Sheridan) 1786-89; SA 1790.

(Strickland.)

SHERLOCK, William **fl.1759-c.1806**

Portrait painter, engraver, and miniaturist. Perhaps born in Dublin c.1738. Studied at St. Martin's Lane Academy and won premiums for a drawing and engraving at Society of Arts 1759-60. Then studied engraving in Paris 1761. Exh. portraits, miniatures and small whole lengths at SA 1764-80. He seems later to have exh. miniatures and small portraits at RA between 1796 and 1806 (from 1804 as 'W. Sherlock senr'). There is confusion between the exhibits of himself and his son (born 1775; entered RA Schools 1794) who only started calling himself 'William P. Sherlock' in 1801. The son specialised in watercolour copies after Wilson *(W.G. Constable, Wilson, 148/9)* and engraving, but may have produced portraits too.

(Strickland.)

SHERRAT, Charles **1770-c.1792**

Perhaps only a miniaturist. Born 1 March 1770. Entered RA Schools 1786. A portrait miniature was exh. by 'E. Sherrat' 1787 and one by 'C. Sherrat' 1792.

SHERRIF(F) See SHIRREFF, C.

SHERWIN, John Keyse **1751-1790**

Mainly an engraver; also painted historical compositions and portraits. Born East Dean, Sussex, May 1751; died London 24 September 1790. Son of a labourer, he showed great promise in drawing and won five awards for drawing and engraving from the Society of Arts between 1769 and 1778. Pupil of John Astley 1769; RA Schools as engraver 1770; studied with Bartolozzi until 1774. Exh. RA 1774-84; SA 1778. He specialised in historical compositions 'in chalks and crayons', but they were not distinguished. The most singular, which he engraved himself, is a Poussinesque 'Finding of Moses', 1789, enacted by a group of society ladies *(Smith's 'Nollekens', ii, 73ff.)*. He was a very competent engraver and succeeded Woollett 1785 as 'engraver to the King', but he went to pieces.

SHIELLS, The Misses **fl.1783-1790**

Two sisters, Mary and Sarah, daughters of a Lambeth nurseryman, were hon. exh. of portraits and fancy figures FS 1783; SA 1783 and 1790; RA 1784 and 1787.

SHIPLEY, Georgiana **fl.1781-1806**

Amateur portrait painter. Died 1806. She was daughter of the Bishop of St. Asaph and married Francis Hare Taylor. She was friendly with Reynolds and exh. a portrait RA 1781.

SHIPLEY, William **?1715-1803**

Drawing master and possibly occasional portrait painter. Probably born London 1715; died Maidstone 28 December 1803. Said to have been a pupil of Charles Philips (q.v.). Drawing master in Northampton 1753; moved to London 1754, where he opened Shipley's Academy, which had an influential teaching role before the foundation of the Royal Academy schools. He was more or less the founder of the Society of Arts, 1755.

(Sir Henry Trueman Woods, The History of the Royal Society of Arts, 1913, 7ff.)

JOHN SIMMONS. 'Richard Tomb.' 30ins. x 25ins. s. & d. 1772. Bristol City Art Gallery.
The sitter was a Bristol merchant, and Simmons was the leading local portrait painter at the time.

SHIRREFF, Charles *c.*1750-*c.*1831
Deaf and dumb miniaturist, who also painted histories and portraits in crayons in his earlier years. Born Edinburgh *c.*1750; last recorded 1831. Came to London 1768; entered RA Schools 1769 (silver medal 1772). Exh. FS 1770-73; RA 1771-96 and 1810-23; BI 1810-23; SBI 1830-31 (latterly entirely miniatures). He worked at Bath 1791-96; went to India 1797, at first to Madras, and then Calcutta *c.*1799-1809, where he had considerable success. On his return he settled in London.

(Long; Foster.)

SHIRVING See SKIRVING, A.

SHUTER, Thomas fl.1725
Worcestershire portrait painter. Full lengths, of a pedestrian character, of '2nd Earl of Plymouth' and 'Sir John Packington', are both signed and dated 1725 (Worcester Guildhall).

SHUTER, William fl.1771-1779
Landscape and flower painter. Exh. SA 1771-77; FS 1774-79; also still-life pictures RA 1774-76. Perhaps he was father of a **'W. Shuter'** who exh. portraits SA 1791 and by whom an extremely provincial 'Family group', signed and dated 1798, was sold 14.11.1958, 54.

SIGURTA, Luigi fl.1764-1774
Exh. a portrait RA 1774. A signed work of 1764 is noted with the suggestion that he was a Venetian and also an engraver *(Th.-B.).*

SILLETT, James 1764-1840
Still-life painter and miniaturist; also painter of scenery. Born Norwich 1764; died there 6 May 1840. He began as an ornamental and herald painter, but came to London *c.*1787. Exh. RA 1796-1837 (only still-life and flower pictures until well into the 19th century). Norwich in 1803; then King's Lynn until he returned to Norwich 1810. In 1815 he was President of the Norwich Society of Artists, but seceded.

(Redgrave.)

J.H. SIMPSON. 'Hester Winn.' 47ins. x 38ins. Inscribed (?on the back) and dated 1752. Christie's sale 9.12.1955 (232).
This painter is not otherwise known.

SIMMONS, John *c.*1715-1780
Bristol painter, best as a portraitist. Born Nailsea *c.*1715; died Bristol 18 June 1780. He ran a business as a house and ship painter at Bristol. His earlier portrait style shows a knowledge of Hogarth. By the 1770s his portraits are on a par with those of Beach (q.v.) and are of excellent quality. Exh. RA 1772 and 1776 (from Bristol). Three portraits and an altarpiece are in the Bristol Gallery.

(Redgrave.)

SIMON(S) See SYMONDS, C.

SIMONS, E. fl.1798
Exh. a flower picture RA 1798 from a Liverpool address.

SIMPSON, Miss fl.1799
Hon. exh. of 'A view on the Wye', RA 1799.

SIMPSON, J.H. fl.1752
Feeble portrait painter in manner of Enoch Seeman (q.v.). A portrait of 'Hester Winn', signed 1752, sold 9.12.1955, 232.

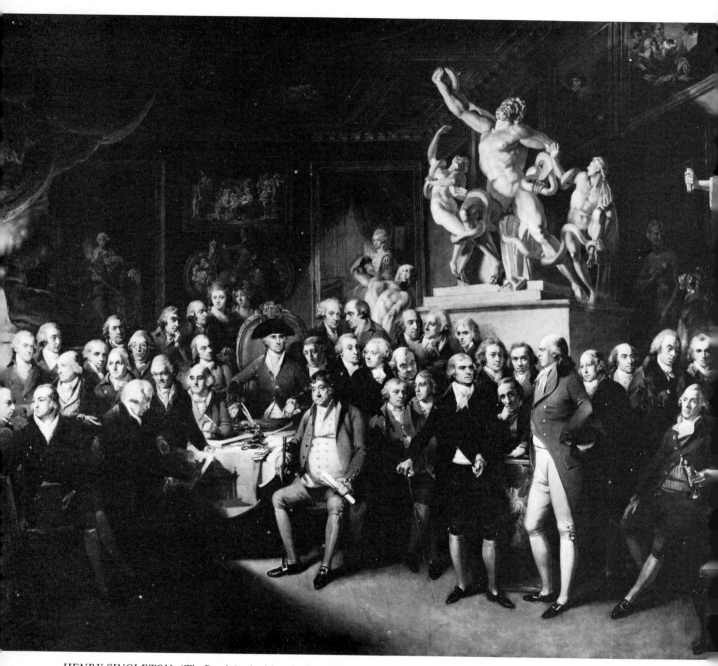

HENRY SINGLETON. '*The Royal Academicians in General Assembly under the presidency of Benjamin West.*' *78ins. x 102ins. s. & d. 1795.*
Royal Academy of Arts, London.
The picture does not represent the Academicians of a particular year, since it includes Chambers (d.1796) and Sir William Beechey (not eligible till 1798). Perhaps portraits went on being included up to 1800.

SIMPSON, John fl.1745-1750
Landscape painter and printseller in Dublin 1745-50.

(Strickland.)

SIMPSON, Thomas fl.1775-c.1785
Exh. an urban view, in crayons, at RA 1775. He also signed a 'Capriccio with ruins' in the manner of Marco Ricci (q.v.) in an Adam scheme of decoration at Oxenfoord Castle *(E.C-M.)*.

SINGLETON, Henry 1766-1839
Painter of portraits, history and literary genre; did much work as an illustrator. Born London 19 October 1766; died Kensington 15 September 1839. Entered RA Schools 1783 and won silver and gold medals 1784 and 1788. Exh. SA 1780 (a precocious drawing) and 1783; and very abundantly at both RA 1784-1839, and BI 1806-39. He showed promise as a portrait painter and his 'General Assembly of the Royal Academy', painted in the 1790s (Royal Academy), is remarkable, but he mainly exhibited scenes of literary genre in the manner of Morland or Wheatley, many of which were engraved. An uncle and sister were miniaturists.

(DNB.)

SISSON, Richard c.1730-1767
Irish portraitist in oil, crayon and miniature. Schoolfellow of Burke at Ballitore; died Dublin April 1767. Pupil of Bindon (q.v.) and later studied in France and Italy. Worked in London 1759. Exh. portraits in Dublin 1765-67. He was an artist of almost no merit.

(Strickland.)

SIVED, G. fl.1780
Exh. a portrait and 'a girl gathering grapes by candlelight', FS 1780.

SKEAK, Edmund fl.1790
Exh. a 'view from Isleworth', SA 1790.

SKELLY, Lt. Col. Francis fl.1792-1794
Talented amateur painter of Indian views. Died Bombay January 1794. Hon. exh. RA 1792 and 1794. He might have been a cousin of Colonel Gordon Skelly (1766-1828).

(Grant.)

SKETCHLEY fl.1783
Exh. a flower piece, FS 1783.

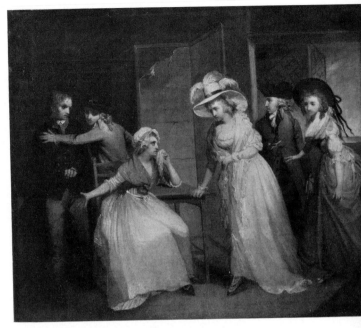

HENRY SINGLETON. 'Scene from The Adventures of David Simple *by Sarah Fielding.' 13½ ins. x 17¼ ins. Engraved by R. Laurie 1788. Christie's sale 3.5.1946 (81).*
A blend of early Morland and Wheatley in style.

SKIRVING, Archibald 1749-1819
Scottish portrait painter, mainly in pastel, but also a miniaturist. Born near Haddington 1749; died Inveresk 1819. Exh. miniatures at RA 1778 (as Shirving), and a portrait 1799. He was in Rome 1790-94. Later worked mainly at Edinburgh, where he taught crayon drawing, at which he was highly competent. Several examples are in Edinburgh galleries.

SLACK, John fl.1750
Very provincial Cheshire portrait painter. Signed and dated 1750 a very pedestrian full length of a centenarian keeper at Lyme Park.

SLATER See SLETER, F.

SLATER, Joseph 1750-?1805
Painter of portraits and other subjects in crayons. Born July 1750; date of death alleged to be 1805. Entered RA Schools 1771. Exh. FS 1772; RA 1773-74. Perhaps the 'J. Slater' who exh. portraits RA 1786-87. Possibly the father of one or more miniature painters.

(Long — for a confusion of Slaters.)

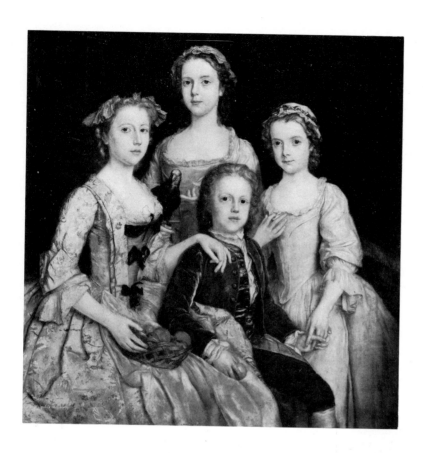

STEPHEN SLAUGHTER. 'Four children of Sir Edward Walpole.' 44ins. x 43½ins. s. & d. 1747. Minneapolis, Institute of Arts.
The most lively and ambitious of Slaughter's known portraits.

SLAUGHTER, Stephen 1697-1765

Fashionable portrait painter in Dublin and London. Probably baptised London 13 January 1697; died Kensington 15 May 1765. Supposedly the 'Mr Slaughter' who subscribed to Kneller's Academy 1712 *(Vertue, vi, 169)*. "Lived abroad near 17 years at Paris and Flanders" *(Vertue, iii, 77)*. Returned to London 1733. In Dublin first in 1734, and later for some years in the middle 1740s. Employed for oils and crayons for Althorp between 1736 and 1739. 'Keeper of the King's Pictures' 1744. Very few dated portraits after 1750 are known. His style and development are like Knapton's (q.v.), but Slaughter goes in for more ornate costume.

(A.C. Sewter, Connoisseur, CXXI (March 1948); Crookshank and Knight of Glin, 1969.)

SLEIGH, William fl.1776

Recorded in a document as a portrait painter at Cork, 1776.

(Strickland.)

STEPHEN SLAUGHTER. 'Michael Cox, Bishop of Ossory.' 49ins. x 39ins. Signed. Christie's sale 16.11.1962 (47).
Said to date 1745. This is more typical of Slaughter's normal Irish portraits.

SLETER, Francesco 1685-1775

Decorative and history painter, probably originating from and trained in the Veneto. Died Mereworth 29 August 1775, 'aged ninety'. In England by 1719. His style has affinities with Amigoni and Sebastiano Ricci (qq.v.). He did a great deal at Canons and Stowe (now all destroyed), but Price's stained glass windows from his designs survive at Great Witley, and there are some ceilings at Mereworth Castle and Moor Park (1732).

(E.C-M.)

SLOUS, Gideon fl.1791-1839

Mainly a miniaturist. From a Huguenot family settled in Jersey. Exh. RA 1791 (from Deptford) 1796-1839. In 1799 he showed some rustic genre pictures. His children, who were artists, understandably changed their name to Selous.

(Long.)

SMART, John 1756-c.1813

East Anglian portrait and landscape painter. He is probably the John Smart who entered the RA Schools 1783, aged 27. Born 4 March 1756; last exhibited 1813. He exh. portraits and landscapes of Suffolk scenes RA 1786-1813, always from an Ipswich address (1788 from Norwich).

He has often been confused with John Smart (1741-1811), who was one of the ablest and most prolific miniaturists. Their exhibits may have sometimes been confused in the RA Catalogues.

SMART, Samuel 1754-c.1787

Portrait and miniature painter. Born 12 December 1754. Entered RA Schools 1771. Exh. RA 1774-87 (miniatures entirely before 1781); SA 1777-78. It seems doubtful that his name was also Paul and a 'Paul Smart' may have been another miniature painter.

SMEASTERS fl.1767

Exh. 'a landscape and figures', FS 1767.

SMIBERT, John 1688-1751

One of the founding fathers of American portrait painting. Born Edinburgh 24 March 1688; died Boston, Mass., 2 April 1751. He learned coach painting and copying in London 1709ff. In Edinburgh until 1719, when he went to Italy (Florence, Rome and Leghorn) until 1722. He had a bust practice as a portrait painter in London 1722-28 *(his English sitter book in: Sir David Evans & others, The Notebook of J.S., Mass. Hist. Soc., 1969).* The major portrait of his London period is the full length 'Benjamin Moreland', 1724 (BAC Yale). In 1728 he accompanied Bishop Berkeley to Newport, RI, and he settled in Boston as a portrait painter, 1729.

(H.W. Foote, J.S., 1950.)

SMIRKE, Robert 1753-1845

Subject painter and illustrator. Born Wigton, near Carlisle, 15 April 1753; died London 5 January 1845. At first apprenticed to a London coach painter named Bromley, but entered RA Schools 1772. Exh. SA 1775-78; RA 1786-1800, 1805 and 1813. ARA 1791; RA 1793. He specialised in scenes from literature or the theatre, usually of small size, and often with a slightly humorous content (Don Quixote, Falstaff, &c.). He worked for Boydell's Shakespeare Gallery and for Bowyer and did a good many poetical illustrations. His work is always neat and elegant, and he does not seem to have painted much in his later years. He was sufficiently notorious for his 'radical' views for George III to refuse, in 1804, to accept the Academy's appointment of him as Keeper.

SMITH, Charles 1750-1824

Portrait and subject painter. An Orcadian; born September 1750; died Leith 19 December 1824. Entered RA Schools 1771 and exh. portraits SA 1776 as a pupil of Mortimer. He intended to go to India in 1777, but did not go until 1783 and may have visited Italy instead. In India he travelled considerably and had some success with the native princes, and he later had his portrait engraved as 'Painter to the Grand Mogul' *(Foster; Archer, 179ff.).* Back in England he exh. portraits and classical themes at RA 1789-97 (in 1794 from Edinburgh). He then took to writing unsuccessful musical entertainments and returned to Scotland about 1823. He is supposed to be the C. Smith who also exh. RA 1813-23; BI 1817 and 1822.

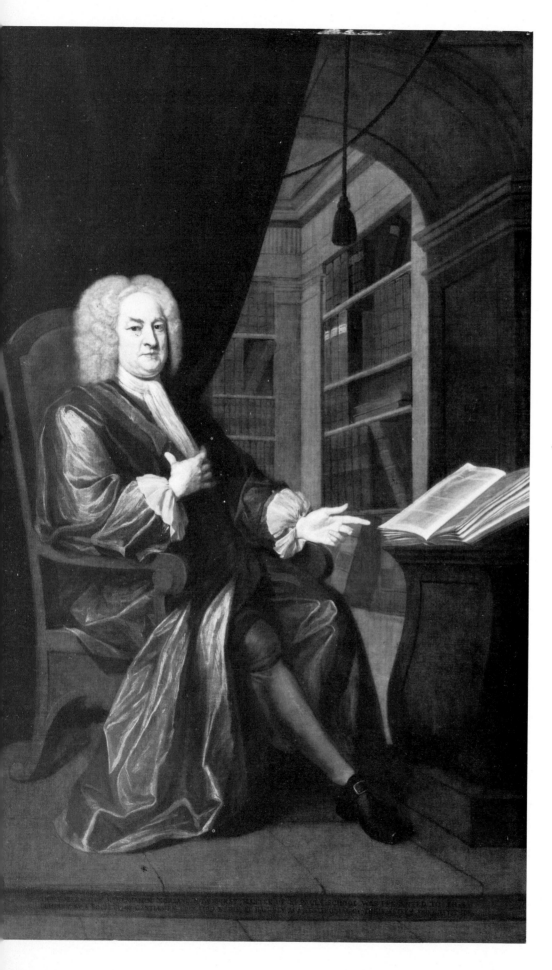

JOHN SMIBERT. 'Dr. Benjamin Moreland.' 95¼ ins. x 59ins. Documented as 1724. B.A.C. Yale. The first Master of St. Paul's School. This was the most ambitious portrait Smibert painted before leaving England for the U.S.

SMITH, Charles Loraine 1751-1835
Amateur painter of sporting scenes. He was of Enderby Hall, Leics., and an hon. exh. RA 1795-99 and 1805-6.

SMITH, Edward fl.1740s
He signed a portrait (signature not checked) of a girl, sold S, 21.3.1979, 59, which was related in style to Mercier.

SMITH, Francis ('Francesco') fl.1764-c.1778
Painter of mainly foreign topographical views, especially of Naples — of which he may have pretended to be a native. He accompanied the last Lord Baltimore to Constantinople 1764, where he made watercolours of Turkish court ceremonies (two at Windsor), which were engraved. Exh. SA 1768; RA 1770-73, mostly views of or near Naples modelled on the style of Jolli (q.v.); some are at Apsley House.

(Grant.)

EDWARD SMITH. 'Katherine Stackhouse' (Mrs. Jonathan Rashleigh). 29½ ins. x 24½ ins. Sotheby's sale 21.3.1979 (59). Said to be signed. The painter is not otherwise known.

GEORGE SMITH of Chichester. 'A cabbage and a joint.' 23½ ins. x 29½ ins. s. & d. 1751. Sotheby's sale 18.12.1963 (68). Before specialising in artificial landscapes, George Smith had quite a good practice in still life painting.

SMITH of Chichester, George 1714-1776
Prolific painter of the rural scene. Born Chichester 1714; died there 7 September 1776. He painted still-life in the 1750s. He won premiums for landscapes at the Society of Arts 1760, 1761 and 1763 (that of 1760 engraved by Woollett 1762). He exh. abundantly at SA 1760-74; RA 1774. He often worked in collaboration with his brother **John** (born Chichester 1717; died there 29 June 1764) who exh. SA 1760; FS 1761-64. Their work is almost indistinguishable and they turned out genuine rustic landscapes, frost pieces, and 'classical landscapes' vaguely in the manner of Claude, which were remarkably popular and many of which were engraved by the best engravers of the time (Woollett, Vivares, &c.). Their landscape etchings are less skilful. For their elder brother, **William** (whose landscapes are hardly to be distinguished from theirs), q.v. There is considerable monotony about their charming works, which make very limited demands on the intellect.

(Grant; W.H. Challen, Sussex Arch. Colls., XC (1952), 130-131, 141ff.)

GEORGE SMITH of Chichester. 'Classical landscape.' 53¾ins. x 67¾ins. Sotheby's sale 10.3.1965 (115).
Traditionally the picture which won a premium at the Society of Arts in 1761.

GEORGE SMITH of Chichester. 'Winter Landscape.' 17ins. x 25ins. Signed. Formerly Col. M.H. Grant.
Winter scenes were a second speciality of the Smiths of Chichester, of which this is a good specimen.

SMITH, George **?1763-c.1802**

Painter of portraits and occasional miniatures. Probably the George Smith who entered the RA Schools 1794, aged 31. He may have been the 'G. Smith' who exh. miniatures from a Wapping address 1790. Exh. RA 1791-1802. After 1800 a number of other G. Smiths also exh. at RA.

SMITH, Henry **fl.1741-1769**

Provincial portrait painter in a style which owes something to Highmore. Perhaps 'the obscure Norwich portraitist Henry Smith' (died January 1769) *(Fawcett, 75)*. He signs 'HS' in a monogram. Dated works are known from 1741, when he was in Scotland (examples at Wemyss Castle, Dunrobin and Arniston) and charged four guineas for a 30 by 25ins. (Wemyss Castle accounts). In 1742 he was working in Devonshire *(Farington 13 Oct., 1809)*.

SMITH, James **fl.1773-c.1784**

Provincial portrait painter of rather modest powers, in oils, crayons and miniature. Exh. SA 1773 (miniature); FS 1776 (crayons); RA 1779-82 (some confusion over J. Smiths). These need not have been the 'James Smith' who signed a large family group of the '5th Lord Middleton', *c.*1784 (Birdsall) and, also in Nottinghamshire, painted a large group of the Dashwood family.

(1790 ed. Thoroton's History of Nottinghamshire, i, 9, ii, 215).

SMITH, John See SMITH of Chichester, G.

SMITH, John Raphael **1752-1812**

Best known as a superlative mezzotint engraver and as a print publisher; but he also painted portraits in crayons and miniature and an occasional fancy theme in oils. Born Derby 1752; died Doncaster 2 March 1812. Son of Thomas Smith 'of Derby' (q.v.). Apprenticed to a linen draper. Began with miniatures and scraped his first mezzotint 1769. He produced a great many mezzotints and became 'mezzotint engraver to the Prince of Wales' 1784, but gave up engraving in 1802. He exh. crayon portraits at SA 1783 and variously at RA 1779-1805. For many years he specialised in doing small size (9 by 7¼ ins.) crayons with great speed and in great abundance, latterly visiting the northern cities (York, Sheffield, Doncaster, &c.) for this purpose. He also published some three hundred prints, many of them by himself. His daughter **Emma**, born 17 September 1783; still alive 1828. Exh. miniatures, historical themes and views, mainly in watercolour, RA 1800-5. His son **John Rubens**, born London 23 January 1775; died

JAMES SMITH. 'Anne (Dashwood) Mrs. J. Cartwright.' 29ins. x 24ins. Christie's sale 23.7.1948 (103).
A provincial Nottinghamshire portraitist in the 1780s; the same hand signed a large group of the family of the 5th Lord Middleton.

New York 21 August 1849. RA Schools 1797. Exh. portraits and scenes of literary genre RA 1796-1805. He emigrated to the United States in 1809, where he had an active career as painter, engraver and teacher *(Groce and Wallace)*.

(Julia Frankau, Life of J.R.S., 1902; Ralph Edwards, Connoisseur, XC (Nov. 1932), 299ff; and XCIII (Feb. 1934), 96ff.)

SMITH, Thomas **fl.1745-1767**

Topographical and picturesque landscape painter; known as 'Smith of Derby'. Died Bristol 12 September 1767. One of the earliest professional painters of views of country houses and well-known beauty spots. Many of his landscapes were engraved by Vivares and others, but few originals are known. Exh. SA 1760-61 and 1767; FS 1767. He occasionally introduced poetical figures into classical landscapes and he took his art sufficiently seriously to name his sons Thomas Correggio Smith (who became a bad miniature painter), and John Raphael Smith (q.v.).

(Grant.)

THOMAS SMITH. 'View from Durdham Down, near Bristol.' 39ins. x 49ins. Engraved by Benoist 1756. Bristol City Art Galleries.
The artist has a pretty silvery tone. It is not clear whether he is the 'Smith of Derby', who is chiefly known for views of country houses. One of a pair.

W.A. SMITH. 'A sportsman, with dog and game.' 49ins. x 39½ins. s. & d. 1791. Sotheby's sale 29.5.1963 (41).
One of a group of signed portraits by a rather elusive portrait painter only known as working in north east Scotland.

WILLIAM SMITH. 'Mary, Duchess of Richmond.' 29½ins. x 24¾ins. s. & d. 1759. Christie's sale 4.12.1936 (78).
A brother of George Smith of Chichester, he was a provincial portraitist in the Chichester area.

SMITH, W.A. (William) 1753–c.1793
A 'William Smith' born 29 December 1753, entered RA Schools 1772 and exh. miniatures RA 1774 (an exhibitor in 1802 was probably another). He signed either as 'W. Smith', or 'W.A. Smith' or 'WAS' a number of miniatures in the 1780s and 1790s connected with the family of the Duke of Gordon *(Long)*. The same signatures are found on oil portraits executed in north east Scotland in a rather loose style dating from the same years: one of 1791, sold S, 29.5.1963, 41, is much in the style of Reinagle.

SMITH, William 1707–1764
Portrait and still-life and landscape painter. Born Guildford 1707; died Chichester 27 September 1764. Elder brother of George (q.v.) and John Smith 'of Chichester'. Exh. still-life pictures at FS 1761-64, but was mainly known as a portrait painter (dated examples are known from 1748 to 1759) of no very decided character. He also painted landscapes hardly distinguishable from those of his brothers.

SOLDI, Andrea c.1703–1771
Italian portrait and history painter. Born Florence c.1703 *(Vertue, iii, 84)*; died London January 1771. He travelled in the Levant and had settled in London in 1735, where he had a very good business as a portrait painter for about ten years. Later his best portraits are of other foreign-born artists, e.g. 'Roubiliac', 1751 (Dulwich); 'Rysbrack', 1753 (BAC Yale). He also painted a few distinguished 'Family conversations'. The most varied and considerable group of his portraits is at Newburgh Priory. His 'Self portrait', 1743, is at York *(E.C-M.)*. His portraits have strong character and a 'European style, but his life-style was too extravagant to support his career. Exh. SA 1761-66; FS 1769.

(Cat. by John Ingamells, Walpole Soc., XLVII (1980.)

SOLOMONS fl.1782
Exh. FS 1782 a 'portrait of an artist' from an address in Houndsditch.

355

WILLIAM SMITH of Chichester. 'A fanciful view of Tivoli.' 32½ins. x 44ins. s. & d. 1753. Sotheby's sale 10.3.1965 (118).
Without a signature it is impossible to tell William and George Smith's 'classical landscapes' apart.

SOMMERS, Charles fl.1739-1753
Portrait painter of small-scale full lengths. Buried
London 14 May 1753. A large group of 'Sir
William More-Molyneux and family', 1739 is at
Losely; a portrait of 'Robert Morris' (sold
29.4.1938, 46) is in the manner of Devis. On 1
August 1752 he took Richard Linnell as an
apprentice.

SOUILLARD, Jean fl.*c.*1750
A Frenchman who painted fresco copies of
Raphael's cartoons in the chapel at Lixnaw, co.
Kerry, before 1756. They were soon destroyed.

SOWERBY, James 1756-1822
Illustrator of botanical works. Died 25 October
1822, aged 66 *(Redgrave).* He exh. still-life, land-
scape, &c. SA 1774, 1776 and 1783.

*ANDREA SOLDI. 'Michael Rysbrack.' 45ins. x 34½ins. s. & d.
1753. B.A.C. Yale.*
The great Flemish sculptor (1694-1770), who worked in
London. He is shown with a model of a 'Hercules' different
from the big 1756 marble made for Stourhead.

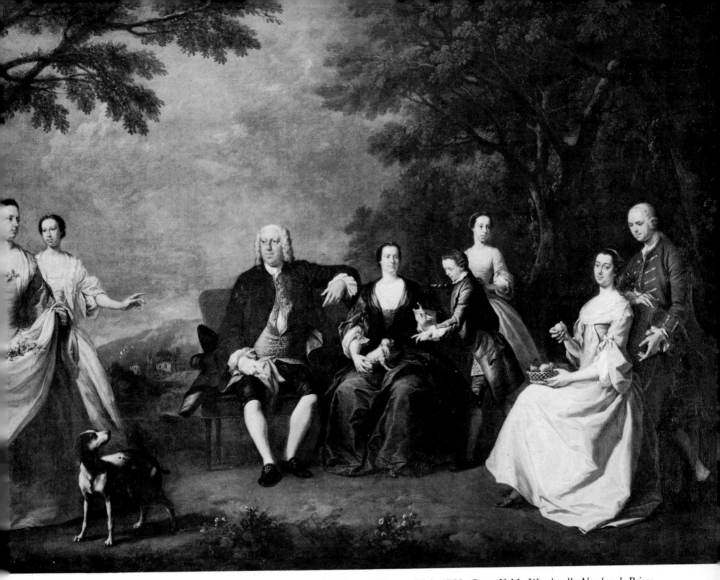

ANDREA SOLDI. 'Thomas, 1st Earl Fauconberg with his family.' 47ins. x 65ins. s. & d. 1755. Capt. V.M. Wombwell, Newburgh Priory, Coxwold.
In his few conversation pieces Soldi produced more sophisticated compositions than his native English counterparts. This is the most accomplished.

SPACKMAN, Isaac fl. *c.* 1750-1771
'A painter of animals, principally birds'. Died Islington 7 January 1771.

(Redgrave.)

SPENCER fl. *c.* 1760
A very competent imitation of Panini at Squerryes Court is traditionally ascribed to 'Spencer'.

SPENCER, Mrs. fl. 1783
Exh. a head in crayons FS 1783. The artist was probably Lavinia Bingham (1762-1831), who had married in 1781, and whose husband became the 2nd Earl Spencer late in 1783. She was a talented artist and friendly with Reynolds.

SPENCER, Thomas fl. *c.* 1730-*c.* 1763
Sporting painter; a pupil of James Seymour (q.v.); best known from engravings. He charged 15 guineas for a portrait on horseback in 1760.

SPILSBURY, Maria 1777-*c.* 1823
(Mrs. John Taylor)
Painter of portraits and of sentimental scenes in a 'feminine' style. Born London 1777; died Ireland *c.* 1823. Daughter of the engraver John Spilsbury. She was an hon. exh. RA 1792-1808; BI 1806-13. In 1809 she married John Taylor (q.v.). She moved to Ireland in 1813 and continued to exhibit in Dublin up to 1819. Her favourite scenes, a number of which were engraved, involved peasants or children or both.

(Strickland.)

CHRISTOPHER STEELE. 'Martha Rhodes.'
39½ ins. x 34½ ins. s. & d. 1750. Private
collection.
The first teacher of George Romney, from
whom Romney derived the neatness and
directness of his early style.

SPOONER, Rev. Mr. fl. 1766-1774
Exh. pictures of almost every sort, but especially
'Deceptions', at FS 1766-74, from an address at
Chesham, Bucks.

STABLE fl. 1767-1775
Artists of this name exh. 'a large drawing' FS 1767,
and a portrait SA 1775.

STABLES fl. 1783
Exh. portrait, genre, landscape, &c., FS 1783.

STACKHOUSE, J. fl. late 18th C
'Painted flowers and fruit' *(Redgrave).*

STANDLEY fl. 1764-1769
A '— Standley' exh. crayon portraits at FS 1764.
He may well have been the same as a '— Stanley'
who exh. crayon portraits SA 1768-69.

STANLEY See STANDLEY

STANNEY, John fl. 1730
Signed and dated 1730 a 'Vanitas', sold 2.4.1971,
129, but the writing on the paper may be Dutch.

STAVELEY, W. fl. 1785-1805
Painter of portraits, usually of small size, and of
miniatures; possibly from York. Exh. RA between
1785 and 1805.

(Long.)

STEELE, Christopher 1733-1767
Portrait painter. Born Egremont, Cumberland, 9
July 1733; died there 1 September 1767. Studied
under a painter named Wright at Liverpool and
under Carle van Loo in Paris for a year, before
settling at Kendal, 1750. Romney was apprenticed
to him at Kendal in 1755, but he became
excessively itinerant after 1756 — York, Lancaster,
Dublin, Manchester, Liverpool, West Indies
(1762) — before returning to Cumberland. His few
signed portraits are neat and crisp and of excellent

quality. His influence on Romney was considerable.

(Mary Burkett, Four Kendal Portrait Painters exh. cat., Kendal, 1973; do. Burlington Mag., CXIX (May 1977), 347 and (Nov. 1977) 774.)

STEPHANOFF, Fileter N. ?1754-after 1791
Portrait and history and scene painter; of Russian origin. Probably the Stephanoff (first name uncertain) who entered RA Schools 1774, aged 29. Exh. RA 1778, 1779 and 1781, and painted stage scenery. He committed suicide soon after 1791. His wife, **Gertrude** (d.1808) exh. still-life at RA 1783 and 1805. A daughter **(M.G.)** exh. flowers 1793. Two sons also were painters.

(Edwards; E.C-M.)

STEPHENS, Peter fl.1753-1767
Amateur landscape painter from an armigerous Shropshire family. Working in Italy c.1753-c.1760, perhaps mainly in Rome and in a tradition derived from Wilson. Etchings after some of his Italian views were published in 1767.

(B. Ford, Walpole Soc., XXXVI, 58.)

STEPHENSON, Joseph 1757-after 1785
Born 20 January 1757. Entered RA Schools 1782. Exh. portraits at RA 1785.

STEPHENSON, Timothy fl.1701ff.
Portrait painter active in the north of England, certainly at Newcastle and possibly also at Carlisle and York. There is a mezzotint by John Smith, 1701, of his 'Thomas Smith, Dean of Carlisle', which gives the name Timothy. Two ovals 30 by 25ins. of 'Ralph Grey and his wife', in a Rileyish manner (formerly at Poundisford Park), were painted 1701 at Newcastle and appear in accounts at £10 5s. to 'Mr Stephenson'.

STEUART, Charles fl.1762-1790
Scottish painter of British landscapes. Said to have been a Gaelic-speaking Athollman, he and his brother, the architect George Steuart (d.1806), owed their patronage to the Duke of Atholl. He may have learned the decorative landscape tradition from James Norie (d.1757) who worked at Blair in the 1750s. Exh. London FS 1762-64; SA 1764-90. He painted large decorative landscapes of local scenery at Blair Castle 1766-78, and did others for Lord Bute of the scenery of Mountstuart and Luton Hoo.

(D. Irwin, Apollo, CVI (Oct. 1977), 300ff.)

STEVENS, Johannes fl.c.1700-1722
Topographical and decorative landscape painter, of Dutch origin. Died London 6 October 1722. He specialised in small overdoors *(Vertue, iii, 8)*; but also painted large topographical works, e.g. 'South prospect of Hampton Court, Herefordshire', c.1700 (BAC Yale) in the style of Knyff.

STEVENS, Justin fl.1743-1771
Portrait painter in Ireland, where he died 1771. His name at birth was Pope, but he took the name of Stevens and was uncle of the painters Pope-Stevens (q.v.). He seems to have been the 'J. Stevens' after whose portraits there are engravings dated 1743-49. He was a feebler Irish equivalent of Dahl.

(Strickland; Crookshank and Knight of Glin, 1978.)

STEWART, Thomas 1766-c.1801
Portrait painter. Born 19 October 1766. Entered RA Schools 1782 (silver medal 1788). Exh. RA 1784-1801. A portrait of 'Miss Inge' sold 28.11.1930, 151, has affinities with Downman. A daughter, **Miss M. Stewart,** exh. portraits and a history at RA 1791-1801, and was a pupil of Stubbs 1799/1800.

STOKER, Bartholomew 1763-1788
Irish painter of portraits in crayon, and miniatures. Born in Queen's County 1763; died Dublin 12 June 1788.

(Strickland.)

STOKES, Thomas fl.1737ff.
A portrait of 'Sir Stafford Fairborne', signed and dated 1737, was sold 24.2.1883, 273; and two undated mezzotints after his portraits are known *(Chaloner-Smith, 927).*

STONE, John fl.1752ff.
Apprenticed to Benjamin Wilson 28 April 1752 for seven years.

STOPPELAER, Charles fl.1703-after 1745
Portrait and still-life painter. Worked in Dublin (as a foreigner) 1703-38, when he moved to London. A portrait in the Dublin Gallery is signed and dated 'Londini 1745'.

(Strickland.)

C. HERBERT STOPPELAER. 'Unknown man.' 30ins. x 25ins. s. & d. 1763. Christie's sale 22.2.1963 (18).
Stoppelaer had a considerable practice in Norfolk, in a tradition of portrait painting that goes back to Heins.

STOPPELAER, Herbert fl.*c.***1735-1772**
Itinerant portrait painter. Died London April 1772. Said to have been born in Dublin and to have come to England with Thomas Frye (q.v.), where he practised as an itinerant portrait painter. He painted full lengths of two Mayors of Norwich *c.*1755/6 and was again working in Norfolk 1763. Exh. SA 1761-62 and 1771. His works have no distinctive style. His signature seems to be C.H. Stoppelaer.

(Edwards.)

STOPPELAER, Michael fl.*c.***1735-1775**
Brother of the last. Bad comic actor, scene painter and occasional portrait painter.

(Strickland.)

STOR(E)Y, J. **fl.1789-1793**
Exh. RA 1793, from a Plymouth address, a marine picture of an incident which had taken place at Plymouth in 1789. A more rural scene has been reproduced *(Grant).*

STOTHARD, Thomas **1755-1834**
The most pleasing and prolific book illustrator of his day; he also painted novelistic and poetical subjects a good deal in oils. Born London 17 August 1755; died there 27 April 1834. Apprenticed to a designer of silk patterns, he taught himself to illustrate novels and poems and his first illustrations date from 1779 *(list of illus. up to 1800 in Hammelmann; see also A.C. Coxhead, T.S., 1906).* Entered RA Schools 1777 and began to exhibit 1778. ARA 1791; RA 1794. Librarian to RA 1812 and very active in Academy affairs. His large oil paintings were not numerous but he executed pictures for Boydell's Shakespeare Gallery and for the Poetic and Historic Galleries of Bowyer and Macklin. He painted mythological compositions on the staircase at Burghley (1799-1803) and in the dome of the Advocates Library, Edinburgh (1822). He also painted many small oil studies with romantic (and rather wishy-washy) figures in landscapes of Venetian sparkle. In later years he made many illustrations for the works of Scott, Byron and Rogers. Exh. RA 1778-1834; BI 1806-23.

(Anne Eliza Bray, Life of T.S., 1851; Shelley Margaret Bennett, T.S., thesis for UCLA, 1977.)

STOWERS, Thomas **1754-1813**
Amateur landscape painter and a pupil of Wilson. Born 6 December 1754; last exhibited 1813. Entered RA Schools 1775. Exh. RA 1778-1811; BI 1807-13. A son of the same name also exh. RA 1805-8.

(W.G. Constable, Wilson, 143.)

STOWLEY **fl.1775**
Exh. a crayon portrait at FS 1775.

STRANOVER, Tobias **1684-after 1731**
Animal and still-life painter. Baptised at Sibiu 10 July 1684. He worked in Dresden and Hamburg and seven signed pictures are in the Schwerin Gallery. He was latterly in London and was paid 10 guineas for a 'fowl piece with a Peacock in it', 21 July 1731 *(Lord Fitzwalter's accounts, Hants. Record Office).*

DANIEL STRINGER. 'Self portrait.' 23½ins. x 19½ins. Sotheby's sale 15.10.1947 (69).
The attribution is traditional and is confirmed by another self portrait of 1776 now in the Tate Gallery. These portraits anticipate the early 'Caravaggesque' style of Opie.

STRINGER of Knutsford

A family of painters, probably a father and two sons. The father, **Francis** was an 'artist and colourmaker' at Seacombe, Wallasey, Cheshire (*Rimbauld Dibdin, 75*), who probably painted animals and sporting subjects at Dunham Massey, 1764, and Oulton 1774-78 (*cat. of Pictures at Oulton Park, 1864, 53/4*). The two sons were: **Samuel,** a Cheshire landscape painter, who exh. Liverpool 1774, lived at Knutsford and was said to be 'lately dead' in 1784; (four landscapes were formerly at High Legh Hall, one signed 'S.S. 1781'); and **Daniel,** born 14 June 1754. Entered RA Schools 1771. Was a good portrait painter in a powerful style like the early Opie ('Self portrait', 1776 in Tate Gallery) but is said to have degenerated into a Cheshire soak.

(Redgrave.)

STRUTT, Joseph 1749-1802

Occasional history painter, but very prolific antiquarian draughtsman and engraver. Born Springfield, Essex, 27 October 1749; died London 16 October 1802. Apprenticed to the engraver W. Ryland, and entered RA Schools 1769. Exh. RA 1779-84 — mainly drawings, but he won the gold medal for a history painting of 'Aeneas and Creusa', 1770. From 1773 he devoted himself mainly to medieval antiquities and drew and engraved his own illustrations for a series of remarkable antiquarian publications. In 1785/6 he published a *Dictionary of Engravers.*

(Redgrave; DNB.)

STRUTT, William Thomas 1777-1850

Still-life and miniature painter. Born London 7 March 1777; died Writtle, Essex, 22 February 1850. Younger son of Joseph Strutt (q.v.). He was a bank official but exh. RA 1795-1822, animals and still-life at first, but mainly miniature portraits after 1806.

(Long.)

GILBERT STUART. 'Thomas, 2nd Earl of Chichester.' 30ins. x 25ins. Inscribed and dated 1785. Saltram (National Trust).
One of a group of portraits at Saltram by Stuart in a style which suggests Benjamin West, tempered by Romney.

361

STUART, Charles See **STEUART, Charles**

STUART, Gilbert **1755-1828**
American portrait painter, active in Britain
1775-92. Born North Kingstown, R.I., 3
December 1755; died Boston 9 July 1828. He first
learned painting from Cosmo Alexander (q.v.) at
Newport, whom he accompanied briefly to
Edinburgh 1772/3. He left Newport for London
1775 and worked in Benjamin West's studio
1777-82, where he formed his portrait style. He
had a successful practice in London from 1782 to
1787, when he fled to Ireland to escape his
creditors. Exh. RA 1777-82 and 1785. His best
English portraits reveal also a study of Romney
and Copley (qq.v.). To demonstrate that he could
paint more than 'heads-and-shoulders' he exh.
1782 the remarkable 'Mr Pelham skating' (NG
Washington). In Ireland he did good business but
again debts forced him to return to America
1792/3. He developed a new style in the United
States and, after suceeding with his portraits of
'George Washington', he became the most famous
portraitist in the U.S., settling at Boston after
1805.

(Groce and Wallace with bibl.)

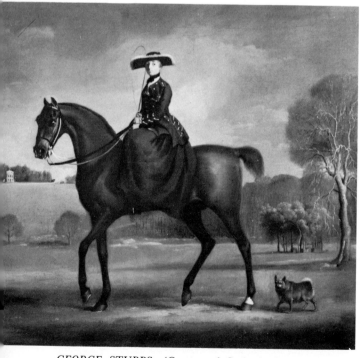

*GEORGE STUBBS. 'Countess of Coningsby in the costume of
Charlton Hunt.' 25ins. x 29½ins. Christie's sale 18.11.1966 (117).
Stubbs was a very capable portrait painter and was basically
miscast as a 'sporting painter'.*

STUART, James **1713-1788**
Architect and occasional decorative painter, known
as 'Athenian Stuart'. Born London 1713; died
there 2 February 1788. He is mainly known for *The
Antiquities of Athens* (jointly with Nicholas Revett,
first vol. 1762, second 1789). For his architectural
career, see *H.M. Colvin,* but he claimed to be a
painter and was painter to the Society of Dilettanti
1763-69 (but did nothing) and succeeded Hogarth
as Serjeant Painter 21 November 1764 (equally
doing nothing). About 1759 he painted
('villainously' according to Walpole) a closet at
Wimbledon House, now destroyed, but a painted
room at Spencer House survives, of the same date
(E.C-M.). He exh. abundantly at the FS 1765-83,
mainly architectural drawings and watercolours,
but a fair sprinkling also of historical, allegorical or
mythological themes.

STUBBS, George **1724-1806**
Painter of portraits, animal pictures, heroic animal
histories and poetical scenes of rural life. Born
Liverpool 1724; died London 10 July 1806. His
artistic training, such as it was, was in the north of
England and he was studying anatomy at York in
1750. He began as a portrait painter in a style not
unlike that of Richard Wilson (q.v.). In Rome in
1754. An interest in horses developed early and in
1758 he began his dissections of horses in a remote
part of Lincolnshire, which eventually resulted in
the engraved work 'The Anatomy of the Horse',
1766, one of the most monumental achievements of
the age — which unfortunately branded Stubbs as
a 'horse painter', which was a low category in
public and artistic opinion. About 1759 he settled
in London and was well employed in the 1760s in a
series of pictures which faithfully and beautifully
displayed the English sporting nobleman or gentle-
man as he lived in the country: 'The Grosvenor
Hunt', 1762; 'Whistlejacket', 1762, a life-size
study of a horse (on loan to Kenwood); a wonderful
series of friezes of 'Mares and Foals', 1762-68; and
the set of four pictures called 'Shooting', 1767-70
(BAC Yale). Exh. SA 1762-74 (President in 1773);
RA 1775-1803. ARA 1780, but his appointment as
RA in 1781 was never ratified. In the 1770s,
assisted by Wedgwood, he became much
preoccupied with painting on ceramic plaques, and
somewhat modified his technique *(Stubbs and
Wedgwood, Tate Gallery cat., 1974).* A few con-
versation pieces (with animals) which are among
the masterpieces of the genre, were painted
1767-69: 'The Melbourne and Milbanke families',
1769/70 (NG), and he painted in the 1770s a series
of pictures of wild animals, ('Tigers', 'Lion

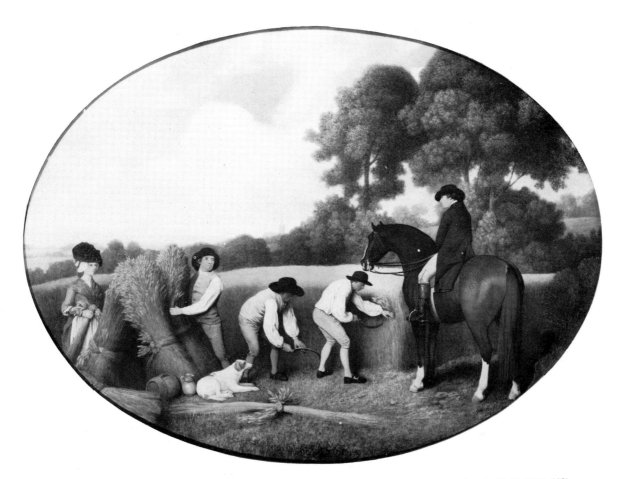

GEORGE STUBBS. 'Reapers.' Enamel plaque. 30¼ ins. x 41½ ins. s. & d. 1795. Sotheby's sale 18.11.1959 (43).
This poetical invention and a companion of 'Haymakers', were first painted by Stubbs in 1783.

attacking a horse') against wild landscapes, which are heroic animal pictures. He also tried his hand at history pictures ('Phaeton', &c.) but he never achieved the reputation he deserved. In the 1780s he painted a few poetical rural subjects: 'Haymakers' and 'Reapers' (Tate Gallery and National Trust, Upton House) which are among the most natural and musical scenes of rural life. In 1793 he painted some novel pictures for the Prince of Wales, and his life-size portrait of the exhausted horse 'Hambletonian', 1799 (Lord Londonderry) is one of the most moving and solemn pictures. He was planning another vast engraved work on animal anatomy when he died. He also made some remarkable animal mezzotints in a novel method. His son **George Townley Stubbs** (c.1756-1815), who exh. a horse painting at RA 1782, was also a competent engraver of his works.

(Constance Ann Parker, Mr. S., the Horse Painter, 1971; Basil Taylor, S., 1971.)

STUBL(E)Y, Thomas fl.c.1730-1738
His name (T. Stubly) is given as the painter of a very competent 'Portrait of Peter Monamy', in a style like an early Highmore, mezzotinted by Faber Junior 1731. A portrait signed and dated 'Thos. Stubley pinx. 1738' is recorded as formerly at Hengrave Hall *(Farrer, 183)*.

STULPNER, J.H. fl.1785
Exh. RA 1785 two pictures of 'A Faquir of the East Indies'.

STURT, Captain fl.1775
Hon. exh. of landscapes at SA 1775.

SUDDENWOOD, Mrs. H. fl.1798-1800
Exh. pictures of flowers RA 1798-1880.

SUMMERS, Charles See SOMMERS, Charles

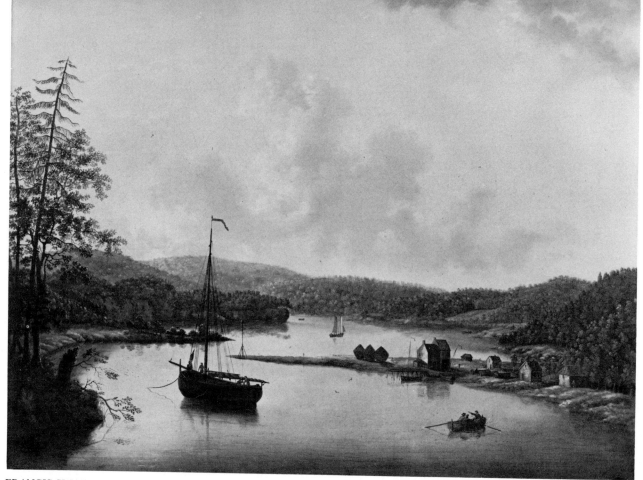

FRANCIS SWAINE. 'Gaspe Bay in the Gulf of St. Lawrence.' 27½ins. x 35½ins. s. & d. 1764. Sotheby's sale 8.11.1950 (134).
Based on an engraved drawing by Capt. Hervey Smyth. Swaine was an all-purpose painter of subjects with a marine content, and this is exceptional.

SUMMERS, S.N. fl.1764
Exh. 'a small whole length of a boy' at FS 1764. He was presumably father to another S.N. Summers (born 1774) who entered RA Schools 1793 and exh. a miniature RA 1795, and landscapes and portraits 1801-6.

SWAINE, Francis *c.*1720-1783
Painter of marines and seafights. Exh. FS 1761-83; SA 1762-83. He won a premium at the Society of Arts 1764, and painted quite competently in the manner of Monamy, after whom he named his son, **Monamy Swaine,** who exh. FS 1769-74 still-life, genre and marine subjects.

(Archibald).

SYER, K.S. fl.1798
Exh. 'Melancholy', RA 1798.

SYKES, F. (?Francis) fl.?1752-*c.*1809
Probably a painter of small whole lengths and conversations; also a miniaturist. Perhaps in Paris 1752-55. Member SA 1765. Exh. SA 1776 a whole length, from a York address. Still living at York 1809.

(Long.)

SYKES, George d.1771
Portrait painter in oil and miniature. Died Yarmouth 1771 *(Fawcett, 89, n.77).* Exh. SA 1770 'Portraits of two young artists'. A 'Sykes junior' exh. SA 1773 and 1774 a 'conversation' and drawings with a red-hot poker.

(Long.)

SYKES, William 1659-1724
Portrait painter, copyist and dealer. Died Bruges 20 December 1724 and had three post-mortem sales *(Vertue, i, 142ff.).* He was a follower and copyist of Kneller and perhaps had a Jacobite clientele (cf. a full length signed and dated 1715 of '3rd Earl of Derwentwater'). Vertue also mentions a 'Sykes junior', who seems to have been a restorer and dealer. Redgrave calls him a portrait painter and says he died 'shortly before 1733'.

SYMONDS, Charles fl.1718-1737
Decorative painter. Apprenticed to John Devoto (q.v.) in 1718 (as Simon). Painted ceilings for the Duke of Chandos at Canons, before 1725, and at Chandos House, 1737, both destroyed.

(E.C-M.)

T

TAITT, G.W. **fl.1797-1810**
Exh. RA two portraits in 1797 and 'A wolf' in 1810.

TAPPEN, G. **fl.1797-1799**
Hon. exh. RA 1797-99 of three pictures (a portrait and two of a more or less sporting type).

TAPPING See TAPPEN

TASSAERT, Philip Joseph **1732-1803**
General purposes and drapery painter; also restorer and picture dealer. Born Antwerp 18 March 1732; died London 6 October 1803. Master in Antwerp Guild 1756/7. He came to London *c*.1758 and became assistant to Hudson. He painted histories and landscapes and an occasional portrait, usually in imitation of some old master, but was mainly active as an expert and in the commerce of the arts. Exh. SA 1769-83 (President in 1775); FS 1779; RA 1785 (portraits). A son, **Philip,** born June 1758, exh. histories SA 1783, from a Munich address.

(Edwards.)

TATE, Richard **fl.1770-1787**
Liverpool merchant and amateur painter in crayons. Died Liverpool 1787. Exh. copies of Wright of Derby (q.v.) in crayons at Liverpool 1774.

(Rimbault-Dibdin.)

TATE, Thomas Moss **fl.*c*.1770-1825**
Amateur painter at Liverpool. Died March 1825. Son of Richard Tate (q.v.) and quite young when he became friendly with Wright of Derby there in 1770, whose work he copied and imitated. He painted some crayon heads, but mainly landscapes, and took to watercolours in the 1790s.

(B. Nicolson, Wright of Derby, 1968, 139.)

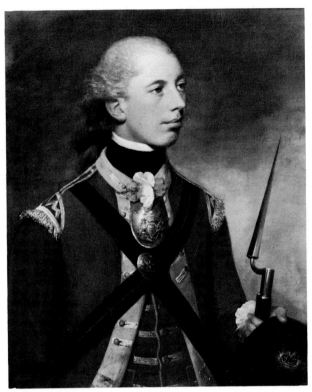

WILLIAM TATE. 'Cornwallis Hewitt.' 29 ¼ ins. x 24 ¼ ins. s. & d. 1781. Sotheby's sale 29.7.1953 (73).
Tate was a pupil of Wright of Derby, but had a slightly more innocent feeling for character.

TATE, William **1748-1806**
Professional provincial portrait and occasional history painter. Born Liverpool September 1748; died Bath 2 June 1806. Brother of Richard Tate (q.v.); pupil of Wright of Derby at Liverpool *c*.1770/1. His style is modelled on that of Wright and he also looked at Romney; it has pleasing individuality. He practised mainly at Liverpool and Manchester until he moved to Bath in 1804. Exh. SA 1771-75 and 1791. Entered RA Schools 1777. Exh. RA 1776-1804. He finished off Wright's uncompleted portraits after his death in 1797.

(B. Nicolson, Wright of Derby, 1968, 138ff.)

TAVERNER, William *c.*1703-1772

Amateur landscape painter, mainly in watercolour and bodycolour — in which medium he was an important pioneer. Born ?London *c.*1703; died there 2 October 1772. He was grandson of a face-painter, **Jeremiah Taverner,** after whom a single mezzotint is known datable about 1690. He followed his father's profession of the law but had a large reputation, as early as 1733 *(Vertue, iii, 68)* as a remarkable painter of landscapes. In his watercolours he produced many natural English scenes, but in oils his pictures are mainly in imitation of Gaspard Poussin (there is an actual copy of a Gaspard at Stourhead).

(E.C-M.; Mallalieu.)

TAYLOR fl.1765

Hon. exh. of 'A piece of fruit', in crayons, SA 1765.

TAYLOR, G. fl.1790

Exh. 'Mr Harley as Richard III', RA 1790.

TAYLOR, John 1739-1838

Drawing master and portraitist in all mediums; often mentioned in Smith's *Nollekens* as 'Old Taylor'. Born London 1739; died there 21 November 1838. Pupil of Hayman and at St. Martin's Lane Academy. His oil work is of no consequence, but he specialised in pencil portraits, of which he drew an enormous number, many at Oxford 1767-71. Exh. all kinds of portraits SA 1764-77; FS 1767; RA 1778-1824; BI 1808-38, as well as many themes from literature.

TAYLOR, Mrs. John See SPILSBURY, Maria

TAYLOR of Bath, John 1735-1806

Wealthy amateur landscape painter and etcher, known as, and signs, 'Taylor of Bath'. Son of an English merchant-adventurer; baptised Philadelphia 24 August 1735; returned with his parents to Bath 1762; died Bath 8 November 1806. He specialised in landscapes with classical ruins, several of which are engraved. There are examples in the Royal Collection. It was fashionable, during the Bath season in the 1760s and 1770s, for people like Garrick and Smollett to admire his works.

(Arthur S. Marks, American Art Journal, Nov. 1978, 81-96.)

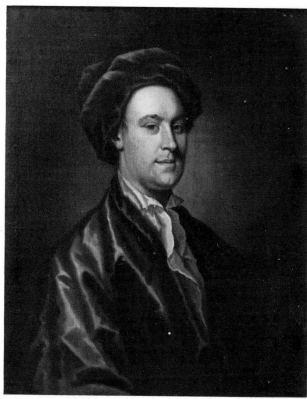

ROBERT TAYLOR. 'Unknown gentleman.' 29ins. x 24ins. s. & d. 1737. Christie's sale 29.10.1948 (18) as 'Alexander Pope'. Clearly a professional portraitist in the tradition of Richardson. He may have escaped mention by Vertue because of Jacobite sympathies.

TAYLOR, Peter (or Patrick) 1756-1788

Scottish decorative and house painter, who occasionally attempted portraits. Died Marseilles 20 December 1788. His portrait of 'Robert Burns' in SNPG.

(E.C-M.)

TAYLOR, Richard fl.1775-1791

Hon. exh. RA 1775-91 of rustic genre figure pictures and landscapes, some of which may have been in oils.

TAYLOR, Robert fl.1737-1755

Portrait painter, possibly with Jacobite connections. Signed and dated works (or engraved portraits, by Faber Jr. and McArdell) are recorded from 1737 to 1755: e.g. 'Robert Gwynne', 1747 (Cardiff). His style is close to that of Richardson (q.v.) and quite competent.

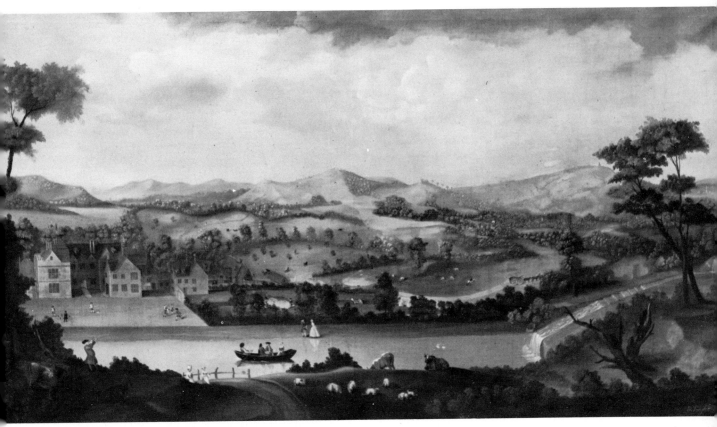

WILLIAM TAYLOR. 'View of Stanway House and Park.' 55ins. x 102ins. s. & d. 1748. Stanway House.
An attractive provincial landscape painter, not otherwise known.

TAYLOR, W. **fl.1748**
An attractive panoramic landscape with a view of
Stanway House and park, Glos., is signed and
dated 1748.

TAYLOR, William **1750-after 1775**
A William Taylor, born 6 May 1750, entered the
RA Schools as a painter 1775.

TELLSHAW, Frederick **fl.1728-1745**
Provincial imitator of Kneller. Portraits are
reported signed and dated 1728 and 1745.

TENDI, Andrea **fl.1790-1797**
Italian history painter. Sought entry to RA Schools
1790. Exh. RA 1793 'The fine arts persecuted by
Ignorance and protected by Jove', and 1797
'Tideus'.

TERRY, Robert **1731-after 1770**
Exh. portraits, landscapes and 'A dandelion' FS
1762-63; SA 1769; RA 1770. Entered RA Schools
1770, aged 39.

THEED, William **1764-1817**
Began as a painter of portraits and histories, but
after 1800 only a modeller and sculptor. Born 3
August 1764; died London 1817. Entered RA
Schools 1786. Exh. RA 1789, a portrait. In Rome
*c.*1791-96. Exh: RA 1797-1817, at first history
paintings up to 1800. ARA 1811; RA 1813. His
paintings are not known, but his sculpture is quite
distinguished.

(Gunnis.)

THIRSBY, J. **fl.1798**
Exh. two portraits RA 1798.

THOMAS **fl.1797**
Hon. exh. of 'an Italian view', RA 1795.

THOMAS, Mrs. **fl.1775**
Exh. 'An old woman's head' and 'St. Catherine',
FS 1775.

THOMAS, A. **fl.1783**
Exh. fruit, flower, and still-life pictures SA 1783
and FS 1783.

THOMPSON, Thomas

A 'Thomas Thompson', born 14 July 1762, entered RA Schools as a painter 1780. A 'T. Thompson' exh. miniatures RA 1793 and 1795; ?another exh. marine subjects RA 1797-1810. A 'Mr Thomas Thompson junior' exh. from Wallworth 'a small whole length of a lady', FS 1783.

THOMPSON, William 1750-1785

Landscape painter with a preference for Cumberland and Westmoreland. Entered RA Schools 1775. Exh. RA 1781, 1782 and 1785. Seems to have died 1785.

(Mallalieu.)

THOM(P)SON, William c.1730-1800

Portrait painter and drawing master. Born Dublin c.1730; but trained and practised in London, where he died 1800. Known as 'Blarney Thompson'. Exh. SA 1760-77 and perhaps FS 1782. There are mezzotints after two portraits in oils; and small full-length portraits in chalks, 1770, not unlike the work of H.D. Hamilton, were sold S, 2.8.1961, 17. He married money and gave up painting. He published *The conduct of the Royal Academicians while members of the Society of Arts from 1760 to their expulsion in 1769.*

(Strickland.)

THOMSON, Henry 1773-1843

Painter of portrait, history and large-figure genre. Born London 31 July 1773; died Portsea 6 April 1843. Entered RA Schools 1790 and was a pupil of Opie 1791. He studied and travelled in Italy 1793-98, returning by way of Vienna and Germany in 1799. Exh. RA 1792-94 and 1800-25; BI 1806 and 1808. ARA 1801; RA 1804 and was Keeper of the RA 1825 to 1827, when he had to retire to Portsea owing to ill-health, after which he was only able to paint marine sketches. His 'Crossing the brook', RA 1803, epitomises the upper class rural domestic style, which he exploited also in portraits. He also made many designs for book illustrations.

THORNBOLD fl.1783

Exh. 'Cattle', FS 1783.

THORNE, R. fl.1788-1802

Exh. landscapes, one with a portrait, RA 1798, 1799 and 1802; appears in the index only of RA 1788.

THORNHILL, Sir James 1675/6-1734

The leading British decorative history painter of his age, and an occasional portrait painter. Born in Dorset 25 July 1675 (or 1676); died Stalbridge, Dorset 13 May 1734. Apprenticed to Thomas Highmore (q.v.) 1689-97, but he learned chiefly from studying, and probably assisting, Verrio and Laguerre (qq.v.). Freeman of Painter-Stainers Company 1704, and began painting scenery 1705. He also made a considerable study of architecture. From the time he began his work at Greenwich in 1708, which was not completed until 1727, he was in a fair way to being the leading baroque decorative painter in England. He visited the Netherlands and Paris in 1711 *(Sir J. T. 's sketchbook travel journal of 1711, ed. K. Fremantle, 2 vols., Utrecht, 1975);* became a director of Kneller's Academy also in 1711, which he took over as Governor 1716. In 1720 he succeeded Thomas Highmore as Serjeant Painter and was knighted. His main surviving decorative schemes (apart from the

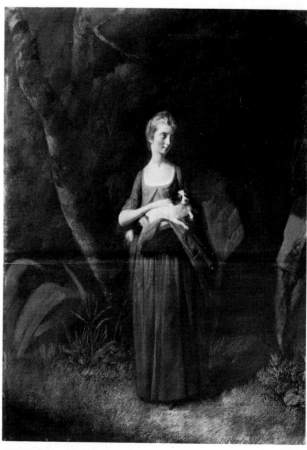

WILLIAM THOMPSON. 'A lady of the Cunningham family.' Chalks. 23ins. x 16¼ins. s. & d. 1770. Sotheby's sale 2.8.1961 (17/2).
One of a pair. Thompson was a drawing master but seems to have abandoned portraiture fairly early.

Painted Hall at Greenwich) are at Hanbury Hall, 1710; the ceiling of the Hall at Blenheim, 1716; Charborough Park, 1718; St. Paul's (in grisaille) 1714-19; chapel at Wimpole, 1724. The death of his patron Lord Sunderland in 1722, and the rise of Lord Burlington, as arbiter of taste and patron of William Kent, clouded his later years; but he became M.P. for Weymouth in 1722 and ran an Academy in his own house. His numerous drawings are more lively than his paintings, but he was an accomplished decorator in the traditional baroque style. Three rather solemn portraits are at Trinity College, Cambridge.

(E.C-M., i, 265ff; ii, 322ff. with bibl.)

THORNTON, Thomas **fl.1778-1785**
Exh. landscapes RA 1778-85 (watercolours in 1785); hon. exh. SA 1783, from an address in Doctors' Commons.

THURGAR, Miss Lucy **fl.1783**
Exh. 'a Charity Boy' and 'Child and dog', FS 1783.

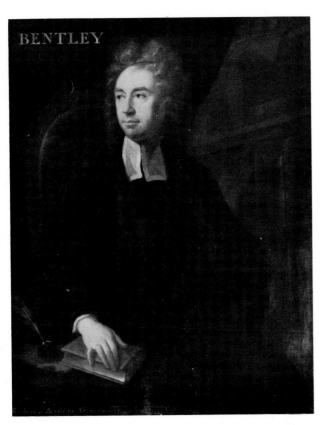

Sir JAMES THORNHILL. 'Richard Bentley.' 50ins. x 40ins. Inscribed as painted 1710. The Master's Lodge, Trinity College, Cambridge.
Thornhill did not often bother to paint portraits, but he was in fact a good interpreter of academic character.

PETER TILLEMANS. 'A gentleman on horseback.' 39½ins. x 49ins. Signed. Christie's sale 2.11.1945 (154).
An enlargement, as it were, of the small figures in Tillemans' views of Newmarket Heath.

THURSBY, Miss **fl.1793**
Hon. exh. of 'Dove-dale, morning', RA 1793.

THURTLE (THUSTLE), F. and S. **fl.1799**
Hon. exhs. of 'Scene in the Castle Spectre' and 'A view in Wales', RA 1799.

THURZAN, Miss Mary **fl.1783**
Hon. exh. of a portrait SA 1783.

TICHBOURN, Mrs. Mary **fl.1763-1766**
Exh. three crayon portraits, SA 1763-66.

TIDD, Julius **fl.1773-1779**
Exh. drawings at FS 1773-75; SA 1773 (as 'Master Julius Tidd') and an oil landscape FS 1779, *(Grant, iii)* in the manner of Ibbetson. Presumably a son of the Julius Tidd, 'merchant at Holborn' who had another son born 1760, who is equated with him *(Mallalieu)*.

TILLEMANS, Peter *c.***1684-1734**
Topographical painter and draughtsman; also painter of sporting conversations. Born Antwerp *c.*1684; died Norton, Suffolk, 19 November 1734. Trained as a copyist of Teniers and battle pictures and brought to England by a picture dealer 1708. He was employed by John Bridges 1719 doing topographical drawings of Oxford and in Northamptonshire. He developed a good practice

PETER TILLEMANS. 'Chelsea Hospital, with Walpole House, from across the Thames.' 28½ ins. x 47½ ins. Signed. Private collection.
In a Flemish tradition, but leading up to the river views of Samuel Scott.

in doing views of country houses, sporting prospects of Newmarket Heath, &c., and was one of the creators of the sporting conversation piece. He held quite a position in the London art world and was the teacher of Angellis, Nollekens, and Arthur Devis (qq.v.). He also tried his hand at stage scenery.

(E.C-M.; Robert Raines, Walpole Soc., XLVII (1980).)

TOBIN **fl.1776**
A 'Mr Tobin' was hon. exh. of 'A view in North Wales', RA 1776.

TODD **fl.1783**
Exh. 'Shipping', FS 1783.

TOMKINS, Charles **1757-1823**
Landscape painter in oils and watercolours, but chiefly an engraver. Born London 1757; died 1823. Son, and presumably pupil, of William Tomkins (q.v.) and elder brother of a better-known engraver, Peltro William Tomkins (1759-1840). Won a silver pallette at Society of Arts 1776. Exh. RA 1773-79 (mostly 'stained drawings' but some views in oils). After 1779 he gave up painting and took to landscape engraving at which he was very successful.

(Mallalieu.)

TOMKINS, Montague **1773-after 1796**
Born 1773. Entered RA Schools as an engraver 1794. Exh. 'Mischievous pleasure', RA 1796.

WILLIAM TOMKINS. 'A river view with a ruined castle.' 28ins. x 36ins. s. & d. 1765. Christie's sale 11.11.1955 (117).
Naturalistic English views, with only slight concessions to the Dutch tradition, made Tomkins a very popular painter.

TOMKINS, William c.1732-1792

Landscape painter and copyist; also painted still-life and animal subjects. Born London c.1732; died there 1 January 1792. He exh. abundantly FS 1761-64; SA 1764-68; RA 1769-90. ARA 1771. He was one of the most favoured painters of views of gentlemen's seats and of picturesque views in their parks, in a style deriving from Lambert (q.v.). Twelve were painted for the Earl of Fife and an accessible group is at Saltram (National Trust) 1770ff.

(Grant.)

TOMS, Peter fl.c.1748-1777

Portrait and drapery painter. Died, probably of intemperance, 1 January 1777. Pupil of Hudson; described as an 'eminent painter' in *Universal Magazine*, Nov. 1748. He was employed by Reynolds as a drapery painter from 1755 to c.1763, when he went briefly, but unsuccessfully, to Dublin. Later employed as drapery painter to Francis Cotes (q.v.) until 1769. Unwisely made a foundation RA 1768. Exh. RA 1769-71 'An allegorical picture', a portrait, and 'The burdock and other wild plants: a specimen of a work to be published'. He was an exceptionally competent drapery painter, but his own portraits are unknown.

(Edwards.)

TONELLI, Anna c.1763-1846

Painter of miniatures and crayon portraits. Born Anna Nistri at Florence c.1763; died there 22 July 1846. She married a violinist named Tonelli. She taught drawing to the children of the 2nd Lord Clive (later Earl of Powis) and lived with the family

CHARLES TOWNE. 'Thomas Parker's chestnut hack at Towneley Hall.' 34¼ins. x 47½ins. s. & d. 1796. Sotheby's sale 7.7.1965 (120).
A pattern of picture Towne repeated very abundantly.

in London and India 1794-1802. Exh. RA 1794 and 1797. She specialised in small oval crayon portraits (there is a group at Powis Castle).

TOPPING, F. **1781-1786**
Hon. exh. of landscapes (several of which were not in oil) RA 1781-86. At RA 1783 M. Topping also exh. a 'View near Sittingbourne in Kent.'

TOWNE, Charles **1763-1842**
Landscape, sporting and cattle painter. Baptised Wigan 7 July 1763; died Liverpool 6 January 1842. Trained under a coach painter at Manchester and in good practice there when he first visited London in 1797 and was fascinated by de Loutherbourg (q.v.). Exh. occasionally RA 1799-1812. He retired to Liverpool, where he was Vice-President of the Liverpool Academy 1812. Some of his small landscapes are quite neat and his horse pictures were popular.

TOWNE, Francis **1739/40-1816**
Painter of landscapes in oil but now chiefly famous for his watercolours. Born 1739/40; died London 7 July 1816. His activity was largely based on Exeter, where he taught drawing. Studied at Shipley's school, London, *c.*1754, with Pars, Cosway, and Humphry (qq.v.), with whom he always remained in touch. Won premium at Society of Arts 1759. Exh. SA 1762-73; FS 1763 and 1766; RA 1775-1810; BI 1808-15. He settled in Exeter (with visits to London) *c.*1767, but finally moved to London 1807. He exhibited mainly oils, but he is now best known for his impressive watercolours, which have an economic and individual style, but were unknown in his lifetime. The chief series of these were Rome, 1780/1 (BM), Switzerland, 1781, English Lakes, 1786. Most of his oils are sensitive views of Devonshire scenery, done for the local gentry.

(A.P. Oppé, Walpole Soc., VIII (1920), 95ff; Mallalieu.)

TOWNE, T. **fl.1787-1791**
Exh. portraits, one in crayons, and 'The Albion mills on fire', 1791, RA 1787-91.

TOWNLEY, C. **fl.1797**
An obviously professional 'C. Townley' signed and dated 1797 a landscape *(reproduced Grant, iii)*. Another, undated, was sold S, 16.4.1958, 160. It is unlikely that he was the engraver and miniaturist Charles Townley (*c.*1746-*c.*1800) who exh. some portraits in black chalk FS 1782-83, and miniatures at RA 1779-95.

C. TOWNLEY. 'A Village Church.' Wood. 10½ ins. x 14½ ins. Signed. Sotheby's sale 16.4.1958 (160).
From the 1790s. One of a pair of signed landscapes known by this mystery painter, whose figures suggest he had looked at Morland.

TOWNSEND, John **fl.1776-1778**
Exh. crayon portraits at SA 1776-78.

TRAMPON, R. **fl.1708**
A portrait of 'Robert Knox', a Captain in the East India Company, apparently dated 1708, is in the NMM, Greenwich. It is quite competent, need not have been painted in England, and the painter is otherwise unknown.

TRENCH, Henry **fl.1700-1726**
Irish history painter of more promise than achievement. Died in London 1726. (Redgrave gives him as Henry French.) In 1700 he won a prize at the Accademia di S. Luca, Rome, and he studied for ten years with Maratta and Giuseppe Chiari. He met with little success in England 1722 and returned to Italy 1723 to spend two years under Solimena; but died soon after returning.

(E.C-M.; Fleming, Adam, 39.)

TRENT, S. **fl.1783**
Exh. a landscape SA 1783.

TRESHAM, Henry 1751-1814

Painter especially of scriptural and classical histories; he at first also made portraits in various mediums. Baptised Dublin 21 February 1750/1; died London 17 June 1814. Studied in Dublin and won prizes there 1768-70. Painted histories and portraits in chalk and oils at Dublin up to 1775, when he moved to London. Taken to Rome, allegedly by John Campbell (Lord Cawdor in 1796), he remained in Italy, mainly Rome, but also Naples and Bologna, until 1789, and was active in art dealing as well as in studying to paint. He exh. twelve historical subjects (several of them drawings) at RA 1789. Exh. RA 1789-1806. ARA 1791; RA 1799. He gave up the practice of art from ill-health in 1806, but succeeded Opie as Professor of Painting 1807-9. He continued writing and art dealing until his death. He painted specimens for all the historical series, Boydell, Macklin and Bowyer, but his style is flimsy and mannered and better suited to drawing than painting.

(Strickland; Crookshank and Knight of Glin, 1978.)

HENRY TRESHAM. 'The Earl of Warwick's vow previous to the Battle of Towton.' 17¼ ins. x 14¼ ins. Exh. RA 1797 (429). City of Manchester Art Galleries.
Tresham was a specialist in painting subjects for the various historical and literary 'galleries' which flourished at the end of the century. He here shows the influence of Fuseli.

TROKES fl.1773

A 'Mr Trokes jun.' exh. 'A lion and lioness', FS 1773.

TROTTER, John fl.1756-1792

Irish portrait painter. Studied in Dublin *c.*1756. Died Dublin February 1792. He studied in Italy *c.*1759-73. Married Mary Anne Hunter, daughter of Robert Hunter (qq.v.) in 1774. He continued to exh. portraits in Dublin up to 1780. His later small scale portraits are said to show the influence of Wheatley.

(Strickland; Crookshank and Knight of Glin.)

TROTTER, Mrs. John See HUNTER, Mary Anne

TROTTER, Thomas 1756-1803

Mainly an engraver. Born London May 1756; died there 14 February 1803. Entered RA Schools as an engraver 1779. Exh. RA, literary themes 1780 and 1782, portrait drawings 1785-86, antiquarian drawings 1801. He was friendly with Blake and ended as an antiquarian draughtsman. Presumably he was not the same Thomas Trotter, who exh. 'A Roman Charity', SA 1771.

TRUIT fl.1778

Exh. 'A cobler [*sic*] and his family: half length', SA 1778 with an address 'at St. Omer or at Mr Greenwood's, Haymarket.'

TRUMBULL, John 1756-1843

American portrait and historical painter; also soldier and diplomat, &c. Born Lebanon, Conn., 6 June 1756; died New York City 10 November 1843. He had some military and artistic training in America and was eventually a pupil of Benjamin West (q.v.) in London 1784-89, during which period he made a visit to Paris and looked at the work of Mme. Vigée-Lebrun and David. Entered RA Schools 1785. Exh. RA 1784-86 (portraits and two scenes in West's style from classical history). Again in England in a diplomatic role 1794-1804; and a third time 1806-16, when he exh. RA 1809, 1811, 1812 (portraits, landscapes and religious themes); BI 1810-13. He sent a portrait from New York to the RA 1818. His best known works are scenes from American revolutionary history (mostly at Yale) and were painted in the U.S.

(Autobiography, ed. T. Sizer, 1933; Groce and Wallace.)

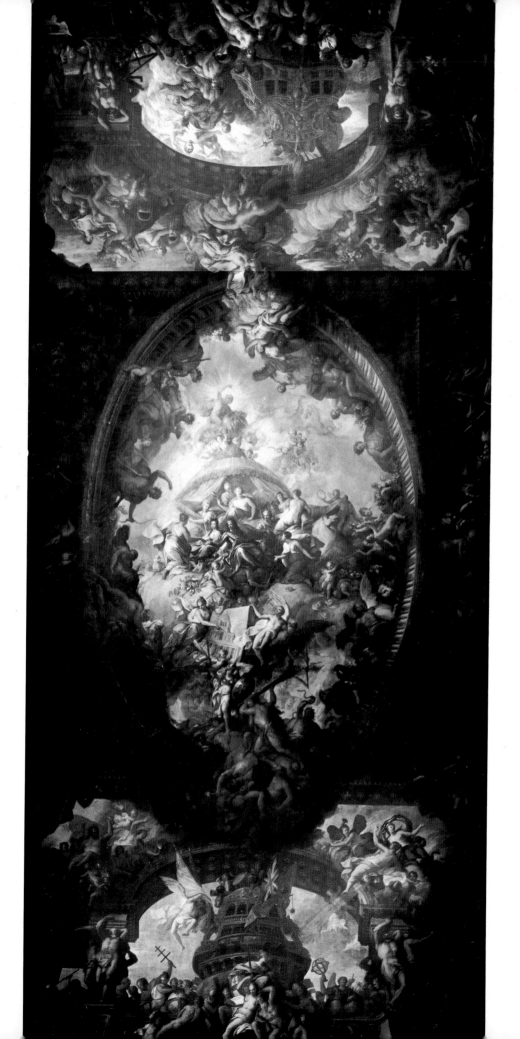

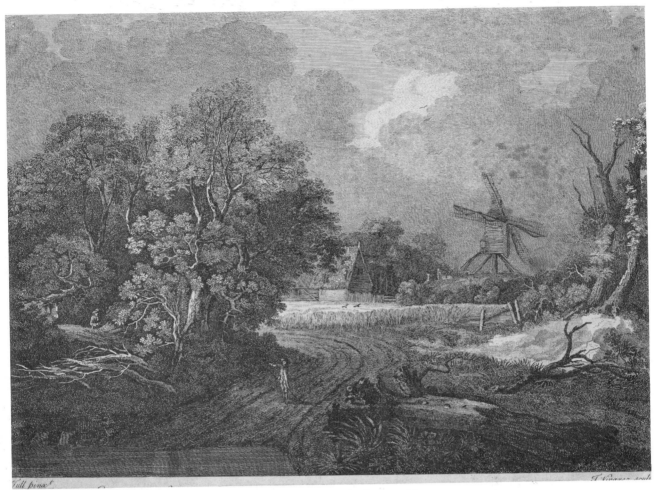

EBENEZER TULL. 'Landscape' engraved by Vivares. (The original painting is untraced.)
Tull's landscapes, now almost wholly known from very good engravings, such as this, have affinities with Gainsborough's early style and may now be passing under his name.

TUCKER, Henry　　　　fl.1758-after 1762
Portrait painter in oils; worked at Dublin 1758-62, and said by Pasquin later to have 'worked with success' in the north of England.

(Strickland.)

TUCKER, L.　　　　fl.1771
Signed and dated 1771 'a snow scene' *(reproduced Grant, iii).*

TUCKER, Nathaniel　　　　fl.1725-1743
Portrait painter; known from mezzotints after portraits datable 1725 to 1743 *(Chaloner-Smith).* He had an armorial bookplate dated 1740.

TUDOR, Joseph　　　　?1695-1759
Irish landscape and scene painter. Perhaps baptised Dublin 22 September 1695; died there 24 March 1759. Probably influenced by Vanderhagen. He was the leading Dublin landscape painter of his time, but his panoramic views are now chiefly known from engravings.

(Strickland; Crookshank and Knight of Glin, 1978.)

TULL, Ebenezer　　　　1733-c.1762
Landscape painter. Born 1733; died before 20 January 1762. In his own lifetime sometimes called 'the English Ruysdael', and his little landscapes (identifiable from the engravings of six by Vivares and Elliott) are very much in the style of the young Gainsborough's early Suffolk imitations of Dutch landscapes — several of which were in Tull's posthumous sale 1762, Lugt 1223. Exh. SA 1761. He was, for most of his life, a master at St. Olave's School, Southwark.

(John Hayes, Burlington Mag., CXX (April 1978), 230-233.)

Sir JAMES THORNHILL. Part of the ceiling of the Painted Hall at Greenwich, Royal Naval College (the centre of the Lower Hall). 1708-1712.
The subject is 'William and Mary giving Peace and Liberty to Europe'. It is the most ambitious baroque ceiling decoration by a native British painter.

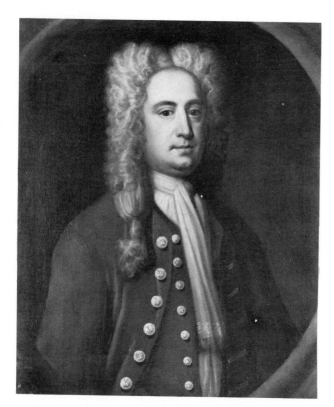

JOSEPH TYMEWELL. 'Henry Streatfield' (1679-1747). 29ins. x 24ins. s. & d. 1737. Christie's sale 25.3.1966 (58). One of a group of signed and dated portraits in the same sale by a (presumably Kentish) local provincial painter otherwise unknown.

TUNNA, G.B. fl.1761-1765

Italian portrait and historical painter from Val d'Ossola. Pupil of G.M. Borgnis (q.v.), at whose death in 1761 he came to England. He was advertising portraits in chalk or oils at Norwich 1765.

(E.C-M.; Fawcett.)

TURNER, Daniel fl.1782-1801

Topographical landscape painter and etcher; probably also a miniaturist. 'Mr Turner' exh. FS 1782-83 miniatures and landscapes, some in watercolours. 'Mr D. Turner' exh. London views RA 1796-1801. His views are usually small and neat and of the neighbourhood of London.

(Grant.)

TURNER, George 1752-c.1820

Painter of portraits and fancy subjects. Born 1 June 1752; last recorded in 1820. Entered RA Schools 1782. Exh. RA 1782, 1790-1813; BI 1807-20. Portraits of two of his children (born 1777 and 1784) were engraved with a dedication to C.J. Fox. He ran a drawing academy.

TURNER, James fl.1761-1790

Painter of portraits, miniatures and fancy subjects. Said to have been Irish and to have died 1790. Exh. SA 1761-83. There is a mezzotint (?c.1764) after his 'Rabbi Hart Lyon' by E. Fisher.

TURNER, Joseph Mallord William 1775-1851

One of the greatest European romantic painters; and rival only to Constable as the greatest English landscape painter. The most remarkable of English watercolour painters. Born London 23 April 1775; died there 19 December 1851. Entered RA Schools 1789. Exh. RA 1790-1850. Up to 1796 his exhibits were all in watercolour. His first work in oil, RA 1796, is in the Tate Gallery.

(Martin Butlin and Evelyn Joll, The Paintings of J.M.W.T., 1977, for his entire work in oil.)

TURNER, Miss Mary fl.1798

Exh. 'The Diana tulip', RA 1798.

TURNER, Miss Sophia 1777-after 1793

Daughter of George Turner (q.v.). She exh. three scenes from plays, two of which at least were probably drawings, RA 1791-93.

TURNER, William 1763-c.1816

Landscape painter. Born 25 March 1763. Entered RA Schools 1785. Exh. RA 1787 (drawing), 1792, 1808-13, 1816. He should not be confused with the watercolour painter 'William Turner of Oxford' (1789-1862).

TURPIN fl.1765

Exh. 'A piece of flowers', SA 1765.

TUSCHER, Marcus 1705-1751

Painter, architect, illustrator, &c. Born Nuremberg 1 June 1705; died Copenhagen 6 January 1751. Studied in Rome and Florence c.1728-38; came, via Paris and Holland, to London in 1741 *(Vertue, iii, 111)* where he painted a small conversation piece of 'George Moser and his wife' which impressed *Edwards*. He settled in Copenhagen in 1743, where he became a court artist.

(Th.-B.)

TYMEWELL, Joseph fl.1721-1737

Portrait painter in Kent. He signed and dated in 1721 a group of portraits of the Streatfield family (of Chiddingstone, Kent), sold 25.3.1966, 55-58, in a provincial version of the style of Richardson. One was said to date 1737 also.

U

UPSDELL, P. fl.1791

A 'Master Upsdell' was the hon. exh. of a landscape at SA 1791.

V

VALDRÉ, Vincenzo c.1742-1814
(VALDRATI, WALDRÉ)

Historical, decorative and scenery painter; architect. Born Faenza c.1742; died Dublin August 1814. Studied in Parma under Baldrighi and at Rome. In London by 1774 when he exh. 'Jupiter and Thetis', FS 1774. Doing scenery for the King's Theatre 1777; worked at Stowe c.1777-88, where some quite elegant ceilings survive (Apollo, June 1973, 577ff). Later he lived in Dublin, where he did some painting in Dublin Castle and became architect to the Board of Works.

(E.C-M.)

VAN AKEN, Alexander c.1701-1757
(HAECKEN)

Painter and mezzotint engraver. Probably born Antwerp c.1701; died London 1757. Younger brother and assistant of Joseph Van Aken (q.v.), with whom he lived and whom he succeeded in 1749 as drapery painter to Hudson and others. Vertue reports him as less good than Joseph in this role. His English mezzotints range from 1722 to 1738.

VAN AKEN, Arnold d.1735/36
(HAECKEN)

'Painter in oil of small figures, landscapes and conversations'; also an engraver (Vertue, iii, 77). Died London 1735/6. Perhaps the eldest brother of Joseph and Alexander (qq.v.). He engraved in 1736 a set of prints of fish, 'The Wonders of the Deep', after his own drawings. He is not otherwise known.

VAN AKEN, Joseph c.1699-1749
(HAECKEN)

Painter of genre and portraits, but best known as the top drapery painter of his age. Probably born Antwerp c.1699; died London 4 July 1749. He came to London with his brothers c.1720, and first painted genre scenes and conversations in the style of J.J. Horemans (R. Edwards, Apollo, XXIII (Feb. 1936, 79-85). About 1735 he took to specialising in painting the draperies, with the greatest refinement, of most of the portraits by Hudson, Ramsay, Davison and a number of other painters in London and the provinces — for which he had a series of standard poses. Horace Walpole remarks that "almost every painter's works were painted by Van Aken". Ramsay and Hudson were his executors, and many of his drawings are confused with Ramsay's in the SNG.

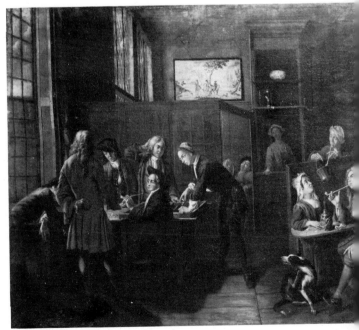

JOSEPH VAN AKEN. 'Interior of an alehouse.' 25ins. x 30ins. Signed. Christie's sale 31.7.1953 (106).
Still in an entirely Dutch tradition. This composition seems to have been repeated several times.

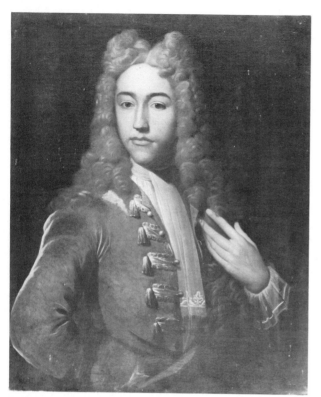

RICHARD VAN BLEECK. 'Unknown man.' 29½ ins. x 24½ ins. Signed. Christie's sale 22.6.1979 (108).
Probably from the 1730s. It is like a Dutch version of Kneller.

VAN ASSEN, (Benedict) Anthony 1767-*c*.1817
Mainly designer and engraver of genre, history, portraits. Born 12 December 1767; died *c*.1817. Entered RA Schools 1783, silver medal 1788. Exh. RA 1788-1804, mainly drawings and an occasional miniature. He was mainly an illustrator but a rather feeble one.

(Redgrave.)

VAN BLEECK, Pieter 1697-1764
Portraitist and mezzotint engraver. Born The Hague 1697; died London 21 July 1764. Son of Richard (q.v.). He was already practising in London 1723 *(Vertue)* and married in 1745 a Roman Catholic lady of good family. Exh. SA 1761. He engraved a number of his own portraits, the finest of which is 'Mrs Cibber as Cordelia', 1755 (BAC Yale). His quality is variable but his best work is neat and distinguished.

VAN BLEECK, Richard *c*.1670-*c*.1733
History and portrait painter. Born The Hague *c*.1670; died, probably in London, *c*.1733. Father of Pieter (q.v.). Member of the Guild at The Hague, 1695; first visited London 1699 (his 'Sir James Holt', *c*.1700 is in NPG). Back at The Hague 1705/6, but latterly much in England, where his most successful portrait practice was, notably among Roman Catholic families. A 'Fainting of Esther', 1712, sold 6.12.1946, 1, is perhaps a theatre scene — his father was an actor.

(Th.-B.)

RICHARD VAN BLEECK. 'The fainting of Esther.' 45ins. x 61ins. s. & d. 1712. Christie's sale 6.12.1946 (1).
Perhaps probably painted in Holland; it may well be a theatre scene rather than a straight 'religious history'.

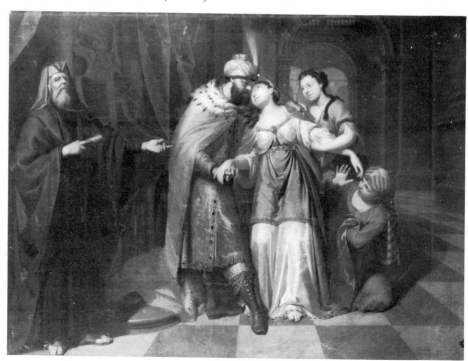

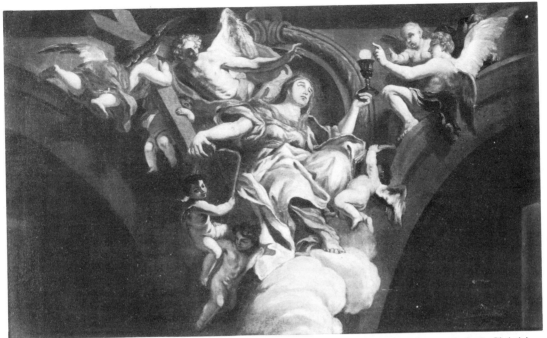

?JOHN VANDERBANK. 'Allegory of Faith.' 18¼ ins. x 30ins. Signed 'Vanderbank' (and traces of a date). Christie's sale 19.5.1967 (49).
A 'modello' for the spandrel of a church dome. From the signature it could equally be by Moses Vanderbank — but their manner is identical. (In 1981 at Pasadena as 'Solimena'.)

VANDERBANK, John 1694-1739

History and portrait painter and book illustrator. Born London 9 September 1694 *(Mrs. Finberg, TLS 24 Dec., 1954, 837)*; died there 23 December 1739. Son of John Vanderbank the well-known tapestry weaver. Studied from 1711 in Kneller Academy; in 1720, with Cheron (q.v.) founded his own Academy in St. Martin's Lane. He was a very lively draughtsman and his painting virtuosity is like that of Hogarth. Vertue thought that only intemperance prevented him from being the best portraitist of his generation. From 1720 he had an increasingly large clientele for portraits, often full lengths, and many are signed and dated. His chief book illustrations are for *Don Quixote* and he also painted many small versions of these (some in the Tate), dating from 1731 to 1736, to satisfy his creditors. A few wall paintings are known and many drawings suggest an interest in historical subjects which he did not have much chance to pursue.

(Hammelmann.)

JOHN VANDERBANK. 'A gentleman in red.' 49½ ins. x 39½ ins. s. & d. 1731. Christie's sale 1.7.1938 (124).
Very typical in execution, with vividly smudged high-lights.

BENJAMIN VANDERGUCHT. 'Self portrait.' c.25ins. x. 20ins.
s. & d. 1780. Robinson & Foster's sale 17.6.1943 (53).
The inscription on this portrait: 'se ipse pinxit,/1780. Aet 27' is
the evidence for his date of birth. He may have studied with
Zoffany.

JOHN VANDERBANK. 'Mrs. Townsend.' 50ins. x 40ins. s. & d.
1738. Sotheby's sale 18.5.1938 (44).
Vanderbank more often than not signs and dates his pictures:
unsigned pictures may often be studio repetitions.

BENJAMIN VANDERGUCHT. 'A girl as a shepherdess.' 30ins. x
25ins. s. & d. 1772. Christie's sale 3.3.1967 (146).
A Zoffany influence seems also possible here.

VANDERBANK, Moses *c.***1695-after 1745**
History painter. Younger brother and probably pupil of John Vanderbank (q.v.) than whom he was even more improvident. His only known works are three flimsy altarpieces of 1745 in the church at Adel, near Leeds.

(E.C-M.)

VANDERGUCHT, Benjamin **1753-1794**
Painter of portraits and theatre scenes. Born 1753; drowned Chiswick 16 September 1794. Studied at St. Martin's Lane Academy and entered RA Schools 1769, silver medal 1774. His style in portrait and theatre scenes is similar to that of Zoffany (q.v.) and he had some patronage from Garrick from 1772. Exh. FS 1767-70; RA 1771-87, when he gave up painting and reverted to his father's profession of picture dealing and cleaning. His best theatrical conversation is a 'Scene from The Register Office', RA 1773 (Leicester).

VANDERGUCHT, Michael **1660-1725**
Engraver and occasional painter. Born Antwerp 1660; died London 16 October 1725. Pupil of Bouttats at Antwerp 1672/3. In England before 1700. A portrait and a conversation piece in oils at Knole have long been ascribed to him. He was grandfather of Benjamin (q.v.).

BENJAMIN VANDERGUCHT. 'Moody and Parsons in a scene from The Register Office.*' 40ins. x 50ins. Exh. RA 1773 (298). Leicestershire Museums and Art Galleries.*
Authenticated by the mezzotint by J. Saunders 1773. It is very close in style to Zoffany's theatre scenes.

ANDREAS VAN DER MIJN. *'Still life with fruit.' 39ins. x 49ins. Signed 'A. Vandermijn' and dated 1777. Christie's sale 10.11.1961 (58) as 'Agatha van der Mijn'.*
The pyramid is a curious element in a still life. The date makes it almost certain the painter must be Andreas.

VANDERHAGEN, John fl. 1702
Painter on the Earl of Derby's staff at Knowsley 1702 at £20 a year (*Lancs. Record Office, Knowsley MSS, DDK 15/24*).

VANDERHAGEN, Joris 1676-?1745
Landscape painter. Said to have been a grandson of the Dutch landscape painter Joris vander Hagen (1615-69) and to have worked in Ireland. A single work dated 1716 is known (*Crookshank and Knight of Glin, 1978, 55*).

VANDERHAGEN, William fl. 1722-1745
Painter of topographical landscapes, seapieces, and historical scenes; also decorative and scenery painter. Recorded in Ireland 1722-45, when he had lately died. He had previously painted topographical views in England and Europe.

(*E.C-M.; Crookshank and Knight of Glin, 1978, 55-61.*)

VANDERMEERE, John 1743-1786
Irish still-life and scene painter. Baptised Dublin 13 July 1743; died there 1786. He won prizes for art at the Dublin School in 1756 and 1758, but by 1768 had given up art for the stage.

(*Strickland.*)

VAN DER MIJN, Agatha fl. *c*. 1700-at least 1728
Flower and fruit painter; sister of Herman (q.v.) with whom she probably came to London *c*. 1721 (*Vertue*).

VAN DER MIJN, Andreas 1714-at least 1777
Painter of still-life and mezzotint engraver. Born Antwerp (or Düsseldorf) 1714; last dated work 1777. Second son of Herman (q.v.). His engravings are mostly after pictures by his own family, including a portrait by himself. Exh. fruit pieces FS 1764 and 1768. Rather sumptuous fruit pieces signed 'A. van der Mijn' are probably by him rather than his aunt Agatha; e.g. Anon sale 10.11.1961, 58, of 1777.

(*Chaloner Smith.*)

VAN DER MIJN, Cornelia 1709-at least 1772
Painter of flowers and portraits. Baptised Amsterdam 29 October 1709; last recorded 1772. Daughter of Herman (q.v.). She is presumably the 'Mrs Van der Mijn' who exh. still-life and occasional portraits FS 1764-72. A flower piece is in the Rijksmuseum, Amsterdam.

FRANS VAN DER MIJN. 'An unknown man.' 29¼ ins. x 24½ ins. s. & d. 1757. Sotheby's sale 23.5.1962 (144).
Frans van der Mijn shows himself approximating to the new style of Reynolds.

VAN DER MIJN, Frans *c.* 1719-1783

Painter of portraits and 'fancy heads'. Probably born Antwerp 1719; died London 20 August 1783. Third son of Herman (q.v.) and perhaps his assistant up to his death in 1741. He had a good fashionable portrait practice in Amsterdam 1742-49, but settled in London *c.*1750, where he had a good, mainly middle-class practice, especially in the 1750s, though some clients were deterred by his insisting on smoking a pipe while painting! His English portraits are fairly close to those of Highmore (q.v.), and the best have considerable individuality. Exh. FS 1761-72.

(A. Staring, Nederlands Kunsthistorisch Jaarboek, 19 (1968), 171-203.)

HERMAN VAN DER MIJN. 'Carew Hervey Mildmay.' 93 ins. x 56½ ins. s. & d. 1733. Sotheby's sale 6.2.1957 (17).
His most ambitious work. Horace Walpole, who saw this at Hazelgrove in 1762, misheard the painter's name as Vanderbank and says he was kept painting it at the house three months.

HERMAN VAN DER MIJN. 'Unknown lady.' 49ins. x 39ins.
s. & d. 1732. Christie's sale 12.2.1954 (72).
The rather metallic conventions for drapery painting are
Dutch and so is the whole presentation.

ROBERT VAN DER MIJN. 'Still life of fruit.' 19¾ins. x
25½ins. s. & d. 1757. Private collection.
One of a pair: the only ones at present known.

VAN DER MIJN, George *c.*1726/27-1763

Portrait and genre painter. Born London *c.*1726/7;
died Amsterdam 10 December 1763. The youngest
son of Herman (q.v.) by his second marriage. His
painting career was entirely in Amsterdam and
after 1741. It is probable that known portraits
signed 'G. van der Mijn' are by him, but they
could be the work of his eldest brother, **Gerard,**
born Amsterdam 1706, 'history and portrait
painter in England', of whom nothing is known.

VAN DER MIJN, Herman (Heroman) 1684-1741

Flower, history and portrait painter. Born
Amsterdam 1684; died London November 1741.
He began as a flower painter; took to history and
portrait at Antwerp and Düsseldorf and came to
London *c.*1721. He was the father of a number of
painter children (qq.v.), whom he trained. He
developed a good portrait practice in England and
has a neat, slightly metallic style, with meticulous
accessories. He did some work for the royal family
*c.*1727 and his most ambitious works date from the
early 1730s, the largest being 'Viscount Chetwynd
and family', 1732 (Earl of Shrewsbury coll.). He
was in Holland again 1736/7.

(*A. Staring, Nederlands Kunsthistorisch Jaarboek, 17 (1966),
201-245.*)

VAN DER MIJN, Robert 1724-after 1764

Painter of still-life and portraits. Born London
1724; last recorded 1764. Son of Herman (q.v.).
Exh. FS 1762-64. Two fruit pieces of 1757 are
known.

VAN DER PUYL, (Louis François) 1750-1824
Gerard

Dutch portrait painter. Baptised Utrecht 4 March
1750; died 1824. Taught at the painting school,
Utrecht, from 1804 and was Director 1807. He
worked in England *c.*1783-88. Exh. RA 1785-88.
His clients tended to be connected with the Royal
Society: 'Professor Anthony Shepherd', 1784 (The
Old Schools, Cambridge); 'Conversation at
Thomas Payne's the Bookseller', RA 1788
(Philadelphia Mus.).

(*Th.-B.*)

VAN DER SMISSEN, Dominicus 1704-1760

German portrait painter. Born Altona 1704; died
there 1760. He visited London *c.*1738 and *c.*1757.
A portrait of 'John, Earl Granville', engraved
1757, is at Longleat.

GERARD VAN DER PUYL. 'Thomas Payne, his family and friends.' 35ins. x 47ins. s. & d. 1787. Exh. RA 1788 (13) as 'A conversation'. Philadelphia Museum of Art (given by John H. McFadden Junior).
Thomas Payne of the Mewsgate was a bookseller. The sitters are all identifiable: see Dibdin's *Bibliographical Decameron*, III, 435. The ladies' hats of 1787 were rather extravagant.

VAN DER VAART, John 1653-1727

Portrait painter and mezzotint engraver; also specialist in landscape, drapery and still-life. Born Haarlem 1653; buried London 30 March 1727, aged 74. Came to England 1674 and was naturalised 1708. He long painted drapery and accessories for Wissing, on whose style his own portraits are modelled. He had given up mezzotinting before 1700. After 1713 he was best known as a cleaner, restorer, and 'expert'.

(Vertue, iii, 32; Croft-Murray and Hulton, 484.)

VAN DE VELDE, Willem 1633-1707

The best painter of seapieces of his age; also a portraitist of ships and of naval historical scenes. Baptised Leyden 18 December 1633; died Greenwich 6 April 1707. Known as 'the Younger' to distinguish him from his father, Willem van de Velde 'the Elder' (*c.*1611-93), who was his first teacher; he later studied with S. de Vlieger. He and his father migrated to England in 1673 and were given appointments by the Crown as official naval painters. He was also a great master of the unofficial marine subject and had a prevailing influence on later British sea painting. Two sons, **Willem**, baptised 4 September 1667, and **Cornelius**, 1675-1729, are said to have imitated their father's works, and a signed Cornelius is at Greenwich.

(Hofstede de Groot, VII; M.S. Robinson, cat. of V. de V. drawings at NMM, Greenwich, 2 vols., Cambridge, 1958, 1974; Archibald.)

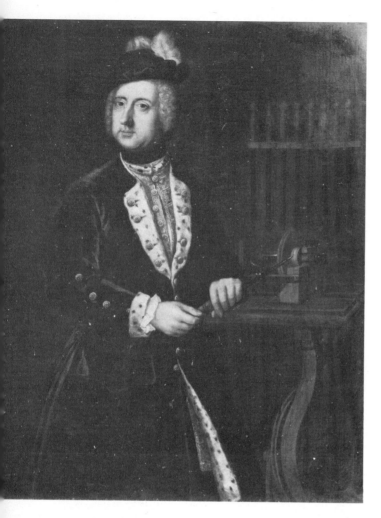

JOHN VANDIEST. 'Anthony, 6th Viscount Montague, turning at wood.' 50ins. x 40ins. s. & d. 1735(?6). Robinson & Fisher sale 29.4.1937 (98) as 'Thomas Chippendale'.
There are several versions of this; Vandiest liked using 'turning at wood' as a motive for portraiture.

VANDYKE, Peter 1729-after 1795

Drapery and portrait painter: Said to have been born in Holland and brought to England by Reynolds as a drapery painter *(Redgrave)*. A signed portrait of the early 1760s, sale S. 25.5.1966, 156, certainly shows an imitation of Reynolds. Exh. portraits SA 1762; FS 1764-72. A whole length of 1779 of a 'Tennis player' suggests knowledge of Zoffany (q.v.). Later he settled in Bristol, where he painted small portraits of 'Coleridge' and 'Southey' in 1795 (both NPG).

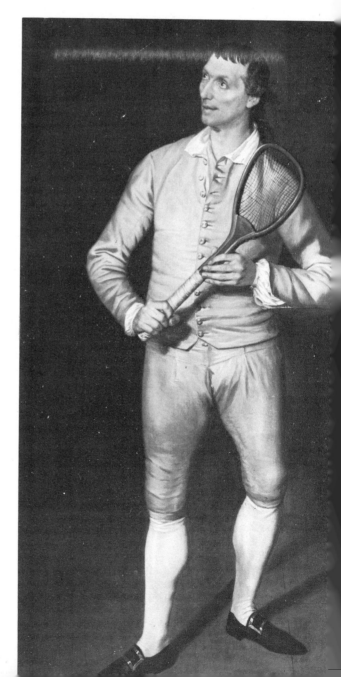

VANDIEST, Adriaen 1655-1704

Dutch painter of decorative ideal landscapes. Born The Hague 1655; died London 1704. Son and pupil of marine painter Willem Vandiest. Came to England 1672 and was much employed in painting overdoors, overmantels, &c. He was a very prolific painter of rather dreary landscapes in either a Roman or Flemish style, and of moonlights, harbours, &c.

(Ogdens; Archibald.)

VANDIEST, John fl.1695-1757

Portrait painter, copyist, and occasional landscape painter. Son of Adriaen Vandiest (q.v.). He was already copying Kneller in 1695 and may have been a pupil. Dated or engraved portraits date from 1721 to 1757, and are moderately wooden. He also occasionally painted 'Mediterranean harbour' scenes.

PETER VANDYKE. 'A tennis player.' 76ins. x 47ins. s. & d. 1779. Christie's sale 15.10.1957 (148).
This could perhaps be an actor in a character part.

VAN GAELEN, Alexander **1670-1728**

Dutch painter of battle pieces and state occasions. Born Amsterdam 28 April 1670; died 1728. Pupil and clever imitator of Huchtenburg. He visited Germany and came to England *c.*1697 and remained until after 1704. He painted several battles of William III and royal occasions of both William III and Queen Anne. A signed example is at Brighton.

(Miller, 1963, 167.)

VAN HAECKEN See VAN AKEN

VAN LOO, Jean-Baptiste **1684-1745**

Frenchman, known in England only as a portrait painter. Born Aix-en-Provence 11 January 1684; died there 19 September 1745. He worked in the south of France, Turin and Rome, where he studied under Luti, until he settled in Paris 1720. *Agréé* at the Academy 1722; Academician 1731. He came to England December 1737 and left, after a year's ill-health, October 1742. His immense success in London as a fashionable portrait painter is chronicled by Vertue, and by 1739 he was the favourite painter of the Prime Minister (Sir Robert Walpole) and had painted the 'Princess of Wales, her family, and household' (St. James's Palace). His style was smarter than Richardson's, and it had some influence on Hudson — and his manners and manner suited the upper classes better than Hogarth's. His later life was divided between Paris and Aix. Of his three painter sons, the eldest and most talented, **Louis-Michel,** Toulon 1707-Paris 1771, Academician 1733, was Court Painter in Spain 1737-52, and visited London 1765, when he exhibited four portraits at the SA, one of the French Ambassador. He was a more elegant portraitist than his father.

VAN OLST, J. **fl.1790**

A visiting Flemish painter, who exh. still-life SA 1790.

VANSOMERS, John **d.1732**

The *Gentleman's Magazine* records the death in London on 23 March 1732 of 'Mr John Vansomers, an eminent Dutch painter'.

VAN STREACHEN, Arnold **fl.*c.*1735**

A small, sketchy and feeble whole length of the '1st Earl of Hardwicke', *c.*1735 (Middle Temple) is ascribed to an otherwise unknown 'Arnold van Straechen'.

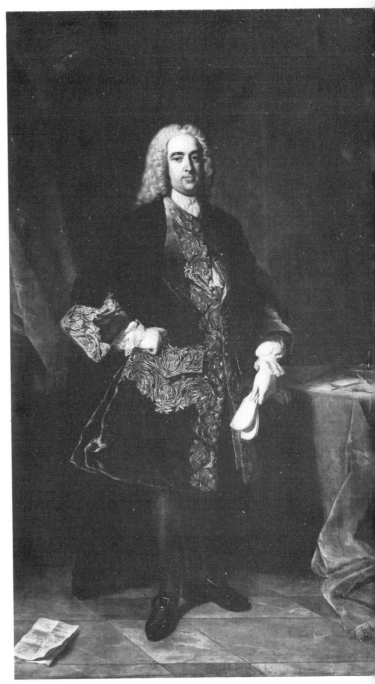

JEAN-BAPTISTE VAN LOO. 'The Right Honble. Thomas Winnington.' 96ins. x 60ins. s. & d. 1741. Corporation of the City of Worcester.
Van Loo created the ideal formula for the portrait of a Whig politician, which explains his popularity with Sir Robert Walpole.

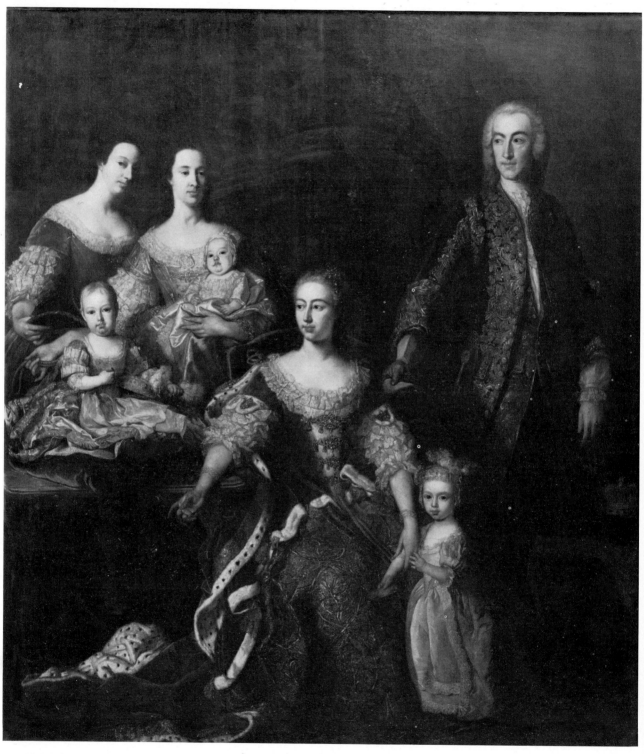

JEAN-BAPTISTE VAN LOO. 'Augusta, Princess of Wales with her family and household.' 87¾ ins. x 79ins. s. & d. 1739. St. James's Palace (reproduced by gracious permission of Her Majesty The Queen).
The man standing at the right is Lord Boston.

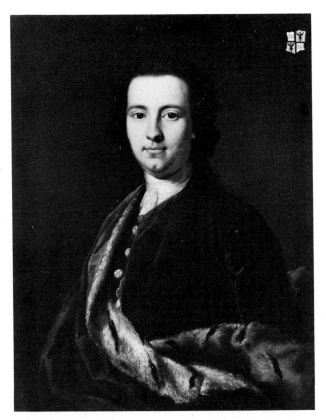

JEAN-BAPTISTE VAN LOO. 'George Montagu.' 29ins. x 24ins. Name and date (1739) on back. Buccleuch collection, Boughton House, Northants.
Bust size Van Loos of this kind are relatively rare.

VARDON, S. fl.1772-1803
Exh. at first still-life and later rustic genre fitfully at RA 1772-1803.

VASLET, Lewis 1742-1808
Portrait painter in oils and especially in crayons; also a miniaturist. Born York 1742; died Bath November 1808. At first an ensign in the army, but left the service, travelled in Italy, and showed miniatures at the RA 1770 as 'Lewis Vaslet of York'. He exh. RA 1770-71, 1775 and 1782, latterly from Bath. York and Bath were his main centres in an itinerant career: he was at Oxford 1780 and 1796, and stayed there for four months in 1790, advertising himself as 'artist in crayons (miniatures and likenesses)'. His best crayons are extremely accomplished. In Bath in 1787 he advertised that he also painted wild animals, gentlemen's seats, still-life, &c. *(Long)*. He compares favourably with Downman.

(J. Ingamells, Apollo, LXXX (July 1964), 33-34.)

VAUX, J. fl.1797-1798
Exh. landscapes RA 1797-98 from a Croydon address.

VERBRUGGEN, Jan 1712-1781
Amateur painter of landscapes and marines. Born Enkhuyzen 1712; died Woolwich 27 October 1781, where he was for many years a master founder. Exh. 'A view of a town in Holland', SA 1772.

VERELST, Cornelius 1667-1728
Flower painter; son of Harman Verelst (*c*.1643-1702, worked in England from 1683). No works are known; father of John and Willem (qq.v.) *(Weyerman, 111, 272/3)*.

VERELST, John fl.1698-1734
Portrait painter. Died London 7 March 1734. Probably son of Cornelius Verelst (q.v.). Signed and dated works range from 1699 to 1734. He makes his sitters look rather unattractive and has a very curly 'V' to his signature.

VERELST, Maria 1680-1744
Painter of portraits in large and small. Born Vienna 1680; died 1744. Sister of Cornelius (q.v.). She had considerable musical and intellectual attainments and specialised in small portraits on copper (*c*.7 by 6 ins.), but also painted on the scale of life.

(Goulding and Adams, 488/9.)

VERELST, Simon 1644-1721
Flower painter and portraitist. Baptised The Hague 21 September 1644: died London 1721. Brother of Harman, and the first of the family to come to England 1669 *(Pepys)*. He was the most famous flower painter of his time, but went mad and painted gigantic roses in later life. He also painted a number of curiously mannered portraits.

(Frank Lewis, Simon Pietersz Verelst, Leigh on Sea, 1979, with list of flower pictures.)

VERELST, Willem fl.1734-*c*.1756
Painter of portraits and conversation pieces. Died *c*.1756. Probably younger brother of John (q.v.). He was the best portraitist of the family, painting both life-size portraits and Devis-scale conversations. His major work is 'The Common Council of Georgia receiving the Indian Chiefs', 1734/5 (H.F. Dupont Museum, Winterthur, U.S.A.).

(Egmont.)

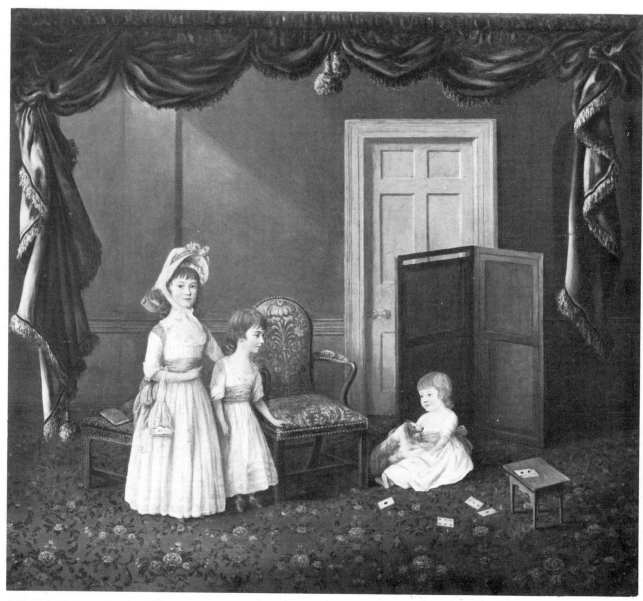

LEWIS VASLET. '*The Brydges children.*' *34ins. x 39ins. Signed (with monogram) and dated 1795. Formerly with Leger.*
The theatre-curtain effect is an unusual convention.

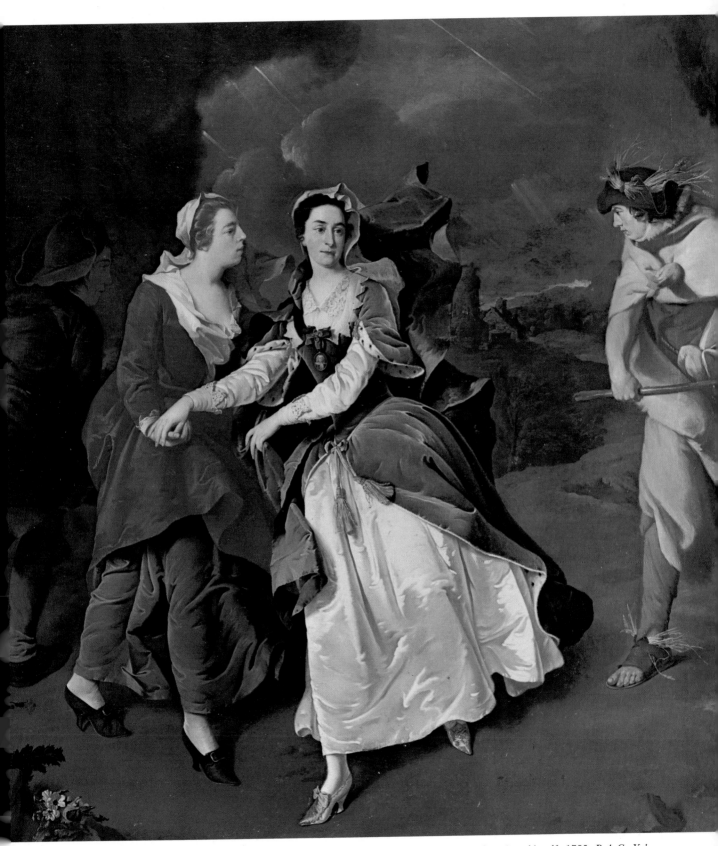

PIETER VAN BLEECK. 'Mrs. Cibber as Cordelia.' 81½ ins. x 81½ ins. Engraved in mezzotint by the painter himself, 1755. B.A.C. Yale.
The version of *King Lear* illustrated is that by Nahum Tate, in which Cordelia is accompanied by her maid.

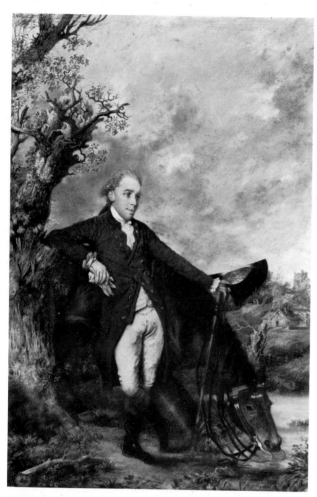

LEWIS VASLET. 'Unknown gentleman.' Crayons. 29½ ins. x 19½ ins. s. & d. 1783. Sotheby's sale 15.5.1957 (30).
Vaslet was one of the most accomplished crayon portraitists, but does not often include a landscape setting of this sort.

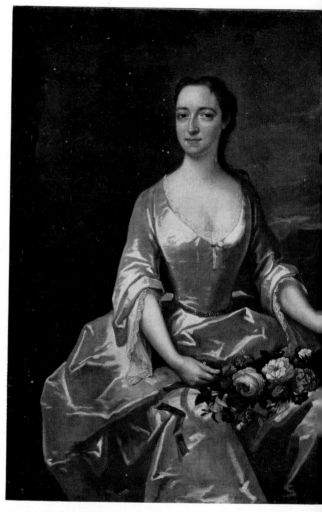

JOHN VERELST. 'Honble. Mrs. Thomas Arundell.' 50ins. x 40ins. s. & d. 1734. Private collection.
The slightly metallic effect is typical.

VERNEY, James fl. 1753

On 8 February 1753 'James Verney, painter' was elected a member of The Gentlemen's Society of Spalding.

VERRIO, Antonio c. 1639-1707

Decorative and historical painter. Born Lecce c. 1639; died Hampton Court 15 June 1707. His training was mainly Neapolitan and French and he introduced into England in 1672 a taste for vast baroque mythologies on wall and ceiling. He was immensely admired, notably by Charles II, for whom he did a great deal of work at Windsor (mostly destroyed), but his execution is usually vulgar and second rate. From 1688 to 1698 his chief work was at Burghley; from 1700/1 he did a good deal, which survives, at Hampton Court.

(E.C-M., i, 50-60, 236-242.)

VIDAL, L. fl. 1790-1792

Exh. flower pieces at RA 1790-92, in one case not an oil.

VIEIRA, Francisco 1765-1805

Portuguese painter of history and portraits. Born Porto 1765; died Funchal, Madeira, 1805. Pupil of Domenico Corvi at Rome. He came, via Germany, to London. Exh. histories and mythologies RA 1798-99; painted an altarpiece for the chapel of the Portuguese Legation 1800. In 1802 he became 'pintor da Camara' in Portugal.

(E. C-M.)

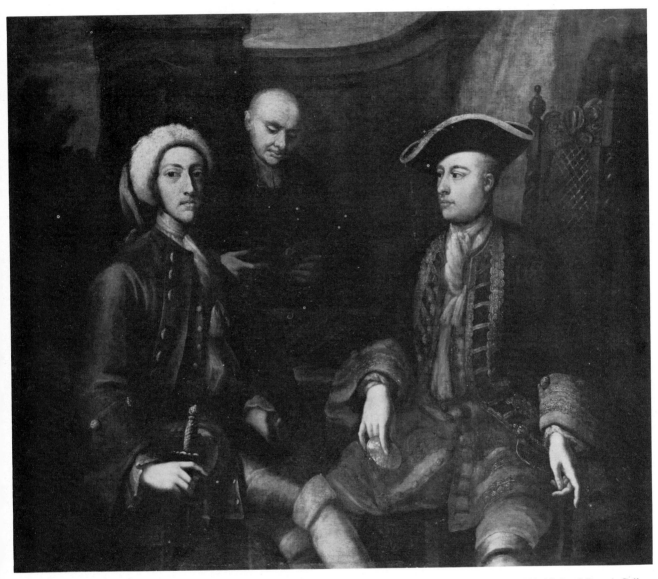

JOHN VERELST. 'John, 2nd Duke of Montagu, and James, Lord Tyrawley.' 56½ins. x 69ins. Signed 'V.p./1712'. National Portrait Gallery (2034).
This odd signature seems to be that of John Verelst and this curly 'V' is the same as in his full signatures.

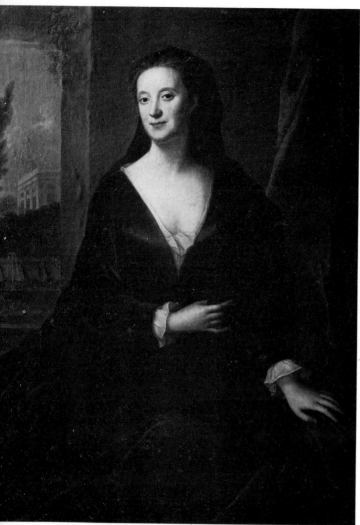

MARIA VERELST. 'Lady Grisel Baillie.' 50ins. x 40ins. Inscribed and dated 1725. Lord Binning, Mellerstain.
Although Maria Verelst usually works on a smaller scale, she was a perfectly capable portraitist on the scale of life.

VILLEBRUNE, Mary de fl.1772-1782

Painter of portraits and fancy heads in oils and crayons. Exh. SA 1771-74; RA 1772, 1777 and 1782 (in 1777 only as 'De Villebrune du Noblet'). Her work is not known.

VISPRÉ, François Xavier c.1730-c.1790

French painter of portraits, miniatures, and still life, now known only for crayons. Born, probably at Besançon (*Brune*), c.1730; last recorded in London 1789. The younger of two brothers, who seem to have worked together until the elder, **Victor,** disappears in Dublin about 1778. From 1764 both painted still-lives of fruit on glass, and Victor is known for nothing else. Signed crayons are only known with the signature: 'Vispré' and the exh. records of the two brothers is confused.

Provisionally it has seemed best to assume that all crayons so signed are by François Xavier. Both brothers worked in Paris in the mid-1750s as decorative painters (*Brune*) and came to London about 1760; both went to Dublin 1777 and François Xavier returned to London 1780. Victor exh. fruit pieces on glass RA 1770-72; SA 1763 and 1773-78 (latterly from Dublin). François Xavier exh. 1760-77, 1780 and 1783; RA 1788-89. The crayons portraits are excellent likenesses and technically very competent. They were Huguenots and friendly with Roubiliac.

(Noon, 1979, 48-49.)

VITALBA, Giovanni fl.1769-1785

Landscape artist. Entered RA Schools 1769. Exh. RA 1771, 1773, 1775 and 1785, mostly drawings, but one landscape in oil. A '— Vitalba' who exh. a view of Venice RA 1798 was probably a different person.

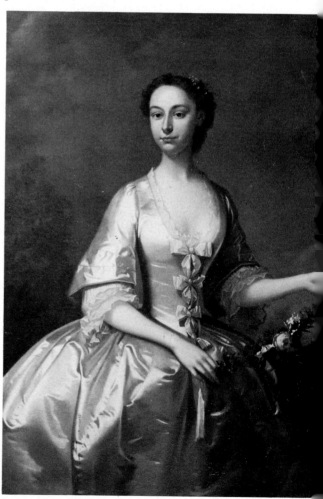

WILLEM VERELST. 'Unknown lady.' 49ins. x 39ins. s. & d. 1741. Christie's sale 8.7.1949 (143).
Willem carried on the Verelst family portrait tradition from about the time when John died.

FRANÇOIS XAVIER VISPRÉ. 'John Farr.' Pastel. 17ins. x
23½ins. Signed. Ashmolean Museum, Oxford.
The signature simply reads 'VISPRÉ PINX.'. The name of the
sitter is traditional; he is reading Horace.

FRANÇOIS XAVIER VISPRÉ. 'Madame Roubiliac (Celeste de
Regnier).' 29ins. x 24ins. Christie's sale 20.3.1953 (120).
The second wife of the sculptor. The companion portrait of
Roubiliac is at the B.A.C. Yale.

VOGELSANG, Isaac 1688-1753

Dutch cattle and battle painter and painter of
accessories. Born Amsterdam 1688; died London 1
June 1753. Pupil of Huchtenburg. In England by
at least 1722. He toured Ireland, with some
success, and Scotland 1735/6 (Vertue). He normally
painted backgrounds and animals in the paintings
of others.

(Strickland.)

W

WADDINGTON, S. 1736-1758

Only known from Redgrave's statement that he "painted some good landscapes in a classic style... and died at the age of 22 in 1758".

WAGG fl.1783

Exh. 'A Deception', FS 1783.

WAGGNER fl.1783

Exh. two landscapes, FS 1783.

WAITT, Richard fl.1706-1732

Scottish painter of Highland portraits and still-life. Died 1732. Said to have been a pupil of Scougall (q.v.). His portraits are sometimes decidedly savage; a very accomplished still-life of cauliflowers and meat, 1724, is at Edinburgh.

WALDEGRAVE, C. fl.1769-1781

Exh. landscapes FS 1769-76; RA 1780-81.

WALDRÉ, Vincent See VALDRÉ, Vincenzo

WALDRON, William fl.1768-1801

Irish painter of flower pieces, portraits, especially theatrical portraits, and religious history. Apprenticed in Dublin 1768; started on his own 1772. Employed by Dublin Society's School 1779 till he retired in 1801. Exh. in Dublin 1770-77.

(Strickland.)

WALE, Charles fl.1780

Exh. a portrait of a gentleman, FS 1780.

WALE, Samuel 1721-1786

Mainly a designer of book illustrations and book-plates, but an occasional painter of history. Probably born Yarmouth 25 December 1721 (though Farington says he died aged 73); died London 6 February 1786. Apprenticed to a goldsmith (Goldley) 1735; learned book illustration at St. Martin's Lane Academy from Hayman and Gravelot (qq.v.). Presented two of the circular 'Views of Hospitals', which are very neat, to the Foundling Hospital 1748, but his normal exhibits were historical scenes, often sketches or stained drawings. Exh. SA 1760-67; RA 1769-78, when he became paralysed. He was a Foundation RA and the first Professor of Perspective. His character was valued by the Academy and he was given the sinecure of Librarian in 1778. He was the most prolific designer of book illustrations up to the time of Stothard.

(Hammelmann.)

RICHARD WAITT. 'Still life of vegetables and meat.' 23ins. x 30ins. s. & d. 1724. National Gallery of Scotland, Edinburgh. A great deal more accomplished than Waitt's portraits, which often have rather a savage air.

SAMUEL WALE. 'St. Thomas's Hospital.' Diameter 22ins. Painted 1748. Thomas Coram Foundation, London.
One of a pair of circular views of London Hospitals presented by Wale to the Foundling Hospital in 1748 (for a companion, see Richard Wilson, page 418.)

WALES, James 1747-1795
Landscape and portrait painter; also engraver. Born Peterhead, Aberdeenshire, 1747; died Bombay 18 November 1795. Trained in Scotland. He exh. portraits from a London address at SA 1783 and 1791; RA 1788-89. In 1791 he went to Bombay where he practised with success as a portrait painter. He also produced architectural drawings and landscapes, some of which he engraved himself.

(Forster; Archer, 333-355.)

WALING, C. fl.1799-1800
Exh. what were probably landscapes, RA 1799-1800.

WALKER, W. fl.1782-1789
Exh. still-life pictures at RA 1782, 1784 and 1789. 'The little cherub — a portrait', RA 1791, was probably by another painter of the same name.

WALKER, William 1779-*c.*1809
Portrait painter. Entered RA Schools 1797. Exh. portraits RA 1797-1808. Said to have died *c.*1809.

WALKERSON fl.1783
Exh. 'Shipping', FS 1783.

WALL, Dr. John 1708-1776
Amateur painter. Born Powick, Worcs., 12 October 1708; died Bath 27 June 1776. He was a practising physician at Worcester and also a chemist and prominent in the establishment of the Worcester Porcelain Company. He was an hon. exh. of allegorical and classical subjects RA 1773-74. Some of these and a 'Self portrait', in a style deriving from Richardson (q.v.) are in the Dyson Perrins Museum, Worcester.

(DNB.)

Dr. JOHN WALL. 'Self portrait.' 30ins. x 25ins. Dyson Perrins Museum, Worcester.
The attribution is traditional and probably correct. Wall's historical compositions have a rather more amateurish air. He was a physician and concerned with the establishment of the Worcester Porcelain Factory.

WALLIS, George Augustus 1770-1847

Landscape painter in a style reflecting contemporary German art; also active in the trade in old masters. Of a Scottish family; born Merton, Surrey, 15 February 1770; died Florence 15 March 1847. Exh. RA 1785-86, among watercolours or drawings, and then travelled with his wife through France and Switzerland to Naples, where he appears 1789. Exh. RA 1794 'A view of Paestum' and another Italian view, probably watercolours, from a Naples address. From 1794-1806 he was in Rome, acquiring the nickname of 'the English Poussin' but associating mainly with the German painters, Carstens and Koch, whom he rivalled in painting Ossianic subjects, one of which, as well as landscapes and history pictures, he exh. RA 1807. Pursued old masters in Spain 1807-10; then to

THOMAS WALMSLEY. 'Landscape with a ruined church.' 25ins. x 32ins. s. & d. 1798. Christie's sale 16.7.1965 (117).
Walmsley interprets both Irish and English landscape into more or less international picturesque terms.

Heidelberg, of which he painted views. He also exh. RA 1815 and 1836, but settled for good in Florence in 1818, where he became a member of the Academy. Both his daughters married German artists.

(Whitley 1800-20, 122ff; Th.-B.)

WALMSLEY, Thomas 1763-1806

Landscape painter in oils, watercolour and gouache. Born in Ireland (but not Irish) 1763; died Bath 1806. He practised a little as a scene painter in London and Dublin (and this may have affected his ideas of composition) before 1790, when he settled in London. Exh. SA 1790; RA 1790-96, when ill-health caused him to retire to Bath. At first he showed mainly scenes from Wales and the Lakes, but in 1796 he showed Irish views, some of which he made into aquatints. His style probably owes something to Barret (q.v.).

(Grant.)

WALPOLE, Mary Rachel c.1758-1827

Hon. exh. RA 1782 of a portrait of her sister, Caroline. She married 1798 Rev. Ashton Vade.

HENRY WALTON. 'The market girl.' 49¼ins. x 39¼ins. Exh. RA 1777 (360). Christie's sale 16.11.1962 (82).
Walton's genre pictures of this kind clearly reveal French influence and show much greater refinement of tone and sentiment than comparable English examples.

WALTON, Henry c.1746-1813

Painter of single portraits, conversations and refined domestic genre. Born Dickleburgh, Norfolk, c.1746; died London 19 May 1813, aged 67. He had a private income all his life and was hardly a professional artist. A pupil of Zoffany (q.v.) c.1769/70. He exh. conversation pieces and small-scale portraits of great elegance SA 1771-73. He 'made frequent journeys to Paris' (*Dawson Turner, Outlines in Lithography, 1840, 21*), and about half a dozen pictures of domestic genre, which reveal a knowledge of Chardin (and probably of Greuze) were exh. SA 1776; RA 1777-79. A number of these were engraved and they are masterpieces of a new kind of genre painting in England, which soon became vulgarised by Wheatley and Morland (qq.v.) — which may be why Walton gave up painting them. His conversation pieces of the 1770s are also highly original and informal and were painted for Norfolk friends. He never exhibited after 1779 and retired to a property he had bought at Brome, Suffolk, whence he gave advice to a number of private collectors of old masters, and exercised the role of *marchand amateur*. A group of portraits, painted c.1790-1800 for the Henniker family, shows a complete change of style and a lapse into a manner reminiscent of Opie (q.v.).

(Rev. E. Farrer, Connoisseur, XXV (1909), 139ff; Walton exh., Norwich, 1963.)

WANTER fl.1783

Exh. 'Mars and Venus', FS 1783.

WARBURTON, F. fl.1798-1802

Exh. pictures of shipping and marine views, RA 1798-1802.

WARD, Francis Swain c.1734-1805

Landscape and miniature painter, &c. In the Madras Army c.1760-64; and again 1774-87, retiring as Lieut. Colonel. He won a premium for a sea piece from the Society of Arts 1765 and exh. a flower piece SA 1765. Exh. SA 1768-73, mainly views (probably drawings or watercolours) of Indian scenery. Died at Negapatam 1805 (*Mallalieu*). Redgrave says he painted oil landscapes also of British scenes.

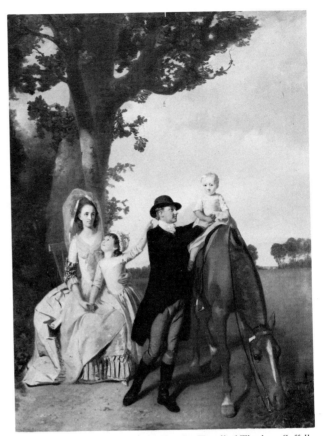

HENRY WALTON. 'The Rev. Charles Tyrrell of Thurlow, Suffolk, with his family.' 44½ ins. x 34½ ins. With Leger 1979.
Probably from the end of the 1770s. Walton's East Anglian portrait groups are always of friends and have a curiously intimate feeling.

HENRY WALTON. 'A lady of the Henniker family.' 35½ ins. x 25 ins. c.1800. Sold at Thornham Hall 27.5.1937 (1011).
One of a group of portraits of c.1800 of the Henniker family, which are documented. They are totally unlike his groups of the 1770s and suggest the influence of Opie.

JAMES WARD. 'Fight between a lion and a tiger.' 40ins. x 53½ins. s. & d. 1797. Exh. RA 1798 (209). Fitzwilliam Museum, Cambridge.
One of the first of Ward's pictures of wild beasts, most of which date after 1800.

JAMES WARD. 'Animals in a farm yard.' 24½ins. x 29ins. s. & d. 1799. Christie's sale 21.11. 1980 (4).
An exercise in the manner of Morland, a style in which Ward specialised in his earlier years.

WARD, James 1769-1859

Best known as an animal painter, but he explored every kind of subject; also a good mezzotint engraver. Born London 23 October 1769; died Cheshunt 23 November 1859. He first studied mezzotint engraving under J.R. Smith (q.v.), and his own elder brother William Ward (1766-1826); and the collection of his engraver's proofs, which he presented to the British Museum in 1817, on abandoning the art, is one of the most important archives of the craft. He began by painting rustic scenes in the manner of his brother-in-law, George Morland (q.v.). Exh. SA 1790; RA from 1792; he had also shown a few portraits and animal pictures before 1800, and became 'Engraver in Mezzotinto to the Prince of Wales' 1794. But his main career as an immensely prolific painter of cattle pictures, sporting pictures, heroic landscapes *à la* Rubens, pretentious histories and romantic horrors, took place after 1800. ARA 1807; RA 1811. Exh. RA 1792-1855; BI 1806-47. At his best he is an

THOMAS WARRENDER. 'A trompe l'oeil.' 23¾ ins. x 29ins. The painter's name is on a paper in the rack; the latest date given is 1708. National Gallery of Scotland, Edinburgh.
Perhaps a Scottish imitation of the Dutch painter, Evert Collier (d.c. 1706), who worked in England in the later 17th century.

immensely distinguished artist, at his worst, frankly absurd. He is extensively and variedly represented at BAC Yale.

(Wood, C., bibl.)

WARREN, John **fl.1764-1779**
Irish painter of portraits and landscapes in crayons. Entered Dublin Society's school 1764; exh. from 1768; dated landscape drawing known of 1779. In 1777 he sent crayons portraits from an address in Bath to Dublin and the RA.

(Strickland.)

WARREN, W. **fl.1796**
Exh. a flower piece, RA 1796.

WARRENDER, Thomas **fl.1673-1713**
Burgess painter at Edinburgh, and specialist in still life. Recorded 1673-1713. Sale S, 12.11.1980, 48, bought for NG of Scotland.

WATERHOUSE **fl.1780**
Exh. six landscapes, FS 1780.

WATHEN **fl.1783**
Exh. a landscape, FS 1783. Probably the watercolour painter James Wathen of Hereford, c. 1751-1828.

(Mallalieu.)

WATLINGTON, Miss **fl.1774**
Exh. portrait drawings 'in chalks' and a drawing after Gainsborough, FS 1774.

WATSON, George **1767-1837**
Scottish portrait painter. Born Overmains 1767; died Edinburgh 24 August 1837. After some training under Alexander Nasmyth (q.v.), he is said to have worked in Reynolds' studio in London c. 1785-87, before returning to settle in Edinburgh. In Scotland he played second fiddle to Raeburn (q.v.), whose style much influenced his own, but his presentation of character is tamer and his brush

JOHN WEBBER. 'A party from H.M.S. Resolution shooting sea-horses.' 48ins. x 62ins. Signed. Exh. RA 1784 (140). H.M. Admiralty.
The scene recorded took place in 1778. Webber was official artist to Captain Cook's third and last voyage and painted a group of pictures for the Lords of the Admiralty.

strokes are less lapidary. His best work is still confused with that of Raeburn. He was President of the short-lived Society of Associated Artists at Edinburgh 1808-12; and first President of the Scottish Academy 1826-37. Exh. RA 1808-23; BI 1812-28.

WATSON, Robert 1754-1783
Painter of portrait, rustic genre, and history. Born Newcastle 20 April 1754; died India, aged 28. He was apprenticed to a coach painter at Newcastle, but entered RA Schools 1775. He exh. six pictures RA 1778, which showed great promise, but gave up painting to become an engineer in India.

(Whitley, i, 344.)

WATSON, William d.1765
Irish painter of portraits in oil and crayons. Died (rather young) Dublin 7 November 1765. He was brother to the mezzotint engraver, James Watson, and his one known signed crayon portrait of 1762 *(Crookshank and Knight of Glin, 18)* is very close in style to Cotes (q.v.). His wife exh. flower and fruit pieces in crayons and watercolours at Dublin 1768-71 and at FS 1771.

(Strickland.)

WATTÉ, Abraham 1776-1816
Painter of fancy heads and fancy subjects. Entered RA Schools 1797, silver medal 1801. Exh. 1797-1816.

WATTS, John late 18th century
A landscape painter known only from Redgrave's citation: "Born about 1770, he practised his art in London. He drew views in Scotland and Wales, and painted several pictures in oil. His works attracted some attention in his day."

WATTS, Simon 1745-after 1783
A 'Simon Watts' entered RA Schools 1772, aged 27, but it is not indicated that he was a painter. A 'Mr Watts' exh. views of Highgate, SA 1775; and 'S. Watts' or '— Watts' was an hon. exh. of landscapes, one of Richmond Hill, RA 1780-83.

WAY, Mrs. John See HAMILTON, Harriott

WEAVER, M. fl.1766-1767
Recorded as a portraitist visiting Ireland from Bath in 1766/7.

(Strickland.)

WEBB(E) fl.1712
A painter at Oxford; elected mayor for the third time in 1712. Only otherwise known for antiquarian drawing (*T. Hearne, Collections, iii, 319, 457*).

WEBB, Westfield fl.1761-1772
Exh. portraits, flower pieces and a landscape, SA 1762-72. He is perhaps also the 'Mr Webb'' who painted a ceiling (destroyed) at Ragley in 1761 (*E.C-M.*). Edwards takes a poor view of his art.

WEBB, William fl.1766
Exh. flowers, insects and a mouse, SA 1766.

WEBBER, John 1752-1793
Landscape painter, draughtsman, and etcher; also capable of portraits. Born London 1752, son of a Swiss sculptor, Weber; died there 29 April 1793. Trained in Paris *c.*1770-75. Entered RA Schools 1775. From 1776 to 1780 he was draughtsman on Captain Cook's last voyage and, on his return, superintended the engraving of his drawings for the Admiralty; also published etchings and aquatints on his own. Landscape and scenes from the South Seas remained the principal themes of his oil paintings (several belong to the Admiralty). Exh. RA 1784-92. ARA 1785; RA 1791. Swiss scenes begin 1788; the Wye 1790; and Lake Como 1791. His painting style is rather garish, glossy and linolear. His posthumous portrait of Captain Cook, 1782, is at Trinity House, Hull.

WEBSTER, John fl.1799
Hon. exh. of a Shakespearean scene, RA 1799.

WEBSTER, Joseph Samuel fl.1757-1796
Portrait painter in oil, crayons and miniature. Died 6 July 1796. A portrait of 'George II' (a copy after Hudson), signed and dated 'J.S. Webster' 1760, was sold 22.4.1960, 95. He is probably the 'Mr Webster' or 'S. Webster' (identified by Graves and Redgrave with a Simon Webster, a watercolourist) who exh. SA 1762-80; FS 1763, was apparently a pupil of Hudson, and after whom mezzotints of several portraits (especially of clergymen) are known up to 1781. He signed and dated 1757 a portrait of 'Mrs Hannah Maria Edmunds' (as 'S. Webster'), sold 15.7.1955, 154, in a style which owes everything to Hudson.

JOSEPH SAMUEL WEBSTER. 'Mrs. Hannah Maria Edmunds.' 49ins. x 39ins. s. & d. 1757. Christie's sale 15.7.1955 (154). This painter (who signs 'S. Webster') was clearly a pupil of Hudson, but probably painted his own drapery.

BENJAMIN WEST. 'Earth.' 1779. Royal Academy of Arts, Burlington House.
One of a series of 'The Elements' painted for the ceiling of the Lecture Room at Somerset House in 1779 and later transferred, with the Royal Academy, to Burlington House.

WEDDELL, Mrs. William *c.*1750-1831
(Elizabeth Ramsden)
Married 1771 William Weddell of Newby Hall (d.1792). Amateur painter; she painted a ceiling at Newby *c.*1780.

(E.C-M.)

WEEKS, James fl.*c.*1750
'James Weeks, painter' was elected a member of the Gentleman's Society at Spalding in 'the first half of the eighteenth century' *(Nichols, Literary Anecdotes, 1812, vi, 119).*

WELLER, J. fl.1718
A chalk 'Self portrait' in the British Museum is dated 1718, aged 30.

WELLES, J. fl.1784
Hon. exh. RA 1784 of 'A town of the Mohawk-indians surprised by a detachment of British soldiers sent to restrain the scalping scouts'. In the index, his name is given as 'S. Wells'.

WELLINGS, William fl.1782-1801
Silhouettist and miniature painter who exh. one theatrical scene, RA 1793.

(Long; Mallalieu.)

WELSH, Ephraim 1749-after 1771
Entered RA Schools 1770, aged 21. Exh. a portrait of a lady in crayons, SA 1771.

WENTWORTH, Lady Anne *c.*1721-1769
Daughter of the 1st Marquess of Rockingham; married, 1744, 3rd Earl Fitzwilliam. Horace Walpole says she painted in oils and crayons *(Walpole Soc., XVI, 14, n.6).* She probably took lessons from Mercier, who painted a portrait of her, with pallette and canvas, 1741.

BENJAMIN WEST. 'Cicero discovering the Tomb of Archimedes.' 49ins. x 72ins. s. & d. 1804. Christie's sale 16.11.1962 (96).
An exercise in West's Poussinesque manner, which he was employing well before 1800. The picture is now in the Yale University Art Gallery.

WEST, Benjamin 1738-1820

Historical and religious painter and portraitist. Born Springfield, Pennsylvania, 10 October 1738; died London 10 March 1820. He learned the 'mechanical part' of art in Pennsylvania, but his early American works are depressing, and he left America for Italy in 1760, never to return. He travelled in Italy 1760-63, and received a good deal of guidance from Mengs and Gavin Hamilton (q.v.); he learned to paint history pictures in the style of Gavin Hamilton, but with figures 'Poussin size'. In 1763 he decided to settle in London as a portrait painter, but his exhibits at SA 1764-68 were mainly historical works, which were well received and, about 1768, he became George III's favourite painter — a position of great profit, which he never lost, although the King eventually saw through him. A Foundation RA he exh. RA 1769-1819, and succeeded Reynolds as President 1792. Exh. BI 1806-20. His 'Death of Wolfe', RA 1781 (Ottawa) marks something of an epoch as the painting of a contemporary historical scene in

BENJAMIN WEST. 'General Kosciusko as a refugee in London.' Wood. 12ins. x 16ins. s. & d. 1797. Christie's sale 13.7.1945 (175).
Small works of this kind (which seem almost to anticipate Delacroix) are among West's most genuinely original contributions to art. The picture has been bought by Oberlin University.

BENJAMIN WEST. 'Jacob blessing Ephraim and Manasseh'. 39 ¼ ins. x 50 ½ ins. s. & d. 1766. Exh. SA 1768 (177). Sotheby's sale 15.7.1959 (128).
Painted for Lord Grosvenor. This more or less neo-classic style was one of the first 'history' styles exploited by West.

something approaching contemporary dress, but his more usual historical styles are neo-classical or romantic. He was also a prolific portrait painter, painted some landscapes and designed stained glass. His huge religious pictures, intended for a chapel at Windsor Castle, are now at Bob Jones University, Greenville, South Carolina, and show the virtues and defects of his limited mind.

(Earlier bibl. in Groce and Wallace; fullest listing of religious and historical works in John Dillenberger, B.W., the Context of his life's work, San Antonio, Texas, 1977.)

WEST, C. fl.1787
Exh. RA 1787 a 'Landscape with the Egyptians finding the cup in Benjamin's sack'. He might also be the '— West' who exh. two portraits RA 1790.

WEST, Francis Robert c.1749-1809
Irish painter of portrait and history in crayons. Born Dublin c.1749; died there 24 January 1809. Son and pupil of Robert West (q.v.) whom he succeeded as master in the Dublin Society's school. Exh. Dublin 1770-1801.

(Strickland.)

WEST, Raphael Lamarr 1766-1850
Indolent history painter. Born London 8 April 1766; died there 22 May 1850. Son of Benjamin West (q.v.). Entered RA Schools 1781. Exh. occasional history pictures at RA 1781-84 and 1791, and painted one picture for Boydell's Shakespeare Gallery. He was in the U.S. 1800-2, where he had intended to settle, but he returned to London and more or less gave up art, but did some lithographic work.

WEST, Robert fl.1735-1770

The elusive 'parent of the arts in Dublin'. Died in Dublin late in 1770, where he had founded the first School of Design, which he ran from c.1740-70. No certain works are known, but it is possible that he painted the signed and dated (1735) conversation piece, 'Thomas Smith and family' (Upton House, National Trust), but this somewhat pedestrian English piece does not chime with the tradition that he studied in Paris under Boucher and C. van Loo and was a superlative figure draughtsman.

(Strickland; Crookshank and Knight of Glin, 1978.)

WEST, Temple 1739-1783

Amateur painter of views of landscape character, preferably with shipping. Died London 17 September 1783, aged 44. He had spent some time in the army and retired as Lieut. Colonel. Hon. exh. RA between 1773 and 1778.

(Edwards.)

WESTALL, Richard 1766-1836

Predominantly a watercolourist and book illustrator, but he also painted portraits and domestic and rural subjects in oils. Born Hertford 2 January 1766; died London 4 December 1836. Apprenticed to a silver engraver 1779-84. Entered RA Schools 1785. He was a very abundant exhibitor at RA 1784-1836; BI 1806-34. He began with chalk portrait drawings and soon specialised in subject pieces in watercolours; but he produced a good many small domestic subjects in oils and a few large and rather mannered historical and religious pictures. He painted pictures for Boydell's Shakespeare Gallery and for Bowyer and Macklin's historic and poetic Galleries. ARA 1792; RA 1794. Many of his illustrations now look slightly absurd. His last activity was as drawing master to Princess Victoria. The landscapes of his younger brother, William Westall (1781-1850), do not begin till after 1800.

WETHERILL, Arthur fl.1773-1783

Exh. miniatures at SA 1773 and RA 1783. A signed small portrait (13½ by 11 ins.), called 'Earl of Orford' (Lewis coll., Farmington, Conn.) owes a good deal to Reynolds. His wife exh. portraits which were not miniatures SA 1773 and FS 1783. A '— Wetherill' exh. two landscapes (one with gypsies and one with a scene from Tasso), RA 1779, from an Ipswich address.

WEZEL fl.1782

Exh. a landscape with cattle, FS 1782.

WHARAM, H. fl.1795-1797

Exh. portraits of a horse and a dog, RA 1795 and 1797.

FRANCIS WHEATLEY. 'Stephen Sullivan of Ponsbourne Park.' 30ins. x 25ins. From the later 1770s. With Charles Young 1980. While Zoffany was in Italy, Wheatley became the fashionable painter of small-scale whole lengths.

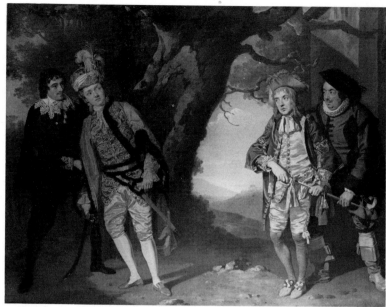

FRANCIS WHEATLEY. 'The Duel scene from Twelfth Night, act ii, scene iv.' 39¼ ins. x 49¼ ins. Exh. SA 1772 (374). Manchester City Art Galleries. Engraved in mezzotint by J.R. Smith 1774 as 'Miss Younge, Mr Dodd, Mr Love & Mr Waldron...'. In it Wheatley shows considerable sense of humour.

WHEATLEY, Francis **1747-1801**
Painter of portraits, history, domestic and sentimental genre. Born London 1747; died there 26 June 1801. Trained at Shipley's Academy and won prizes for drawing at Society of Arts 1762/3; RA Schools 1769; but largely self-taught, and learned much from associating with J.H. Mortimer (q.v.) in painting the Saloon ceiling at Brocket Hall, 1771-73. Exh. SA 1765-77 and 1783 (a Director 1774); RA 1778-1801. ARA 1790; RA 1791. He began with small scale portraits and conversations which reveal a knowledge of Zoffany (q.v.). He was in Dublin (to escape creditors) 1779-83, where he had good success as a portraitist and notably painted 'The Irish House of Commons', 1780 (Lotherton Hall, Leeds); he also took to painting landscape views in watercolours. Back in London 1783, his principal activity was working for Boydell and the printsellers, specialising in sentimental literary themes and domestic genre in an English variant of French *sensibilité*. He also did some historical pictures for the Shakespeare Gallery, &c., from 1788. In the 1790s his powers were much diminished through gout and his last oils were painted in 1799. He produced a steady stream of watercolours in the same over-genteel vein as his oil paintings, which culminated in 'The Cries of London', RA 1793-95, which were enormously popular in engravings. He was a neat portraitist, with clear and attractive colour, and his genre scenes suited the middle-class taste of the times to perfection. He has long been best known from engravings. His oils are abundantly represented at BAC Yale.

(Mary Webster, F.W., 1970.)

WHEATLEY, Mrs. Francis See POPE, Alexander, 1763-1835

WHETHERILL See WETHERILL, Arthur

WHITBY, William **fl.1772-1791**
Portrait painter; also painted a 'Venus and Cupid'. Exh. SA 1772 and 1791; RA 1775, 1780-81, and 1789 (the boxer 'Richard Humphries', an engraving of which he published himself).

WHITCOMBE, Thomas **1763-after 1824**
Painter of seafights and marine subjects. Born 19 May 1763; died after 1824 (NMM says ?1834). Entered RA Schools 1782. His three signed and dated sea fights at NMM, Greenwich, suggest he may have been present at Gibraltar. Exh. RA 1783-1824; BI 1820.

(Archibald.)

WHITE, Charles **fl.1772-1780**
Painter of flower pieces. Died Chelsea 9 January 1780. An example, signed 'C.W. 1772', is in the Hermitage, Leningrad.

WHITTON, Luke **fl.1736**
A pair of portraits, signed 'Lucas Whittonus pinxit 1736' are recorded as formerly at Brickwall House, Northiam (*Notes and Queries, series I, vii (23 Apr. 1853), 406*).

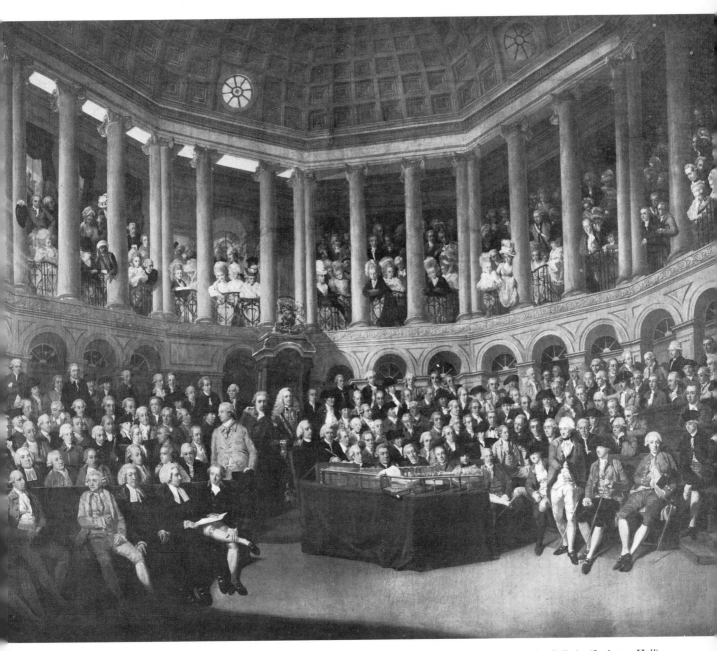

FRANCIS WHEATLEY. 'The Irish House of Commons, 1780.' 64ins. x 85ins. s. & d. 8 June 1780. Leeds City Art Galleries (Lotherton Hall).
A key to the identity of the sitters was published in 1801, but not the picture itself, which is an astonishing collection of faithful likenesses.

ISAAC WHOOD. 'Unknown young lady.' 49½ ins. x 39½ ins. s. & d. 1742. Sotheby's sale 13.4.1960 (115).
Only a signature can distinguish a Whood from the work of several of his contemporaries.

WHITWELL, William ?late 18th century
A very competent copy exists of the Windsor Canaletto 'Isola di S. Michele', signed 'Wm. Whitwell/after/Canaletto'.

WHOOD, Isaac 1688/89-1752
Portrait painter and professional copyist. Died London 26 February 1752, aged 63. He had a good practice from the 1720s and, in the 1730s, was much employed by the Duke of Bedford (*G. Scott Thomson, Letters of a Grandmother, 1943*) in copying family portraits. His own style is close to that of Vanderbank or Seeman (qq.v.), and he copied Kneller (q.v.) with remarkable fidelity. He was made a member of the Spalding Gentleman's Society in 1721 and was an early Antiquary.

WICKSTEAD, Philip fl.1763-1786
Portrait painter. Won premiums for drawing at SA 1763 to 1765; died in Jamaica between 1786 and 1790. Arrived in Rome 1768, known as 'a pupil of Zoffany', where he remained until 1773 having some success with portraits of English visitors (*B. Ford, Apollo, XCIX (June 1974), 453 — his only known Roman work repd. ib. 411*). In 1774 he was taken by William Beckford of Somerley to Jamaica, where he developed a talent for painting negroes and the local gentry, and remained until Beckford left in 1786. Exh. SA (from Jamaica) 1777-80. He is later said to have taken to drink and died before 1790. Possible Jamaican portraits (how documented is not indicated) published by Frank Cundall, *Connoisseur, XCIV (Sept. 1934), 174/5.*

PHILIP WICKSTEAD. 'Edward East (1732-84) of Jamaica, and his family.' 39ins. x 31¼ ins. Sotheby's sale 18.2.1953 (125).
Although not documented, no other painter, who was clearly a pupil of Zoffany, was working in Jamaica in the 1770s.

WIGGONI, fl.1783
Exh. 'an Officer', FS 1783.

WIGSTEAD, Henry fl.1784-1793
Draughtsman and caricaturist in the manner of his friend Rowlandson, who perhaps exh. some pictures in oils. Died London 13 November 1793. Exh. RA 1784-88. Another 'Mr Wigstead' was an hon. exh. of two landscapes RA 1798 and is perhaps the Wigstead who died at Margate in 1800 (*Mallalieu*).

WILDE, See DE WILDE, Samuel

WILDER, James 1724-*c.*1792
Trained as a painter and ended as a picture restorer; mainly an actor in London (1751) and Dublin (1756-89). He exh. landscapes and genre occasionally in Dublin 1765-73.

(*Strickland.*)

WILDGOOSE, Thomas d.1719
Miscellaneous painter at Oxford, where he was buried 25 October 1719. He repainted the 'old heads' in the Bodleian 1715.

(*T. Hearne, Collections, iii, 401 and v, 136; vii, 60.*)

WILK(E)S, Miss H. fl.1799
Hon. exh. of 'Spring flowers from Nature', RA 1799.

WILKINS, J. fl.1795-1800
Exh. a sporting portrait and a series of pictures with marine subjects RA 1795-1800. A 'J. Wilkins Jr' exh. 'St Ethelbert's, Norwich', RA 1796. These were probably **John** (born 1767) and **James** (born 1768), sons of Robert Wilkins (q.v.), who had exh. drawings as children at FS 1776, 1778 and 1779 (John only).

WILKINS, Robert 1740-?after 1799
Marine painter in the main, but with deviations. He won premiums for seapieces at SA 1765 and 1766. Exh. FS 1765-82 and RA 1772, 1777, 1779 and 1781. He also painted still-life, and deviated in the 1780s into Greek landscapes after drawings by Athenian Stuart. His ?wife exh. crayons portraits and fancy heads, FS 1773 ('a first attempt') and 1774/5.

WILKINSON, Robert fl.1773-1778
Exh. landscapes, SA 1773-75; RA 1776 and 1778.

JOHN MICHAEL WILLIAMS. 'A gentleman.' 29½ ins. x 24½ ins. s. & d. 1754. Christie's sale 24.7.1970 (280).
An elusive painter, who might well have been a rival to Hudson if he had bothered, but he perhaps gave up painting.

WILLIAMS, Miss Anne fl.1768-1783
Painter of portraits and fancy heads in crayons. Exh. SA 1768; FS 1770-83; RA 1778-79.

WILLIAMS, James fl.1763-1776
Miscellaneous painter of a trivial kind. Exh. every sort of picture at FS 1763-76.

WILLIAMS, John (Michael) fl.1743-1766
Portrait painter of some distinction. Supposed to have died 'about 1780' (*Edwards*). Pupil of Richardson (q.v.). His portrait of 'John Wesley' was engraved by Faber in 1743 and there are mezzotints after several other portraits of clergymen. Exh. SA 1760 'Mr Beard' (engraved 1749); FS 1762-66, when he perhaps gave up practice. His sitters have rather more personal character than those of Hudson (*cf. 'Thomas Lewis' of 1748, Steegman, ii, pl. 44c*). Settled in Ireland and exh. Dublin 1777 (*Strickland*).

WILLIAMS, Miss M. fl.1793
Exh. 'Inspiration', RA 1793.

WILLIAM WILLIAMS. 'Dr. William Greene.' 28½ ins. x 20½ ins. s. & d. 1772. Christie's sale 14.12.1962 (130/1).
An itinerant painter in the provinces, whose portraits derive from the Devis tradition and were usually of small local gentry.

WILLIAMS, R. **fl.1795-1817**
Occasional exh. of portraits at RA 1795-97, 1799, 1813, 1815 and 1817. Perhaps the painter and publisher of a print of 'Joseph Beeton highwayman', published at Lynn 1783.

WILLIAMS, Solomon **1757-1824**
Irish painter of history and portrait. Born Dublin July 1757; died there 2 August 1824. Tried engraving first and entered RA Schools as an engraver 1781, but soon left for Italy, where he travelled, became a member of the Bologna Academy and made many copies after Titian. In Dublin from 1789. Periodically in London up to 1808 where he exh. portraits, fancy pictures, an altarpiece and histories RA 1791/2, 1796, 1803/4, 1806; BI 1807-8. In 1809 he settled permanently in Dublin, where he exh. up to 1821; chosen as a foundation member of RHA 1823 *(Strickland).*

WILLIAMS, William **fl.1758-1797**
Itinerant painter of portrait, history, sentimental genre and theatrical scenery. Won a premium for drawing at SA 1758. Recorded at Manchester 1763; Norwich 1768-70; York 1770ff; Shrewsbury 1780; Bath 1785-87, whence he published an *Essay on Mechanic of Oil Colours,* 1787; later in London. Exh. FS 1763; SA 1766-80; RA 1770-92. His most attractive works are small-scale full-length portraits *(Steegman, Burlington Mag., LXXV (July 1939), 22),* and he had a lively taste in theatrical landscapes *(Fawcett, 76ff.).*

WILLIAMS, William **fl.1777**
Exh. RA 1777, from a St. Albans address, 'A picture of a scull'.

WILLIAMSON, John **1757-1818**
Liverpool portrait painter. Born Ripon 1757; died Liverpool 27 May 1818. He was first a japanner but exh. a portrait at RA 1783 before settling in Liverpool about that time, where he developed a good portrait practice with the local business community. Founder member of Liverpool Academy 1810.

(Walker Art Gallery, Merseyside cat., 1978.)

WILLIS, Miss **fl.1797-1803**
Hon. exh. of views in Wales 1797-98, and in Devon 1803.

WILLISON, George **1741-1797**
Portrait painter. Born Edinburgh 1741; died there April 1797. Pupil of Mengs in Rome before Mengs left for Madrid in 1761. Painted 'Boswell' in Rome 1765 (SNPG). In London from 1767. Exh. SA 1767-70; RA 1771-72. His small-scale 'Nancy Parsons', engr. 1771 (BAC Yale) is pretty in the manner of Liotard (q.v.). In India 1774-80, whence he sent portraits of his chief patron, the Nawab of Arcot, to the SA 1777 and 1778. He left London for opulent retirement in Edinburgh *c.*1784 *(Archer, 99-107).*

WILLS, Miss **fl.1774**
Exh. insect and flower pictures, FS 1774.

WILLIAM WILLIAMS. '*Amelia struck by lightening.*' *35ins. x 44ins. Perhaps RA 1778 (346). Christie's sale 18.11.1966 (21).*
The subject is from James Thomson's *Summer*. A smaller version, dated 1784, is in the Tate Gallery. Williams was also a theatrical
scene painter.

GEORGE WILLISON. 'Nancy Parsons.' Copper. 23ins. x 18¼ins. Engraved in mezzotint by J. Watson 1771. B.A.C. Yale.
Nancy Parsons was "a very celebrated lady of the demimonde". This is not an altogether typical example of Willison's style.

Rev. JAMES WILLS. 'Dr. John Nicoll.' 30ins. x 25ins. Engraved 'J.W. Fecit 1756'. The Governing Body of Christ Church, Oxford. The sitter was Headmaster of Westminster School. The tradition that the J.W. of the engraving was Wills is quite early.

WILLS, Rev. James fl.1740-1777

History and portrait painter. Alleged to have died as 'Rector' of Whitchurch 1777 (Edwards). He studied in Rome, where he acquired a passion for history painting; but he was in London by 1740, where he painted a portrait of 'Lord Egmont' in crayons. Active as a director of the St. Martin's Lane Academy 1743-46 (Vertue, vi), where he was perhaps influenced by Hayman (q.v.). Gave his 'Little children brought to Christ' to the Foundling Hospital 1746. There is an accomplished conversation piece of 'The Andrews family', 1749 (Fitzwilliam Mus., Cambridge). He took Holy Orders 1754 but exh. history pieces SA 1760-61, and anonymously 1767; a portrait FS 1766. He was chaplain to the Society of Artists 1768-73, and it is probable that he was the virulent anonymous critic of the emergent Royal Academy under the signature 'Dufresnoy' in the Morning Chronicle, 1769-70 (Whitley, ii, 272-279). Engravings after his portraits range from 1741 to 1756.

WILLSDON d.1760

The Gentleman's Magazine records the death on 12 July 1760 of 'Mr Willsdon, an eminent painter'.

WILLSON See WILSON

WILMOT, Olivia See SERRES, Olivia

WILSON, Benjamin 1721-1788

Painter of portraits and theatre pieces, etcher, and man of science. Born Leeds 21 June 1721; died London 6 June 1788. He practised as a portraitist with some success at Dublin 1748-50 (Strickland). He was an accomplished etcher and deceived Hudson with a spurious Rembrandt 1751. In the 1750s he was one of the leading portrait painters and his 'Rembrandtesque' chiaroscuro (which concealed indifferent drawing) made him seem to some a rival to the young Reynolds. Known portraits range up to 1769, when he gave up art for scientific pursuits. Exh. portraits SA 1760-61, and

was probably the 'B. Wilson' who exh. 'The raising of Jairus' daughter', RA 1783. His portrait of his friend 'Garrick as Hamlet', engr. by McArdell 1754, initiated the theatre piece, which was taken up by Zoffany, who Wilson tried to exploit as a 'backroom painter', *c.*1760. He was given a sinecure as 'Painter to the Board of Ordnance' 1773. His most ambitious portraits are of Yorkshire sitters: 'Sir George Savile', 'Lord Mexborough', 'Lord Rockingham'. FRS 1751 and treated with more respect than he deserved artistically.

(Autobiographical notes in H. Randolph, Life of General Sir Robert Wilson, 1862.)

WILSON, George 1765-*c.*1820

Painter of subject pictures with fancy titles. Born 14 February 1765. Last exhibited 1820. Entered RA Schools 1782. Exh. watercolours or drawings RA 1785-88. Many pictures probably in oils RA 1793-1819; BI 1809-20.

WILSON, John 1766-after 1783

Born 8 April 1766; entered RA Schools 1782. Exh. a portrait RA 1783.

Rev. JAMES WILLS. 'An elderly lady.' c.25ins. x 20ins. Signed. Unlocated.
On the same scale is the signed group of the Andrews family, 1749, in the Fitzwilliam Museum, Cambridge.

BENJAMIN WILSON. 'Garrick and Mrs. Bellamy in Romeo and Juliet.*' 54ins. x 73ins. s. & d. 1753. B.A.C. Yale.*
This was engraved and was one of the first scenes with Garrick in a character part to be used for advertising in this way.

BENJAMIN WILSON. 'Simon, 1st Earl Harcourt.' 49ins. x 39ins. Dated 1750. Christie's sale 27.3.1953 (123).
The lighting, the expression and the tasselled curtain are all very characteristic of Benjamin Wilson. In 1750, before Reynolds had returned from Italy, the portrait looked very 'modern' and perhaps accounts for Wilson's reputation at the time.

WIL(L)SON, Joseph fl.1780s
His name appears on the back of a small oval portrait (9 by 7½ ins.), in the manner of De Wilde, sold 17.6.1966, 157.

WILSON, Richard 1713-1782
The classic master of British 18th century landscape. Born Penegoes, Wales, 1 August 1713; died nr. Mold, Wales 11 May 1782. Trained at first as a portrait painter in London under one T. Wright (q.v.), he was in good practice as a portrait painter by 1744, but had made experiments in topographical landscape before going to Venice in late 1750. After a year in Venice he moved to Rome by 1752, where he decided to give up portraiture for landscape. He had had a good classical education and the Vergilian qualities of the Roman campagna, together with a study of the work of Claude and Gaspard Poussin, inspired him to create a type of classical landscape, which he thought worthy of a classically educated patron. He was in Rome 1752-57 and visited during these years also the classical scenes round Naples, bringing back many drawings which he used constantly during his later years in England. He became a founder member at first of the SA and then of the RA. Exh. SA 1760-68; RA 1769-80. His grand mythological landscapes (Niobe, Phaeton, &c.), which exist often in several versions, were all produced before 1770 and became known in very handsome engravings; but he did a better business at first in less historically charged Italian scenes and in views of the rural environs of London and Welsh scenes, the finest of which (e.g. 'Snowdon' at Nottingham and Liverpool) are treated in the spirit of classical landscape. The Welsh views of c.1762 in the NG (nos. 6196/7) justify Ruskin's words that "with Richard Wilson the history of sincere landscape art founded on a meditative love of nature begins in England".

BENJAMIN WILSON. 'Philip, 4th Earl of Chesterfield.' 41ins. x 34ins. s. & d. 1752. Leeds City Art Galleries.
This is more the normal level of Benjamin Wilson's portraits.

Wilson also enlarged the style of the 'country house portrait' (the finest series is at Wilton). His art was too distinguished for British patrons, and he was outpaced in the 1770s by the 'lighter styles' of Zuccarelli and Barret (qq.v.). In 1776 he succeeded Hayman (q.v.) in the sinecure of the Librarianship of the RA, but his health broke up and he retired to his native Wales in 1781.

He was endlessly copied and forged in his own lifetime and soon after, and he himself often repeated his more popular designs, especially of Italian scenes, so that the connoisseurship of Wilsons is extremely tricky. The problems are fully discussed and pictures catalogued in *W.G. Constable, R.W., 1953; addenda Burlington Mag., XCVI (May 1954), 139ff, and CIV (April 1962), 138ff; David Solkin, Ph.D. thesis on the Welsh views, Yale, 1978.*

WILSON, Richard **1752-1807**
Birmingham portrait painter. Died Birmingham 18 July 1807, aged 55. Known only from a small full length of the early 1780s of 'Peter Oliver' (Boston).

(Burlington Mag., XCVI (May 1954), 143.)

WILSON, T. **fl.c.1750**
A portrait of *c.*1750 of the '2nd Earl of Egremont' (Dulwich 561) is inscribed on the back 'T. Wilson / Edinburgh', which may well not be the name of the painter. It is now wrongly called 'Benjamin Wilson.'

RICHARD WILSON. *'Ceyx and Alcyone.'* 40ins. x 50ins. Probably exh. SA 1768 (189). Christie's sale 19.6.1970 (36). Engraved by Woollett 1769. The story is from Ovid's *Metamorphoses*. This is one of Wilson's not very numerous heroic 'histories' to which Reynolds (rather unwisely) took exception.

RICHARD WILSON. 'St. George's Hospital.' Diameter 21ins. Presented by the artist 1746. Thomas Coram Foundation, London.
One of a pair presented by Wilson to the Foundling Hospital. These show his landscape style before he went to Italy and finally became a landscape painter.

RICHARD WILSON. 'Horace St. Paul.' 29½ins. x 24½ins. s. & d. 1748. Christie's sale 29.4.1938 (34).
One of Wilson's portraits before he went to Italy. The rather creamy high-lights on the hair and the strong lighting of the face are characteristic.

RICHARD WILSON. 'A Roman capriccio.' 39ins. x 53ins. s. & d. 1754. Christie's sale 20.6.1975 (90).
Painted in Italy for the architect, Matthew Brettingham, with motives from Wilson's Roman sketchbook combined fancifully. The skies of the landscapes he actually painted in Rome are much greyer and less brilliant than the Italian landscapes he later painted in England.

RICHARD WILSON. 'River, with musicians and a ruin.' 27ins. x 20ins. Ashmolean Museum, Oxford.
A pretty example of the ornamental works Wilson painted in England, using motives from his Italian sketchbooks, and sometimes reusing figures he had employed before. Other versions of this precise design are not, in fact, known.

WILLIAM WILSON. 'Shooting partridge.' 26ins. x 26ins. Signed 'G. (i.e. Guglielmus) Wilson'. Björn Molin, Vällingby, Sweden.
Wilson seems to have been a close follower of Francis Barlow.

WILSON, William **fl.1692-1723**
Painter of birds in the manner of Barlow. Already well known in 1692 (Marshall Smith, The Art of Painting). He was the first teacher of Gawen Hamilton (q.v.) and became an auctioneer (Vertue). Sales are recorded 1718 to 1723. A single picture, signed 'G. [i.e. Guglielmus] Wilson' is known (Swedish Private Coll.).

WINDE, Robert **fl.1776**
Exh. FS 1776 'an old beggar and a boy' from an address 'at Mr Dressler's Boarding School, Hampstead'.

WINGFIELD, J. **fl.1791-1798**
Exh. RA 1791-98 pictures of birds or flowers, ending with 'The dead ass, from Sterne'.

WINGRAVE, Francis Charles **1775-after 1798**
Entered RA Schools as an engraver 1789, aged 14; but he exhibited portraits at RA 1793 and 1798.

WINSTANLEY, Hamlet **1694-1756**
Lancashire portrait painter and etcher. Baptised Warrington 6 October 1694; died there 16 May 1756 (Walker Art Gallery, Merseyside cat., 1978). Studied at Kneller's Academy in London c.1718-21; travelled in Italy (Rome and Venice), 1723-25, buying pictures for Lord Derby, who remained his chief patron. Several portraits are at Knowsley in a provincial Richardson style and he etched many of Lord Derby's pictures. He sometimes painted small heads on the spot, which he sent to Van Aken (q.v.) in London to make up into groups (Vertue, iii, 91), e.g. 'The Blackburne Family', 1741 (formerly at Hale Hall).

WINSTON, J. **fl.1797**
Hon. exh. of 'View of a gentleman's house, Horton, near Windsor', RA 1797.

HAMLET WINSTANLEY. 'Mrs. Bannastre Parker.' 49ins. x 39ins. Signed. Christie's sale 28.2.1947 (96/2). Companion to the following.

WOLLASTON, John fl.1738-1775

Portrait painter, mainly known for the very numerous portraits he painted in the Eastern United States. Still alive in 1775. Son, and probably pupil, of a London portrait painter, John Woolaston (q.v.). His 'Whitefield preaching', 1742 (NPG) was engraved by Faber, and he had developed a moderately individual style before leaving for the United States, *c.*1749, where he had considerable influence on native painters in the Central Eastern States. He was active in various cities from New York to Virginia up to 1758, when he perhaps moved to the West Indies. In St. Kitts 1764/5; Charleston 1767; returned to England 1767 *(Groce and Wallace)*. He was encountered at Southampton by John Baker in 1775 *(Baker's Diary, 31 July 1775)*.

WOOD, John George 1768-1838

Landscape painter in oils and watercolours; also illustrator of several books of topographical views. Born 1768; post-mortem sale 1838. Entered RA Schools 1790. Exh. landscapes, some certainly in oils, RA 1793-1811.

(Grant.)

WOODALL, William fl.1773-1787

Exh. landscapes (from an address at Halstead, Essex) SA 1773-74; FS 1775-76; RA 1778-79, 1780, 1787.

HAMLET WINSTANLEY. 'Bannastre Parker' (1697-1738). 49ins. x 39ins. Signed. Christie's sale 28.2.1947 (96/1). Companion to previous plate. The Parkers were of Cuerdon Hall, Lancs. Winstanley was the leading Lancashire portrait painter in the second quarter of the century.

WOODFORDE, Samuel **1765-1817**

Painter of portraits, history and fancy pictures. Born Ansford, near Castle Cary, 29 March 1763; died Ferrara 27 July 1817. He entered RA Schools 1782, and was patronised by the Hoares of Stourhead, who sent him to Italy, where he remained 1785-91, latterly travelling and returning to England with Richard Colt Hoare. Ten of his pictures are still at Stourhead (National Trust). Exh. RA 1784-1815; BI 1806-15. His art was light-weight and his fancy pictures are terrible, but his best portraits are quite accomplished.

(DNB; Farington Diary, ed. Greig, iv, 70/71.)

WOODIN, Samuel **fl.1798-1801**

Exh. pictures of sheep and pigs RA 1798-1801. After 1809 a 'S. Woodin Jr' exh. RA 1809-39 and BI 1810-43 more varied pictures *(Mallalieu)*. A 'J. Wooden', from the same address, also exh. a picture of sheep RA 1799.

WOODINGTON, **fl.1765**

Exh. a portrait, FS 1765.

WOODWORTH, William **1749-1787**

Born 30 October 1749. Entered RA Schools 1771. Exh. still-life and portraits at Liverpool 1784 and 1787.

WOOLASTON, John *c.* **1672-1749**

Portrait painter of modest pretensions. Born *c.* 1672 *(Walpole);* died impoverished in the Charterhouse July 1749. Father of John Wollaston (q.v.). His portrait of 'Thomas Britton', 1703 (NPG) is surprisingly independent of Kneller.

WOOLLEY, William **1757-1791**

Landscape painter. Born 30 April 1757. Entered RA Schools 1773. Exh. landscapes FS 1773-74; SA 1775-76 and probably also 'a portrait' from a Charlton address, 1791. A landscape like a tame de Loutherbourg is reproduced in *Grant.*

WOOTTON, John **?1678-1764**

Painter of landscapes and horses. Born Snitterfield, Warwickshire, 1678 or 1682 *(Kendal, Walpole Soc., xxi, 25ff.);* buried London 13 November 1764. Studied under Wyck (d.1700) and possibly Siberechts. At some date in the early 18th century he visited Rome, where he developed a picturesque landscape style, under the influence of Claude and Gaspard Poussin's works, which he used for decorative purposes (especially overmantels) until the end of his life. He was painting sporting

JOHN WOLLASTON. 'Samuel, 1st Viscount Hood.' 49ins. x 39ins. s. & d. 1748(?5). Christie's sale 20.11.1936 (44). One of the few so far known portraits painted in England before Wollaston moved to the United States.

pictures as early as 1714 and for fifty years was *the* horse painter for the aristocracy, painting single horses, sporting conversations and events, pet animals and, occasionally, life-size horses, in enormous numbers. He also painted battle pictures and often collaborated with portrait painters (Dahl, Jervas, Richardson, &c.) in equestrian portraits. In addition to classical landscapes, he also painted views of country houses. In the early 1730s he painted hunting compositions for the halls of Althorp and Longleat. His chief familiars in the world of artists were Gibbs and Kent (q.v.). He gave up painting in 1761.

(E.C-M; for his prices see Goulding and Adams, 493.)

JOHN WOOTTON. 'Italian landscape in the manner of Gaspard Poussin.' 47ins. x 71ins. Whitworth Art Gallery, University of Manchester.
Wootton painted Gaspardesque landscapes of this sort all through his life. They were the kind of picture the 'collecting classes' in England thought a landscape should be.

JOHN WOOTTON. 'Nobby with a groom.' 52ins. x 74ins. s. & d. 1752. Christie's sale 19.3.1954 (93).
This is a bit larger and grander than the endless number of Wootton's named horses 'with groom'. The arms over the doorway are those of the Earl of Cork.

THOMAS WORLIDGE. 'Robert Neale, M.P.' 29ins. x 24ins. s. & d. 1757. Christie's sale 9.4.1937 (20).
Worlidge's portrait style suggests a study of his Dutch contemporaries.

WORLIDGE, Thomas **1700-1766**
Portraitist in pencil, crayons, oils and various miniature techniques, but best known as an etcher in imitation of Rembrandt. Born Peterborough 1700; died Hammersmith 22 September 1766. He began with small pencil portraits and miniatures and learned from an itinerant Italian, A.M. Grimaldi (d.1732) whose daughter became his first wife. He worked a good deal in Bath as well as London. His oil portraits show some concession to the changing style of the 1750s, but are undistinguished. They are often signed 'TW'. Exh. SA 1761 and 1765; FS 1762, 1765-66. He sometimes painted as well as etched in imitation of Rembrandt.

(Long.)

WORRALL, Otwell **fl.1784**
Exh. a crayon portrait of a child, Liverpool, 1784.

WORSDALE (Worsdall), James *c.***1692-1767**
Portrait painter and rake. Died London 11 June 1767. Servant, pupil, copyist (and claimed to be bastard son) of Kneller, who turned him out of the house. He was capable by 1724 (portrait formerly at Hengrave Hall) of competent imitations of Kneller. He painted royal portraits (presumably copies of Kneller) for the Nisi Prius Court, Chester, 1733. By 1735 he was in Ireland, where he was active in forming and painting the Hell Fire Clubs *(Louis C. Jones, The Clubs of the Georgian Rakes, 1942)* of Dublin and Limerick. Back in London *c.*1744, where he was made Painter to the Board of Ordnance. He was a mean creature *(Vertue, iii, 59; Crookshank and Knight of Glin, 1978)*. He also wrote farces.

THOMAS WORLIDGE. 'An old lady.' 35ins. x 28½ins. s. & d. 17(?6)1. Christie's sale 8.12.1950 (173).
A deliberate exercise in the manner of Rembrandt. Worlidge also did etchings in the manner of Rembrandt.

WORTHINGTON, T.G. fl.1795-1804

Hon. exh. of landscapes at RA between 1795 and 1804. Up to 1798 he appears as 'J.G.', but later always as 'T.G.'.

WRIGHT, Edward fl.1730s

Portraitist and copyist; friend of the painter Richardson.

(Notes and Queries, series I, vii (1853), 294.)

WRIGHT, Edward c.1753-c.1773

Landscape painter; probably son of Richard Wright of Liverpool (q.v.). Exh. landscapes SA 1769-73. Died 'aged about twenty' in or soon after 1773 *(Rimbault Dibdin, 61).*

WRIGHT, J. fl.1782-1791

Painter of shipping pieces. Exh. RA 1791. He is also presumably the 'Mr Wright' who exh. 'A hulk at Sheerness', FS 1782.

JAMES WORSDALE. 'Unknown gentleman.' 49ins. x 39ins. s. & d. 1724. Hengrave Hall sale 1952 (1797).
A careful but pedestrian imitation of the style of Kneller (who, Worsdale claimed, was his father).

JOSEPH WRIGHT of Derby. 'The Old Man and Death.' 25ins. x 30ins. Walker Art Gallery, Liverpool.
A larger version (40ins. x 50ins.), now in the Wadsworth Atheneum, Hartford, was exh. SA 1774. Wright always enjoyed experimenting with light.

JOSEPH WRIGHT of Derby. 'Miss Monk.' 48¾ ins. x 39¼ ins. Painted 1760. Christie's sale 23.6.1978 (48).
A metallic version of Hudson's style, painted at Lincoln in 1760, when Wright was still an itinerant provincial portraitist.

JOSEPH WRIGHT of Derby. 'Sterne's Maria.' 63ins. x 45½ ins. s. & d. 1781. Exh. RA 1781 (100). Derby Museum and Art Gallery. For this popular subject see also the painting by Thomas Gaugain on page 144. The influence of antique sculpture is apparent in this, and it has affinities with certain Wedgwood designs.

JOSEPH WRIGHT of Derby. 'Francis Burdett.' 50ins. x 40ins. Painted c.1762/3. Christie's sale 15.5.1936 (19).
One of a group of portraits of 1762/3 of friends in the dress of the Markeaton Hunt (navy blue coat, red waistcoat and yellow trousers). These are the beginnings of Wright's Derbyshire provincial style.

JOSEPH WRIGHT of Derby. 'Vesuvius from Posilippo.'
Wood. 24¾ ins. x 32½ ins. Paid for 1788. B.A.C. Yale.
Although Wright's studies of Vesuvius were made
when he was in Naples 1775, he continued painting
variations on this very popular theme until the end of
his life.

JOSEPH WRIGHT of Derby. 'The Blacksmith's Shop.'
50½ ins. x 41 ins. s. & d. 1771. B.A.C. Yale.
One of Wright's industrial 'candlelights', which are
his most original contribution to English art. A
variant, of about the same size, also dated 1771, has
lately been acquired by the Derby Museum and Art
Gallery.

painted Charles Danby.

WRIGHT (of Derby), Joseph 1734-1797

Painter of portraits, 'candlelights', landscapes and poetical and literary themes. Born Derby 3 September 1734; died there 29 August 1797. He was the first painter of real quality to prefer living in the provinces (other than at Bath) to London, and the first to explore, in his subject pictures, the scientific interests of the industrial revolution, several of whose leaders (e.g. Wedgwood and Arkwright) were among his chief patrons. Pupil of Hudson 1751-53, and again 1756-57, he was mainly based on Derby until his visit to Italy late in 1773, but he toured the Eastern Midlands 1759/60, and was settled in Liverpool 1769-71, doing a very good business as a portraitist for prosperous middle-class families. Exh. SA 1765-76 and 1791; FS 1778 and 1783. He became justly famous in the 1760s for his experiments in candlelit subjects, especially those illustrating contemporary life, of which the two finest are 'The Orrery', SA 1766 (Derby) and 'An experiment on a bird in the air-pump', SA 1768 (Tate Gallery). These are wholly new inventions. In 1774 and 1775 he was in Rome and Naples, where he witnessed an eruption of Vesuvius, which became a favourite theme for later paintings, and was influenced by Vernet's pictures to carry his experiments in lighting into the field of landscape. Returning to England, he spent an unprofitable fifteen months at Bath from 1775, and settled again in Derby in 1777 for the rest of his life. Exh. RA 1778-94. He was elected ARA 1781; RA 1784 — but he declined the honour and later held the RA in considerable suspicion.

His finest portrait groups date from the 1780s: the 'Coke family' (Derby); 'Mr and Mrs Thomas Gisborne', 1786 (BAC Yale), and his Derbyshire landscapes, which often experiment with moonlight and odd conditions of sunlight, date from these years. In his last years he suffered from much ill-health and was depressingly valetudinarian and cantankerous, but he painted some large Shakespeare pictures for Boydell. He was one of the most interesting artists of his generation and his work is well represented in the Derby Museum.

(His work is well documented from a number of account books and is fully treated in Benedict Nicolson, J.W. of D., 2 vols, 1968.)

JOSEPH WRIGHT. 'Unknown lady.' Wood. 12½ ins. x 9½ ins. s. & d. 1777. Christie's sale 20.11.1953 (91).
This rather trivial painter, of American origin, should not be confused with Joseph Wright of Derby.

JOSEPH WRIGHT of Derby. 'Francis and Charles Mundy.' 71½ ins. x 54ins. Painted 1782. Exh. RA 1782 (165). Christie's sale 19.11.1965 (54).
This is in Wright's more sophisticated Derbyshire style, after his visit to Italy.

WRIGHT, Joseph 1756-1793

American painter of portraits and miniatures. Son of Mrs. Patience Wright, the modeller in wax. Born Bordentown, New Jersey, 16 July 1756; died of yellow fever at Philadelphia 1793. Followed his mother to England after 1772; became a pupil of West and was working at Norwich 1773/74 *(Fawcett, 79)* where his portraits are rather doll-like variants of West's. Entered RA Schools 1775. Exh. a portrait SA 1780, and a portrait of his mother modelling a head in wax RA 1780. Returned via Paris to US 1782, where he worked in New York City and Philadelphia.

(Groce and Wallace.)

RICHARD WRIGHT. 'The Fishery.' 35½ins. x 53ins. Signed. Engraved by Woollett, 1768. Sotheby's sale 23.11. 1966 (42).
This is perhaps Wright's best known work and makes it seem very unlikely he was 'self taught'.

WRIGHT, Richard *c.* 1720-*c.* 1775
Liverpool painter of marine subjects. Born
Liverpool *c.* 1720; in practice there by 1746; he died
'before 1775' *(Edwards)*. He is said to have started
as a house and ship painter. Exh. SA 1762-73; FS
1764, and won premiums from the Society of Arts
for 'seapieces' 1766 and 1768. He painted the
marine view in the background of Reynolds'
'Duchess of Ancaster', SA 1764, and he gave a
London address at the times of his exhibiting. He
was a competent self-taught painter. His widow,
Louisa, exh. still-life pictures, mainly fruit pieces,
SA 1770-77. An elder daughter, **Nancy,** born
Liverpool 29 May 1748, exh. landscapes SA
1772-73. Another daughter, **Elizabeth,** born
Liverpool 21 March 1751, exh. landscapes SA
1773-76. His son, Edward (q.v.) also painted land-
scapes.

(Walker Art Gallery, Merseyside cat.; Archibald.)

WRIGHT, Thomas fl. 1728-1737
London portrait painter, copyist and picture
dealer, of rather modest talent. Employed as a
copyist by Sir William Heathcote 1728-37 *(MS. cat.
of Hursley Park)*. Took Richard Wilson (q.v.) as a
pupil for six years 1729. Presented a portrait of
'Joseph Bowles' to the Bodleian Library 1729.
Painted 'Simon Yorke' of Erthig, 1737 *(A.L. Cust,
Chronicles of Erthig, 1914, i, 258)*. He may be the
Thomas Wright who was buried at St. Paul's,
Covent Garden, 25 August 1749.

WYATT, T. fl. 1797-1804
Exh. three landscapes at RA 1797, 1800 and 1804.

WYMER, R.W. fl. 1786
Exh. a landscape and a 'farmyard', RA 1786.

WYNNE, Richard fl. 1775
Hon. exh. of 'a Head of a Bacchant', SA 1775.

Y

YATES, Lieut. Thomas, RN *c.*1760-1796
Talented painter and engraver of marine subjects. Entered the Navy 1782; died 29 August 1796. Exh. RA 1788-94.

(A. Wilson.)

YEATHERD, John **1767-1795**
Portrait painter. Entered RA Schools 1788, aged

21. Exh. a portrait RA 1795, which was probably the portrait of 'Roger Flexman' of which a mezzotint by himself was published 1795 (taken over by another publisher 1796).

YORKE, Hon. Mrs. **fl.1771-1775**
Hon. exh. of landscapes in crayons SA 1771-75. She was Agneta Johnson, 2nd wife of Hon. Charles Yorke (d.1770) and died 1820.

Z

ZEEBROS **fl.1783**
Exh. 'A Smith's forge by moonlight', FS 1783.

ZEEMAN See SEEMAN

ZEER
FS 1783. Perhaps an error for Serres (q.v.).

ZOBLE, B. **fl.1798**
Exh. two landscapes with cattle, RA 1798.

ZOFFANY, Johann **1733-1810**
Portrait and history painter; the leading master of the theatrical conversation and upper-class conversation pieces. Born (Johannes Josephus Zauffaly) near Frankfurt a/M. 13 March 1733; died Strand-on-the-Green 11 November 1810. Trained at Regensburg as a German rococo history painter, but could adapt himself to any style at will. At Rome (with a brief interval back at Regensburg) 1750-57, where he studied under Masucci and became aware of what Mengs, Batoni and Dance were doing with British patronage. After a short interval at the court at Ehrenbreitstein, he came to London 1760 and was rescued by Garrick from servitude as a backroom painter for Benjamin Wilson (q.v.). With Garrick's encouragement he created a new kind of naturalistic theatre piece (usually advertising Garrick and popularised by good engravings). These were exh. SA 1762-69 as well as his best domestic conversation pieces.

Introduced in 1764 to the royal family, he produced remarkable informal royal portraits and groups, so that George III nominated him an RA

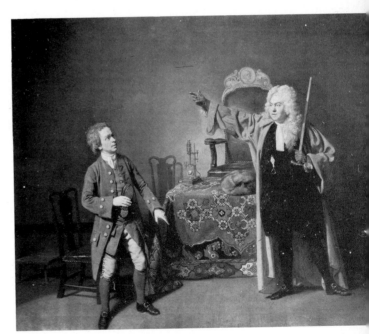

JOHANN ZOFFANY. 'Foote and Weston in The Devil upon Two Sticks.' *40ins. x 50ins. Exh. SA 1769 (214). From the Castle Howard collection.*
The play was a satire by Foote on the medical profession, who imitated in it, with great success, the President of the Royal College of Physicians. This is one of the last, and most completely naturalistic, of his theatre scenes.

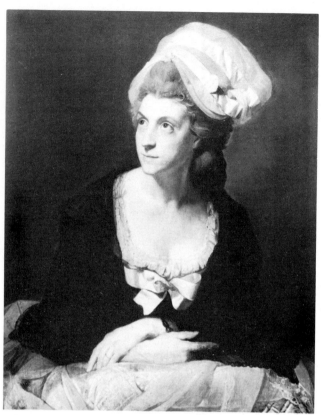

in December 1769. Exh. RA 1770-1800. His scale of life portraits, e.g. 'Mrs Woodhull', *c.*1770 (Tate Gallery), show remarkable powers of imitating Reynolds. His crowning work of this period is the 'Royal Academicians at the RA', RA 1772 (Royal Collection). Sent to Florence 1772 by Queen Charlotte to paint 'The Tribuna of the Uffizi' *(O. Millar, Z. and his Tribuna, 1966)* he lingered in Florence until 1778 (with a visit to Vienna in 1776, where he was made a Baron of the Holy Roman Empire by Maria Theresa). On his return to London he found that his own vogue and that of the conversation piece had evaporated, and he spent 1783-89 in India, where he made a fortune from portraying the British residents and the native princes. Only a few pictures of consequence, such as 'Plundering the King's Cellar, Paris', RA 1795 (formerly at Mentmore), date from after his return from India, and by 1800 he had given up painting altogether. Some of his best works are small scale full-length portraits.

(Mary Webster, Z. exh. cat., NPG, 1976.)

JOHANN ZOFFANY. 'The artist's second wife.' 29½ ins. x 24¼ ins. Painted c.1781/2. Ashmolean Museum, Oxford.
Up to 1979 in the possession of the painter's descendants. Absolutely certain portraits by Zoffany on the scale of life are not numerous, and they probably often pass under other names. At his best, as here, they are extremely accomplished.

JOHANN ZOFFANY. 'Earl Cowper, his wife, and the Gore family.' 30ins. x 38ins. Painted in Florence about 1775. B.A.C. Yale.
Painted for Lord Cowper about the time of his marriage (1775) with the eldest Gore daughter, at whom he is gazing, and who stands in front of a picture of a classical wedding. Zoffany has caught the rather raffish tone of Anglo-Florentine society, which contrasts with his sober London family groups.

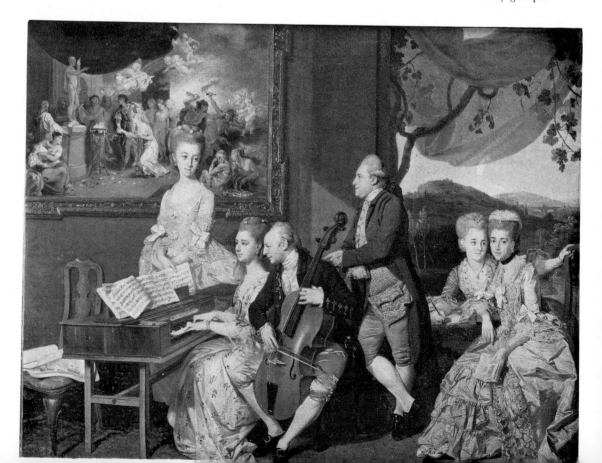

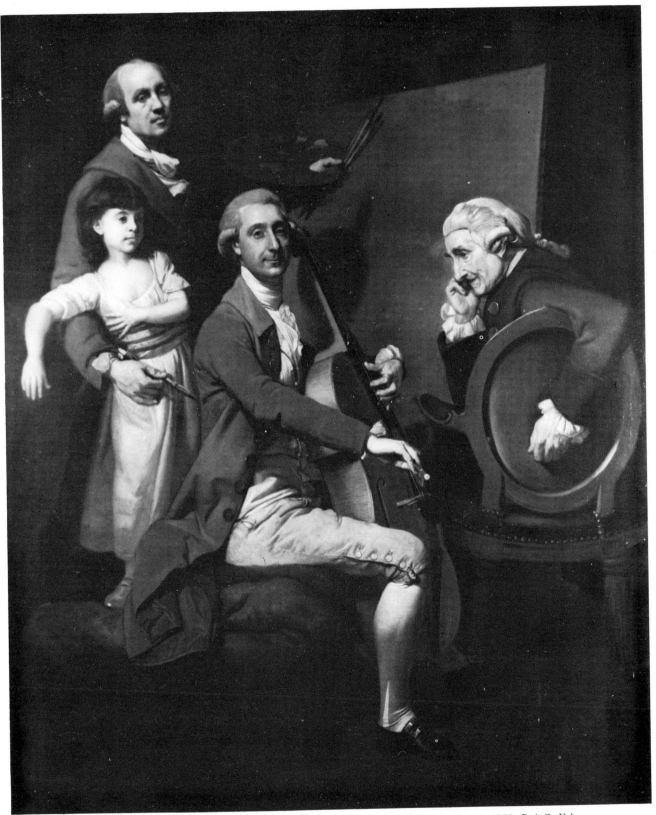

JOHANN ZOFFANY. 'The artist with his daughter and musical friends.' 77ins. x 65¾ins. Painted about 1780. B.A.C. Yale.
Painted before Zoffany went to India; Zoffany's eldest daughter was born about 1776. The musicians are perhaps Giacobbe and James Cervetto. Zoffany associated much with musicians.

JOHANN ZOFFANY. 'Plundering the King's Cellar at Paris Aug. 10. 1793.' 40¼ ins. x 49¾ ins. Exh. RA 1795 (18). Sotheby's sale (at Mentmore) 25.5.1977 (2423).
One of the few pictures Zoffany painted for exhibition after his return from India. It was perhaps painted in conscious imitation of pre-revolutionary French paintings.

ZUCCARELLI, Francesco 1702-1788

Italian painter of rococo landscapes with pastoral (or occasionally mythological or literary) figures. Born Pitigliano 1702; died Florence 1788. In Venice from *c*.1730. In the works for which he is known he belongs to the Venetian school and was much influenced by Marco Ricci (q.v.). Encouraged by Consul Smith he first came to England 1752-62, but later returned with greater success 1765-71. Exh. FS 1765-66 and 1782; SA 1767-68. He became a foundation RA and exh. RA 1769-73. Many examples of his work are in the royal collection. On returning to Venice he became briefly President of the Venice Academy. His light, pretty, and totally unserious landscapes appealed to British taste and that of George III, to the detriment and irritation of Richard Wilson (q.v.).

E.C-M.; M. Levey, 'F.Z. in England', Italian Studies, XIV (1959), 1-20.)

ZUCCHI, Antonio Pietro Francesco 1726-1795

Decorative and historical painter. Born Venice 1726; died Rome 26 December 1795. Trained at Venice. He left Venice for Rome in 1761 with James Adam, with whom he travelled in Italy 1762, making drawings of decoration. He returned to Venice but accepted an invitation from Robert Adam to come to London in 1766, where he became Robert Adam's chief decorative painter, and developed an elegant neo-classic style. ARA 1770. Exh. infrequently at RA between 1770 and 1779, mainly architectural themes. He married Angelica Kauffmann (q.v.) 1781, with whom he retired the same year, via Venice, to Rome. Exh. FS 1783 a 'Jupiter and Calista', from Rome.

(E.C-M.)

FRANCESCO ZUCCARELLI. 'Mrs. Clayton's house at Harleyford, 1760.' 23ins. x 35ins. John Warde, Squerryes Court, Westerham.
Painted for John Warde 1760. Engraved by Thomas Major. It is a typical Zuccarelli view of the Venetian countryside, with contadini
figures, with an accurate view of an English villa included.

FRANCESCO ZUCCARELLI. 'Macbeth and the Witches.' 37ins. x 47ins. s. & d. 1760. Christie's sale 14.12.1956 (52).
Engraved by W. Woollett, 1770. An unusual example of a Shakespearean theme for Zuccarelli: unrelated to the stage and with the
landscape in imitation of a Gaspard Poussin storm scene.

Bibliography

With abbreviations used and some notes on sources

Archer Mildred Archer, *India and British Portraiture, 1770-1825,* 1979.

Archibald E.H.H. Archibald, *Dictionary of Sea Painters,* Antique Collectors' Club, 1980.

Audin and Vial Marius Audin and Eugène Vial, *Dictionnaire des artistes et ouvriers d'art de la France: Lyonnais,* Paris, 2 vols., 1918/9.

Baker's Dairy *The Diary of John Baker, Barrister of the Middle Temple,* ed. Philip C. Yorke, 1931.

Bewick Memoirs *A Memoir of Thomas Bewick* written by himself, 1862.

Boydell Shakespeare Gallery The most compendious record of this is *The Boydell Shakespeare Prints,* Arno Press, New York, 1979 (with an introduction by A.E. Santaniello).
This reproduces the 100 large engravings and also the 100 small engravings (some of them repeated) from the 9 vol. octavo edition.

Brun Carl Brun, *Schweizerisches Künstlerlexikon,* 4 vols., Frauenfeld, 1905-1917.

Brune Abbé Paul Brune, *Dictionnaire des artistes et ouvriers d'art de la France: Franche-Comté,* Paris, 1912.

Chaloner Smith John Chaloner Smith, *British Mezzotinto Portraits,* 5 vols. and a vol. of plates, 1878-1883.

Collins Baker. Lely C.H. Collins Baker, *Lely and the Stuart Portrait Painters,* 2 vols., 1912.

Colvin Howard Colvin, *Biographical Dictionary of British Architects, 1600-1840,* 1st edition 1954; 2nd 1978.

Constable, Richard Wilson W.G. Constable, *Richard Wilson,* 1953.
This includes valuable notes on Wilson's pupils and imitators and painters whose works have been confused with Wilson's.

Croft-Murray and Hulton Edward Croft-Murray and Paul Hulton, *Catalogue of British Drawings — British Museum,* vol. 1, 1960; vol. 2 (by Croft-Murray) should appear in 1981. For Croft-Murray, see also under **E. C-M.**

Crookshank and Knight of Glin Anne Crookshank and the Knight of Glin, *Irish Portraits 1660-1860.* Catalogue of an exhibition held in Dublin, London and Belfast. 1969/70.

Crookshank and Knight of Glin, 1978 *The Painters of Ireland, c.1660-1920.*
This has the largest collection of illustrations of paintings by Irish painters and valuable bibliographical notes, but a certain number of the attributions are rather speculative.

Delany, Mrs., 1861 *Autobiography and Correspondence of Mrs. Delany,* 1861.

Dennistoun James Dennistoun, *Memoirs of Sir Robert Strange, Kt. and Andrew Lumisden,* 2 vols., 1855.

Descamps J.B. Descamps, *La Vie des Peintres Flamands, Allemands et Hollandais,* Paris, 4 vols., 1763.

Dimier. 1930 Louis Dimier, *Les Peintres français du xviii siècle,* Paris and Bruxelles, vol. 1 1928; vol. 2 1930.

DNB *Dictionary of National Biography,* 22 vols.

Donzelli and Pilo Carlo Donzelli and G.M. Pilo, *I Pittori del Seicento Veneto,* 1967.

Duleep Singh H.H. Prince Frederick Duleep Singh, *Portraits in Norfolk Houses,* Norwich, 2 vols., c.1927.

E. C-M Edward Croft-Murray, *Decorative Painting in England 1537-1837,* vol. i: Early Tudor to Sir James Thornhill, London, 1962.

E.C-M do. vol. ii: The Eighteenth and Early Nineteenth Centuries, 1970.
This has lists of known works and very full bibliographies and has been a major source of reference.

Edwards Edward Edwards, *Anecdotes of Painters,* 1808.
Planned as a continuation of Walpole: it is largely derived from personal knowledge, and, although sketchy, is sometimes our only source of information.

Egerton Judy Egerton, *British Sporting and Animal Pictures 1655-1827* (in the Paul Mellon Collection), London, '1978' [actually 1980].

Egmont *Diary of the 1st Earl of Egmont, 1730-1747,* in Historical MSS. Commission, 3 vols., 1920-1923.

Farington *The Diary of Joseph Farington, 1793-1821.*
Quoted under the day of entry. The full text is still being published (vols. 1 to 6 ed. K. Garlick and A. Macintyre) and has only reached 1804. For later dates the 8 vols. of excerpts (ed. Greig. 1922ff.) have had to be used. Farington was extremely inquisitive about the dates of birth of his fellow artists.

Farrer Rev. Edmund Farrer, *Portraits in Suffolk Houses (West),* Bernard Quaritch, London, 1908.
The MS of *Suffolk Houses (East)* is in the Ipswich Public Library.

Fawcett Trevor Fawcett, *Eighteenth Century Art in Norwich,* in *Walpole Society,* XLVI (1978), 71-90.

Fleming, Adam John Fleming, *Robert Adam and his Circle in Edinburgh and Rome,* 1962.

Forcella Vincenzo Forcella, *Iscrizioni delle Chiese e d'altri edificii di Roma,* Roma, 14 vols., 1869-1884.

Ford, Byres Brinsley Ford, *James Byres,* in *Apollo,* XCIX (June 1974), 446-461.

Foskett Daphne Foskett, *A Dictionary of British Miniature Painters,* 2 vols., 1972.

Foster Sir William Foster, *British Artists in India 1760-1820,* in *Walpole Society,* XIX (1931), 1-88; brief additional notes in XXI (1933), 108/9.

Goulding and Adams Richard W. Goulding and C.K. Adams, *Catalogue of the Pictures belonging to the Duke of Portland. K.G.,* 1936.

Grant Colonel Maurice Harold Grant, *A chronological History of Old English Landscape Painters,* 3 vols., n.d. and 1947.
A revised edition in 8 vols., Leigh on Sea, 1957-1961. Colonel Grant had looked attentively at a great many bad pictures and he illustrates many landscapes attributed to little known painters (usually signed, but he gives no indication). There is a great deal of waffle but he lists engravings.

Groce and Wallace George C. Groce and David H. Wallace, *The New York Historical Society's Dictionary of Artists in America 1564-1860,* New Haven and London, 1957.
This is the most compendious one-volume dictionary and has the essential bibliographical information.

Gunnis Rupert Gunnis, *Dictionary of British Sculptors 1660-1851,* 1953.
There is also a very slightly revised edition (n.d.).

Hall, Marshall Marshall Hall, *The Artists of Northumbria,* Newcastle upon Tyne, 1973.

Hammelmann Hanns Hammelmann, *Book illustration in Eighteenth Century England,* ed. T.S.R. Boase, 1975.

Harris John Harris, *The artist and the Country House,* 1979.
Very abundantly illustrated but with many speculative attributions.

Haswell-Miller and Dawnay A. Haswell-Miller and N.P. Dawnay, *Military paintings in the Collection of Her Majesty The Queen,* 2 vols., 1966 (plates) and 1970 (text).

Hayward List A list, preserved in the Print Room of the British Museum, of artists of British nationality who visited Rome between 1753 and 1775. Compiled by or for Richard Hayward, the sculptor (see *Walpole Society,* XXXVI (1960), 37, n.9).

Hearne Thomas Hearne, *Remarks and Collections,* 11 vols., Oxford Historical Society.

Herrmann Luke Herrmann, *British Landscape Painting of the Eighteenth Century,* 1973.

Hofstede de Groot *A Catalogue Raisonné of the works of the most eminent Dutch Painters of the Seventeenth Century,* English edition, 8 vols., 1908-1927. (Vols. 9 and 10 exist only in the German edition, Esslingen, Stuttgart and Paris 1926 and 1928.)

Hutchison Sidney D. Hutchison, *The Royal Academy Schools, 1708-1830,* in *Walpole Society,* XXXVIII (1962), 123-191.
This is often the only source (unquoted in the text) for the christian names and dates of birth of many minor painters. When a previously unknown date of birth is given for a

painter who entered the RA Schools, this is the source. Artists of course are notoriously unreliable about their dates of birth but these were the dates accepted at the time.

Ingamells John Ingamells, *The English Episcopal Portrait 1559-1835,* Paul Mellon Centre (privately published) 1981.

Irwin, 1966 David Irwin, *English Neo-classical Art,* 1966.

Irwin, 1975 David and Francina Irwin, *Scottish Painters at home and abroad, 1700-1900,* 1975.

Jackson, 1892 William Jackson, *Papers and pedigrees mainly relating to Cumberland and Westmorland,* 2 vols., 1892.

Jones, Memoirs *Memoirs* of Thomas Jones, ed. A.P. Oppé, in *Walpole Society,* XXXII (1946-1948).

Kauffmann, 1973 C.M. Kauffmann, *Catalogue of Foreign Paintings,* Victoria and Albert Museum, London, vol. i: Before 1800, 1973.

Kerslake John Kerslake, *National Portrait Gallery: Early Georgian Portraits,* 2 vols., 1977.

Leger Galleries exh. 1978 *'The Montagu Family at Sandleford Priory' by Edward Haytley, 1744,* in an exhibition of English Eighteenth Century Paintings, June-July 1978.

Long Basil Long, *British Miniaturists,* 1929.

Although not always as up to date as Mrs. Foskett's *Dictionary* (q.v.), this is much richer in incidental information.

Lugt Fritz Lugt, *Répertoire des Catalogues de Ventes Publiques intéressant l'art ou la curiosité,* vol. I. Première période, vers 1600-1825, La Haye, 1938.

Mallalieu H.L. Mallalieu, *The Dictionary of British Watercolour Artists up to 1920,* Antique Collectors' Club, 2 vols., 1976, 1980.

Marlier Georges Marlier, *Les séjours à Londres et à Hambourg du portraitiste Jean-Laurent Mosnier,* in *Actes du XIXᵉ Congrès International d'Historie de l'Art,* Paris, 1959, 405-411.

Millar, 1963 (Sir) Oliver Millar, *The Tudor, Stuart and Early Georgian Pictures in the Collection of Her Majesty The Queen,* 2 vols., 1963.

Millar, 1969 (Sir) Oliver Millar, *The later Georgian Pictures in the Collection of Her Majesty The Queen,* 2 vols., 1969.

Nichols John Nichols, *Literary Anecdotes of the Eighteenth Century,* 9 vols., 1812-1815.

Nicolson *Diaries of William Nicolson, Bishop of Carlisle,* in *Transactions of Cumberland and Westmorland Antiquarian and Archaeological Societies,* N.S. vols. I-V (reprinted in one vol. Kendal, 1905).

Nisser Wilhelm Nisser, *Michael Dahl and the contemporary Swedish School of Painting* (in England), Uppsala (London), 1927.

Noon Patrick J. Noon, *English Portrait drawings and miniatures,* Yale Center for British Art, 1979.

O'Donoghue Freeman O'Donoghue, *Catalogue of Engraved British Portraits. . . in the British Museum,* 6 vols. (the last two with Henry M. Hake), 1908-1925.

Ogdens Henry V.S. Ogden and Margaret S. Ogden, *English taste in Landscape in the Seventeenth Century,* Ann Arbor, 1955.

Owst G.R. Owst, *Iconomania in eighteenth century Cambridge,* in *Proceedings of Cambridge Antiquarian Society,* xlii (1949), 67-91.

Papendiek *Court and Private Life in the Time of Queen Charlotte: being the Journals of Mrs. Papendiek,* ed. Mrs. Vernon Delves Broughton, 2 vols., 1887.

Pavière Sydney H. Pavière, *A Dictionary of British Sporting Artists,* 1965.

Poole Mrs. Reginald Lane Poole, *Catalogue of Portraits in the possession of the University, Colleges, City and County of Oxford,* vol. i, 1912; vol. 2, 1925; vol. 3, 1925.

Redgrave *Dictionary of Artists of the English School,* new ed. revised to the present date, 1878.

The latest one volume work including artists of all sorts and periods, but now often out of date. It is only given as a reference when information from other sources is not available, but it can almost always be looked at with profit.

Rimbault Dibdin E. Rimbault Dibdin, *Liverpool Art and Artists in the Eighteenth Century,* in *Walpole Society* VI (1918), 59-93.

Rombouts and Van Lerius Ph. Rombouts and Th. van Lerius, *De Liggeren en andere Historische Archieven der Antwerpsche Sint Lucasgilde,* 2 vols., Antwerp 1864-1876 (anastatic reprint Amsterdam 1961).

Romney, Rev. J. Rev. John Romney, *Memoirs of the Life and Works of George Romney. . .also some particulars of the life of Peter Romney, his brother,* London, 1830.

Smith's 'Nollekens' John Thomas Smith, *Nollekens and his times,* 2 vols., ed. and annotated by Wilfred Whitten, 1920 (original edition 1829).

Steegman John Steegman, *A survey of portraits in Welsh Houses,* vol. i *(North Wales),* Cardiff, 1957; vol. 2 *(South Wales),* Cardiff, 1962.

Strickland Walter G. Strickland, *A Dictionary of Irish Artists,* 2 vols., 1913.
A most remarkable work, with lists of works where possible. Strickland had access to a number of papers which no longer survive.

Talley, Bardwell M. Kirby Talley, *Thomas Bardwell of Bungay,* in *Walpole Society* XLVI (1976-1978), 91-163.

Talley and Groen M. Kirby Talley and Karin Groen, *Thomas Bardwell and his Practice of Painting,* in *Studies in Conservation,* 20 (1975), 44-113.

Th.-B. Dr. Ulrich Thieme and Dr. Felix Becker, *Allgemeines Lexikon der bildenden Künstler, von der Antike bis zur Gegenwart,* 37 vols., Leipzig, 1907-1950.

Urrea Jesus Urrea Fernandez, *La Pintura Italiana del Siglo XVIII en España,* Valladolid, 1977.

Vertue or **Vertue MSS** The notebooks of George Vertue (in British Museum), published in *Walpole Society: Vertue i,* XVIII (1929-1930); *Vertue ii* XX (1931-1932); *Vertue iii,* XXII (1933-1934); *Vertue iv,* XXIV (1935-1936); *Vertue v,* XXVI (1937-1938); index to *Vertue i-v,* XXIX (1940-1942); *Vertue vi,* XXX (1948-1950).
These were the basis of Walpole's *Anecdotes* (q.v.) but contain a mass of facts which Walpole did not use.

Vesme *Schede Vesme (L'Arte in Piemonte dal XVI al XVIII Secolo),* Società Piemontese di Archeologia e Belle Arti, 3 vols., Torino, 1963, 1966 and 1968.
These are extracts relating to artists from the Piedmontese archives accumulated by Alessandro Baudi di Vesme.

Walker Art Gallery, Merseyside cat. Walker Art Gallery, Liverpool, *Catalogue of Merseyside Painters, People and Places,* 1978.

Walpole Horace Walpole, *Anecdotes of Painting in England,* original edition 4 vols., 1765-1771.
I have used the most convenient edition, 3 vols., 1876, ed. by Ralph N. Wornum and including the additions of the Rev. James Dallaway.
A volume of extracts from Walpole's Collections, by Frederick W. Hilles and Philip B. Daghlian, was published by Yale University Press 1937 as *Walpole's Anecdotes of Painting in England,* vol. V.

Wanley *The Diary of Humfrey Wanley 1715-1726,* ed. C.E. and Ruth C. Wright, the Bibliographical Society, London, 1966.

Waterhouse (1978) Ellis Waterhouse, *Painting in Britain 1530-1790,* 4th edition, 1978.

Weyerman Jacob Campo Weyerman, *De Levensbeschryvingen der Nederlandsche Konst-Schilders. . .,* 3 vols., The Hague, 1729.

Whitley William T. Whitley, *Artists and their friends in England 1700-1799,* 2 vols., Cambridge, 1928.
Maddeningly published without references, but the MSS Collections, giving many of Whitley's sources, are in the Print Room of the British Museum.

Whitley 1800-1820 William T. Whitley, *Art in England 1800-1820,* 1928.

Wilson Arnold Wilson, *A Dictionary of British Marine Paintings,* 1963.

Wood, C. Christopher Wood, *The Dictionary of Victorian Painters,* 2nd edition, Antique Collectors' Club, 1978.

Wood, H.T. Sir Henry Trueman Wood, *A History of the Royal Society of Arts,* 1913.
On pp.162-212 are lists of the chief prize winners.

Yorke *The Travel Journal of Philip Yorke 1744-1763,* in *Publications of the Bedfordshire Historical Record Society* XLVII (1968), 125-163.

Datable Illustrations

Chronological list of those illustrations which are either dated or fairly closely datable, 1700-1800

1700 Knyff (p.211).
1702 Meller (p.237); J. Richardson (p.310).
1707 Medina (p.237).
1708 Knyff (p.210); Thornhill (p.374); Warrender (p.401).
1709 D'Agar (p.97).
1710 Coning (p.86); J. Griffier (p.150); G.A. Pellegrini (p.274); Schuermans (p.335); Thornhill (p.369).
1711 T. Hill (p.171).
1712 R. Van Bleeck (p.378); J. Verelst (p.393).
1713 Parmentier (p.267); G.A. Pellegrini (p.273).
1714 Maubert (p.235); T. Murray (p.253).
1715 S. Ricci (p.308).
1717 Kneller (p.210).
1719 W. Kent (p.204).
1720 A. Bellucci (p.48); Ferrers (p.125).
1721 Hysing (p.190).
1722 Angellis (p.30); G.B. Bellucci (p.49).
1723 Gibson (p.144); Petton (p.279); J. Richardson (p.311).
1724 J. Alexander (p.24); Smibert (p.350); Waitt (p.396); Worsdale (p.425).
1725 Dellow (p.106); G. Lambert (p.215); J. Richardson (p.310); M. Verelst (p.394).
1726 Angellis (p.30); W. Jones (p.198); Saunders (p.332).
1728 Aikman (p.23).
1730 P.A. Rysbrack (p.327).
1731 J. Highmore (p.170); J. Vanderbank (p.379).
1732 Amigoni (p.19); Casteels (p.74); Dahl (p.98); Hogarth (p.176); C. Philips (p.282); H. Van Der Mijn (p.384).
1733 C. Philips (p.280); H. Van Der Mijn (p.383).
1734 C. Collins (p.85); J. Verelst (p.392).
1735 Amigoni (p.28); Gawen Hamilton (p.157); Hysing (p.190); Nebot (p.255); J. Vandiest (p.386).
1736 Amigoni (p.28); Dandridge (p.101); Davison (p.104); E. Seeman (p.337).
1737 Robert Taylor (p.366); Tymewell (p.376).
1738 T. Black (p.54); C. Collins (p.85); C. Philips (p.281); T. Ross (p.320); P.A. Rysbrack (p.328); J. Vanderbank (p.380).
1739 Carpentiers (p.70); Fayram (p.123); Heins (p.167); Ramsay (p.295); I. Seeman (p.338); Van Loo (pp.388/9).
1740 Hogarth (frontispiece); Buck (p.65); Fellowes (p.124); Frye (p.132); Knapton (p.208).
1741 Bardwell (p.37); Kyte (p.212); P. Mercier (p.239); Van Loo (p.387); W. Verelst (p.394).
1742 P. Mercier (p.239); Reyschoot (p.307); Whood (p.410).
1743 Heins (p.167); Reyschoot (p.306); S. Scott (p.337).
1744 Beare (p.46); Haytley (p.156); J. Highmore (p.170); Knapton (p.208); E. Penny (p.275); Scaddon (p.332).
1745 Denune (p.107); Gainsborough (p.134); Hogarth (p.176); Slaughter (p.348).

1746 Du Pan (p.114); J. Green (p.149); Mosman (p.250); Pond (p.288); Reynolds (p.301).

1747 Beare (p.45); Cotes (p.91); Cranke (p.94); Green of Oxford (p.149); J. Highmore (p.170); G. Lambert (p. 215); Slaughter (p.348).

1748 G. Lambert (p.215); P. Mercier (p.238); William Taylor (p.367); S. Wale (p.397); R. Wilson (p.418); Wollaston (p.421).

1749 A. Devis (p.109); S. Scott (pp.335/6).

1750 Gravelot (p.148); R. Hill (p.171); Steele (p.358); B. Wilson (p.416).

1751 Adolph (p.22); J. Astley (p.34); Bardwell (p.36); Hubner (p.184); Knapton (p.209); E. Langton (p.217); J. Seymour (p.341); G. Smith (p.351).

1752 Gavin Hamilton (p.155); Hudson (p.186); Luyten (p.229); J.H. Simpson (p.345); B. Wilson (p.416); Wootton (p.423).

1753 W. Smith (p.356); Soldi (p.356); B. Wilson (p.415).

1754 Canaletto (p.69); Gainsborough (p.135); Liotard (p.225); Ramsay (p.295); J.M. Williams (p.411); R. Wilson (p.418).

1755 A. Devis (p.108); Hudson (p.185); H. Pickering (p.283); Ramsay (p.296); Reynolds (p.301); Shackleton (p.342); Soldi (p.357); P. Van Bleeck (p.391).

1756 A. Cozens (p.92); Judith Lewis (p.223); Schalch (p.334); Wills (p.414).

1757 T. Mitchell (p.242); F. Van Der Mijn (p.383); R. Van Der Mijn (p.384); J.S. Webster (p.403); Worlidge (p.424).

1758 Mathias (p.234); E. Penny (p.274).

1759 E. Alcock (p.23); H. Pickering (p.283); W. Smith (p.355).

1760 G. Chalmers (p.75); Dance (p.99); Exshaw (p.121); Morison (p.245); Pyle (p.291); Ramsay (p.319); G. Romney (p.319); Joseph Wright (p.426); Zuccarelli (p.435).

1761 Casali (p.73); Chamberlin (p.78); Lindo (p.224); Pine (p.285); Pugh (p.290); G. Smith (p.352); Worlidge (p.424).

1762 Dawes (p.105); R. Hunter (p.188); John Lewis (p.223); Nebot (p.255); Ramsay (p.295); Schaak (p.333); Joseph Wright (p.426).

1763 C. Alexander (p.24); Harvie (p.161); Reynolds (p.302); J.I. Richards (p.309); C.H. Stoppelaer (p.360).

1764 Black (p.53); Cotes (p.91); Maucourt (p.236); E. Penny (pp.274/5); Rymsdyk (p.326); Swaine (p.364).

1765 Cotes (p.90); Delacour (p.106); Ramsay (p.296); John Russell (p.325); D. Serres (p.338); W. Tomkins (p.371).

1766 Catton (p.74); Falconet (p.123); Forrester (p.129); N. Hone (p.180); Jouffroy (p.199); Keyse (p.206); McLauchlan (p.230); Marlow (p.232); Patch (p.269); B. West (406).

1767 Carpentiers (p.70); J. Clarke (p.82); Cotes (p.91); Dance (p.99).

1768 H. Barron (p.41); Chamberlin (p.76); G. James (p.193); Marchi (p.231); Peters (p.277); G. Romney (p.316); R. Wilson (p.417); R. Wright (p.430).

1769 Allan (p.26); M. Gardiner (p.140); Garvey (p.143); Gilpin (p.146); T. Kettle (p.205); Reynolds (p.303); Zoffany (p.431).

1770 Allan (p.26); Barret (p.40); H. Barron (p. 41); Baudenbach (p.43); Berridge (p.51/2); Lion (p.224); J.I. Richards (p.309); G. Romney (p.318); W. Thompson (p.368).

1771 John Atkinson (p.34); Baker (p.35); Brompton (p.60); Hickey (p.169); Pine (p.284); A. Runciman (p.322); Sanders (p.331); Willison (p.414); Joseph Wright (p.427).

1772 Barry (p.42); W. Hodges (p.174); A. Kauffmann (p.202); T. Kettle (p.205); Killingbeck (p.206); Mortimer (p.248); Simmons (p.344); B. Vandergucht (p.380); Wheatley (p.408); W. Williams (p.412).

1773 N. Dall (p.98); Haughton (p.162); Mullins (p.251); Reynolds (p.304); Seton (p.339); B. Vandergucht (p.381).

1774 Canter (p.69); Forbes (p.128); T. Jones (p.197); A. Kauffmann (p.200); T. Kettle (p.205); J. Mortimer (p.248); Parkinson (p.266); E. Penny (p.275); J. Rigaud (p.311).

1775 Dance (p.100). Feary (p.124); H.D. Hamilton (p.157); N. Hone (p.179); W. Jefferys (p.194); W. Jones (p.198); Killingbeck (p.207); T. Roberts (p.314); Zoffany (p.432).

1776 Barry (p.42); Cipriani (p.81); W. Hodges (p.174); Parry (p.267).
1777 S. Elmer (p.119); Garbrand (p.140); Northcote (p.259); Sanders (p.331); A. Van Der Mijn (p.382); Walton (p.398); Joseph Wright (p.429).
1778 T.A. Devis (p.110); Doughty (p.112); Downman (p.113); Hagarty (p.154); Holman (p.178); Ibbetson (p.191); C. Lewis (p.222); Reynolds (pp.305,324); W. Williams (p.413).
1779 Barbut (p.36); T. Burgess (p.65); Gardner (p.141); Gaugain (p.144); N. Hone (p.179); North (p.258); Quadal (p.292); Vandyke (p.386); B. West (p.404).
1780 Chamberlin (p.78); Copley (pp.80,87); Humphry (p.187); More (p.244); Reynolds (p.304); B. Vandergucht (p.380); Wheatley (p.409); Zoffany (p.433).
1781 Carter (p.72); Chalmers (p.76); Hickey (p.169); Parkinson (p.265); W. Tate (p.365); Joseph Wright (p.426); Zoffany (p.432).
1782 Bigg (p.52); Burney (p.67); Downman (p.113); Gainsborough (p.137); T. Jones (p.213); Reynolds (p.304); J.F. Rigaud (p.312); Joseph Wright (p.428).
1783 Allan (p.25); Beechey (p.47); Carter (p.71); Foldsone (p.128); Fuseli (p.133); Gainsborough (p.139); Home (p.178); Poggi (p.287); Vaslet (p.392).
1784 Ashford (p.33); Bourgeois (p.56); Gavin Hamilton (p.155); W. Hamilton (p.158); Haughton (p.163); P. Hoare (p.172); Hoppner (p.182); Loutherbourg (p.227); Northcote (p.260); Opie (pp.262/3/4); A. Runciman (p.322); Salisbury (p.329); Webber (p.402).
1785 A.W. Devis (p.109); A. Pether (p.278); Pocock (p.286); G. Stuart (p.361).
1786 Alleyne (p.27); Gainsborough (p.136); Garrard (p.142); More (p.244); Nasmyth (p.254).
1787 Gainsborough (p.139); Grignion (p.151); Lawrence (p.219); Ramberg (p.294); Rising (p.313); Van Der Puyl (p.385).
1788 Beach (p.44); De Wilde (p.111); W. Hamilton (p.159); A. Kauffmann (p.201); G. Ralph (p.293); Reynell (p.300); Singleton (p.347); Joseph Wright (p.427).
1789 Beach (p.44); Bruyn (p.64); S. Collings (p.84); James Harvey (p.161).
1790 Barker (p.39); M. Brown (p.62); S. Collings (p.84); Livesay (p.226); Loutherbourg (p.226); J. Millar (p.240); Peters (p.276); A. Pope (p.289).
1791 Artaud (p.32); Beck (p.46); R. Cosway (p.89); Gooch (p.147); Hoppner (p.181); G. Morland (p.246); D. Pellegrini (p.272); W.A. Smith (p.355).
1792 Fagan (p.122); W. Murray (p.253); P. Reinagle (p.299); Rouby (p.321).
1793 L. Abbott (p.21); Anderson (p.29); Barker (p.38); M. Brown (p.62); A.W. Devis (p.109); Dupont (p.116); Edwards (p.118); Freebairn (p.130); Hickel (p.169); G. Morland (p.246); Northcote (p.261); J.F. Rigaud (p.312); M. Shee (p.343).
1794 Fielding (p.126); Hardy (p.160); Raeburn (p.216); Lawrence (p.220); Lawrence (p.221); Mosnier (p.250); M. Shee (p.343).
1795 Chandler (p.79); Howes (p.183); Lawrence (p.220); John Russell (p.325); Singleton (p.346); Stubbs (p.363); Vaslet (p.390); Zoffany (p.434).
1796 Beechey (p.47); Northcote (p.259); J.F. Rigaud (p.312); C. Towne (p.371).
1797 Arnald (p.31); Fielding (p.127); Maynard (p.236); G. Romney (p.318); Tresham (p.373); J. Ward (p.400); B. West (p.405).
1798 Danloux (p.102); De Longastre (p.107); Gilpin (p.145); W. Payne (p.271); Walmsley (p.398).
1799 Marshall (p.233); Rathbone (p.297); Rooker (p.320); J. Ward (p.400).
1800 Head (p.166); Walton (p.399).

Other books on art published by the

Antique Collectors' Club
publishers of standard reference works

**This volume is one of a series of three dictionaries dealing with British art.
The other two are:**

The Dictionary of Victorian Painters *by Christopher Wood*
 The revised 2nd edition contains details of some 11,000 artists together with 540 examples of their work.
 This substantial book has 764 pages and is universally accepted as the standard work of reference on
 British art of the period 1840-1900.

The Dictionary of British Artists 1880-1940 *by Greutzner and Johnson*
 Details some 41,000 artists working during this fertile period, many of whom feature in no other work of
 reference. The information for this 567 page book was obtained from a large number of contemporary
 sources including 49 of the main exhibition centres during the period.

**A separate series deals with paintings in terms of subject matter.
These include:**

Dictionary of Sea Painters *by E.H.H. Archibald*
 The Curator of Oil Paintings at the National Maritime Museum, Greenwich. 700 black and white and 32
 coloured illustrations, together with drawings and discussion of the evolution of ship design, flags and
 other means of dating paintings. The subject is covered on a global basis and has already won wide
 critical acclaim.

The Dictionary of British Watercolour Artists *by Huon Mallalieu*
 The standard work on British watercolour artists.
 Volume I The Text, 298 pages.
 Volume II The Plates, 268 pages, 804 black and white illustrations.

Other art titles include:
Dictionary of Western Sculptors in Bronze *by James Mackay*
The Royal Society of British Artists 1824-1893. *A listing of all the artists and their works exhibited.*
British 19th Century Marine Painting *by Denys Brook-Hart*
British 20th Century Marine Painting *by Denys Brook-Hart*
Dutch Painters of the 19th Century *by Marius*
Collecting Miniatures *by Daphne Foskett*

The Antique Collectors' Club has 11,000 members and the monthly journal sent free to members
discusses in more depth than is normal for a collectors' magazine the type of antiques and art available to
collectors. It is the only British antiques magazine which has consistently grown in circulation over the past
decade.

The Antique Collectors' Club also publishes a series of books on antique furniture and horology, together
with various standard works connected with arts and antiques. It also publishes a series of practical books,
invaluable to collectors, under the general heading of the "Price Guide Series" (price revision lists published
annually).
New titles are being added to the list at the rate of about ten a year. Why not ask for an updated catalogue?

The Antique Collectors' Club, 5 Church Street, Woodbridge, Suffolk, England
Telephone 03943 5501